FABRIC

ALSO BY VICTORIA FINLAY

Colour: Travels through the Paintbox

Jewels: A Secret History

The Brilliant History of Color in Art

FABRIC

THE HIDDEN HISTORY OF THE MATERIAL WORLD

VICTORIA FINLAY

PEGASUS BOOKS
NEW YORK LONDON

FABRIC

Pegasus Books, Ltd.
148 West 37th Street, 13th Floor
New York, NY 10018

First Pegasus Books paperback edition November 2022
First Pegasus Books cloth edition June 2022

ISBN: 978-1-63936-390-2

10 9 8 7 6 5 4 3

Printed in the United States of America
Distributed by Simon & Schuster
www.pegasusbooks.com

For the Maisin of Papua New Guinea, the weavers of Harris, the kente makers of Ghana, the ajrak woodblock printers of Sindh, and all those many, many others who are still painting, weaving, pressing, knitting and sewing hidden magic into their cloth.

Sometimes the quilts were white for weddings, the design
Made up of stitches, and the shadows cast by stitches.
And the quilts for funerals? How do you sew the night?

'The Design', by Michael Longley

CONTENTS

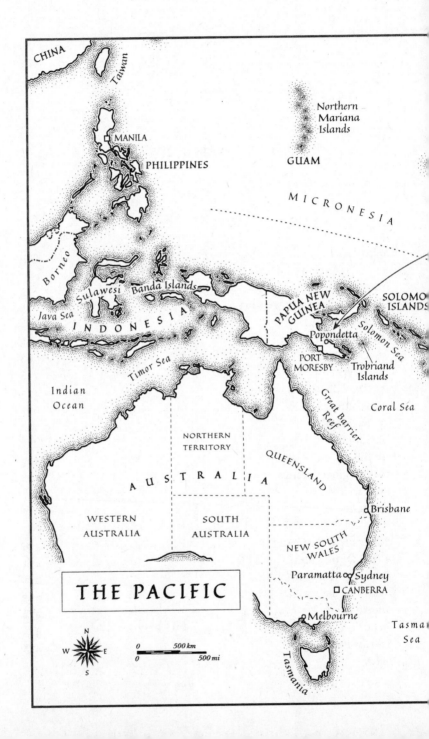

THE PACIFIC

CHINA

Taiwan

MANILA

PHILIPPINES

Northern
Mariana
Islands

GUAM

MICRONESIA

Borneo

Sulawesi Banda Islands

Java Sea

INDONESIA

PAPUA NEW
GUINEA

SOLOMON
ISLANDS

Popondetta

Solomon
Sea

PORT
MORESBY

Trobriand
Islands

Timor Sea

Indian
Ocean

NORTHERN
TERRITORY

Great Barrier Reef

Coral Sea

QUEENSLAND

A U S T R A L I A

WESTERN
AUSTRALIA

SOUTH
AUSTRALIA

Brisbane

NEW SOUTH
WALES

Paramatta Sydney

CANBERRA

Melbourne

Tasman
Sea

Tasmania

N
W E
S

0 500 km
0 500 mi

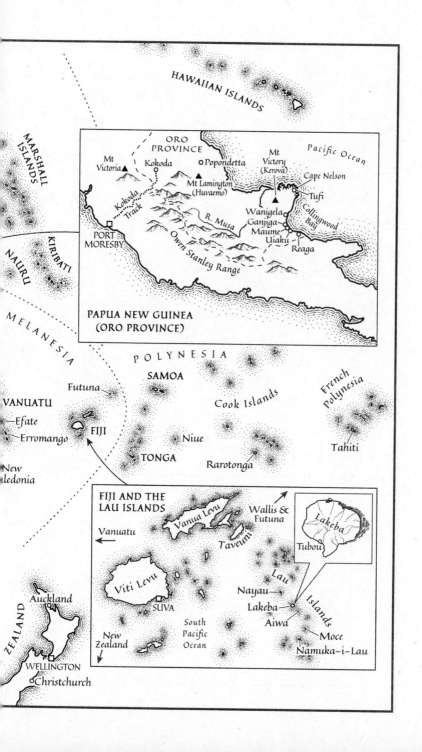

HAWAIIAN ISLANDS

MARSHALL ISLANDS

Pacific Ocean

ORO PROVINCE

Mt Victoria ▲ Kokoda ○ Popondetta Mt Victory (Kerova) Cape Nelson

Mt Lamington (Huvaemo) ▲ ▲ Tufi

R. Musa Wanigela Collingwood Bay
Ganjiga
Maume
Uiaku

PORT MORESBY Owen Stanley Range Reaga

Kokoda Track

NAURU

KIRIBATI

PAPUA NEW GUINEA (ORO PROVINCE)

MELANESIA

POLYNESIA

SAMOA

Futuna

VANUATU
—Efate
—Erromango FIJI

New Caledonia

Cook Islands

French Polynesia

○ Niue

TONGA Rarotonga

Tahiti

FIJI AND THE LAU ISLANDS

Vanua Levu Wallis & Futuna

← Vanuatu Taveuni

Lakeba

Tubou

Lau

Viti Levu

SUVA

Nayau—
Lakeba ○
Aiwa

Islands

Moce

Namuka-i-Lau

ZEALAND

Auckland ○

New Zealand

South Pacific Ocean

WELLINGTON □
○ Christchurch

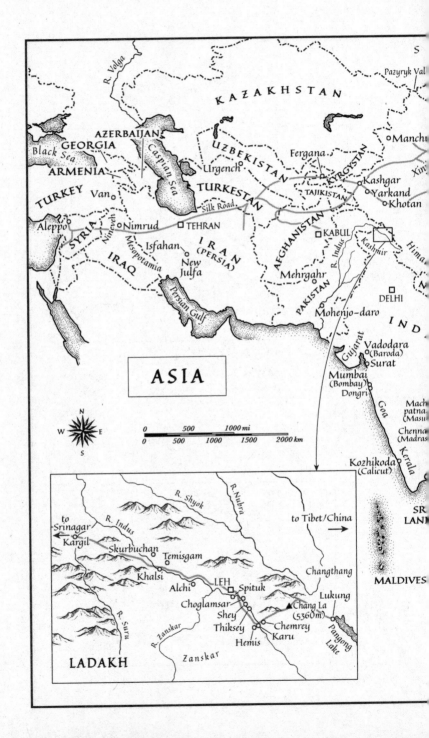

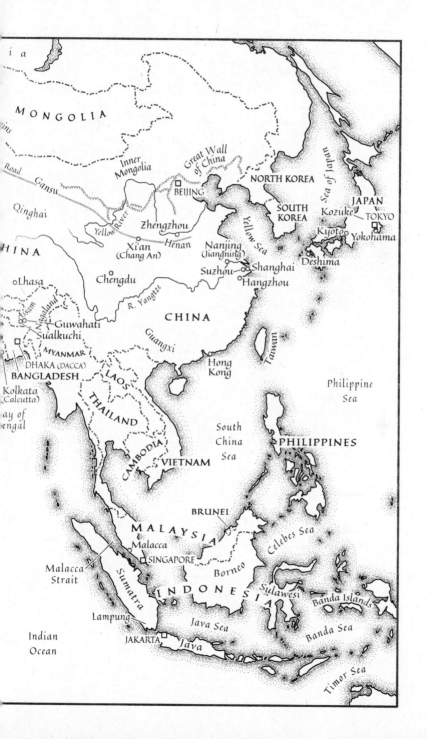

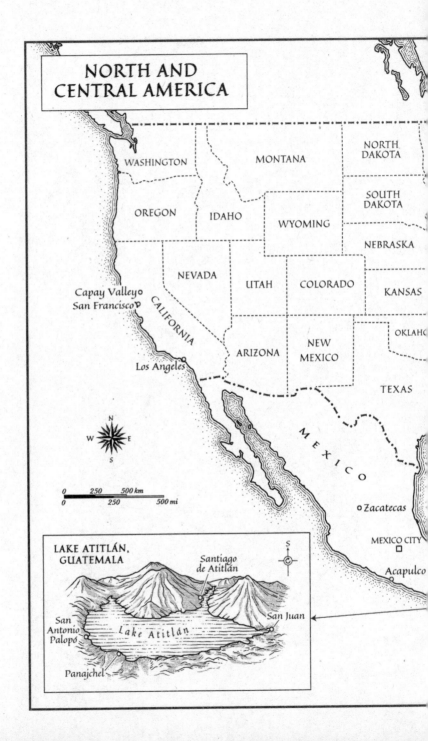

NORTH AND CENTRAL AMERICA

WASHINGTON

MONTANA

NORTH DAKOTA

OREGON

IDAHO

WYOMING

SOUTH DAKOTA

NEBRASKA

NEVADA

UTAH

COLORADO

KANSAS

Capay Valley
San Francisco

CALIFORNIA

OKLAHO

Los Angeles

ARIZONA

NEW MEXICO

TEXAS

N
W E
S

M E X I C O

0 250 500 km
0 250 500 mi

Zacatecas

MEXICO CITY

Acapulco

LAKE ATITLÁN, GUATEMALA

Santiago de Atitlán

San Antonio Palopó

Lake Atitlán

San Juan

Panajchel

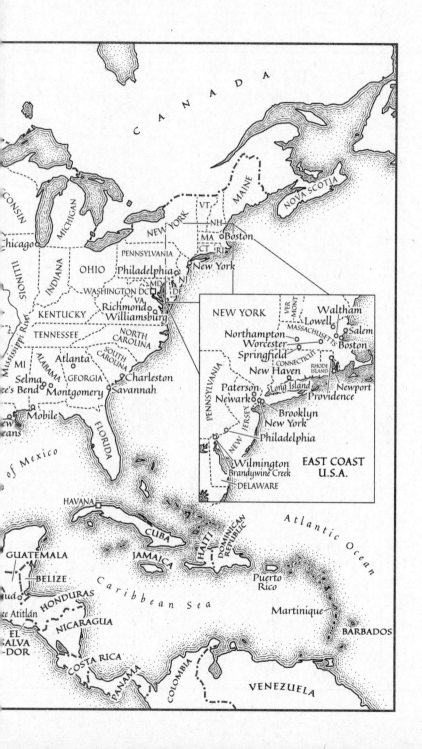

C A N A D A

CONSIN

MICHIGAN

Chicago

VT

NEW YORK

NH

MAINE

NOVA SCOTIA

MA

Boston

CT RI

New York

PENNSYLVANIA

OHIO

Philadelphia

INDIANA

MD DE

WASHINGTON DC

NJ

VA

KENTUCKY

Richmond

Williamsburg

TENNESSEE

NORTH
CAROLINA

Mississippi River

SOURI

MI

ALABAMA

Atlanta

GEORGIA

SOUTH
CAROLINA

Charleston

Selma

e's Bend

Montgomery

Savannah

New
eans

Mobile

FLORIDA

of Mexico

**EAST COAST
U.S.A.**

NEW YORK

VER
MONT

Waltham

Lowell

MASSACHUSETTS

Salem

Northampton

Worcester

Boston

Springfield

CONNECTICUT

New Haven

RHODE
ISLAND

PENNSYLVANIA

Paterson

Newark

Long Island

Providence

Newport

Brooklyn

New York

NEW JERSEY

Philadelphia

Wilmington

Brandywine Creek

DELAWARE

HAVANA

CUBA

Atlantic Ocean

GUATEMALA

BELIZE

HAITI

DOMINICAN
REPUBLIC

JAMAICA

uá

e Atitlán

HONDURAS

Caribbean Sea

Puerto
Rico

EL
SALVA
DOR

NICARAGUA

Martinique

BARBADOS

COSTA RICA

PANAMA

COLOMBIA

VENEZUELA

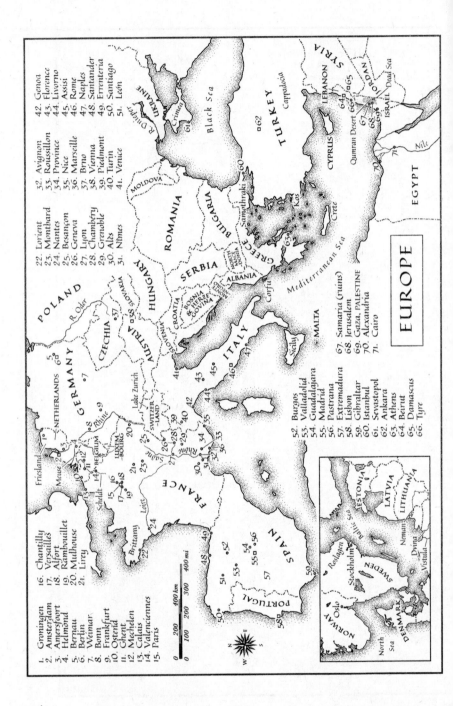

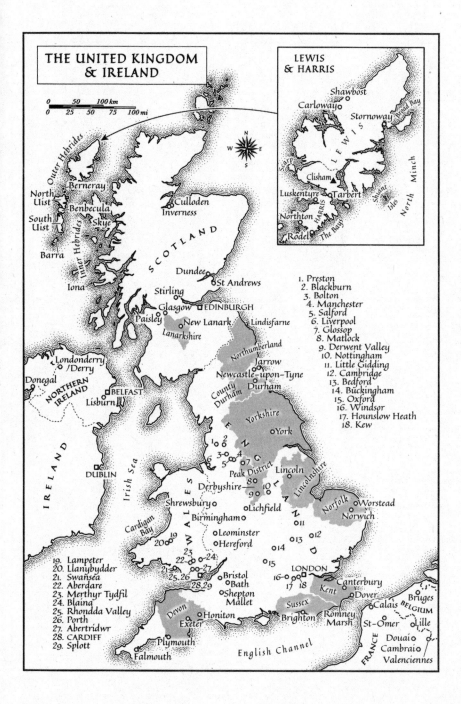

THE UNITED KINGDOM
& IRELAND

0 50 100 km
0 25 50 75 100 mi

LEWIS
& HARRIS

Shawbost
Carloway
Stornoway
Broad Bay

LEWIS

Scarp
Clisham
Luskentyre
Tarbert
Shiant Isles
HARRIS
Northton
The Bays
Rodel
North Minch

Outer Hebrides
Berneray
North
Uist
Benbecula
South
Uist
Skye
Inner Hebrides
Barra
Iona

Culloden
Inverness

SCOTLAND

Dundee
St Andrews
Stirling
Glasgow EDINBURGH
Paisley New Lanark Lindisfarne
Lanarkshire

Londonderry
/Derry
Donegal
NORTHERN
IRELAND
Lisburn BELFAST

IRELAND

DUBLIN

Irish Sea

Cardigan Bay

WALES

Shrewsbury
Birmingham
Leominster
Hereford

Lampeter
Llanybydder
Swansea
Aberdare
Merthyr Tydfil
Blaina
Rhondda Valley
Porth
Abertridwr
CARDIFF
Splott

Devon

Plymouth
Falmouth

Northumberland
Jarrow
Newcastle-upon-Tyne
County Durham
Durham
Yorkshire
York

E
N
G
L
A
N
D

Peak District
Derbyshire
Lichfield

Lincoln
Lincolnshire
Norfolk Worstead
Norwich

1. Preston
2. Blackburn
3. Bolton
4. Manchester
5. Salford
6. Liverpool
7. Glossop
8. Matlock
9. Derwent Valley
10. Nottingham
11. Little Gidding
12. Cambridge
13. Bedford
14. Buckingham
15. Oxford
16. Windsor
17. Hounslow Heath
18. Kew

1
2
3 7
6 4
5

8
9 10

11
13 12
14
15
LONDON
16 18
17 Kent
Canterbury
Dover
Calais Bruges
BELGIUM
St-Omer Lille
Douai
Cambrai
Valenciennes

19. Lampeter
20. Llanybydder
21. Swansea
22. Aberdare
23. Merthyr Tydfil
24. Blaina
25. Rhondda Valley
26. Porth
27. Abertridwr
28. CARDIFF
29. Splott

20 19
23
22 24
21 27
25, 26
28, 29

Bristol
Bath
Shepton
Mallet
Honiton
Exeter
Sussex
Brighton Romney
Marsh

FRANCE

English Channel

INTRODUCTION

It was 7 November 1992, the seventy-fifth anniversary of the 1917 October Revolution, and less than a year since the Soviet Union had collapsed. For the first time there would be no official celebration of communism. Red Square in Moscow was closed by the new authorities 'for repairs'. But nearby, Manezhnaya Square was crowded, waiting for something to happen; journalists and undercover police mingled with local people whose world had collapsed and who now had no money for bread. Armed soldiers lined the square. Snow was falling.

The Russians standing beside me in the crowd began to look worried. Then, from a direction I was not expecting, hundreds of people appeared in a silent procession. They were twenty wide, and dozens deep, most of them old men and some old women, all with grey hair, all in military uniforms, some hobbling, others with backs straight for the march. I ducked under the closing cordon of soldiers pushing the crowd back. I was the only one to get through. I ran towards the marchers, pulling out my camera from where I'd been keeping it warm in my jacket. Through the long lens I could see them close up. Their expressions were set, and hard to read. I found myself focusing tight on their clothes. The khaki woollen cloth of those who had been in the army, and the white cloth worn by the navy, puckered at the seams as if hand-sewn. Some of it was torn.

It was this – the frayed, patched, repaired fabric that represented how the people walking towards me had lost everything they believed in, how they were not going to be looked after as promised, how they were proud – that left me, still almost alone in the gap between the marchers and the surging crowd, taking pictures as tears froze on my cheeks.

After that, I began to notice how fabrics can give a glimpse of something truthful, a clue to what is underneath the surface of things.

I learned that the word 'clue' itself comes from an Old English term for a ball of yarn that can be unwound to show the right path. And, almost in passing, I saw how the stories of fabrics, their histories, are about endeavour and work and secrets and feuds and inventions and abuse and beauty and ugliness, and sometimes they are about tenderness. There were stories, I thought, and I wanted to know them.

It took a long time to get there. I had a journalism career in Hong Kong, returned to England, married, wrote three books, and spent twelve years working with my husband for a small international environment charity. But in early 2015, I was approached about the fabric idea. I both wanted to do it and knew I could not. My father had been ill for ten years after a catastrophic brain haemorrhage, followed by a stroke. He had been a medical miracle and survived, but now his dementia was getting worse and it was harder for my mother to look after him.

'Do the book!' she said. But the book I wanted to do would take several years and many journeys and I might not be there to help her.

'Don't say no just yet,' she said. We both knew she meant that my father would probably die soon. We talked about it with my father too; we talked freely about death in our family. He also said I shouldn't say no just yet.

That April my mother came to visit me in Bath. My husband, Martin, was away and we had the whole weekend to ourselves. The American Museum was running a show titled 'Hatched, Matched, Despatched – and Patched', about the fabrics people use at key life moments.

'We should go,' she said. 'Just in case you decide to write that book.'

In the final room, the funeral room, there were two burial skirts made somewhere in Wales, by sisters, to wear in their coffins. We imagined the making of them, a hundred and twenty years or so before: the warmth of the coal fire, a kettle boiling, adjusting of reading glasses, of woollen shawls shrugged around shoulders, the laughter at remembered stories from long ago, the teasing about whether it would still fit when it was your time to go. Such skirts are rare now, of course, as most of them ended where they were intended to, but these two – long, black, glossy, cotton satin,* one

* Cotton satin is made from cotton fibres that have been combed so they are

diamond-quilted and the other with fine zigzags – were stored in an attic and not used.

Then on a wall nearby we saw a quilted patchwork made in Llanybydder in Wales in 1911 by a widow, Ada Jones, just after her husband died. The caption stated that a friend stayed with Mrs Jones for the first six weeks of her mourning, and helped her to sew it. It was mostly dark crimson, with scattered scarlet diamonds, and a long scarlet strip at the centre with two spider-like black crosses at top and bottom. It was the opposite of restful, though perhaps it gave some repose.

'We should do that,' my mother said.

'What do you mean?' I asked.

Many friends would come to express condolences after my father died, she said. This way we could all sit companionably. It would give us something to think about when we wanted to stop thinking about anything. 'And the funny thing,' she added, 'is that it would probably be the worst patchwork in the world.' She had never had a loving adult around to teach her to sew as a child. She hadn't been able to teach me. We'd always said we really should learn, and a shared project would mark a new kind of beginning, at a time when we'd need a new beginning.

I drove her back home to Devon, and we told my father about the worst patchwork in the world. He laughed. We all felt happy because it seemed we'd sorted something important.

Four months later my healthy, vibrant mother died. It was absolutely unexpected. I had not known grief could be so physical. That visit to our house in April had been her last, it turned out, and I kept on looking at the chair she had sat on at the table when we'd stayed up late making plans. After my father died she would move to live near us in Bath, we would travel to India, we'd have adventures. Her hands had turned the cloth napkin, folding it and unfolding it as we talked about shaping a happy life without him.

I had written in the past about the colours of mourning – black in Britain, white in Hong Kong, yellow in Brittany, mauve for 'half'

long and silk-like. It's often woven with the weft passing under one warp thread and over three or four, so the finished cloth feels like satin. It's sometimes called 'sateen'.

mourning as you begin to emerge from the first hard frost of grief.*
But now I understood mourning clothes for the first time. I needed
an armband, a ribbon, any kind of sign that would be understood by
strangers and friends to say I couldn't be relied on, that I was to be
treated carefully, that I was not, for a while, in this world.

My father died three months and a day later, at home, in the
moment between me wetting his lips with cotton wool and turning
away for a drop more of water. I was bereft but I was glad for him.
And in the months between the two deaths, as my brother and I strug-
gled with all we needed to do to keep our father out of hospital, when
we felt lost and fractured into small pieces, I found myself trying to
call my mother back. 'Where are you?' I kept crying in my head. 'You
can't have gone. We have to make the patchwork!'

But as I did this, I came to realise I could make it after all. I'd
go out into the world and uncover stories of barkcloth and cotton
and wool and linen and silk and some of the other fabrics people
have invented and used and worked into being. I'd meet some of the
people who made them and learn about some of the people who'd
changed the way they were made. I'd explore that quality of truth in
fabric I had seen through my lens in Moscow and never forgotten. I'd
learn the histories, and I'd find out more about the connection the
material we can see has with the non-material world we cannot see.

And that book – this book – would be my patchwork.

I wasn't, in the beginning, going to talk about my parents. But
they kept appearing in surprising ways. So this is, on occasion, a ghost
story. Or a book written while grieving, and emerging from grieving,
which is also a ghost story in its own way.

* In the early twelfth century, Balderich, abbot of Bourgueil in the Loire Valley,
observed with curiosity that the Spanish dressed in black when their relatives
died. Until the fifteenth century it was normal in France and England to dress in
the brightest colours and the finest clothes to honour the dead.

SOME WORDS BEFORE WE START

The **warp** is the first set of threads on a **loom**; it's the skeleton of the cloth, the along.

The **weft** is the second set of threads, the skin of the cloth, the across.

I remember the difference because the last two letters of warp, reversed, are the beginning of 'primary'. And 'weft' is just another word for 'weave' – although curiously one of the old words for weaving was warping (*worpan* in Anglo Saxon, *verpa* in Old Norse) with its sense of projecting an object through space, or of wrapping, enveloping, binding and tying.

The warp threads need to be the strongest: if they break, the whole cloth is lost. They also need to be twisted harder than the threads that will run across them. This led to the word 'warped' meaning twisted or perverted: turned away.

A **shuttle** is the container holding the weft. It moves in predictable ways, back and forth – space shuttles and airport shuttles are named for it. 'Shuttle' is from the same origin as 'shoot', as in 'fire a projectile', and 'shut' as in 'bolt something closed'.

To **weave** a cloth or a '**web**' you need to pass the weft threads through the warp, over and under and over and under. You can do this more quickly by passing the shuttle through a tunnel in the warp called a **shed**. 'Shed' – from the same root as the German *scheiden* meaning 'to separate'. Which is, in turn, from the same root as the Greek *schizo*, to split.

The shed is created by a **heddle**, which uses cords or wires to lift different warp threads, ready for each pass or '**pick**' of the shuttle going through. Heddle is from the Old English *hefeld*, from the same root as 'heave', or the German *heben*, to raise.

If the heddle lifts every other warp thread each time, that is **plain weave** or **tabby**. If it lifts two or more neighbouring warp threads at

a time that is **twill**, from the same root as 'two'. It makes a diagonal pattern; denim is a twill.

The end of the pick, where the weft thread turns round on itself, is called the **selvedge**, the 'self-edge': the edge of cloth that is created through the action of the shuttle.

Yarn was traditionally made by twisting raw fibre on a **spindle**, a stick with a **whorl** near its base to give it weight as it turns. And the raw fibre would often be stored on another stick, sometimes cleft, called a **distaff**, to make it easier to handle before it met the spindle. In the past – from Spain, to Britain, to Germany, to Iceland – people called their mother's kin the distaff side, their father's side the sword.

1

BARKCLOTH

In which the author learns how fabric can be a magical pathway for gods travelling between worlds and discovers that barkcloth close up looks like noodles. And while she finds some curious books of cloth samples from Captain Cook's journeys two hundred and fifty years ago, she also tries to see it being made in Papua New Guinea. Or Fiji. Or Vanuatu. Or the Congo. Or anywhere at all.

It was 19 November, my birthday. My mother had died twelve weeks before, and my father wasn't doing well. My brother was with him. I'd be going to see them the next day but for today I was in London with my husband, and we'd taken the day off. I'd wanted to see an exhibition at the British Museum, hoping an encounter with the past would somehow help me in the present. We walked from the Tower of London, past St Paul's, along Fleet Street. Outside Dr Johnson's house, my mobile phone rang. It was my brother. It wasn't about my birthday. He wanted me to know the doctor was coming later. She was probably 'going to recommend a syringe driver' for our father's morphine and the other drugs he was taking, and this was the signal he was going to die. The pavements were grey after that, and the sky was grey, and the exhibition on the Celts was grey too. Later, at lunch, I couldn't eat the food.

What were we going to do with the rest of the day? We looked at each other helplessly. Then we saw a small notice by the northern stairs of the museum. Pacific Barkcloth Exhibition. Room 91. We could try that.

It was dark and there were luminous objects on every wall. Most of it was cloth, that was obvious, but it wasn't just cloth; that was obvious too. It had zigzags and patterns and whiteness and blackness and a quality of curiously textured brownness or bright reds or yellows. And dazzle. There was plenty of dazzle. The texture and

pattern of some of the pieces of fabric provided a strange, almost psychedelic, visual experience. It was neither flat two dimensions nor solid three. It was like it was two-and-a-half dimensions, with the extra half allowing a kind of mystery to enter in.

The Pacific was settled from about sixty thousand years ago by successive waves of people arriving from Southeast Asia. On Western maps it has, since the eighteenth century, been divided into Polynesia (including Hawaii, Samoa, Tonga and Tahiti), Melanesia (including Fiji, the Solomon Islands, Vanuatu and New Guinea) and Micronesia (including Guam, Kiribati and the Marshall Islands). When you look at the map, with islands like scatterings of salt on the blue tablecloth of the vast ocean, it seems astonishing that they had the courage to set out at all, and equally amazing that they survived.

Micronesia has only ever had a woven fabric tradition, so it's not part of this chapter, but many future Melanesians and Polynesians carried with them from the Asian mainland various saplings: paper mulberry, wild fig and breadfruit. And they beat the bark of those trees into cloth.

The word 'barkcloth' has always sounded itchy and unappealing. It turns out that it's seriously badly named. It's not made from the outer, dead bit of a tree, which botanists call the rhytidome and we generally think of as 'the bark'. It's from the next layer in, hardly bark at all, the soft inner periderm layer through which what you could call the 'blood' of the tree flows. It's the layer that brings sap up to the leaves and back down to the roots. Far from being dead, the 'inner bark' is the part of the tree that is most alive.

Most communities have their own name for barkcloth: siapo in Samoa and nearby Futuna, ngatu in Tonga (pronounced -gatu with a silent 'n'), masi in Fiji, nemas in Vanuatu, hiapo in Niue and probably hundreds of different names in Papua New Guinea where there are eight hundred and fifty separate languages. But they also all use a borrowed word, tapa. It comes from the Hawaiian word kapa, which originally didn't even mean the whole of the fabric, just the edges, the unpainted parts, the liminal areas of cloth.

And ever since people set sail into the unknown Pacific with saplings on their outrigger canoes, they've invented all sorts of imaginative and sacred ways to decorate the cloth they could make from them.

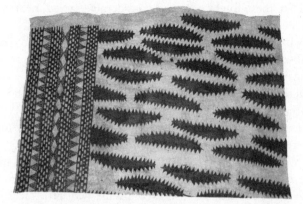

Two-hundred-year-old barkcloth from Rarotonga.

In Hawaii, people created a kind of corduroy effect on some of their barkcloth, using incised bamboo rollers covered in red pigment. On top of the red, they painted black triangles like backgammon motifs. These zigzags were sacred. They represented both genealogy and human spines, as if to say that records of our parents and their parents and their parents' parents are held in the bones of our backs, holding us up, and making us who we are.

On Niue, they cut out sections to make fringes like cowboy jackets; the Samoans glazed theirs with oil to make it shiny. In Tonga, people used sharks' teeth and shells to stamp the cloth: from a distance the patterns looked big and bold, but close up there was a perfect intricacy of tiny stamped shapes.

Standing there, in the British Museum, I realised that looking at cloth properly is all about moving in, then away, so the impressions shift and change.

I stopped for a long time in front of a black-and-white barkcloth from Rarotonga, the largest of the Cook Islands. It showed thin, leggy creatures like stick insects, surrounded by black diamonds. From a distance the black was rich like velvet, and when I got close I could see every line was made blurry by tiny zigzags. The border is similar to one on a cloth also from Rarotonga, used to wrap a 'wooden staff god' from Rarotonga, suggesting, as the museum label said, that

'cloths like these might have had considerable sacred meaning'. But you could tell anyway. The pattern pulled you in and danced.

My brother sent me a text. Our father wasn't going to die today. I breathed out. I knew that I could be present here now, rather than floating like a zigzag on top of the patterns I was seeing.

There were several pieces from Papua New Guinea. The Kovave dance masks, like enormous bird heads in a dream, had been made from stretching barkcloth across bamboo frames: they were teaching tools, created to pass knowledge to young initiated men about how magic worked. There were also six New Guinea loincloths made in the 1890s with busy, curling, abstract patterns that played games with my eyes. One looked like it showed a spine with little faces pulling open the vertebrae and peeping through. Another had interlocking blocks like capital Es and Fs dropping down the long cloth like a sepia Tetris video game.

Most of the New Guinean cloths were a century old or more, but then I found some from 2014. It seemed the Ömie people in Oro province in the southeast were still making barkcloth, and it had astonishing patterns.

Sarah Ugibari, the oldest of the Ömie painters, born around 1919, had painted a cloth covered in diamond shapes like the 'gods' eyes' you make when you wind successive colours of yarn around crossed sticks. They were surrounded by black, red and yellow zigzags like the lines around the BLAM!!! in a comic strip. They depicted the fruit of a local tree. However, Ugibari wasn't painting the fruit, but the design of the fruit as it was tattooed around her late husband's navel. I briefly wondered why you would have tattoos around your navel, but then I understood that it is of course one of the most symbolic parts of the body. It is our closest link to another person, to the beginning of life.

As I walked, I felt the colours and the seams of my world coming right again. I felt wrapped in something that might actually comfort me. Towards the end of the exhibition there was a quote from Mary Pritchard who was one of the women making barkcloth – which she called siapo – on Samoa in the 1980s. 'No one who makes siapo and who has experienced that silent communion ever feels they are making mere handicraft,' she said. 'Something deeply felt, like a prayer, gets into your being, your limbs, and through them into the siapo itself.'

I was in that one room for two hours as if I was in a dream. When

I woke and came to the end, Martin was there, quietly reading a book. I asked him just now, three years later, what he had thought. 'I felt you'd at last found somewhere that gave you some peace,' he said. 'It was a room full of ritual, and it was simple, and somehow that took you out of the pain. It was you again.'

And because it *was* me again I knew then that soon, in time, once my brother and I had helped our father through his last journey, I would take a journey myself, to find out more about this cloth which, with its issues of sustainability and adaptation and key life moments and hard work and design and invention and the fine art of wrapping, sums up so much that is important about all fabric. And which also, when I had really needed it, had seemed to comfort me.

But I would start with reading about a British expedition to the Pacific two hundred and fifty years before in 1768, when the crew were fascinated by cultures that were so different from anything they knew. One of the things that astonished them most was the sophistication and beauty of the cloth. And the person who was most interested in it was the chief naturalist, who a decade earlier had learned to look at the layers of the world.

And some of it is fine, like muslin

It was the summer of 1757. Joseph Banks was thirteen years old, and already the despair of his teachers for 'his extreme aversion' to studying. One day, wandering slowly back to school along a green lane, entranced by the summer evening and the flowers covering both sides of the path, something extraordinary happened. He realised in a kind of vision that his time would be better spent learning about those shimmering plants than the boring Greek and Latin he was forced to study. He also found in that realisation a kind of pathway to what his life could be. It was a tiny epiphany, one that anyone could have had, but it would change his life and it would give Britain a collection of plants, textiles, stories and seeds it still treasures. It would also mean he would be the first British person to write about barkcloth.

But that was the future. First Banks needed to find out about those plants. He found local women who gathered medicinal herbs for druggists and he paid them sixpence for each new piece of botanical information. Later he was 'inexpressibly delighted' to find a torn copy of Gerard's 1597 *Herbal* in his mother's dressing-room, and he

was allowed to carry it back with him to school. The following term his tutor was surprised to see him reading, while his friends were outside playing sport.

When Banks was in his early twenties, he heard about an expedition to 'the new discovere'd country in the South sea' – the one we now call Tahiti, in the Society Islands.

The government's ostensible reason was to measure a 'transit of Venus' which happens only twice in a century, and could be used, it was hoped, to work out how far the Earth was from the Sun, and help navigators calculate where they were on the sea.

The government's secret reason was to learn more about the mysterious southern continent.

Joseph Banks just wanted to see plants.

He was awarded the commission as chief naturalist. And he spent ten thousand pounds of his own money – the equivalent of around £1.7 million today – kitting out the expedition with the latest scientific equipment, a splendid library and a natural history dream team made up of a portrait and landscape artist, a botanical artist, several assistants and Dr Daniel Solander from Sweden, protégé of Carl Linnaeus, the father of taxonomy.

HMS *Endeavour* left Plymouth on 26 August 1768, captained by the thirty-nine-year-old Yorkshireman, James Cook. She sailed east towards Brazil then down past Cape Horn, sighting Tahiti on 10 April 1769.

While they were still offshore, Captain Cook drew up a list of 'Rules to be observed by every Person in or belonging to His Majesty's Bark the Endeavour', which included 'cultivating friendships with the natives', treating everyone with humanity, not pilfering the stores, and not exchanging any kind of cloth or iron for anything but provisions. Only when they had all agreed to the Rules were the men allowed to go ashore.

Over the next few days, they were invited to take part in several welcome ceremonies – which included a great deal of fabric exchange.

The first consisted of local people coming on board the *Endeavour* and 'taking off great part of their clothes and putting them upon us'. A few days later, in one of the villages, Cook and Banks were each given very long, perfumed pieces of cloth made from the bark of a tree. 'My peice of Cloth was 11 yards long and 2 wide,' wrote Banks. 'For this I made return by presenting him with a large lacd silk

neckcloth I had on and a linnen pocket handkercheif, these he imme-
diately put on him and seemd to be much pleasd with.'

It was reckoned in Tahiti 'no shame for any part of the body to be
exposd to view except those which all mankind hide,' he wrote. But
when the people did wear cloth, 'mostly from the Bark of a tree', they
often wore it as extremely long strips, with the richest men coming
to visit the *Endeavour* with so much cloth rolled around their loins as
'was sufficient to have clothed a dozen people'. At sunset the women
tended to bare their bodies down to their navels, which Banks likened
to how British ladies would pull off any finery they'd used during the
day and change it for 'a loose gown and capuchin.' He also noted that
the Tahitians kept their cloths immaculately clean. 'The superiour
people spend much of their time in repairing, dying, &c the cloth,
which seems to be a genteel amusement for the ladies here as it is in
Europe.'

There was a great deal of interest in the clothes worn by the over-
seas visitors too. On one occasion, Banks stayed the night in a village
quite far from the ship. When he awoke at 11pm, he found all his
clothes missing. Making his way, naked, in the darkness he bumped
into Captain Cook who 'was my fellow sufferer, he had lost his stock-
ins and two young gentlemen ... had each lost a jacket'. He covered
up with a piece of barkcloth provided by a local, and returned to the
ship the next day half in English dress 'and half Indian'.

Banks saw three different kinds of barkcloth. The rarest was 'the
colour of the deepest brown paper' and it came from something akin
to a wild fig. Despite its slightly oily, corrugated texture, people loved
it because it was more naturally water resistant than the other kinds.
The more senior people in the villages would perfume it, and wear it,
Banks said, 'as a Morning dress,' by which he meant the formal attire
for daytime.

The second was from the breadfruit tree, *Artocarpus altilis*. It was
coarse and was mostly judged to be second-rate, 'worn chiefly by
people of inferior degree*'.

But the finest cloth was from what he would identify as the paper
mulberry, later to be given the scientific name *Broussonetia papyrifera*.
In Tahiti it was called 'aouta', Banks noted, and it could be of 'as

* Among the Maisin in Papua New Guinea, breadfruit tree barkcloth was used for
practical things like baby carriers and for certain kinds of wrappings.

many different sorts almost as we have of Linnen'. The best sort, hoboo, was 'almost as thin as muslin'. When a piece of aouta was dirty, it was carried to the river and washed, 'chiefly by letting it soak in a gentle stream fasned to the bottom by a stone, or if very dirty wringing it and squeezing it gently.' Washed pieces were then laid over each other and beaten together, after which they became 'a cloth as thick as coarse broad cloth, than which nothing can be more soft or delicious to the feel.'

Banks spent many hours watching women dyeing and painting the barkcloth. The yellow came from the root of the *Morinda citrifolia* or noni tree, whose fruit is sold today as a superfood. It was very bright and pleasing. The red was also exceedingly beautiful, 'and I may venture to say a brighter and more delicate colour than any we have in Europe,' he wrote. 'The beauty, however, of the best is not permanent; but it is probable that some method might be found to fix it, if proper experiments were made.'

I'd learn later that the red dye is called mati, and that making it involves an amazing transformation. There is nothing intrinsically red about the milky juice of the *Ficus tinctoria* fig, nor anything at all red about the leaf of the *Cordia subcordata* or sea trumpet (which is now also called the kerosene tree because it burns so well). But the combination of the two makes a brilliant scarlet created by a chemical reaction which scientists are still trying to understand today.

Banks described how after they'd been dyeing the cloth the women didn't wash the colour off but instead made special efforts to keep it on their fingers and nails 'on which it shews with its greatest beauty'. They used it as an ornament, the way we use nail varnish or henna today, and Banks was curious to see how women sometimes borrowed the dye from their friends, 'merely for the purpose of dying their fingers'.

During their stay, an old woman of consequence died. First her body was wrapped in 'a profusion of Good Cloth' and then it was taken to a high, covered platform, or funeral house ('*tu papow*'), and – to the 'disgust of every one whose business requires them to pass near it' – it was left to putrefy.

The men and women had very different mourning ceremonies, although both involved the ritual use of textiles. Banks was astonished to watch the mourners in the women's ceremony smashing shark's teeth into their own heads while keening around the body.

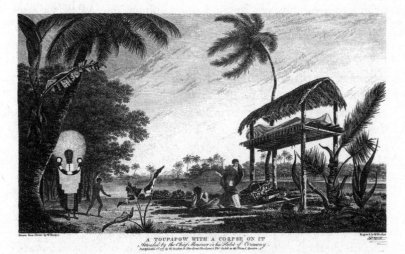

A TOUPAPOW WITH A CORPSE ON IT
Attended by the Chief Mourner in his Habit of Ceremony

Chief Mourner with tapa skirt and feather headdress, and a corpse
shrouded in barkcloth. After Captain Cook's second voyage to Tahiti.

They used barkcloth to mop up the blood gushing down their faces
and then ritually threw the pieces under the funeral house. They did
the same with the barkcloth used to wipe their eyes so that 'under
the awning were numberless rags containing the blood and tears they
had shed'.

The men's ceremony followed. It was led by a Chief Mourner
dressed in a costume 'so extraordinary that I question whether words
can give a tolerable Idea of it.' In the end, Banks did not even try to
describe it but in the published version of his journals he included an
engraving which shows a strange, tall figure standing with its back to
a dark woodland while to the side the long, thin shape of the corpse
lies on a high platform wrapped in rolls of undecorated cloth.

The drama of the Chief Mourner's costume starts at his barkcloth-
covered chest with a shimmering shell curtain, then moves up past a
great crescent-shaped plate to a towering headdress made from fifty or
so tailfeathers of tropical birds (like the ones Banks and his comrades
had been spotting and shooting ever since they passed the Tropic of
Capricorn). Looking at the scale of it, from his feet to his feathers, the
Chief Mourner must have been more than three metres high.

Banks was keen to get hold of the costume. But even if he was

willing to break one of Captain Cook's unbreakable Rules (the one about not exchanging cloth or iron for anything but provisions) he had nothing that would induce the Chief Mourner to part with it. It was only on Cook's second voyage that an exchange was made, swapping the precious costume for some splendid red feathers they had previously bartered for in Tonga.

There are only six remaining Tahitian Chief Mourner costumes in the world and the Royal Albert Memorial Museum in Exeter has one of them. It was brought back in 1792 by Lieutenant Francis Godolphin Bond of HMS *Providence*. I saw it in the 2018 Oceania exhibition at the Royal Academy in London. It is still a wonder. Above the chestnut-coloured barkcloth skirt – which looked like the waterproof kind from the *Ficus* fig tree – there was a cape made of paler cloth, with tightly stencilled and stamped zigzags and diamonds hard-punched into the cloth like codes. Once it would have been red, yellow and black. And although any mati scarlet had faded long ago, as Banks had warned it would, the shape and structure means the overall effect is still dramatic.

It was constructed to seem as if it contained a face far above the wearer's actual head. This made it like the mask of a giant, an alien, a terrifying puppet. No wonder Banks struggled to describe it. With a man inside it dancing a dance of grief through the woods and between the houses, with the clack of the shells, the shimmer of the feathers and the swish of the fabric and people running from it with a real fear of being beaten I could imagine that this figure, clad in ritual barkcloth, would, in its movement and its strength, have expressed something about the violence of grief we sometimes need at funerals, and do not always get.

Fifteen bodyguards

The Ömie, who had painted two of the pieces I'd admired in the British Museum, had a website, an email address, an art administrator and a history of overseas exhibitions. How hard could it be to arrange a visit? I wrote emails and real letters; the phone went unanswered. I contacted Brisbane gallerist Andrew Baker, who exhibits Ömie barkcloth. Andrew was helpful, and confirmed I was using the correct address and should keep trying. Then he warned me to be careful. When the art administrator visits Mount Lamington 'he goes there

with fifteen bodyguards,' he wrote. I scribbled down '15 bodyguards' and circled it several times.

Would twelve do the job? Ten? Six? Fifteen was such a specific number and it sounded hard to arrange.

I usually travel alone but this was going to need backup. On my first day as a student at St Andrews in 1983, I knocked on the door of the room next to mine and met Katia Marsh. We became immediate friends. She'd just been hitchhiking in Peru and her room was full of insanely bright woollen things. I later learned her great aunt was the textile designer Enid Marx, whom I would meet – just once – in a charmingly chaotic home in Islington, surrounded by pictures and fabrics, some of which I recognised from having sat on them in the London Underground, for which she had designed upholstery in the 1930s.

Katia and I had always talked about having an adventure together. She's also a professional photographer. By coincidence she had just been photographing her great aunt's archive of notes at the Victoria & Albert Museum and she'd found several photocopies of barkcloth designs; Enid Marx had found the curved and striped patterns inspiring for her own work.

Katia said she would come.

Painting a cloth to protect a mountain

The modern Ömie story of barkcloth started on the morning of Sunday 21 January 1951, when a mountain in southeast Papua New Guinea exploded. None of the white administrators had even known it was a volcano. It had just been a remote, benign mountain they'd named after a remote, benign governor of Queensland who never actually saw it.

The local people knew it was not benign though, and foreign missionary women who had climbed it in the early 1930s had reported a great roar at the summit. 'Sister, listen,' a local guide had said to one. 'That big noise not river.' But nobody in charge had taken it seriously and now Mount Lamington, which the Ömie people call Huvaemo, was the worst volcanic catastrophe for half a century, and some three thousand people were dead.

When there was a major earthquake in the Papua New Guinea Highlands in 2018, it was almost impossible for people to get messages

out. It was harder in 1951. The Huvaemo eruption would likely have gone largely unnoticed by the rest of the world except that at exactly the moment the mountainside blew out, a Qantas DC3 plane was about to land at the nearby town of Popondetta.

A 'terrible cloud' rushed towards the plane, but the pilot managed to circle around and head out to safety. As he did so one of the passengers reached for his camera and, pointing its fixed lens towards the window shot off the full roll of 35mm film, posting it to *The Sydney Morning Herald* as soon as he landed. The pictures looked like the atomic clouds over Hiroshima and Nagasaki eight years earlier. They were syndicated around the world.

On the ground, it was horrific. There were bodies hanging in trees with their skin burned off. Hundreds of the dead were huddled together in a church where they'd been attending services.

Police described roads so full of human remains you could scarcely avoid stepping on them.

And afterwards many things changed.

There were two main tribes living on the mountain: the Ömie and the Orokaiva. The Orokaiva were worst hit and many left. The few who returned years later came back with new ideas and new ways of doing things which mostly didn't involve making barkcloth.

The Ömie were in a less devastated area, though some of their houses are so close to the volcano that their windows look directly into the crater. When the aftershocks were over, the elders spent many days discussing what to do. For them, Huvaemo was not so much a mountain (nor even a volcano) but the centre of their spiritual world.

One elder, Chief Warrimou, said he had a dream that the ancestors were unhappy. Some years earlier, missionaries had forbidden people to tattoo sacred designs onto their bodies, and some of the Ömie elders believed the eruption was a message from the ancestors to say they were angry that their designs were being lost. So although most of the tattoos had been done on the young men, Chief Warrimou now asked the women to keep alive the knowledge of the tattoos, and paint them onto barkcloth.

In 2002 a Sydney art gallery owner, David Baker, heard about the cloth being made on the mountain, and took a small plane to an airstrip close by. He fell in love with the designs. He encouraged the Ömie to make barkcloth to sell, and in 2006 held the first major show

of their work in Australia. Previously the Ömie cloths looked different, with sparse imagery and more open spaces. But with Baker's encouragement, the paintings changed. They became busier, and more packed with symbols, influenced perhaps by the Australian aboriginal desert painting movement, which started – in its contemporary, acrylics-on-canvas, sense – in the Northern Territory in the 1970s.

Knowing the world through painting it on tapa

I still hadn't worked out how to visit the Ömie. I wrote to writers who had visited the area, to missionaries, to missions, to local government, to anthropologists. Several people tried to be helpful. Nobody could actually help.

Meanwhile seven beautiful catalogues arrived from Brisbane. They showed page after page of shimmering designs in black, red, yellow and white, which told in symbols some of the traditional Ömie stories.

One tells the origin myth of barkcloth designs. It says how, once upon a time, an old woman had a string bag that was so strong it could hold the sun and the moon. Every morning she would climb to the top of Huvaemo and hang the sun in the sky. Then her daughters in the villages below would take cloths they had made from the trees, and use them as canvases to paint everything they saw in the sun's light: the fruits and the ferns and the spider webs, the bones of river fish, the paths of ants, all the motifs on the barkcloth designs today. When they were exhausted, their mother would climb back to the peak. She would put the sun into her bag and replace it with the moon, allowing her daughters to rest.

Another introduces the first Ömie woman. Her name was Suja, which means 'I-Don't-Know'. Like many of us, Suja was born into a complicated world she initially didn't understand. Her transformation, like Eve in *Genesis*, is about a shift from ignorance to knowledge. But unlike Eve, Suja didn't need to break any laws. Her shift was made by taking a piece of tapa, soaking it in red river mud to symbolise her menstrual blood and her potential for having children, and then painting on it pictures of mountains and rivers, the beaks of birds and leaves on jungle vines, butterflies and belly buttons and slugs and eggs. And so by the very act of painting, she began to be one who knows.

Today, the Ömie artists continue that tradition of knowing and giving birth to the world by painting it. Which doesn't mean the patterns are figurative. Most are abstract, although one of the few male painters, Rex Warrimou, son of the elder who had that dream in 1953, paints his with little outline people, so the ancestor stories will be as clear as he can get them.

How much to charter a helicopter in Papua New Guinea?

One of the travel agents I'd contacted in Port Moresby replied to say she couldn't help, but she gave me the address of Florence Bunari, who arranges tours based out of Popondetta. Florence wrote back to say she usually takes people on the Kokoda Track – the ninety-kilometre trail over the Owen Stanley Range where for four months in 1942 Papuans and Australians fought the Japanese in appalling conditions.

She had never organised anything to the Ömie before. But she'd heard they still make tapa, and she would check.

A while later, she confirmed that the airstrip David Baker used in 2002 was closed. By foot it might take several days, and it wasn't clear what the best route was. She would look at the options. Or I could always charter a helicopter.

For a few ridiculous minutes, I found myself doing an internet search on: 'How much does it cost to charter a helicopter in Papua New Guinea?' but it's the kind of question where if you have to ask, you can't afford it. I started to look for other places to learn about barkcloth.

To insulate from unmanageable power

On the Lau Islands, in the bit of Fiji that is so far to the southeast it is almost in Tonga, barkcloth was believed to be a ladder into this world. It was also the only material that could protect ordinary people, and the land itself, from danger and unmanageable power in the myth of the Stranger King.

In his 1985 book *Islands of History*, American anthropologist Marshall Sahlins retells the ancient story. One day, a handsome, fair-skinned stranger had an accident far out at sea. A shark saved him and dropped him onto the beach of the island of Viti Levu. When he

wandered into the interior he was captured by the tribe. Eventually they accepted him and allowed him to marry the chief's daughter. When the chief died, the stranger became chief, not only of that island but of all the Lau islands, where he was called Tu'i Nayau, or paramount chief of Nayau island and thus of all of Lau.

By the time Sahlins arrived in the 1980s, the Lau islanders could trace ten generations of Tu'i Nayaus, and the investiture ceremony had long been a reenactment of the myth. Like any coronation, it's a rare ceremony. The last time was in July 1969, when Ratu Sir Kamisese Mara (later both president and prime minister of Fiji) was installed.* So Sahlins didn't see it himself, but he listened to many eyewitness accounts and recounted how people told him it had happened on the island of Lakeba, where Mara had been born.

In 1969, the new paramount chief arrived by sea, like the Stranger King. He was set ashore at the village of Tubou and walked to the local chief's house, led by local chieftains of the land. The next day, he continued to the ceremonial ground at the centre of the island. And at no time did he touch the earth, because all the paths were completely covered by tapa.

Chiefs in Fiji were believed to transmit a dangerous power into anything they touched. The English Methodist missionary Thomas Williams, who visited in 1840, remembered how he once left the house of a chief carrying a delicious ripe plantain, and handed it to a child sitting outside. It was snatched away by an old man, with 'as much anxiety as if I had given the child a viper. His fear was that the fruit had been touched by the King and would therefore cause the child's death.'

The only thing that could protect people was barkcloth.

It's tempting to think that the special paths are the ancient Fijian equivalent of red carpets – a way of giving prestige to honoured people, as if to say they don't have to touch the ordinary ground like the rest of us. Yet it's almost the opposite. The new chief is so dangerous during his investiture that he has to be kept away from the people and the land, in case he hurts them.

Then on the second day of the ceremony the new leader drank a ceremonial bowl of kava – a sacred drink made from the root of

* His son, Ratu Finau Mara, was reportedly invited to succeed in 2006 after his father's death, but no installation ever took place. Ratu Finau Mara died in 2020.

Some of the pieces of Pacific barkcloth collected during Cook's
voyages, compiled into a book by Alexander Shaw in 1787.

the shrub *Piper methysticum* – and the local chief tied a piece of white
Fijian tapa around his arm. That was the moment he was said to
hold the 'barkcloth of the land', the 'masi ni vanua'. And that was the
moment he became paramount chief.

The two barkcloths – the one he walked on and the one that was
held – were different.

The barkcloth he walked on was like the ngatus from Tonga,
made by felting or gluing many different barks together, and then
stencilling the cloth with patterns. The Lau Islands have a special rela-
tionship with Tonga. It has always been easy for Tongans to come to
Lau: the winds carry them. It is harder to get back, so over the years
many have stayed. The Tongan-style barkcloth is popular on Lau, but
it is also symbolic of things from overseas – like the Stranger King
himself.

The other barkcloth, the white 'Fijian' masi, is made from younger
trees, perhaps only six months old, with the inner bark just eight centi-
metres wide, about the width of a woman's palm, when it's removed

from the tree. It is then folded and beaten, folded and beaten, like making filo pastry with sticks. It is such a difficult process that even in the 1980s, there were only a few women who could still do it.

In some parts of Fiji, the white masi was hung in strips from the roof at the sacred end of a temple. People believed it was the path down which the god descends to enter the priest's body before a ceremony: a kind of secret doorway from another world. Some believed that without barkcloth, it was impossible to make a connection with the sacred. In the 1840s, the Rev. Thomas Williams mentioned to a traditional priest on Fiji's Taveuni Island how some of the tribes in the New Hebrides (now Vanuatu) thought themselves wise, and had many gods, yet they were living in destitute conditions without even any barkcloth to wear. The priest was horrified. 'Not possessed of masi, and pretend to have gods!' he muttered repeatedly, with contempt.

It's no surprise that people in Lau were horrified when in 2013 the national airline tried to trademark fifteen traditionally owned barkcloth designs to use on its planes. When Air Pacific rebranded itself as Fiji Airways, it commissioned masi maker Makereta Matemosi from Namuka-i-Lau to adapt traditional designs to decorate the fuselage, uniforms and upholstery. But when it wanted to do what modern corporations like to – which is to make sure nobody else can use their branding – it ran into trouble. Because like the tapa itself, the designs can be exchanged and they can be given, but they can never be taken.

I looked up the Lau Islands. There are more than fifty, totalling fewer than 500 square kilometres of land scattered over a sea area of about 115,000 square kilometres. It's as if the Isle of Man were split into fifty fragments and hidden throughout a sea almost the size of England. Or if New Orleans were scattered in pieces around Louisiana. Although there are some closer groupings, it's mostly a long way by boat from one island to another.

There's one flight a week to Lau from the Fijian capital Suva. And that one doesn't land on any of the islands known for masi, so even if I got on a flight I'd have to find someone to take me further by boat, and get permission from the chiefs beforehand. I thought I might risk it, but then I learned that sunglasses are taboo in Lau. I have an eye problem that means I need sunglasses even on grey days. It wasn't going to work.

Reinventing barkcloth in Vanuatu

Vanuatu then? It's the next island nation west of Fiji. Most of the eighty-three inhabited islands don't have barkcloth traditions, but Erromango (the next stop south from the main island of Efate) does. And it's a fine one. In the British Museum's Pacific Barkcloth exhibition, the Erromango tapa, or nemas, was outstanding. Huge depictions of sea urchins and birds and a spirit-being, all painted with great, free, generous brushstrokes on big, rough canvases. I'd loved it. There was a quote by contemporary nemas maker Sophie Nempan, describing the dry season on Erromango: 'When the coral tree sheds its leaves and its flowers bloom ... at that season women are cold and their grass skirts are frayed, then they make barkcloth ...' Which was maybe true in 2000 when she said it. But was the barkcloth still being made, in the dry season or any other season, anywhere in Vanuatu today?

I learned that the people of Erromango* call the time before the Europeans arrived 'The Good Time'. That was when things balanced. But when The Good Time ended, history was brutal. After Cook, many other strangers arrived, from Europe and also from elsewhere in the Pacific, all carrying muskets and all looking for things to trade. Some brought malaria mosquitoes in bottles and smallpox in blankets so that the people living on the islands would die, and the incomers would have freer access to the sandalwood and sea cucumbers. They didn't care who died. In the 1830s, Erromango elders passed a law which translates as No More White Pigs. Despite this, Reverend John Williams visited in 1839, just a few days after white sandalwood collectors had killed a chief's young son. Williams was killed and eaten. In 1872, two more missionaries, Hugh and Christina Robertson, arrived and stayed until 1913. Under their tenure, Erromangan women could attend church only if they removed their barkcloth chest coverings and replaced them with missionary cloth. The Robertsons took, bought, confiscated, and were given, a great mass of Erromangan material culture during their four decades on the island, and when they left in 1913, they donated or sold much of it to museums overseas. As a result, the Australian Museum in Sydney now has the world's largest

* On his second voyage, in 1774, Captain Cook landed briefly, before a violent incident meant that his ships had to leave. People offered them yams, saying 'armai n'go(n)'go', meaning 'it's good to eat'. Cook's crew misunderstood, and named the place Erromango.

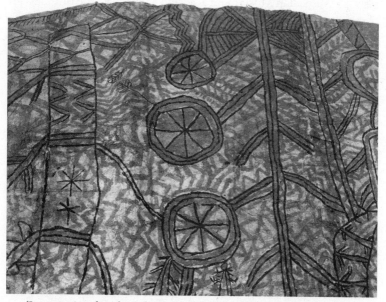

'It was painted with exuberant shapes like stars and centipedes and what looked like (but couldn't be) the segments of a lemon.' Detail from nineteenth-century Erromango nemas in the Hunterian.

collection of early Erromangan painted barkcloth. It's made mostly from breadfruit bark, which is darker and wider than paper mulberry.

So much of the island's material culture was destroyed or removed during this period that local chiefs told people to paint their clan histories on the walls of secret caves, so that if it all disappeared, people in the future would know the people and gods that had once been here.

I learned from Kirk Huffman, an anthropologist friend previously based in Vanuatu, that the caves still exist, and they still show the designs, although they are still secret, and can't be visited by outsiders. He said people on Erromango had stopped making barkcloth a century ago. However, in 2002, the Pacific Collections officer at the Australian Museum (Yvonne Carrillo-Huffman, who happens to be Kirk's wife), brought photographs from the museum's collection to show the islanders – and later she and her colleagues raised money for Sophie Nempan and her uncle, Chief Jerry Taki Uminduru, to

visit the Australian Museum in 2003 and 2006 to see the originals for themselves. When they returned, they were determined to bring the customs back – and now many people throughout Erromango know how to make nemas.

Kirk hadn't heard from Chief Jerry for a while, but it might be possible to find him, and see if I could learn from Sophie how to make barkcloth. Although I'd have to be fit. There are no roads and getting to the village means a very steep cliff climb from an isolated bay where a boat would land.

I was hoping to go in the next few months, I wrote.

In that case there's a problem, he told me. It was cyclone season, and when the worst storms strike, the people have to shelter for weeks or sometimes months in caves and other safe places. The island had been hit by 'Super Cyclone' Pam in March 2015. When the villagers emerged after three months, they found no houses, no communications, no barkcloth trees, no plants, no food. They had to start from scratch. 'They are very cheerful and resilient people,' Kirk wrote. 'Though barkcloth might not be their biggest priority at the moment.'

I'd also need a research permit from the Vanuatu Cultural Centre. Things take time in Melanesia, Kirk added. It's always best to plan a year or two ahead.

I started to look at Tonga. Barkcloth in Tonga is huge – at major ceremonies the ngatu cloth can be forty metres long or more, stencilled in bold symmetrical patterns, and as wide as a road. Or I could try Tahiti or the two Samoas. Tapa still has a ritual role in all those places. But by now it was cyclone season. I followed them on the map: Gita, Hola, Linda, Iris, Josie, ripping through the islands of the Pacific, their impact made more violent by climate change. I watched as one after another destroyed lives and Parliament buildings and the homes of hundreds of people. The 2018 cyclone season was one of the worst on record.

The Book of Barkcloth

When Margaret Bentinck, the Duchess of Portland, died in 1785 at the age of seventy, she left one of the greatest natural history collections the world had seen, including one of the earliest European collections of Pacific barkcloth. In a century where everyone who could

afford it had a mania for collecting, the Duchess of Portland – who had sponsored all three of Captain Cook's voyages – outshone them all.

When she died, not one of her four children was interested in the collection. As soon as their mother was buried, they prepared it for sale.

The auction at Privy-Garden Whitehall was one of the biggest ever private auctions: it took place over thirty-eight days. The thirteenth day, Monday 8 May 1786, was dedicated to 'artificial curiosities'. Lot 1369 included 'a stone adze, a cloth-beater, a mallet and a pair of mother-of-pearl castinets, from Otaheite,' while Lot 1372 had a grass mat from Angola, as well as the 'body linen, made of bark, of Oeerea, Queen of Otaheite with some of her majesty's hair, braided by herself'. Lot 1376 included 'three large and various small specimens of cloth, made of the bark of the cloth tree'. And Lot 1378 included 'various specimens of the inner bark of the Lagetto tree', which is also called lacebark and comes from the Caribbean. Like tapa, lacebark is also taken from the inner bark of a tree, but you don't have to beat it out, it just unfurls of its own accord, forming a natural kind of netting.

The following year, a small book was issued by Mr Alexander Shaw of No. 379, Strand. It was titled: 'A catalogue of the different specimens of cloth collected in the three voyages of Captain Cook, to the Southern Hemisphere; with a particular account of the manner of the manufacturing the same in the various islands of the South Seas.' There are fewer than seventy copies and the wonder of them is that – following an eight-page letterpress pamphlet – each contains thirty-nine or more specimens of the tapa collected during Cook's voyages (plus, in most copies, one piece of lacebark, probably from the Duchess of Portland's sale).

A few stories are given in some detail and the most moving tells of how, when Cook was moored off Tahiti in 1773 during his Second Voyage, one chief 'took a particular liking to an old blunt iron, which lay upon one of the officer's chests'. He pushed a young boy, about nine years old, towards the officer, as if to say to 'take him in exchange'. The officer, knowing he could not keep the child, yet curious as to the outcome, made the exchange, whereby a girl, 'who appeared rather young for the mother', sprang from the other side of the ship, 'and with the highest emotions of grief seemed to bewail

the loss of the infant.' The lieutenant took the child by the hand and presented him to her, at which 'she unbound the roll of cloth which was round her body … and having spread it before him, seized the boy, and jumping into the sea both swam ashore'.

It is from that cloth, the account says, that specimen thirty-four was cut. And that was the one I was most interested to see.

The trouble is that many of the volumes of Shaw's book have been rebound in the intervening centuries and the ordering has not been maintained. So in the one held in the Royal British Columbia Museum in Canada, sample thirty-four is tiny with yellow, red and black triangles. In the National Library of Australia, sample thirty-four is like musical staves: five black lines, a space, then five more black lines: with single red stripes slashed across them. And when at last I was able to see the British Library copy (after it had been withdrawn from circulation temporarily, for an exhibition) it appeared that the skirt of the young woman who rescued the child had been pale natural white, without any markings at all.

As I looked through the book, I imagined what the room at the Shaw home, or office, might have looked like the day the barkcloth was sorted for the seventy or more copies being prepared. Apprentices or family members cross-legged on the floor, using the long rolls of strange fabric as cushions; several pairs of tailor's scissors but not enough for everyone; curses because this servant or that friend had become confused about which was number thirty-four and which number thirty-five; or left the door open so the wind blew through to muddle up the piles. Or did they all just shrug and put the cloth samples in anyhow, as who would ever know?

It was frustrating not to know. Then I remembered reading how the eccentric eighteenth-century owner of the Museum of Curiosities in Leicester Square, Sir Ashton Lever – who had himself bought barkcloth from the Portland Collection – had believed too much system led to the strangulation of both pleasure and curiosity. So I stopped fixating on which piece was which and began to focus on the fabric itself. Because, in the end, my interest was not in the classifying or the numbering or even the story that Shaw had given. It was in touching the pieces; imagining them being made on islands that were still in The Good Time; imagining that these might have been the very pieces that Joseph Banks had written about and marvelled at and watched being made.

I came to number six, which according to the index was 'from Otaheite, used for bedding'. In photographs, it looks plain. But to the touch it was quite indescribably soft. Like cotton wool or fleece but it had heft to it and flop and strength, like the synthetic chamois cloths you use to dry cars after washing them. It was delicious: I kept returning to it. And I wondered whether it might be the same kind – perhaps the very same piece – that Banks had most admired: the cloth from Tahiti 'than which nothing can be more soft or delicious to the feel'.

The Ömie say yes

I'd all but given up on getting to see barkcloth in Papua New Guinea. Then I heard back from Florence.

She'd learned there was a road that led to one of the Ömie villages. She'd sent Peter, one of her guides; he'd walked it in three hours. We'd take longer, but surely not *that* long. The chief was amenable to our visit, and the village constable, and the women who made and painted tapa. It was almost too easy.

Like angel hair noodles

While I was waiting to finalise the trip, I went to visit a team at the University of Glasgow who were reaching the end of a three-year Pacific Barkcloth project. Professor Frances Lennard was in charge of the Scottish side of a collaboration with the Smithsonian and the Royal Botanic Gardens at Kew, all of which had important tapa collections, though very little research work had been carried out on the two British collections.

'We wanted to look at barkcloth as a material,' she said. 'People have done a lot about it as a designed object, but the big thing for us is that it's hard even to identify what fibre it's made out of.'

One of the more surprising revelations for the project's Pacific Art historian, Dr Andy Mills, was what tapa looks like under low-magnification microscopy.

'It looks a bit like angel hair noodles,' he said. 'The strange thing is that the actual fibres are translucent, like a web. You'd think that the pigments are going to colour the fibres and they don't at all, they just sit on the outside ... You see something that seems to be dark brown but it's only that on the surface.'

He said that he had previously understood in theory that matter is almost entirely empty space when you get down to the subatomic level, but when he saw the barkcloth under the microscope he felt he had experienced it.

'As an art historian you're used to being able to pick things up and handle them and you think about them in terms of being the bark of trees or something akin to paper. But the reality is really quite strange and wonderful. It's only by really engaging with the tapa that you get a sense of the deeper material reality of a superficially straightforward thing. You realise this is a miniature world that exists but that you've never seen before.'

The original basis of the Hunterian Museum was the collection left to the University of Glasgow in 1783 by William Hunter, who as well as being gynaecologist to Queen Charlotte, and a leading professor of anatomy in London, had also been a personal friend of Captain Cook and almost a neighbour of Joseph Banks. For the first seven decades after his death, everything was kept on open display in a room heated by two coal fires.

'This is Scotland and it's cold; imagine the soot on all the barkcloth over all that time,' Andy said.

They are making up for it now. Each long piece is wrapped over tissue paper around a roller, and kept in a temperature- and humidity-controlled environment.

One of these is a huge black-and-yellow piece of nemas from Erromango, which Andy carefully unfurled from its giant roller. It was painted with exuberant shapes like stars and centipedes and what looked like (but couldn't be) the segments of a lemon. It would once have been worn as a cloak. The material was so fibrous that the original makers had done something clever with the back. They had pulled little barkcloth strings out of the structure of it in order to make naturally integrated ties so they could roll it and carry it around.

Barkcloth for the king

Florence was getting final prices from the Ömie and checking that this was barkcloth-making season, if there was such a thing.

Katia went to get her vaccinations. When we talked she sounded subdued. The doctor in her local clinic also works as an expeditions medic, and a short time before he'd been in the Highlands of Papua

New Guinea with a film crew. They'd had a team of guides with whom they'd got on well. He had just heard that after his team had left the guides had had an altercation with another tribe. It was about taking foreigners across a different piece of land and not sharing the money with the landholders.

The guides had been beheaded.

When Florence wrote a few days later to say that the trip had fallen through, I was almost relieved. She explained that another faction in the Ömie area had emerged and they were angry because they wanted a share in whatever profits were to be had from our visit.

'Of course, you can go if you want to,' she said. 'But I'm afraid it's not safe and I can't bring you. I'm sorry.'

Perhaps it was time to switch continents. A few months before, Katia had sent photos from her great-aunt Enid's archive, including a 1961 photo of an Mbuti tribesman in the Ituri rainforest in the Congo, cutting bark off a tree. Mbuti barkcloth had been famous in Europe; Picasso had owned some. I searched for 'Where to see barkcloth in Congo'. But tens of thousands of people had fled that month from Ituri Province into neighbouring Uganda after tribal fighting had escalated. This was not the time to think of barkcloth in Congo.

Two years before, colleagues working on environment programmes in Uganda had brought back satchels made of chestnut-coloured cloth. They said it was barkcloth, though it was quite stiff, like densely packed short hairs, and it looked nothing like the tapa from the Pacific. I did some research and learned that six hundred years ago, barkcloth in Buganda (now the central Region of Uganda) was so important that only the royal family could wear it. Anyone else had to wear animal skins if they wanted to look well dressed. In 1862, John Hanning Speke, the first British person to see Lake Victoria, was granted an audience with King Mutesa I of Buganda. He reported that the king was wearing a splendid yellow barkcloth that looked like starched corduroy, though he also saw different, harder cloth used by ordinary people for clothes, as well as for awnings to give shade from the sun. It was made by cutting a whole strip from around the trunk of a wild fig tree. This operation did not kill the trees, Speke reported. If you covered the wound with plantain leaves it would heal, and the tree could be used again later.

After Uganda was made a protectorate of the British government in 1894, colonial administrators discouraged the making and wearing

of barkcloth because they wanted people to buy British cotton. Bark-cloth had a brief revival in 1953 when people started wearing it on the streets to protest the arrest of King Mutesa II of Buganda by the British, and recently it has been identified as a sustainable fabric, hence the satchels. I started looking at flights to Kampala.

And then I heard from Florence.

She told me that her father was from the Maisin tribe, in Colling-wood Bay, where some of those nineteenth-century optical illusion loincloths I'd seen in the British Museum were made. He lives in a village called Maume, in a place called Uiaku. Women there still make tapa. It's still really important to them. Perhaps she could arrange a visit to Collingwood Bay instead?

Obviously I said yes.

She said she'd ask the elders.

2

TAPA

*In which, without fifteen bodyguards or a helicopter, the
author eventually learns to beat a tree into a loincloth, sees for
herself the relationship between face tattoos and tapa designs,
and hears how barkcloth is helping save an ancient forest.*

'Pot Moby?' The Englishwoman at the Philippine Airlines desk in
London strained to hear.

'Port Moresby,' I repeated. 'It's the capital of PNG – of Papua
New Guinea.' She nodded, though clearly this hadn't helped. She
called a colleague over.

'These people say they're going to Pot Mossy. I've no idea where
that is.'

We hadn't heard back from our travel agent Florence for weeks.
We would only find out later that the Maisin tribe's form of village
decision making requires consensus from all the elders, so they keep
refining details until everyone says yes.

And then everyone *had* said yes.

'You can go,' Florence said.

Within days, my photographer friend Katia and I were flying to
Port Moresby via Manila, along with the PNG Aussie Rules Football
team returning home in triumph and waving an oversized gilt cup.
And now, after a short flight east across the Owen Stanley mountain
range to the Tufi airstrip, we were on a small dinghy with an out-
board engine, navigating southwards over a turquoise sea.

The local map was like looking at the back of your own left hand
with the fingers wide and the thumb stretched out. At the top, where
the fingers are, are the long underwater valleys and headlands of the
Tufi fjords. Then the shoreline becomes the C of the web between
index and thumb and here we were in the great curve of Collingwood
Bay, fifty kilometres from tip to tip, heading south to Maume, nestled

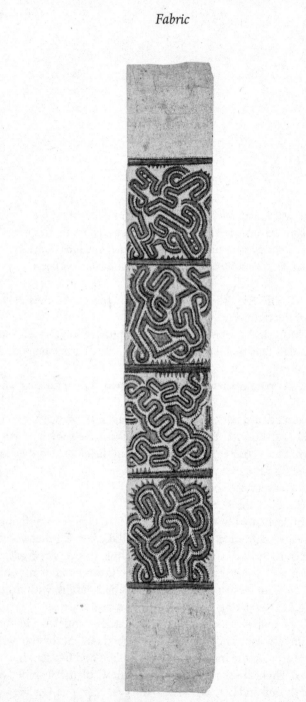

A *koefi*, or loincloth, made by Victoria Kunei in Uiaku in May 2018.

at the halfway point. To our right was a hem of sand, edging miles of green jungle stretching back to blue mountains. We slowed almost to a stop for a reef and saw a shoal of fish a hand's reach below. Later we slowed again when we saw birds circling and, below them, flashing silver fins.

'Tuna,' said Scott Bunari, Florence's brother, who had come down from Popondetta to be our guide. He was in his early forties, muscular, with a shaven head and an instant smile. He was dressed in jeans, a baseball cap and a black T-shirt. He'd come to collect us with his stepbrother Bartholomew and their neighbour George. As soon as they saw the fins, they all picked up nylon lines and let them run out in our wake. Bartholomew passed me the spare one, though Scott was anxious. 'When they pull, they pull!' he said, and kept looking at me as if any moment I might disappear over the side. The hooks were made of bent medical needles, with the plastic syringes making bright red and blue lures. 'We re-use everything,' he said. 'You'll see.'

I had a fantasy of arriving at Maume village with a huge tuna, but none of us caught anything.

After an hour or so, Scott pointed inland to a dark gash where jungle should be and was not.

'Wanigela,' he said. I wanted to look away, like I want to look away from the sad bits in movies. But I followed the brown scar until it disappeared. Wanigela is where the logging of Collingwood Bay has been concentrated for thirty years. 'They'll tell you about it,' Florence had said when we'd met at Port Moresby airport. 'They'll want to tell you. It's part of the barkcloth story. But they'll wait until they're ready.'

Forty minutes later, the dinghy turned to shore. There was a small river opening into the sea at an angle; it was hidden behind trees, so you wouldn't see it if you didn't know. We chugged upstream. At first there was just greenery, then we saw two anchored outrigger canoes with piles of netting flashing in the sun.

'Duck!' Scott said, and we all bent to go under a low bridge before the boat pulled up at a grassy bank, edged with washing lines. The men and boys were mostly wearing shorts and T-shirts, and the women and girls were in colourful dresses or skirts and bright blouses. Most people were barefooted. We stood beside an archway garlanded with red and orange flowers. We had this short moment at

the threshold, before the adventure started. I searched inside myself for the residual ache of sadness that had settled there since my parents had died. And I didn't find it. I felt perfectly happy.

The young chief, Arthur Sevaru, his name pronounced something like 'Atta', made a short address. Then two other men spoke and two women put garlands around our necks and led us to the guesthouse. It had just been built, and we were its first foreign guests. It was made of thick mangrove trunks and thatched with palm, with the floor raised on legs nearly two metres high. There was a large veranda and five doors leading to rooms behind.

There was barkcloth on almost every surface. Some pieces were wide, eighty centimetres or so. Those were the skirts, we'd learn later, while narrower ones were the loincloths. Almost all were painted with red labyrinths outlined with black. Most of the black lines had dots or triangular fin shapes zigzagging outside them.

'Please sit.' Scott indicated the floor of the veranda where there was more tapa painted with those powerful dark red mazes. 'We can't!' I whispered back. 'We might sit on the barkcloth.' He grinned. 'Yes. It's our way of saying you are honoured guests.'

We sat.

Many people lined up to introduce themselves. Some told brief stories and others said only their names, and some – although only the older women – had tattoos on their faces. We shook hands with each of them and in that way we were welcomed formally by the Maisin.

I slipped my hand down to my side to touch the cloth I was sitting on. It was dry and fibrous and softer in one direction than another, like the hair of a wiry dog. I tapped it; it made a soft drumming sound. I was going to like this cloth. It had muscle to it.

Scott took us to the men's meeting platform. It stood waist-high from the ground and had no walls, just a roof thatched with sago leaves. There were about a dozen men sitting on pale mats, woven from pandanus. There were representatives from each of the five village clans and others from the villages nearby. They invited us to say who we were, and what we wanted from our stay. Outside the sun was at its height; I could see the sandy centre of the village, blinding white and empty of people. There was just a huge black pig, called Nixon, snuffling along the edges. He had a silhouette like a cartoon hog, all angles and height.

'We want,' I said, 'to know about tapa. We want to see it made. But more than that we want to know what it means.' They listened and then after we had finished, they talked among themselves in Maisin. I watched Nixon turn off towards the bush, his large backside and tiny tail carrying him out of sight. The hair on his back gathered into a ridge like a short Mohican. Or the fins along the outline of a barkcloth design.

We returned to the guest house for lunch, and met the women who had been assigned by the tribe to be our personal guides. Jesset Sagi and Jane Gangai would be living with us, and there was also Annie Sevaru, Arthur's wife, who was coordinating how the women in the village would contribute food for us, in a rota organised according to clan.

Women began coming up the stairs, as they would do every mealtime, carrying cloth-covered dishes; them saying 'Oro oro oro' and us saying 'Oro oro oro' back, and asking them to join us and sometimes they would and we'd talk and there'd be laughter.

This is Oro Province, Scott had told us earlier. When you're walking through a village and hear 'oro oro oro' you will know you have been noticed, because *oro* means welcome.

That first meal included silver-skinned fish cooked in coconut and our first taste of taro – like pale sweet potato but starchier and less sweet – without which, for the Maisin, a meal hasn't really taken place. Afterwards, the women continued talking but it felt as if they were waiting. They were looking at Annie. Finally, she laughed, called over a small child, and sent him climbing one of the slim trees in front of the guesthouse. He quickly ascended five metres until we couldn't see his head, just two feet linked with a piece of white cloth, giving them traction against the trunk. 'One time that would have been tapa between his feet, for climbing,' Jesset said.

The boy returned with a bunch of green fruits like citrus limes. It was betel nut, and they called it 'buai', which sounded like 'blue-eye'. The women divided the little fruits. Annie put one into her mouth, chewed it, then dipped a stem of what she called 'mustard' – which looked like a tiny speckled spatula – into a tub of white powder called lime. It was made from pounding burned mollusc shells over a fire made from sago branches.

She put both the mustard and the lime into her mouth. After a few moments she smiled, and her teeth were the colour of blood.

The green nut and the white powder and the brown twig had somehow combined to make, hey presto, scarlet everything. It was a momentary miracle of colour, like the mati dye that so intrigued Joseph Banks in Tahiti in 1769, creating bright red from things that were not red at all. And it was also an important part of Maisin culture, a mild intoxicant, a way to stay awake or to relax.

'After lunch we ladies like to sit and chew,' Annie said, as the others pulled out their own lime pots and made their own teeth red. 'We call it Maisin lipstick.'

Throughout our stay Katia and I would discuss whether to try chewing. 'I won't let you,' Jane said once. 'It's so bad for you.' Jesset said that the first time she tried she'd felt ill the whole day. And that's what persuaded us: each day there was so precious, we didn't want to waste any time being sick. So we never did chew, in the end.

Arthur came back, along with Adelbert Gangai, another elder. They had red mouths too. They had put together a programme. Tomorrow we would see how tapa is made. Later we could go to the mangroves to collect shells for cutting the leaves used to make ink and see the ancient form of village governance in action, beside a fire under the stars. We could row canoes to see how people travelled to trade tapa in the past, and still do today. We could talk to the women with tattoos to learn how they connect with tapa designs. And also there might be a feast.

With all that in the future was there anything else we might like to do right now?

We looked at each other. 'We'd love to pop over to see a garden,' I said, to see the trees growing, before we saw how they were made into cloth.

There was an explosion of laughter. 'You can't just pop to a garden,' Gangai said. 'It's far! Maybe seven kilometres, and it's hard going.' He consulted with Arthur. 'We'll make it easier for you and later in your stay you can go and see a garden that's closer.'

So instead we were taken around the village, past fifty or so thatched houses made of mangrove wood, raised on stilts, and with shaded verandas above and platforms below. The houses of each of the Maume clans are in different areas, with the three 'peacemaker' clans at the front, closest to meet people coming by sea, and the two 'warrior' clans behind, closest to the hills.

There are thirty-six Maisin clans, based in nine villages along

Collingwood Bay. Their language is one of the rare ones in Melanesia that don't seem to be related to anything else. Only about three thousand people speak it: the chances of me having randomly found Florence, or anyone else who could arrange for me to come to this centre of barkcloth-making, had been extremely small.

Scott pointed out the wobbly bridge that led to the beach. We weren't allowed to walk across it: it was too precarious.

'It's not just that you could fall in the water,' Scott said. 'It's that if you *do* fall in, then any ladies seeing you would have to jump in in sympathy. And then to thank them you'd have to organise a feast. So better just take a boat.'

We learned that unless there's a special occasion you don't go through the middle of the village plaza but stay around the side.

'Like with tapa,' Jane said. 'We Maisin always start with the edges.'

As we walked, it was as if there were two places occupying the same physical space. There was what we were seeing now, and there was what we would have seen before 11 May 2007. That was the day Cyclone Guba arrived. Maume had been beside the beach then; now it was that wobbly bridge away from the sea. Guba spat sand over the fertile land close to the village. She tore up the church and part of the school and several of the houses; she carried away chickens and pigs; and she ripped through the gardens, stealing the food crops and most of the barkcloth trees. Most people lost almost everything. Nobody died, though, and they were grateful for that.

In the night I heard something I couldn't make sense of. It seemed almost like the sound of my own unconscious. It was rhythmic, soft, a mix of caress and hiss. I crept off my bed and opened the door to the veranda. Jesset had her back to me and was on her knees, sweeping with a small loose brush. She looked serene, in a private world. I looked at my watch. It was a quarter to three.

I went back to bed and after a while the sweeping stopped. But then there came the same soft sounds from other houses around us, like when the jazz percussionist whispers a drum brush on cymbals and you know something is about to happen. As dawn came, I heard tapping. Pang-pang-pang, so regular. Like a building site in a street far away or a woodpecker on a tree close by. Then a pause and it resumed. I lay back on my mattress, basking in it. It was tapa being made in one of the houses. Sweeping and tapa-making, these were the morning sounds of the Maisin.

Scott appeared to tell us that we weren't to go near the plaza until he came to collect us. There was to be a surprise.

When he returned, he led us around Annie and Arthur's house, past the men's meeting platform, and towards the centre of the village.

It had been transformed from a place you walk around the sides of into a place where things happen. There were five big woven pandanus mats on the ground; everywhere there were pink and orange flowers and there were people, and many children, and a sense of excitement.

'This is the first time they have done a tapa demonstration outside,' Scott said. 'They've designed this for you.'

When I'd first talked to Florence about this journey to find barkcloth I had imagined that we would be detached observers. I had not expected this exuberance, nor the fact that the showing of tapa would in itself be a gift.

The cutting

There are five stages in the making of barkcloth. As we walked into the sunshine, Scott whispered that there might have been more but there are five clans in Maume and each of them wanted to have an equal role, so in planning the demonstration they had divided it into five, and the first would be the cutting of the bark.

At the first pandanus mat stood Georgina Sevaru, wearing a blue batik blouse and a painted tapa skirt with a red border around it. It was tied with a plain tapa belt. In her grey hair were brown feathers and red flowers. In her hands was a thin, silvery pole, which, the day before, had been a tree growing in her own garden. It was a year old, a metre and a half long. If she'd wrapped her finger and thumb around it, they would just have touched. This was the size for a men's loincloth or *koefi*. For a skirt, or *embobi*, she would have let the tree grow for another six months.

Georgina scraped off the outside crust and showed us the cross section of what was left. The main thing, she said, is to look at the rings. We looked at the rings. There was a central core, and then there was the ring of recent growth, which would become the tapa. 'You see the circle's not quite even? The bark hasn't grown equally all around the tree?' It was true. Perhaps it was about where the wind

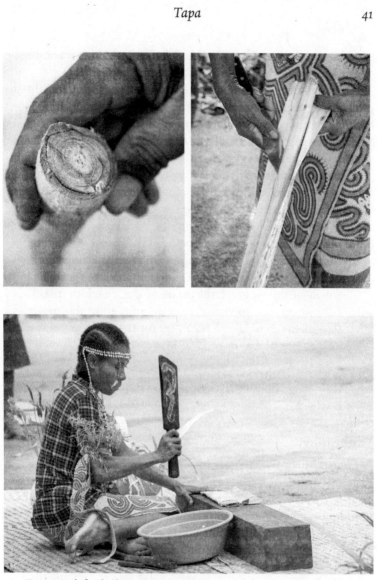

From top left, clockwise, Georgina Sevaru shows the cross section of the *wuwusi* – she'll cut where it's thinnest; Georgina cuts down to separate the inner bark from the core; Quincy Siroven uses her grandmother's *fisiga* to beat the inner bark into cloth.

blew harder or the sun shone less, but the inner ring was more an ellipse than a circle and one side was thinner.

'That's where we cut,' Georgina said. 'The thin bit will be the edges of the tapa. The width doesn't matter so much at the edges because we will cut them anyway, but the centre must be strong.' She cut down from top to bottom with her bush knife and it was like slicing a leek.

Within moments she had removed the core, which would be used for furniture, and had opened up the inner bark. It was a flattish surface, about eight centimetres wide, a metre and a half long, perhaps half a centimetre thick, with the inner side covered in moist droplets as if – like us – it was sweating in the heat.

'We'd normally do this cutting in the garden,' she said, 'so we don't have to carry the whole tree.'

It smells of mown grass, the inside of the barkcloth tree. That's what I wrote in my notebook after encountering the newly cut inner skin of the *Broussonetia papyrifera* for the first time. But when I returned to England at the end of May and there was mown grass all around I realised that the barkcloth straight out of the tree had smelled more like a meadow *before* being mown. The scent was fresher, lighter on the breeze.

The beating

At the next mat, twenty-five-year-old Quincy Siroven was holding a barkcloth beater or *fisiga* made of black wood, with a simple design like a curly bracket scraped onto it in white paint. It was like a half-scale cricket bat; one plane flat and the other slightly triangular, with two sharpish edges down the sides. It was different from beaters I'd seen from the Pacific, with their four equal faces ranging from thickly corrugated to fine. Instead the Maisin beaters had three gears: the edges for the first bit, almost flat for the second, and totally flat for the third.

Quincy was wearing a checked shirt over her *embobi*, as well as layered necklaces of white shells. She had two armbands with red flowers and painted tapa ribbons attached to them. She also had a shell headband with small sections of pink coral suspended on string, so they swayed as she moved.

She sat on the mat and put the piece of inner bark on a square

wooden beam in front of her, with the smoother, wetter side up. I felt it with my thumb-nail. It was like a slice of ginger, all fibre and moisture. She started hitting it across the diagonal with the edge of the *fisiga*, moving the bark with her left hand as she bashed with the right. It expanded quickly, like pastry straight from the fridge.

After reaching the end, she went back and beat along the opposite diagonal, like cross-hatching a drawing. The sound was echoey, surprisingly high. Higher than the sound I had heard that morning. In some Pacific Islands, the women select the beams and beaters specially for their pitch, to make a kind of tapa music across the village. They don't do that in Maume, Quincy said. Her mother had taught her to beat tapa when she was nine. She usually uses a metal beater for this part when she does it for her own use. For the demonstration she'd borrowed the *fisiga* from her grandmother, who had used it for at least fifty years.

The Maisin don't, like some other Melanesians and Polynesians, combine two or more barks by sticking them together or by felting to make a bigger cloth. They also don't, as other Pacific people do, soak the bark before beating it. 'We don't need to,' she said. 'Our tapa trees are soft already.'

When she reached the end, Quincy rolled it up. She took a heavier wooden mallet called a *fo* and hit the whole roll together. Each time it got wider and thinner. She had a tub of water beside her and regularly touched the surface of the barkcloth with drops on her fingers.

'We don't want it to be too dry or it might tear,' she said. The ribbons of tapa attached to her armbands shivered as the beater moved. After about half an hour, she had finished: the tapa was almost as wide as her lap.

Now it would hang on a washing line under her house out of the sun for a couple of days, she said, hanging the piece to show us. After the demonstration day, I would notice cream-coloured cloths drying on lines under many houses. Although once I saw some pale tan cloths from a distance, hanging under a house. Small tapa? I asked. But when I got closer, they were clearly cotton nappies for babies. I felt like the Don Quixote of tapa, tilting at the wrong things.

The mending

As we turned to the next mat, I realised the sophistication of this

demonstration. The women had planned not only to show us what happens to the cloth at each stage, but also to take us a step further each time into Maisin traditional dress.

All of our guides were wearing barkcloth skirts but Georgina had had a blouse on, as had Quincy, along with more shells and those hypnotic ribbon armbands. For the third stage, thirty-two-year-old Mary Dora Mokada was wearing a triangle of painted tapa tied around her chest and knotted at her back like a bikini top. She had a white cockatoo feather in her hair and orange flowers at her ears. Her armbands were an exuberance of pink and red hibiscus, with bright green fronds like the tail feathers of birds of paradise.

In the past, Mary Dora explained, their grandmothers used to sew patches over the holes in the barkcloth using needles made from the smallest wing bone of the flying fox.

'Then, as time went by, they found some glue.' She pointed to a shrub with little green berries, growing beside one of the houses. They call it *bukaplas* – *plas*, or *plasta* means sticky as in sticking plaster, and *buk* is book, because the children use the berries to stick papers into their schoolbooks. It's not native to the area but was introduced a few generations ago. It looked like *Cordia dichotoma*, known as the Indian cherry tree, or in Australia the more vivid 'snotty gobbles'.

We helped Mary Dora mend the holes. There were about twenty of them where once upon a time a branch had tried to push through. The holes were different shapes: long, round or crescent, like the phases of the moon.

It is rather like fixing punctures on a bicycle. You tear an appropriately sized patch from a tapa offcut then squeeze the glue-berry around the hole, leave it a moment to get tacky then fix the patch and press.

When she'd finished she took some scissors and cut the edges to make them straight. Once upon a time it would have been a stone axe, she said.

'But scissors are easier.' The barkcloth would now be stored flat under a sleeping mat until it was ready to be painted.

'We call it our Maisin ironing.'

It is also, Jesset said, about putting 'a bit of ourselves' into the tapa.

The designing

Scented smoke drifted from the other side of the plaza. Fifty-three-year-old Velma Joyce from the Ogaiyo clan was crouched over a small pile of burning coconut husks, fanning the flames with a palm leaf. She had made tongs by folding a thin strip of wood in half, and as soon as the husks were charcoal she dropped them into a pot of cold water. Afterwards she mashed the mixture with her hands, squeezing a black liquid into a plastic bowl – I tried it: it was like oily clay, slightly crunchy. Then she took fresh leaves from a wild creeper she called *wayangu*, collected from the bush earlier that morning, and shredded them into the bowl using a pair of sharp, round mollusc shells the size of her palm. The clam inside had been eaten for dinner, the shells would later be burned into lime powder, and now they were instant scissors. 'Triple purpose,' Scott said. It would be four to seven days before the paint was ready, Velma said.

When she stood up to go and collect a bowl of paint she had made a week before, I saw her clothing properly. She looked spectacular. Her narrow armbands had posies of feathery flowers tucked into them, alongside black cassowary plumes giving a sense of shimmer and down. Her clan is the only one that has the right to wear cassowary, she explained. She wore a wide headband with flat coral stripes alternating with black shell, all outlined with thin shell lines of white; it had been passed on by her great-grandmother. The belt holding up her tapa skirt was somehow woven into diamond shapes. It looked like it was made with blue, brown, yellow and green beads.

'Do you know what that is?' Scott asked. We didn't. 'They stripped the coatings off old electrical wires and cut them into small pieces to make a belt,' he said. 'You see how we use everything.'

Most Maisin women's face tattoos finish just under their chin, but Velma's continued down her neck, ending at her collarbone. Below it she was bare-chested, with an exuberance of necklaces, including several apricot-coloured shells as wide as her wrists.

Although they now have steel pots and Western clothes and a modest cash economy, the Maisin still, even today, maintain their own traditional chains of exchange. They have trading relationships all the way up and down the coast. The best shell necklaces come from south of Milne Bay. The round, black pots for feasts come from Wanigela where there is an excellent volcanic clay. The price is a big pot for a tapa skirt, a small pot for a loincloth; and there are other

fixed prices for stone axes, pigs, headdresses, necklaces, canoes and pandanus mats.

All the people in Collingwood Bay and Tufi are aware that they need to keep making and (just as importantly) *wanting* those traditional things. They know that if they stop wanting tapa and clay pots and shells and dugout canoes it's not just the material objects that will be lost. Something intangible and vital – the relationships in this complex world with people who speak different languages and with whom they need to be friends rather than fight with about land rights and fishing rights – will be lost too. So they consciously try to sustain their need for them, by holding ritual feasts, and teaching their children how to make and use these things.

Velma had returned with another pot of paint, which she called *mii*. It was thick as mud and it smelled awful. It had the stink of silage – fermented grass – or the smell you pick up when you drive past a pig farm in the countryside. There was another note to it that wasn't decay, but more like the darkness of certain flowers. I moved closer to try to work it out and got it on my nose. We all laughed.

Velma sat on the mat with her legs in front of her and put a flat piece of wood on her lap. She had a betel nut in her cheek, which had the effect of making the round circles on the cheeks of her face tattoo stand out like contour lines. 'You have to chew to do good design,' she said. She picked up a stick from a black palm tree. It was the size of a pencil and she used it to draw two lines around the border.

Maisin tapa almost always starts with painting an edge, Scott said. It's about spacing, so you understand the boundaries. But it's also symbolically about marking a beginning in any enterprise.

When she had finished the border, Velma stopped. She breathed out, and seemed to go into a different space. After a moment she was ready. She started by drawing four straight parallel lines in the middle of the cloth. She joined two of them and curved the others around. Straight line. Curve. Join. Straight line. Curve. Bold diagonal. Curve. It was mesmerising. Whenever the end of the pen became clogged she snapped it off and started again. She dipped the pen frequently; each dip gave just two or three centimetres of design. The labyrinth kept expanding.

In the background I heard somebody making a canoe, a deeper pounding than tapa. A baby cried. A bird screeched. ('What's that?' we would ask, in the beginning, when we heard a new call. 'That's

a bird,' they would answer, only specifying the species if it was a hornbill, whose sound was unmistakeable, like the low hum of a helicopter coming slowly into land. One flew over now.) Then the background faded and for a while it was just the paint and the bark-cloth and the lines.

'The blueprint is up here,' said Gangai, tapping his forehead as Velma worked. 'This takes time. Sometimes days. You have to chew betel to keep yourself going.' When it's not a demonstration for visitors, the women design on their own, sitting quietly, away from children and distractions. A 'nice design' usually comes from being focused, Scott said.

When I'd done research among aboriginal artists in Australia, I'd learned that there were things you can ask and things you cannot. And that there were hidden maps beneath the surface of art just as there are hidden messages beneath the surface of language. I knew the Ömie painted animals and myths into their art. I wondered if the Maisin did something similar.

'Does this represent anything?' I asked.

'No,' said Jesset. 'It's just from Velma's mind. Whatever comes into her mind she just puts it on the tapa.' The other women agreed. 'The design, it's just imagination.' They were keen to tell me that there was no story; that aspect was important. And yet, as I'd hear later, it was in fact *part* of the story.

After finishing the lines, Velma picked up a thinner black palm pen and started to add dots – *sufifi* – along some of the lines. Just on one side, never on both. She added little crosses and triangular fins where she thought the patterns needed some interest. As she drew, she was conscious of the space between the lines, she said. Where there were dots was a message to herself in the future, to say that this side will be left unpainted. And where there were no dots, she would know to put the red paint. It doesn't sound hard, but watching her, I found that I couldn't hold the information in my head; I couldn't work out what it would look like in the end.

Making red

There are two ingredients in the red. One is bark from the *saman* tree. The other is leaves from the *dun* tree, which gives the paint its name.

Jane Oiro, Bartholomew's wife, and representing the Kaiso clan,

showed us how she tore thin strips from the pink *saman* bark then layered them with the pale green leaves in a traditional clay pot placed on a cooking fire. As she put the ingredients in, topping them up with water, her necklaces rattled lightly, like the first drops of rain.

She had another pot that had been boiling for two hours and was ready. The red was the red of strawberry juice, not of blood; it had a softness to it. She took a dried pandanus fruit, which resembled a tiny shaving brush without a handle, and tested the paint on a spare scrap of barkcloth. When she was happy with the quality, she put a cloth she had designed earlier onto a board on her lap and started to paint between the black lines, using the dots as her guide. This was the first coat. Later she'd go over it again.

As soon as the red was on, the maze made sense in a different way. It was as if, when it was just black and white, the tapa was full of possibilities: it could go one way or another; your eye flipped between the lines. But with the red, it became as if your eye was being guided along roads that run parallel then veer. The experience of looking became more playful.

The tapa was absorbent, but not like blotting paper. The paint sat on the top for a while and then sank in. I was reminded of what I had learned in Glasgow about how tapa is always itself below the paint, which stays on its surface. That is its nature.

In the old days, Jane said, there were rules. 'When you painted red, you couldn't chew and you had to be quiet,' she said. I had read that there were other rules too: that men and infants couldn't come close for fear that they might weaken the power of the paint; that you couldn't say its name while you were using it, substituting instead the word for 'red blood'; that you couldn't have sexual relations before painting; that the red could be regarded as veins in the human body, running in meanders and creating life. Those rules were part of the past.

'Nowadays you have to sit and think, but there are no restrictions,' Jane said.

As with Velma, Jane's ritual costume had no blouse. Her shell necklaces seemed almost crocheted into each other; she looked glamorous. Down her back a chain of shimmering shells extended to her belt, ending with four palm-sized shell rings the colour of the moon. They were *yua*, carved from the giant clam. They're valued throughout the country; in some areas they're sacred, and in many places they're exchanged, like money.

The pattern on Jane's skirt was like nothing I'd seen so far. It was the same black and red colours on cream. But the design was sparser. It had simple zigzags – straight lines, not curved, and plenty of empty space. She said it was the pattern of crocodile skin.

'Only our clan wears this,' she said. 'It is for special occasions.'

It was a clan design, an *evovi*, and unlike the other patterns we had seen it did not come from the imagination. It came from the place where the myths and the stories were stored. Some of the clan designs come from long ago and were passed from mother to daughter, Scott said. They might represent mountains, or a river eel, or the patterns on a chief's lime-pot. Other designs came from dreams, and from the Maisin belief that sometimes dreams connected you with spirits.

When Gangai was a child, the old women used to keep pots of *mii* and a spare page of tapa beside them as they slept. 'They woke and transferred their dreams onto the barkcloth,' he said, laughing. 'The whole house would stink of that black paint.'

The dream might have been a snake, he said, 'or wind blowing over woven fans or the legs of a wallaby or the ears of a wallaby.' And after you had dreamed them those designs could not be transferred to anybody else, except by inheritance.

As he talked, I watched Jane going over the red lines a second time. The colour had begun to glow scarlet in the sunshine.

While the Ömie tapa makers had decided that they *would* sell cloths with their tribal designs, the Maisin had long ago made a different decision. They had designs that came from the imagination and they would sell those to help pay for their children's education or for medical supplies. But they also had other cloths with designs they had earned or had inherited the right to wear. It's not that those designs are secret. But they are sacred, and they are not for sale.

I tried painting.

'You've got to be fast, as it dries quickly … Yep, you're doing fine, dip it again.'

It needed a lot of dipping. Mine was uneven; Jane had done it so quickly and smoothly.

'The same hand that the brush is in, use that one to support the board.'

That was easier.

I found myself thinking how much easier it was, and the moment

I had that thought, the red blotched. I went back over it, to make it more evenly uneven.

There was something addictive about following the lines. I hadn't joined the craze for colouring books in the early 2010s, but now, on a mat in Papua New Guinea with a board on my lap and a pandanus brush in my hand, I thought I understood. You just want to do a little more. I liked the way the colour paused a moment before it sank. I wanted to see that again and again.

After everyone had packed up, and we were back in the guest-house drinking black tea, Jane and Jesset said that the morning had been good for the Maisin too. 'We learned about our own culture today, and so did the children. They didn't know some of the things that were said.'

Gardens

One day we went to a garden. Not to the closest one. The Maisin had decided that we could go to one of the gardens seven kilometres away after all: we'd clearly passed some kind of test.

Jesset carried my bag, and a band of children came with us. There was the atmosphere of a holiday outing and they sang songs. Most carried bush knives. I couldn't get used to the sight of infants running with huge, sharp knives in their hands.

At first it was easy going. And then we got to the mud. At times it was above our knees. The Maisin were barefooted, and Katia just pushed through, her boots soaked already. If I'd known how much mud there would be I'd have done the same. But instead I swapped between flip-flops on the dry ground and bare feet in the mud and water, and I felt every stone.

There was laughter and excited talk behind us. 'They were looking at your footprints,' Scott said. 'All the women know every-one's footprints so they can see who's in the garden today, and whether they were in a hurry or tired ... and they were saying yours look so different.'

I looked at the ground carefully after that. Only Katia's boot prints were clear. Everything else was tiny indents. Nothing really to tell. And I thought about how if two people could look at the same path and one of them could see the subtle histories and presences and speeds of those who had walked there before, and the other

couldn't see anything, then might not their response to the subtleties of designs in art and fabric also be entirely different?

The river meandered like a tapa design; sometimes we crossed it and sometimes we waded along. At some points the water was above our waists. I understood now why Jesset had insisted on carrying my bag. This is the journey the women do almost every day. Those with babies carry them up to the gardens in their empty string bags or bilums; in the afternoon they carry them back, perched on top of the vegetables.

The path rose; we were in the foothills. As we turned a corner, I was distracted for a moment by a small black snake, freshly killed, being prodded by two children, and then I looked up.

What made me think so clearly of the Garden of Eden? It wasn't just the snake. Nor was it just the orange and pink flowers with yellow butterflies over a lusciousness of green. Nor the clusters of thin *wuwusi* paper mulberry trees like ghostly sentinels at gates you could not see. Nor even the plump white cockatoos, with their spiky yellow haloes, flying up like chattering cherubs at our arrival. There was something abundant and wonderful about this place. It had so many layers of heights: creepers on the ground, taro with their heart-shaped leaves at knee-height, waist-high ferns, and the giant, ancient trees of the jungle clustering around the sky. And although almost nothing was in straight lines, and there was a lot of wild, it was like finding constancy in chaos. You knew a gardener's mind had made this, and that every little taro or tomato plant, every bean, every sweet potato, every *wuwusi*, every something you didn't recognise, was planned, watched and loved.

This is the kind of shifting cultivation we learned about in geography as 'slash-and-burn' and today is known as 'swidden'. At school, we were taught that it was damaging for forests, although ecologists now realise – as the people who do it have always known – that it's beneficial, and perhaps vital, to the diversity of life. A Maisin garden will be fertile for two or three years, and then it needs to be left for a decade or more until you can use it again. Jane Oiro had made this one just nine months before, so the previous garden was still partly productive, and she was using it for bush bananas, sugar cane, and some of the tapa.

There are at least sixteen varieties of *Broussonetia papyrifera* in the world. The Maisin are proud of theirs. In the 1980s, they told anthropologists they were nervous that other tribes might take their

saplings and make their own cloth from them. In 2018, they were still nervous, mentioning their concern several times.

Most of the *wuwusi* were about five metres high, with branches forking out at the three-metre point. The leaves had serrated edges and were shaped like the spades suit in cards. And they were large, at least thirty centimetres long, about the length of a school ruler. The trees in Jane's new garden had been planted in two lines five metres apart, so they'd grow straight and not compete with each other. But in her old garden they came in clusters of five or six where they had been cut at ground level and new shoots had sprung up. Paper mulberry can do that: in some parts of the world it's seen as an invasive species, choking out native flora because it uses so much water. When Cyclone Guba came, many were blown down – their roots run shallow.

Is there a *wuwusi* tree ready to be cut, I asked. There was rapid discussion. Jane looked at her trees, assessing them. There was one. It was six metres tall but skinny, the width of her wrist, just enough to be a loincloth – 'for a fifteen-year-old boy' someone joked. She cut the undergrowth then walked around it with her bush knife, making about twenty hacks at ground level. When it fell, she cut it where the branches started. It all took less than two minutes.

As we started home, with Bartholomew carrying the little tapa tree, Annie came back from her own garden further up. She had filled her bilum with taro and sweet potatoes, and was carrying it on her back, with the string handle straining over her forehead. I asked if I could try. 'It's heavy!' she laughed. It was astonishingly heavy. Heavier than my travel bag, which had weighed in at fifteen kilograms. I could only carry it ten metres. My neck muscles were simply not strong enough.

She carried it seven kilometres, through the mud and water, and she didn't break a sweat. 'We start when we are little girls,' she said, indicating a child with a tiny bilum string stretched across her forehead. Like all the Maisin women, Annie's arms and shoulders were taut muscle. In the UK, they would all have been athletes.

Where tapa designs came from

'I was sixteen when they said it was my time for tattooing.'

Sarah Hector leaned back against a piece of tapa hanging on the wall of the veranda. We'd finished our dinner of sweet potato, fried

fish and, of course, taro. And now we and several Maisin women were sitting around on pandanus mats, under the silver glow of a solar lamp. They put betel nuts into their mouths and we sprayed ourselves with mosquito repellent. Then Sarah told her story.

'The one who tattooed me was my auntie and she had come from Reaga down the coast.'

The old rules said that, just like painting the red, you couldn't chew betel nut while you were being tattooed. 'Was that tough?' I asked, and all the women laughed, their Maisin lipstick looking black under the lamp. 'Very tough!' Sarah said.

She had a choice about whether to have it done. 'I decided to because it's our culture. I was nervous. But my auntie told me: you must be strong. You are here to get a tattoo, not to get scared or to turn your face away. Now lie down straight and be brave.'

That first day, Sarah's auntie sketched designs on a piece of tapa according to what she thought would suit each girl. The girls, who had never seen their own faces – mirrors were not common in Collingwood Bay in 1979 – used the drawings to decide on the designs they would carry for the rest of their lives.

On her tapa Sarah would have seen a symmetrical pattern with lines about a centimetre apart and about half a centimetre thick, centred on three lines down her nose becoming, when they reached her forehead, two separate arcs of three lines each. She would have seen those lines become curved when they reached her cheeks, and a series of waves at her chin. But always managing to be the same distance from each other, always managing to seem planned, filling every space.

Then when she had agreed to the design, Sarah lay on her back in the semi-darkness of the interior, and her auntie knelt behind her. She put Sarah's head on her lap and drew the patterns in ink. Then she punctured her skin along one line, and the process began. She used metal needles, though earlier it had been done with thorns. But the ink was a traditional recipe. Like the black *mii* paint, it was made from crushed and wetted coconut charcoal mixed with a special leaf, though it was a different leaf, and it didn't smell as bad.

The repetition became lulling after a while and there was a sense, Sarah said, of something exciting being created. It was hard being kept inside in that prescribed isolation that had been part of the girls' coming of age ritual for so many centuries. They weren't even able

to wash for the two or three months that it took for the tattoos to be made and the scars to heal.

But when at last Sarah and the other girls emerged into the sunshine to show off their new faces, everyone was excited. This was their design. Their beauty had emerged.

Their faces had gone from *foe*, which they pronounced 'fwey' and translated as 'white', to fully realised – designed. They use the same word, *foe*, for blank tapa.

Only one other group of girls was tattooed in this village after that, before the custom finally stopped, although it continued for a while among other tribes around Tufi.

'I was one of the last,' Sarah said. 'I was lucky.' She put her head back and laughed.

We knew that the long piece of tapa on the wall behind her had come from her own garden. Sarah had beaten it into cloth but Jesset, her niece, had designed it. Unusually, it had no border, nor was it divided into four or five similar sections like most tapa. Instead, it was a single, unbroken painting of shapes like links in a chain, rocking down the length with a sense of movement. Which gave what happened next an almost mystical power.

Because as Sarah laughed, just for a moment, in the half-light, her tattooed face merged with the tapa cloth and seemed to switch places in a piece of optical magic. And I knew what she was going to say.

'Tapa is like tattoos and tattoos are like tapa,' she said. 'They come from the same place.'

This was one part of the story-that-wasn't-a-story, about the designs that 'just' come into the minds of women. Growing up, they see tattoos on the faces of their mothers, their aunts, and (if they are older than fifty) their sisters and friends, though not usually on themselves: mirrors are still not a thing. Chevrons on a forehead, circles around a cheek, curves tumbling down a neck – these are lines that represent beauty and creativity, as well as culture and familiarity. It is hardly surprising they've been inspired by them.

There is another part to the story. It's found in the betel nut, the mild intoxicant they chain-chew while designing; in the quietness they require to do it; and in the quiet breath they take before they start. Designing 'just from the imagination' is the story the tapa makers don't tell in words. As with the tattoos, it's about pathways into the subconscious.

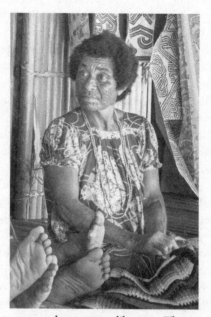

'Tapa is like tattoos and tattoos are like tapa. They come from the same place.' Sarah Hector telling her story in the guesthouse.

Within a day, I'd stopped finding it startling to see a tattooed face; within three days I began to recognise the designs from different tribes along the coast – lines wider apart suggest she's from Wanigela, more diagonals and she's probably from Tufi. I began to find the tattoos beautiful; if I'd stayed longer I'd probably have wanted one myself.

'Where is that place?' I asked Sarah. 'Where do the Maisin say tapa and tattoo design come from?'

The women conferred. We became used, in our time there, to this kind of conversation. It was all about finding the point of agreement. The men did it too: during their meetings they never voted, they waited for everyone to agree. It was calming to listen to, like circling and murmuring. In this conversation, they were deferring to Annie, and she was the one who spoke then in English.

'There is a story, but we don't know it. You'll need to ask the elders.'

The next day we asked the elders, and after conferring, they told us the story. How one day a long time ago a deep hole appeared

beside the river that runs north of Mount Victory, which they also call Kerova. And out of it emerged a band of people, complete with the knowledge of clan designs and magic and how to make barkcloth and tattoos and a garden. And later they came south around the coast, to this village, and they found tapa trees that were much better than anything they had known before, and they called them *wuwusi*, and they settled and became the tapa makers.

Later, back in the guesthouse, I relayed the myth of the hole in the ground to Annie and the other women. They nodded. 'Yes, this is the story we thought,' Annie said.

The story had sounded familiar to me too, and when I returned home to my anthropology books I worked out why. There is a myth from the Trobriand Islands (some two hundred kilometres north-east of Collingwood Bay) that originally people lived in villages underground, with lives very similar to our present life on the earth, together with clans and designs and magic and even property claims. In 1914, when this was documented, islanders could point out the precise places, the 'grottoes, clumps of trees, stone heaps, coral out-crops, springs' where their ancestors had emerged.

The word for this kind of origin story is autochthonous, from the Greek words *auto*, self, and *khthon* earth or underground. It means something or someone that has sprung from the land fully formed. As itself.

The word is reminiscent of the essential nature of barkcloth. Bark-cloth emerges fully formed from the tree; the design of it emerges fully formed from its maker's mind. Unlike almost all other cloth in the world it doesn't have to be knitted or woven or felted. It is there already. And the role of the makers (just like that of parents with a child, the Maisin say) is simply to let it become itself.

But better.

A missive from Wanigela

One morning I went swimming in the sea. It was just after dawn but the water was warm. My shorts and T-shirt ballooned around me as I kicked back in the water. I looked over at the coconut trees along the beach, each planted and owned by a family, and at the wisps of wood smoke rising at each wooden house, and I listened to the echoes of barkcloth beaters, the individual rhythms resounding across the bay.

It was all astonishingly beautiful. Then, when I got out of the sea, I joined a gang of small Maisin children, huddled in their colourful towels, sitting along a giant log, drying off before breakfast.

Scott was there, looking for a phone signal to send a text. He pointed to a number painted in fat white figures at the end of the log: it looked like DC5716. The log had been washed up in a storm a few weeks back. It had come from Wanigela. 'There've been more recently,' he said. 'The company must be logging. There's no other explanation.'

Beating the tapa and counting to five

Scholarstica and Lillias were sitting on the platform beating tapa. They invited me to try. I remembered learning how to use a pasta machine, starting on the thickest setting and then working down: if you tried forcing it through the thinnest space straight away, the dough would fall apart. Tapa is like that; it needs to be coaxed. If you hurry it, the body will not hold.

Once I got into a rhythm, it wasn't too difficult, although the beater kept landing anyhow. This piece, I warned Scholarstica, was going to be rather uneven.

I remembered reading how, in 2009, a team from Guangxi Museum in south-west China discovered the oldest known barkcloth beater in the world. They dated it to 5900 BC. It was stone and it measured just six centimetres by seven. You could tell it was a tapa beater because of the grooves on both sides. When I read about it, I had been puzzled as to how anyone could beat tapa effectively with something about the length of a credit card. But then I heard about how barkcloth was made from *Ficus*, fig tree bark, until about a century ago by communities in Central Sulawesi in Indonesia. Each family traditionally had a set of five barkcloth beaters: two big wooden ones for the first stages, then to finish it they used three smaller grooved stones like the one found in China – the stones hafted with rattan handles to make them springy like fly swatters. This made the cloth softer, though it was hard work.

A band of children had arrived, laughing at me trying to beat Schola's barkcloth. I thought I would entertain them by learning the Maisin numbers. Sese ('sessay'). One. Sandei. Two. Sinati. Three. Fusese. Four.

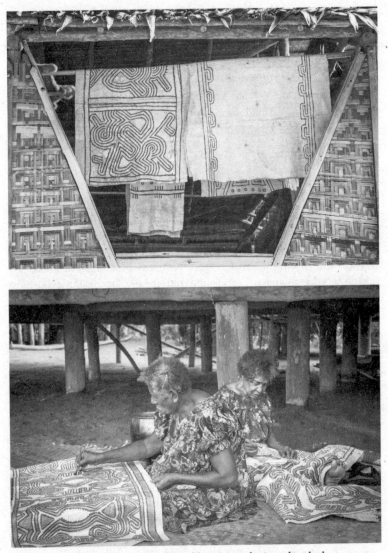

Above: Everywhere we could see tapa drying: the cloths
to the right and behind show traditional evovi designs;
to the left is a design 'from the imagination'.
Below: Two friends in Ganjiga village sit together to paint.

'What's five?' I asked after I'd repeated the other numbers enough times to remember them, with my barkcloth slowly expanding to the count.

'Fuckety-tarossi,' one child said, or that's what it sounded like. Crikey. I moved quickly to six and seven. Fuckety-tarossi sese. Fuckety-tarossi sandei. I stopped. I checked. A child showed me her exercise book.

It was spelled *faketitarosi* and it was the real Maisin words they were teaching; they weren't teasing me. I then realised that not only did it sound, deliciously, like swear words in English. It also sounded like it was in base five.

The women confirmed that the Maisin counting system was based on hands and feet. You count five fingers then it's one hand one finger, one hand two fingers. Then two hands (*faketitautau*). Then two hands one foot one toe.

'What happens when you get to two hands and two feet?'

'For twenty, we say *tamati* which means "one man",' said one woman who had come to watch. 'And then we say: "One man one hand two fingers" and that is twenty-seven, it works like that.'

It is a counting system that other tribes further up Collingwood Bay share in their own languages. It is useful for calculating how many pieces of tapa you are making, or how many pots you need for a feast. It's not a system for pure mathematics.

Nor for auditing the numbers of trees, tens of thousands or more, that had already been taken from the ancient forests inland from Wanigela, far above the gardens of the villagers.

How tapa is saving the forest

In the early 1990s, the Maisin elders debated whether to allow commercial logging on their traditional land.

After the Second World War, PNG's rainforest had been protected to some extent by its diversity. A mix of nine thousand species makes logging complicated; you want to concentrate on one or two commercially viable ones. So while forests in Indonesia and Malaysia (and the Amazon and Congo and too many places) were destroyed rapidly, early logging in PNG happened on a smaller scale. But by the 1980s, Rimbunan Hijau, the vast Malaysian company responsible for felling hundreds of thousands of ancient trees every year ('the Monsanto of

'This cloth is helping protect a whole ancient forest.' The
edge of Maume and a road to the gardens behind.

forests,' one Maisin elder said) had moved in, together with Japanese
companies looking for cheap plywood.

Most of the land in Papua New Guinea is communally owned
by tribes. And if you're going to take the forest legally, you need the
approval of many landowners. In the beginning, the way companies
did it was to promise to provide schools and medical centres, and
they would perhaps also offer bribes. Then they'd take out a ninety-
nine-year lease, using a government agency or local company as
go-between. Stories spread that – despite promises – gardens were
being destroyed along with the forest; that medical centres hadn't
materialised; that the landowners had no say on the logging; that the
oil palms that replaced the trees supported no cassowaries or wild
pigs or other animals hunted for feast days; that the huge profits were
not passed on.

That is the point at which the Maisin said no.

It wasn't easy. Many tricks were employed: one company even
created fake documents with forged signatures from tribe members
living in Port Moresby. The Maisin were enmeshed in expensive court
battles they could not have won without support from conservation

groups. Their first win was in 2002 and they thought it was done, but it was not. Court cases were fought one after the other.

'In 2016, the national court ruled there can be no logging in the whole of Collingwood Bay,' Gangai said. 'It's illegal. But we still see logs like the one on the beach coming down from Wanigela. And those are only the ones that floated free.'

The logging companies have power because people need cash. Houses, food, canoes and medicinal herbs come from the land. But villagers need clothes and schoolbooks and school fees. They want solar lamps and chargers and phones. They need doctors. Florence had warned us – the day before we flew from the UK – that there were no medicines in Oro Province and I'd raced around Bath buying paracetamol from every pharmacy that was open. But we had not realised that 'no medicines' really meant nothing. Not even a sticking plaster. There was a clinic, but it was closed. In an emergency, they have to travel the hundred and fifty kilometres to Popondetta in an outboard dinghy, spending hundreds of dollars on fuel.

When the logging crisis started, there was almost no money in the villages. But there was tapa. And in the 1990s, with the help of Greenpeace and others, a tapa cooperative was set up. Families were given hand-operated sewing machines. They learned how to make barkcloth into hats, headbands and bags, and other tourist items. A few men and women went overseas for tapa exhibitions in museums.

'For thirty years, tapa has been the shield protecting our rainforest,' Gangai said.

It wasn't perfect: there were rumours that some people weren't treated fairly; the cooperative didn't last. But tapa brought money into the village and it still does. It has solved some of the problems. It has, at least for now, saved the Maisin from needing to sell their trees.

'There is cloth like this, from outside, for ordinary days,' explained Jesset later, pointing to her cotton skirt and T-shirt. 'And that's OK. But then there is tapa, which is also cloth and it's completely different. And you could say it saved our lives.'

What is the meaning of the tapa?

'The men have asked you to join them now,' Scott said on the morning of our last full day. 'They want you to tell them what you

have learned about the tapa. Not to tell them the process. They want you to tell them what you think it means.'

'OK,' I said. 'Give me five minutes.'

'Rather you than me,' Katia said, laughing at my look of panic.

It felt like an exam I hadn't known I was going to sit. The Maisin had given us so much that I wanted to do them justice – and now I had five minutes. I ran for a notebook and quickly sketched a mind map with the word 'Barkcloth' at the centre, and veins of ideas travelling outwards. I scribbled notes about the work it takes to make it, the vital role of women, the way the patterns play with the eyes, the meditation in making it, the practical use of it, and how there are secrets wrapped in its two dimensions. Then I paused, and added a note to say that the tangible, the mystical and the practical are somehow all held within it – in how it's exchanged, how it's made, and how it simply *is* – all at the same time. These were all things that are particular to tapa but also shared with every other fabric in its own way. And then there were the special things, the rituals, the way it had brought cash and protected the forest. But as we went across the veranda my eye was caught, as it always was, by the tapa on the wall. And I knew what I wanted to say.

'They'll be talking about other things before you arrive,' Scott said. 'They don't talk about the thing they are going to talk about until they do.'

'What do you know so far?' asked Gangai, when they stopped talking about the other things.

'Tapa is like the heart of the Maisin,' I said. There was a murmur of agreement. 'It's not something pretty that your grannies used to make. It's how you mark your rituals, and it's how you make your money and how your children are educated. It pulls everything together, and everything leads back to it.'

But there is something else, I said. In the life of the village, there are certain due processes. Like just now when they were talking about other things before the real thing, or how the women, when I asked them the origin story of the Maisin, said I should ask the elders first. Or how if we'd fallen in the water, others would have jumped in too, in sympathy. Or how we had needed to give our gifts of books and medicine to Arthur to distribute to everyone fairly, rather than handing them to individual people.

'Things here are not set in stone, but there are ways of doing them. There are pathways. And tapa design is also pathways. They

can go one way or another way. But they all follow the rules. And perhaps tapa is a reminder about the importance of that.'

'Have we passed the test?' I heard Katia whisper to Scott. 'You're doing good,' he whispered back.

I looked around then in the half dark, at these people who had been so generous. Outside in the cooking house, the women were chatting, preparing a special dinner for the evening. I knew each voice; so many of them were now friends. I'd expected chasing bark-cloth to be an adventure, and it had been. But it had been something else. It had been authentic and truthful. This was a small community struggling against huge forces, and although they had problems and worries, the people were powerful and united.

As if he had read my mind, another elder, John Wesley Vaso, said there was one more thing to add.

'When you pull on tapa, it expands and you see a lot of fibre that comes with it, and it's very strong,' he said. 'I want to apply that to Maisin society. Maisin has thirty-six different clans. Like the tapa, we have extended out. But if you cannot break the tapa as a fibre you cannot break the Maisin as a tribe.'

'Write about us,' Arthur said. 'Tell people outside how barkcloth is a small thing. But it is saving our big forest.'

You learn through doing

That last afternoon, watching Jesset painting, I thought of how patterns are repeated in fabrics and wallpaper and how sometimes when you see them on a large scale, they are much more than the sum of their parts. I tried to copy the lines into my notebook as Jesset painted them. She created islands and caterpillars and crescent moons. She hatched her paths with spears; she added tiny posts and dots to one side and not another. I remembered a game I had had as a child where you could make fantasy rail tracks from straight pieces and curved pieces, and how, by turning them over each other, they became rivers and shanty towns and impossible pathways in my imagination, like a way of curving time and space.

'You don't teach design with words, but by watching and doing', Jesset said. She had learned by watching her mother, as her daughter has learned from watching her, as her husband Leonard – who has started painting tapa to earn money for the family – has also learned.

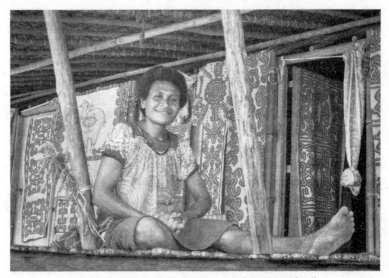

Annie Sevaru at the Maume guesthouse, with all
the walls and doors covered in barkcloth.

We learn; we draw; we make the designs go to the edge of the page;
we start again; we concentrate; we squint; we hum a little. This is
work and it is play.

It became dark and Jesset borrowed our head torch in order to
keep painting. She kept it overnight and we heard later that she had
stayed up for hours. In the morning, she had four paintings, two for
each of us. Two were the ones we had seen her create, and two were
surprise ones that she and Leonard had made, with writing on them.
Mine said, in rounded letters with an outline of dots: 'Thank you very
much for your short stay with us & we hope you'll come back again
in the future Victoria.' It is on the wall of my study, as I write.

When we left, there were many gifts: *embobi* and loincloths but
also tapa bags, hats, even mobile phone cases made to measure by
Jane's husband George on their sewing machine. Giving farewell gifts
is Maisin tradition, and it was moving.

As our dinghy pulled out from the grassy riverbank and we waved
to our friends gathered with their babies in their arms and children
running around, waving back, both Katia and I, to our surprise, found
ourselves crying.

Rolling back the cloth

We had left the Maisin a few days before and had gone north to spend some time in the fjords. We were both covered in sandfly bites, and whenever we saw each other rubbing them we'd say 'scratching!' to remind the other person to stop. Mine hadn't healed. On the way to a birds of paradise forest with a guide before dawn, dozens of sticking plasters had dropped off my arms and legs, and on the way back we'd picked them up feeling like Hansel and Gretel finding our way home. The skin was red and the bites were weeping. I took paracetamol and wrapped bandages over them and tried not to scratch and figured I'd be home soon.

Early on the last morning, Katia was on the beach photographing the men setting up a triangular sail on the outrigger canoe we'd hired to bring us back to Tufi. At one time the sail would have been made of tapa, though this one was a patchwork of plastic strips that looked as if it had been made on a village sewing machine. I sat on the grassy peninsula watching them, feeling grateful for all the twists and turns in the story that had brought us to Collingwood Bay.

The scene in front of me fell away as if it was itself a dream, and to my surprise I found myself talking to my mother. I told her what had happened in the past two weeks and how grateful I was now for all the things that had seemed to be frustrating as I planned to find barkcloth. I remembered the kapa from Hawaii with its sacred spinal zigzags, and the PNG loincloth in the British Museum that had a design like human vertebrae. I imagined her and my father sitting in the bones of my back, looking out and holding me up. At the end – oddly, I know, I knew even as I did it that it was odd – I said I hadn't asked this before, but if she *was* around, I'd really like her to show me.

I felt a hand on my shoulder. A woman from the village. 'The coconuts!' she said, pointing upwards. 'The wind. It's not safe.' I laughed and moved, thanking her, amused at the coincidence.

On the beach our host, Lancelot Ginari, looked worried. The wind had just picked up, there was a storm coming. We looked around. It seemed fine. We needed to catch a plane.

You can go, he said, but I'll follow. We put our bags beneath a tarpaulin on the small platform between the hulls and settled ourselves where we were told. As two young men rowed us past rocky promontories, the sky to the east began to darken. Lancelot on his smaller canoe was now a bay behind. He phoned in to our steersman on his mobile. We should get ashore. Quick.

We were just in time. The black clouds roared in, the air went cold and we ran across the beach to a shelter, joining people huddling around a fire as the rain lashed. We were lucky, Lancelot said, if we'd still been at sea we'd have overturned.

Two hours later the sun returned. We arrived back at Tufi Resort in a dinghy with an outboard engine that Lancelot had located, and checked our luggage in for the flight. The manager's wife, Roya Boustridge, looked at my arms.

'I don't like that one bit,' she said. 'We have a team of volunteer doctors from Australia coming for lunch, I'll ask them to look.'

'They're here to help local people,' I said. 'I can't ask them.'

'I insist,' she said.

After lunch Dr Barry Teperman from No Roads Expeditions checked my arms and legs. When I removed the plasters, the red under my skin had spread even further.

'Have you felt feverish or dizzy?' he asked.

'Not really,' I said. And then I remembered. 'Though I did find myself talking aloud to my dead mother this morning.' He looked at his colleague, the kind of look that you pretend you haven't noticed because it said too much.

'You have cellulitis,' he said. It was serious. It had triggered sepsis, which was my body responding to infection. Untreated, it can lead to organ failure. And death.

'You're lucky,' he said, cutting a strip of just enough of the team's precious antibiotics to get me home.

'A day or two more without these and we'd be airlifting you out.' I learned later that there were only two lunchtimes every year that an emergency medical team visited at the resort, and this was one of them.

'OK, Ma, enough of the saving-my-life thing,' I muttered as we got on the small aircraft a short time later. 'I believe you're here. Honestly I do!'

As we took off across the emerald water of the fjords I found myself hallucinating that the tapa in my hands had done for me what some tribal people in the Pacific believe tapa has the power to do. I imagined that for a moment it had rolled back the curtain between worlds and had shown me a glimpse of that flip between one way of being and another.

Or you could just say it was the sepsis talking.

Ending with the trees

Fate, or my mother, had one last treat for me. I'd wanted to know more about the logging, and behind me on the plane were two men, chewing gum and playing music on their mobile phones without bothering with earpieces. They weren't tourists. Katia was sitting by another window and we caught each other's eye. I knelt up and said hello and asked where they were from. 'Malaysia,' said one. 'Indonesia,' said the other. I asked if they'd been on holiday. They said they had been at Wanigela. How nice, I said, how long had they been there? Six months. I looked perplexed. Hadn't someone mentioned that the logging companies had been forced to leave? A law or something?

'We're a different company,' one said, 'a new one.'

'Interesting,' I said. 'Are you logging too?'

They looked at each other, sly glances with a flash of warning. 'No', the other one said, 'We're just building a road. We're waiting for permission. It'll come.'

I clutched the bundle of tapa from my Maisin friends and thought of the huge log that had washed up on the beach, the many others they'd seen drifting past on the current. The barkcloth had more work to do. And we had more work too when we returned home, doing what we had promised, telling people about the cloth which comes from the skinny little trees that are holding up a whole forest.

COTTON

In which the author learns how the trick to spinning
is keeping everything in balance; and comes to
understand that the history of cotton is also a history
of speed, mythology and disappointment.

On 13 August 3114 BC, the maize god created three stars in the constellation of Orion. Later he built the four corners of the cosmos and set a tree to grow through its centre. When everything was ready, he set the stars and the planets and the Milky Way in motion. At that moment, time began. Mayans carved this creation story onto a stone in the temple of Quiriguá in south-eastern Guatemala in the eighth century. And the glyph, or symbol, they used for setting the cosmos in motion was a whorl, the circle with a hole that is at the base of just about every hand-held spindle in the world. The whorl is the weight that gives the spindle its momentum and grace. It's the centre of its stored kinetic power. And it's the object that lasts when the yarn and the wooden spindle stick are gone. It's the flattish roundish disc made of clay, amber, bone, stone or metal that allows us to know that people have been spinning since at least the Stone Age.

And definitely before 3114 BC.

How not to spin

The Mayans in Guatemala say that Lake Atitlán is the navel of the planet: the place where our world was once connected to its origin. It is also astonishingly beautiful, very deep and very blue, and surrounded by volcanoes that look exactly how volcanoes are meant to look. 'It is really too much of a good thing', wrote Aldous Huxley in a travel guide in 1934.

Each of the dozen or so settlements around the lake has its own

traje tipico, or traditional costume, which means that you know, even from a distance, where someone wearing it comes from. During Guatemala's long civil war between 1960 and 1996, wearing your *traje* could be dangerous, especially if it identified you as being from a village suspected of insurgency. Many people disappeared because of the costume they were wearing. Many who survived stopped wearing any traditional costume at all.

But the custom is returning. It's usually only Mayan women and children who wear *traje,* although every Sunday in the town of Santiago de Atitlán beside the lake, the streets are full of men wearing pin-striped black-and-white calf-length cotton shorts, hand-embroidered with astonishing, colourful depictions of birds. Each place has its own speciality. The women of Santiago are known for their embroidery, while San Antonio Palopó is famous for its colourful cloths made with foot looms. And San Juan is a village famous for backstrap loom weaving.

I've been told that I'll find weavers everywhere in San Juan. But not today. I stop a young woman near the jetty, where the waterbus from the main town of Panajachel dropped me off. She has a basket of washing on her hip and is heading to join other women, standing in the water, bashing cloth against stone.

'Where will I find the weavers?' I ask in Spanish. She points up the steep, narrow road leading away from the lake and I follow it. Past a baroque church; motor scooters; three boys playing football. No weavers. As I go higher, it becomes dustier, and tourist shops give way to local shops and still no weavers. Doubling back, down a different road, I see a small wooden shop. It seems closed but one of the shutters is open. I peer in. Bright fabrics are bursting out of every space. Everywhere, there are embroidered *huipils* – local blouses – cascading in piles. There are so many joyfully mad colour contrasts – blue diamonds on purple hatches; pink diamonds in lime-green frames – I'm lost in the dizzy brightness.

At first it seems that there's no one in. Then, partly illuminated by yellow stripes of sunlight shining through wooden slats, I see an old woman sitting on the floor. Her clothes are camouflage among the woven rainbows of the interior. She has a turquoise sweat-shirt and a coral scarf over a skirt with horizontal broken stripes in orange, turquoise, magenta, green, white and blue. Something about it keeps drawing my eyes. In her right hand is a spindle, with

a maroon-coloured whorl the size, shape and colour of a plum. She is holding it upright in a pottery bowl. I watch. She has a mass of cotton wool in her left hand and she is using her right to tease a line out from it. Then, stylishly and casually, she sets the spindle turning. It's mesmerising, as if she's a conjurer and the thread is emerging from inside her sleeve. On the counter, there's a dusty sign in Spanish that says she's eighty-four and the oldest hand spinner in the region. I realise it's a good thing I haven't found a weaver yet. Because before I learn about weaving, I need to know about spinning. And I would like to learn from her.

'Atkola!' I say, using the word I have learned for 'hello' in Tz'utujil, the Mayan language most common in this part of Atitlán. There are two other Mayan languages around the lake so I don't know if I'm right, but she looks up, and at the same time a younger woman comes out of a door at the back. She is in another striped skirt, a darker one, with an orange blouse and a powder-blue cardigan. Her name is Francisca; her mother is Dominga Perez Celada and she is eighty-nine. ('Ah that notice!' Francisca says. 'It's old and we should change it'.)

Dominga has been spinning cotton since she was small. She became a widow many years ago; her husband died of what she says was a bad cough, *tos fuerte*, which from Francisca's mime could have been asthma or tuberculosis. She had eleven children, three boys, the rest girls. She taught all her daughters to spin.

'Would your mother teach *me* to spin?' I ask.

They discuss it and say that she would. Dominga indicates that I should sit in front of her on the floor and she pulls two baskets towards her. One contains a mass of cinnamon-coloured cotton, the other contains white; each is bursting out of brown crusty husks. If she'd told me it was wool I might have believed her; it looks so like it, even down to what appear like hard little droppings caught up in its mesh. No wonder cotton was once called the 'vegetable lamb'.

'This one is Guatemala cotton,' Dominga says, picking up the brown. 'It is called *ixcaco*' – her Xs were like 'shhhs' – 'you can only hand-spin it.' Its botanical name is *Gossypium mexicanum*, and it has such short, fluffy fibres that most machines can't make sense of it. For many Maya – living across southern Mexico, Guatemala, Belize, El Salvador and Honduras – it's sacred. It's still used to tie a baby's umbilical cord and to protect people from the evil eye. The white

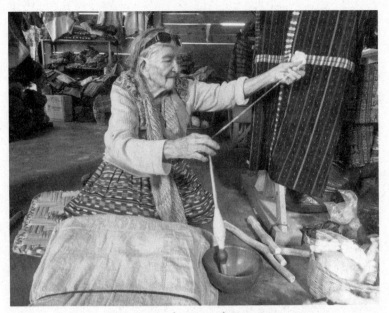

My spinning lesson with Dominga.

is *Gossypium hirsutum* – literally 'hairy cotton', but more commonly known as 'Upland cotton' – which is also from the Americas.

'This is the one we'll be using,' Dominga says, taking a handful of the white and passing it over. '*Ixcaco* is too hard for beginners.'

Before I can learn to spin, she says, I must first learn to prepare the cotton – and the first thing is to pull out the *pepitas*, or seeds. I isolate one with my nails. It doesn't want to shift. I think of pumpkin seeds in their fibrous nests and I try to slip the ropes of cotton over them. It looks like you should be able to pop them but it's more like tearing, millimetre by millimetre. While I'm doing that, Dominga places a cushion on the floor with such a sense of intention it seems like I'm at the edge of ritual. I realise that she's nearly blind; she sees better with her fingers than her eyes. Then she holds out her hand for the cotton. She tuts when I pass her what I've done.

'It needs to be cleaner,' she says, pulling out several pieces I'd missed. Then she places it on the cushion and picks up two sticks, painted blue. Then she bashes the flatness out of it, folding it over and hitting it again, as if she was making a cotton version of puff pastry.

'The forked sticks are faster,' Francisca whispers, indicating a pair on the floor. 'But she chooses the blue ones each time, because they don't stick.' Dominga drums hard and rhythmically, ba-da-bam, ba-da-bam, until the fibre is like clouds. Cumulus at first, the sunny day cloud, but she keeps going until it's finer and more stretched, like the patchy cirrocumulus ice-crystal clouds at the top of the sky.

In the past a batting cushion like the one Dominga is using would have been covered with goat hide and stuffed with dried maize husks. The drumming on the plastic sacking of this one sounds like it's coming from somewhere deep, and far away.

Holding the beaten cotton with her left hand, Dominga rolls it between her fingers and draws it out, tugging then easing, tugging then easing, until it becomes the beginning of thread. Now with a twitch of thumb and forefinger, she joins it onto the yarn already on the spindle (it looks easy; it isn't) and turns the spindle clockwise, towards herself. Always in spinning there is the drawing out and there is the twisting, and for Dominga this was like a single movement.

This is the way cotton is traditionally spun by hand – towards the spinner. It gives what's called an 'S twist' because when you hold it up in front of you, the strand crosses from the top left to the bottom right, like the central curve of the letter S. The other way is a Z twist because it goes from the top right to the bottom left, and it's the twist most common in linen. It matters in weaving that the twist in the yarn should be correct, otherwise the cloth will fight itself: with the wrong twists on the warp and the weft, the individual threads will want to unravel once the fabric has been woven, and it won't have the structure to hold itself strong.

There's a Navajo myth from Arizona about the time the chief medicine woman taught the people to spin cotton. They started by turning the spindle anticlockwise, pushing it away from their bodies in a Z twist. But the medicine woman was strict. If they wanted to trade the cloth for turquoise and shells, they should spin the other way, she said, 'or the beautiful goods will depart from you'. One of

the old Navajo words for spindle was *yudi yilt ya'hote*, 'turning around with the beautiful goods'.

To say 'turning' to describe Dominga's use of the spindle makes her action sound pedestrian. Dominga dances it; she gives it life. And as the spindle turns as if by its own momentum, a strong thread follows. I've seen hand-spinning before, with wool and linen, but this is different. One difference is that wool grows as individual hairs on a sheep's body; spinning it out is like returning it to its nature. And linen grows as the stem of a plant; it also wants to be in lines. But with cotton its nature is to be a mass, a soft bed for seeds. Spinning it is not returning it to anything. It's transforming it.

Dominga hands me the spindle. 'Now you take it,' she says.

Strange to think that a few generations ago picking up a spindle would have been as natural for me as picking up a pen. I'd have understood the balance of the thing, I'd have known its quality. This is Dominga's spindle; I'd guess it's a good one. But my fingers feel clumsy; this is an unfamiliar world.

I think of the maize god teasing out time. But if his thread were anything like the one I'm mauling my way through then we're in for a very short cosmic ride indeed. Within two centimetres it's broken.

'It has to turn,' Dominga says. 'It has to turn until it makes sense to pull it'. She resets it and hands it back. It breaks again. I'm using the wrong side of my brain. My left brain says let it out slowly, concentrate, make yourself do it right, oh why can't you do it right? But my right brain knows I'm concentrating too hard.

'Stop concentrating,' Dominga says. 'You have to understand the thread, but not by thinking ... you'll know, you'll feel when it's going wrong.' But it's always going wrong, I think. I try harder. Outside the sound disappears. It's me and the thread and ... Damn. It's broken again.

'Mould it between your fingers,' she says, sighing at my ineptitude. 'When it breaks you have to connect it back to the centre.' And she shows me again. And again. And again. And as I keep trying, I realise how natural it must have been, not very long ago, for most of the human world to use spinning as a metaphor. For turning chaos into order, muddle into line. And for making something that can't be unravelled out of whatever was there before.

I stay so late that there are no public boats back to Panajachel, and I have to find the only hostel, high up on a hill, in the dark. I still can't spin. But I have learned something about connecting.

Dominga has given me a bit of the cotton to take home. It feels so innocent. It has no weight or bulk to it; it doesn't smell of anything. It's soft. But I think about how it's in the nature of material things to have an immaterial element to them as well, and how you always need to think about both. Cotton has this lightness, this quality of being drawn into fine threads, that is like its magic. Yet it was once picked by slaves. It started the Industrial Revolution. It employed vast numbers of young children. The way most of it is made today spews huge quantities of chemicals into the earth and into the water table. I bounce the cotton on my palm and see that it's not even formed. It's difficult to think that in the history of this cloudy, soft, light material there can have been so much suffering.

The backstrap

Two days later I'm in a garden in Panajachel, tied to a tree.

Or rather, I'm tied to a belt which is tied to a cord which is tied to a couple of hundred loops of cotton which are tied to a tree. This is a backstrap loom and it's both simple and slightly baffling. I'm at the Maya Traditions Foundation and my teacher is Zenaida Florinda Péres Cúmez from San Antonio Palopó. She's forty and she learned weaving from her mother when she was eight. In 2008, Zenaida was one of two Guatemalan women chosen to go to Minnesota as a cultural ambassador and ever since she's been respected around the lake as a weaving teacher.

The first thing to do, Zenaida says, is to decide what colours I want to use. I don't know. It feels like I've no information or experience to make that kind of decision. Then I look at the *huipil* (blouse) that Zenaida's wearing. From a distance it had seemed purple, but close up it is thin vertical stripes in about ten colours and only a very few of those are actually related to lavender. There are blues and greens and whites and reds. It's as if the *huipil* is purple in the way a mountain range from a distance is purple, because the picture plays with your eyes and your expectations.

'I'd like to use *your* colours,' I say. 'The colours of San Antonio.'

She picks out red, purple and sky blue, then adds white, orange, yellow, dark blue, green and black. 'In my years of teaching foreigners,' she says, smiling, 'nobody has ever asked if we could use my colours.'

Zenaida demonstrates the backstrap loom.

The first three were the traditional colours of Mayan cloth. Red once came from cochineal, from the bodies of bugs that infest prickly pear cactuses in the desert. Indigo, which would have been used for the sky blue, was originally from local plants. And once upon a time, the purple that Zenaida's grandmothers would have used was from sea snails, or *caracoles*. When I'd researched my first book, *Colour*, in 2000, I'd found one of the last guides in Mexico who knew how to find them. His name was Santiago de la Cruz and he took me to a coastal village where he knew a fisherman crazy enough to surf his boat on the crest of the waves onto a remote beach. Then he showed me how to pull each *caracol* gently off the rocks and place it onto unbleached cotton threads until it had left its dye and we could put it back. Then we watched the yarn changing colour like a bruise: yellow, then green, then lavender, as Mayans have watched for centuries. The purple yarn, and the stripy red, blue and purple skirts it was woven into, smelled like the sea. Today in Guatemala most people use threads coloured with synthetic dyes, but it's good to see that the traditional colour combination is important, even so far inland.

Red is the strongest colour, Zenaida says, which is why we're going to use it for the main stripes, and for the weft, which will mostly be hidden.

'Red is the blood of our grandmothers,' she says. 'And it's also to remember those who have died for our people.' Blue is for heaven – 'of course' – and the yellows and oranges are for sunsets and sunrises. 'They measure out time,' she says. 'The rising and falling of the sun is like life.'

Is it also like the rhythm of weaving? I ask. Zenaida laughs.

'Weaving's not symbolic. Weaving's work.'

To start that work, we need a warp, or *urdidora*, the set of parallel yarns that have to be stretched along the loom before the actual weaving can start connecting them together. Zenaida walks over to what looks like an upside-down table. There are eight rectangular 'legs' sticking up in two rows of four, though today we're making a relatively simple weave so we'll only need one of those rows. She says the warp frame in her own home has twenty-three legs, 'but this one's simpler'.

Like most cloth made on backstrap looms, the fabric I'm going to create will be warp-faced (meaning we won't see the weft in the final cloth, just the warp) so this stage is important. If we'd been making a weft-faced or single-colour fabric, we'd have chosen just a single warp colour and kept winding it round the frame, but now we have to plan the pattern in advance. It's like writing: some pieces you have to plot carefully. That's warp-faced. Others, you get the basic structure and then adjust the details as you go. That's weft-faced.

Zenaida winds a red thread six full circuits around the four sticks, doing a figure of eight between the last two each time she comes to them. 'This is a plain stripe,' she says. Then she cuts the red thread with her teeth and ties the blue onto it with a neat, fast knot. She winds the blue round three and a half times, then smiles.

'This one is the first magic one,' she says. 'You will see later what it does.'

Tying a yellow thread onto the blue, she takes it just half a circuit round, a single journey, before adding another colour for a full circuit. She continues, using each colour – purple, orange, yellow, green, dark blue, light blue, and then back the same way in reverse, some plain stripes with their full return journeys and others 'magic' ones with their half circuits. And each time she passes the yarn through

the space between the third and last legs of the frame, she does that figure of eight. After about a hundred circuits, she stops. 'We're halfway through,' she says. Then she copies the pattern in mirror order, to make it symmetrical. When it's done, we have a hank of what looks like stripes, but with nothing holding them together. It's like being able to see the skin of something, without a skeleton to give it form.

Zenaida calls the crossing point the '*corazón*': the heart.

'It is like the heart in my body,' she explains. 'Nothing works without it.'

Going out into a covered area in the sunny garden, Zenaida takes six sticks, each about twenty-five centimetres long. She puts one at each end of the warp, where the knots are. The third stick is to become a string heddle, the tool that will lift some of the warp threads up, leaving a shed, or space, for the weft to pass through. She makes it by looping a bright blue nylon cord between the stick and each warp thread so that by tugging it one way the even warps will be pulled up, and by tugging it the other the odd ones will be. I find it hugely complicated, but Zenaida scarcely has to look at it, her hands managing without effort while she talks. She tells me about her family; her two sons whom she's struggling to pay through high school; her hopes that they'll find work as pedal-loom weavers, the trade for which her village is famous, and which – unlike backstrap weaving – is done by both men and women. She also tells me about a new weaving cooperative, which means that for the first time she and other women are able to claim a decent proportion of what each textile is sold for to tourists.

Once she's finished the string heddle, Zenaida places two more sticks to hold the *corazón* open, and assigns the last, a flat one, longer than the others, to be the batten. It's the size and shape of a school ruler, though it's a finer piece of wood.

Then she fixes one end of the warp to a tree and the other to a belt that she straps around her hips. She puts red weft thread onto a shuttle and quickly weaves six or seven lines – or picks – to fix the end stick closest to her in place. Then she takes the belt off and rotates the cloth so the belt is now fitted to the other end.

'This is to fix it,' she says. 'I won't turn it around again.'

In the old days, when a baby was in breech position, a Maya midwife would pass the sticks of a backstrap loom over the mother's

belly as an echo of this practice of turning the cloth at the beginning of a weaving: it was old sympathetic magic, to encourage the baby's head to rotate towards the birth canal.

And now it's me, sitting on the floor with the belt around my hips and the warp like a mixed-up rainbow in front of me. And I'm trying to memorise the movements as I saw them when Zenaida was weaving and I was crouched beside her, the simple repetition of raising the string heddle for the weft to go one way and then the stick on the other side of the crossing place for the weft to go the other way, and each time shooting the shuttle through the space, or 'shed' that has been opened up. 'Heddle right. Shuttle through. Batten tight,' I mutter, remembering what it looked like from the side. 'Heddle left. Shuttle through. Batten tight … Heddle right …' Each time I pass the shuttle from one side to the other, I shift forward or backward with my whole body as Zenaida has shown me, to allow the shed to open and to close, to loosen and to tighten. It is a strangely intimate movement.

And now I see what Zenaida was describing as 'magic' when she prepared the warp. Because wherever she had made the colours travel only a single journey, tiny tapestry-style stitches now seem to emerge from the back of the cloth. There's a yellow alternating with a dark blue; an orange with a sky blue, lines of dots while the other ones are stripes.

I see the cloth growing; I feel like a creator.

And now I understand in my own body why the Mayan moon goddess Ix Chel should be the deity of both weaving and birthing. Before, the connection seemed theoretical and logical: they are both women's activities, they are both acts of making. But when you sit on the floor with your legs in front of you, moving to and fro with a great umbilical-like cord emerging from your hips, then you can't mistake the actual link.

It's not just the Maya. In Norse mythology, the goddess Frigg was both weaver and midwife. In ancient Egypt, the words for being and weaving had the same root, *ntt*, which was also the name for Net or Neith, the goddess of creation, who was said to reweave the world freshly each day on her loom.

Backstrap looms don't leave much of an archaeological trace. Stripped to their elements, they're just a few sticks and some strings, so we know less about how the technology spread than we do about

the fixed looms, which used stone or metal weights. But as I slowly keep adding pick after pick to my cloth ('Heddle left, shuttle through, batten tight …'), I think about the women in the Americas who have been weaving this way for millennia.

The earliest archaeological finds of cotton in the Americas date back six thousand years – from Huaca Prieta in north-west Peru – while the earliest dated urban find is more than four thousand six hundred years old, at the pre-ceramic site of Caral in the Supe Valley, some two hundred kilometres north of Lima, and twenty-three kilometres in from the sea. In a series of digs in the 1990s, archaeologists found that in almost every building, every pyramid, every home, and every sunken circular plaza, there were traces of cotton seeds and cotton fibres. They even found a few fragments of undyed cotton textiles preserved in the desert atmosphere.* Some could be dated to 2600 BC, making this the oldest known city in the Americas. Ethno-botanical traces showed that cotton shrubs were grown all around the site, irrigated by a complex series of channels. They were so numerous that it's likely the whole economy had centred on cotton.

Flutes were discovered, made of pelican and condor bones and carved with images of birds and animals found only in the rainforest far away, suggesting that cotton was traded over hundreds of kilometres. Midden heaps at Caral contained clams and anchovies, despite its distance from the sea, and when a large cotton fishing net from the same period was uncovered at the coast, archaeologists concluded that fishing communities on the Pacific had probably bartered their catches in exchange for cotton from Caral. They speculated that the improvement to fishing technology that the fibre offered – bigger, stronger nets – allowed them to catch more fish and trade them further. And that already, at least four thousand six hundred years ago, the cultivation of cotton had begun to change the world.

* One Caral find was the earliest known *khipu*, an arrangement of strings used in ancient Peru in place of writing. The number and type of knots, the colours, the fibres (cotton, or camelid from llamas or alpacas), the direction of the twist all contributed to a complex system of communication and record-making.

The spindle of the world

I keep weaving, muttering my three-step mantra, and go into a kind of dream. As I gaze towards the tree that is supporting the other end of my loom, I find myself thinking about the sacred tree at the centre of the maize god story. The Maya say it was the *Ceiba pentandra*, which grows to be tall and curiously gnarled, like an elephant or a very old human being. In English the name is kapok, after the Malay word for a similar tree. It produces a fluffy fibre that can't easily be spun but was once used for stuffed toys and pillows. I remember my father once told us that his army sleeping bag had been full of kapok, and that bits kept pushing their way out of a hole; each time he mended it there'd be another hole somewhere else. Then as my mind wanders ('Heddle right. Shuttle through. Batten tight …'), I realise something about that old Mayan story. It makes me stop weaving for a moment and stare ahead with a kind of wonder.

Because if the turning of the cosmos is the whorl, then the Tree of the World – the ceiba – is the spindle stick. It even comes with its own fluffy fibre.

It is all connected.

The cotton that grew in India

The species of white cotton I had tried to spin in Guatemala is now the cotton of almost all the world. Today, 90 per cent of commercial cotton is this *Gossypium hirsutum*. But for a long time, people struggled to work with it. The nature of its seeds, those I had found so tough to extract during my lesson with Dominga, meant that until industrial developments towards the end of the eighteenth century most cotton in the rest of the world was an entirely different species, *Gossypium arboreum*, or tree cotton. And for thousands of years it was largely cultivated in India, where it is regarded as sacred as well as useful.

When a Hindu boy from one of the three higher castes reaches a certain age, his family traditionally holds a ceremony. It is called the *upanayanam* and it is said that on this day he is reborn. His head is shaved, leaving a single tuft of hair at the centre of his scalp, and he is given a long, three-stranded thread to reflect the aspects of the envisaged world that come in threes: past, present, future; Brahma, Shiva, Vishnu; deep sleep, dreams, wakefulness; body, speech, mind. He will

wear that thread – or a replacement, when it wears out – for the rest of his life. The type of fibre is important. If he is of the Vaishya – merchant – caste, it will be wool; if Kshatriya – warrior caste – it will be hemp. But for a child of the priestly Brahmin caste, the thread is cotton, which is said to be the purest. ,

In India, many sacred words are also textile words. *Tantra*, or sacred text, is related to *tantu* meaning thread and it suggests patterns that are woven. *Sutra*, or sacred saying, comes from *sīvyati*, to sew or join together (we have the word in English, 'suture', and also probably in 'sewing'), and it's an allusion to connecting ideas. *Grantha*, meaning script or holy book, is from a word for knotted thread, and these ideas, and the threads themselves, have been present in the Indus valley for many thousands of years.

Pink cotton on a silver vase

When a foreigner first spotted Mohenjo-daro (in present-day Pakistan) in 1827, he thought he'd stumbled upon the ruins of some kind of castle. What he was looking at was the world's largest surviving Bronze Age metropolis, the heart of the Indus Valley Civilisation. During excavations a century and a half later, one of the discoveries was a fragment of cotton fibre stuck to a silver vase. The cloth had once been pink (or perhaps orange or red, depending on what mordant, or fixing agent, had been used) and it had been dyed using the root of the madder plant. It was woven four thousand six hundred years ago – roughly contemporary with the finds in Caral and it remains the oldest piece of decorated cotton cloth ever discovered. But it's not the world's oldest trace of cotton thread: that was much older. It was found at Mehrgahr, five hundred kilometres west of Mohenjo-daro. It was a scrap of fibre found curled inside a copper bead, probably holding a necklace or a bracelet together: a thing of utility rather than something precious in itself. It came from the tomb of someone who died in the sixth millennium BC, more than seven thousand years ago.

For millennia, this species of cotton would be found only in the Indus valley, with people in the Middle East and Africa domesticating their own indigenous, leafier species and most Europeans seeing no cotton at all. But in 492 BC the Persian king, Darius the Great, ordered the first invasion of ancient Greece, followed by years of warfare that

forced both sides to upgrade their ship technology. Around that time, trading networks in both the Mediterranean and the Arabian Sea began to expand.

And Indian cotton started to travel.

The earth tips on its spindle

Once a year the northern hemisphere of the planet tips like a spindle whorl to move towards the sun and once a year it tips to move away from it. This gives us the seasons and it also gives us the trade winds. In India, the winds are called monsoons, and they always begin after 21 June, when the sun in the northern hemisphere reaches its most northerly angle.

On that day there is a pause, a time of stillness, and then, first slowly and then more strongly, the winds over the great oceans change direction. They're no longer cool air coming from the north to fill the vacuum left by heat rising in the southern hemisphere. Now the winds start to come from the south – great hot air masses rushing up to fill the space left by the warm air beginning to rise in the north – and they carry within them heavy rain.

The timing is such that the Indian climate was perfect for growing cotton.

It also meant that before the age of steam, the international sea trade had very specific dates. If you were intending to sail to India from the Cape of Africa you'd have to leave after July, when the winds were strong enough to push you across the ocean. Then, if you were captain of the ship, you'd have to slow down, delaying your journey across the Indian Ocean to time your arrival for September, when the winds would have softened enough to allow you to sail into harbour without being blown over.

Returning, you'd ideally leave in January, when the north-east wind begins to pick up after midwinter's still moment on 21 December, in order to have enough power to get you back to the Cape.

Captains from the Arabian Gulf and from Africa and South East Asia had equivalent timings, all of which meant that, from at least two thousand five hundred years ago until the end of the nineteenth century, international trading ships aimed to arrive in western India in September or October, and to leave at the beginning of the following year.

In those few months, the ports were frenetic; it was the maritime equivalent of the tax office on the day when everyone's trying to file their annual returns. There was so much noise: the heavy human sounds of cargoes being loaded and unloaded; travellers arriving and departing; beggars; pedlars; horse-drawn tonga carriages pulling up, and the constant creak and yaw of ships moving in and out from anchorage. Until I understood the absolute demands of this sailing season, I never noticed how many historical letters written in India to correspondents overseas about cotton and other trade matters are dated January and early February. They had to do that to catch the annual maritime post. Once I'd become aware of this, I couldn't miss it.

Cotton for spices

Indian, Arab, Chinese, Persian, Greek, Roman and South East Asian trading ships have followed the monsoons in this way for millennia. In Indonesia, this led to the establishment of powerful city states, with large seasonal populations as boats and crew waited for several months every winter while the winds changed direction. There were traders from all over India, as well as Arabs, Egyptians, Somalis, Turkomans, Kenyans, Armenians and others. By the tenth century, these cities were so busy and cosmopolitan that an Arab visitor remarked how the place was so full of foreigners that even the parrots spoke many different languages.

In 1511 the Portuguese captured Malacca in today's Malaysia, hoping to take over the international trade routes in Asia. Until then there had been a thousand Gujarati merchants from north-east India permanently stationed there, and a further four or five thousand Gujarati seamen who came and went with the winds. Many brought Indian cotton and traded it for spices.

A lot of the cotton bound for Europe at that time – as well as the silks, dyes, spices and pigments – would enter the Continent through Venice, as it had for generations. 'Whoever is Lord of Malacca has his hand on the throat of Venice', wrote Lisbon apothecary Tomé Pires, who was made factor, or trading company agent, in Malacca that year.

In Malaysia and Indonesia, fabric was a traditional expression of wealth – in *tapis* sarongs made with threads wrapped in gold and silver leaf, and in *ikat*, where patterns are dyed onto the thread *before* it is woven, meaning that the designs appear like magic during the

weaving process, and when you look at the cloth it seems to shimmer as if it is both in this world and somewhere else.

Silk was sourced from China, and hemp – a fibre from the cannabis plant that makes a strong, rough cloth for work clothes and is where we get the word 'canvas' – they could grow themselves. But thanks to the monsoon patterns, the dry season in the Malay Peninsula didn't last long enough for them to grow cotton, meaning that it was always in demand.

The weave of the wind

The importance of cotton goods from Asia is traced in many European words.

Calico, after Calicut (now Kozhikode) in Kerala, where many printed cottons were made.

Chintz, after *chīnte*, meaning spatters in Hindi and Urdu.

Cotton itself, from the Arabic *al-qutun*, which the Portuguese still call *algodão*.*

Dungaree, from the coastal village of Dongri north of Mumbai, where a heavy-duty blue (or sometimes white) cotton cloth was once made.

Sindon – Greek for a fine cotton garment – from Sind, alluding to the Indus river.†

Gauze, from the Palestinian city of Gaza.

Gingham, from the old Malay *genggang*, meaning striped, or separated by a space. Long before it became a simple checked cotton cloth, it was a striped fabric made on backstrap looms. There's still a word, *renggang*, in modern Bahasa, which means a space, or a rift in between.

* *Carbasus* – used by the Roman poet Catullus (in *Carmina*, poem 64) to refer to (linen) sailcloth, and also an archaic word in English for surgical gauze – derives from the Sanskrit for cotton, still used in Hindi as कपास, *kapaas*.
† In the Gospel of St Mark (14:51), there is an enigmatic episode after Christ has been arrested when a young man wearing nothing but a good-quality shirt (*sindon*) is caught by the soldiers and runs away naked, leaving the garment behind in their hands. By that time *sindon* was also a word for shroud (hence sindonology, the study of the Shroud of Christ) so the disappearance of the boy, leaving the cloth, prefigures the disappearance of Christ from the tomb three days later.

And of course, there is muslin. The English word for that astonishing, diaphanous, and once extremely expensive textile comes from the port of Masuli (now Machilipatnam) on the Coromandel Coast halfway up the eastern coast of India. But that's just where it was traded, because the best kinds were always from Dhaka in today's Bangladesh, where it is still called *dhakai* (or *jamdani*, the name given to it by the Mughals).

Today, it's still made with skill and with old-fashioned bamboo looms, in the same villages by the river, where the alluvial soil has for millennia been ideal for cultivating the best kind of tree cotton. But although the cloth is very fine, people today can't quite reproduce the delicacy of the muslins of earlier times. It's not just that the thread is no longer always spun with a hand spindle early in the morning after the dew has created the right humidity, and by young girls whose hands have just the right amount of natural oil. Nor is it that the warp thread isn't always steeped for two days in lampblack before being strengthened with a mixture of rice powder and shell lime. It is also that the *Gossypium arboreum* cotton tree is not quite the same today as it once was. The cross-breeding over the years has changed its nature in ways that we cannot ever know.

But if we can't quite see it any more, we do know the effect of the veil-like cloth it was woven into, this fabric whose best nature was to be scarcely visible. In his *Natural History*, Pliny mentions a 'wool' that was found 'in forests', and made into a translucent cloth of which he disapproved. 'The labour is immense and very distant regions ransacked to supply dresses through which our ladies may display their charms in public', he wrote. A century earlier, the comic writer Publilius Syrus wondered in a poem if it was the same 'for a bride to dress in the weave of the wind/ As stand openly naked in these cloudy threads'.

Indian writers were also stirred by this quality of muslin. 'Expanded smoke' one poet called it, 'vapour of milk' another. In 1322, the Sufi writer Amir Khusrau wrote that it was so fine 'a hundred yards can pass through the eye of a needle ... It is so transparent and light it looks as if its wearers are not dressed in anything at all, but have only wiped their bodies with pure water.'

But the best muslin hasn't only been desired for what it revealed (in all senses of the word) about its wearers. People also wanted it for what it could buy.

When the emperor stole his own gifts

Early European traders in South East Asia mostly wanted spices: pepper from Sumatra, nutmeg from the Banda Islands. When they realised that their trading partners were more interested in cloth than in gold, they decided to buy cotton in India and compete with Gujarati merchants to trade it in Indonesia. But first they needed to set up cotton trading offices in India, and this is what the Portuguese, Dutch, English and French all attempted to do.

In 1615, King James VI of Scotland (James I of England), sent thirty-five-year-old Thomas Roe to be England's first ambassador to India. His main mission was to negotiate with the Mughals (who had conquered the northern part of India in the previous century) to set up a trading base in Surat, the main seaport in Gujarat. One of Roe's many problems was that he had brought gifts that were hopelessly inadequate. In fact – as Emperor Jahangir liked to point out – they were 'five times' less impressive than those brought by the East India Company whose envoys had arrived before Roe and had failed.

'For presents, I have none, or so meane that they are woorse then none; so that I have resolved to give none,' he wrote back to London. Nor were recipients shy of turning down gifts they didn't like. A ring he'd given the governor of Surat had been returned 'as too poore of valew'. The emperor had been interested in a small painting but only so he could lay a wager that his court painters could imitate it so well that Roe would never tell the difference – to his great delight, they succeeded, although Roe emphasised that the light that day was very bad.

In that first year, Jahangir was reluctant to discuss Surat and its cotton at all. Sometimes when Roe raised the subject, he would look up and see that the emperor was asleep.

New gifts arrived with the fleet the following September, but the delivery for Roe was intercepted before he even saw it. The emperor took everything, including velvets intended for sale, as well as presents intended for other people, and a new hat for Roe. Roe was furious, even more so because some of the presents from London were inappropriate and patronising and he would have liked to have edited them in advance.* He broke all protocol by having a showdown (he standing on the ground beside his horse, Jahangir high up

* These included carvings of horses, lions, deer, dogs and a bull. 'Did you thinke in England that a Horse and a Bull was strange to me?' the emperor asked.

on an elephant), saying how the situation had humiliated both him and his king. The emperor answered that he liked some of the gifts very well, and his wives particularly liked the hats. He said he would give Roe what he wanted, if he could only keep the 'toyes'.*

So in 1618, Jahangir granted the English formal trading rights in Surat. It wasn't exactly what London had hoped for – it did not, for example, allow any Englishman (except Roe himself) to carry any kind of sword in town. Nor did it allow English traders to construct the kind of smart, heavily fortified English kind of building they had in mind. Instead they had to rent. But with that permission, given only after the emperor stole his own gifts (gifts desirable mostly because it looked like they might be demanded back), a balance of power shifted a few centimetres, and the East India Company, through the English government, had its first toehold in India, with all the troubles, riches, corruptions, cruelties and manifold cultural exchanges – as well as, of course, the cotton itself – that this would bring.

The cotton wheel turns

Like a wheel slowly picking up speed, Indian cotton began to move faster and further. Within a few years of the first Portuguese trading ships returning from India, cotton was being traded throughout Europe: in the mid-sixteenth century a villager in Errenteria in the Basque country of northern Spain reported seeing Portuguese pedlars arriving with their 'calicús' (which were also called *pintados* or 'painteds'). After the Spanish took the Philippines in 1571 they established a trade route between Manila and Acapulco, and Indian cottons started arriving into Mexico alongside Chinese silks. They were bought with silver that was being extracted by the tonne from Zacatecas in Mexico and Potosí in Bolivia, and so began the era of the Mexican dollar as the international currency of Asia.

In France, the patterned cottons coming by ship from India became known as *indiennes*, while the ones coming overland via Persia were called *perses* (regardless of where they were actually

* In addition he asked for a quiver and case for his bow, 'a Coat to weare, a Cushion to sleepe on ... and a paire of Boots, which you shall cause to be embroidered in England of the richest manner ... for I know in your Countrey they can worke better than any I haue seene.'

made). Many of the latter were transported on an extraordinary annual trade journey known as the 'Great Caravan', which involved fifteen hundred camels walking in a line from Persia to Aleppo every June and July. By 1640, both these kinds of cottons were arriving in North America too, transported across the Atlantic to Boston, via Lisbon, Brittany or London.

Wherever they landed, they were a sensation. It wasn't just the fineness of some of them and the practical utility of others and the fact that unlike wool or silk or linen they could be easily washed: it was the incredible variety of colours and patterns that were printed or painted on them and – a marvel at the time – the way they didn't seem to fade.

Dyed with indigo – an Indian dye much stronger than any of the blues then found in Europe – they made a dark-blue cloth that smelled like a mix of old books and yeasty bread. Dyed red with madder – in a recipe that for a long time was a secret and known as 'Turkey red' – they were as bright as the expensive cochineal dyes coming in on Spanish ships from the New World. And the patterned ones, the chintzes … it's hard to look at the kinds of fabric that usually go by the name of chintz today and understand the absolute desirability of what was arriving in Europe three and four hundred years ago.

Yet I was struck – visiting the Victoria & Albert Museum's 'The Fabric of India' exhibition in 2015 – to find how much I was drawn to the exuberant patterns and bright natural colours of the early Indian painted and printed cottons. There were big woodblock print repeats and astonishing greens and pinks and reds, and bright sky blues from indigo. There were also depictions of plants and leaves that must then have seemed so exotic to European eyes that it was almost impossible to imagine they actually existed, somewhere in the vast, almost unknown world towards the east. If I'd lived then, I think I'd have craved it too.

A terrible triangle

The books mostly call it the triangular trade, but that comfortingly regular shape doesn't hold within in it a sense of the spiralling despair created by the Transatlantic cotton trade after the sixteenth century. This is how it worked.

Seventeenth-century English curtains, inspired by Indian chintz designs.

European ships went to West Africa carrying Indian calico.

They exchanged it for men, women and children, who were transported in appalling conditions to Brazil, the West Indies and North America.

Those who survived the journey were sold as slaves, forced to work, some of them in cotton plantations.

The money paid for them went, in part, to pay for more cotton.

Which meant that the triangle, the circle, the spiral of despair, kept turning and turning.

Invention of the *indiennes*

In Marseilles, household inventories as early as 1580 included *indiennes* as bed hangings, though it took longer for them to be made into clothing. The imported ones were expensive and local makers were quick to find ways of imitating them: a tradition that remains in the bright French-made Provençal fabrics that are still called *indiennes* today. Southern France was then a centre for making playing cards – a relatively new technology and entertainment – and it wasn't a huge step to move from printing cards to printing cloth. Both involved carving several wooden blocks, charging each with a different colour, and sequentially applying them to a flat surface with a steady hand, or steady instrument, to make something that resembled the pricier Indian imports.

Many Armenians arrived: by the end of the sixteenth century their country was in the middle of a bitter land grab between the Ottomans and the Persians. Hundreds of thousands of people became refugees, and everywhere they settled they opened shops and cafés, as well as fabric print-shops and dye-works specialising in indigo and Turkey red. Some were invited to Persia and settled at New Julfa outside Isfahan in today's Iran,* which still has its Armenian quarter and is still famous for its cloth. Others went to India, where they learned, and perhaps also influenced, how calicos were made; and still others

* In 1605 the Shah of Persia gave the Armenian inhabitants three days to leave Old Julfa or be massacred. Those who survived were encouraged to settle on the edge of Isfahan and bring their knowledge of the textile trade. Old Julfa is now an archaeological site in the Nakhchivan Autonomous Republic of Azerbaijan, a landlocked region bordering Armenia, Iran and Turkey.

to Aleppo in today's Syria and Diyarbékir in today's Turkey, and to Venice and Livorno and Amsterdam and Marseilles. Their expertise in textiles came in part from a particular element of Armenian Christianity that involves the ritual concealing and revealing of the altar with screens and curtains. By the tenth century, Armenian monasteries had developed ways of printing cotton with stories from the Bible – a portable equivalent of stained glass, but in cloth – and laypeople in the towns around them took up the skills too.

In the 1650s, printed cotton dressing gowns became fashionable in Europe. The French called it dressing *à l'Arménian* after the people who both sold them and wore them, and the gowns themselves were called *indiennes*. In Britain, they were called banyans, after a Hindi word for merchant. Their origins can be traced to 1609 when the Dutch East India Company was granted trading rights with Japan and began to bring an adapted form of silk kimono back to Europe. These comfortable, stylish gowns, worn by both men and women, reflected what must have felt like a new era: less fussy, less ruffled, less lacy clothes marking a new, plainer century and, with the rise of Protestantism in some parts of Europe, a new, plainer form of religion. But the silk ones were expensive, and very quickly versions made with Indian chintz became popular too, not only in Europe but also in Japan (where legend has it that cotton was introduced in 799, by a young man shipwrecked from China, though it had only been widely adopted after the Dutch arrived).

Another early use for chintz in Europe was as handkerchiefs for people who took snuff. By the late seventeenth century there were millions of snuffers, both men and women, from all classes, in all nations. In 1713, Louis XIV's sister-in-law Liselotte von der Pfalz wrote a letter about how horrid she found the whole thing. 'With a nose soiled with tobacco dust, a person looks as if they've fallen into the mud. The King detests it, but his children and grand-children take it, even though they know how it upsets him.'

Snuffers would take a pinch of tobacco dust between thumb and forefinger, hold it against one nostril then the other and sniff. Meanwhile, they'd have a handkerchief ready to catch the brown powder. And it needed to be a special kind. Linen and plain ones would be a mess after a single sniff. But cotton, washable, and with enough variable chintzy markings to hide the spatters, was ideal for a serious snuffer.

A million pieces

Bed hangings, handkerchiefs and dressing gowns were all very well, but in general European buyers were slower to take up cotton than the various East India Companies wished. In 1682, director of the East India Company Sir Joseph Child decided to expedite matters by ordering two hundred thousand ready-made cotton 'shifts and shirts' to be made up in Madras – today's Chennai. He ordered 'some of the coursest sort [of strong blew Cloath] for Seamens & ordinary peoples', from his correspondent in Fort St George, the site of the East India Company's first trading settlement in south India, 'as well as white Midling, for ... Midle sort of People & some fine enough for Ladies, & Gentlewomen'.

This enormous order, the first of its kind, was a blatant attempt to kill the European demand for linen by flooding each sector of the market with cheaper cloth, manufactured using the skilled and cheap labour of India. Child confirmed as much, adding that it was 'the onely way I know to introduce the using of Callicoe for that purpose in all those Northern parts of the world'. But Child was ahead of his time. The era for mass marketing of cheap pre-made cotton clothes from Asia was far in the future and the company was left with a hundred thousand pieces stuck in the warehouse. And a massive loss.

The un-made-up Indian cottons, however, turned out to be a tremendous success. A million pieces landed in England in 1684 alone. Everybody loved them. Everybody, that is, except the people whose families had been making linen, silk and wool for generations. They couldn't compete. They petitioned against it. They protested and rioted. And then, for a while, they won.

Both England and France passed strict laws banning cotton. But the stipulations covered by those laws were different. France would ban every kind of cotton for a while. England would only ban certain kinds. And what might seem to be a fairly small difference between the two would change the course – and balance – of industrial history.

France first

By the end of 1686, pressure from silk and linen makers meant that no painted or printed cotton could be brought into France. And by then, printing cotton *in* France was forbidden as well. For a short

while, French people could still legally buy plain Indian cotton goods, although they had to pay heavy import duties on them. By 1691, even these were banned. So apart from one loophole allowing traders a 'reasonable lapse of time' to get rid of their existing stock (and meaning that the upper classes would claim for nearly a century that their new cotton dresses and upholstery coverings were just made up from old stock stored in warehouses) and another allowing a very few aristocratic families to print cloth for their personal requirements, the only new cotton that could legally touch French soil was in closed packages, intended for re-export.

Ships from India arriving in France would unload either at the port of Lorient (founded in Brittany after 1666 for the specific use of the recently founded French East Indies Company) or at Nantes on the Loire (which by 1700 would be France's biggest port). There they would be met by an agent of the unpopular *fermiers généraux* – tax farmers-general – whose main occupation was enforcing tax duties for the government. The agent would watch as the sealed bales were unloaded into a locked facility until their transport onwards.

Those locked facilities were not always very locked, however, and crew members on the ships from India also had their own calico stashes to which their bosses, also on the make, turned a blind eye. Incoming ships routinely dropped many bales of cotton along the French coast; local people waited in rowing boats to heave them from the water.

Like the Mughal emperor, who would give anything to keep the goods he wasn't allowed to have, the French ached for cotton, and were prepared to pay for it. There were heavy penalties for those who ignored the law. Mild offenders were beaten or fined fifty livres or more; repeat offenders could be executed. According to the tax farmers-general (who had an interest in giving high numbers) between 1726 and 1729 alone, sixteen thousand men were either 'hanged, sent to the galleys or killed, gun in hand' for smuggling calico and tobacco. But people smuggled anyway.

Forbidden cotton was like a drug; the habit had to be fed.

The smuggling years

In Grenoble in the 1720s and 1730s, 'Big Jeanne' dominated the market for calico. Her butcher son collected the deliveries from outside the

city then she divided them into smaller consignments, which she sold on to low-level dealers from her base in the Rue Très Cloîtres. I looked online to see what that street looks like today, and stopped in astonishment. Because as the Google Street View car passed the junction of Rue Très Cloîtres and Rue Servan in October 2018, its camera randomly recorded something I'd never seen on Street View before: a young man in a grey hoodie is being stopped and searched by three armed police officers. The façades of Big Jeanne's old hunting ground might all have been rebuilt but dealing in contraband appears to be still very much suspected.

There were Big Jeannes and their hefty sidekicks in just about every town in France. Some of the big-time smugglers who supplied them became folk heroes. The best-loved was Louis Mandrin. *Robin des Bois français* they called him; the French Robin Hood. He smuggled for profit, of course, but also for revenge against the tax farmers-general. No hiding in dark gullies for Mandrin: his caravans of cotton and tobacco involved hundreds of horses and hundreds of armed riders. When the Mandrin show came to town, a drummer would announce its arrival; government agents would vanish, and the people would gather to buy. Meanwhile, all around the eastern frontiers – Geneva, Basel and Neuchâtel in Switzerland, Mulhouse in Alsace, Amersfoort in Holland – fabric factories sprang up to feed the demand, printing cottons and linens, and becoming increasingly sophisticated in their techniques as the years went on. These places grew rich from the trade, and some of them are still rich from it today.

Back in England

On 24 June 1720, Dorothy Orwell was walking in Red Lion Fields in Hoxton in East London when she was attacked by what was later described in court as 'a Multitude of Weavers'. They 'tore, cut and pull'd off her Gown and Petticoat by Violence, threat'ned her with vile Language, and left her naked in the Fields'. She was terrified but when she was asked to identify her attackers she did not. As the jury at the Old Bailey would hear a few weeks later, the whole incident happened because she was wearing a 'calicoe' dress. And the weavers of linen and silk and fine wool in England felt that 'calicoe' was a threat to their livelihoods.

I feel a connection with Orwell. Because in the early hours of

20 April 1987 in Times Square in New York, something similar happened to me. I was twenty-two, a student, and I was surrounded by a random mob of more than fifty young men and a very few women who held me, punched me, threatened me with at least one knife and tore my dress half off. I remember seeing my shoes on the pavement as I was lifted up to be hit again. The only reason I wasn't left as Orwell was left was because the police arrived at speed. I was too shocked to remember what my assailants looked like. The police brought in a boy in a red T-shirt to where I had been taken to recover, but I couldn't know for sure if he had been an attacker. I wouldn't identify him because I wasn't certain, even though the police were exasperated that I didn't, and urged me to identify him anyway. I'm interested that – for whatever reason – Orwell did the same.* It made me understand – in a way that returns in dreams – what an intimate, mocking kind of assault it is, to attack women through tearing their clothing. It's about power and humiliation. It goes beyond people worrying about their pride and their livelihood; there are deeper scores being settled too. And the Calico Acts encouraged that.

In Orwell's day, the newspapers called a woman seen wearing printed cottons 'Callico Madam'. 'Callico Bitch' is what she was called in the streets.

An irony is that in June 1720, Orwell probably wasn't even breaking the law. There had been a Calico Act on the English statute books since 1700. But it only covered calicoes that had been printed, painted, dyed or stained in 'Persia, China, or East India', stipulating that, from Michaelmas 1701, that is September of that year, they should be:

locked up in Warehouses appointed by the Commissioners of the Customs, till re-exported; so as none of the said Goods should be worn or used, in either Apparel or Furniture, in England, on Forfeiture thereof, and also of 200 *l.* Penalty on the Person having or selling any of them.

Two hundred pounds was a massive fine in 1701, equivalent to

* Only one man, Peter Cornelius, stood trial for the assault on Orwell. The evidence turned on whether he held a piece of 'Callicoe in his Hand'. He was found guilty and was transported with ninety-one other convicts to Maryland later that year.

more than forty thousand pounds today. Plain Indian muslins were still legal, but they had a 15 per cent duty. Merchants got around the law by importing undyed cotton from India and paying skilled textile workers – usually Protestant refugees who had arrived after persecutions in France – to print it.

That's probably what Dorothy Orwell was wearing and what she was punished for. The year of Dorothy Orwell's attack, a second Calico Act was drawn up, though it only came into play in 1721. It prohibited using and wearing almost all kinds of cotton from India or anywhere else, especially those that were 'printed, painted, stained or dyed'. There were three main exceptions: fustian (the cotton-linen twill blend used mostly for working clothes, which looked like cotton but was exempt from the printing and dyeing rules); muslin (because it was worn rarely and by the rich, and also because it couldn't be replicated by linen); and blue calico (because it was worn exclusively by the poor). This law wouldn't be repealed until 1774, although it would be modified in the 1730s to allow printed cottons, as long as the printing was done in Britain.

So while across the Channel in France, nobody could spin or weave cotton, in England – as long as the product fitted within the permitted categories – anybody could.

And they did.

Make it faster, make it cheaper

We learned their names at school. John Kay, His Son Robert Kay, James Hargreaves, Richard Arkwright, The Other John Kay, Samuel Crompton, James Watt, Edmund Cartwright, Eli Whitney. I had to recite them when I was fourteen. I can recite them now. They were the men who liked machines. They were the men who invented, imagined, managed, bullied, betrayed and coaxed the Industrial Revolution into life.

The men who made machines

In 1718, a fatherless fourteen-year-old boy in Lancashire started work as apprentice to a reed maker. Reed-making involved fashioning the comb-like objects, employed to separate each warp thread from its neighbour. In those days, reeds really were made of reeds so they

often broke, meaning that they were always in demand. But not long after he started, young John Kay had the idea of making them with flattened metal wires, and before he was twenty he was travelling up and down the country selling his almost unbreakable invention to weavers. As he visited home workshop after home workshop, he had a new idea.

Whether you were making linen, wool, worsted – combed wool – or cotton, there were two sizes of loom. Narrow looms were worked by a single weaver, who'd spend the day throwing the shuttle from one hand to the other while moving the heddle up and down with a foot pedal. Broad looms, obviously, were broader, two metres or more, wider than a person's outstretched arms. So they needed two weavers side by side: the main weaver who'd operate the pedal and throw the shuttle from one side, and an assistant to catch it on the other and throw it back.

But what if you could propel a shuttle (equipped with a metal tip and set onto wheels) along a track fixed to the reed? And what if you could control it with just the flick of a string?

Those are the kinds of thoughts John Kay was having as he touted his reeds throughout the country, and in 1733, before his thirtieth birthday, he patented a machine that would allow weavers to do just that. It could be used for cotton, wool, silk or linen. It would mean that it would take only half the number of weavers to make the same amount of broadcloth. It would mean that some people who'd been able to earn a living would face the poorhouse, or starvation. It would threaten the camaraderie that broadcloth weavers had enjoyed for many centuries. But it was also brilliant.

I saw a replica of Kay's loom attachment being demonstrated at the Quarry Bank Mill museum in a former cotton factory outside Manchester. Originals are hard to find because so many were destroyed, first when the weavers realised how radically a few wheels and a piece of string would change their world, and later when people invented better ways of doing the same thing. Watching the volunteer casually flicking the cord that threw the shuttle, I felt like a dog being teased, trying to catch sight of a biscuit being thrown from one hand to the other.

'Do it again!' I begged as the shuttle flew from side to side just too quickly for my eyes to see it. 'Again!'

By the winter of 1746, Kay and his son, Robert, were heading

to France where their invention was attached to linen and woollen looms (or anything really, apart from the forbidden cotton), and receiving in return a fourteen-year privilege and a royal pension of two thousand five hundred livres a year. John Kay was a difficult man to deal with. '[He is] annoyingly hard to control', wrote Étienne Mignot de Montigny, whose job at the French Ministry of Commerce involved overseeing textile improvements. 'He is however a man of genius … and his demands aren't that great.' In England, Kay had called his invention the wheel shuttle, but in France it became known as the '*navette volante*'. This translated back into English as the 'flying shuttle': a much better name.

Kay was still in France in 1757 when Louis XV repealed the cotton ban – although at the same time putting such huge taxes on it that smuggling continued with even more vigour, now that you could wear the fabric and nobody would know if you'd paid duties on it or not. By 1764, Robert Kay was telling the Society of Arts in London that French cotton weavers were now extensively using his father's shuttle, together with an invention of his own, which added what he called a 'dropbox', containing several shuttles, allowing weavers to switch easily between colours of weft. Robert's improvement – on top of the repeal of the ban in France and the general march of new scientific ideas – marked a point when weaving in Europe really started to speed up. And for a while, cotton spinners couldn't keep pace.

Spinning machines speed up too

The first spinning wheel was invented about two and a half thousand years ago in India. You couldn't use it for the very finest fibre but for everything else it was faster than the drop spindle. The technology arrived in Europe in the Middle Ages. It was improved upon, and by the eighteenth century 'Saxony' wheels with simple treadles could be found just about everywhere in Europe. It's the spinning wheel in every illustration of a Grimm's fairy tale; it's the wheel of Disney cartoons.

Every time I tried to understand how it worked by reading about it, I failed. Something I thought of as fairly basic technology seemed impossible to get my head around when looking at it in only two dimensions.

Finally, I had the chance to try one – in the garden of a neighbour

who uses it to spin the wool from her three alpacas. I realised then that when I'd looked at pictures, I'd always been distracted by the wheel. It's the biggest bit so it always seemed as though it should be the most important. But the wheel is just the power generator – or rather the power amplifier, as the real power generator turned out to be me: first with one hand, to get the wheel moving, then with a simple foot treadle that is attached to the wheel, to keep it going.

The business end of the machine, however – where the spinning action is – is at the side, a small section I'd scarcely noticed. This is the spindle mechanism. It involves a flyer – a horseshoe-shaped piece of wood connected to the wheel drive – spinning around a central, horizontally placed bobbin, while twisting the raw fibre fed into it through a tube at its base.

When I first sat down at the spinning wheel, I was confident that it couldn't be harder than using the drop spindle. I expected that I would be flicking the treadle and spinning along in no time. Instead it was like being on a bicycle for the first time. There were so many near-impossible acts of balance and coordination to be managed simultaneously that I simply couldn't imagine doing them all at the same time. If I paused on the treadle at the wrong point, the wheel would reverse direction, with the weight and plunge of a playground swing, sending all the other elements into free fall. If I paid any attention to that, then my hands would freeze and forget to draw out the thread to feed into the tube leading to the flyer and it would either wind itself into a frizz or – more often – break.*

In a way, it was all about the mechanics of wood and levers and string. But, just as with the simple spindle I had tried to use in Guatemala, the first connection is still where the fingers of the spinner hold and draw the roving – the carded unspun fibre – and then let it go. And my own fingers couldn't let the fibre go smoothly enough and instead it became a knubbly thing that would make no loom happy. This little spindle attached to its big spinning wheel was like a creature waiting to be fed: hungry, demanding, wanting more of me than I could give it. Though if I'd been born two centuries earlier,

* I used a single drive wheel with a Scotch tension system. It was supposedly one of the easiest for beginners: only the flyer moves, and the inner bobbin turns with the pressure from the newly formed thread pushing against it. Other wheels have double drives, letting both bobbin and flyer link to the wheel.

I probably wouldn't have thought twice; whatever my family background, I might well have been spinning since I was a small child. It would have been like knowing how to ride a bicycle.

Operated by somebody who could actually work it, the Saxony wheel was highly efficient, compared to the drop spindle. However, although it was suitable for wool and linen, it couldn't handle cotton, with its much shorter fibres. That still needed a simpler 'Great wheel',* cranked by hand, without a flyer, and with a mechanism more akin to the original spindle wheels invented in India.

No kind of wheel, nor the drop spindle, could create more than one thread at a time.

And all the spinners in the world couldn't keep up with the new flying shuttle looms.

The Industrial Revolution begins

In 1760, George II died, and for formal mourning many people in Britain adopted India muslins, which had been readily available in Britain for more than a century. Now, however, the demand was unprecedented. It drove linen gauzes out of fashion and hundreds of linen gauze weavers out of employment. It also meant that anyone who could invent an efficient machine to allow people to spin fine cotton muslin in England would probably become very wealthy indeed. It's no coincidence that 1760 is often cited as the year the Industrial Revolution began – in Britain – with a hunger for textiles that could not be satisfied.

Long before the word 'revolution' was used to describe the overthrow of an established order, it was used to tell of the natural turning of things – planets mostly, sometimes wheels. So it's appropriate that one of the greatest inventions of the Industrial Revolution started, in a way, with a spinning wheel that fell over.

* In the Channel Islands the wheel was also called the Jersey wheel, in Ireland the long wheel, in Wales the Welsh farm spinning wheel, in Scotland, the muckle wheel, and in the US, the wool, or walking, wheel. It had either three legs or four, and in every case the wheel drove the spinning mechanism by means of a drive belt, which was often made of tightly twisted flax or cotton.

A wheel overturned

One day in the early 1760s, the story goes, a spinning wheel overturned on the floor of a weaver's workshop at his home near Blackburn in Lancashire. The accident could have been caused by one of the weaver's thirteen children running past. As it lay there, still turning, the weaver noticed how the spindle mechanism kept rotating. 'He expressed his surprize in exclamations which are still remembered', wrote Abraham Rees, in his *Cyclopaedia* of 1819. 'And [he] continued again and again to turn round the wheel as it lay on the floor, with an interest which was at that time mistaken for mere indolence.' The weaver, James Hargreaves, had previously experimented with adding more spindles to a spinning wheel – if you're going to turn a big wheel to work one spindle, why not arrange it so it works two or more? – but he'd set them horizontally, like on the Saxony wheel, and it hadn't worked. Now, as he watched the fallen wheel, with its spindles pointing upright, he had the thought that if he were to deliberately position them in this way something interesting might result. He built a simple prototype, making a clasp for drawing the cotton from the stalk of a briar split in two. It seemed to work. He sold a few to his neighbours. It was kept secret for a while, but when his wife, 'or another family member', mentioned to somebody that she'd 'spun a pound of cotton during the short absence from the sick bed of a neighbouring friend', local hand spinners broke into Hargreaves's house and destroyed the machine and some of the furniture too.

But it was too late. Something had been created, the wheel had shifted. Hargreaves moved the family to Nottingham and kept on working on what he called his 'spinning jenny' – gin being Lancashire dialect for engine, with jenny its diminutive.

Hargreaves registered the patent in 1770, though it mostly only brought him grief. His jenny made soft threads, good enough for the weft of ordinary cloth. But it wasn't strong enough for the warp and it wasn't fine enough for muslin. And because it threatened their work, the hand spinners hated it.

Beautiful mills and a great deal of rain

Around the same time, and not too far away, a barber and wigmaker from Preston was puzzling over the same problem. Even though he had no experience in textiles, Richard Arkwright was a practical man,

a born entrepreneur, who would never let a small thing like inexperi-
ence stand in his way. Bolton – where Arkwright had set up his own
barber's shop when he was still a teenager – was a busy little textile
town even then, and being a barber was at least as good a profession
then for hearing gossip as it is today. By 1767, it would have been clear
to anyone in Lancashire and beyond that textile machinery was the
business to get into. It was the Silicon Valley of its time. It was spar-
kling, controversial, called for a combination of skills that nobody
had needed before, and produced something that the world wanted
more of. It also held up the distant hope of impossible wealth for just
about any man (whatever his background) with the courage and luck
and inventiveness to have the right idea at the right time and to be
able to push it through. It also attracted conmen and spies, and people
shamelessly bent on copying technology.

Arkwright was a natural inventor and loved the kind of puzzles we
might find today in crackers or IQ tests, 'of how to form squares from
oblongs without adding or diminishing ... and a Hundred curious
knackey things that one cannot find words to explain'. Not long after
he'd set up his own business, he invented (at a time when everyone
wore wigs) a wig dye that didn't wash off in the rain. And now, in his
mid-thirties, he set himself to wondering whether there was a way
of improving previous spinning machines so that they could keep up
with the ever-increasing demand. A few people had tried, and had
invented machines driven by ox power that could spin thread, but
none had had more than limited success.

Arkwright recruited a watchmaker called John Kay ('the other
one') – who had already been experimenting with automating spin-
ning wheels for cotton. One of the sticking points was how to replicate
the fingers of the spinner as they work on the roving, drawing it out,
holding it and letting it go – a process that involves several movements
that a hand spinner does simultaneously, but which early spinning
machines struggled to reproduce.

Arkwright and Kay decided to use a series of rollers, geared so
that each set would be faster than the ones before, covering the top
ones in leather to imitate the touch of a human spinner's fingers.
Their machine was different from previous attempts in two signifi-
cant ways. First, the top rollers were weighted, and second (and most
importantly) they were also adjustable according to the staple, or
length, of the cotton. Cotton fibres vary in length from plant to plant:

if you put the rollers too close together you're in danger of them gripping both ends of a single fibre and ripping it; if you put them too far apart they might miss some of the fibres entirely and the yarn will be full of lumps. Arkwright and Kay were the first to understand how important it was to position them precisely. Though it was only Arkwright who made serious money out of it.

When the first 'spinning machine patent' was registered in 1769, it was registered in Arkwright's name only. It was initially designed for horsepower, although Arkwright soon worked out that it would work better with water. The invention would be known as the 'water frame' and the yarn it made would be called 'water twist'.

He found investors – including the entrepreneur Jedediah Strutt who had become a millionaire from inventing the 'Derby rib machine' for knitting stockings – and chose a piece of land in the Derwent Valley in Derbyshire. The property included the rights to use the fast-flowing Bonsall Brook and Cromford Sough to power the mill, and it was also close enough to a population of men, women and children who would be prepared to work in such a place. By 1770, his first five-storey mill was recruiting; four years after that he was successful in lobbying Parliament to repeal the Calico Act of 1721. Now he could spin all kinds of cotton in his factory. And at last people in Britain could once more buy all kinds of cotton legally.

By 1775, Arkwright was buying his children riding clothes and elegant watches and they were talking of going to France on holiday, 'and the whole Town believes they are gone there but every body thinks they will not like it', wrote Strutt's daughter Elizabeth to her father. The following year Arkwright opened a second, bigger, cotton mill next to the first. It had the world's first indoor toilets for workers. Not because Arkwright cared so much about their comfort, but because it meant they spent fewer minutes away from the shop floor. Those first mills were well built, and they were tourist attractions; people thought them splendid. In 1783, the artist Joseph Wright painted Cromford Mill at night, showing it with every neoclassical Georgian window blazing with light.

'These cotton mills, seven stories high, and fill'd with inhabitants, remind me of a first-rate man of war and, when they are lighted up on a dark night, look most luminously beautiful', wrote traveller John Byng when he visited the Derwent Valley in June, 1790. 'I saw the workers issue forth at seven o'clock, a wonderful crowd of young

people, made as familiar as eternal intercourse can make them; a new set then goes in for the night, for the mills never leave off working.' However, although admiring their scale and their contribution to the national trade, he regretted the impact the cotton mills had made on both the people and the landscape in just twenty years.

> The rural cot has given place to the lofty red mill and the grand houses of overseers; the stream perverted from its course by sluices and aqueducts will no longer ripple and cascade. Every rural sound is sunk in the clamours of cotton works, and the simple peasant ... is changed into the impudent mechanic.

The original waterwheel room at Cromford Mill is still there, although the wheel is long since gone. The place is dark even in the middle of the day, and the bare brick and stone walls reach up several storeys. I can see where the floors once were, but now most of them are stripped out and the place echoes like a mine. There's a slight smell of damp and iron, combined with the bright aroma of the new pinewood that's been used to make the walkways of the industrial heritage museum that the whole site has become. After the audiovisual display is over, and once the ghost of a portly Arkwright senior – his belly straining against the buttons of a yellow waistcoat as in one of the portraits he commissioned for himself – has stopped walking through walls and postulating about his own success, I stand in the quiet, scribbling. I could be in the ruins of a fortress. Or a jail. I can hear water. I can see traces of the stove used to make the air steamy enough for the raw cotton to become humid and ready to open itself out into thread. I think about how, when I lived for a few years in the former textile mill town of Glossop, outside Manchester, I experienced the weather that is one of the reasons the whole region became famous for cotton. Not only did they have the labour and the children and the poverty and the land and the water rushing off the Pennines: Lancashire and Derbyshire also get a lot of rain.

There are no ground-floor windows facing the road from the old part of Cromford Mill; the only windows on that side are small and very high up. Arkwright knew how angry the hand spinners might be, the museum guide explained. Arkwright also understood how many people would want to spy on his machines. He was right to be afraid. Many people – from rival businesses and other countries – would try

to copy the technology, and Arkwright would spend a great deal of time and money trying to prevent them, as well as defending himself from accusations that he had copied other inventors to furnish his mill. In 1774, just as the Calico Act was repealed, Britain passed laws banning textile workers from travelling to America, for fear that they would carry technological secrets with them.

'But whatever he did, the technology was passed on anyway', the guide said. 'And try as he might, Richard Arkwright couldn't stop it.'

I stood, imagining Arkwright standing in that exact place and wondering what spies might be outside wanting to look in. I tried to imagine, in this now great echoing empty chamber, the noise there would once have been in the factory, every hour of day and night. Because once it started, that huge box-wood waterwheel, containing a seed of the Industrial Revolution within its frame, was very hard to stop.

Ghost house in the woods

If you had been passing an old Tudor house in the woods outside Bolton at night in the mid-1770s, you might have heard strange, unaccountable sounds or seen lights flickering at unexpected times. The locals said the place was haunted. But the noises and lights came from the rented room of a young man, Samuel Crompton, who wove muslin by day to support his widowed mother, and spent his evenings playing violin with the Bolton orchestra to earn enough money to pay for his third occupation: that of secret inventor.

Hargreaves's spinning jenny didn't have enough spindles and although Arkwright's mills had been churning out huge quantities of cotton since 1771, the yarn wasn't fine enough to make the magical muslins so many people wanted. Crompton's mother demanded he produce a minimum amount of muslin cloth every day (and when he'd been younger she'd beaten him if he hadn't), but before he could even start, he had to go around the cottages begging fine weft yarn from the hand spinners, half an ounce (fourteen grams) a time. And sometimes he'd call and it would already have gone. On those occasions, he had plenty of time for what he called 'the habit of thinking'. He got hold of a spinning jenny and started thinking about how he could adapt it to make more yarn.

His late father had made extra money from building musical organs. Now Crompton used the tools he'd inherited and began to tinker at night, buying extra equipment with the shilling and sixpence he earned from each concert he played with the orchestra. He blended the best of the spinning jenny with everything he could learn about Arkwright's waterwheel system, and, by 1779, twenty-six years old, he was ready to announce his invention. He called it the 'mule' because it was neither one thing nor another. But it did something neither Hargreaves's jenny nor Arkwright's frame could do. It produced fine, strong cotton and it spun it quickly enough to keep up with the muslin weavers.

Those were dangerous times to invent Britain's best spinning machine to date. That year, rioters destroyed more or less every jenny in use around Blackburn. By the time they arrived at Crompton's workshop they found nothing: Crompton had long since taken his machines to pieces and hidden them behind a wall. When things had calmed down and he could reinstall his prototype, he had another problem: he couldn't afford a patent. 'To destroy it I could not think of; to give up that for which I had laboured so long was cruel. I had no patent, nor the means of purchasing one. In preference to destroying, I gave it to the public,' he wrote, years later.

Several manufacturers said that if he put his machine on display, they'd pay him. He received a sixty-pound down payment and the first thing he did was spend five guineas on a silver watch. Unfortunately for him, the manufacturers found the machine easy to reproduce, and that sixty pounds was almost all he received from it for a very long time.*

In the early 1780s, as mill owners throughout the country set up versions of his mule without paying him a penny, Crompton moved with his wife Mary and son George to a farmhouse two miles north of Bolton, where he cultivated a few acres, kept three or four cows and tinkered with his inventions. Sometimes the family helped out. George remembered how when he was young his mother used to

* Parliament didn't remunerate Crompton until 1812. By then half a million people were earning their daily wages on machinery devised from his imagination, and his mules were spinning some forty million pounds – nearly twenty thousand metric tons – of cotton every year. They gave him £5,000, which even the Chancellor of the Exchequer felt was a quarter of what he deserved.

put the batted cotton wool 'into a deep brown mug* with a strong ley of soap suds. My mother then tucked up my petticoats about my waist, and put me on the tub to tread upon the cotton at the bottom.'

The farmhouse was haunted by hundreds of curious visitors – including Richard Arkwright himself, who wangled an introduction one day through a niece. They were all keen to see the improvements Crompton was supposed to have made on his original machine.

To prevent all these potential spies from seeing too much, Crompton built a secret fastening on the door leading upstairs. One day, when he was away, the textile industrialist Robert Peel (father of the future prime minister), who had made much of his money from printing calico, came to visit. The story told within the family was that when Mary was out of the room, Peel gave George half a guinea and asked him where in the house his father worked. He was just pointing out the nail head that lifted the concealed latch to the attic when his mother returned, and by a look warned him of the mistake he was about to make.

All those mules and all those mills resulted in a great deal of cotton yarn. An astonishing amount of it, of all grades and degrees of fineness, spun and twisted and spooled onto bobbins. Now the weavers couldn't keep up. Whatever was to be done with it all?

A clergyman gets involved

One day in the summer of 1784, a group of tourists found themselves having a drink together in Matlock, Derbyshire. They had all just visited Arkwright's Mill nearby. The conversation turned to what was going to happen when Arkwright's fourteen-year patent for his water frame ended the following year. Once anybody with a spot of capital and a bit of interest in machinery could set up a spinning factory, the whole country would be flooded with yarn, someone said. Weavers would never be able to keep up, and before long, all the extra would be exported to the Continent 'where it might be woven into cloth so cheaply as to injure the trade in England'.

One of the men at that table was Edmund Cartwright, a clergyman in his early forties. There was one obvious solution, he pointed

* Mug then referred to an earthenware vessel, or bowl.

out, which was to apply the same ideas to weaving as to spinning, and make a mechanical loom. Not possible, said a man from Manchester, 'on account of the variety of movements required in the operation of weaving'.

That man knew looms. Cartwright, on the other hand, had never actually seen one in operation nor – on his own admission – had he ever spent even an idle moment wondering how they worked. But he did know about a different kind of machine, shown in London the previous year, attracting huge and admiring crowds. The astonishing Automaton Chess Player – also known as the Mechanical Turk – consisted of a life-sized robotic figure dressed in oriental clothes who would take on all comers at chess. It appeared to work by being wound up like a pocket watch every ten moves or so, and its inventor was always meticulous about letting the audiences see all the wheels, levers and mechanisms inside it before it started. If the Chess Player could win at chess, Cartwright argued, there was no doubt that a Weaving Machine could be applied to the altogether simpler task of making cloth.

'It struck me,' Cartwright said later 'that, as in plain weaving, according to the conception I then had of the business, there could be only three movements which were to follow each other in succession.' And how hard could that be?

When he returned to his rectory in Leicestershire, he decided to build the machine that would justify the argument. He still didn't think to look at a loom, which is probably why his first prototype – made with the help of a carpenter and a smith – was such a monster. 'The reed fell with a force of at least half a hundred weight,' he said later, laughing at himself, 'and the springs were strong enough to have thrown a Congreve rocket.* In short, it required two powerful men to work the machine at a slow rate and only for a short time.' Nevertheless, he patented it in April 1785 and thought his work was done. 'I then condescended to see how other people wove and you will guess my astonishment when I compared their easy mode of operation with mine.'

He tried again. And again. And just over two years later, in August 1787, he took out another patent. That loom initially ran with ox-power but he later adjusted it to make use of the steam engine that

* A British artillery rocket first used in the Napoleonic Wars.

James Watt had patented in 1769. Those looms had a long way to go to become anything like the power looms we know today, but Cartwright had made the very first. And the second. And the third. And perhaps if anyone had told him then that the Automated Chess Player was a hoax – controlled by a small person who was extremely good at chess, with their legs hidden in two hollow cylinders disguised in what seemed to be a complex gearing mechanism – he might not have had the courage to just go ahead and invent what he had imagined. And perhaps if he hadn't, our power looms today might have been just a little different, with the seed of a different creator within them.

All that thread and now all that cloth. India could no longer produce enough cotton to feed the machines. So where was it all to come from? Increasingly, in the eighteenth century, it was being grown in the Caribbean and in Brazil, making the triangle of the triangular trade tighter, as the descendants of slaves from Africa were forced to produce exactly the thing that would, after its spinning and weaving in Europe, pay for the enslavement of more Africans.

But it wasn't being grown much in America. For a long time, and until the very final years of that century, it didn't seem as if America was going to be able to grow very much useful cotton at all.

Two kinds of cotton

There were two main kinds of commercial cotton in the US.

One was Sea Island cotton, *Gossypium barbadense*, later also called Pima cotton after the tribe on whose land in Arizona it was grown, experimentally, in the 1920s. It has a long staple, which means that it can be woven into excellent cloth. Over many centuries Inca farmers had bred it to produce smooth seeds that were easy to remove with just fingers and thumbs. But it was a fussy plant: it liked islands and coastlines and wouldn't thrive inland. This was the one that in the eighteenth century was grown mostly in Brazil and the West Indies, with just a few plantations on the coast of the United States. Today, most of the world's Sea Island cotton is grown in Egypt,* where long

* In 1817, French engineer Louis Alexis Jumel was invited by Egypt's ruler Muhammad Ali Pasha, to set up a spinning and weaving factory near Cairo. While visiting a retired Ottoman officer named Mako (or Maho) Bey el Orfali,

staple cotton began to be cultivated commercially from the 1820s, and where it is famous for the soft, fine, bed sheets it can be made into. A great deal is made of the thread count* of Egyptian cotton in comparison, say, with cotton from China or Uzbekhistan or the United States. But it's rarely mentioned that it's from a different species of plant.

The other kind was Upland cotton, the *Gossypium hirsutum* (hairy or 'fuzzy-seed') that I'd attempted to spin in Guatemala. If Sea Island is the racehorse of cotton, Upland is the workhorse. It'll grow nearly anywhere warm, and it tolerates being treated with indifference. If it's planted in spring, it's ready for picking by the end of summer. But, as I had found, the seeds are horrible to pull.

A cotton gin – a device for deseeding cotton – had been invented in India two thousand years before. It worked well with India's tree cotton, forcing the fibres through spiky rollers like a mangle, but was no good for Upland because of its particularly stubborn seeds.

And although there were several ginning machines doing the rounds of the Southern States (Thomas Jefferson tried to buy one as early as the 1770s), for a long time Upland cotton couldn't compete with Sea Island because it was so difficult to prepare. It was so unusual that in 1784 eight bags were apparently seized by the officials at the Liverpool docks, on the grounds that so much cotton would never have come in from America.

he happened upon a cotton tree he didn't recognise. Grown as an ornamental, it nonetheless had a longer and stronger fibre than most other cottons. He started to experiment with the new strain. At first it was a great success. But after just a few years of commercial breeding the quality deteriorated. In 1827 Sea Island cotton seeds were imported across the Atlantic for cross-fertilisation. The resulting strain, variously called Mako (or Maho) or Jumel Cotton, which thrives in the climate and soil of lower Egypt, still gives one of the best types of commercial cotton in the world.

* Thread count is the number of threads in a square inch. Sometimes it's said that the higher the thread count the higher the quality but the reality is more complicated. A fabric with 100 threads per inch of warp and 100 per inch of weft has a 200 thread count. But so too does one with 70 in the warp and 130 in the weft. And if one of those includes a sateen weave – of, say, one vertical thread over three horizontal ones – it might feel softer to the hand. A long staple cotton too, like Sea Island or Egyptian, will be softer, as will thread that has gone through a singeing process, with the fuzz burned off.

A fully original machine

Then in late 1792, a twenty-six-year-old almost penniless recent graduate from Yale called Eli Whitney decided to spend some time tutoring rich people's children in the South. He stopped for a few days at a rice plantation in Georgia, and overheard some visitors bemoaning the lack of a decent machine for de-seeding Upland cotton. And six months later, having never previously even *seen* raw cotton, and apparently not having stirred from the plantation's basement for all that time, Eli Whitney emerged, having invented a cotton gin that would change history.

It's a good story. But in the early 2000s, US historian Angela Lakwete dug into the archives and found some documents that suggested the truth is more complicated. In particular she found a cryptic letter written a few weeks before submitting his first patent in June 1793, in which Whitney wrote that he 'had become very expert in the Hocus Pocus line [and had] only two grades more to rise before [becoming] Chief of all the Magicians'.

Another letter that November was received by Whitney from Thomas Jefferson, then Secretary of State. He acknowledged receipt of drawings and plans of the gin, and noted that all that was now needed was a working model. He had a considerable interest in the success of the invention, he said, because he was aware that cotton was so important for the domestic economy. He wondered, however, if the machine had yet been thoroughly tested 'or is it as yet but a machine of theory?'

Then a PS: 'Is this the machine advertised the last year by Pearce at the Patterson Manufactory?'

It could be true that Whitney was such a very secretive inventor that he went into that basement room on 1 November 1792 and literally did not go outside until the following April when he appeared with a fully original new machine.

But it is more likely, as Lakwete discovered, that this was a carefully curated myth.

Because it was only if Whitney had been hidden away all that time that he wouldn't have found out about the invention of a gin in December 1792 by English textile machinery expert William Pearce, now based out of Paterson, New Jersey, who claimed that it 'will produce very near 300lb, of cleaned cotton per day, and requires only the assistance of children'. And if Whitney could be proved to

have known about it, it would have put his own patent application into jeopardy. He needed to be able to prove that what he had was genuinely new, rather than something cobbled together from other people's ideas. Hocus Pocus, you might say. From the Chief of all the Magicians. And it is Whitney's name that I learned as a fourteen-year-old, not Pearce's*: an example of how, with all those spies around, what some inventors needed to invent most was stories.

Whitney's gin worked by rotating a cylinder covered with coarse wire teeth through a tightly spaced metal grate. It allowed the fibre to be pulled through, leaving the seeds behind. Although it required only one attendant rather than two, an improvement in efficiency, the earliest version tore the fibre, resulting in quite poor-quality cotton. Other inventors began to use his principle to find slightly different solutions, including replacing the cylinder with an axle fitted with fine-toothed circular saws (and naming it the 'saw gin'). The ensuing patent battles almost bankrupted Whitney, and meant that he made no money from his invention.

Not a moment idle

Regardless of who first thought of it, the American cotton gin put the world out of balance in both an extraordinary and an appalling way. Previously it had taken a person an entire day to clean by hand what the cotton gin could now do in just a few minutes. In 1793 just half a million pounds of this cotton were shipped from America to Britain. Seven years later it was nearly eighteen million and by 1825 it was two hundred and fifty million pounds coming out of the four main southern ports of Charleston, Savannah, New Orleans and Mobile – making up nearly three-quarters of Britain's total cotton imports. And almost every single pound of it was grown and picked by men, women and children of African heritage forced to work as slaves.

In 1841 Solomon Northup, a free-born man from New York, was kidnapped and forced into slavery on a cotton plantation owned by a

* Pearce had immigrated in 1791, and immediately found work procuring machinery for a cotton mill in Paterson, a project of Alexander Hamilton's investment group, the Society of Useful Manufactures. The gin he claimed to have invented came to nothing: a patent was never issued.

violent, thuggish man called Edwin Epps. His memoir, *Twelve Years a Slave*, describes the appalling conditions.

The hands are required to be in the cotton field as soon as it is light in the morning, and, with the exception of ten or fifteen minutes, which is given them at noon to swallow their allowance of cold bacon, they are not permitted to be a moment idle until it is too dark to see, and when the moon is full, they often times labor till the middle of the night. They do not dare to stop even at dinner time, nor return to the quarters, however late it be, until the order to halt is given by the driver.

The day's work over in the field, the baskets are 'toted,' or in other words, carried to the gin-house, where the cotton is weighed. No matter how fatigued and weary he may be – no matter how much he longs for sleep and rest – a slave never approaches the gin-house with his basket of cotton but with fear. If it falls short in weight – if he has not performed the full task appointed him, he knows that he must suffer. And if he has exceeded it by ten or twenty pounds, in all probability his master will measure out [by which Northup meant 'increase'] the next day's task accordingly. So, whether he has too little or too much, his approach to the gin-house is always with fear and trembling.

It was, he wrote,

the literal, unvarnished truth, that the crack of the lash, and the shrieking of the slaves, can be heard from dark till bed time, on Epps' plantation, any day almost during the entire period of the cotton-picking season. The number of lashes is graduated according to the nature of the case. Twenty-five are deemed a mere brush, inflicted, for instance, when a dry leaf or piece of boll is found in the cotton … one hundred is called severe: it is the punishment inflicted for the serious offence of standing idle in the field.

In the late 1780s the abolitionist movement in America had a powerful voice. But once cotton became so profitable a few years later, people didn't want to hear it. It's likely that the slave trade in America might have ended much earlier if the cotton gin hadn't come along and made Upland cotton a success.

How cotton mills came to America

In the beginning, most American cotton went to Europe to be spun and woven, and then some of it would return months later as finished cloth, with other countries' profit margins attached. But as the nation's first Secretary of the Treasury Alexander Hamilton soon realised, the real profit would come if Americans could spin and weave the fabric for themselves.

'You have to write about Francis Cabot Lowell,' said just about every American I mentioned this book to, continuing along the lines of: 'he was an American who went over to Lancashire when the cotton mills were an industrial secret and memorised the machinery and brought the plans back and started our Industrial Revolution ... There's even a town called Lowell named after him, or by him, I don't remember.'

I wanted to learn more about Francis Cabot Lowell. I was curious about what feat of memory it would have involved to remember those cotton machines just from seeing them once. And I wanted to visit Lowell, Massachusetts, which was indeed America's first cotton manufacturing town, named in his honour by his friends.

The man who remembered a factory

It had snowed more in the night and by morning the roads gleamed with furrows. It was early April; I'd been expecting warm spring weather but now there were no taxis, no buses and I had several kilometres to walk to the cotton mill museum. I just had canvas running shoes to wear. At the last minute, I tied two plastic bags around them with elastic bands. In places the puddles were knee-deep and slushed with ice. By the time I'd crossed the first road the bags were in tatters and my feet were soaked and cold. As I approached the town centre, I started seeing the canals: the Hamilton (after the Founding Father), the Pawtucket (after the falls), and the Merrimack (after the river), and at every bridge I saw marvellous tall chimneys and attractive, renovated industrial buildings reflected in the half-frozen water. The old mills could almost have been university buildings, with white-framed early nineteenth-century-style windows set within neat red bricks.

As I crossed the last bridge there was a clicking and all the lights in the few open shops disappeared. Power was out. This was the closest I'd get to seeing Lowell as the workers had seen it when it was

Lowell in 1844. Twenty-three years earlier it had been fields.

founded in the 1820s. Shivering now, I walked over the bridge across Eastern Canal, and reached the factory gates. They were shut.

'Closed for snow,' said a man, stopping his four-by-four on his way out of another old mill, which, like almost all of them, had long since been converted into apartments. Why I had thought the museum would be open in this weather, I don't know. But a friend from New England had once told me that they knew all about snow in his part of the world so I'd figured a little bit in April wouldn't throw out the system. In the days of cotton, it would have been open. The mill was always open in Lowell. Anyway, it would have been warmer inside. Warm and damp: that's what cotton likes for its unravelling.

In the old days there would have been hot air pumping out of the mill in weather like this. 'In the winter the steam would be float-ing over the bridge forming tiny little snowflakes', is how one of the workers once described it. I imagined a gaggle of young women from the early days, charging past me in their clogs across the snow to make the 5 a.m. bell, to start a day that would have been fourteen hours long, six days a week. It was hard to imagine that this silent place was once a place of clocks and time and hourly wages and piece rates. And noise.

Lowell, Massachusetts started as a model of factory management. Most of the workers were young women: farmers' daughters who'd come for a few years, live in safe accommodation – no male visitors allowed, cultural talks, house mothers – and then go home and live

their country lives, but with that small initial experience of the city. And the experience of having your own money was a great thing in an era when even rich women usually had no cash of their own.

There had been textile factories in New England before Lowell. In 1786, when Francis Lowell was about eleven, his mother's first cousins had set up the Beverly Cotton Manufactory near Salem, Massachusetts. It had forty workers – including nine who spent their days pulling out the seeds in the days before an effective gin – and the spinning machines were powered by two horses in the basement. The enterprise was underfunded as well as underpowered, and it closed in 1807. Francis saw the mistakes of his relatives, and learned from them.

In 1810, he went to Europe, and when he returned, he and his friends, Nathan Appleton and Patrick Tracy Jackson, started researching how to open their own mill, recruiting technical expert Paul Moody to help with the machines. Their first mill opened at Waltham on the edge of Boston in 1814. It was the first factory in the world to have all the processes of manufacturing cloth – from raw material to finished bales – under one roof. Its success was helped by Francis Lowell's successful lobbying for increased tariffs on imported cotton in 1816. But his health had never been good, and he died of pneumonia in 1817, aged forty-two.

Four years later, his partners realised that to expand they needed a location with water power. They heard about the deep Pawtucket falls above the village of East Chelmsford, beside the Merrimack River. Their first visit was during a light snowfall. Standing at a high point, they could see below them a dozen farmsteads and houses and around them only fields and woodlands.

'There'll be twenty thousand people living here in our lifetime,' Jackson predicted. And as the snow kept falling, they thought about their dead friend and decided to name the new town after him.

Jackson's prophecy would come true, and more. In his lifetime, there would be fifty large mills in Lowell and dozens of smaller ones. Within just fifteen years, this would be the second-largest city in the state after Boston. It would also be a new kind of place. A factory city. A place of making. A model of American Industry.

The next day, the Boott Cotton Mills Museum is open. I'm upstairs when one of the looms on the floor below is switched on. I can feel it with my feet. It's only one machine but it wracks the whole

building. I can only imagine what it would have felt like with all the looms working. I find a label showing a quote from mill worker Mary Paul, in 1848: 'I never worked so hard in my life,' she said, 'but perhaps I shall get used to it. I shall try hard to do so for there is no other work that I can do unless I spin and that I shall not undertake on any account.'

I go downstairs, with the treads juddering beneath my feet, and talk to the volunteer standing beside the working loom, which was made in the 1870s. It has taken Robert Kay's dropbox and Edmund Cartwright's power loom and transformed them into a rotating case of shuttles, shooting a progression of colours across the looms at great speed and noise, with long red, black, and white stripes of warp feeding in from the far side, and a red-, black-, and white-checked cloth emerging from the near. It was all so much faster than the looms dating from a few decades earlier. 'What happened?' I ask, when the volunteer stops the machine and removes his ear protectors. 'The civil war happened,' he says. 'This is machine gun technology.'

What does he think about the famous tale of Francis Lowell's memorising the workings of the Lancashire mill? He grins. 'I reckon he got it a different way, though it's not such a good story. Maybe from one of his Scottish friends?'

The many letters of Francis Cabot Lowell

What am I hoping for in the Francis Cabot Lowell archive in the Massachusetts Historical Society in Boston? It's too much to hope that Francis or his correspondents would talk about any prodigious feat of memory that had entered into family legend and that had caused him to know how to create a cotton factory. But might I find a sense of genius? A hint of a visionary? An indication of understanding things in three dimensions? Or a sense of thoughtfulness, to understand what it was in him that made the town bearing his name a model for decent mill ownership? A clue to a 'Scottish friend' with knowledge of mill mechanics? Or at least an account of going to Lancashire and seeing some machinery.

The Lowell letters arrive in box files that flip open into folders.

I pore over his schoolboy debate notes, his correspondence from a trip to France just after the Revolution, his letters to friends. I find nothing (though he did have one rather good idea of a Book

Warehouse, which a friend, James Rupsell, said did not strike him 'as a thing that promises much more than a living' and Francis did not pursue it).

In 1810, Francis took his family to Britain, partly for reasons of health, partly to give his children an extraordinary experience, and also, no doubt, to find out more about the textile business that already interested him. He and his wife Hannah based themselves first in Edinburgh and later in Bristol. He wrote many letters home. The only Scottish person I find frequently mentioned is the writer Anne MacVicar Grant. As a child before independence she had lived in America for some years, following her soldier father to New York. On her return to Scotland, she had kept her contact with American friends, while corresponding with many Scottish thinkers, writers and politicians of the day. The Lowells stayed with Grant in Edinburgh's New Town, and left their children with her for several months, while they travelled round the country, visiting other cities.

I am standing as I read. It keeps me awake in hour after hour of deciphering two-hundred-year-old handwriting in sepia-coloured ink. I come to a letter datelined Lancaster '3 o'clock afternoon August 1st 1810', written soon after he had arrived in the UK. Come on, Francis, I will. Please say something about the Lancashire cotton mills. And as I stand, a jazz trumpet starts playing above my head, riffs and riffs of counterpoint, as if I'm in a film and this is the decisive moment, the Great Realisation.

But no.

> I am not going to describe it not only because I am incapable of
> it but because I hate always to read such descriptions myself – it
> is very seldome that they give me much an idea of a place – or
> any pleasure.

Damn.

Soon after Francis reluctantly returned home with his family in 1812 – prompted by the declaration, that June, of war between the United States and Britain – he went on a tour of cotton mills in America. The first had opened a generation earlier, having been constructed using information exported illegally by a worker from Jedediah Strutt's mill in Derbyshire. But by 1812 the machinery was already outdated and the mills couldn't compete with the output of

Britain and India. 'We saw several manufacturers, they were all sad and despairing', he wrote.

They can't have been *that* discouraging, however, as now (jazz soundtrack begins to reassert itself) it is a year later and he is writing to say they have advertised for machine makers for their first mill at Waltham near Boston.

And now here it is. In a letter written on 12 October 1813 to Paul Moody:

> We have a very good opportunity to send to England to get any information we wish. Will you write me word, whether you wish any information, of any kind about the construction of any of the machinery, or the manner in which any part of the process is performed.

> Yours FCL

> PS Please to send me an answer as soon as possible as the Gentleman will leave ... for England in a few days

I turn back a few days to a letter I'd skimmed, one sent by Hannah to Mrs Grant. Hannah had written that she had wanted to send a little package containing canton crêpe with a young friend, Mr Gibbs, but she hadn't because Francis thought it 'might lead to a search among [Mr Gibbs's] own articles which would be troublesome to him'. I'd initially thought of the 'Scottish friend' as a man. But could it, in fact, have been the well-connected Mrs Grant? Or at least one of her friends?

So there it is, the closest to an indication of spying I can find. A letter showing Francis sending some unnamed person to Britain, primed to ask technical questions about cotton machines, and at the same time an indication that this Mr Gibbs (who might well be his secret envoy) might be heading directly to Scotland and that Francis was nervous he might be searched.

And, as I read that last letter, the drumming (I promise) starts again louder and cymbals clash. How strange, I think. But as I leave at the end of the day I see the notice announcing that the large terraced town house next door to the Massachusetts Historical Society is Berklee College of Music – America's de facto university of jazz. The whole time I had been hearing students rehearsing.

The difference that a syllable makes

Back home, I call my friend Nell in Edinburgh.

'Did you find anything about his amazing feat of memory?' she asks.

I say that I hadn't. That I'm now not convinced it was true. There were so many mills by then that setting up another one didn't require a feat of brilliance, just good connections.

'But I liked him,' I say. 'I didn't expect to.' Then she says:

'Are you going to Lanarkshire?'

'Say that again?'

'Lanarkshire ... New Lanark.'

'What?' (No jazz in the background, but if there had been it would have been discordant, wilful.)

'New Lanark cotton mill in Lanarkshire, just south of here,' she says. 'We went there for a school field trip. It's the first Scottish cotton mill. And it's a good mill, not a cruel one. You should go next time you're up.'

New Lanark, I find when I look it up, was established in 1784 after Richard Arkwright was invited to a formal dinner at Kelvingrove in Glasgow. It was just before Arkwright's patent on the cotton frame ran out and everyone was keen to see what would happen next. One of the other guests was David Dale, a former cattle-herder turned Flemish yarn importer turned first agent outside Edinburgh for the Royal Bank of Scotland. They talked. The next day, Dale took Arkwright to view the Falls of Clyde, where the river tumbles in a series of rapids. Standing there, looking down at the rushing water, Arkwright said that Lanark would probably 'become the Manchester of Scotland; as no place he had ever seen afforded better situations'. And he agreed to back the venture.

From early on – and led by Dale's visionary son-in-law, the Welshman Robert Owen – New Lanark operated under unconventional rules. It was a place where families were given decent houses, where there were schools, a sickness fund for workers, and a nursery for the infants of factory workers – the first in the world. It was a place where no children under ten were employed, in a business arena where it was normal to employ children of four or five. Lanark's workers were motivated not by punishment or withdrawal of wages but by a device called the 'silent monitor', a wooden cube that could be turned to one of four colours, indicating how well you were doing. White was very

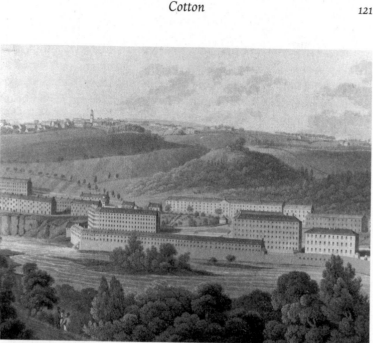

With its schools, sickness fund, nursery and cooperative store New Lanark was a model textile town. Acquatint by John 'Waterloo' Clark, 1825.

good, yellow was good, blue was could be better, and if the overseer turned your cube to black then your name went into a public book. Too long on black and you could lose your job.

Owen also brought in a rule of no beatings for children. Other people thought he was mad. But he didn't believe in violence. He believed in a vision of what factory work could be.

Dale would later build Blantyre Mills a few miles from Lanark, followed by other mills all around Scotland. In 1823, Blantyre was where the explorer David Livingstone started work when he was ten. Owen's social improvements meant that young Livingstone had the chance to attend night school, and later found the backing to study as a doctor and become a missionary. Livingstone gave Scottish cotton workers a wider world to believe in, and they championed him as their own. 'When he was lost in Africa and HM Stanley went out in search of him, our first question every morning was: "Any news of Dr Livingstone?"' a Glasgow power loom operator remembered long afterwards. 'When at last we heard he had been found there was a day of rejoicing like a coronation.'

There is no record of Francis Lowell visiting Lanark, although it would have been surprising if he had not. He and Hannah stayed in Edinburgh for much of their time in Britain, and they would have met the local luminaries. In Mrs Grant, they also had a friend in common: we know from other letters that she knew Robert Owen well enough to introduce him to another young American, Henry Ticknor, in 1819. Whether he heard about them first-hand or by reputation, Francis might well have been inspired by Owen's ideas of fairness and careful management, which would later be at the heart of operations in Waltham and then at Lowell in its early days.

And Lanarkshire does sound a lot like Lancashire. It would be a natural mishearing.

Like a gas lighter clicking

More spinning. More looms. More cloth. And, in this balancing exercise of innovations, more problems.

There was the pollution. Every time a mill opened, the air got worse. Manchester became one of the most polluted cities in the world. A guidebook to Manchester Cathedral in 1901 noted that the stained-glass windows were blackened 'by the incrustation of carbon deposited on their outside by the perpetual smoke of the city'; and that the fog finds its way into the building 'and hangs beneath the roof, lending an air of mystery to the whole place'. The rich built their homes to the south-west of the city; the direction the wind mostly comes from. The north-east, which is where the wind mostly goes, became one of the poorest areas, thick with the dirt of industry, much of it from cotton.

There was also the constant fear of fire. At Quarry Bank Mill, I talked to one of the guides. He said that one day, when he started in the 1980s, a visitor told him that she had worked in the spinning room half a century before. She described to him how the air was full of cotton dust. Then 'you'd have a feeling like a gas cooker lighting … almost a sound of clicks' and everyone would throw themselves on the floor as a sheet of flame lit up all the lint suspended in the air. 'Then it would be clear for an hour or two until the lint built up again.'

There was also the toll on the workers. You 'kissed the shuttle' to push a piece of weft yarn through it, which led to the staining and rotting of your teeth, and what was called 'spinners' cancer' (not

actually cancer but byssinosis or brown lung disease). Few in the early nineteenth century lived even to their fifties. Conditions were so bad that when in 1842 a young German from a wealthy textile family in the Rhine Province was sent to Salford to work for the family firm he was so shocked that he wrote a book about it. Friedrich Engels's *The Condition of the Working Class in England* was published in 1845. Three years later, having persuaded the radical German journalist Karl Marx that change had to come from the working classes, they co-authored a book and titled it *The Communist Manifesto*.

The human considerations that so horrified Marx and Engels might have been of little interest to most European industrialists before they inspired the communist revolutions of the early twentieth century. However, there was another problem that had them really worried. There were now so many spinning factories and so many looms. But was there enough demand?

Cracks in the pattern

The looms of Lancashire and Derbyshire were spitting out cotton by the kilometre, and so by that time were the looms of Prussia and Holland and elsewhere in Europe. There was only so much the home markets could wear or drape or upholster. The factory owners needed new markets, where the climate was good for lighter clothes and where the people already loved and understood cotton. 'Manchester goods' became a brand name for English cotton in general, as it was marketed aggressively overseas, and in particular to the British colonies: Australia, India, New Zealand, West Africa, the West Indies and elsewhere. Other European countries – France and the Netherlands in particular – also marketed their own cotton textiles to their own colonies.

In the mid-nineteenth century, hundreds of African soldiers from today's Ghana, then the (Dutch) Gold Coast, were sent to the Dutch East Indies, today's Indonesia, to fight for the Dutch. It was thought that they were less likely to sympathise with the independence fighters than local soldiers might be. Those who returned home brought souvenirs of their adventures and one of the most popular was batik wax resist fabric, made in the traditional Indonesian method, where the designs had been painted onto the cotton with wax. When it was dipped in dye, the parts covered by wax were left undyed; fabric was often dyed several times to produce exuberant patterns. And

sometimes the wax isn't solid, but cracks a little, leaving threads of colour.

The most popular fabrics among the African soldiers were the ones with dramatic crackles – the ones that the Indonesians didn't much like. In the 1840s Dutch manufacturers sent Dutch-made imitation cotton batiks to Indonesia. It didn't catch on. But where it did catch on was in West Africa, and these exuberant designs with their trademark crackles soon began to seem African to their core. And although foreign manufacturers everywhere – including Manchester – were soon trying to make commercially printed cottons for West Africa, the ones designed and printed in Holland using wax were widely reckoned the best. They became known as 'Real Dutch Wax'. Or later just 'Hollandais'.

The lost spinning wheels of India

Back in the UK, thousands of tonnes of finished cotton goods from Lancashire were being shipped to Bombay, Madras and Calcutta. They would be exchanged for tea and silk and indigo, as well as for opium, which would be traded on to China in a brutal strategy to swap it for *their* textiles and tea. Soon, British and Indian entrepreneurs were trying to spin cotton in India – although it attracted heavy taxes from the British government. When the Bowreah Cotton Mill opened in 1819 at Fort Gloster, fifteen miles upriver from Calcutta, it was the first steam-powered cotton mill in the country.* How could hand spinners and handloom weavers compete?

By 1840, the Indian craft industry, even for fine hand-spun muslins, was under strain. That year, a Select Committee of the House of Commons was formed in order to discuss a petition by the East India Company to remove the duties on Indian goods. 'We have destroyed the manufactures of India', testified Mr Larpent, Chairman of the East India and China Association, to an assembly that included the

* The first fully Indian cotton mill wasn't established until 1854. The Bombay Spinning and Weaving Company was Mumbai's first cotton mill, built by Parsi entrepreneur Kavasji Nanabhai Davar at Tardeo, in the south of the city, and worked by steam. Later the mills in Bombay would employ a quarter of a million people; today most are closed, with the land being fought for between those wanting to provide good accommodation for the poor, and those wanting to provide elite accommodation for the rich.

Before freight containers, millions of cotton bales were
loaded individually into the holds of ships.

young William Gladstone, future prime minister. Larpent said that in
1814 more than a million pieces of Indian cotton goods had gone to
Great Britain; by 1835 it was a quarter of that. The change the other
way was even more dramatic. In 1814, around eight hundred thou-
sand yards of cotton cloth went from Britain to India (and that's not
including the cloth made by British-owned firms in India, where the
profits also returned to the United Kingdom).

Twenty-one years later it was fifty-one million.

'The decay and destruction of Surat, of Dacca ... and other places
where native manufactures have been carried on,' Larpent said, 'is
too painful a fact to dwell upon. I do not consider that it has been in
the fair course of trade; I think it has been the power of the stronger
exercised over the weaker.'

But it didn't stop, and through the rest of the century more and
more cotton mills were set up in India, leading to the rapid decline
in ordinary people spinning and weaving fabric in their homes. Yet

despite all these new industrial-scale mills throughout the subcontinent (many of which were backed by Indian capital), the international trade in finished cotton mostly went one way – from west to east. By 1913, three billion yards of English cotton cloth were shipped to India: nearly sixty per cent of all the cotton in Lancashire.

Take up the handloom. Or is that the spinning wheel?

In 1909, the Indian lawyer and activist Mohandas Gandhi wrote *Hind Swaraj*, a call for Indian home rule urging India's intellectuals to join a non-violent struggle and, as part of that, to 'take up the handloom'. This was the logic of Gandhi's boycott of British textiles:

1. Britain needs India to buy its cotton.
2. India needs independence from Britain.
3. If Indians stop importing cotton and make fabric themselves then Manchester will suffer.
4. If Manchester suffers then Britain suffers.
5. If Britain suffers then it might let India have its independence in exchange for becoming a trade partner for cotton once again.

At the time, Gandhi had seen neither a loom for weaving nor a wheel for spinning. And in fact he muddled them up. As his grandson Rajmohan Gandhi explained later, in that early call for action when his grandfather wrote 'handloom' he actually meant 'spinning wheel' or *charkha*, as the traditional version was called in India. And yet despite this, his descriptions of the 'imagined energy, economic, political and psychological' flowing from the 'handlooms' (i.e. spinning wheels) were so vivid and inspiring that thousands of women and a smaller number of men answered the call to try it, for the cause of Indian independence. It was hardly surprising that a man in Gandhi's position had never knowingly seen a *charkha*. Although he had grown up in Gujarat, the former hinterland of homespun, he had been born in 1869, long after the country had begun to rely on British cloth, or the produce of India's own steam-powered cotton mills. Indeed by the time Gandhi returned to his homeland in 1915, from South Africa where he had been a civil rights activist and lawyer since 1893, it seemed there were almost no *charkhas* to be found at all.

A volunteer, Gangaben Majmudar, said she would locate some. She struggled to find even one, but then in Vijapur in north-east Gujarat, she came across hundreds, 'all lying in attics as useless lumber'. She arranged for them to be brought back to Gandhi's new ashram in Ahmedabad and then found people able to repair them. She also found local women who said they were happy to try spinning this cotton at home but only if they could be sure of sourcing enough raw cotton, and only if there was a guaranteed market for their finished yarn.

A friend of the ashram had a mill in Bombay that could supply the raw cotton and while Majmudar found spinners and weavers who would transform it into *khadi*, or homespun cloth, Gandhi was actively persuading people to wear it. He told all the members of the Indian National Congress that they not only had to spin cotton, they also had to pay their membership in cotton yarn they had spun themselves. Wearing white *khadi* would be a badge of nationalism.

The British, for obvious reasons, didn't like the plans.

But people closer to Gandhi also opposed them too at first, including his own wife Kasturba, as well as several women in the household of Jawaharlal Nehru, leader of the Indian National Congress and the future first prime minister of India. Kasturba Gandhi was initially so reluctant about the *khadi* idea that she led other women in an argument with her husband about how horrible it was to wear. On that point he didn't give way though he did give way on another. White was a colour worn primarily by men and by widows, and widowhood was a terrifying state for women in India. Many married women drew the line at this requirement and soon *khadi* was being produced in many bright colours.

'I thought of Gandhiji as a brigand', remembered the poet Kamala Das, whose mother had been forced to wear nothing but white and off-white *khadi* cloth since her betrothal in 1928.* 'I thought it his diabolic aim to strip ladies of their finery so they became plain and dull.' The comment was in part humorous, but in this element of the Swadeshi movement – the national independence movement that started with people taking back control of their cloth – there might

* Das remembered her grandmother spinning *khadi* yarn on a *thakli* (spindle), 'holding it aloft over her head in the afternoon, while the others slept and the old windows creaked in the heat'.

be a faint echo of something that also drove the calico mockery in England in the eighteenth century: a desire that, in the name of patriotism, women would be required to be plain.

In 1931, Gandhi arrived in London for a Round Table conference on Indian independence. When he had been a law student in England several decades earlier he had worn suits. Now he wore a *khadi dhoti*, or loincloth. A mill owner in Darwen in Lancashire invited him to see the hardships the boycott was causing ordinary families. Photos from that visit show some of the three thousand or more people who had come to meet him standing around a thin man swathed in white cloth. They look excited and in awe. A weaver tried to tell him how hard it was now that India wasn't buying their cloth. Gandhi smiled.

'My dear,' he said. 'You have no idea what poverty is.'

In 1947, India won independence, thanks in part to the revolution caused by the mass spinning and weaving of *khadi*. By that time, there were three million handlooms in India and in both Pakistans. And many, many spinning wheels.

India's new government promised modernisation and innovation. But by then the main competitor for cotton manufacture wasn't Europe, whose textile-making force was nearly spent. It was China. And then it was Hong Kong.

Cotton moves to Hong Kong

C. C. Lee had a problem. The youngest son in a family of successful Shanghai cotton mill owners had been sent to Hong Kong by his father. His job was to make sure that a ship carrying tens of thousands of spindles as well as some expensive cotton machinery from the US was granted its import licence to unload its cargo in China. But now the whole operation was stalled.

It was 1946. The Asia-Pacific War had been over for less than a year, and people all around the region were desperate for clothes. In the previous half-century, the city of Shanghai had become the Lancashire of China, employing more than half a million textile workers and making several families, including the Lees, extremely rich.

But now the Nationalists had taken control; they wouldn't let any machinery into the country unless they could profit from it with foreign currency, which Lee couldn't provide. He didn't know what

to do. He couldn't get the spindles into Shanghai; the ship couldn't wait around forever. He'd have to unload in Hong Kong. And it made sense to see if he could do anything with the equipment while he was there.

Nobody thought Hong Kong would be anything but useless for cotton spinning. There's a sweet spot of humidity for cotton and it's not found in Hong Kong's intense summer dampness of 80 per cent or more. It was also the case that there weren't enough skilled people to make a viable workforce at that time, and – as Lee said in an interview many years later – the workers of Hong Kong were more famous in those days for their enjoyment of *yum cha* tea breaks than for their dedication to factory work. But he had few options. He leased an empty place in To Kwa Wan, close to Kai Tak airport on the Kowloon side of the harbour. Then he brought down sixty skilled workers from Shanghai to train the new workforce. He also made a decision to concentrate on coarser cotton, which might just survive the humidity. By the end of the year, Hong Kong's first cotton spinning factory was open for business.

Three years later, Mao Zedong's Communist army would take Shanghai from the Nationalists so quickly that not even the winning side knew what was happening. In 1949, more than a hundred thousand mainland refugees would flood over the border every month. So not only would labour shortages no longer be an issue but the Hong Kong government would be desperate for there to be something the refugees could do for work. It would welcome the cotton industry – it solved a problem.

In that first year, however, as the threat of revolution glowered over Asia, there seemed to be a real stumbling block, and it wasn't connected to the climate. Hong Kong didn't have a home market to speak of, and it didn't have a garment industry either. That year the factories of Kowloon spun and twisted so much cotton yarn that most of it ended up mouldering in warehouses because there was nowhere to send it.

Then on 25 June 1950, backed by newly communist China, North Korea invaded South Korea and the Korean War began. China was placed under a trade embargo and there was an instant market for army canvas and uniforms. When the war was over, policymakers in Washington set their minds to developing strategies to boost Asian economies: it was one of the best ways they could think of to stack

the odds against communism. One of the ideas was to promote cheap textiles from Asia.

To take advantage of this, Hong Kong needed to make its yarn into cloth, and it needed to do it quickly. Weaving factories sprang up, both in Kowloon alongside the spinning mills and also pushing out into the New Territories where land was cheap and workers could be housed.

The US developed a complicated quota system allowing cotton goods to be imported from Asia, even at the expense of its home industries. But in Britain, there was a growing resistance against the tonnes of cheap cotton garments coming in from Hong Kong, especially when in 1961 Britain found itself a net importer of cotton yarn and textiles for the first time in two and a half centuries. The following year, the British Government fixed an annual ceiling of sixty-four million square yards of Hong Kong cotton. America soon followed with its own limits.

But Hong Kong companies were new to the game, and nimble. So there are too many tariffs on cotton? Then they'll switch to nylon and polyester, which have no tariffs. So the OPEC oil crisis in 1973 has led the price of nylon – a fabric made largely from oil – to soar? Then they'll return to cotton.

And, anyway, by then two things had happened.

Through the 1960s, clothing companies in Europe and America had started to sell cheaper, mass-market garments, turning to Asia to manufacture them.

And in the mid-1960s, an engineering team in Czechoslovakia, then part of the East European communist bloc, had come up with a new kind of spinning technique for coarser cloth, which was effectively spinning without a spindle. They invented it just in time for the technique to be exported to the West before Czechoslovakia was invaded by the Soviet Union in 1968 and the borders closed. It was called 'open end spinning'; and it involved using saw-toothed wires to separate the mass of cotton into single fibres, then using a fast stream of air to twist them into yarn, rather like passing them through a turbo-charged tumble dryer. The resulting yarn was hairier than that made by conventional spinning machines but it was quicker and cheaper to make and it meant that denim and T-shirts became available for everybody. Cotton was new again. Cotton was cheap. It was the 1970s. Everyone could have cotton.

The looms, too, had begun to change. Most cotton today doesn't have a selvedge – the side of the cloth where the shuttle flips around like a swimmer doing a racing turn before starting back again in the other direction. To make all the towels and sheets and T-shirts and shirts and jeans and so-called instant fashion much of the world uses and wears today, people have found ways of making cloth, and especially cotton cloth – the seeds, the trees, the yarn, the cloth, the sewing of the cloth – cheaper and cheaper and cheaper. One of the many efficiencies is that instead of wasting energy turning the shuttle around at the end of a line, each weft is shot through the shed at the speed of a gun. At the end it is cut and a new weft is shot through the next shed. At the speed of a gun. There is little time for niceties if you're going to transform millions of tonnes of seed capsules into cloth every year.

But what if there still wasn't enough cotton? And what if cotton just shouldn't be that cheap?

Real Dutch cotton

David Suddens is a turnaround guy in the garment trade. In the 2000s, he was brought in to revitalise the British bootmaker Dr Martens. He turned it around. In 2015 he was invited to do the same for Vlisco, the company that has been making 'Real Dutch Wax' fabrics in Holland for West Africa for a century and a half. He planned to turn it around.

Vlisco fabrics cost many times more than the copies that can be found everywhere in West African markets. Of course they do: they have to pay their designers; their genuine wax resist techniques are more expensive than conventionally printed versions; their factory is in the Netherlands; and they have tougher legal obligations to dispose of chemicals responsibly. But with increasing numbers of cheap copies coming from China, they were in trouble. One of the first things that Suddens did was to ask consumers in Africa what they thought. They loved the bright designs and the branding, they said. But they wondered why the cotton didn't feel quite as they remembered from the old days.

Suddens said he wanted to visit the suppliers. 'Previous chief executives have never been to visit the suppliers,' he was told. He visited the suppliers. It involved taking a fast train west from Beijing for several hours then getting in a car and being driven for several hours more, through falling snow. When he arrived, he found an

old-fashioned factory using shuttle looms. 'With a selvedge!' he said. He decided to try a different supplier, in Pakistan, which produced fabric that he thought had a better hand touch.

Hand touch, or fabric hand, is a thing in textiles, along with 'heft' and 'drape' and 'weight' and 'density'. When we buy clothes, we often choose them according to how the fabric feels as we brush our hands against it; experts try to quantify this in terms of surface friction, rigidity, twist, hairiness and softness, as well as other measurable criteria. And it's vital to have some way of assessing such a subjective thing. For sellers, a cloth having or not having a good fabric hand can mean gains or losses of millions of dollars. For buyers, it often just comes down to a feeling.

Suddens had some sample yards made up. 'I showed it to the Togo buyers and said, we've got new fabric, what do you think?' They discussed how it felt, how it took the dyes; how the designs seemed to have a sharpness and resonance.

'They liked it. Then they said what about the price? I said it would be five per cent more. There was an uproar. "It's not worth it," they said. "Can't we have two and a half per cent?"'

The next meeting was in Benin.

'Here's the existing fabric and here's the new one,' he told them. Those buyers weren't impressed from the start.

'At the end of the meeting, they said "what's the price?" and I said that if they didn't think the new fabric was better then I wasn't going to force it and there was no point in even mentioning the price. Turns out the Togolese had called the Benin traders and said: "whatever you do, don't say you like it; he just wants to charge us more."'

When I met Suddens, he was in discussions about expanding to a potential new textile park in Nigeria's Kaduna Province. A cotton mill was set up there in the 1950s before independence, but it failed soon after, partly due to the competition from Hong Kong and China, and partly due to a sense in Nigeria that foreign cloth is more desirable. Now it's Chinese money backing the textile park, although everyone will have to negotiate complex rules on import tariffs, as well as work out how to modify designs to appeal to younger consumers, who like Western fashion but also want to be proud wearers of African culture. 'It needs to be a way that speaks African culture without looking like something their mothers or grandfathers wore.'

As I listen, it seems that these issues – duties, trade protection, the compromise of quality for quantity, the shifting requirements of a new generation – are conversations that have happened since the Romans were importing Indian cotton two thousand years ago.

Now Suddens is talking about the future of a cotton manufacturing industry in Africa, pointing out that once a country reaches a certain point, its economy tends to turn away from textile manufacturing, as wages increase costs beyond what the market wants to pay. 'You don't know how long it'll take,' he says. 'But you do know that everything is accelerating. Japan industrialised and it took about twenty years; Singapore industrialised and it took about fifteen; China industrialised and it took about ten – look how fast Shanghai changed beyond all recognition – and everything is getting faster and faster … But will it be five years in Africa?'

Once Africa industrialises, he guesses, the labour in the garment and textile trade would probably move to being performed by robots.

'There'll be nowhere else left to go.'

Reaching to the moon

If you placed every bale of raw cotton grown in 2020 end to end, you'd make a chain that would go four times around the equator. If you stacked them on top of each other, you'd make a precarious tower 160,000 kilometres high. Three years' worth would carry you well beyond the moon.

To grow so much, cotton itself had to change.

The cancer train

Every night, a train rattles three hundred kilometres across the state of Punjab in northern India, arriving at Bikaner in Rajasthan at around six o'clock in the morning. Its twelve coaches are usually full. On timetables, it's marked as Train 339. Mostly people just call it the cancer train.

Nearly everyone on board either has cancer or is caring for someone with cancer, and they travel so far because the local private hospitals are too expensive. The Acharya Tulsi Regional Cancer Treatment and Research Centre, a government hospital in Bikaner,

will look after them, even if it means they have to travel through the night. Most passengers on Train 339 come from Malwa and Malwa is Punjab's cotton belt. A 2010 study by the Postgraduate Institute of Medical Education of Research in Chandigarh found that the incidence of cancer is higher in Malwa than elsewhere in the state. The *Hindustan Times* reported that Malwa consumes three-quarters of the pesticides used in Punjab (which uses twice as much pesticide as the rest of the country). And pesticides and artificial fertilisers are like a drug. After using them for a while, the land can't do without them.

For a while back in the early 2000s, it had seemed that cotton farmers might not need pesticides any more. The big problem with cotton is the pink bollworm, a moth larva the colour of a ripening raspberry that is so resilient that farmers have reported how you can drop it in a bucket of poison and it will keep on swimming. During most of the twentieth century, efforts to combat it were largely based around a bacterium named *Bacillus thuringiensis* (or Bt) after its curious long shape (*bacillus* is Latin for stick) and the fact that in 1908 a scientist in Berlin learned that insects infesting a batch of flour from a mill in Thuringia had died after eating it.

For years, different kinds of Bt insecticides had been used on crops around the world. Now in the late 1990s a team at the US chemical giant Monsanto discovered and patented a way of using Bt proteins to modify the genetic code of cotton seeds. They called it 'Bt cotton' and branded it 'Bollgard'. And if their patent meant that it was illegal for farmers to collect the seed – so that they would have to buy seed from the company rather than reserving part of their own crop as in the distant past – then perhaps that was a small price to pay for stopping the pesticides.

But it wasn't a small price. And it didn't fully stop the pesticides.

After an expensive marketing campaign, many farmers in India bought Bt cotton in the early 2000s. At first, it seemed there was a leap in productivity but within a few years a new kind of pink bollworm had appeared and this one didn't care what the cotton was called. It ate it anyway, and it didn't die.

In some countries, farmers managed by dedicating around a quarter of their cotton acreage to conventional cotton (which would be sacrificed), allowing ordinary bollworm moths to appear and mate with Bt-resistant ones, reducing the chance of later generations being born with the resistance. But in India – where the timing

of the monsoon means that cotton has to stay longer in the fields, multiplying the chances of the bollworm growing to maturity, and where most farmers can't afford to reserve so much land for crops they won't use – biotech's opponents argue that it has been a disaster.

Add to this the spiralling debt from buying high-priced seed and fertilisers; the multi-million-rupee scandals of pesticides watered down by corrupt officials (allowing whitefly and other pests to attack); and a country-wide purchasing system that will only accept certain limited varieties of cottonseed, meaning farmers can't easily switch back to non-GM crops. The first twenty years of the twenty-first century saw three hundred thousand suicides by farmers and farmworkers in India. Many of the deaths in Punjab were in Malwa. Many were cotton farmers. Some did it by drinking pesticide, after the failure of the so-called 'Bollgard' crops.

Caramel, pink and the green of bright water

There is one last cotton invention in this chapter. It's been the smallest in its impact and yet it contains within it the seed of something that might be greater than all the others: a glimpse of a different kind of future.

It involves a natural-coloured cotton similar to the *ixcaco*, the sacred brown variety I found in Guatemala at the beginning of my quest. The one I was told was too hard for beginners to spin, because the fibres were too short; the one that I had been told could not be spun by machine.

In 1982, in her early twenties, American entomologist Sally Fox was given some seeds for brown cotton. They were in the US Department of Agriculture seed bank, and the venerable older plant-breeder who passed them to her said that they had come from Cajuns – Acadians, descendants of French settlers – in Louisiana. They appeared to be naturally resistant to pests, but the staple was too short to be spun by machine. He wondered whether anything could be done.

I interview Fox by phone one California morning as she walks around her farm testing the machinery. 'I was a spinner, that was my hobby,' she says. 'And I was enchanted by the idea of this cotton.' It was partly its resistance to disease but mostly it was the colours. They were like soft shades of caramel or caffè latte, which, rather than fading over time, grew stronger each time the fabric was washed.

It meant that it could be interesting commercially, because without bleaches or dyes (or expensive disposal of chemicals) it would be cheaper to produce natural khaki cloth from it,* and also it wouldn't cause the toxic run-off that most chemical dyes produce today. There was one problem.

'The fibres themselves were just so awful; so rough; so miserable to spin,' she says, and then we pause as she starts the tractor and goes to one of her fields. Fox had studied insects not plants, and in retrospect that was part of her gift. She had no idea you weren't supposed to be able to breed across different types of cotton, so she did. She mixed the Louisiana brown cotton with strains of Pima cotton (the one earlier called Sea Island), each time selecting the parent plants by the ones whose fibre she could spin most easily. She also hadn't studied industrial textile techniques 'but it turns out that the things you need for hand-spinning are the same things you need for machine-spinning. You need it to be long and strong and fine. And that's what I got out of this cotton, despite the fact that it was supposed to be impossible.'

One day she saw something astonishing. There, in the boll of a plant bred from two naturally brown parent plants, was raw cotton of an entirely unexpected colour. It was a kind of aqua green – sea turquoise mixed with moss and mint amidst a foam of white.

'I cried,' she says. 'For like an hour ... I hadn't imagined there could even *be* such a colour.' Later, also nestling far down hidden inside the natural genetic codes of these brown cottons, she turned up bolls that were red and pale pink. 'Some people say there's a blue in there too, but I've never seen it.'

She grew more, always organically, registered the names Foxfibre® and Colorganic®, and set up a business that soon had a turnover of several million dollars. But it grew too quickly (that old cotton story) and meanwhile mills in America were closing and local farmers were terrified that her cotton might contaminate their conventional Upland seeds.

* In the past, natural-coloured cotton in India was made into cloth that was called *khaki*, or earth-colour. In the nineteenth century it was mostly used for army uniforms. By the First World War most army khaki was made with bleached white cotton dyed back with chemical colours to a greenish brown. In 1914 the German army didn't have access to those dyes, leading to a supply crisis and the rapid development of that side of the German dye industry.

'I took the chance; I lost,' she says, about how her business failed. But she kept her seeds, and after a while she saw how this strange, wonderful cotton was the one thing that really interested her. She relocated to where she was the only cotton farmer for miles – the Capay Valley north-east of San Francisco – found one of the few remaining mills in the US to spin her fibres, and made provisions for some two hundred sheep to provide manure and eat the cotton stubble as well as grow their own superfine wool. She's still growing brown (and occasionally green) cotton, and it's still organic, she says. Though she couldn't blame anyone for wanting to use herbicide now and again.

'I don't use it, but the weeds are the worst bit for sure.' Then she says goodbye and starts the tractor again to drive to another part of the field to clear more weeds.

Of all the inventors in this chapter, I realise, Fox is not only the only woman. She's also the only one who was drawn to the business by the chance of making things slower.

It is all about balance

Everything is about balance. A faster loom, a faster spinning wheel to feed the faster loom, an even faster loom to use up all the spun cotton, the need for more clothes to use up all the woven cotton, a faster wheel, a faster loom, new markets of people able to buy all the new clothes, a need for more cotton, a need for a new kind of cotton that fights its own pests, a faster loom, a faster wheel and here we are spinning and spinning our cosmos around, and the more we make the more we destroy and here we are. The maize god is speeding up time.

4

WOOL

In which the author finds one of the earliest guides to selective sheep breeding hidden in a Bible story; learns why British people weigh themselves in stones; and buys the most expensive socks she can find.

'What are those?' a visitor to our village once asked, pointing to a field.

'What are what?' a neighbour answered, afraid her tree knowledge might be found wanting.

'Those grey things?'

'Which grey things?'

'The animal things.'

'Do you mean the sheep?' she asked, cautiously.

'Oh, yeah. Cool. I've never seen sheep before.'

It seemed strange that anyone might not recognise a sheep. But then I imagined another conversation.

Visitor: 'What are those?'

Me: 'What are what?'

Visitor: 'The animals in the field.'

Me (slightly smugly): 'Oh. Those are sheep.'

Visitor (smiling in some astonishment): 'I know they're sheep. But what *sort* of sheep?'

Me (chastened): 'Oh [pause] I have no idea.'

I have lived in the English countryside for nearly twenty years, first in a cottage in the Peak District east of Manchester, where sometimes over breakfast we would spot a few escaped lambs nudging each other along the lane and we'd shush them back to their field with brooms instead of crooks. Later, moving to a village near Bath, we rented a cottage just below a lambing barn. I was once allowed to spend the night watching the ewes giving birth. But I still didn't know my Portlands from my Romneys, my Dorset Downs from my … to

be honest, as I first wrote this sentence, I couldn't think of another common wool sheep from southern England. I see sheep every day when I walk; they're in the fields either side of the paths, and higher up on the hills. Wool is what paid for most of the ancient buildings of this landscape. It's not as if I had an excuse.

I wrote to British Wool, the association of sheep farmers that auctions and markets almost all the wool in Britain today. By return I received a wonderful colour guide to the seventy-four breeds of sheep in the UK (more than any other country in the world), and that afternoon I carried it with me on one of my favourite walks.

Sheep spotting wasn't much harder than bird spotting; I was astonished I'd never learned it before. There was a little flock of Suffolks, with ebony faces and bare black legs and fat white fleeces. Like the clip from many of Britain's other finest wool breeds, the fleece on their backs would probably end up in Japan, used for stuffing futons.

In another field, there was a small herd of Jacob's sheep (which I did recognise), with their two or four horns and mottled brown-and-white coats. They were first seen in England in the seventeenth century, making the grounds of stately homes look decorative. Today their wool is mostly used by craft hand spinners.

Further on, there were half a dozen plump ones with cream-coloured coats that made me smile. They had short, curly fleeces, woolly legs, white flashes along their noses and neat pinkish teddy-bear ears that stuck out sideways. It had started to rain, and with the book half covered by my coat I couldn't immediately work out what they were. It wasn't lambing season but they did in fact look like giant lambs: they had a kind of comic alertness to them, an endearing quality which made me stay there, stubborn to learn what they were. Then I found the page.

More than eight hundred years ago, sheep like these had been bred by the monks at Leominster, near Hereford, when they were called Lemster Ore (meaning Leominster Gold) because of the wealth they once brought. Today they're called Ryelands and they – or rather their ancestors, because as we'll see, sheep don't stay the same through the generations – were once the very finest breed of wool sheep in England.

These ones – as I learned later from their owner, who just keeps a few of them in his fields – had been introduced because they're more

docile than Suffolks. And the Ryeland ewe lambs raise more money than other British wool breeds, even now.

Three kinds of invasion. Three kinds of sheep

Sheep were first brought to the British Isles about six thousand years ago. The original animals were small and long-legged, and probably looked like today's Soay breed on St Kilda in the Hebrides – skittish, goat-like, with horns like crescent moons. The Neolithic sheep didn't need shearing, which was useful because people didn't have shears. Often their winter coats would just drop off in springtime and could be picked up from the ground. If not, the fleeces would be loose enough by June or July to be peeled, or 'roo'-ed, directly from the animals' backs.*

When the Romans occupied Britain, they brought their own sheep. These ones had white faces and fine wool, and they were bred with the native breeds to make a new kind of sheep that came to be seen as special. Cloth made from the wool was said to be 'spun so fine that it's like a spider's web', and in the third century most went straight to Rome.

In the ninth century, the Vikings invaded. Their sheep had black faces and horns: you see their descendants in the Blackface and Swaledale breeds, which even now are still found mostly in the north wherever the Vikings settled.

Neolithic primitives, Roman luxuries, Scandinavian hardies. From these three very different sheep evolved all the breeds and cross-breeds that have made British wool unique, and at times important. In 1192, returning from the Third Crusade, King Richard the Lionheart was kidnapped by Leopold V, Duke of Austria, who had a running vendetta with him. The ransom was a hundred and fifty thousand silver marks, the equivalent of three years' national income. Landowners were to give up a quarter of their earnings; the church was ordered to donate most of its silver; and no doubt the peasants were made to give more than they could afford in labour and crops. But it was the Cistercian monasteries who really managed to get the English king back to England. They owned the best sheep in the country, including

* The English word 'roo' shares an origin with the Old Icelandic *r'yia*, to pull wool from a sheep, and with the Old Russian *r''vati*, to tear, tug and pluck.

the Lemster Ores, and they donated the year's entire wool clip. The Lion had been paid for by the Lamb.

The Cistercian order had been founded a century earlier, partly as a response to the corruption of many of the oldest monasteries in Europe – those of the Benedictine tradition. If the Benedictines had luxury, the Cistercians would have simplicity. If the Benedictines wore black habits and comfortable linen underwear then the Cistercians would wear white habits of itchy, unbleached wool. If the Benedictines had all but forgotten St Benedict's sixth-century rule that monks should work as well as pray and study, then the Cistercians would get out into the fields, and plant crops and look after sheep. Cistercian monasteries were mostly in remote areas and the land that surrounded them was largely poor. The sheep, carefully bred by the monks, ate this scrubby grass. And because of it, not despite it, they grew the finest wool in the country.

The earliest guide to sheep breeding

Grasper was on the run. He had tricked his father into giving him his older brother Hairy's inheritance and now Hairy wanted to kill him. His mother told him to hide out with her brother, White, many days' journey north. On the way he had a dream about having many children and numerous descendants over many generations. Arriving at his uncle's village, he caught sight of his cousin, Ewe, and fell in love. His uncle said they could marry only if Grasper agreed to spend seven years herding his sheep. But seven years later, when he looked at his new wife – who had been veiled at the wedding – he realised it wasn't Ewe he had married but her older sister, Weary. The trickster had been tricked.

When Grasper complained, he was told that he'd have to work another seven years if he wanted to marry Ewe. He agreed, married Ewe as well, and kept working for nothing. It all seemed extremely unfair. Except that Grasper was gaining a superpower. Over those fourteen years, he had learned more about sheep than his uncle would ever guess, and he had had an idea …

This is a retelling of the earliest 'How To' guide to selective sheep breeding. The account is found in the Book of Genesis, inside the story of Jacob, the mythic father of the twelve tribes of Israel. The names are important, as they are not names so much as ciphers

Seventeenth-century engraving of the meeting between
Jacob and Rachel, whose story contained hidden
clues about breeding sheep for wool.

for each character's role. Jacob means the one who grasped his
brother's heel at birth; Esau is Hairy; Laban means White; Leah
means Weary; while Rachel is the Hebrew word for Ewe. And the
story also holds, concealed within it, a narrative of what happens
when a Ewe born of a White sire is matched with a vigorous male
whose twin has red hair.

After his second seven-year term, Jacob asked to continue
tending his father-in-law's flock. He said that instead of wages he
would have something that appeared easy for Laban to give. White
sheep and goats were the most valuable because white wool can be
dyed more easily than dark. So Jacob's proposal was that after seven
more years they would divide the flock: his uncle would have all the
white animals, while he would keep any black, brown or speckled
ones.

Laban agreed – and then promptly removed all the dark and
speckled animals from his herd, leaving Jacob with only the white

ones to breed from. He would have known that offspring usually carried the characteristics of their parents, and imagined that with no speckled or dark sheep in the flock, his son-in-law's chances of taking a substantial wage were slim.

But Jacob knew something that Laban did not. In his years as a shepherd, he would have seen how white rams and white ewes can still sometimes produce lambs with coloured wool. Perhaps he was particularly interested in the subject because he was the twin to such a different kind of man. Or more likely this whole part of the story is all just code for more ancient wisdom and mythology.

At breeding time, Jacob peeled bark strips off tree branches and put them in the watering troughs so the ewes would see stripes at the moment of conception. In the first year, a few dark and striped lambs were born. Jacob separated those into pens and bred from them. The second year he did the same, and there were more dark and striped lambs. By the seventh year, almost the whole flock was dark and striped. And Jacob's.

The trick with the bark strips was likely a conjuror's distraction. Because Jacob didn't need witchcraft, or an act of God. What he needed was an understanding of how genetic traits pass through the generations. It wouldn't be explained scientifically until 1866 when the Austrian priest, Gregor Mendel, described his observations of pea plants, but as the Jacob story shows it has been understood by shepherds since at least the Bronze Age.

How Jacob's trick worked:
a brief introduction to genetics

As in humans (and peas), every cell in a sheep's body contains two copies of every chromosome, each holding genetic information. One comes from the father and the other from the mother. Some characteristics have a dominant version and a recessive version, and for sheep, the characteristic of wool being white is stronger than the characteristic of being brown, black or striped. This isn't surprising because pigment in wool requires melanin and both chromosomes have to favour it for a cell to produce it. White fleeces are just the absence of melanin: it doesn't require anything to be switched on.

So each brown sheep in Laban's original flock had two colour chromosomes because if it had even one non-colour one, it would have shown up white.

Meanwhile, each of the white sheep would have had either two white chromosomes or – and this is the critical thing for Jacob's story – one coloured and one white. You wouldn't know which was which just to look at them, but if you'd watched the flock carefully for fourteen years then you'd know which ones had parents and siblings with pigments in their heritage and you'd have seen how in some descent lines the characteristic of being brown or striped can return within a single generation.

It means that, in the first year, as long as he mated only those sheep with coloured chromosomes in their heritage, about one in four lambs would have pigmented wool, and could be moved over to Jacob's separate flock. Of the other three white ones, two on average would have one coloured chromosome, hidden, and only one would have no chromosomes for colour. One trick of telling the two varieties apart was to look for the more vigorous animals. Jacob said later that he had learned this in a dream, in which an angel told him that it was the male animals 'which leap upon the flocks' that give rise to offspring that are streaked and speckled. The technical term is 'hybrid vigour' or 'heterosis', and it means that the stronger animals (being effectively the first generation of a hybrid) were most likely to carry the pigment gene, so those are the ones that he would selectively breed from.

The percentages meant that over six years Jacob's wager was a certain bet.* As long as he was organised – and the Book of Genesis, describing his careful corralling and penning, suggests he was – then within that time he could make the entire flock speckled or dark.

* The characteristic of the wool being uncoloured is dominant, so it can be coded as A. The characteristic of it being pigmented is recessive so it can be coded as 'a'. If a white AA ram mates with a white AA ewe then the lamb will definitely be AA, and white. If a white AA ram mates with a white Aa ewe, or vice versa, the lamb will either be AA or Aa, but it will definitely be white. But if a white Aa ram mates with a white Aa ewe there's a 25 per cent chance that the union will result in a striped or dark-coloured aa lamb. And if that's a male, then each time it mated with a white AA ewe, there'd be a 50 per cent chance the offspring would be Aa; and if with a pigmented aa ewe, it would be a 100 per cent chance that the lambs would be aa, i.e. coloured.

Jacob not only became a wealthy man and had his revenge on his father-in-law, but he also gave a story to inspire generations of herdsmen. It was the model of how to transform the random chance of sheep breeding into a meticulous programme of selectivity, and so change and improve the quality and value of wool. It was also a joke by nomadic pastoralists against settled farmers, which was always one of their favourite kinds of jokes.

Mendel's ideas didn't appear out of thin air. When he arrived, at the age of eighteen, at the philosophy faculty at Olomouc University in Moravia in 1840 he was inspired by work carried out over the previous two decades by his head of department, Jan Karel Nestler. And Nestler's studies had revolved around two connected questions. How can sheep breeders systematically improve the wool of their animals? And (prefiguring Charles Darwin's *Origin of Species* by nearly four decades) how might that investigation into breeding sheep for better wool relate to how nature produces new species, through forces seemingly beyond the human imagination?

The missing breed

There was one type of sheep I was expecting to find in the British Wool book, but it wasn't there. Which surprised me. Even as I write I have checked again, in case I missed it. Because, despite many opportunities, and a national history of selective breeding, the list of seventy-four named sheep breeds in Britain does not actually include the one in the world most famous for its wool.

In which the author buys the most expensive socks she can find

'You'll love me for this advice,' said my friend Mimi, when I announced that I'd decided to mark turning fifty by going on an eight-hundred-kilometre pilgrimage across the top of Spain to Santiago de Compostela. And that I'd have to leave within a week if I had a hope of getting there by my birthday. There'd be no time for actual preparation, just a bunch of emails to say I'd be away. And a shopping list.

'Go to a hiking store and get the most expensive socks you can find,' Mimi said. 'You can thank me later.'

I went to a hiking store and looked along the rack of women's

walking socks. Eight pounds. Twelve pounds. Thirteen pounds. I
picked up the thirteen-pound ones.

'Are these the most expensive you have?' I asked the assistant.

'No,' he said. 'The most expensive ones are in the back. We don't
always leave them out. People steal them.'

He returned with an ordinary-looking pair of short, dark-grey
socks. They were marked at twenty-three pounds. That was more
like it.

'Seventy per cent merino,' he said. 'They're warm and soft, and
if you're lucky you won't get blisters. They turn into felt around
your feet. The wool's from Australia,' he said. Then he looked at the
label more closely. 'No. New Zealand. It's always one or the other.' I
bought two pairs.

'I'll buy them for you,' said my mother when I told her.

'You really don't have to,' I said.

'But I'd like to, then I'll feel as if I'm walking beside you.'

At the time I didn't think about why a wool with a Spanish name
always came from New Zealand (or should that be Australia?) rather
than Spain (or should that maybe be South America?).

Of course I'd heard of merino wool before. But as I walked and
limped and limped some more along that magical ancient path across
northern Spain, blessing those socks (and Mimi and my mother)
almost every kilometre of the way, I had plenty of time to wonder
idly about many things, and the origin of merino was one of them.

I didn't use search engines on my mobile phone as I walked –
it didn't seem pilgrim enough – so I didn't find out straight away.
But one night in a hostel in Burgos, I met a man from Valladolid, a
hundred and sixty kilometres to the south-west. He had promised to
go on a pilgrimage if his sister survived leukaemia. And here he was.
Aching and happy.

He'd followed a circuitous route, walking north-east from Valla-
dolid to join the main Camino, along a wide path called the 'Cañada
Real', which he said you could translate as something like 'the Royal
Gorge'. It used to be a sheep track. He'd always wanted to follow it.
It was overgrown in parts, though cyclists and walkers were starting
to use it more often.

'You know the Merino sheep?' he asked. I said I sort of did and
mentioned my grey socks. 'Well, they used to travel up and down
it every year, before the whole world went industrial. As you walk,

you'll cross several of those old tracks, even if you don't notice them.'

I didn't know then, that winter before the year my parents died, that I'd be writing a book about fabric. Even the suggestion was five months in the future. But I still looked, up and down, whenever a wide path crossed our own, and wondered if it was a track that sheep related to my socks had passed along, before the world went industrial.

The trackways

There are dozens of ancient trackways crossing Spain from north to south, south to north. Some of them are over five hundred kilometres long. For many centuries, every springtime on 15 March tens of thousands of shepherds would leave their winter homes in the plains of southern Spain and guide their sheep north – so many that at times it would have seemed the droving roads themselves were white and grey and black and brown and the colours of stones. And the sound of it! The bleats, the bells, the occasional rough shouts from men and boys; it would have been as if the land had breathed for a moment into life. And then in a few days they would have passed, and you could have heard birdsong again. In some years, there were reportedly three million sheep travelling the roads; in others there were said to be as many as six. Whatever the precise total, that is a massive amount of sheep.

By 15 June, the herds would have arrived at the mountains north of Burgos and León, the last serious pieces of high land before the Atlantic. They would stay there all summer, leaving by 15 September to be home by Christmas. They were the longest sheep walks in the world.

The main droving roads, the cañadas, were seventy-five metres wide, that is the width of a soccer pitch, or twice the width of an eight-lane motorway, with hard shoulders and central strips included. They had stones piled up on either side to keep the sheep in and other people out. They were remarkable, too, for the rich grass that grew all along them, fertilised over centuries by the droppings of millions of sheep. Sheep manure was always valuable as fertiliser for the fields and as fuel for the homes. In the post-Roman period in Britain, it was one of the most important reasons for keeping sheep, more important even than wool.

The biggest droving corridors had been designated as 'royal' since 1273 when a delegation of shepherds met with King Alfonso the Wise to report an urgent issue. As the Moors had been pushed out of southern Spain, settlers had arrived to claim the farms and villages they had left behind. The common grazing lands and the ancient sheep trackways were proving very tempting for the newcomers too: they were so fertile, and for most of the year there was nobody to guard them. Alfonso helped the shepherds to establish an organisation called the Mesta, which aimed to protect them, their livestock and the wealthy owners of the flocks. It would become one of the most powerful worker-led organisations in Europe. With thousands of men crossing the country twice a year with large numbers of valuable animals, there would inevitably be disputes, so Alfonso established the position of itinerant judges whose job it was to punish landowners for re-marking their boundaries. They also made sure that the droving roads stayed open; judged on the ownership of strays and generally kept the peace. In the beginning, these *alcaldes entregadores* reported directly to the king. But in the sixteenth century they became officials of the Mesta itself. By that time they were extremely influential men, representing an industry that had become Spain's most lucrative home-grown export, so valuable that it was called 'white gold'.

The landowning classes, who saw the land occupied by the droving roads as their own, generally loathed the officials of the Mesta, who were visible, prominent and often outspoken embodiments of the ancient conflict between farmers and pastoralists.

The droving, or *trashumancia*, was an astonishing undertaking.

The sheep were divided into huge flocks, or *cavañas*, which were owned by some of Spain's most important families. The top *cavañas* were like brand names ('brand' itself is derived from the practice of burning marks onto livestock animals to identify them). The best were Perales, Negretti, Escurial, Paulur, Guadaloupe and Infantado. At one time just to have mentioned those names would have conjured up a league table of wealth and prestige. The names were rolled around tongues with envy and pride, and were shorthand for some of the causes of national wealth and national debt across Europe.

Each *cavaña* was run by a senior shepherd, the *mayoral*, who was paid four times more than anyone else. For each one thousand sheep, there were at least six shepherds, each with a different role and title: the 'right-hand man', the 'companion', the 'helper', the 'person', the

'spare' and finally the lad – a boy who walked behind the herd to make sure that none of the sheep were lost at the back.* Others were hired for the lambing, and later for the shearing, which took place at vast stations along the routes, before the wool was sent off for cleaning, sorting and selling. In winter the shepherds stayed in huts; the rest of the year they would sleep under the stars, wrapped in woollen cloaks. They'd mostly live off bread and dripping. Not mutton though, unless a sheep wasn't strong enough to go on. It wasn't their favourite food.

There would be about six *mansus* – tame castrated rams or wethers – per thousand sheep, trained to walk ahead of the rest of the flock. (The bells round their necks are where we get the word 'bellwether', meaning something that indicates a change of direction.) They were obedient to the voices of the shepherds who rewarded them with small pieces of bread. There would also be four sheepdogs: powerful Spanish mastiffs with droopy jowls and heavy coats the same pale beige as the sheep. They wore *carrancas*, or collars studded with spikes, because when the sheep were on the road, the wolves were on the watch.

It was a huge effort. Why did they do it?

Southern Spain in summer is extremely hot. The grass dries into hay, and it can't sustain anything like six (or even one) million sheep. But in winter, partly because of those scorched summers, the grass in the south is particularly rich and full of nutrients. That's when the lambs are born, and good grass is needed.

Meanwhile, far to the north, the mountains have good grazing in summer, but the winters are severe. So if you have enough men who don't mind living outdoors, and enough super-wide tracks for them to walk along, and enough common land for the sheep to graze on, then transhumance has always made a strange kind of sense.

The droving system seems to have suited the sheep too. If for some reason a flock didn't leave the southern pastures on time, the sheep would become anxious, and some would escape and travel the roads anyway, on their own.

* The terms for these, in order, were *rabadán, compañero, ayudador, persona, sobroa* and *zagal*.

Benimerine sheep meet Roman sheep

By the time King Alfonso made the Mesta official in the thirteenth century, the system of transhumance in Spain was already very ancient. The fifteenth of any month – the day always given as the one for the shepherds to leave their pastures – was important in the Roman calendar. It was full moon; they called it the *ides** and they considered it a good day for starting a journey. If you also consider the careful planning of the *trashumancia* and the way the flocks were divided into decimal units like Roman legions, it seems likely that many of the droving traditions were established, or at least refined, during Roman times.

When they conquered parts of Spain in the third century BC, the Romans found nomadic pastoralism already established – Basque archaeologists in 2016 announced that they had discovered rock shelters that had been used as seasonal livestock enclosures more than five thousand years ago. And as the new territory of Hispania became more stable for the Romans after the last warring tribes in the north had been defeated in 19 BC, the settlers brought in their own sheep breeds and updated the old practices.

The agricultural writer Columella, born in Spain in the first century AD, described his uncle's breeding experiments, which involved introducing wild rams from Africa to fine Italian ewes. The latter were probably from Apulia (today's Puglia in the south), which, according to the poet Martial, had the palest fleece and the softest wool. The Apulian is thought to have been one of the early ancestors of the Merino, mixed with African sheep first brought over by Romans (including Columella's uncle) and then later in the Moorish period by the Benimerine tribe (from where the name 'merino' might have originated).

The system went on for centuries. The walk twice a year; the shearing once a year; the selling of most of the raw wool to France, England and the Netherlands; a threatened death penalty for anyone who exported the precious sheep without permission; the permission never granted. It wasn't perfect as trade protection, but mostly it worked.

* *Ides* has the same etymology as the word 'divide'; it is the day that splits the lunar month in two.

Then, at the dawn of the eighteenth century, a sixteen-year-old French boy succeeded to the throne of Spain.

A new royal family

In October 1700 the king of Spain, Charles II, only thirty-nine but enfeebled all his life, made a decision. He had no children. He would be the last of the Spanish Habsburgs; Europe was about to go to war over who should be his heir and the best possible candidates were dead. So he signed over the crown to his distant relative* Philippe, Duke of Anjou, teenaged grandson of King Louis XIV. Then he died.

When he heard, Philippe was not pleased. He couldn't even speak Spanish. He liked Anjou. And Versailles. And his life there. He was also aware that succession wasn't going to be easy: the Austrians had their own candidate. They, and the English, the Dutch and others, were not going to let him claim the throne without a struggle.

The following year, he became Philip V, and the Wars of Spanish Succession started. By their end, fifteen years later, Britain would have gained territories and trade agreements that would give it an empire that lasted centuries. Spain would have lost the Spanish Netherlands (loosely corresponding to today's Belgium and Luxembourg) causing border fragilities that would play out far into the future. And as part of all that, the future of all kinds of European textiles – wool and linen and lace and others – and the massive deficits and surpluses of national economies that they represented, would be transformed in fascinating and unpredictable ways.

A new Spanish cloth

By 1703, an expanding army meant that increasing numbers of uniforms were required, and the nineteen-year-old King Philip was realising the seriousness of the fact that his adopted country did not have the textile capacity to clothe even its own soldiers. He liked the idea of starting a Spanish Royal Manufactory, inspired by the French Royal Manufactory in Paris, the Gobelins, which had been supplying the kings of France with fine tapestries, and later upholsteries, since

* Philip was Charles II's half great-nephew, descended from his half-sister Maria Theresa, wife of King Louis XIV.

1602. Spain had the raw material. How hard could it be to make good cloth? The French could do it, and the Dutch, and the English, and the Italians. Some of that was down to technology and tradition but a lot was down to expertise. If the Spaniards could get hold of both the machinery and the experts, then – with that merino wool at their command – surely they could do even better?

The plan became more pressing after 1713, when Spain was forced to sign away Gibraltar in exchange for Britain's agreement to withdraw from hostilities. Losing Gibraltar made Spain furious, as did losing the Spanish Netherlands. Making a Royal Manufactory deliberately to hurt English, Dutch and Flemish trade seemed a sweet thing. And worth all sorts of state subsidies.

Philip settled on Guadalajara, about sixty kilometres north-east of Madrid. It was close to the great Spanish silk city of Pastrana. It was also where he'd been married to his beloved Maria Luisa, who'd died in 1714, and he was fond of the place.

The Royal Cloth Factory opened in 1719. It had a spectacular location, across from the fifteenth-century palace of the Mendoza family, one of Spain's wealthiest wool exporters and owners of the famous Infantado brand of Merino sheep. And perhaps if Philip had chosen another man to be in charge, the factory would have been a more immediate success. But instead he appointed the ambitious, rapacious Frieslander Johan Willem von Ripperda, who was more interested in lining his own pockets than in manufacturing the lining of anyone else's.

Initially, most of the cloth made at the Royal Manufactories went to the army, which had no choice about accepting it, and to the Spanish colonies in the Americas, which had very little choice. However, the home market was different. Despite opening a special shopping outlet for Spanish cloth in Madrid, almost nothing was actually sold. Rich Spaniards preferred their fabrics to come from Genoa, England, the Netherlands and France. Ripperda had forgotten – if he'd ever known or cared – that when you're selling textiles you're not just selling the feel of a cloth and the fall of a fold: you're selling lifestyle and image and brand. You're selling a story. And the Guadalajara cloth story just wasn't good enough.

To make matters worse, the English were now dumping high-quality woollens into Spain at low prices. It was a matter of national pride.

After 1740, the situation ramped up. The British and Spanish were warring again. The British briefly boycotted Spanish wool, and the Spanish redoubled their efforts to make better cloth.

By then Ripperda had long since been accused of embezzlement, before fleeing Spain and later dying in Morocco. But his son-in-law Balthasar de Argumossa had overcome the family shame and he was hired by the Royal Cloth Manufactory to go on a buying and recruiting mission to the fabric towns of northern Europe.

He returned with various promising bits of machinery. The greatest textile inventions of the eighteenth century were yet to come, but the belief that there were going to be important technological improvements was in the air. And like everyone else, Spain wanted to be a part of it.

Argumossa also brought home a crew of skilled English, Irish, French and Dutch textile workers, all excited by the promises of generous wages. Those who weren't Catholic had to convert, but the Spanish Inquisition (which would last, in name at least, until 1834, and was still feared in the 1740s) was content to have them come in if they did so.

The import of new technology and new skills meant that Spanish manufactories began improving. It became clear to their competitors in Britain, France and the Netherlands in particular that they in turn were going to need to improve their home-grown wool. Quickly.

France tries to breed a superfine wool sheep

In 1766, Louis XV's finance minister Daniel-Charles Trudaine predicted a national wool emergency in France if the Spanish manufactories used up all the best Spanish wool. He gave the task of breeding a French superfine wool sheep to the naturalist Louis-Jean-Marie Daubenton, who opened a state-funded experimental farm at Montbard, two hundred kilometres south-west of Paris. Daubenton brought in sheep from Roussillon, Flanders, England, Morocco and the Himalayas (though not yet from Spain, which wouldn't release the stock) and the breeding began.

He documented the results in his bestselling 1782 book *Advice to Shepherds*. It was like an FAQ for people wanting to take part in the pastime of sheep breeding, newly fashionable among rich hobbyists. There were many questions about improving the quality of the

fibre. The worst wool was called kemp, from the Old Norse *kampr* meaning whiskers or hairy. It is brittle and you can't dye it. It can be found in patches even on the finest sheep, and breeders try hard to avoid it.

> Q: Can ewes with kemp be made to produce lambs which have no kemp?
> A: If a ewe with middling kemp is coupled with a ram without kemp, their lambs will have no kemp. If the ewes have a great deal of kemp the lambs will also have some of it, but less. If this lamb, being female, is coupled afterwards with a ram without kemp, their lamb will have none of it.

And here once more is the clue to this whole sheep endeavour. It is, and it has always been, about metamorphosis, selection, getting beyond the randomness of chance, and – that Jacob story again – the desire to get rich from wool in a few carefully planned generations.

There were problems though. The French military didn't want to pay the market value for Daubenton's increasingly fine cloth, which made it hard for the place to subsidise itself. And, he complained, it was really hard to find good shepherds. Young people in France just weren't that interested.

An elusive Spanish sheep

Although Daubenton struggled to get Merinos, there had already been two small breakaways from the Spanish herds. In 1660, after King Louis XIV married the twenty-one-year-old Infanta Marie-Thérèse of Spain, his finance minister Jean-Baptiste Colbert had been allowed to buy a few Spanish sheep. The experiment was unpopular with French shepherds, however, and it was abandoned.

Next up, in the 1720s, was Jonas Alstroemer, a charismatic Swedish businessman who was no stranger to smuggling sheep. In 1715, having seen how much better English cloth was than Swedish, he had chartered a ship in London and smuggled a small flock of English sheep to Gothenburg: if he had been caught he would have been executed. Later, he smuggled tools, technology and textile workers out of France and Holland to start a woollen industry in his home town of Alingsås in southern Sweden. Alstroemer might have argued that he took beggars off the streets and made some beautiful cloth. Others

remarked on the low wages, and that working conditions were so bad that it was common for workers to run away.

In 1723, Alstroemer managed, despite the odds and the Spanish laws against him, to get a small flock of Merinos out of Spain, and many people were surprised to see that these southern European sheep could survive happily in the snow and the cold. For years, those in the trade had assumed that merino wool could come only from flocks grazing on those particular Spanish pastures, and walking those particular Spanish droving roads, when in fact it seemed (for the first generations at least) that the Merino could thrive almost anywhere.

Breaking the power of the Mesta

When Philip V's son Charles III ascended the throne in 1759 he was less interested than his father in keeping exclusive hold of the Merino breed. By then the institution of the Mesta had too many powerful enemies, and the privileges of its special officials were seen as both obsolete and inconvenient. Charles wanted to break it. He also had serious problems with an unhappy population. On the surface, it was a protest at an unpopular law that banned men from wearing long Spanish capes (which could conceal weapons) and broad-brimmed hats (which could conceal identities) in favour of fashion styles imported from France. But mostly it was because there had been a terrible harvest and people couldn't afford bread. The 1766 riots stirred Charles to make immediate agricultural reforms, part of which involved claiming farmland back from the Mesta. So he started sending Merinos to friendly countries as diplomatic gifts. Throughout the 1760s and 1770s, little flocks were shipped to Saxony,* the Netherlands, Hungary, Austria and Ireland. France came late to the game, despite being just over the Pyrenees and trying to negotiate for sheep from the beginning. And England, for obvious reasons (Gibraltar being one of them), was right at the bottom of the gift list.

* In Saxony the breeding programme was so successful, after a gift of one hundred rams from Spain in 1768, that by 1781 they no longer needed to import English or Spanish wool.

A Merino sheep descended from the Negretti flock in Spain.

A letter from Lincolnshire

Joseph Banks had never planned to get involved with wool. In the thirteen years since he had returned from the Pacific in 1769, his life had changed dramatically. The adventurer and butterfly-collecting bachelor had become celebrity scientist, baronet, husband, president of the Royal Society, confidant of the king, and a generally busy man. He had little time to visit the family estate in Lincolnshire or get involved in its affairs.

But in spring 1781 Lincolnshire was in crisis. It was a sheep-grazing county and the market for English wool had just collapsed. The American colonies were fighting their way towards independence so they weren't going to be importing English wool any time soon. And since it was illegal to export wool from Britain to anywhere but the British colonies, landowners had little bargaining power against the Yorkshire wool buyers, who had pushed the price right down. Lincolnshire landowners had no idea how much the wool would be worth in Europe, even if they could get it there, but meanwhile a surplus of wool was building up in their barns and they needed a strategy.

'When we know the price and value of our wool abroad, we shall

endeavour to come as near it as possible [with the English wool buyers]',
landowner Charles Chaplin wrote to Banks at the end of 1781, sending a
box of samples down to London by courier. By January 1782, Banks had
hired a Swede, Charles Hellstedt, as a commercial investigator, and had
secured a special passport for him from the Secretary of State.

Hellstedt spent the next six weeks visiting Calais, Ostend, Brussels,
Amsterdam, Groningen, and many places in between, pretending
to be a merchant looking for orders for English wool. What he found,
towards the end of a century that had been remarkable for its European
wars (and still had more to come), was disdain.

'I didn't expect in the Centre of a commercial nation to find the
hatred of the inhabitants against all that is English', he wrote from
Amsterdam on 25 January 1782.

> I have always gloried, when on my travels, to pass for an Englishman,
> but here I am glad to shelter myself under the much lower
> tho' true appellation of a Swede, nor would they believe me to
> be one, did I not speak high Dutch, which they say the English
> people never learn. Some good natured persons have advised me
> to assume the character of an English American, which people
> are much carressed here.

The journey was nevertheless worthwhile. The prices Hellstedt
was quoted suggested that, in a free market, sheep farmers could
raise at least three times more abroad than they were receiving at
home. It was time, the landowners of Lincolnshire felt very strongly,
to repeal the Wool Laws.

A brief history of English Wool Laws up to 1781

Woollen cloth had been England's most important export since the
early Middle Ages. Much of that was due to the high quality of its
materials and the skill of its weavers. But in part it came from laws
that taxed it when it was doing well and protected it against international
competition. And many of those laws and tax codes were very
strict indeed.

In 1275, Edward I paid for his military campaigns by instituting
a 33 per cent wool tax, inspiring the nursery rhyme 'Baa Baa Black
Sheep' in the process. It described an arrangement whereby one bag

of profit went to the king (the master), one to the church (the dame), the last third to the farmer, leaving just about nothing for the shepherd-boy 'who cries down the lane'.*

Two reigns later, Edward's grandson Edward III, seeing how the weights and measures for wool in his kingdom had reached chaotic proportions, passed laws† standardising wool sacks, wool stones and the avoirdupois pound, mainly to facilitate the Continental trade of wool. These were among many decisions that Edward would make about the wool trade in his fifty-year reign, leading to his nickname 'The Royal Wool Merchant'.

Winchester's Westgate Museum has a unique set of original weights from that time. They are stamped with Edward III's royal arms, after he claimed the French throne in 1337, showing English lions quartered with French fleurs-de-lys.

They should have been destroyed long ago because each time new standards were made they came with commands to break up the old ones. But royal commands were not always followed, so we have them still. They come in seven, fourteen, twenty-eight, fifty-six, and ninety-one-pound weights. They look like plum puddings, with flat bottoms and round handles, like kettlebell weights you find in gyms. The basic seven-pound unit in Edward's time later gave way to the fourteen-pound unit. In Britain and Ireland we still use it. Not to weigh raw fleeces, but to weigh ourselves. In fourteen-pound wool stones. Though now we just call them 'stones'. And most of us have absolutely no idea why.

In 1338, just after the start of the Hundred Years' War against France, Edward III stopped all imports of wool and cloth from Europe for everyone except himself and his family. He also banned

* The earlier version was 'Baa Baa Black Sheep, Have you any wool? Yes, Sir, yes, Sir, three bags full. One for the Master, one for the dame – None for the little boy that cries down the lane'. Later publishers thought it was kinder if the child were to get a bag for himself (and not cry).

† In 1341, when Edward was twenty-eight, he ordered the treasury to make standard weights to be used on auncels, or hand-held balances, 'and send the same into every county'. Eleven years later, in 1352, all these weights were cancelled because too many big wool merchants were cheating small sheep farmers with them. In 1357 a completely new set of weights was ordered to 'be sent to all the Sheriffs of England'. This is believed to be when the Winchester weights were made.

the export of all English wool, and invited hundreds of displaced Flemish weavers to settle in England. They brought their skills and the industry thrived.

In 1363, Edward made the town of Calais (which he had annexed in 1347 after a year-long siege) the main market town, or 'Staple', for English wool exports. Many merchants from England settled there; the town's official language was English, and for some time it was the only place that foreign merchants could do deals on English cloth. It would stay that way for nearly two centuries, France eventually taking it back in the cold winter of the flu pandemic in 1557 to 1558, when it was hard for the English to summon enough healthy men to do anything, let alone cross the icy Channel and defend a city.

Some people tried to bypass the new rules. In the 1370s, Genoese cloth merchants hired a young Englishman named Geoffrey Chaucer to advise them on how to sell their Italian cloth in London. He was unsuccessful, though later he would get a job as customs inspector at Wool Quay, near the Tower of London. There he would run into some of the 'best connected and least scrupulous crooks on the face of his planet', and much of the job would involve looking the other way. Wool does not have much of a mention in *The Canterbury Tales*, but well-connected and unscrupulous crooks do.

Where the Chancellor sits. Uncomfortably

When Edward came to the throne in 1327, England was exporting thirty thousand wool sacks and five thousand lengths of cloth a year. By the end, in 1377, there were almost no raw wool exports, while more than half of England's foreign income came from finished woollen cloth. To make sure the country's lawmakers would remember this, he decided that the Lord Chancellor – traditionally the chair of the House of Lords – should always address the House from a large wool bale in the middle of the floor. The seat is still there. It is rectangular, backless, and covered in red cloth like a scarlet ottoman, with a cushion sticking out of the middle. Until 2006, the Lord Chancellor addressed the House from it; since then it has been the seat of the Lord Speaker. It is still called the Woolsack, as it has been for centuries, although for a while it was not actually filled with wool.

When upholsterers opened it in 1938 for a long-needed refurbishment they found it full of horsehair, a traditional filling for soft

furniture. It was quickly and quietly restuffed. In 1966 it was filled again, more formally, with wool from fourteen wool-producing Commonwealth countries: Australia, Basutoland (now Lesotho), Canada, Cyprus, the Falkland Islands, India, Kenya, New Zealand, Pakistan and Swaziland (now eSwatini), as well as England, Scotland, Wales and Northern Ireland. In 1983, after the Falklands War, the Woolsack was unstitched and extra wool from the Falkland Islands was pushed in, to reinforce a political point about ownership of the islands.

In terms of content, it now had the right shape, but in terms of comfort it was no longer as easy to sit on.

'When my father occupied the Woolsack, our wise Victorian ancestors had it stuffed with horsehair', reported Quintin Hogg to the House of Lords, when he was Lord Chancellor in 1986 (his father, Douglas Hogg, had had the role in 1928 and 1935):

> This was then thought to be inappropriate and the present arrangement, that it should be filled with wool, was in fact arrived at by general consent ... I think those who made the latter arrangement did not quite understand that wool when sat on rapidly becomes felt. The article in question has at the moment two large grooves in it which slope outwards. But I fully agree with my noble friend that on the whole we may expect to leave things as they are for the time being.

The politics of flat caps

In 1571, to boost the domestic industry, Queen Elizabeth I passed a law that every man, and every boy above the age of six, with the exception of the nobility and gentlemen, should wear felted and knitted English woollen caps on Sundays. Failing to do so meant a penalty of three shillings and four pence, or about five days' work for a tradesman. Tenant farmers were particularly worried by the so-called Cappers Act. More sheep meant less land for them to use to grow food. And the poor were affected too. Not only did they have to spend money they didn't have on a piece of clothing they didn't want, but more wool meant less grain, and less grain meant less bread. This was effectively a sumptuary law. You knew your place if you had to wear a woollen cap.

William Shakespeare was seven when the act was passed – so

he had to wear one. In 1583 his favourite uncle, Henry Shakespeare, himself a tenant farmer, was fined for not doing so.

Smugglers get involved

By 1660, wool cloth was two-thirds of England's foreign trade. When Charles II returned to England that year, he passed an act making it a felony (the most serious kind of crime) to export raw wool from England. It meant that the English weavers of fine cloth were assured of their supply. It also meant that the money English sheep owners could get for their fleeces instantly fell.

Those were the bad old days of the Romney Marsh gang and other armed smugglers. They dug tunnels down to the beaches of Kent and Sussex to make it easier to load wool onto French sloops, and they chased government officers with guns. They were called owlers: a word that came from 'wool' but also referred to their night activities and the viciousness of their swoop. In the 1660s, an estimated twenty thousand woolpacks containing the fleeces from about a million sheep reached Calais illegally every year, and more went to other European ports. The owlers were rarely convicted. Many magistrates were landowners and supporters of the free trade in wool, and therefore of the smugglers;* if the wool from their sheep ended up on the Continent they could get more money for it. Ordinary people were also not fans of the export embargo: it made wool clothing more expensive; it meant taxes were higher; and it meant farmers and farmworkers received lower incomes. It didn't seem fair.

King Charles II passed another wool law in 1666. The previous year, more than one hundred thousand people in London alone had died of plague. Scotland closed its borders. There were no fairs and no exports. England was in crisis, and its main trade item, woollen cloth, was in crisis with it.

The 1666 Act 'for Burying in Woollen onely' ruled that everyone had to be buried in a woollen shroud, and the fine for not doing so was five pounds – more than two months' wages for a skilled tradesman. Informants would earn half of that for reporting on their neighbours. It was deeply unpopular. The crux was the word 'onely'. Only. Wool

* The mayor of Hythe, Julius Deeds, once organised a gang to retrieve sixteen bags of wool seized by the Revenue. He was cleared by a jury in 1692.

was not just to be an outer wrapping to keep the dead warm: no other textile of any kind – no linen, hemp, gold thread, nothing at all – should be in the coffin. There should be none of your own clothes, none of those outer signifiers in cloth of what you had been in your life. Just an itchy woollen blanket. And there was always someone to check that your relatives had complied. It was humiliating.

Wealthier families usually paid the fine. Often, one of the family members would turn informant with everyone's quiet agreement, effectively halving the total fine.

The poor mostly capitulated. What choice did they have? You can still find churches in England that have kept their records about who was and was not buried in wool.*

By 1781, when the Lincolnshire landlords asked Banks for help, you'd no longer get the death penalty for smuggling wool (although it was still forbidden). It was also no longer an expectation that you would be buried only in wool and nothing else (although it was still on the statute books). But as European countries fell in and out of war with each other, the trade arrangements around wool were causing a real conflict between the new breed of manufacturers and the old breed of landowners. It was a rift between town and country, between manufacturer and producer, and to an extent between north and south. It was a kind of – fairly civil – civil war.

This was the atmosphere in which Sir Joseph Banks was writing his letters in support of allowing landowners to sell their wool wherever they wanted. And although his efforts did not, in the end, lead to a repeal of any laws, this new and rather reluctant interest in sheep led to something quite unexpected. A commission from the king. And two unusual gifts.

Monsieur Ram and Madam Ewe

In 1780 a nineteen-year-old from Montpellier turned up at Banks's

* St Peter's at Marksbury in Somerset still has its separate list of parishioners buried in wool. In Ulpha in the Lake District corpses were interred in woollen shrouds (without coffins) for longer than elsewhere: the people were poor, and the wool from Herdwick sheep was so important to the local economy. When wooden coffins became the fashion again in the nineteenth century the Ulpha graveyard had to be extended. Coffins take up more space, and all that air between them and the corpse often led to ground collapse.

house at Soho Square. Later in his life Pierre-Marie-Auguste Brous-sonet* would inspire the Latin name for the barkcloth tree, *Broussonetia papyrifera*, the so-called 'paper mulberry', but at this stage he was more interested in animals than in plants, and Joseph Banks gave him access to some of the finest scientific minds in London. Two years later when he returned to France he joined Daubenton, who by then had moved his experimental flock of sheep to the National Veterinary School in Alfort, outside Paris.

In 1785 Broussonet wrote to Banks that two Merinos were on their way to Britain. Ostensibly they were gifts from the scientists at Alfort to the president of the Royal Society in London in the interest of science. But they were also a mark of gratitude from a young man to a mentor who had been kind to him early in his career, and whom he knew, from the Lincolnshire crisis, was particularly interested in wool.

'Monsieur Ram' and 'Madam Ewe' arrived at the end of the summer. They each had an iron collar stamped with Joseph Banks's address at Spring Grove. They were the first real Spanish Merinos ever to be seen in England. And very odd they looked. Good wool sheep were often the ugliest. They were bred to provide the finest fibre over a long life, not to look beautiful, and Merinos often had skinny legs and loose skin in great folds, to maximise the amount of wool they grew on it.

Banks commissioned two blue coats from the first two years' shearings of Monsieur Ram and Madam Ewe and introduced ewes from Scotland, Sussex, Lincolnshire and nearby Hounslow Heath, to see what kind of lambs would result.

King George III watched with interest, and decided that he wanted a flock of his own. Banks was finding his own land too limited for the kind of penning and segregation he needed, so he gave all his sheep – including Monsieur Ram and Madam Ewe – to the king, and then he started writing letters to correspondents all over Europe, trying to get the king a flock of full-blood Merinos.

* The barkcloth tree is dioecious, meaning that specimens can be male or female. In South East Asia, where it's native, you can find both types, but in the Pacific all the trees are female, probably descended from sterile trees carried thousands of years ago by settlers. Those ones do not flower but have to be grown from root stocks or by coppicing. Broussonet was the first in Europe to be recorded as planting a female tree beside a male, resulting in flowers and fruit. It was then clear that there had been a mistake: this was no mulberry.

By the closing years of the eighteenth century, and with small flocks of Merinos flourishing all over Europe, Spain's determination to keep them from the British was fading. In 1791, the Count and Countess del Campo de Alange wrote from Estremadura (the far west of Spain where rules from the centre have less traction), informing the British chargé d'affaires in Madrid, Anthony Merry, that they had decided to send a small flock of Merinos to King George. The five rams and thirty-five ewes that embarked at Santander in northern Spain in October were from the Negretti *cavaña*, one of the best, second only (in Banks's estimation) to the Perales. The Negretti were giant, muscular animals with curled horns and so many wrinkles that they gave the effect of wearing an oversized pullover over an already substantial greatcoat. In return, a set of English carriage horses went from the royal stables at Windsor to Estremadura.

All this brought the king's flock to around a hundred pure Spanish Merinos 'among which yours', as Banks wrote to Merry, 'are certainly the best'.

By the way, he added, if it was possible to send up to a hundred more 'without running any risk of another lot of Horses becoming the necessary political return', the king would be extremely grateful.

Not long afterwards the king was sent two thousand sheep from the Paular *cavaña*. Four hundred died in the rough crossing but the others were walked to Windsor and joined the rest. It must have been an impressive sight, sixteen hundred spectacularly different-looking sheep, walking along English roads with their Spanish shepherds and huge mastiffs all following the tame wethers with their bells. And when they arrived the experimental breeding programme began in earnest.

The decline of the Merino in Spain

For the future of the Merino sheep, it all happened just in time. The Napoleonic Wars were about to start. The flocks in Spain would be decimated, those blood lines lost, the shepherds scattered to the battlefields. But in little pockets all over Europe, expatriate Merinos were breeding and they were about to travel further than they ever had before.

The rise of the Merino outside Spain

The Spanish flock at Windsor (the only Merino breeding programme in Britain) was largely a failure, although an element of Merino DNA is probably in just about every domesticated sheep in Britain today.

In part it was the weather, which was consistently awful,* and the animals' skin and health suffered. In part it was the stock. As Philip Walling describes in *Counting Sheep*, the wool at the first cross was improved; but the sheep were instantly less good for meat. 'To add insult to injury at the next cross the wool deteriorated unless the ewes were back-crossed with a Merino, in which case the carcass deteriorated even further.'

Farmers didn't warm to them either: all those folds and dewlaps didn't appeal to the eighteenth-century aesthetic for simple lines.

The lack of success was irritating, especially as the Saxon and French breeds were doing so well. Their descendants, the Saxon Merino and the Rambouillet Merino are still important, while – as I saw from my book of sheep breeds – they don't even get a namecheck in Britain today.

But in the end it didn't matter. Because in the Cape of Africa, and Australia, a tragedy, a coincidence and several duels were about to happen, and the Merinos would start on the longest journey of their lives.

Twenty-six Cape Merinos

'Nothing will give me greater pleasure than to receive the Spanish sheep, and to look after them with all possible care, wishing at all times to show that nothing is closer to my heart than my fatherland', wrote Captain Robert Jacob Gordon in 1778 to the Dutch Secretary of State Hendrik Fagel. Despite his Scottish name, Gordon's family had been Dutch, from Gelderland, for two generations. The twenty-five-year-old soldier had already been in Cape Town for over a year, and as second in command of the Dutch garrison he was ready to experiment with any industries that might prove useful to the future of the colony.

* In the twenty-four years of the Spanish flock at Windsor, there were only four good years for agriculture, six average, and fourteen that were 'poor, bad, or disastrous'.

He was a tall, stout, jovial man who spoke many languages, sang, both in Gaelic and his own version of Khoikhoi tribal songs, and was an avid collector of plant and animal specimens. When the memoirist William Hickey visited in July 1777, Gordon invited him to climb Table Mountain. He arranged a surprise breakfast in a cave and then two of his servants began to play African flutes: 'such celestial sounds burst upon our ears. It seemed to come from the air above us.' At the top they stumbled across a black snake so poisonous it could kill a man in twenty minutes. They brought it back, pickled in a bottle of gin.

When the six Merinos arrived in 1779, Gordon put them on Robben Island – notorious today as the prison where Nelson Mandela was incarcerated for eighteen years. Even in Gordon's time it was a place for political prisoners, including indigenous leaders from South Africa, slave mutineers from Malagasy (now Madagascar), and captured rebel chiefs from the Dutch East Indies (now Indonesia). Gordon had decided to keep the Merinos on Robben Island so that they could have space to breed before being entrusted to the Dutch colonists 'because in this land people are very against sheep with short thin tails'. Native sheep were fat-tailed. Good for meat and for desert conditions. Not very good for wool.

By 1780, Gordon was glad to send news to Fagel that 'the wool from a lamb's lamb, both born here, is as fine as that of the originals. They are even healthier than the sheep of this country. So I expect something great for our state from this.' That year Gordon married a Swiss woman, Susanna, and became the commander at Cape Town.

The sheep continued to do well and in 1789 four more rams and six ewes, from the Spanish Escurial flock, were sent to the Cape to add to the growing herd on Robben Island.

That same year a young couple in England were making plans for the adventure of their lives.

'It's almost always from Australia ...'

The duels had started before they had even left the harbour at Plymouth. Elizabeth Macarthur, twenty-three, not long pregnant, was settling herself and her infant son Edward into the tiny and smelly cabin she had been horrified to learn they would be sharing with the captain, John Gilbert. Meanwhile, her twenty-two-year-old husband

John was on shore facing off against that very same Captain Gilbert, on account of the awful cabin, the dreadful stink of chamber pots from prisoners below, and the fact that Gilbert had seven days earlier punched him in the chest. On Gun Wharf, the two men walked away from each other, turned, and fired. Both missed, although Gilbert was left with a hole in his coat. Honour satisfied, they returned to the ship where many hundreds of people were being settled into far worse accommodation than that of the Macarthurs.

The *Neptune* was one of the ships, together with the *Surprize* and the *Scarborough*, which became collectively infamous as the Second Fleet, heading in January 1790 towards the newly established colony of Australia. In its hold there were 499 convicts, of whom at least 158 would not survive the journey. The men would be kept in irons; the women would be forced to provide sexual services for the soldiers and crew.

Macarthur was a young lieutenant, a fighting man in every sense, the son of a draper. Elizabeth was the daughter of a gentleman tenant farmer, who'd married the year before, after falling pregnant. Their intention had been to make their fortunes and return to England, but although he would go back twice, she never would.

When they arrived in New South Wales in June that year, Macarthur became known for arguing. He argued with the governor, his fellow officers, anyone at all. The more troublesome he was, the quicker he got what he wanted. A new governor was appointed, and in 1793, the Macarthurs were awarded a hundred acres at Parramatta, twenty kilometres west of Sydney, with some of the best land in the colony. They called it Elizabeth Farm, and, 'with unrestricted access to convict labour', cleared it so quickly that they were awarded another hundred acres. They bought sixty Bengal sheep from Calcutta and began to appreciate the mathematics of profit from wool.

Tragedy in Cape Town

Back in Europe, politics had ignited. The violent storms of the French Revolution had exploded into a tempest of terror, and now almost the whole of Continental Europe had entered into war. In 1794, France invaded the Dutch Republic. The Prince of Orange, hereditary head of state, fled to England, and the following year a British fleet arrived at the Cape, claiming that the prince had authorised them to occupy

the Dutch colony in his name. After a few skirmishes, Colonel Gordon handed Cape Town over to the British in September 1795. His troops accused him of treason. On 25 October he committed suicide in his garden, surrounded by the plants he had collected over two decades.

Susanna was left with four young sons, a house she no longer wanted, a collection of rare botanical specimens, and thirty-two Merino sheep. In 1797, just as she was starting to sell up before returning to Europe, a ship arrived from Australia. It was looking for supplies in general and for new breeding sheep in particular. The naval officers on board used the opportunity to purchase twenty-six of the Cape Merinos, and when the ships arrived in Sydney the Macarthurs bought six of them.

How Macarthur got a free ride

By 1801, they were the biggest sheep rearers in the colony. Macarthur hadn't grown any more amiable, and that year he wounded his commanding officer in a duel. The governor, Philip Gidley King, sent him back to London for a court martial. He didn't like Macarthur. 'There are no resources which art, cunning, impudence and a pair of basilisk eyes can afford that he does not put in practice', King observed. But his decision played, unwittingly, to Macarthur's advantage.

Leaving Elizabeth to look after the farm and taking some samples of their own (excellent) Merino wool with him, Macarthur left for England. He would be away for four years and it would be the most lucrative free trip of his life.

He returned to England with fortuitous timing, just as the first ever of His Majesty's Merino rams were available for sale at auction at Kew (he bought several and sent them back to Parramatta), and also as the prices of just about everything, including cloth, were inflated by the Napoleonic Wars. He was able to lobby for a scheme that he had just thought up, that is, boosting colonial wool production as a patriotic act to protect England against Napoleon. It mostly involved giving him a further grant of five thousand acres in New South Wales in which to breed Merino sheep. It would have been ten thousand, but Joseph Banks – brought into the discussions because of his earlier experience with sheep breeding for King George – didn't trust Macarthur. When Macarthur returned to Sydney with his pardon from the king, he used the British government's official approval to wangle

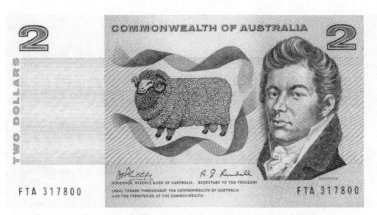

The Australian two-dollar note with its Merino sheep and portrait
of John Macarthur was legal currency from 1966 to 1988.

(despite the governor's resistance) five thousand of the most valuable
acres in the entire colony.

In 1807, their eldest son Edward, now nineteen years old, took
the first cargo of his family's merino wool to England. England was
short of merino after Napoleon had cut its supplies from Spain. The
Australian fleeces secured an excellent price.

Macarthur returned to England once again in 1809 for another serious
misdemeanour, after joining a rebellion against the New South Wales
governor, William Bligh (of the Mutiny on the *Bounty* fame). This time
Macarthur would be gone for eight years. As well as sorting out another
pardon and promoting Australian wool whenever he could, he spent
some of the time studying wine-making in France. Meanwhile, Eliza-
beth – with six children under seventeen, including an infant – managed
the flocks and exports of wool so ably that she should rightfully be called
the real founder of the merino wool industry, for a country that today
provides about 80 per cent of the world's production.

Elizabeth did most of the work. But it was John's picture on the
Australian two-dollar note.

'Or New Zealand ... one of the two ...'

When English settler Samuel Butler arrived in what he called the
'townlet' of Christchurch in New Zealand in 1860, he found that the

all-engrossing topics of conversation were 'sheep, horses, dogs, cattle, English grasses, paddocks, bush and so forth ... I cannot say that I heard much else'. He was curious about some of the expressions people used.

> I was rather startled at hearing one gentleman ask another whether he meant to wash this year, and receive the answer 'No.' I soon discovered that a person's sheep are himself. If his sheep are clean, he is clean. He does not wash his sheep before shearing, but he washes; and, most marvellous of all, it is not his sheep which lamb, but he 'lambs down' himself.

For a land where sheep farming had been 'the great business' for nearly twenty years, Butler was surprised on his early excursions into the hills not to actually see any sheep. Sheep are in 'mobs', he learned. 'And unless one comes across the whole mob, one sees none of them.'

Butler was twenty-four, a recent Cambridge graduate, the son of a vicar, and the grandson of the bishop of Lichfield. Until 1859, he had been preparing for ordination. But he had begun to question his faith, and had decided to give it up. He wanted to be an artist but his father had so disapproved that Butler had left for New Zealand that October, determined to show he could earn his own way in the world.

He sent detailed calculations home to his father in letters, expressing his astonishment at how much money could be made out of wool. Five hundred ewes bought in January 1860 would amount to 'two thousand five hundred and eighty-two sheep' by 1867. And he wouldn't even have to look after them: he would simply place them in the charge of 'a squatter whose run is not fully stocked' and let the money multiply.

Land could be claimed in allotments of a few thousand acres, called 'runs', that were rented in short-term lease agreements from the government. So Butler found a run that was still available but, learning that a rival wanted exactly the same piece, found himself in a breakneck race down from the hills to stake his claim in time.

> I had not gone far when, happening to turn round, I saw a man on horseback about a quarter of a mile behind ... we rode for some miles together, each of us of course well aware of the

other's intentions, but too politic to squabble about them when squabbling was no manner of use. It was then early on the Wednesday morning, and the Board sat on the following day I shall never forget my relief when, at a station where I had already received great kindness, I obtained the loan of a horse.

That run, and the whole venture of rearing sheep for wool, made him wealthy. It also gave him images and experiences that would reappear in his writing. When twelve years later, back in England, he published a satirical novel about a strange community living in the mountains of a country far away, he called it *Erewhon* (or 'Nohwere', backwards). But it was the Upper Rangitata sheep district of Canterbury Province that he was describing.

Many runholders were most interested in building the size of their flocks, but there was also an ongoing debate about how to improve the quality of the wool. Charles Darwin's *Origin of Species* had been published in 1859. Butler had bought one of the first copies to land in Christchurch, and the book featured in spirited debates in the local newspapers about the relevance of those theories to the breeding of sheep.* *The Lyttelton Times*, one of Canterbury's main broadsheets, was full of advertisements for Merino rams and ewes from Prussia, France and Saxony, as well as many from New South Wales. The North Island had proved too wet for Merino sheep. But by then a distinct New Zealand breed of Merinos was emerging on the South Island, fitting for the land's changeable weather and its wild, mountainous, natural pasture. They were smaller and woollier than their cousins bred in Australia, growing fleeces of just under two kilograms per animal, as opposed to 1.1, which was the average in New South Wales. By the early 1860s, the small, hardy New Zealand breed was producing such good wool – 'fine, long, thickly laid in square locks' – that some rams were being sent to the imperial flock in France, to improve the stock there. The skill in careful breeding has

* Darwin uses the example of sheep several times in *The Origin of Species*. In Saxony, he writes, 'the importance of the principle of selection in regard to merino sheep is so fully recognised, that men follow it as a trade: the sheep are placed on a table and are studied, like a picture by a connoisseur; this is done three times at intervals of months, and the sheep are each time marked and classed, so that the very best may ultimately be selected for breeding.'

been maintained. Today New Zealand is the world's largest producer of cross-bred wool, and the fourth-largest producer of wool of any kind.

Including my merino socks.

Remember the actual sheep

In all the talk about what sheep give humans, I mustn't forget the actual sheep. Because the wool industry is not always kind to animals. The Spanish shepherds, faced with the problem of needing to identify the flock, often branded them on their faces. In 1787, at Louis XVI's experimental farm at Rambouillet outside Paris, English naturalist Arthur Young was shocked to find that the animals were kept in a situation 'I had rather forget than describe'.

In the historical stories I have told of the international transportation of sheep, there were always a substantial number that died, and the issue hasn't gone away today. Millions of sheep are transported around the world every year. With an average cargo ship carrying sixty thousand animals, you are under no legal obligation to even report the first twelve hundred deaths. An undercover film taken on a ship heading from Fremantle to the Middle East in 2018 recorded dirty pens, carcasses piled up, and a testimony that crew members regularly slit the throats of lambs born on the ship and threw them overboard. And Australia is said to have some of the best live export standards in the world.

The merino wool industry has been particularly criticised. Those folds in the skin of the sheep can lead to maggots. Particularly around the breech – the buttocks area, where urine and faeces can get caught in the wool – this can lead to terrible infestations. Some farmers choose to remove the skin around the breech with shears. The pain of this method, known as mulesing, is said to be similar to castration, but lasting longer. In 2018, New Zealand banned the practice, while the Royal Society for the Prevention of Cruelty to Animals in Australia is campaigning for alternatives. In the short term, farmers can spray insecticide or cut with anaesthetic. But ultimately it's back to selective breeding. They need to favour lambs with smoother skins, so they're less susceptible to flies.

Sheep can be clever, despite their bad press. A study at the University of Cambridge in 2017 showed that not only could sheep be trained to choose certain faces in photographs while rejecting other, similar ones, but that they also recognised images of people they

REPRESENTATIVE TYPES OF SHEEP.

1. Southdown ram. 2. Blackfaced Highland ram. 3. Cotswold ram. 4. Romney ram. 5. Rambouillet ram. 6. Leicester ewe. 7. Suffolk ewe. 8. Diagram of sheep, showing parts: a. mouth, b. nose, c. forehead, d. poll, e. neck, f. withers, g. girth, h. loin or back, i. rump, j. tail, k. leg, l. hock, m. underline, n. udder or belt, o. knee, p. forequart, q. bucket or breast, r. shoulder, s. throat. 9. Same. Merino ewe. 10. Romney ram. 11. Cheviot ewe. 12. Oxforddown ram. 13. Dartmoor lamb. 14. Hampshire Down ram. 15. Delaine Merino ram. 16. American Merino ram. 17. Lincoln ram. 18. Shropshire ram. 19. Australian Merino ram. 20. Dorset Horn ram. 21. Sheep-tailed ram.

Sheep-spotting in the nineteenth century included
American, Australian and Saxon Merinos.

knew. On seeing the image of one of their handlers (whose photo they'd never seen before), the sheep did a 'double take'. They first checked the unfamiliar face, then the handler's image, then the unfamiliar face again, before deciding, in most cases, to choose the photo of the person they knew.

A shepherd on the way to Santiago

I didn't make it to Santiago de Compostela for my birthday, or anywhere close. My right knee blew out like a grapefruit on the second day and I was very slow. When the day arrived, I was still several hundred kilometres away from my destination. I had always stayed at government hostels, but that evening one of my new walking friends was waiting at the base of the last hill as I and my sticks tapped down the darkening path after a day of rain and fog. 'We've found a bed and breakfast,' she said. 'There's home-made food and a shepherd and a fire. And your own shower. We reserved a room for you. I think you'll love it.'

So I found myself, celebrating the birthday that symbolically brings you closer to death than to birth, in a simple, private house in the Spanish hills, with four other pilgrims and a shepherd who sat in an armchair by the wood-burner, humming and laughing softly. Our host always invited him in winter: his own home had no electric light or heating. He was a very old man, thin and small, with thick gnarled hands like the branches of trees. I sat beside him for a while. He was older than my father and much less mentally alert; but it made me feel, for a moment, close to my parents.

He had dementia, so he couldn't speak for himself. But our host volunteered that he thought he'd been involved in some of the transhumance walks when he was a boy, between the wars.

'Like all of you, he knows about walking,' he said. 'He's done the old sheep trails.'

TWEED

*In which the author finds out why the emperor Charlemagne cursed
English cloth; and learns the secrets of the colours of certain tweeds.*

I hadn't imagined, when I first thought about my fabric journeys,
that I should decide to go in January to see people weaving in north-
ern Scotland. There are so many other months with better weather
and the chance of sunlight after four o'clock in the afternoon; I had
thought that I'd go in late spring or summer when dusk ends around
midnight and it's joyful to be in the north.

But on the evening of the three-month anniversary of my father's
death, I was lying in a hammock in Guatemala, thinking about him.
I felt exhausted with sadness, but grateful too, for the chance – an
invitation to Mexico for an author talk – to visit Central America and
to start to move on.

Twenty metres away was a small hostel kitchen with an open
window and I could hear two women discussing making food and
climbing a volcano. I drifted, remembering how after my father's
stroke my mother had gone to the hospital every day for six months,
bringing food she had spent the evenings making for him, willing him
to return from his coma, and how later he had said that he'd turned
back because my mother had called him. But that it was nice there,
wherever 'there' was.

'That's kind that you're thinking about us.' I heard my father's
voice in my head, above the murmur of cicadas. 'But you should
really go down to the kitchen.'

'What do you mean?' I whispered. But there was no answer. I
have imagined hearing my parents' voices three times since they died;
this was the first and it felt odd and unsatisfying.

But I did as he asked. I went down and bumbled around, heating
some water and thinking I will never, ever, tell anyone about this.

One of the women said goodnight, and I talked to the other while sipping my drink. Her name was Katie. She was a computer graduate from America. And she was coming to the end of an astonishing fellowship that involved travelling the world learning about knitting and weaving. The only rule had been that in all that year, she couldn't touch base in the United States.

She gave me many tips, some of which have played out in the research for this book. And one of them was to go to Scotland in winter.

Winter's when people make things, she said. The dark months are the fabric months.

Harris. And Lewis

If the top of Scotland is a warrior's shoulder, then the Outer Hebrides are his cloak, pulled on to protect against the Atlantic weather. The region, which is also called the Western Isles, or the Islands of Strangers, is a chain of more than a hundred islands stretching two hundred kilometres from the north to the south. The main ones are Lewis, Harris, Berneray, North Uist (pronounced Yuwist), Benbecula, South Uist, and Barra; except that Lewis and Harris are one island. They form a kind of top-heavy figure of eight and look as if they could easily be divided three-quarters of the way down where there's a natural thin neck at the town of Tarbert. But the two are carved in a less likely place above the neck, right across a wide piece of flatland on the Lewis side, in a straight line evidently made by drawing on a map with a ruler.

'Do you know why that is?' I asked the man beside me on the plane as we flew north-west from Glasgow, through snow clouds over Skye. He said that he'd always been told that when Leod, son of the Norse chieftain Olaf the Black, died in the thirteenth century, his two sons set to arguing about how the island should be divided. The younger son didn't want to just have the smaller section so he'd demanded some extra land from the top.

'You could just think of them as Higher and Lower, Harris and Lewis,' he said. 'That'll give you an idea of the landscape.'

'I'm guessing then that you might be from Harris,' I said. He smiled and said he was. There's still a sense of competition between the two. He went on to say that many islanders are from the Clan

MacLeod, meaning 'Child of Leod'. And some say that the name Lewis, Leòdhais in Gaelic, might mean marshy, *leodghuis*, but that it might be derived from the original chieftain's name. Leod.*

'Memories are long here. Everything comes from the land.'

His Hebrides accent was soft. It sounded almost Scandinavian, a sound memory from when the Vikings ruled the Western Isles from 853. The Outer Hebrides stayed in the Norse Kingdom for longer than many other parts of Scotland and did not return until the Treaty of Perth in 1266.

I had heard the shipping forecast that morning as I drove to the airport in the dark. Fisher, German Bight, Dover, Trafalgar, Shannon ... the promised weather got better and better then worse and worse until somewhere near the end was Hebrides. 'South backing south-west. Seven to severe gale nine.' It didn't sound good. Though perhaps some rain and cold would make it more likely that I'd find a weaver working at a loom.

Harris Tweed® is not just any kind of woollen cloth. It is a registered, trade-marked woollen cloth: the only textile that is protected by an Act of Parliament, the cloth equivalent of Parma ham, or Roquefort cheese, or Champagne or indeed Stornoway Black Pudding. The trademark, in the shape of an orb, doesn't just establish what it is, but where it's from and how it was made, and that it was woven by hand. And if what I was going to see was not actually pre-industrial wool cloth-making, then it promised at least to represent a particular kind of response to industrialisation.

A short coat

At the terminal in Stornoway, all the taxis had gone. 'There's a bus along soon,' the woman at the information desk said. 'You'd better wait for it outside. When it's gone, it's gone.'

That severe gale nine whipped round my legs, pushing me against the bus shelter. It was very cold. My coat was too short. It reminded me of a story of a much earlier trademark British cloth, famous throughout eighth-century Europe. I'd read how Charlemagne, King of the Franks, had written to King Offa of the Mercians in 796, complaining that the English cloaks he was importing were too short, and

* Harris is said to come from the Gaelic for hilly: *hearadh*.

asking 'that you get them made just like the ones we used to get in the old times'.

'What's the point of these skimpy little things?' Charlemagne asked in his letter. 'They don't cover me in bed. When I'm riding they don't protect me from the winds and the rain. And when I answer the call of nature I catch cold because my backside is frozen.' Although I wasn't answering the call of nature, I had a sense of what he had meant. I was glad when the heated bus, full of light, rolled around the corner and stopped for me.

'Everything is closed,' my hotel owner said when I arrived in town. 'You won't see much of the tweed.'

The secret of the colours

The hand-written sign on the door said 'Closed'. On that cold afternoon in early January, the Lewis Loom Centre looked like it had been closed for years. Outside there was a rusting piece of metal machinery, abandoned flowerpots, a peeling black door and a huge sign, 'Tax free sh—', half-obscured by a tree. I was taking photos when there was a rustling, and the door opened.

'Hello!' said a friendly voice. 'You'll be wanting to come in?' Ronnie MacKenzie was seventy-two and he had taught in the textile department of the local college for twenty-one years before retiring. There were four departments then: textiles, building, engineering/electronics, and navigation: all related to the so-called indigenous industries of the islands. 'In those days, you could weave your own cloth, build your own wall, wire your own house and go fishing,' he said. 'Now it's all business studies.'

Ronnie had come in to check for leaks. In a warehouse built during the Napoleonic Wars there are almost always leaks, somewhere. This was the first time he'd been in since before the New Year. I was lucky.

Inside, it was the size of a barn, with inner walls lined so haphazardly with piles of cloth and objects it was as if all the different aspects of tweed – its history, colours, jackets, handbags, patterns, processes and possibilities – had taken part in an endurance race some years ago and were now lying exhausted where they had fallen. There were scale models of looms resting against old posters for British wool; there were cloth samples stuck on roof beams, next to

tailored jackets parading haplessly on hangers; there were teddy bears with tweed kilts; there were old clocks and red rugs; and there were random handwritten notes in felt tip: 'Mr + Mrs Perrins of Worcester formed a company in Stornoway "Ceemo" Tweeds 1960s'; 'Ralph Lauren Patterns – Exclusive'. And everywhere the label: an orb with a cross above it and the words 'Hand Woven in the Outer Hebrides' and *'Harris Tweed'* (sometimes with, and sometimes without, the little ® symbol that shows that this fabric has been registered with a national trademark office).

Ronnie gave me a brief lesson in the basic patterns.

The plain twill is a single colour, but when you look closely you see a kind of diamond pattern moving up the weave. Then there's the 'two-and-two' (two of each colour, alternating), the four-and-four, called the 'houndstooth' or 'dogtooth', and the eight-and-eight, the bigger houndstooth (which Ronnie also called the 'wild dogtooth'), with the darker blobs like rockets (or what Ronnie called 'fox heads on stilts') zooming diagonally through the cloth.

Ronnie showed me another houndstooth but this time the fox heads were dark brown on a sandy base, with rusty squares making an 'overcheck' around it. Patterns, like smells, sometimes have the power to yank you into the past and leave you hanging. And I was tugged back through the years to the many times I'd seen my father wearing a jacket with a pattern like that. I had squeezed him into it, wriggling his hands through the sleeves, smoothing it over his back, tucking a handkerchief into the pocket, on the morning of my mother's funeral. It had kept him warm in his wheelchair at the front of the church that day, with a blanket around his knees.

'Today I think I will allow myself to cry a little,' he had said then, as we waited for the service to start. And we heard him, and we were stilled.

He wore that pattern one last time. He himself wouldn't have cared what he was wearing in his coffin, but if she had been alive my mother would have insisted that he wore something smart, so that is what I chose.

He was buried in wool, although not, as the 1666 law had demanded, 'onely in Wool'. 'Did you remember to bring in the underwear for your father?' the funeral director had asked me, late on the afternoon before his funeral. And no, I hadn't. And by then we had thrown it all away. I had to run around their market town, racing

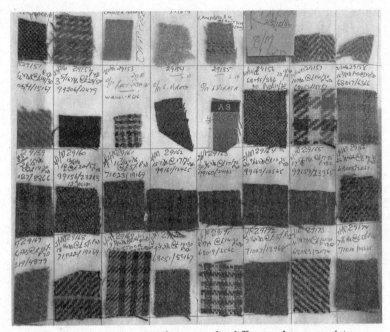

Tweed-spotting requires knowing the difference between plain
twill (unpatterned); barleycorn (plainish with flecks); striped twill;
overcheck (with large overlaid squares); dogtooth; houndstooth; and
herringbone that can have zigzags twelve spaces long or more.

against the clock of closing time. I knew that in so many, many ways
it didn't make any difference if my father went commando to his
cremation, and I knew too that it did. There was one shop still open.
I didn't explain about the funeral; the sales assistant offered me the
choice between a pair of underpants with cartoon characters or some
designer ones that my father would never have forgiven me for paying
thirty pounds for, to be worn just once. I was hovering in indecision
when the assistant dived into a box and found me some forgotten
three-packs. Should my father (I actually found myself wondering
this, as the shop owner waited by the door to close up) wear white,
black or grey? Black, I thought, for a funeral.

'Then there are the herringbones,' Ronnie was saying, bringing
me back to now. And there they were, zigzagging six up and six
down, or eight by eight, or twelve by twelve, or as big a pattern as

you want, 'though the bigger the design the more it's bought by city people'.

Everywhere there was the famous black-and-white 'glen checks' pattern, or Glenurquhart (pronounced Glenochert), with its little houndstooth squares at the centre of a cross made of stripes. When a fine red overcheck is added, it's called a Prince of Wales, because Queen Victoria's eldest son, later Edward VII, was extremely fond of wearing it. As with sheep spotting, tweed spotting was not only fun, it was also about opening up new ways of observing the familiar.

'And don't just look at it with your eyes,' Ronnie said. 'Close your eyes and see it with your hands. That's the best way to distinguish the handwoven from the machine.' I picked up a sample. It was a kind that at another time I'd have ignored – brown herringbone, eight … no twelve … by twelve – and yet now I saw that the 'brown' was made up of chestnut and black and wren-coloured; the 'white' had salmon there too, and lemon, and something else I couldn't tell. The tweed had a subtle thin sky-blue stripe running through its warp every seven centimetres or so, and a matching red stripe across the weft to make half-hidden squares. And I noticed that around the blue warp stripe the diagonals changed into an almost marbled pattern, as if a shoal of fish were swimming through calm waters and flecking the surface. I closed my eyes. The cloth tickled my fingers like the lightest echo of Velcro. I smelled it and it pulled me back to walking along British beaches in winter. All ozone and coat.

I hadn't expected that I would actually like the tweed. It was what my parents' generation, or, really, *their* parents' generation wore. I thought I would find it historical, important, crafted, curious and perhaps, secretly, a little dull. But in Ronnie's dark and jumbled resting place for lost wools, counting the little squares, examining the patterns, I started falling in love with it.

In addition to the browns and the greys, there was plenty of bright. Russet-orange, violet-blue, red-wine-maroon, pink-moss-green. And, as I'd seen with that herringbone, even many of the greys and browns were the colours of various clouds and various skies and various winter fields, sometimes with that elusive stirrup of blue. As I scribbled down my observations of the yarns in the cloth, I began to see what was happening. Nothing had quite its own colour; it was always something else as well. It's an exercise in harmony, and it also means that even in a conservative jacket in a colour like a brown or

a blue, there can be something astonishing built up inside the wool: in the body of those formal colours there can be candy pink, heather purple, sun yellow.

'You've got it straight away,' Ronnie said approvingly. The colours of *Harris Tweed* (which could also be called Harris-and-Lewis-and-both-Uists-and-at-least-three-other-islands Tweed) are mixtures, subtle and tremulous. They are never exactly themselves. And they are never quite even. They play with your eyes, tease them, gentle them, like one of those magic eye games where you have to focus somewhere else to see the story.

'You've come all the way to Lewis and you've seen the secret right away,' he grinned. 'Now what are you going to do with the rest of your time here?'

The tale of the Orb

'Our Harris Tweed suits cannot be beaten. The ordinary tailor's price is 55s. We have now made arrangements with the Highland peasants ...'

This was the claim of several advertisements in London newspapers in the spring and summer of 1906, for suits that could be made for thirty-two shillings and sixpence each by a London tailor, Henry Lyons.

But it turned out that the cloth had never been anywhere near the so-called 'Highland peasants', nor the Outer Hebrides, nor even anywhere near Scotland. It had been woven in a mill in Huddersfield in Yorkshire – and the Board of Trade decided to prosecute.

Henry Lyons appeared before magistrates at the Thames Police Court on 10 August 1906, probably expecting no more than a fine. He was sentenced to two months in prison and when he heard the verdict, he 'fell down in a fit', the *Daily Mail* reported. The punishment was later reduced on appeal to twenty pounds and costs, but the point had been made. Knocking off *Harris Tweed* was a real crime.

Ever since the 1840s, demand for the tweed from the Outer Hebrides has risen and fallen. At the time of the Henry Lyons trial, the prices were unusually high. The newly crowned King Edward VII and his wife Queen Alexandra had visited in 1902. As the Prince of Wales,

Only tweed handwoven in the
Outer Hebrides can carry the orb.

he had already had a kind of tartan named after him, so it wasn't sur-
prising that as king he decided to follow up the visit with an order for
some of the finer tweeds he had been shown. The rest of Britain fol-
lowed, and throughout that decade the weavers of Harris and Lewis
were kept busy at their looms.

The increase in sales led to an increase in questions about what
Harris Tweed is and should be. If you were paying extra for a kind of
artisan quality and story, then what exactly were the rules defining
that quality and story?

It was called 'Harris' tweed, so obviously at least some of the
cloth should be made in Harris, but is that the only valid place? What
if it were made in Lewis? Could it come from another Outer Hebrides
island? Another Scottish island not in the Outer Hebrides? Or what
if it were made to the same quality but in someone's house in the
Highlands, on the Scottish mainland?

Should it be spun by hand, or would machine-spinning be accept-
able (given how long it takes by hand, and how much more consistent
a yarn machine-spinning provides)? Could those spinning machines
be anywhere, or just the Outer Hebrides?

And should the sheep that grow the wool be only from the
islands? From just Scotland? Or England and Wales as well? Or would
anywhere do, as long as it's virgin wool and hasn't been recycled from
other clothing? Or how about if it was woven from shoddy – yarn

made from rags – and made in the Far East or the US but reminded buyers vaguely of the patterns of nineteenth-century Scottish tweed (as happened often in the 1920s)? Could the factories be sued for calling it Harris?

If the rule was that it had to be handwoven 'at home', then how many looms could be in a home? What if a husband and wife both want to weave? (Or a father and son, a mother and daughter?) Under those circumstances, would two looms in a home still be authentic? How about three? And how close by does it have to be to qualify as 'at home'? Would a shed in the garden be acceptable? What about a shed in the village, if you didn't have a garden? A shed a hundred metres away? A kilometre? And just how automated could a 'handloom' be?

These seem, some of them, quite tedious and technical questions. But answering them has involved a robust mix of philosophy and philanthropy, economics and rivalry, brazen cheating and passionate letters to editors, as well as opportunistic interest groups testing every potential loophole. Because there's a lot of money involved, potentially, if you get it right. One company in the early 1960s pushed the definition to fraying point by shipping in the yarn, erecting a shed full of looms on the quay at Tarbert, employing local people to weave it, then sending it straight out again to be finished. The resulting cloth was from Harris, but only in the sense that it had once had a working holiday there.

Through the years, the answers to the questions have been arrived at by an almost Socratic system of testing and argument. You have to keep things in balance, you have to allow the community to thrive, you have to make sure that the decisions made don't throttle demand or suffocate supply. Don't let monsters in, don't lock the individual weavers out.

It is like one of those computer games that involve making decisions to create a settlement or a country, except that if you get things wrong in a computer game you won't lose a tradition that has quietly become a national treasure. You won't put families out of work. It's also like juggling: you need enough balls in the air to keep it wonderful, and keep potential buyers – and weavers and mill owners – engaged enough to be interested in it, but not so many that everything falls down.

The Lyons case was one of the reasons why the Harris Tweed Association (now the Harris Tweed Authority) was set up in 1909.

Its remit is to promote and maintain the authenticity, standard and reputation around the world for the cloth that bears its name. It is the body that checks the tweed, and verifies that it is worthy of the prized Orb.

'We go down to the mills,' said Kristina MacLeod of the Harris Tweed Authority. 'And then we stamp the cloth, and we make sure that it has a document to say that it was dyed and spun and woven here, at the home of the weaver, and a record of who in the mill finished it. And that is also where our income comes from: from the levy we charge to the producers, for stamping the Orb* on the cloth, thereby making it Harris Tweed®.'

A river that's a cloth

Weaving was always part of the lives of crofters in Scotland. A favourite was a simple twill weave wool ('tweels' in the Scots dialect), which involved passing the weft under two warp threads then over one, then under two etc., resulting in a sense of diagonal procession in the cloth. A popular story is that in 1832 a trading company in the Borders sent a package of tweels down to a Mr James Locke in London, with a scribbled invoice. He read it as 'tweed'. The Tweed is one of the great salmon rivers in Scotland, where wealthy men and women liked to go fishing, wearing hard-wearing tweel cloth. He could see the name's potential, so he used it in the publicity material for his local clients. It was the right time for such a word to catch on, because by the 1830s Scottish fabrics of all kinds had been in high fashion for a decade.

Highland dress for men had been banned in Scotland in 1746, along with bagpipe music. Also the opportunities for outsiders to buy land in the Highlands had been expanded. It was all punishment for the Jacobite risings by Scottish supporters of the descendants of the deposed Catholic King, James II (James VII of Scotland – Jacobus in Latin). And although the Dress Law was repealed in 1782, by then most people in Scotland saw kilts and tartans as an old-fashioned kind of costume anyway, not something to prize or wear. That had changed in 1820 when King George IV visited Edinburgh – the first visit to

* The Orb Certification Mark is printed on beeswax transfers, which are ironed onto the reverse of the fabric at the final stage of the finishing process.

Scotland by any reigning monarch for a century and a half – and the king appeared in Highland dress so splendid that when he emerged from his dressing room he was reported to have looked into a mirror and said 'I cannot help smiling at myself'. The Scottish landowning families had ordered new Highland-inspired clothes for the occasion, and from there the fashion spread to England and elsewhere.

Though it was very different from the cloth worn by the people who actually worked the land.

How Harris was bought, sold, sold out and rescued

Some of the cloth woven by the Highland crofters was for their own use, to make into clothes or shawls – or blankets, which they called plaids.* But the other vital use of the tweed was as part payment of the rents. And there were always rents to pay. Most Scottish islands were owned by rich families, and although some stayed in the same family for generations, others were bought and sold quite casually, as fortunes waxed and waned. So most people who lived on that land did so as tenants, and as tenants they were often dependent on the whims and demands and entrepreneurial abilities of their landlords. On a good year they might be able to pay their rents in crops, but in other years they might have to pay in anything they could make, and that could include wool and yarn and twill cloth. That's how it went for centuries in Scotland, not just for the Outer Hebrides, but also for most of the inhabited islands, and the Highlands too.

And then came the Clearances: the practice of pushing people off the land they had worked for generations in order to make room for wool – burning their houses, resettling them on marginal land, and establishing enormous sheep farms where they used to live. Harris and Lewis were no different.

In 1779, Harris had been sold to a Captain Alexander MacLeod. He'd been decent, helping the islanders build a small wool-spinning factory, bringing textile machinery in for the first time, and setting in place the sense that cloth-making was a special part of a Harris identity. But a generation later his son doubled the rents and insisted that they be paid in kelp, a kind of seaweed containing potash and iodine

* In North America, plaid is a general word for checked cloth but in the Gaelic-speaking areas of Scotland it referred to blankets, whether patterned or plain.

used in dyeing and explosives, and therefore much in demand during the Napoleonic Wars. Kelp collecting involved standing in the icy sea for long hours pulling seaweed off rocks. There wasn't much time for planting crops or tending to animals, so instead crofters planted potatoes – which were easy – and made it their staple food. When the kelp price crashed in 1815, the next MacLeod decided that the only way to make Harris pay for itself was to turn it into a huge sheep farm. Meaning that the majority of the islanders had to leave.

The factor of this MacLeod, Donald Stewart, set to the task of clearing hundreds of crofters out of a forty-mile stretch of good farmland in the west side of Harris, to what, he claimed, was 'better land in the east', although everybody knew that it was not. Crofter Donald McDonald testified to a parliamentary inquiry that as a boy he had seen his mother, with her day-old baby, taken out of their house in a blanket while the place was pulled down. 'My father asked MacLeod, who was proprietor at the time, whether he would not allow them to remain in the house for a few days, but permission was not given', he said. Such callous practices didn't bring any material benefits to the MacLeods anyway: within twenty years they were bankrupt.

In 1834, the estate – now heavily in debt – was bought by the fifth Earl of Dunmore, whose son Alexander inherited two years later, along with his wife Lady Catherine Herbert, the glamorous daughter of a Welsh earl and a Russian countess. And it would be Catherine, more than any of the men in this story, who would play the crucial role in the story of *Harris Tweed*. Not that she visited the island very often in the early days. It was a long way from the family home of Dunmore Park near Stirling. There were no trains, and the roads were appalling, particularly if you were pregnant. Which she frequently was.

The sixth earl died in 1845, at the age of forty-one, leaving Catherine with four children under eight. It was appalling timing to be responsible for an estate in the Scottish Islands, and for the hundreds of people who depended on it. Harris's clearance policies had already led to most tenant farmers having to make the impossible choice between moving to the poorer Bays area in the south-east, or accepting the offer of free passage to Nova Scotia. Now the whole island was about to be plunged into a calamitous famine. It would last six winters and take many lives and it would turn the island's main trade to cloth.

The industry started, according to local mythology, some time between 1839 and 1849 (information about the exact year perished along with many other documents when the London offices of the Dunmores' solicitors were destroyed in the Second World War blitz). That was when the Dunmores (or perhaps just Lady Dunmore) sent an order to their tenant weavers for twill cloth to be made in the Murray tartan. The idea was that it would be used to make up a uniform for the ghillies and keepers on the estate; and also that, during difficult harvests, it would be a way for hard-pressed tenant families to be able to pay the rents they owed without their children having to forgo food. But when the bales of cloth were completed, they were of such wonderful quality that it wasn't just the staff who wore the new material. Lady Dunmore made it into skirts and suits and shooting clothes and wore it as often as she could, and especially when she had a house party of people visiting, who might put in their own orders. Because it was clear from the offset that this cloth was something that the outside world wanted: this was what might save the crofters and their children from starvation.

Lady Dunmore established training schools and sent a few young women to the mainland to learn additional textile skills – knitting and embroidery and the use of different kinds of looms – so that they could teach their neighbours when they returned. She encouraged the weavers to bring their cloths – their 'webs', as they were known – to the estate house at Rodel, where she or her staff would measure and inspect them, and then pay for them in cash. At the end of the season, all the bales would be despatched to tailors in Edinburgh, Glasgow, Manchester, Leeds and London, as well as to private buyers keen to acquire what soon became the only proper gear for hunting and shooting, as well as the increasingly popular game of golf.

Other Scottish landowners followed Lady Dunmore's lead. As well as recreating clan tartans, it also became fashionable to commission new tweeds in the colours of one's own landscape – purples, greens, browns and greys – and these became known as 'Estate Tweeds'. Often, it was the Harris weavers who were commissioned to make them.

From the very beginning, Lady Dunmore had been aware that it was important to keep the quality high. Whenever somebody brought in a tweed with a mistake in it, she would buy it anyway, for a slightly reduced fee, and would put it aside 'for charitable purposes'

so the weaver would not starve, but also so it would not be sold elsewhere and damage the reputation of the small, but expanding, cottage industry. She was lucky in her timing. The arrival of 'Harris Tweed' as a concept coincided with the emergence of the Arts and Crafts movement – championed by her acquaintance, John Ruskin – which promoted local products crafted by hand, to counter the rapid industrialisation of the nineteenth century.

By 1857, the fabric from Harris was already so famous that in Glasgow a 'smelling house' had been built, so imitation tweed could be 'inoculated' with the smell with which tweed was always associated: the earthy tang of the peat fires, in the weavers' homes.*

Lady Dunmore died in 1886. In her lifetime, she had helped the weavers of Harris survive the leanest years, but after her death, although women continued to make the webs, they did not get as much money for them. Buyers began to reintroduce the 'truck' system, which involved paying weavers in food rather than coin. A piece of fabric that had taken weeks to make would be exchanged for a bag of grain, but the weavers agreed because they were hungry. Then the cloth would be traded from person to person for more and more money, until it found its way to a tailor, in Edinburgh perhaps, or York or London, and 'ultimately to a smart suit in a Highland shooting lodge or Norwegian fishing, or to India or the New World'.

The weaver's story

'The UK sunshine today is only in Harris and Lewis,' announced the forecaster at BBC Radio Scotland as I drove south in my rental car. We not only had the only sunshine, we had bright colours too. Over on the mainland, the mountains were white and mysterious, like visions of a mythical country. On the island, the terrain was rusty and wild, filled with lonely lakes and deep and lovely vistas.

Lewis becomes North Harris very suddenly. Even having seen the map in my guidebook, I had expected there to be some kind of physical clue, but there was no apparent change in the red moorlands and

* In around 1919 entrepreneurs set up weaving sheds in Ness, Barvas and Carloway on Lewis. They were to be heated by peat stoves, and it was agreed by those who wanted to make money from the tweed that 'it wouldn't be a bad thing if a little smoke is allowed to escape into the shed for advertising purposes'.

marshlands. Lewis to Harris and Harris to Lewis is simply marked with a sign. *Fàilte*. Welcome. And then you keep driving.

After skirting Harris's highest mountain, the Clisham (whose three-billion-year-old slopes are said to be the oldest visible fragments of Europe), the road opens up to reveal perfect, wide, sandy Atlantic beaches. I stopped the car and walked towards the sea. Powdered sand and turquoise ocean; nothing between here and America. Before me was one of the beaches farmed for kelp during the French wars. Behind me was the rich soil for which the MacLeods had evicted people, all for the sake of farming sheep.

Kristina at the Harris Tweed Authority had suggested I visit weaver Rebecca Hutton, who lives in Northton at the far end of Harris.

'It's just about as far as you can drive from here,' the man at the car rental at the Stornoway Ferry terminal had said. The satellite navigation system agreed. After the very first roundabout, the electronic voice had told me to continue for fifty-three miles and then I would be at my destination.

Rebecca was in her mid-thirties, with short blonde hair, wearing a black 'USA' -logo T-shirt, jeans and trainers, with a pouch of tobacco and a pack of cigarette papers in her hand.

'I thought you'd be older,' I admitted, as we settled down in her shed with mugs of tea and chocolate biscuits. 'I was expecting somebody more like your mother's age. Or maybe your grandmother.' Rebecca rolled a cigarette, and grinned.

'There's a generation missing from the *Harris Tweed* industry,' she said.

In her mother's time – the late 1970s – the US market for tweed had collapsed. By then barely five hundred thousand metres were being made in Harris and Lewis, from seven million metres in the industry's heyday. 'It was just seen as an old thing, there's no point in that any more … And then it sort of came back.'

Her loom shed was purpose-built, and had clear panels in the roof, so there was light everywhere. There were dozens of bales and samples of cloth in all sorts of delicious colours: coral and sea blue and yellow and mist, as well as mud and earth and night sky. There were spools of yarn thrown into boxes, a radio on a shelf, an iPad on a table, and price lists and mysterious yarny things in plastic sacking.

Taking up almost half the space was a Hattersley single-width

'Taking up almost half the space was a Hattersley single-width loom.'

loom. It had been built in the 1970s in Keighley, Yorkshire and was one of the last ones the company had made. It had been shipped to the Outer Hebrides just when the market was collapsing, and for nearly forty years – until Rebecca took delivery in 2011 – it had lived in a corner of a Lewis mill, still in its wooden packing. No one had even bothered to open the box except to raid it for a few spares.

It was about a metre and a half wide with a sturdy forest-green cast metal frame, set up with warp threads in stripes of blue, pale grey and thunder. Beside it was a blackboard with weaving notations scribbled in white chalk; a laminated cartoon strip in Gaelic, Rebecca's first language, showing a weaver putting bales of cloth in a little country van; a dartboard; and a faded printed sign saying 'To you it might only be a shed, but to me it's a sanctuary'. From the window, there was a view of straw-coloured hills and of the house that Rebecca shares with her father and her younger brother, David, who suffers from severe epilepsy.

The loom was set up to do a 'patchwork' weave, using leftover yarn. Rebecca said that she does it by putting the old half-used pirns

(the mini bobbins that go in the shuttle) into a bag, then she picks them with her eyes closed to make random patterns. 'It's a good way to use old yarn,' she said. 'It's random so you see colour combinations you'd not have thought of yourself, and sometimes you look and you think "ooh, I'll keep that".'

The word on all the *Harris Tweed* authentication labels is 'handwoven' but it could almost be described as 'footwoven'. The mechanism is driven by two treadles. When Rebecca started treadling, it gave the impression that she was riding a bicycle. (It's an up, down motion: newer looms are even more like bicycle pedals.) Her hands were working all the time though, checking the tension of the cloth, pressing against it, watching for breaks.

The sound it makes is a kind of soft industrial Ker-rum-ba, Ker-rum-ba, Ker-rum-ba, Ker-pause, adjust, Ker-rum-ba, Ker-rum-ba; quite noisy but not unpleasing, like skittle pins tumbling down a slide. If I hadn't been there, the soundtrack to the *Harris Tweed* weaving process would probably have had an audiobook added to it. She loves audiobooks. 'I did try to listen to music but then I started weaving in time to it. Which was fine until the beat changed into something else.'

Her family had been weavers for generations. Her mother and her aunts never learned to weave, however, 'because they said, what was the point?' When her mother died in 2003 and Rebecca became her brother's main carer, she could never have thought that she, or anybody her age in Harris, would ever weave. The smallest of the five Lewis mills, Carloway, was struggling; the largest mill at Shawbost was about to close, and the Kenneth Mackenzie Group, which owned the other three mills, was up for sale.

But there were a few tiny initiatives, which, in retrospect, showed that the industry was not totally defunct. Throughout the 1990s, Donald John Mackay in South Harris was busy on his single-width loom making special commissions, including white tweed for Scottish brides. And half a dozen weavers on Lewis were using double-width rapier handlooms and making a living.

Double-width rapier handlooms are not only twice the size of the single-width and as expensive as a new car, Rebecca said, but the technology is different. With rapier looms there isn't a shuttle. The weaving process begins as usual with the weft whizzing from left to right through the warp. But when it gets to the end, it doesn't

turn and go back on itself, making a selvedge in the old way. Instead the thread is cut, the empty rapier retracts, and the next weft thread shoots out the same way left to right, into the reconfigured shed. It is very quick. It gets its name because the instruments carrying the weft are long and thin, like swords.

On a shuttle loom, every weft line – or pick – has to be calculated in twos ('because where you go out with a yarn, you also have to go back with a yarn'), while on a rapier loom it doesn't have to be an even number. In practice it usually is, however. It's unsettling to see tweeds with weft threads in odd numbers, Rebecca said, if you're used to the other.

Rapier looms make a wider, lighter cloth, the kind you might wear in the summer. And the pedal versions were invented in 1987 specially for the Outer Hebrides, as *Harris Tweed* is the only cloth in the world where you have to, by law, use only human power, not electricity.

Where Rebecca can only listen to books or the radio because she has to concentrate, double-width weavers can actually read a book or even watch TV while pedalling, as there are alarms fitted onto the loom to announce when a thread has broken, which is the usual thing that stops work.

'But I only wanted to do the single-width, with shuttles – it feels that you get more connection with the cloth,' she said. Double-width looms were originally more popular among weavers in Lewis. Double looms are faster, heavier, flashier – the sports cars of hand-loom technology, you could say, compared to the classic cars of single-width.

But single-width or double, there was no sense in 2007 that this was something a young person in Harris might ever think she could make a living from. That was the year Rebecca and her brother went to live on the mainland to get treatment for David, and by the time they returned a few years later, everything about the weaving in Harris had changed.

First, Donald John Mackay, then fifty-two and just about the most famous name in Harris, received a phone call from America. He was at his loom, in his tin shed overlooking the sea at Luskentyre, and it was his wife and business partner Maureen who picked up. The caller said that they were from Nike, the biggest sports shoe manufacturers in the world. They wanted a thousand metres of tweed in six weeks for a limited-edition trainer, could he do it? Mackay calculated. He

The *Harris Tweed* trainer that helped turn an industry around.

weaves about twenty-five meters a day. If he put in some extra hours, it was just about possible. He said he would. Then they called back. They were sorry. They'd got the zeros wrong. They needed ten thousand metres, could he still do it? And Mackay, feeling a little weak, said that he'd see what he could do.

There was no way he could do it on his own, and yet he had given his word. And, in a scene that as retold sounds like the pivotal moment in a quirky comedy about an industry in a crisis, Mackay contacted Shawbost mill and said that he needed help. He needed everyone to join together to get this order done. And they did, and Nike got its swampy-green-coloured tweed, and shoe collectors got their special edition of the Terminator trainer. And other fashion companies, including Chanel (which had been using tweed since the 1920s, when Coco had an affair with the Duke of Westminster and liked the fabric his friends were wearing for fishing), had a reminder that this ethical and lovely and sustainable fabric was still being made, on the very edge of Europe.

The Nike order wasn't quite in time to save Shawbost mill though.

'Have you heard of Haggis?' Rebecca asked, seeming to change the subject.

'Yes,' I said. I wondered if she was going to make the usual Scottish joke about hunting little haggises. I wasn't going to fall for it, but, equally, I didn't want to spoil her fun. But the story she told was the cautionary tale of textile entrepreneur Brian Haggas, who, when he arrived in the islands in 2006, appeared to represent the biggest disaster the industry had ever faced.

Haggas bought the three Kenneth Mackenzie mills (which were responsible for 95 per cent of Harris's tweed production). He closed two and invested into the third. His plan was to simplify the estimated eight thousand tweed designs to four, then sell it not as cloth but as finished jackets. He knew that he nearly had a monopoly. He made seventy-five thousand jackets and waited for the orders.

There were a few things he hadn't calculated. First, he had been so elated during his market research to find that almost everyone he talked to had heard of *Harris Tweed* that he hadn't considered that this might not necessarily translate into orders.

Second, he had not understood, as Lady Dunmore had understood, that *Harris Tweed* will only sell if it is seen as rare and special. And seventy-five thousand of the same thing is not rare and special enough.

Third, he had not realised that a lot of the demand came from tailors and fashion designers who wanted to use the tweed in their own garments.

But the most important thing that he had failed to understand was that the people of Harris (and Lewis, and Berneray, and Uist, and the others) would fight back. He would be their crisis. And strengthened by the sense of community that the Nike deal had provided, they would pull through.*

'People suddenly realised that nobody owns *Harris Tweed*,' Rebecca said. 'The weavers need the mills to dye the yarn and finish the cloth; the mills need the weavers because they aren't allowed to make the cloth themselves, and the Harris Tweed Authority has the

* In 2019, Haggas made a surprise gift of the Kenneth Mackenzie mill to his local manager, safeguarding eighty jobs, telling *The Herald* that the tweed 'is an integral part of the Western Isles and, as such, should be owned and produced by the islands and any profits should remain there to enhance the life of the people'.

Orb but it can't make the cloth. Everyone needs everyone else.' And everyone needed a miracle, she said.

And then a miracle arrived.

In 2007, there was an announcement that the 'derelict' Shawbost mill would reopen. The initiative was led by former British Labour trade minister, Brian Wilson, and the money came from a self-made Scottish oil millionaire and Conservative supporter, Ian Taylor. The two had met during a British trade mission to Cuba in 1998. At four o'clock in the morning they had found themselves in the surreal situation of sitting up with Cuban president Fidel Castro 'drinking the last two bottles of 1956 Bordeaux' in Havana, and forming an unlikely and lasting friendship across political lines. It meant that when Wilson called him eight years later to say the *Harris Tweed* industry was in trouble, Taylor decided to help.

With a former chief executive from the Harris Tweed Authority as managing director, the support of the weavers, and some big sales in Italy (including to Manolo Blahnik, the designer shoe brand), the business began to pick up.

'So what seemed to be the worst thing that could happen turned out to be the best thing. It gave the people the kick up the backside they needed,' Rebecca said, lighting another cigarette.

It meant that the island's community development company, Harris Development, was able to run weaving courses and rent out looms, and when Rebecca heard about that in 2011, she signed up. Because just as her forebears combined the weaving with the general tasks of their daily lives, she realised that she could be a carer and a crofter and earn a living from the cloth as well.

'The only thing that isn't done in the islands is the scouring [washing] of the fleece because the fleeces are sent away to the mainland to the British Wool Board to be graded, and the scouring's a messy job,' she said.

'And the growing of the wool, of course. You'd have to clear all the people out to get enough sheep in the islands to give you enough fleece. That's happened once already and we don't need it again.'

I drove back via the south-east coast of Harris: the infamous Bays area to which so many crofters were despatched during the time of the MacLeods. It had narrow, windy black roads around narrow, windy black hills. I drove past peaty lakes and isolated houses. It was tough driving in the twilight; I didn't go higher than third gear. And

these were tarmacked roads. A hundred and fifty years ago there had been no good roads and no good bridges.

'The people are quite accustomed to work bad land,' Angus Campbell, an old crofter from Plocropool, told a parliamentary committee in 1884 about the banishment to the Bays. Then there wasn't even a bridge to the church. 'For I have seen the coffins carried upon our shoulders dragged through the flood – six men strung together and following the course of the stream in order to keep themselves from being swept away with the bier upon their shoulders.' The factor during this period had said that he had offered the crofters 'better land in the east'. But as I could see, there was no better land in the east.

Rebecca's forebears had been among those who had moved to the Bays in the nineteenth century. And when the potato famine came there'd have been nothing for them. Nothing except, perhaps, the weaving.

The wool in the mill

Billy MacLeod took me around the Carloway Mill the next morning. He said his name was Neil, but everyone called him Billy.

'Even I've forgotten why, it's been like this since school.'

'*Harris Tweed* is what you'd call dyed in the wool,' Billy continued. The expression is more commonly used now to refer to someone with fixed beliefs. For wool it means that the dye is applied before spinning and weaving, so the colour is less likely to fade.

In the old days, the dyeing would take place beside a soft peaty stream: the water would be put into black iron pots and heated, with the dyeing materials dropped in like infusions of tea. They used to make purple from a dye invented in the 1750s by a Scottish coppersmith, George Gordon. He had been repairing an old copper boiler in a dye-house in London when he noticed that the process for making orchilla dyes (from an expensive plant from the Canary Islands) had a striking similarity to his Highland grandmother's recipe for a purple dye made from lichens. With his chemist nephew, Cuthbert, he experimented with various combinations, and when they produced a lovely, stable, violet dye, Gordon called it 'cudbear', a whimsical reference to his nephew's name.

Dark blue came from woad or bilberries, while broom gave a paler blue, more like the colour of a summer sky. Orange was found

in peat soot, magenta came from dandelion, and dark green from teasels. The blacks came from boiling tree bark, or more rarely and more luminously, from the roots of water lilies.

Today, as well as natural, undyed wool, the mill uses a mixture of mineral and synthetic dyes (most of them heat-set with chemicals) rather than dyes made from plants. It's not only the need for reliably consistent colours, it's also that the natural plants are in short supply. In the nineteenth century, one of the most popular colours was a rusty gold from crotal (or grey stone Parmelia, *Parmelia saxatilis*), a crumbly lichen which crofters in the nineteenth century used to scrape off the rocks with spoons. But at the height of the *Harris Tweed* success, it quickly became almost extinct in Harris and Lewis and for the most part had to be imported from Skye.

Billy demonstrated how the virgin white wool that had come in in bales weighing a third of a tonne went into big stainless-steel dye vats, and then it was boiled and then dried in a huge spin dryer. It smelled nice, of clean sweaters in the rain. Once the wool is dyed and dried, it is blended. This is the process that Ronnie at Lewis Looms had told me was the 'secret' of the tweed; and there is certainly something wonderful about it.

The recipes are secret, so I couldn't see them, but if the blending I was seeing had a written formula it might have been something like: '30 per cent dark chocolate; 30 per cent black; 30 per cent white; 5 per cent dark orange; 5 per cent rye.' Plus vegetable oil to make it soft.

Once Billy's colleagues had made the right measurements, the three hundred and fifty kilograms of mixed-colour wool were sucked down into the floor through pipes, like the request slips in the New York Public Library. I saw it next in the blending room, which he called 'the tumbling room': a whole small room (though with a very high ceiling and a roof light) where the wool was pushed and propelled by air. From the viewing window, it looked like a cyclone of brown and black and white and orange and sandy-coloured cotton wool balls, all tousling and ruffling, jumbling and tumbling. This is how the complicated 'brown' of that herringbone that had charmed me at the Lewis Loom Centre had been formed. Like a colour-storm.

After enough time had passed, Billy opened the door, and the mixed wool spilled out. It looked almost as if the ancient Lewis granite of the hills, in its winter whites and browns with flashes of orange and rust, had been transformed by a sorcerer into something soft.

Then the mixture set off on its journey through the mill. First it would be carded on noisy machines and then twisted on a series of large frames onto thousands of cones. Later the warp threads would be gathered in specific order, depending on the type of weave, and wound onto heavy cylindrical beams, themselves like bobbins, though looking more like truck axles. Then they would be delivered to the weavers, along with the correct yarn for the weft.

I saw one of the finished batches of spun yarn. The general impression was of chocolate brown, but when I looked properly, there were those other flecks, of white and black and orange and sand; and it tricked my eyes in just the way the finished cloth would be designed to do.

In the old days, the finishing would happen in the house of one of the weavers, and it would be a sacred as well as a celebratory event. In England the process is called 'fulling' or 'tucking' or 'felting', but in Scotland it was always called 'waulking'. Its purpose is to make the cloth thicker and softer and to get rid of the lanolin, part of the natural showerproofing of a sheep.

In 1775, Dr Samuel Johnson witnessed a waulking in Skye. His friend and biographer James Boswell wrote about it in his diary.

Last night Lady Rasey shewed him the operation of wawking cloth, that is thickening it in the same manner as is done by a mill. Here it is performed by women, who kneel upon the ground and rub it with both their hands, singing an Erse song all the time.* He was asking questions while they were performing this operation, and, amidst their loud wild howl, his voice was heard in the room above.

The waulking songs usually took a question and answer form, with one woman singing the question and the rest giving the response. When Dr Johnson asked for a translation, he was told that 'the chorus was generally unmeaning.' A 2016 BBC radio documentary suggests

* The landlord, once he had cleaned his stinging eyes, said he was glad to have his fields sown for free. He didn't know that the protesters had actually sown a bag of sago pearls – which look, from a distance, like seeds – and that those fields would yield no harvest for anyone that year.

otherwise. Waulking action begins slowly and speeds up towards the end: it's not difficult to see why it attracted creative sexual analo-gies. Dr Peter Mackay from the University of St Andrews consulted Gaelic singers (including his own aunt) and found that many of the images were actually extremely rude and very funny. They included longing to be the gun of a lover (oiled, primed and rubbed), or, on Skye, refer-ring to the great glistening, phallic basalt monolith known as The Old Man. No wonder the women didn't want to explain the details to two male strangers in 1775.

The important ingredient in waulking is very stale urine. Scottish journalist Finlay John MacDonald, who grew up in Harris, remem-bered visiting a character called the Black Shepherd when he was a child. It was the 1920s. The shepherd's wife plied him with tea, and whenever he stood up 'at nature's insistence' she reminded him to be sure to 'use the tub now'. That tub had stood for so long that its fumes 'would have brought tears to the eyes of a seaman', MacDon-ald wrote, adding that it was the urine, rather than the peat, that gave Harris cloth its famous 'Home Counties' smell.

He had once seen the tubs used as weapons. The landlord of Harris was playing the age-old game of landlords in Harris and giving the good land to newcomers. One day, in anger, the local men divided the landlord's best fields between them and began to plough them and sow them. Meanwhile the women had an astonishing idea.

They formed a human chain from their houses 'and pail after pail of malodorous urine [was] passed down the line to be generously thrown over the landlord'.* The ringleaders were imprisoned and the tweed suffered, too. There was an acute shortage of mature urine for waulking that year 'and an enterprising shop-keeper somewhere cashed in on it by importing bottled ammonia ... For the pee-tubs of Harris, time was trickling out'.

When Annie Johnston described the waulkings of her childhood in Barra in 1910, she said that the toughest cloth to work was the blue cloth woven to be worn by the men on the fishing boats. It had to be thick and waterproof, and needed two teams working in turn.

* The landlord, once he had cleaned his stinging eyes, said he was glad to have his fields sown for free. He didn't know that the protesters had actually sown a bag of sago pearls – which look, from a distance, like seeds – and that those fields would yield no harvest for anyone that year.

In 1934 German film-maker Werner Kissling spent a summer filming a documentary on Eriskay, north of Barra. The women waulking tweed included Peddy McMillan, Mary Theresa McInnes and Mary Johnston.

Five to ten women would sit along each side of a grooved board that was about five metres in length and rested on trestles. The web would be unrolled and saturated with stale urine, warm water and soapsuds. Then the women, singing all the time, would work it vigorously across the grooves of the frame, so that it moved sunwise around the table, until it had shrunk to the required width. Sometimes, when they were tired, the board would be put on the ground, and then they would work it with their feet rather than their hands.

Our word to walk – to go from place to place, to pass along, to travel on foot, to wander, to journey – is the same word as waulk. It comes from the movement of the cloth as it is shifted around the table in a rhythm. It is a Germanic word that came into Old English, and the sense can be found in German today. If you want to say 'to walk' you say *gehen* or *wandern*, while *walken* is purely a textile word, related to the journey of wool after it comes off the loom, before it is finally ready to be thought of as cloth.

Once it was thickened, the waulked tweed would be washed in a stream, and then folded and rolled as hard and even as they could make it. Finally, it was consecrated. This would be done by three women, with the oldest one beginning. She would take the tweed and move it round the frame a full turn. 'I give a sunwise turn dependent on the Father,' she would say. 'I give a sunwise turn dependent on the Son,' the next would say. 'I give a sunwise turn dependent on the Spirit,' the youngest would say, and the magic of the ritual would be done.

6

PASHMINA

*In which the author meets a fibre that led
to the invasion of a kingdom.*

When I was nineteen, I went to work as a volunteer teacher in a Tibetan refugee camp in Ladakh in northern India, high in the Himalayas, east of Kashmir. With the optimism of youth, I packed only one change of clothes, convinced that I would pick things up while I was in India. But I had adopted, enthusiastically, the local five-stage method of washing – bash clothes hard against a rock in the river; watch dust run out; bash again, wring and dry – and the cheap cotton shirts and trousers I'd bought in Delhi fell apart within two washes, while my clothes from home developed holes as well.

On my day off, I took the bus into the capital, Leh. In 1984, tourists didn't visit Ladakh in the vast numbers they do today, and I hadn't seen anywhere where I could buy clothes suitable for teaching in. Almost all the local women, even the young ones, still wore *goncha* – traditional dark-crimson calf-length gowns woven from thick sheep's wool to keep them warm through the bitter winters. The Tibetan refugee women had their own lighter *chuba* dresses, made of grey cotton for summer, with striped aprons tied around their waists to indicate that they were married. If I were to try wearing either outfit around the camp, everyone would just laugh. What I needed was a tailor. And some cloth.

I walked away from the main market with its vegetable sellers and Kashmiri-owned antique stalls and headed towards the narrow back streets, which smelled of kerosene and cow dung. The streets were trimmed with stalls selling fabrics and I absent-mindedly felt the bales as I passed. Rough, rough, rough, rough, nylon-slippery, rough … nothing to make the kinds of clothes I was imagining. And then, at the back of a row, was something soft. I stopped and felt it again and

looked. It was almost laughably plain, the colour of a sparrow, or of the desert foothills of the mountains around us. But the texture was marvellous. I pulled a sample out and it inflated slightly, like it was breathing. The shopkeeper appeared, as if by magic.

'What is this cloth?' I asked.

'It's *pashm*, madam,' the shopkeeper said.

The late twentieth-century fashion rediscovery in the West of pashmina shawls was still a decade in the future so the word meant nothing to me, but it sounded nice, like the soft 'puff' the material made when it was unfolded.

'It's from a goat,' he said. 'It's very famous.'

'I haven't heard of it,' I said, stroking the fabric, wanting it.

'You should know about this,' he said. 'In 1834, the Indians from the plains invaded Ladakh to take the pashm from us. This is not just fabric. It's life and death.'

'Is it like cashmere?' I asked, because that's what it felt like. He said that it was from the same goat, though cashmere is wool from the whole fleece, so it can vary in softness, while pure pashm is only from the belly.

The price he quoted was more expensive than the Olympus Trip camera my parents had bought me the Christmas before.

I couldn't afford it. Even if I could, it was too soft to make into the shirts and trousers I needed. So I didn't buy it. But I wanted it; I wanted it very much.

I went back to look for him a few times. I tried again the following summer when I returned to Leh, a social anthropology student now with a dissertation to research. I visited all the little streets near the polo ground where I was sure the magic fabric shop had been, paced the grid methodically up and down. But I never found it, or him, again.

For which a kingdom was lost

If you visit Ladakh today, it feels like the end of a road. It's a series of mountains and valleys in a high, dry corner of India, flanked by Pakistan and China on two sides and by snowy mountains on all sides. It's a place of army camps and disputed borders and, at its margins, road sentries wearing military uniforms, to whom you need to show a sequence of Inner Line Permits, to allow you to access each area.

Beyond Ladakh to the north and east there's nowhere you are allowed to go overland. Only nomads can cross the frontiers, and since the 1963 Indo-Chinese war even some of those have been excluded from their old grazing grounds, on the Tibet side of the border.

But it wasn't always so. For most of its history, Ladakh was a between place not an end place, a seam and not a hem. It was the trade route linking northern India with Tibet and the ancient markets of Yarkand and Kashgar in today's Xinjiang region of China. For most travellers in the past, Leh was just a place to stop on the way to somewhere else.

It's an astonishingly high, dry region, even today only passable by road from May to October. The land below the white peaks is the colour of dry earth and stones and natural wool, except for those places where water tumbles from the glaciers, and then the landscape bursts into bright green threads of fields and apricot orchards where people have lived for thousands of years.

It is an extreme contrast to the valley beside it: Kashmir, always fought over, still fought over, because it is rich and fertile and full of flowers and good soil, and it is beautiful in summer and strategically placed between powerful nations. And also, for a long time, because it made a special, expensive fabric that the rulers of many lands and many different religions longed for. And it had almost unique access to the wool.

It's not clear how long that's been going on: the art historian Moti Chandra suggested in 1954 that the medieval writer Kshemendra recorded in the eleventh century 'the shawl-weaving industry of his country', when observing that a tutor employed to teach the children of a household he knew of was instead whiling away his time in 'spinning (*kartana*), drawing out the patterns (*likhanam*) and weaving the patterns on the strips with *tujis* or eyeless wooden needles'.

It was a process, Chandra said, that was 'analogous to the modern shawl-weaving in Kashmir'.

Other scholars have challenged that eleventh-century date, but certainly, by the fifteenth century, a hundred years after Kashmir had converted to Islam, a very particular kind of technique had emerged. One legend claims that the eighth Sultan, Zain-ul-Abidin, who reigned from 1418 to 1470, summoned Nakad Begh, a famous weaver from Turkestan. He asked him to come and work for him, and adapt his community's techniques for making flat-weave kilim carpets to

It takes many bobbins and several years to make a Kashmir kani shawl.

the making of precious shawls. Another has it that the skills came a century earlier, with a Sufi scholar and saint, Mir Syed Ali Hamadani, who brought with him hundreds of craftspeople from Central Asia to revitalise Kashmir's skills and economy.

It was certainly around this time that an unusual and elaborate tapestry technique came into use among the shawl makers of Kashmir. It involved using several colours of weft thread to build up the design. Instead of a shuttle, each colour was stored on a long wooden bobbin until it was needed again. It became known as 'kani', after a Persian word for bobbin. It was complicated, and all those colours along the weft made for a fairly messy reverse side. So the best decorated Kashmir kani shawls often came in twos. They were called 'doshallahs', which translates as 'two-shawls', and they were worn together, back-to-back, so that the wrong side was never seen by other people. I'd noticed them at times in museums and in antique shops and I'd seen pictures of all the bobbins – sometimes up to two hundred of them – lined up across the loom like colourful pick-up sticks. But I'd never looked at them carefully.

An arrival and a departure

In August 2015, I flew to Leh to join a snow leopard conservation

project. We were going to hold workshops in remote monasteries in Zanskar to explore with Buddhist monks and nuns how they could be central to animal conservation. I had been back to Leh only once since I'd taught there in the 1980s, and, as I'd discussed with my mother the weekend before I left, if I ever *did* write 'that fabric book', the visit would be a chance to research the fibre for which a remote mountain kingdom was once overthrown. I might even get to Kashmir and watch it being woven into shawls.

The only way to survive arriving by air into a place that is three and a half thousand metres above sea level is to treat altitude sickness with respect. You fly into Leh early in the morning and stay in bed for the first day, otherwise the headache is hard to shift and can last for several days.

I'd been good. I'd drunk plenty of water, had gone to bed straight away hugging a hot-water bottle, and had slept in my hotel room all day. It was a military zone so foreign phones didn't work. There was nothing to distract me. In the evening, I started to read.

First, I realised that the colours of the snow leopard – grey and white and sandy and black – are the same colours as the Ladakh wool: the colours that blend with the land, the colours of the land itself. There are only seven thousand snow leopards in the wild now, and only three hundred in Ladakh: they stay high in the mountains and are extremely hard to spot, even by experts. I looked through the dark window glass to where I knew the mountains were, and I thought of the snow leopards far away and about how fragile their future is.

Then I turned the page and read about the animals that the snow leopards like to eat. Two of them were animals that produce incredibly soft kinds of fabric. One was *Capra hircus*, the domesticated Himalayan goat, also known as the pashmina goat. Its ordinary coat is very fine, less than nineteen microns thick, finer than merino wool, and it is used to make all true cashmere sweaters. But when these goats are kept at very high altitudes, the hair that grows on their bellies over the winter is even finer, less than fifteen microns, and it can be removed from the goats by combing. This is the wool that is called *pashm*. This is the wool that makes the pashmina shawls.

Then there is another prey animal, that makes another kind of shawl – the wild Tibetan antelope or chiru, which lives mostly on the Changthang plateau in the east of Ladakh and the west of Tibet. And its finest, soft, belly wool is less than ten microns thick.

CASHMIR GOAT.

It is called shahtoosh, meaning 'king of wools', or, perhaps, 'wool of kings'. A shawl woven from it is called a 'ring shawl' because despite it being enormous (about one metre by two metres), it can be passed softly and smoothly through a wedding band without getting stuck. It's also extremely warm.

For a long time, the sellers of shahtoosh claimed that they only used hairs that chiru had shed while moulting, and indeed when British travellers visited Kashmir and Ladakh in the early nineteenth century, they also reported that the hairs were plucked from bushes after the animals scraped them off in springtime. One visitor reported that some people believed it to be a kind of cotton.

However, the shawls have always fetched astronomical prices. In the past they were prized dowry items; an article I found later in *National Geographic* estimates that in the twenty-first century they could cost up to twenty thousand dollars, and even when they were still legal, the cheapest were more than a thousand. With that kind of price tag, many traders didn't wait until passing wild antelopes conveniently brushed their tummies against a shrub. They shot them. Five female chiru or three males died for each shawl and over a century numbers went down from around a million to seventy-five thousand. Shooting chiru has been illegal since 1979; since the early

2000s the shawls have been illegal too, as well as unethical. My snow leopard conservation colleagues had promised to tell me more when I met them the next day.

Meanwhile, I reminded myself of how the domestic pashmina goats are grazed on the highest passes. Many of them spend their summers on the Changthang plateau, close to where the chiru live. The people who tend them are often nomadic, although some are settled pastoralists. The nomads follow ancient trackways and they don't always pay heed to political borders.

When I had first come to Ladakh in the 1980s, the whole of the Changthang had been closed to foreigners and we used to look towards the east and dream of going there. Now an edge of it was open, with a permit that was apparently easy to obtain. Perhaps while I was here, and after my workshops had finished, I could go, and see the summer pastures of pashmina goats for myself ...

I read until I fell asleep. Then at two o'clock in the morning there was a knock on my door.

It was Nabi, the hotel owner. He was a kind man; I'd stayed with him once before and had come to know his family. He looked serious.

'Your husband is on the telephone,' he said and he passed me the handset.

I felt sick. I'd been dreading it and expecting it too. Every time I'd said goodbye to my father since the stroke that nearly killed him ten years before I had wondered if it would be the last time. I took the phone. There was a pause. I heard the crackle of static. And my heart.

'I'm so, so sorry,' Martin said after a moment. The phone crackled again.

'I'm sorry, I didn't hear,' I said. I looked out of the window at the blackness. Scared. And then I did hear.

'It's not your father. I'm so, so sorry. It's your mother.'

She'd had a subarachnoid brain haemorrhage. Such a strange word. It sounds like spiders and it means the space on the inside of the skull, lined with a mesh of blood vessels, like a web. It can be surprisingly vulnerable, sometimes.

My mother had been at home, with a friend, drinking coffee. Without warning, she had grasped her head in pain. I later heard that it's the most painful headache possible. She had the presence of mind, and courage, to walk behind the wheelchair of my father, who was partially deaf, to reach the sofa where he couldn't see her. She'd

screamed in silence so he wouldn't have to know. The friend had called the ambulance. My mother was in intensive care. The doctors weren't expecting her to survive the night. The hour.

My brother was there.

Nabi left me the phone and Martin booked me on the first flight to Delhi. It would leave at seven forty. It was three o'clock now.

And then there was just me in a small room with the dogs barking outside and the dark garden.

I looked around the room. There was nothing to pack. There was nothing to do. But I couldn't sleep.

I had always been cautious in Leh after dark: some of the stray dogs have rabies. But now I left the hotel and walked and walked in the velvet night. It was as if I didn't exist in the real world any more. I floated along small alleys, through main streets. I was in a deep valley between high mountains, and I was in a ward in a Devon hospital. I heard dogs close in and saw their eyes reflecting the streetlights. They snarled. I didn't care. I reached out to one. It licked my hand.

I stood beside a giant prayer wheel, big as a barrel, set up beside the roadside. I turned it, clockwise as you have to. But what I wanted was to turn back time. My mother had always wanted to see Ladakh, my growing-up place, and now she never would. Or perhaps she would. I pushed the prayer wheel again, praying for a miracle.

I smelled the wood fires being lit before dawn and heard the call to prayer from the mosque. I was empty, exposed, I was so light I was adrift, I was lint in the air.

On the palace on the hill I could see a line of prayer flags. I knew they were blue, white, red, green and yellow – always in that order to represent sky, air, fire, water and earth – but now in the half-light they just looked moth-coloured, little triangles and squares on a line on the crag. The cloth is said to hold the prayers that are printed on it, and then, when the breezes blow, to release them to the elements, with the wind carrying the prayers and the hope far away, to those who need them.

I needed them. My mother needed them.

I remembered how, when I was eight or nine, she had taught me to check myself. She had studied to be a yoga teacher and had practised meditation for as long as I could remember.

'First check your toes, Toria,' my mother had said. 'Then your knees, then your hips, then your stomach. Then your ribs, your heart,

your throat, your eyes, your head, the top of your head. Find where you're happy and find when you're scared or not comfortable. And stop in those places and breathe into them.'

And now as I breathed into those empty, frightened spaces, I sensed something. It was to become familiar. A dog turning around and around in my bowels, trying to get comfortable. I had never known the bowels were a nesting place for grief. But that night I began to learn that grief makes many places in the body heavy.

It felt as if there were three of us walking the rubble-strewn streets of Leh that night. There was myself there in the present time, afraid of tomorrow; there was myself there as a teenager thirty years before, afraid of nothing; and there was my future self there too, the only one of us who knew how this story would work out.

Except, I wondered: after all this, would I ever go back to Ladakh?

An invitation

'I wonder if I'll ever go back to Ladakh,' I said idly to Martin one morning a year later.

'Do you want to?'

'I don't know. I don't know if I could bear to.'

A few hours later, I received an email. It was an invitation to speak at a government-sponsored conference about a Buddhist monk, Sri Kushok Bakula, who had died thirteen years before. He had been a great environmentalist, a holy man, a diplomat, and the charity had worked with him. It would be in October. In Leh. Could I come?

I had admired Sri Kushok like I had admired few others. I could meet the snow leopard team this time. I could take my mother. I could research pashmina. I wrote back, feeling a fizz of excitement. 'Yes.'

Ancient fabric; new ideas

I was far from the first European to develop a fascination with this softest and finest of fabrics. Kashmiri shawls had been arriving in Europe in dribs and drabs since the early 1600s, when Thomas Roe, England's first ambassador to India, was given one by the Mughal Crown prince Khurram (later the emperor Shah Jahan) in 1616. They were undergoing the particularly tricky bit of negotiation over the

trade concessions we encountered in the cotton chapter, and he found the gift of an expensive shawl to be a complicating factor, and rather a nuisance, since he wanted a permit to trade, not a piece of pretty material, which he wasn't, by the rules of his own engagement, really allowed to keep.

'And pressing mee to take a Gould shalh, I answered wee were but newly frendes', he wrote in his journal for 5 August 1616. According to Roe's editor William Foster, in 1899, this was the first time the word 'shawl' had been written in English. Roe didn't think to gloss it in the book he published on his return, however, so perhaps the concept of a shawl was known to his readers after all.

In the following century and a half, a few more of these gifts from the Mughal court were brought back to Europe – by diplomats, obviously, but also by soldiers, missionaries and East India Company traders. But in the strange way of these things, it took two revolutions, one in North America, one in France, to turn these curiosities into an ultimate fashion item.

In 1776, the US declared independence from Great Britain. Thirteen years later, the French people overthrew their monarchy.

New kinds of politics were born in Europe and America in those years, and with them, new kinds of fashion emerged. The ruffles and the flounces, the big hair and hoops and shot silk and fake beauty spots and the entire rococo world of Versailles no longer worked. For men, the fashions were more sober: darker clothes with fewer frills: the pantaloons and banyans (long coats) of the last century altered and tightened, ready to evolve within a generation or so into the trousers and frock coats of the Victorian period.

Some of these newly expressed ideals seemed inspired by a (fairly vague) harking back to sophisticated, ancient cultures not dominated by religious structures; societies that championed a sense of simplicity, of casting off the fripperies of corrupt courts; new societies with senates, consuls, Roman kinds of things, no kings. The trend was catching: even those places that still retained the older kinds of political structures began to look for something new in their fashion. So in those last years of the eighteenth century, dress designers throughout Europe and America started looking to classical images and statues for inspiration: clean lines, white dresses, flat silhouettes.

Many Roman statues showed women wearing loose garments made from a long rectangular piece of cloth, which appeared in their

stone depictions to fall softly and be made of something sheer like muslin or silk. The item was called a *palla* in Latin and it was, both actually and linguistically, very similar to the *pallu*, which is the name in India for the long, draped end of a sari, or indeed the edge of a Kashmiri shawl. Both words describe a sheer garment that reveals a woman's physical features while allowing her to appear demure at the same time.

Many Roman women no doubt did wear the *palla* modestly, so that the shape of their body would be obscured. However, like any draped garment, it could also be worn more strategically, to emphasise the wearer's shape and bearing.

Such soft draped fabric suited the new simple dress shapes that were called Regency style in Britain and Empire style in France. But classical style originated in Mediterranean climates, and saris were designed for Indian latitudes. Paris and London were not quite as warm. And this is where the cashmere shawls came in. They could be arranged in graceful folds over the sheer fabric of the new dresses, looking startlingly different (at first), while keeping the wearer warm.

By the late eighteenth century, pashmina shawls had begun to arrive in Europe as fashion items rather than as diplomatic gifts. A 1778 English fashion plate shows a woman in formal dress clearly wearing an Indian shawl around her shoulders. And in exile at St Petersburg after 1791, Louis XVI's former favourite portrait artist Élisabeth Vigée Le Brun used them liberally in her *tableaux vivants* – which were carefully composed static scenes complete with live models, a popular form of entertainment. 'I used to choose the most handsome men and the most beautiful women and drape them with some of the countless cashmere shawls at our disposal', she said.

In around 1799, Napoleon Bonaparte sent a parcel back to Paris for his wife Marie-Josèphe-Rose – Joséphine. He was then a senior army officer, fighting a campaign in Egypt. She was a beautiful, Martinique-born divorcée, aware that everything Egyptian was extremely fashionable and keen to receive whatever treats her husband had found for her. When she learned that rather than sending anything Egyptian he had despatched two Kashmir shawls, she was disappointed.

'I have received the shawls', she wrote to her eighteen-year-old son Eugène de Beauharnais, who was in Egypt as aide-de-camp to his stepfather. 'They may be very fine and very expensive but they are very ugly. Their great recommendation is how light they are.'

'I do not think this fashion will take off', she then predicted, adding that it didn't greatly matter, as she was pleased at their warmth.

Three of her friends also received Kashmir shawls from their soldier husbands. At first – wrote a contemporary – they all 'wore them only because the dress was strange for we all thought it fright-ful, and not to be adopted. However, from that time they became the universal rage; and truly unfortunate was the *élégante* who could not procure one of these *ugly* shawls.'

Joséphine herself eventually procured between three and four hundred of them.

'She had dresses made of them, coverings for her bed, cushions for her dog', her lady-in-waiting Madame de Rémusat recalled. 'She always wore one in the morning, which she draped about her shoul-ders with a grace that I never saw equalled.'

Napoleon, who thought that they covered her too much, 'tore them off, and more than once threw them in the fire; after which she would then send for another'. Once, in 1800, Joséphine was so busy having her shawl folded according to the 'fashion of the Egyp-tian ladies' before leaving for the premiere of Haydn's *Creation* at the Paris Opera, that her husband departed before her at a more crack-ing pace than usual, while her own carriage was unexpectedly later than scheduled. It meant that when a bomb intended to kill the First Consul exploded in the Rue Saint-Nicaise, it did so between the two, catching neither of them.

The close shave only encouraged Joséphine's passion for shawls: after that she bought all the fine ones offered her, no matter the price. 'I have seen her buy shawls for which their owner asked eight, ten and twelve thousand francs', de Rémusat reported. 'They were the great extravagance of this Court, where those which cost only [two thousand francs] were looked at disdainfully, and women boasted of the prices they had paid.'

Over the Channel it was the same. Englishwomen were paying two to three hundred pounds for the best ones. The same money could buy a small house, and was at least five times the annual salary of a labourer. The fabric wasn't just for women. George Bryan Brum-mell (also known as Beau) – the main male fashion influencer of the 1820s who introduced the suit and necktie to European salons – wore the same cashmere waistcoat every morning for many years. It had been cut from a shawl, which 'from the beauty of its quality, must

have cost a hundred guineas', his friend William Jesse estimated. 'The ground was white, and though the waistcoat had gone through a French washerwoman's hands for many winters, it was still in as good a state of preservation as himself.'

The wool was the thing. No other wool could compete with the finest pashm, either for softness or for strength. The weavers of Kashmir and the traders of the plains needed more and more wool to fulfil the demand. So they looked towards Ladakh and Tibet to find it.

Wool treaties and wool wars

While Kashmir had been invaded many times over the centuries, Ladakh had stayed a fairly independent Buddhist kingdom since its creation in the tenth century during a time when the wider Tibetan empire was fraying at the edges.

There had been some challenges to that independence since, including in 1664, when the Ladakh king had been forced to beg the Mughal emperor Aurangzeb for help against a likely invasion from Tibet. But its status for many years as a buffer zone between two rival powers helped protect it. And both sides had an interest in protecting the trade routes of the precious pashm wool.

Then in 1681 a joint Tibetan-Mongolian army marched on Leh, slaughtering many of its inhabitants and capturing almost the whole kingdom except for one fortress along the trade road to Kashmir. It held out for three years until Mughal forces eventually came to its assistance. The resulting treaty, signed in 1684 at the king's palace at Tingmosgang (now Temisgam), changed the shape of the cashmere wool trade for hundreds of years, as well as reconfiguring the religious, political and economic future of everyone in the region.

As a concession to the Tibetan-Mongolian victory, Ladakh was reduced to half its former size. The frontier was fixed (to roughly where it's being fought over by India and China today);* and the Dalai Lama's Mongolian-style Gelugpa, or 'Yellow Hat', brand of Buddhism (still the most prevalent) was formally imposed above the three other Himalayan Buddhist sects as well as the indigenous Bön shamanistic faith.

* That border included the Lhari stream at Demchok and an imagined line across Pangong Lake.

As a concession to the Mughals a large mosque was built in Leh, a system of regular tribute was instigated, and, most importantly for our story, the rules about the sale of goat wool from West Tibet to Kashmir via Ladakh were fixed by treaty for the first time.

From then on all goat wool was to be sold to Kashmir for a fixed price.

Four Kashmiri merchants were to live at Spituk – the settlement where the road from Leh first meets the Indus valley – and these were the only people permitted to trade on behalf of Kashmir for pashm wool. They would pay for it with silver coins, and bricks of black tea, which were in high demand throughout Tibet where butter tea is a staple.

In addition, only Ladakhi merchants were allowed to cover the roads between Spituk and the Tibetan border to buy goat wool from Changthang and Tibet. Neither Kashmiris nor Tibetans were granted this privileged access.

Over the next one hundred and sixty years the Tingmosgang treaty just about held. But the Mughal empire was getting weaker. Hindu Dogra and Sikh leaders were filling the vacuum. And the British East India Company was all the time gaining power. That same period also saw growing demand from Europe for Kashmiri shawls. And Kashmiri shawls needed the wool from the high pastures of Ladakh and Tibet.

Not a single blade of grass

It was summer 1834 when General Zorawar Singh headed north from the plains, accompanied by ten thousand well-armed and well-trained Dogra soldiers. (This was the invasion that the shopkeeper in Ladakh had told me about.) His aim was to take control of the pashmina wool trade routes.

They marched up the Suru Valley through Zanskar towards Leh. The local people were terrified – for their own safety but also for the safety of their crops. These are harsh climates and tough mountain landscapes, and if you're left without food or animal fodder or seeds, you might not survive the winter. Zorawar Singh won their support by ordering his men not to 'touch even a blade of grass'. They obeyed, and his progress up the valley was made easier by the villagers' gratitude for this.

When they reached Ladakh, King Tshepel Tundup Namgyal invited a small group to meet him and negotiate an agreement. And then he laid an ambush. The Dogra delegation would have been eliminated had not one of the members escaped and run for help. Zorawar Singh was so furious by the betrayal that he stripped the royal palaces of everything he could find – silver, gold, tea … and all the pashm wool. Later, after leading an invasion of Tibet, the Dogras successfully established a monopoly on the shawl wool trade, and in 1846, after the first Anglo-Sikh War, in which the Dogras had sided with the British, Ladakh officially joined the princely State of Jammu & Kashmir, under the Dogra ruler, Maharaja Gulab Singh.

As part of the absurd terms of the agreement Gulab Singh signed that he 'acknowledges the supremacy of the British Government and will in token of such supremacy present annually to the British Government one horse, twelve perfect shawl goats of approved breed (six males and six females) and three pairs of Cashmere shawls'. In exchange, when he visited British-controlled territory, the Maharaja would receive a nineteen-gun salute.

And so the independent kingdom of Ladakh became part of India. It did so not just through the vagaries of geopolitical forces that could have a local ruler acknowledging the 'supremacy' of a government based half a world away, but also because of the even less predictable whims of fashion, and the shifting patterns of trade and money that are its constant companions.

The pashm wool supplies have been travelling, mostly unhindered, from Leh to Srinagar ever since: at first on packhorses and yaks, today on brightly coloured trucks. But it still usually happens during the summer when the passes are open, so the shawl makers of Kashmir are able to spend the long, cold winter months weaving and embroidering their magic.

The material remains

I did take my mother to Ladakh. And my father. The ashes were like talc; soft and pale grey. I put a handful of each into two separate Ziploc freezer plastic bags. I labelled them with a blue indelible felt tip as 'M' and 'D so I would know who was who. It looked odd, so I wrote out their names in full. Then I added their dates: Jeannie Finlay, 18 December 1933 to 25 August 2015; and Patrick Finlay, 3 July 1926 to

26 November 2015. That was all more formal than I felt, and increasingly ridiculous, but I wanted to make sure it was more credible, just in case any officials were interested in what I was carrying. I planned to take them as cabin luggage, as I'd take any other precious thing, but the friend with whom I stayed in London the night before was strict.

'What if they don't let you, and then you have to leave them in the rubbish bin along with the nail scissors and bottles of water?'

They travelled in the hold.

The real beginning of the quest

When I arrived back in Leh for the conference, I learned that Indian-controlled Kashmir was under curfew. It was the latest stage of a modern conflict that had started during Partition in 1947, at which point both India and Pakistan claimed it, it was divided in two, and then a separatist movement emerged, demanding full independence from both.

I sat in the coffee shop of The Grand Dragon Hotel drinking tea with Salman Haider, a former Indian Foreign Secretary, and Siddiq Wahid, a Ladakhi academic who had taught at Harvard but was now living in Srinagar. The two were old friends, their interactions joyful, energetic, funny, clever. They discussed the Kashmir situation, which had meant total daylight curfew for the previous three months. Nobody was allowed out on the streets in the daytime; it was hard to get supplies, and it was impossible even to know the extent of the suffering of ordinary families without money from working. Getting to the airport had been difficult for Wahid; he'd had to leave after dark and thought until the last minute that he would not get there on time.

Should I go to Kashmir? I asked them. To see if I can find traditional weavers who will show me how they make their fine, tapestry-worked kani shawls?

'Perhaps,' said Haider, who, when I had told him about this book, had had some thoughtful insights about the nature of quests. I could go, he said. But if I did, this would be the not-finding bit at the beginning of my chapter. 'You won't be able to go outside where you're staying and you won't find what you're looking for. It won't be a resolution. Why don't you see what you can find out here?'

The Grand Dragon Hotel had a shop. It was closed and I was told the manager was in Srinagar. I looked through the window and it was full of shawls, though they didn't look like the best kinds.

After my conference was over I decided to accept the invitation to accompany my snow leopard colleagues when they gave a talk at a government-run boarding school. The school was in the Changthang, near the brilliantly blue, salty, Pangong Lake, which forms part of the border between China and India.

It is a land where many of the world's pashm goats are grazed. It is also a land where the nomads use images of warp and weft to describe the fabric of their society.

When I was teaching in the Choglamsar Refugee Camp school so many years before, most of the children were Tibetan but some were Ladakhi and some of those were the children of nomads in the Changthang. I remember one little girl talking about her family by weaving her fingers through each other. Her mother was married to two brothers – a traditional Ladakhi and Tibetan way of keeping family wealth intact. She showed me how it worked by holding out three of the fingers of one hand – as if to show the warp made up of her two fathers and one mother – and then weaving through them the fingers of the other hand to show herself and her brothers and sisters. As if they were the cloth, spreading out into the future.

Now it was mid-October, so I knew that most of the nomads would have left the high pastures for winter grazing at a lower altitude further south. But perhaps I'd be lucky, and meet someone who herded pashm goats for a living.

Journey to the Changthang

The Indus river in Ladakh flows between two land masses. On the south is the Indian tectonic plate, with igneous rocks, shaped by volcanoes. On the north is the Eurasian plate, with sedimentary rocks, shaped by time. The contrast means that the grazing lands and animals are different on either side of the river. This is a place of small earthquakes and rare species.

'Look at a map of biodiversity hotspots, and compare them to a map of tectonic plates,' said Tsewang Namgail, director of the Snow Leopard Conservancy India Trust. 'They show a remarkable correlation.'

It was as if the most interesting and fragile creatures live in the most interesting and fragile spaces of the world, I thought, settling into my seat on the jeep. They are the between places where one

Tsewang Namgail, Tsewang Dolma and their
son Odkar with Pangong Lake behind.

land slips into another, and if you didn't know better, you might think that it was because they have slipped into our world through the cracks.

We were only ten kilometres from Leh, crossing the dry landscape along the north side of the Indus. Tsewang was driving. Also in the Maruti Gypsy jeep were his wife Tsewang Dolma, who is the Conservancy's religions programme manager, their three-year-old son Odkar, and their colleague Tsering Angmo.

Just before we reached Shey village, Tsewang suddenly stopped the vehicle.

'Urial,' he said. He pointed north to some indistinct forms among the desert rocks. Two of them ... no, three. 'It's two ewes and a lamb between them,' he said, passing the binoculars.

They were red-brown, skittish, with thin hindquarters that seemed to indicate that they hadn't eaten for a while. They looked like deer but they were wild sheep. The females had little curly horns like Chinese Tang Dynasty headpieces. If they'd been male, the horns

would have been larger, curling outwards on either side of the head to form an elaborate letter *m* shape. It was a rare treat to see them. There are only about two and a half thousand urial in Ladakh.

'They're too far down.' Tsewang frowned. In these areas, close to Leh, he had seen urial so close to the road only on very few occasions.

'They've come to find water because the springs are drying up,' he said. 'There's a new road, and the houses and gardens are using too much water.'

The urial is one of the four wild 'prototype' ancestors of all domestic sheep today. The argali is another; it is also found in Ladakh, though on the Indian tectonic plate south of the Indus. It is bigger than the urial and the horns of the males can grow thicker, and curl around themselves up to three times. The other two ancestors of domestic sheep are the North American bighorn, hunted nearly to extinction, and the red mouflon, introduced to Europe by Neolithic people and still found in Cyprus and the Caspian region around eastern Turkey and Armenia.

We went higher and it became colder. This is one of the few places in the world where you can suffer from frostbite and heat-stroke at the same time. We passed villages with square houses, and gardens with willows and apricot trees. In the distance we could see settlements tucked below each glacier, with white temples glistening on the hills around them. Horned larks – plump, like bunting – flew up as we passed. The flowers became more yellow. 'You don't find red flowers high up,' Tsewang said. It was the same with the birds: the red-billed chough (a kind of crow) is found at lower altitudes; yellow-billed choughs only appear as you climb.

This was an ancient road, one of the highest in the world. It had been travelled by people for millennia – traders, pilgrims, soldiers, travellers, nuns, monks and nomads – crossing from one side of Asia to another. Silk came along here, and raw pashmina wool. And after all those years and travellers, and despite the arrival of modern road-building machinery, it is still a precarious route. There are avalanches and rockfalls, and its surface would disappear in ten years if it weren't maintained by permanent gangs of road workers; men and women with their sun-darkened faces hidden behind scarves to stop the dust. They were burning tar in big metal cans at regular intervals: roads in the high Himalayas have a very particular smell. It reminded me of something, but I couldn't for the moment work out what.

As we drove, Tsewang told me that ever since shahtoosh ring shawls had been made illegal, the chiru have been returning to the Tibetan plateau. There are only about three hundred on the Indian side of the border, but most were close to where we were heading, in the area around the hundred-and-thirty-five-kilometre-long Pangong Lake. It has been a conservation success story, although one with complex repercussions.

After the ban, some eighty thousand people involved in the shahtoosh shawl trade in Kashmir needed to find something else to do, and many shifted their attention to pashmina shawls. Some buyers have continued to buy shahtoosh illegally.* But many others have shifted to buying the very finest pashmina: all of which means that since the 1980s there has been increasing pressure on herders to keep up with the demand.

In the past, the nomads kept a fairly even balance of yaks, sheep and goats: yaks for transport, sheep for meat and their own heavy clothing, and goats for wool that could be traded and sold. But now there are fewer sheep, because fewer Ladakhis wear traditional *goncha* robes and also because an increasing number are becoming vegetarian as a result of campaigning by Buddhist organisations. There are also fewer yaks and horses, as more people are using Maruti jeeps to transport heavy goods over the passes.

But despite this, in the twenty years from 1980 to 2000 the total number of livestock on the Ladakh side of the Changthang area doubled from one hundred thousand to two hundred thousand, and today the numbers might be higher. Most are pashmina goats, roaming across the land, and clearing it of the specific kinds of vegetation that goats particularly like (which are most kinds). Goats are famously voracious – on Greece's remote Samothraki island, where

* In 2019 *National Geographic* reported that people arriving on private jets into St Moritz were regularly caught with shahtoosh. Between 2015 and 2018, Switzerland confiscated more than two hundred – representing up to one thousand antelopes. Customs officers can tell the difference between fine pashmina and shahtoosh because under the microscope the guard hairs of the chiru – harder, crinkly hairs, of which there are always a few in every shawl – appear filled with tiny air bubbles, looking like flagstones, while the pashmina equivalent have dark strips with white edges and look more like 'a freshly paved street with pale gutters'. Fines are just a few thousand dollars, significantly less than the price of some of the shawls.

they outnumber humans by a factor of twenty-five, it was reported in 2019 that the seventy-five thousand goats were out of control and had eaten parts of the island into a moonscape. In Ladakh and Western Tibet, some of the land is already like a moonscape and the global increase in demand for pashm and cashmere wool has led to looser soil and deteriorating pastures right across the region.

In addition, some local people have tried to protect their shawl goats by shooting snow leopards, or by putting out poisoned carcasses. 'It's been killing wolves as well as snow leopards,' Tsewang said. 'And there has also been a steep decline in vulture population in Ladakh.'

Odkar had clambered into his lap, wanting to drive. Tsewang let him sit there for a moment while he negotiated some potholes, then heaved him gently into the back and continued.

'If snow leopards become extinct then the populations of wild ungulates will explode,' Tsewang said. And if that happens, together with the increase in shawl goats, the vegetation will disappear.

'It's already leading to floods and a change in the water table,' he said. 'Which is serious when you think that two billion people rely on the water and weather systems from the Himalayas.'

Meeting the goats

We drove over the 5,360-metre Chang La, one of the highest navigable passes in the world, with its military installations and prayer flags. As we descended, I spotted a herd of mostly white goats in a meadow beside the road. Tsewang confirmed that they were the right kind and stopped the jeep.

Their long hair gleamed in the afternoon sun. They had dusty pink noses and long faces that were almost aristocratic. They had soft, floppy ears that looked like ringlets, and the older ones among them had neat black horns. They looked like the goat equivalent of white Afghan hounds. They were adorable.

We talked to the woman who was looking after them. She was sitting quietly on a rock about twenty metres below the road, spinning woollen yarn on a hand spindle. If she was surprised to see us she didn't show it. Her name was Angmo and she came from Taktak hamlet up the way. She didn't know how old she was. She had a hundred and twenty goats. They hadn't yet sold this year's shearing, but the price was decent. 'Better than ten years ago.' Each goat

provides about a quarter kilogram of wool. 'It's OK,' she said, with Tsewang translating. 'It's enough to live on.' A goat came closer and tried to eat my notebook. Angmo kept spinning.

She had sheared the goats seven months ago in March and now the wool on their backs and bellies was strong again, ready to protect them for winter. It would be even thicker by the spring, she said, catching a little white kid so that I could feel how soft its belly hair was. The kid nudged me in annoyance and ran off. Angmo kept spinning.

I watched the piece of wool moving towards the spindle. As it approached, it was rough, unformed; once it was twisted and incorporated into the spun yarn it became strong and fine; it gleamed like the goats. I was going to ask her to show me but there was an eruption of laughter from the jeep behind us. One of Angmo's billy goats was trying to get into the passenger seat where I'd left the door open. We thanked her and raced to stop it. 'They'll eat anything,' said Dolma from the back, laughing as she pushed it away from where it was sampling the seat fabric.

Later, we stopped on a high stretch of road far above any village. 'Bharal,' Dolma said. 'Blue sheep.' Everyone else, including Odkar, could see them straight away and was engaging in lively discussions about whether there were twenty or thirty of them. I couldn't even see one. As Tsering Angmo tried to give me directions (see that rock … move your eyes to the right …) Tsewang explained that the animals are neither blue nor sheep, but slate grey, and halfway between sheep and goats, common prey for the snow leopard.

Then I saw them. One on the scree in the sunshine and twenty (or thirty) more in the shade. You could tell them by their pale legs against the orange rock. Blink and they all looked like scree. With people's eyes so clearly attuned to subtle gradations in the mountains, I thought, it's no wonder that in this region beige shawls can be beautiful.

The next day, at the government school, most of the children were from nomadic families. Boarding was their only way of getting an education, though it meant that many would leave their parents' way of life behind as they dreamed of the things they had learned and seen. I talked to some of the pupils, who confirmed that the pashmina herds had already left for the winter. The ones I talked to hadn't ever been in charge of the herding. 'Not yet. I'm too busy studying,' said Tenzin, who was fourteen. 'Maybe this summer.' As we toured the small nature

reserve, I walked beside one of the schoolteachers, Gen Kunchok Gyalt-sen, who was also a Buddhist monk. Towards the end, I mentioned that I wanted to talk to somebody who had herded pashm goats.

'*I* herded pashm goats,' he said.

I gulped. The jeep was about to leave but I asked him to tell me more. When he was a child, he said, he tended yak and goats for his parents. He did it on and off from the age of eight to thirteen and he learned about where to find medicines in the hills, where goats find grass when their usual high pastures are covered in snow, and what the bleating of a kid sounds like when it's too far away to rescue from a predator.

'And then when I was thirteen I turned to being a monk.'

What did he think about, when he was herding?

'I didn't do so much thinking,' he said. 'Though I did dream.'

What did he dream of?

'I dreamed of climbing the mountains so I could see the world,' he said. 'And then I dreamed of becoming a monk.'

What you seek is sometimes there all along

'Guess what!' I said as I climbed into the jeep.

'What?' Dolma asked.

'Gen-la, the Buddhism teacher, used to herd pashmina goats when he was a boy!' I said.

'*I* used to herd sheep and goats when I was a boy,' Tsewang said.

'You're kidding!' I said. But he wasn't. And two days later, when we were back in Leh, we sat down in his office with cups of sweet milky tea and I heard his story.

Interview with a pashmina goatherd

Tsewang was ten when he was told that it was time he started looking after the animals. Weekdays were for school, but at weekends the children and young people of Skurbuchan village, west of Leh, took it in turns to take all the village's animals into the high mountains to graze. And now it was Tsewang's turn.

That first time, he was nervous. But he knew there were always two households responsible for herding at the weekends, so he hoped that whoever was assigned to go with him would teach him what to

do. Then he saw who the other person was. Another ten-year-old boy. Who also had no idea what to do. And they were both suddenly the only people in charge of several hundred animals.

'We took them to this valley and we were so nervous we didn't want to let them go because what do you do if they don't come back?' They packed them into a small meadow and watched them anxiously. Then a man saw them.

'This guy shouted from the other side of the stream: "What are you doing? That's not the way you herd! They can't graze like that. Let them go up in the mountains. Let them be free." And we thought, OK, if a goat gets killed, we'll say it was his fault. So we let all the goats out and they went out of our sight.'

It was a revelation to both boys that at four in the afternoon all the goats and sheep came from wherever they had been on the mountain and headed back towards the village. And most of them went straight to their own houses without needing anyone to direct them.

And so the routine started. Every six weeks, when it was his family's turn, he would get up early and have a heavy breakfast of buckwheat dumplings. Then he would grab a packed lunch of *tsampa* (roast barley flour) and *chang* (weak barley beer) with a salsa of coriander and chilli and salt and tomatoes that his aunt would prepare.

'I'm remembering it now and my mouth is watering,' he said.

Then he and whoever was herding with him would go around the village, shouting out '*Nor phingshig hey!*', which means 'Bring out your wealth!' And the villagers would shoo their wealth out of their stalls beneath the houses. And baaing and protesting, the wealth would go with the herders to the high pastures to graze. Although the goats that Tsewang herded were pashmina goats, he said, people did not shear the fine wool, for they did not produce pashmina good enough for shawls, due to the warmer temperatures in the part of Ladakh where he grew up.

Not that Tsewang ever wore such a thing as a shawl or a cashmere sweater himself. Like all the other children in the village in the 1970s he wore a *goncha*, made of rough sheep's wool. 'We didn't get a new one very often, but when we did, we put the older one on top so the new one didn't get dusty. We wouldn't change our clothes for the whole winter.'

In summer, they went barefoot. In winter, they wore traditional shoes made from felted wool, though there were some children in the

village who had rubber gumboots. 'I really coveted those; I wanted them so badly.'

He learned to shear the goats with a kind of scissor with curved edges. He'd also clean the fibre once it was shorn. 'We used to have a pile and take two sticks to shake it all so the dust would go. They used to make this swishing sound; I used to like it.'

It was lonely growing up. His mother had died and his father was away, trading, and he was living with an aunt and uncle who were kind, but it wasn't the same. He had a favourite goat whom he loved more than anything or anyone. She was pure white, and he called her Karmo, or 'White-girl'. He used to take her *tsampa* every morning, and after the family ate dinner in the evening he would bring her the leftovers.

One day in the middle of winter, he and his uncle were high up in the glacier with the village herds.

'It was around noon. We were letting them graze in a ravine some distance away.' Then they heard something growling. 'I didn't know what it was. We went looking and some sheep and goats came running towards us. And when we went on there were about six sheep and goats lying there dead.'

There was red blood spilled all over the white snow, he said. 'It was so, so bloody.'

As he got closer he saw that one of the goats was Karmo.

'I cried,' he said, and paused for a moment to remember. It was still very vivid.

'There were snow leopard tracks ... It must have run away when we came but they are so well-camouflaged; it was probably sitting nearby hoping to eat more when we'd gone.'

It was probably the death of Karmo that meant that later, when he had become the first person in his village to get a PhD from a foreign university, the first to work in America, and the first Ladakhi to get a postgraduate degree in wildlife science, Tsewang decided to dedicate his life to protecting snow leopards.

'I realised they are trying to survive in the same harsh environment we are also trying to survive in. So we are all one. And I know from personal experience what villagers feel when snow leopards kill their animals, so I can come up with strategies with them that won't involve taking revenge.'

'I don't often tell that story of Karmo,' he said at the end of our conversation. 'But our journey reminded me.'

The pashmina processing plant

Kashmir was still closed and under curfew. I'd remained optimistic, but it was clear that I wouldn't be able to go. I visited some of the Kashmiri antique shops in the market, and the Government Handicrafts store down the hill, but the shawls were mostly machine-made and even the best handmade ones were nothing like those that had driven people in Europe mad for them three centuries ago.

And then I heard that the shop at the Grand Dragon Hotel had opened. I went in. The manager was twenty-six, friendly, relaxed. His name was Taqadus Wani; he came from a family of Srinagar shawl makers; his father, his uncles, his grandfather all made them. 'Come back tomorrow and I can show you.'

Meanwhile, he suggested I make a visit to the place where the rough fleeces become fine wool.

The sign to the 'Pashmina Processing Plant at Leh' was smashed; its arrow was pointing downwards as if to indicate something underground. I tried to work out where it would originally have been pointing and followed another pot-holed street. When I eventually found the building, it was as ramshackle as the sign.

I tried the main door. It opened to my push, and I went in. There was a wall of high windows, two storeys high, covered in a film of grime that turned the world outside blurry. The corrugated plastic roof let in stained sepia light. The place rumbled like a waterfall and smelled sour, like goats. The floor was covered with sacks. Many were open at the top and greyish and brownish fleeces puffed out of them like woolly ice cream. I wondered where the white wool was. Everything quivered with the noise.

A woman with a scarf around her face was facing away from me, leaning over a rusted cylindrical machine that looked like a liquid-carrying gas tanker. She was tugging brown clumps from a sack and putting them into a grey-blue hopper on the container's rounded top. In the next machine, the wool was being pulled up a rotating wall of spikes before dropping into a long, hair-encrusted tank filled with thick brown water. Steel rollers lifted it into another tank, then another and another. The water looked less murky each time, like different strengths of storm floods.

There were five or six people in the room, and all had face-coverings, all were prodding at things in the water in a desultory way, none seemed to notice me. At the end, the wool was laid out over the floor

to dry in tufts, like grated mozzarella or slightly soggy duck feathers. It smelled of sweaters and was the colour of pale cream.

Behind it was a sign advertising 'The Dehairing Room'. I opened the door and stepped inside. More intense noise. This was where the magic happened. Over a series of five carding machines – in which the wool was fed across great vibrating metal drums covered in tiny nails – the pashm became gossamer, snow clouds, frost patterns on a winter's morning. Each time it held for a moment making cobweb curtains against the metal, until the force of the machine and the incoming wool pushed it on to the next tray and a finer carding drum. At the end, I plunged my hands into the finished pashm, and it was so soft that when I closed my eyes, I wasn't sure if I was touching something or nothing. And it didn't smell of anything any more.

What to do about the moths

Wani pulled out a heavy, teal-coloured suitcase from behind the counter of his shop at the Grand Dragon Hotel. He opened it, and inside there were dozens of folded shawls, wrapped individually in plastic. He doesn't keep the best shawls on view because they fade if they are left in sunlight. Also, people don't always understand them.

'I say the words "one lakh rupees" [about a thousand pounds] and I look at their faces. Then I decide whether or not to show them my special shawls.'

The suitcase smelled of camphor and mothballs. It catapulted me back to my grandmother's house in Scotland. My grandmother wore cashmere suits in moss greens and soft blues. She had started to wear them in the 1920s and I don't remember ever seeing her in anything else. When I was a child I thought it was just how some houses smell, but I realised now that it was the wool she was protecting. Moths – or rather the larvae of moths – have a particular taste for soft wool.

In 1664, François Bernier,* the first European on record as having visited Kashmir, observed the 'prodigious quantity of shawls which they manufacture, which give occupation even to little children'. He

* Bernier was Emperor Aurangzeb's personal and family doctor. When he was summoned to treat a member of the harem, he could only enter if 'a Kachemire shawl covered my head, hanging like a large scarf down to my feet, and a eunuch led me by the hand as if I were a blind man'.

described how everyone – man, woman, Muslim, Hindu – wore one wrapped around their head in winter, passing it over their left shoulder 'like a mantle'. He noted in particular that moths were a huge problem, and that the shawls 'are very apt to be worm-eaten, unless frequently unfolded and aired'.

Camphor, from the *Cinnamon camphora* tree, is the traditional preventative against insects in south and eastern Asia. Arriving in China in 1657, Dominican missionary Fernández Navarrete was astonished at the smell of the camphor trees, noticing how the oil was so strongly embedded in the wood that even the sawdust, placed around the flower beds, was an effective measure to drive away bugs. Naphthalene is even more pungent; I hate the smell. It was first named in 1820, by John Kidd, professor of chemistry at Oxford, who had noticed how you could extract a strong-smelling silvery solid from coal tar. He named it after the Greek, ναφθα, naphtha, meaning bitumen, or pitch. And as the air from the suitcase wafted towards me, I realised that this was what the smell of the high-altitude road-mending in eastern Ladakh had reminded me of: mothballs.

'The smell for me is the smell of home,' Wani said, when he saw me blinking at the fumes. 'People who buy them can store their shawls in airtight containers, but we have to keep pulling the shawls out of the plastic for buyers to look at them, and if we aren't careful those moths just fly in.'*

Tipu Sultan's war jacket

Textiles don't usually last the centuries. It's not just the worms, it's also the sunshine, the heat and the dust, the sweat and the rigours of washing, and changes in fashion that mean that, in many places and times and communities, it's undesirable to wear one's parents' clothes or sit among soft furnishings that were loved a generation before. So although there are still fragments of some Kashmir shawls made in

* In 2019 there was a moth crisis at Newhailes House in Scotland. The National Trust, which owns the house, urgently borrowed some twenty-foot shipping freezers, used to transport frozen goods around the world. Then they wrapped the entire textile collection – carpets, curtains, sofas, chairs and clothing – in acid-free tissue paper and polythene, placed them into the freezers, and left them there at minus 35° until the insects had frozen to death.

the later years of the eighteenth century, there's almost nothing that dates from before then.

Or there wasn't, until an extraordinary discovery was made in 1972.

In his lifetime, Tipu Sultan of Mysore was famous for his luxuries, his tigers and his textiles, as well as for his collection of automata, including the model of a mechanical tiger straddling a mechanical British soldier screaming in fear. He was also famous for warring with the British, doing so four times in seventeen years. In battle, he cut an awe-inspiring figure. His war dress was all about show and panache: bright colours and shimmering silks to inspire the troops, chosen with the expectation that he would never get near enough the front line to have to dodge missiles. But in May 1799, he was killed in action, and all his possessions were captured, including his famous war coat. It was most astonishing in its dissimilarity to any war coat that the English could ever have designed – or imagined. It was hot pink and lime green with bright orange pompoms down each side of the chest, like pastiches of the frog fastenings on British military uniforms. The padded silk was brocaded with blue and white flowers, and the whole was set off with a pink silk helmet above a green silk turban. It would have been dazzling, as well as supremely impractical for combat.

By 1972, the brilliance of the silks had mostly turned to brown, and the coat, by then in the British Royal Collection, was sent to the Victoria & Albert Museum for conservation. When the conservators cut open the seams to remove and clean the padding, they were astonished.

When the coat was made, it had been stuffed with old bits of soft tattered fabrics that must have been found around the palace in the 1790s, and a few of the twenty-eight fragments, which would have been woven long before that time, looked extremely interesting. Once they had been unscrunched and teased flat, it was clear that they were among the most exquisite, and the earliest, examples of kani weaving ever known. And having been kept in the dark for nearly two centuries, they were still bright and lovely. The pashmina pieces, some a few centimetres long, were delicate and luminous. In a monograph issued by the V&A, the colours of one fragment with yellow tulips were described as 'peony red, verdigris and cinnamon on a vanilla ground'; another, with white roses, as 'straw, saxe blue, green muscat, claret, mole, on a saffron ground'. They had a

soft fuzziness to them, from how one colour becomes the next in the twill tapestry technique special to the Kashmir shawls. It usually makes them look slightly, just slightly, hallucinatory: like the dream of a fabric, or like looking at a textile with somebody else's reading glasses, which are just a notch too strong. But these were finer than many of the later pieces the conservators had seen before: the interlocking barely noticeable, the flowers seeming to float on the simple taupe- or amber-coloured grounds.

They could have been woven any time after 1620, which is when Emperor Jahangir went to Kashmir in spring for the first time. He wrote in his diary:

> This year, in the little palace garden and on the roof of the main mosque, the tulips bloomed luxuriantly. The flowers in the territories of Kashmir are beyond all calculation and Ustad Mansur has painted more than one hundred of them.

Jahangir had already, a few years earlier, commissioned Mansur, his court painter, to copy the style of the European botanical flower paintings that had been arriving as diplomatic gifts from Dutch, French and English delegations since his father's time. Now, after his springtime stay in Srinagar, and with the influence of this new kind of painting, the shawls woven in Kashmir – and the carpets too – would change. From around that time the flowers woven into them would combine European and Mughal approaches: less stylised and geometric, with more naturalism, more eye for what the botanical world really looked like.

Listening to the patterns

Wani pulled out shawl after shawl. Some are bought by foreigners, he said, and some by wealthy Kashmiris, but most were bought by Indians from the plains. 'They buy them for weddings or for gifts and then they get addicted,' he said. 'Some women buy one, two, even three in one year.'

Most were rectangles though some were square. Squares came into fashion in Europe in the 1820s when the straight lines of the Empire style were replaced by flared skirts, tiny waists, and huge balloon-like puffed sleeves on which the long shawls caught. So women

A large colourful repeat pattern of simple flowers,
curling tendrils and chilli peppers: this kani shawl in
Wani's shop took more than a year to make.

ordered huge square pieces, almost two metres by two metres, so
they could fold them diagonally to fall to a sharp point down the
centre of their back, while always having only the face side of the
cloth on display.

Each piece made a soft sigh as it breathed out and onto the table
where it lay on the previous ones. Here was the 'puff' that had so
intrigued me the first time I had seen pashm, except that these were
a hundred times more beautiful to look at.

Some had patterned borders, with the centres left unadorned.
Others were fully covered in flowers and designs and those were my
favourites, so rich in tiny chain stitch (or buttonhole, stem stitch,
satin or herringbone) that you could hardly see the shawl wool at all,
except for the edges, which had been woven separately and sewed
on invisibly in tiny darning stitches by the skilled sewing craftsmen
called *rafugars*. Then Wani showed me another: black background
covered by a large, colourful repeat pattern of simple flowers and

curling tendrils and what I realised were orange and scarlet chilli peppers, and – when I stopped concentrating and instead glanced at the design sideways to catch it unawares – what appeared to be the hidden heads of parrots curled inside the swirls. When I picked it up – because it was nothing but a single layer of woven wool without even one embroidered thread to be seen – it was many times lighter than it looked.

'This is the famous kani, the twill-tapestry-woven shawl,' he said. 'This kind is the most expensive.'

At first I didn't love it – in part because of the blur of it that made the designs look like they were made from Lego blocks seen from a great distance, and in part because I was beguiled by the brighter, more obvious, embroidered kind beside it. But then I looked more closely, and after a while I began to understand. These colours weren't laid down in blocks and shapes like paper cut-outs or appliqué or embroidery; it was all more marvellous and complicated than that.

If you imagine one horizontal line of a picture on your computer, it might have five pixels of yellow followed by two of red then one of white and three of blue and so on for another few hundred pixels. The weaver's job is to make that line in thread, and then make the next and then the next so he (the kani weavers in Kashmir are always male) can start to build up the whole picture line by line.

The men that make the kani

I remembered William Moorcroft – veterinarian, working-class, genius with horses, friend of the great naturalist and barkcloth collector Joseph Banks, one-time animal doctor for King George III's flock of Merino sheep – who in 1812 was commissioned by the East India Company to visit the Tibetan plateau disguised as a Hindu trader. His mission was to bring back some good breeding horses but instead he became fascinated by the shawls. His expedition to see some pashm goats took so long that when he returned, after being missing for months, he was given a formal reprimand. Undeterred, he later returned to the area to make a detailed study of how the shawls that had so captivated him were made.

In Srinagar he found weavers who let him watch, and he made detailed notes. He observed how the *pennakam-guru* or warp-dresser began by dipping the warp yarn into thickly boiled rice water to make

it strong, and then how, once the yarn was ready, it required many kilometres of walking up and down to set it up for the horizontal loom.

Three experts were involved in the design making. First the *nakash-guru*, or pattern-drawer, created a black-and-white sketch. Then his colleague the *tarah-guru* worked out the colours for each line, and finally the *talim-guru* wrote it down in a special code and delivered a copy to the weavers. When it was time to weave, this *talim*, or coded list of instructions, would be read out to the weavers by the weaving master, or *ustad*.*

The *ustad* might say, for example, the shorthand equivalent of 'lift three pairs of warp threads and insert a scarlet weft; lift eight and insert sky blue', with each new command requiring the weaver to pick up a different wooden bobbin, around which a different coloured thread had been wound, and insert it through a number of warp threads as commanded. Sometimes the instructions would include making particular loops, called 'double interlocks', at the joins, so that there are no gaps or slits where the colour has changed.

It is always a twill weave, which means the warp threads are always counted in pairs rather than as singles. Pashmina is a very fine wool and these are all very delicate threads – you can fit up to forty-two warp threads and up to eighty-seven wefts (although more usually around forty) in every centimetre – and working in pairs reduces the risk. In a plain weave, if one warp thread breaks, it's a disaster. With twill, if one breaks then the other will hold. It's like insurance.

The weavers follow the designs as they're read aloud, but they often don't have any clear idea as they do so of what they are creating. They can't even properly see the picture emerging – it's upside down to them the entire time they're working on it – but they have to trust it and follow the code of the *talim*.

Moorcroft observed that the three men he watched took a whole day to proceed by 'half a barley-corn'. A barleycorn was a third of an inch, so half a barleycorn was about four millimetres. At that rate, a two-metre shawl would take five thousand working days or sixteen years to complete. But because plain sections were much quicker and because the weavers would sometimes each make different sections that would later be joined together by a *rafugar*, even the finest shawl would not have taken that long, though it still might have taken up

* *Talim* means learning; *ustad* means teacher; *guru* means one who dispels darkness.

to five years. (A barleycorn sounds like an archaic measurement, but although it's no longer commonly used for textiles, people in English-speaking countries still use it, mostly without realising. UK and US shoe sizes are each a barleycorn apart. So, for example, a size five is a barleycorn – a third of an inch – smaller than a size six.)

The weaving techniques as Wani explained them are almost the same as Moorcroft described two hundred years ago. Although computers are now sometimes used at the early stages to help the master weavers translate a pattern into a coded sheet of instructions, it's still very much done by hand.

'The way it works, none of the weavers is quite sure what the final design will look like. So the reader will call from his sheet, perhaps five yellow, change to red, two red, change to orange, seven orange …' They will just keep on going, and the back of the picture will appear before them. 'It's such a special thing to see kani being made, it really is like magic,' Wani said.

Heaven's embroidered cloths

One day, nearly three hundred years ago, an apprentice *rafugar* named Ali Baba, was assembling a kani shawl using the tiny, skilled, invisible stitches he had been taught. And he had an idea. What if he were to imitate the effect of the woven designs by decorating a plain shawl with embroidery? Not ordinary fine embroidery, which uses silk threads and would be too heavy, but embroidery done with pashm yarn, and executed in the small darning-like stitches that the *rafugars* were experts in? It would take a quarter of the time of the kani, and it would also be beautiful. And because the embroidery thread was made from pashm wool the shawls would still be extremely light. William Moorcroft met Baba in 1823. Baba was ninety-two years old then and estimated that he had begun 'to embroider flowers' when he was about thirteen, in the 1740s.

In 1803 an Armenian-Turkish trader, Khwaja Yusuf, started working with Baba and other *rafugars* to produce these shawls in greater quantities. Not only could they be produced at just one-third of the cost of a kani, but they also initially escaped the government duty on kani shawls (around 26 per cent). At the turn of the century, there were only a few men capable of doing such fine stitches over such a sustained period; by the 1820s there were around five thousand.

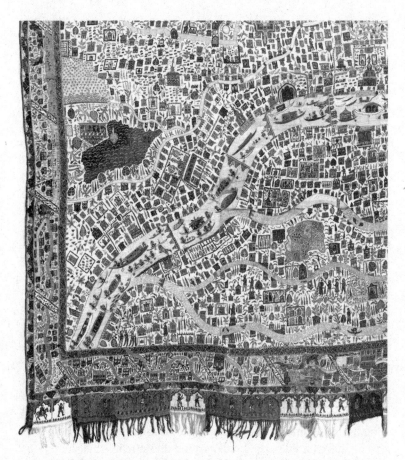

Detail of the *amlikar* map shawl probably commissioned by Maharaja
Ranbir Singh in around 1870, with the trees and houses and people
and boats of Srinagar picked out in darn-stitch, satin stitch and stem-
stitch, using the finest of bright pashmina wools. 190cm by 230.

Many had been displaced by political upheavals in Kashmir during the
previous two decades, and they needed the work.

The embroidered pashmina shawls are called *amlikar*, from the
Persian *amal*, or 'doing', and *kar* meaning 'work'. And although they
are quicker to make than the kani, they are well-named as they
still involve a great deal of work. The embroiderers have developed
special stitches, including the *sozani* – a kind of stem stitch kept in

place by very tiny couching stitches – which is the reason the work is sometimes also called *sozanikar*. They have also developed ways of cutting the loose threads from the back with tiny scissors, so there are no floats to be seen on the reverse. The Victoria & Albert Museum has an astonishing two-and-a-half-metre 'Map Shawl' of Srinagar that was presented to Queen Victoria in around 1870. It shows the great lakes and Mughal gardens and tiny people rowing their shikara gondolas along the wisps of waterways, all embroidered in the tiniest stitches. It has pastel pink city walls and multicoloured houses all worked in the minutest of detail and the most joyful of colours. The miniature inscriptions identifying each building and place of interest are all embroidered in English. It would have taken years.

The embroiderers, who are also always men, start by smoothing the plain shawl on a flat piece of wood, using a highly polished piece of agate. Then they stamp a design onto it with hand-carved wooden blocks. At the end the ink will be washed off leaving no trace, but during the process it provides a clear guide for where the delicate stitches will go.

'It takes five or six days to make the base shawl, then five or six months to embroider it,' Wani said, of the pieces he was showing me. The embroiderers can't work for more than four to six hours in a day, or they would hurt their sight. Even as it is, their eyes are often red and sore. 'So they come in, do a little sewing, walk around, warm themselves at the fire. They chat and then come back and do a little more work.'

Parrot and pistachio and sweetmeat yellow

'We usually have two or three hundred good pieces,' Wani said apologetically, looking over what seemed to me to be an abundance of shawls – maybe thirty or forty – spread on top of each other, with more to the side, waiting to be opened. 'But it's the end of the season; they'll spend all winter making more.'

I kept taking photos as if by focusing in with concentration I'd be able to own each one for a moment. Or perhaps it wasn't so much owning them as wanting to tumble for a short time into their rivers of blue satin-stitched circles strewn with violet and coral flowers, hemmed with fuchsia and turquoise banks.

In the past, the subtle and vibrant colours of Kashmir's pashm dyes were kept within families, passed on from father to son for generations. Some of the recipes had been made since at least Mughal times although at least one arrived with the British. A specific blue-green English woollen broadcloth was boiled to extract a turquoise dye that rendered the pashm the deep, soft colour of Pangong Lake. It was imported specially for the purpose, in quantity – probably the most enthusiastic purchase of any English wool anywhere in the subcontinent. As for the boiled-up English cloth, that was usually discarded. Or given to the poor.

In 1872 Hungarian-born linguist Gottlieb Wilhelm Leitner was crossing a courtyard at Jalalpur, near Surat, in the state of Gujarat, when he found a pattern on the ground. On making enquiries, he learned it was a notation for the pattern of shawls. It led him to compile what he called 'the shawl-alphabet' for up to one hundred colours, each identified by a number, and in the process he became fascinated by the words for the dyes. He recorded many colour names, including 'parrot' (*toti*, a strong emerald green); 'colour of cotton flower' (*kapasi*, a luminous lime green); 'elephant' (*fili* – which is not a grey but a kind of blue); 'shell of almond' (*post badami*, a soft pink); and, my favourite, *zard nabati*, the 'yellow colour of a sweetmeat'.

A few decades earlier, Britain's first Government School of Design (later the Royal College of Art) had opened in Somerset House in London to train industrial designers. One of the triumphs of design they studied was the Kashmir shawl. In his much-read *Grammar of Ornament* in 1856, Owen Jones suggested that, to be visually effective,

> each ornament should be softly and not harshly defined, that coloured objects viewed at a distance should present a neutralised bloom, that nearer approach should exhibit the beautiful details, and that a close inspection should divulge the means whereby these effects are produced ... The ornament in the spandrel of a Moorish arch and in an Indian shawl are constructed on precisely the same principles.

I look close up and I look far away, and I wonder at the effects – the qualities of simultaneous contrast (where certain colours, say a blue next to an orange, induce their opposite in hue and intensity

on neighbouring colours, and are themselves affected in turn so that you don't quite know what you're really seeing) and successive contrast (where if you look for a while at something red, something green looks much brighter). These are the very effects that strongly influenced colour theory in England and France in the nineteenth century, as European weaving businesses tried to replicate the effect of a Kashmir shawl without quite understanding the optical science behind its almost magical colour illusions.

In 1851 Ralph Nicholson Wornum, a friend of John Ruskin and later the Keeper of the National Gallery, wrote an essay entitled 'The Exhibition of 1851 as a Lesson in Taste', using the shawls shown at the Great Exhibition in London to illustrate the complexity of appraising good and bad designs.

> In comparing the Indian shawls with their European copies ... a most remarkable phenomenon develops itself; that is, that the skilled and educated designer of Europe should devote some of his most elaborate efforts in design to the imitation of the crude patterns of the hereditary weaver of the East. The skilful designer of Paris, London, or Vienna, could produce patterns infinitely more beautiful than the most gorgeous specimens of the East, with half the trouble it costs him to make his spurious Cashmeres; but as they could then be no longer mistaken for Cashmeres, their highest merit would be lost.

Today I can see that as well as including beguiling colour contrasts, Wani's genuine 'Cashmeres' still include the flowers and abstract designs that were so popular in Jehangir's time, and they still feature the most famous pattern of all.

It is the teardrop shape also called the boteh or pine cone, and which many people in Britain, and indeed in Kashmir, also know as the 'Paisley', because from the end of the eighteenth century onwards, the Scottish industrial textile town was one of the biggest imitators of Kashmir shawls.

'The design was copied from our designs,' Wani said. 'They wanted to do it more cheaply. And they did. But they never did it as well.'

'What does the boteh represent?' I ask.

'I don't know,' he says. 'Nobody really knows, although everyone has a theory. Why don't you go to Paisley and find out?'

The town named Paisley

A year later, I'll find myself taking his advice and walking the two miles from Glasgow Airport to visit the place that somehow gave a traditional Central Asian design its name. Paisley has been a home of weavers since at least the twelfth century,* and its story is one of textile wealth then poverty then wealth then poverty, clattering into a kind of regularity like the movement of the looms themselves. Its story is also of imitation, of beating the market, undercutting the competition, a tale as ancient as packhorse roads and market towns.

Paisley wasn't the first place in Scotland to imitate Kashmir shawls – Edinburgh shawl makers got there first in 1777 – but the Paisley weavers copied their fellow Scots soon after, and copied them cheaper, which is what led to customers asking to see 'a selection of Paisleys' and for mill workers to be able to afford them as their 'kirking plaids' – shawls for wearing to church on Sundays.

At this point, the noticeboards at the Paisley Museum (a blond sandstone Victorian structure, paid for largely with money from thread) explain that the boteh design came from Mesopotamia – modern-day Iraq – and that its teardrop shape with its turned-over top can be seen on the friezes of Nimrod and Ninevah, held by priests as palmettes, or in the design of the leaves on the tree of life.

'We're not quite sure about any of this,' the museum's textiles curator Dan Coughlan will go on to tell me. The galleries would be closing soon for a huge refurbishment, so when they reopen in 2023 the chances are that 'the boards will say something different'.

He'll agree that as well as looking like a pine cone or a mango or a strangely asymmetrical leaf there's something in the appeal of the boteh that could be more profound than this. The problem, he will say, is that nobody agrees what it is.

I was once told – in Van in eastern Turkey, by a carpet-shop owner who was so calm and thoughtful that I kept going back to learn more – that the Paisley design possibly referenced the seeds of the Syrian

* Paisley was well-known for its linens, because it was close to Glasgow's port and had convenient meadows for bleaching. Its earliest claim to international textile importance was making silk gauze after 1759, later eclipsing Lyon, and even competing with the French lacemakers of Alençon who in 1787 accounted for their hardship by the fact that the court at Versailles 'prefer gauzes, particularly those of England', by which they meant Scotland.

rue, *Peganum harmala*. They're said to protect people against bad spirits. People carry them around in little bags for luck. 'It would be just as lucky to have them woven into your carpets, or your clothes,' he suggested. Later I found that these seeds (which grow around the Mediterranean and at least as far east as Ladakh) were indeed good luck charms, as my Van friend had said, but they are also famed for their psychotropic qualities; some say they're the herb that protected Odysseus from the spells of Circe in *The Odyssey*.

The designs would certainly be lucky for Paisley: through the early nineteenth century, the town's textile businesses boomed, mostly using worsted – combed, long-staple wool – instead of pashmina, in order to keep the prices down. Weavers did well: the town became known for its reading rooms and literary societies, and the suggestion that 'every third man' was a poet. But fashion fortunes rarely last long.

In the late 1860s, crinoline hoops on women's skirts flattened at the front and bunched up at the back – which did not suit the shawl, as they hid the most decorative feature of a bustle skirt, which was its teasing view from the rear. The final hope for the shawl industry was in 1870. That year, as France and the Northern German States fought each other in the Franco-Prussia War, the reports of the battles were being watched closely in Paisley. And they were also being watched in Kashmir. Whenever the Prussians scored a victory, the Kashmir weavers despaired because the Germans didn't much like shawls. When the French pushed forward, the weavers in both places celebrated because they knew that for them to have a future, the French had to win. When they did not, the great era of the shawl ended – in Europe at least, though in America they stayed popular a little longer.

Each shawl coming out of Scotland was technically different, but each was also essentially the same. Shawls had been produced at scale in Paisley throughout the nineteenth century, from about 1805 to the 1880s, each according to the fashion of the day, so an item from the 1860s would have borne little resemblance to one from the 1820s.

In Brooklyn, New York, in 1886, there was a court case where Mary Sullivan accused her neighbour Mary Coffey of stealing her shawl, worth forty dollars. Witnesses for the prosecution said that this was without doubt Mrs Sullivan's twenty-year-old Paisley; they'd have known it among a hundred. Witnesses for the defence said that it was definitely Mrs Coffey's: her children had been warmed by it, her

husband had wrapped it around their baby two years before. Then several clerks from dry good stores testified that all Paisleys just about look the same 'and it would be almost impossible to identify one'.*
So Coffey was discharged. But oh, said the judge. He had never, in all his years of being in court, heard so much swearing.

The ends of the shawls

The disputed shawl would probably have been mass-produced in the 1860s and might, by the time it was produced as evidence, have looked rather worn and frayed. Yet I was surprised to see that on the most expensive handmade real Kashmir shawls in Wani's shop, the warp ends that had once attached them to the loom had not been cut or hemmed, making those look a little worn and frayed as well.

It meant that on the margins of these beautiful and fabulously expensive pieces of cloth there were pale and scraggy threads looking neither beautiful nor fabulously expensive. I asked him why that was.

'We don't finish them until the very end,' Wani explained. It allows the *rafugar* to use the threads from the end of the shawl to darn tiny holes or mistakes in the cloth, which means that the match will be exact. 'I check each one and if there is a hole then I send it back to Kashmir,' he said. 'We don't have the skill to mend it here.'

They usually send them back for washing too: there is something in the quality of the water of Dal Lake and the Jhelum river that is said to give the shawls what French visitor Thomas Vigne in 1840 called their 'ineffable softness'.

I took another picture, and then, when I was done, Wani started to put them away, showing me how to fold.

'First you fold it in half, then into thirds, always the right side first and then the left, so it is one sixth of the original width.' As he returned each one into its plastic, I said I hadn't seen anything like these shawls anywhere else in Leh. 'No,' Wani said. 'I think we have

* Weavers from Paisley would no doubt have disputed this, says Paisley Museum curator Dan Coughlan, as although the shawls looked *about* the same, and it might be *almost* impossible to identify one, closer inspection would have revealed many small differences. He would understand, therefore, if Mary Sullivan was angry that their evidence swung the case in favour of her neighbour.

the best.' Then his sales patter paused. 'Some other people have some good shawls,' he said. 'You just haven't been using the right words …' The magic words, he said, were: 'Do you have a special suitcase of shawls?'

'And if they do have one, and if they think you are really interested, then they will show you.'

A postscript

I had my own special suitcase, back in my room. I had planned that, on my last day in Leh, I'd take the little bags with my parents' ashes down to the Indus. I'd take them to the flat grassy area near the refugee camp at Choglamsar where I'd worked in the 1980s when I was nineteen and twenty, and where I'd once made such a hash of washing my clothes. I'd say a quiet prayer and shake them softly and lovingly into the sacred river. And I really was going to do all of that. Except that, during my last night, I had a dream.

It was my mother.

'It was so lovely of you to take us to India with you, Toria,' she was saying, as if she was just a phone call away. 'Patrick and I have so enjoyed sitting near the window of the hotel room, looking out at the mountains. But we've had a chat about it. And although the sacred river thing is such a kind idea, we've decided we'd rather not. We'd rather go home with *you*.'

So I took them home. At an airport on the way back, I was stopped as I put my hold luggage through an X-ray machine.

'Is that washing powder you are carrying, Madam?' the security officer asked.

I asked if we could talk privately.

He nodded and we went to one side and I explained that although I knew it sounded odd, I'd always promised my mother I'd take her to India. And although the situation was far from perfect – I waved my hands over the little plastic bags with their pale powder, now looking distinctly disreputable – it was the best I could do.

The officer smiled and nodded his head and said he understood. He waved me through.

'I hope you *all* have a good journey, Madam.'

SACKCLOTH

In which the author investigates a different kind of cloth of invisibility; explores the penance that can be stored in fabric; and remembers that her father's family nickname once meant 'jute'.

I've seen sacks.

I've seen them when there were floods in Somerset in 2014, stuffed with sand and holding back the waters from people's houses; I've seen them in reconstructed First World War tunnels in France and Belgium; I've seen them in India and Afghanistan, packed with dry goods, slung across the backs of skinny donkeys. I've seen them on the rare occasions when I've turned armchairs upside down to work out what's happened to the springs, and there it is, that tawny, scratchy fabric, speckled with years of dust. I've seen it frayed and patching up the walls of sapphire mines in Sri Lanka. I've even lost sack races in it. But each time, I've scarcely looked at the actual material. The cloth that makes the sacking had always seemed incidental to how it was being used.

On seeing and not seeing

There's a moment in some plays or operas or ballets where the first part of the action takes place at the very front of the stage; then the light is directed in a different way, and you realise that there's a thin screen between the front and the back. Where before you couldn't see anything, there are now people and props and scenery and spotlights, and a dramatic moment about to happen.

The screen is called scrim, and it is made of some of the same fibres that are used to make sacks, the same kind of fibres used to make camouflage scrim (worn by soldiers, like netting over their

faces). Those qualities of space and strength that make this cloth so perfect for carrying cocoa and cotton and coffee halfway across the world also make it ideal, it turns out, for revealing and concealing scenes of drama.

The story of sackcloth is at times like the purpose of scrim in the theatre. At first, it seems like background: functionally useful, aesthetically ignorable, a mostly unseen backdrop to the histories of better-known fabrics. And yet, when a light is shone on it in a certain way, we can see a sequence of tableaux that tell their own stories of action and danger, goodness and darkness, punishment and riches, prisoners and scams. And maybe, as those stories are revealed, we can see how the tawny brown of natural sacking could even once have been described (in a certain light and with a certain focus of attention) as golden.

A cloth of invisibility

At the centre of Shepton Mallet Prison in Somerset there's a small exercise yard. Three of the sides are fringed by cell blocks, each with just a tiny postbox of a high window, facing only the sky. The fourth side was once the Keeper's House where the governor lived, with huge Georgian windows facing directly into the yard. By the time HMP Shepton Mallet closed in 2013, the prisoners were allowed to work on a small garden, or use a basketball hoop, or jog. But in the nineteenth century, they had to be satisfied with shuffling slowly around and around. They went in single file – anticlockwise, to suggest the notion of turning back time, intended as a physical reflection on how they needed to work to reverse their crimes. And so that none of them should ever catch sight of the governor or any members of his family, they were made to wear sacks over their heads. The loose plain weave of the coarse fibre let in just enough light so that the prisoners didn't trip. But it wouldn't allow them to see anything clearly through the mesh.

In forcing the prisoners at Shepton Mallet to wear sacking as they exercised, the authorities were doing more than simply blocking their ability to see. They were invoking potent ancient symbolism. Because as well as being a practical way of containing things, sackcloth has a secondary reputation. It's the fabric of penitence.

The many ancient uses of sackcloth

The English word 'sack' comes from the Hebrew *saq*, שַׂק, which isn't so much a reference to the purpose of the bags as it is to the kind of fabric that bags for dry goods were once made from. *Saq* in biblical times specifically meant fabric made from the hair of certain goats, which were valued for their milk and their meat, their skins and their kids, and for their cachet when you were showing other people your status in the world. They were also valued for the *saq* cloth woven from their hair. The belly hair was soft, but the hard hair from their backs was used for blankets and tents and waterproof capes (as well as for actual sacks).

Sailors and fishermen liked it because its natural oils would protect them against the salt and the waves better than anything else. It was also used in ancient warfare. When the occupants of a walled city were about to be besieged, they would traditionally tumble great curtains of the stuff over the battlements to deaden the force of the battering rams and stop the wooden supports of the walls from being set ablaze. Their enemies' siege engines would also be covered with *saq* to protect them from the burning arrows fired by the defenders. From the ramparts these great, black-covered engines must have looked like machines from hell.

But in biblical times, putting sackcloth close to your body was also a cultural indication to other people that you were mourning. And the discomfort of a scratchy textile against the skin is a simple kind of pain. It's physical, comprehensible. For some people, it would have been a useful distraction from the seemingly insoluble, certainly scarcely bearable, emotional journey they were taking in their grief.

When Jacob thought his favourite son Joseph had been killed by wild animals, he wore sackcloth. When Job lost everything in a series of inexplicable tragedies, he sewed sackcloth to cover his skin. The Second Book of Kings tells of the King of Samaria walking among his starving subjects with the city under siege. Hearing their laments, the king tore at his clothes in sorrow, and the people saw that underneath the fine fabrics he was wearing sackcloth.

Sackcloth is only mentioned four times in the New Testament, and nowhere does it suggest that Christians adopt it as part of their spiritual training. However, by the time St Basil was setting up a desert monastery in Cappadocia in around 360, this was one of the questions his followers were asking. What exactly *were* the rules of wearing

sackcloth, they wanted to know, using the Latin word *cilicium*, refer-
ring to the region of Cilicia in today's southern Turkey where there
were – and indeed still are – vast numbers of these coarse-haired,
dark-coloured goats.*

Cilicii, St Basil replied (pronouncing it 'kilikiyi' with a hard 'k'
in the way most people did in the fourth century) should not be
used for warmth or other bodily needs, but *pro humilitate animae*, 'to
humble the soul'.† The desert fathers who followed him emphasised
that sackcloth was always private business. Other people should never
know you were wearing it: telling anyone about it only meant that
you were proud, or even boastful. This means that today we mostly
know about the wearing of sackcloth in the past only when it was
discovered in someone's personal effects after they died.

St Francis had worn hair shirts in the early thirteenth century, in
his hermit cave high above the town of Assisi in central Italy. St Rose
of Lima wore them too, in the early seventeenth century, and hers is
one of the sadder examples of how this cloth can also be a component
of self-harm. Rose's story began in 1591, when she was five and playing
with her seven-year-old brother in their garden in Lima. He messed up
her long, fair hair, and when she complained he told her that hell was
full of people who cared about their hair. The taunt changed her life:
from then on it was bread and water fasting, that lovely hair cropped
short, and tunics with sackcloth on the inside until 'her confessors
noticed her health so diminished they took them away'. Soon after she
died, at twenty-eight, a man in whose family's house she had lived for
a while said that he'd seen her hair shirts personally, on the occasions
she washed them and hung them in the sun to dry.

Sackcloth was sometimes used by statesmen too. In the summer
of 1535, Sir Thomas More, the fifty-seven-year-old former English
Chancellor, spent many weeks as a prisoner, pacing the rooms of the
Bell Tower apartment in the Tower of London. He had worn a hair
shirt in his youth when he was testing whether his vocation was to

* The Turkish name for them is *kil keçi*, 'hair goats', or sometimes just *adi keçi*,
'ordinary goats', because even today there are so many of them.
† Q: 'Si licet nocturnam tunicam habere alteram vel cilicium vel aliam quamlibet?'
A: Cilicii quidem usus habet proprium tempus, non enim propter usum corporis,
set propter afflictionem eius inventum est huiuscemodi indumentum et pro
humilitate animae.

become a monk (he decided not), and he had often worn it since as an aid to meditating on his political decisions. Now, as he waited to be executed for opposing Henry VIII's religious reforms, he wore it again. After his death it stayed in his family, and then was given to an order of nuns. In 1935, on the four-hundredth anniversary of his death, he was canonised as St Thomas More and the shirt became a relic. In 2011 it entered the care of the monks at Buckfast Abbey in Devon.

The last photograph I took of my mother, in June 2015, was at Buckfast Abbey Church. My mother almost never let herself be photographed, and almost always respected No Photography signs. But it was such a calm place, and empty. We were having an adventure together on a rare day when we had someone to care for my father, and the light coming from the 1960s stained-glass windows designed by Dom Charles Norris flattered everything it touched. So she said I could take her picture standing beside the coloured glass.

'Shh, Toria. Hurry!' she said, and I hurried. Someone walked in. We tried not to look guilty. It was one of the monks.

'Do you know about St Thomas More's hair shirt?' he asked us, generously ignoring my phone camera.

We didn't, so he took us to see it in the side chapel. Just a square was visible behind the glass, perhaps thirty centimetres by thirty centimetres, deeply folded across the diagonal. The rest had been squashed into a box behind the frame. From a distance it looked like chain mail, but closer up it was like the tough, thin, metallic mesh of a landing net I once saw when I was researching an article about a circus; or the scratchy pile of a bouclé sisal carpet. The thing I found most surprising was the colour. Not black. Nor even brown, nor white, which apparently it might once have been. Instead it was a soft, slippery, silvery grey. Like graphite. And like graphite, in that flattering light, it shone.

I didn't take a photograph.

Another Thomas, Thomas Becket, Archbishop of Canterbury, had several hair shirts, although not even his fellow monks had known about them. In December 1170 Becket was murdered – by four knights, who later said they thought they were following the commands of the king. Leaving Becket's bloodstained body beside the altar, they headed to his apartment to see what precious articles they could find. Opening a chest, they discovered 'two shirts of hair made of great knots', and realised that they had made a terrible mistake: to

them the simple presence of the hair shirts was enough to attest that
the man they had murdered was a saint. Later, the monks preparing
Becket's body for burial said that they had found, under his ornate
bishop's robes, the simple woollen habit of a monk, and beneath that
a shirt and breeches made of hair. They knew from his raw, chafed
skin that 'he suffered great pain', and this clothing was one of the
reasons he came to be revered as holy.*

Becket relics began to appear all over Canterbury, and eventually
all over Europe. They included various pieces of cloth, and many
people believed that just touching them would cure them of their
illnesses. The 1346 inventory of relics held in Saint-Omer Church
near Calais included the following: 'Part of St Thomas of Canter-
bury's tunic. Part of his chair ... Part of the blanket that covered
him, and part of his woollen shirt ... Part of his hair shirt. Some
of his blood.'

Not everyone followed St Basil's guidelines to keep their sack-
cloth-wearing to themselves. In *Tartuffe*, Moliere's 1664 satire on
religious hypocrisy, the main character is revealed as a fraud when he
makes a point of loudly instructing his manservant to put away his
sackcloth ('ma haire') so that other characters will overhear and be
impressed by his piousness.

Some Catholics still wear hair shirts as penance. The Carthusians
and Carmelites are the only ones who wear it by rule; others wear it
by custom, or as an act of 'voluntary mortification'.

I look up 'hair shirt' on a shopping website. Among all the T-shirts
printed with jokes about the wearer's hair (or lack of it), I can't see
anything designed to be worn for penance. An advert for a product to
'make your hair grow' appears on my screen. It keeps appearing all
day; I am evidently now on a database as someone with thinning hair.

I put 'buy a hair shirt' into a search engine and advertisements for
discipline products appear. There are religious ones and secular ones.
I am probably on a different kind of database by now.

* Henry II was furious with Becket, who opposed him on many issues. While in
Paris, he cursed his archbishop, and – the story goes – this was overheard by the
four knights, who wanted to please the king. Henry didn't return to England until
1174. In Canterbury, he walked in penitence to Becket's tomb, where according
to his contemporary, the French writer Guernes de Pont-Sainte-Maxence, he
removed his cloak to reveal a green smock, over a hair shirt.

A 'Sackcloth Hair Shirt', stitched and hemmed around the edges, is $69.99 including delivery. Or I can buy a 'Quality Sackcloth Hair Shirt' with the outer side covered in cotton dyed in purple, which is explained as 'the colour of penance'. It is 'one size fits most' and it costs $129. Molière probably would have laughed.

I wonder now about the people who make these things, hemming them around the edges and adding the little loops for cords. What do they think about as they sew? Where are they based? I contact the website and receive an answer from a man called Mark whose email name is 'Penance'. The hair shirts are made by a seamstress in the UK, he writes, and the material is '12 oz hessian'.

Hessian. Today that word is mostly used to refer to a grade of hard-wearing fabric made from unbleached flax or jute, not quite sacking, more like backing. I remember being handed a rectangle of hessian at primary school, so I could embroider a picture onto it. Partway through the term, the teacher held it up – pitiful, unfinished, poorly chain-stitched picture of a four-mast sailing ship that it was – for the rest of the class to laugh at. This was the worst piece of embroidery she'd ever seen, she said, in her many years of teaching and at that moment the hessian, fabric of penance, truly felt like a fabric of shame. The word is from the state of Hesse in northern Germany, where farming families made it. It appeared in the uniforms and kit bags (and indeed actually *as* the kit bags) of Hessian soldiers, and the soldiers and the cloth became joined in people's minds and in the words.

Sack of shame

Commercial sackcloth items like the ones available on the internet would be worn voluntarily, but wearing sackcloth hasn't always been a choice. In the National Museum of Scotland in Edinburgh, there is a loose tunic in a glass case, separate from the other exhibits. I stood in front of it for a long time, thinking about Janet Gothskirk who on 29 July 1677 was condemned by the church to wear it every Sunday. She had to stand in front of the entire congregation of West Calder Kirk, eighteen miles west of Edinburgh, while the minister preached about adultery. The punishment lasted for months – church records say that it would have stopped earlier if she had shown any sign of being sorry – and it only ended when she was excused due to the 'nearness of her delivery'. The sacking is a faded, sandy colour and the garment is

loose, like a shapeless calf-length coat pocked with holes. There are no fastenings, and the sleeves are so long that they would have covered her wrists and hands, adding an extra little sense of powerlessness. It must have been well-used over the years it served as an instrument of what the officers of the Kirk called 'publick Repentance': at one point, somebody mended the right shoulder, using long, confident tacking stitches to fix a patch the size of a paperback. It was given to the National Collection in 1806 by Reverend J. Muchersy. By then, it was already a curiosity from the distant past, worthy of a museum.

Janet Gothskirk's sackcloth, like most sacking material in northern Europe at the time, was made from hemp or the rougher kind of flax (it's hard, even with a magnifying glass, to tell the difference). By the time she stood unrepentantly inside it, Sunday after Sunday, this kind of rough homespun was already a speciality of north-east Scotland. But from the 1820s onwards, more and more sacking in Britain began to be made from a plant that had previously been almost unknown in Europe, though in Bengal in north-east India it had been used for millennia. Most Hindu families with land raised it in their fields, and there was even a sack-weaving caste: the Kapalis.

We have no English name for this

When he was a boy, everyone called my father Pat. Then, in 1955, he went to India to work with a shipping company. Three years later, back in Britain, he was introducing himself as Patrick, and that's what my mother, who met him soon afterwards, always called him. Since he had gone through a tough divorce during that time in India, I wondered if I was touching on a sensitive subject. But once, when we were on a long drive together, I asked him about the name change. He smiled as he negotiated the motorway traffic.

'When I got to Calcutta I found I'd been accidentally named after a crop,' he said. 'It was like being called Cotton. I'd see my Indian colleagues trying not to laugh. So I changed it.'

Pat is the Bengali for raw jute. Only when the plant has been woven into cloth does it become *chot* in Bengali, although the English word 'jute' probably came directly from Odia, the main language in the state of Odisha – formerly Orissa – where the cloth is called *jhouta* and where a great deal of the crop has always been grown.

'We have no English name for this', wrote a British official from

the Calcutta Board of Trade in March 1791, in a letter listing the kinds of raw materials that might be worth exporting from India. He said that alongside samples of 'clean hemp, rough hemp' in the packet ships heading to London, he had also thrown in some samples of a new kind of fibre. He called it 'jute' though if he'd listened more carefully, it's probable that he'd have called it 'pat' and that could have been our name for it in English today.

In the end, the Indian hemp turned out to be too brittle, and the short seasons and extremes of temperature and humidity meant that it couldn't compete with other sources.

But this fabric the people around Calcutta called 'jute'? It might be just the thing.

What is jute? Or, more exactly, what are jute?

There are two main kinds of jute. Both can be up to five metres high, with stems the thickness of your little finger, growing at about seven centimetres a day and bursting into leaves about a metre from the tip. White jute, *Corchorus capsularis*, will grow just about anywhere in Bengal, but it makes a rougher kind of sackcloth. *Corchorus olitorius*, or 'tossa jute', is fussier, although it is also finer. It doesn't thrive in the flatlands of the Ganges and Brahmaputra deltas where land is cheap. Instead it prefers higher land and better soil. It also needs more work by the farmers. Tossa jute has historically been grown throughout the Middle East and northern India, but while elsewhere it grows to about a metre and a half, in the hot, moist climate of Bengal it gets to three times that, and sometimes more.

Villagers traditionally twisted together a few stalks of either kind of *pat* pulled straight from the ground, and used them for tying boats or lashing crops – or even for tethering wild elephants, it was that strong. To make it into yarn for cloth, though, it needed to go through a rotting, or retting, process. The stems would be tied into heavy bundles as wide as a man's waist and left in a pond or slow river for several weeks, weighted down with logs. When they were soft, the valuable middle layers would be peeled away from the rough bark and the tough inner core, and hung on bamboo racks to dry. At harvest time, between July and October, there would be thousands and thousands of these racks across eastern India. As a correspondent for *The New York Times* wrote:

The stems are tied into bundles and left in water, before being separated into fibres (*left*), to be woven into sacks, and the inner sticks (*right*) to be burned as charcoals.

In India, at certain seasons, under its native skies and in the mass, jute affords a magnificent sight. The railroad, driving through the land from Calcutta to Bombay, takes its travelers past fields and fields of it, with all the beautiful effect of being driven through fields of newly-fallen snow.

Later the jute would be cut, sorted, carded – with its fibres combed into straight, tangle-free lengths – and spun. Like tea, jute is graded on where it was grown as well as how good it is, with '1' being very good and '8' being not very good at all. A connoisseur would know the various textile charms of Assam-1, or Bimli-4 or Jungli-8. The lowest quality was officially graded '*habijabi*', which is a Bengali word for 'rubbishy' or 'all over the place' and is also used as a metaphor. Along with the cuttings – the tough bits of the stem cut off from near the root – *habijabi* fibres weren't wasted but were made into brown paper, or were mixed with other grades to keep overall sacking costs lower.

A disreputable fibre

When those first samples from Calcutta arrived into the port of London in early 1792, sacking in Britain was usually made from flax or hemp, most of it grown in the Russian empire (which at the time included the Baltic States), and often spun and woven in Dundee. At the time, Britain and Russia had an alliance against France. But peace never lasted long and British prime minister William Pitt the Younger was nervous. Russia had invaded the Crimea nine years earlier, taking partial control of the Black Sea and Pitt could see friction ahead. He wanted to reduce Britain's dependence on Russian raw materials. He was keen to explore the possibilities of jute.

In 1794, the superintendent of the Calcutta Botanical Gardens, William Roxburgh, wrote a letter to the head of the Linnaean Society in London, James Smith.

> Since my return to Bengal I have found several plants unknown to me before. Amongst them will be, I think, three or four new genera and more new species ... You will have learned that the bark of *Corchorus olitorius* and *capsularis* is equal to the best flax, a fortunate discovery for India, and for our manufacturers at home. Do you find that it was ever used by the ancients, or any other people, as a substitute for flax?

If Smith found anything relevant, it's lost to history. But it didn't matter. Because for the first few decades none of the major British manufacturers liked jute at all. They called it a 'disreputable fibre', and in part that was because they couldn't work out what to do with it. When, in around 1823, the Dundee linen merchant William Anderson was sent a few bales by his brother in London, he gave it to their mother to test out. 'Like most of the old ladies in those days of hand-spinning [she] was fond of her wheel', he wrote. She found she could spin it into something like yarn, but even the best of the fibres she'd been sent could only be made into the coarsest kind of cloth.

Nothing like linen.

String theory

Anderson kept trying. He arranged for some of the samples to be spun into rope, as the poorer grades of linen and hemp usually were.

This involved a spinner holding a bundle of fibre around their waist, as a kind of human distaff, then walking slowly backwards for several hundred yards along a long alleyway known as a rope walk, teasing the fibres out into a strand while a colleague stood at the end of the passageway twisting it to give it strength, using a wheel.

The experiment made a decent twine, but still Anderson could see no opportunity for profit. A second consignment went to another Dundee man, Thomas Neish, but he couldn't persuade a single spinner to try it. Four years later, he sold the jute at a loss and it was eventually made into doormats.

Dealers in rough linen and hemp began to guarantee that their products did not contain any jute, to reassure buyers worried they might be cheated. Jute was thirteen pounds a tonne, the cheapest flax was twenty-six. The possibilities of quick profits with sleight of hand were obvious.

One of the problems was that it couldn't be easily spun in machines. In India, the jute hand spinners were used to adding a touch of spittle to the thread to soften it. But when you spin by hand you're close to the thread, you can sense what it needs, you can loosen it and twist it; it's like a dialogue. A machine-spinner has none of that nuance, and jute was proving too brittle.

For a solution, industrialists turned to Dundee's second industry: whaling. Whale oil had been used in the recent past in great quantities to light cities. Now that streetlights were beginning to be powered by gas, it looked like the days of slaughtering whales were over. But then the textile mill owners found that the oil was an effective softening agent for jute and the killing continued far longer. It's one of the historical tragedies of this otherwise sustainable crop.

When Bengal mechanised its own jute-spinning process a few decades later, it didn't need whale oil: poppy oil, a cheap by-product of the opium industry, was found to do the job nearly as well.

With the softening and spinning problems solved, the world's first jute-weaving mill was built just outside Dundee in 1838. It was followed by others, though in the beginning they found it hard to compete with flax.

As we saw in the tweed chapter, the 1830s and 1840s were tough times in rural Scotland: enclosures, crop failure, poverty, sickness, hunger and mass unemployment. For some people, the only hope of work involved moving so far away – to Canada, Australia, New

Zealand – that you'd never see your birthplace again. Those going east would often travel in the ships that had just returned from India with the latest crop of jute. The 'migrants out, fibre back' arrangement pushed down the cost of their journeys out. And the tickets bought by the passengers – in their desperate need for a new life where they wouldn't starve – also pushed down the cost of the jute.

Their places in the factories of Dundee were filled as quickly as they left by Irish immigrants who were so desperate that they were willing to work for less than the Scots, to live in worse slums, and to work longer hours. There were stories of Irish people – men, women and children, but mostly women – taking cattle boats over to Glasgow, then walking the ninety miles across to Dundee in the hope of finding work in the sacking mills.

At first, there was much more flax than jute, because of the supply issues and the costs. But then Russia and Britain went to war in the 1850s – over the Crimea, as Pitt had predicted – and the humble jute plant started to turn to gold.

Nobody expected it to be a real war

The tableau shifts. It is 1854 and Russia has destroyed the Turkish fleet in the Black Sea. Britain and France have made an alliance to stop Russia's expansion further south. Neither expects more than a skirmish; the armies are hopelessly unprepared. When the British arrive at the beginning of the year, there are almost no bunks and just one blanket per man: soldiers of all ranks are having to go to bed wearing all their spare clothing because it's so cold.

Now a still photograph from the Crimean War is projected against the scrim of our imaginary theatre. In the foreground is an army encampment: white wooden huts with their windows open, a little gathering of soldiers hunkered down to the right; one man with a hut behind him looking towards us, frozen in time; and everywhere pale tents like little cones, dotted down the hill in what seem random scatterings but probably are not. In the distance is the town of Balaklava – a village, really – with half a dozen tall ships anchored up in the tranquil harbour.*

* The battle of Balaklava is also remembered in the English word, coined at that time, for woollen garments worn over the face, with holes for eyes and mouth.

Balaklava in 1855, photographed by James Robertson.

I see this today and marvel at the emptiness, the apparent calm, the one man who seems to look at us, the chance to see so far back into history.

A Dundee flax or jute weaver of the time might have looked at the same photograph and wondered how much of her own work was there – in the material of the tents, the horse blankets, nose bags, gun covers, supply bags, sandbags and sails, or even in the fabric partitions for the portable darkroom used to develop this early war photograph.

Someone in Calcutta, seeing the same image, might have had a different angle. For them it might have seemed like an opportunity. There'd be no hemp or flax going to Britain from Russia for the foreseeable future, an editorial writer for the *Bombay Times and Journal of*

British women and girls knitted many balaclavas to be sent out to the army, when they heard about the soldiers camped out in the freezing Crimean winter of 1854.

Commerce noted on 6 November 1854. Soon buyers in western Europe would be desperate for jute.

He was right. Before the Crimean War, only fifteen thousand tonnes of raw jute had been going from India to Britain every year. By the time the troops went home two years later, the figure had more than doubled, and the orders kept rising.

Three additional factors would contribute to the ascendancy of jute.

The first was an eighteen-year-old chemistry student's accidental discovery of a drop of purple in his sink. William Perkin's 1856 invention of a new kind of synthetic dye made from coal tar would not only mean that clothes and rugs and fabrics could suddenly and cheaply be a whole rainbow of colours, it would also kill the market for natural indigo. It would mean that the indigo farmers of Bengal would need another cash crop, and fast.

The second was that the Russian tsar, humiliated by his army's defeats in the Crimea, would implement a policy of modernisation that would eventually lead to the abolition of serfdom. Most European countries had abandoned the feudal practice centuries before, but in the Russian empire it hung on, tying people to the estate they were born on. Serfs grew most of the flax in Russia; after the agricultural reforms, the future of Britain's main flax and hemp supply looked uncertain and vulnerable to political forces.

The third was that two men – a Bengali and an Englishman – had just made the first moves to bring industrial-scale sackcloth weaving to Bengal, inadvertently laying the groundwork for the domestic industry after independence.

How to get rich quick from jute

In autumn 1854, a clipper arrived into the port of Calcutta. On its lading certificate was a list of machines that had never been seen in India before. It included: 'One Teazer, one Finisher Card, four Drawing Frames, Two eight-inch rovings (forty-eight spindles each), Two five-inch Spinning Frames (also forty-eight spindles each).' There were at least two men who would be anxious to learn that they had all arrived.

Bysumber Sen was a *banian*, one of the powerful local financial agents in India who provided some of the capital for new ventures

with European partners, and who also acted as general intermediaries and troubleshooters in exchange for a commission and share of the profits

George Acland was an adventurer and a chancer who had arrived in India two years before. He'd been a midshipman in the East Indian Marine Service and a failed coffee planter in Ceylon. Now he was in Calcutta, looking for an enterprise to make his fortune. Textiles were the thing, he thought, as he watched all the raw materials passing through the docks and markets, and his first plan was to get into the ramie business.

Ramie, also called rhea or China grass, and pronounced ray-mee, is a cousin of the nettle. The fabric is strong and silky and people in China and South East Asia have been making clothes from it for centuries. Acland was given the concession to plant it beside the tracks of the newly constructed East India Railway. But he couldn't get it right. 'Tough, gummy stuff', said John Kerr at the Douglas Foundry in Dundee when Acland sent him a sample. It could never compete with other fibres, he advised. 'Better to stick to jute.'

Acland's next plan was to bleach the raw jute before it went to Dundee. With Sen's financial backing he bought some land at Rishra, a few miles upriver from Calcutta. It was a good location: on the west bank of the Hooghly, opposite an army barracks, which added security, and beside a major ferry crossing, which provided an important link between eastern Bengal and the rest of India via the Grand Trunk Road. He recruited his friend, brother-in-law, and fellow bankrupt in the Ceylon coffee caper, John Capper, now based in London. In 1853 and with no apparent experience in chemistry, Capper applied – along with a Thomas Watson – for a patent for the 'bleaching of jute and other vegetable fibres'. It's an extraordinary document. The two were so casual about the process – they named fifteen possible chemicals for steeping the jute, and three different ones for bleaching it – and so vague about the quantities and measures required that it's surprising it was allowed to pass. It didn't make money though, and, in Calcutta, the bleaching venture was also a failure. But by then Acland had had another idea.

Walking around the dried food markets and through the streets he had noticed something curious. Many of the sacks – 'gunny' sacks, after a local name for sack, *goni* – hadn't actually been made in India. They'd been spun and woven in Dundee from jute grown in Bengal,

and then they'd been shipped all the way back again. It would surely make more sense to keep the whole process in India.

The following season, Acland returned to Britain to find out more about the sacking business. In Dundee he was shown around some jute mills; he talked to experts, learned how a good mill should be planned and run, and then, before sailing back to Calcutta, he placed orders for the best machines he could afford.

In the summer of 1855, just as the harvest was ready in the fields, the first jute-spinning mill in India opened. It was called Acland Mill and it would be followed by many more, initially just spinning the jute, but, after power looms were introduced by the Borneo Company in 1859, weaving it as well. The ancient cottage industry of the Bengali villagers had become big business. And, over the century that followed, it would make industrialists in both Calcutta and Dundee very rich.

The major Dundee firms soon set up their own jute mills along the Hooghly, to run alongside their production factories in Scotland. Some of them are still there, enormous white buildings, with their own jetties. A few are in operation, but many are abandoned, tumbling down, their walls covered with mould stains and the tendrils of climbing plants. Once they would have appeared like palaces, with gardens filled with rose bushes and their own bathing ghats. In front were the offices and the Scottish managers' bungalows, with their verandas and fans. Behind were the actual mills, where thousands of jute workers sweated in the heat. And further behind, out of sight, was the cramped accommodation where the workers and their families lived.

An early twentieth-century account by the writer Eugenie Fraser, whose Scottish husband was a jute wallah in Bengal for more than a decade, gives a sense of the conditions. 'My first reaction was to quickly rush through and out the opposite door, but some inner voice told me not to hurry', she wrote about her single visit to the factory during all her years living almost next door.

> Amidst the haze of heat and dust I saw women in damp grey saris, wisps of jute sticking to their hair, poor worn faces clammy with sweat, yet smiling to me in a friendly manner. Men were standing at their looms and the Sahibs walking up and down, with shirts clinging to their bodies, gave me a cheerful wave as I went by as if they were strolling about in some park on a pleasant day.

To me, the deafening roar of the machinery, unbearable heat,
the pervading smell of jute all conspired to create a special hell
– a hell I took great care never to enter again.

From the 1860s onwards, the demand for jute products from both
Bengal and Dundee zigzagged like a piece of freehand sewing done
blindfold on a machine without a stop pedal. Sometimes it soared and
sometimes it sank and sometimes it went off the canvas.

A good coffee crop in Brazil or the Dutch East Indies? The mills
went into overdrive.

A record cotton harvest predicted in the United States? The cargo
holds of the clippers out of Calcutta and Chittagong and Dundee
burst with gunny bags.

A sugar glut predicted in Jamaica? Hundreds of thousands of
extra sacks were ordered.

Flooding predicted anywhere? Everyone wanted sandbags.

A few years of below-average crops? Nobody wanted any new
sacks at all.

Share prices could quarter overnight. And they could double. It
depended on the weather all over the world. Meteorological fore-
casting was a vital skill in the jute trade: as one director of a jute
conglomerate once put it, 'Everyone was waiting for rain in the
Argentine'.

And so it went on. Boom. Bust. Boom. Boom. Bust. A shuttle out
of control, veering from one side of the loom to the other.

The mid-nineteenth-century gold rushes in America, Australia
and New Zealand pushed up the price of jute and linen and hemp
canvas as the miners queued up for tent material, as well as for the
thick brattice cloth* needed to separate sections of the mines and
keep them ventilated.

The westward journeys of European immigrants across America
had the same effect. Those hoop-tented wagons inhabited by pioneer
families looking dazedly into early cameras? Almost all were covered
in Dundee and Bengal linen and jute.

* Brattice cloth was originally named from the medieval Latin '*bretescha turris*' or
'British-style tower' where it was used to protect the structures against missiles.
In time the towers element was dropped from the name, and the word for this
industrial screen material is now effectively 'British' cloth.

A brief post-war jute boom in the mid-1920s brought unimagined wealth to the peasant farmers of Bengal. They mostly spent the money, according to Bengali chemist Prafulla Chandra Ray, 'on bicycles and gramophones and German-made battery torches that they threw away when the batteries ran out'. He recounted how their wives bought *chadars*, or shawls, of the new 'art silk' made from cellulose – they were so much more expensive than ones made of natural silk that even middle-class Indians couldn't afford them. Later, with jute having taken over so many of the rice paddy fields, and its price having plummeted, these same farmers had to borrow money at massive interest rates just to survive.

And there were the wars. In the American Civil War (1861–1865), the mill owners in Dundee and Bengal sent sacking to both sides and grew rich; in the Franco-Prussian war of 1870, so many extra ships left the quays of Calcutta heading towards Europe (again, supplying both sides) that it created a local boom. The trenches of Ladysmith (the Boer War), Flanders (the First World War) and Normandy (the Second World War) would all be reinforced with jute gunny sacks. Though by the time of the Normandy campaign, almost none of them would be made in Dundee.

I decide to go there, to find out what happened.

How to get poor quick from jute

I walk up from Dundee station, turning reluctantly from the new Victoria & Albert Museum, gleaming its shiny reflection into the old, now quiet, docks. I pass the 1920s Caird Hall, with its famously good acoustics, and the Marryat Hall beside it. The first was named after James Caird – jute baron son of a jute baron father – who dedicated it in 1914 and didn't live long enough to hear a note played in it. The second was named after his sister Emma Marryat, who spent a good deal of her substantial sackcloth inheritance finishing her brother's hall, and adding a small one of her own.

The university is to the west (more textile money), and Baxter Park is to the east (even more textile money), and I know from my reading that the coastal road behind me, down to Broughty Ferry on the shore, is lined with the huge Victorian and Edwardian mansions of men who grew rich on cloth. A few miles north is the site of the old Camperdown Works at Lochee, which was once the biggest

factory in the world. It had two railway stations, a few schools, a casino, several churches, a library, too many slum tenements and its own police service.

I'm walking north-west from the town centre and I come to West Marketgait, in the area that was called long ago, but with premonition, Blackness. At the time, it probably meant 'black promontory' with the 'ness' coming from the old Norse for 'nose', but on occasions, over the centuries, the smoke and the pollution has made the name come true. You can still see the traces of the dark in the walls.

I stop with a kind of wonder. So far there have been plenty of small signs of past wealth but no signs of actual industry. But now, ahead of me, across a wide road, there's a half-kilometre or more of mill buildings – granite, three and four storeys high, smooth, neoclassical Victorian, with scarcely a break between. The high, belching, chimneys that were once there have long since been demolished, but the façades are mostly intact. The main one is the Tay Works, built in 1865 by the Gilroy brothers, who were among the showiest of all the textile men. (George Gilroy built himself a house modelled on a Gothic castle, well away from the dirty air of the mills.)

I go under a high archway and walk across cobblestones. At one time, standing in that place, I'd have had to dodge heavy wagons pulled by horses straining with the weight of finished sacking cloth going out and Indian fibre coming in. I imagine the noise on a midday morning a hundred and fifty years ago, the clang and clatter so loud that nobody bothered even to shout when all the machines inside the mills were working.

Ahead, a run-down snooker hall with metal bars on its windows shares quarters with the 'Olde Mill Coffee Shoppe' – locked – and Hope United Church. I perch for a moment on one of the beer kegs outside and look back towards the archway I came through. Thin-faced children in hoodies squat in a corner beneath graffiti-covered walls, passing each other a joint.

At eye level, in the half-rain, the whole place appears desolate. It's hard to imagine that when Dundee was named – 'Dei Donum', 'Gift of God' – it was not ironic. But behind the city, invisible today in the rain and invisible too in the heyday of jute, there are some fine hills. There is beauty here, behind the scrim, but you have to look for it.

When I look up, I can see that the factory buildings are in good condition. From the signs and a security system on the doors, it's

evident that the old offices of the Tay Works have been turned into apartments. They're student flats, I'm told later, while other mills in the city have been turned into private housing. They have thick walls and big windows, giving at least a few people the kind of decent-quality accommodation that the jute barons rarely provided in their own time.

When women worked and men didn't

Flurries of children – little boys in woollen caps and brown waistcoats, girls in white pinafores and mob caps – are running up and down the stairs and through the galleries of the old Verdant Works jute mill, now Scotland's Jute Museum. The children, on a school visit, guided by a harried teacher, pause to press buttons or try out clumsy iron hoops once wheeled skilfully along cobbles by children used to controlling metal; these their only toys. Jute preyed as voraciously on Victorian childhoods as most of the other industrial textiles; there would have been little time for play. They started aged eight, worked thirteen-hour days, and were deafened by noise and sickened by wisps of coarse fibre in their lungs, born to a legacy of bronchitis and tuberculosis. Eleven-year-old boys in Dundee were eleven centimetres shorter and six kilograms lighter than country boys. Most would never even reach five foot in height (one metre fifty-two centimetres), and would die, on average, by thirty-three. Girls were underweight too, and female death from tuberculosis was higher in almost all age ranges. Even Glasgow and Manchester, the other big textile cities, did better, health-wise, than Dundee.

'Juteopolis' was different from most other British textile towns in another important way. Girls and boys would start work at the same age and get the same jobs at the mills, but every girl knew that she would have a job for life, and every boy knew he that wouldn't. Unless he found a job in the offices or opening the jute bales he'd pick up his last wage at the jute mills before he was eighteen. Most of the work wasn't too heavy– women could manage it easily – and adult women were paid less than adult men.

Some of the men could get jobs at the docks or in the shipyards but the shame name for the others was 'Kettle-bilers' – kettle-boilers – because they were expected to make tea for their wives when they came in from their shifts. They were also expected to look after the

children, though often they didn't. In 1846 there was one pub to every twenty-four families in Dundee, and they were open from eight in the morning until eleven at night. Fray is a word for a disturbance and also for loose threads at the edge of fabric. Dundee had both.

It wasn't just the men drinking. In 1895, more women than men were charged for breach of the peace. Sometimes that was the drink and sometimes that was the politics. Dundee had been known as a radical town since the 1790s when its Whig Club praised the French Revolution as a 'triumph of liberty and reason over despotism'. Dundonians were quick to raise their voices against perceived injustice, and many of those voices were female. Between 1850 and 1890 there were more than one hundred strikes involving women.

In October 1907, a suffragette rally in Edinburgh was attended by three hundred women from Dundee, with a sizeable party from the newly formed Jute & Flax Workers Union. Which, unusually in those pre-suffrage times, had half of its executive seats reserved for women.

Winters were the busiest times, the ships leaving Calcutta as soon as the retting and drying were done, and after the Suez canal was opened in 1869 arriving in Dundee any time from November. Then the men working at the docks would rip open the massive bales with metal hooks and use leather straps and ropes to pack them onto carts to get them the mile or so to the mills, bumping over cobbles, trailing behind them the strange, sweet smell of jute. Except that once upon a time the smell was everywhere; if you lived in Dundee, you probably stopped noticing it.

Some people don't like it. Esther – the volunteer at Verdant Works who first showed me some samples of unspun jute – said she hated it.

'It's like wet clothes,' she said, wrinkling her face. Later, when I was alone, I pressed a dry clump of it to my nose and it was a puzzle. What *did* it smell like? I closed my eyes, and I was tugged back and back through the years to a tiny, inconsequential moment in childhood. I was eleven; it was the hot summer of 1976; I'd gone for a bike ride with my friends and now we were lying on our backs in grass so dry it was almost hay. Our freshly oiled bicycle wheels were whirring beside us, bees were humming and there were traces of suntan oil and heat and a distant tang of dog poo and the vague shimmer of leaded petrol floating above the busy road. It was slightly earthy, slightly sweaty, slightly barnyard.

'When I was a bairn, we'd say it's the "perfume of Dundee".'

An older woman's voice cut into my thoughts. I opened my eyes, returned her smile, and was back in today.

I looked at the sliver of jute in my hand. It had been through a few processes already after being picked from an Indian or Bangladeshi field, retted to get rid of the unusable bits, and transported to its factory.

After being removed from the bale and blended, it is pushed through 'the Softener'. It sounds like the evil pet name for an instrument of torture, and for the jute it is not too far from that.

All the machines in the Verdant Works are built on a smaller scale than in real life, made after 1889 as part of a 'mill and factory in miniature' for students training at the Dundee Institute of Technology, now Abertay University. There are eight pairs of rollers in this version of the Softener, but industrial machines had at least thirty-two, with the jute passing along all of them in turn. Each pair looked similar to those old-fashioned manual lawnmowers I remember from childhood – two large, fluted cylinders rotating against each other – although here, instead of sharp edges for grass, the flutes were more like drill bits, with long and lazy helical edges for tenderising the tough grass. In the real industrial process it would have been sprayed at this point with a mixture of water, soap and oil. It's not whale oil now, of course, nor poppy oil, but something mineral, a by-product of the petroleum industry.

The volunteer demonstrating the process threw a clump of fibre in at one end, and pushed the button. There was an almighty churning sound, as if devils were playing dice with rocks, or a load of gravel was being tumbled out of a dump truck.

After a few seconds, the jute emerged onto the conveyor belt and the volunteer carried it over.

'That'll give you an idea of how much softer it is,' he said. And this was even before it would have been 'carded' between yet more rollers, these ones covered in metal pins, or hackles.

I was surprised to find that it didn't feel coarse at all. It was more like a charmingly tousled, dirty-blonde wig – almost as soft as human hair but not quite.

And in America

In America they mostly call it burlap: 'bur' from the old Dutch word

for farmer or peasant, like 'Boer' in South Africa; 'lap' from an old northern European word for cloth. We have it still in English in 'dewlap', meaning the cloth-like skin that folds under the neck of a dog or a rabbit. It's the same word as the Dutch *lap* meaning rag or piece of cloth and the Icelandic *leppur* meaning the same. People in Papua New Guinea took the word from the Dutch. When one of the Maisin women I met while researching barkcloth talked about a skirt, she called it a 'laplap'. I wasn't sure what she meant. 'It's this', she said, pointing to the one she was wearing. 'The cloth we wear to cover our lap.' Two laps? I asked, teasing. 'Yes,' she said, tapping one leg then another. 'Lap one lap two.'

After the Civil War, jute factories began to open across America. The cotton town of Lowell in Massachusetts got into the jute business in 1870; by then there was already a huge mill in Paterson, New Jersey, which extended over seventeen buildings, as well as the Chelsea jute mill in Brooklyn, New York, where in 1886 there was a massive strike by the female workers. 'The strikers are mostly [women] employed principally as spinners and weavers, but include also 80 or more young girls and boys, 14 to 16 years old, who are employed as "doffers" or to replace filled spools on the spindles with empty ones', *The New York Times* reported, adding a few weeks later that the 'girls' were 'lounging around the building and intimidating those who wanted to return to work'. The mill manager, Mr Lyall, said that he was willing to pay 'all that the business would warrant, but that the industry was at the lowest point ever known'. There were only three mills in the country, he said, even though America was the largest user of jute in the world. 'If there was any money in the business there would be 30 mills here, instead of three', he said.*

In Mr Lyall's counting, he forgot to include three other manufactories, all in California. Though it was perhaps not surprising that he missed one of these, as it was the one jute mill in America that needed neither to make a profit nor pay attention to wages or staff walkouts. It was also the only jute mill in the world that employed only men.

The San Quentin State Prison Jute Mill opened on 3 April 1882 in Marin County, California, importing the raw material from Calcutta.

* The strike failed. The owners put job notices in local publications and the mill was soon back at full power, with mostly new hires.

Whenever harvests were good, farmers and shippers
would order more sacks. Potato field, 1945.

It was so successful that in its first year it had contributed a hundred
thousand dollars to the running costs of the prison. Seven years
later, after moving to a twenty-four-hour schedule with the arrival
of electricity, and with the expectation of bumper crops through-
out the country pushing up the demand for sacking in America,
the warden assured trustees that the mill would support the full
two-hundred-thousand-dollar cost of operating the prison, and still
have a hundred thousand left over for the state treasury. His prede-
cessor even tried growing jute – in three nearby counties as well as
on Twitchell Island in the Sacramento delta – using the best seeds
from Bengal. It was a failure. 'While a good article of jute should

attain a growth of from nine to fourteen feet, it did not reach a third of the height in California', conceded a report to the state senate in 1891. The crop requires 'a kind of natural steaming process', the US experimenters conceded. 'The long dry summer of California is death to the jute plant.'

Those were the days when convicts wore stripes, symbolising bars and making them immediately recognisable if they tried to escape. But they rarely did escape from San Quentin, not even when the doors were wide open. In March 1909, there was a huge fire at one of the jute warehouses on the waterfront and prisoners were brought out to fight it, alongside the regular fire service. 'In all 600 men – some of them decidedly dangerous men if handled as such men are usually handled – risked their lives to extinguish the thing', the *San Francisco Call* reported.

> All the time it was like all firefighting … vast confusion … And when it was over every one of those prisoners went back to his cell tired out … many badly burned, others with lungs sore from smoke. They went back to their cells and no one … did it; none tried to escape …. Esprit de corps sounds queerly when one is talking about a prison.

In 1911, a former guard at San Quentin wrote an article about the jute mill for the *Santa Cruz Evening News*. Eight hundred prisoners, supervised by twenty-one guards, produced some sixteen thousand sacks a day. It was achieved by a 'task system' in which each prisoner had a quota after which he could leave for the day. If he didn't meet it, he'd be penalised with extra hours.

In 1893 the future writer Jack London was seventeen, freshly returned from a seal-hunting expedition in the Bering Sea, back living with his mother in Oakland (some twenty kilometres south-east of San Quentin prison), and in keen need of cash. He took a variety of jobs, including thirteen-hour shifts at the Oakland jute mill at ten cents an hour, which was a poor wage even then. Twenty-two years later – as every jute factory in the country was open round the clock churning out burlap bags to send to the trenches in northern France – he used that experience in a novel about a professor with a life sentence, who finds himself tending one of the steam-powered looms at San Quentin gaol.

It was … shortly after my entrance to prison, when I was weaving
my loom-task of a hundred yards a day in the jute-mill … I was sent
to the [strait]jacket that first time, according to the prison books,
because of 'skips' and 'breaks' in the cloth, in short, because my
work was defective. Of course this was ridiculous. In truth, I was
sent to the jacket because I … had elected to tell the stupid head
weaver a few things he did not know about his business.

When people wore sacks in wartime

When the Japanese captured the Dutch East Indies, today's Indone-
sia, in 1941, they did so partly because of its strategic location and
partly for its resources. There was mica, needed for electrical wiring,
and there was the potential, they believed, for growing a great deal of
cotton. But as the war went on, the shortage of food meant that fields
were now mostly utilised for rice paddy, almost no cotton or hemp
was actually grown, and the subsequent lack of material for clothing
became a huge problem, as did the scarcity of sacks.

Before the war, the Dutch East Indies had imported around
thirty million gunny sacks a year from Calcutta to transport coffee
and cotton and sugar and flour. But British India was not going to be
exporting its sacking to Japan-occupied territories any time soon. The
Japanese in Indonesia had to look for alternatives.

First they looked at growing jute, but according to war historian
Shigeru Sato, the climate wasn't right. They also experimented with
kenaf, a kind of hibiscus that's also called rosella or Jamaican sorrel
or Java jute or Deccan hemp, and can, even today, be an adequate
substitute for real jute. But although it had been grown in Java since
the 1920s, these attempts also failed.

The agave cactus had been introduced from Mexico half a century
before, to make a cloth that was rougher than jute but useful for
flooring. In Central America, the fibre was called henequen although
internationally it was known by the name of the Mexican harbour
most of it shipped from: Sisal, in Yucatán. The Japanese found that a
mix of this sisal with coconut and pineapple fibres made a rough but
adequate kind of sacking.

Then the crisis in clothing became worse. Children weren't
going to school because they were in rags; farmers couldn't go into
the rice fields because they had nothing to cover themselves with.

With the industrial spinning mills destroyed, the Japanese Military Administration ordered a million old-fashioned hand wheels and spindles to be made. They also ordered half a million households to grow cotton in their gardens. They calculated that with each person spinning forty grammes of yarn a day, they could begin to solve the clothes problem – once they'd put rice fields to cotton after the first harvest.

But that was next year, and anyway priority would be given to the elite. Meanwhile, ordinary people were desperate for something, anything, to wear right now.

Sisal was too scratchy: nobody could wear it and do a day's work. Then the head of the occupation forces' Department of Industry, Tennichi Koichi, noticed that there were a million tons of sugar, all stored in pre-war gunny sacks from Calcutta. He ordered that all that sugar be transferred to the new kind of sisal-pineapple-and-coconut sacks, and that, freed from their sugar, the Indian gunnies should be used for shorts and shirts and sarongs. Six million sacks could make twelve million pairs of shorts, he calculated.

Albeit extremely scratchy ones.

After the war, it took some time for local textile companies to start producing enough fabric to clothe the people. Even in 1947, four in five people in some districts of Java were still wearing gunny cloth.

The secret of the jute workers

In 2016, just after I'd started researching this book, I took a mid-morning Saturday train from Bath to London. At Reading, with half an hour to go, a man dressed in a kilt settled in opposite me and lined up a couple of lagers on the table between us. Would I like one? he asked, adding that he was going to see an international football match – Scotland against England – at Wembley.

'I would,' I said. We chatted and he told me he was originally from Dundee.

'I'm going to be writing about Dundee soon,' I said. 'I'll be finding out about jute.'

'I used to work in a jute mill, on the spinning machines,' he said, 'when I was a boy. Before the mills closed.'

'Did you enjoy it?' I asked.

'I went mainly because of my dad and the first few days it was

terrible. My hands really hurt, but then I learned the secret.' He paused a beat.

'What was the secret?' I asked.

'An old chap said go into the toilet and piddle on your hands – it'll harden your skin. You'll need it,' he said. He grinned and raised his beer can. 'So I did. And it worked.'

Sacks that last for centuries

'Today we discovered isotactic polypropylene', wrote fifty-one-year-old Italian chemist Giulio Natta in his laboratory workbook in 1954.

He knew it was important. But he could not have seen how much that discovery would change the world. It was going to affect freighting and sacking; it was going to give us training shoes and hygienic replaceable medical products and different kinds of garden furniture; and it was going to give us more than a billion of the same plastic Monobloc chair. It was also going to produce the only type of sackcloth that would win the Nobel Prize.

Natta had fallen in love with chemistry when he came across a book on the subject when he was twelve. 'I read it breathlessly, like a mystery magazine', he told an interviewer. He'd spent several years during the Second World War making artificial rubber from sugar extracted from beetroot ('making gum from turnips' a colleague called it), which had left him with a lasting interest in organic chemistry and in finding substances that would be directly useful.

In 1952 he travelled to Frankfurt to attend a lecture by German chemist Carl Ziegler. Ziegler was talking about a problem that had stalled work in plastics research. It was about the issue of asymmetry in molecules. This quality is called chirality, after the Greek word for hands, because it's the same kind of asymmetry that our left and right hands show. Sometimes the chirality of a thing doesn't matter – a right hand or left hand can equally pick up an 'achiral' object like a tennis racket. But sometimes it does matter, just as a right hand won't go into a left glove. Scientists were working with propylene gas, extracted from oil, and they knew that if they could somehow make it form into a solid, they would have something quite revolutionary. But the molecules were the wrong kind of 'handed'. They weren't joining up.

Woman in central India, carrying a large polypropylene sack.

However, Ziegler said that he'd tried using compounds of aluminium and titanium together as a catalyst. He'd observed how their interaction had produced a two-sided catalyst with electrons that see-sawed between the two sides. Each time the charges shifted, it helped a gas molecule attach to its neighbour, and, in a way, hold hands.

Natta returned home, explained the development to executives at the Milan-based chemical firm Montecatini where he worked, and invited Ziegler to join him in Italy. The two men were in one way as different as left- and right-handed molecules. Ziegler was an academic chemist; Natta had the practical logic of an engineer. They had in common a fascination with fossils,* but not much else. But a year later, with the catalyst of serious industrial research and development money, they found how propylene could become 'poly' propylene, ('lots of propylene'). And once it went into production, there was a lot of polypropylene.

* Ammonites are, of course, also chiral.

The process involves the gas molecules being clicked (with the help of a catalytic agent) into chains of gummy liquid, which is then dried into solid beads, ready to send around the world. The beads can become pretty much whatever you want them to. You can melt them in moulds to make solid objects or – the way almost all today's sackcloth is made – you can squeeze them out into long threads ready to be woven into some of the strongest, most lasting kind of fabric in the world.

In 1956 Natta travelled to America and two years later the first US manufacturer of polypropylene yarn opened in South Carolina.*

After that the polypropylene industry expanded as quickly as a polymer chain. And it chased the places that jute had run to.

Jute can make backing for carpets. So can polypropylene. Jute can make sacking. So can polypropylene. Jute can make ropes. Polypropylene can make ropes too. And sewing thread, and container lorry strappings, and artificial grass for sports pitches. In 1999 I interviewed the Bulgarian-French husband and wife artist team Christo and Jeanne-Claude, not long after they wrapped the Reichstag in Berlin in a hundred thousand square metres of silvery fabric as an art installation. They had used polypropylene, as they always did: they said they liked how it sinuated around the shapes of the building; there's a beauty to that.

'It means you see it and you don't see it, both at the same time,' Jeanne-Claude said.

A sack of the future

Today the polypropylene industry is worth about a hundred billion US dollars a year. It's an amazing success. But it's also a problem.

I was once with a friend who needed to tell her children that she had cancer. I went with her to meet a palliative care expert and we discussed how my friend was going to do it.

'Do either of you know what cancer is?' the expert asked, gently. We realised we didn't, not really.

'Every cell, everything that lives, goes through a process,' she said. Three things have to happen. It's born, it lives, and then it dies. 'But cancer is a cell that doesn't die. That's why it's a problem.'

* Ziegler and Natta won the Nobel Prize in Chemistry in 1963, 'for their discoveries in the field of the chemistry and technology of high polymers'.

A sack that lasts. That used to be the criterion. But we don't want a sack that lasts and lasts. We want a sack that lasts for a while, and then decomposes. Back into the earth.

When Bangladesh became a nation in 1971, two-thirds of its export income came from jute. Next to India, it was the world's biggest jute producer, and the crop was vital for the economy. But nobody expected that to last. Even in Bangladesh and India, polypropylene was seen as better. Elsewhere, people had almost forgotten why they would ever have chosen jute.

But despite the rise of plastic, production of the ancient fibre once used for tethering elephants has somehow held on in Bangladesh. Jute is no longer its top industry in terms of export earnings. That place was quickly taken by the garment industry – cheap labour and the willingness by some factories to overlook fire and safety measures proving a potent lure for many international clothing companies, including high fashion. But Bangladeshi farmers are still growing 1.3 million tons of jute, second only to India's two million, and far more than the other growing nations of China, Thailand and Indonesia.

And there's something different about the cycle of jute's growth this time around. Now, the crazy Himalayan peaks of the old production graph have been replaced by the foothills of a slow climb. And this time the saving of the jute industry has had little to do with the timing of wars against nations, floods in Brazil or freak cocoa harvests in West Africa. This time it's being rescued by the so-called 'war on plastic', better described as the 'war against plastic waste',* because that's where the main problem lies.

In 2010, India introduced 'mandatory jute packaging'. It became compulsory to transport all domestic sugar, grains, rice, animal feed,

* Plastic packaging has some environmental advantages. It can reduce food waste, and it is lighter and less bulky than some alternatives, reducing load sizes (and therefore carbon emissions) when goods are transported. Also, once it's been used in one form, it can be melted down to make into something else. The problems arise when it isn't recycled or disposed of carefully, and particularly when it joins the eight million tons of plastic and uncounted tons of microplastic that arrive in the oceans every year, endangering sea life and adding carcinogens to the seawater. Which will in time become the water we drink, and the water that rains on the land.

fish meal and concrete in sacks made only of jute or similar natural fibres. When Bangladesh followed in 2015 with its own measures, there was a temporary emergency shutdown of all raw jute exports, with the government aware that it would need to have a lot more natural sacking available for domestic use if it was going to achieve its own targets.

Between them, the two countries produce more than three million tonnes of jute, but they have the capacity for much more if the rest of the world follows their lead.

I once visited a wool-scouring factory in Bradford, which cleans most of the wool grown by British sheep, as well as all the wool from Norway and Algeria. I saw huge bales of dirty wool coming in and clean wool and worsted going out, all bound with so much polypropylene sacking that I'd been reminded of a Christo installation. But in the far corner of a storage shed, I saw a few outgoing bales encased in jute sacking.

'They're more expensive,' I was told by the managing director, David Gisbourne. 'But more and more companies are asking for them now.'

At the time I'd thought that it was an old-fashioned thing to be requesting, but I'd been wrong. If we're lucky, this is the beginning of the future.

If we're lucky, the sack of tomorrow has been here all along. Hiding just behind the scrim.

LINEN

In which the author finds odd bits of 'the actual linen' in a drawer she's never opened before.

For a few weeks when I was twelve my class had a magical Latin teacher, Mr Thomas. In our first ever Latin class he started by telling us three things.

1. He'd been present at one of the discoveries of Dead Sea Scrolls in the 1950s.
2. He'd been an extra on the 1959 film *Ben Hur*.
3. He was going to begin our Latin education by teaching us about the Greeks.

For that first lesson he had us chanting the nonsense croaking chorus in Aristophanes' *The Frogs*, learning about some of the more exciting Greek heroes ... and memorising the Fates.

The youngest is Clotho, who spins the thread of our lives, and the Romans called her Nona – Nine – because she turns up in the ninth month, just before our birth. The middle one is Lachesis, who measures the thread and predicts what we'll make of it, and the Romans called her Decima – Ten – because she takes over in the tenth month when we're born. The oldest is Atropos, who will cut the thread, and the Romans just called her Morta – Death. In Greek, *atropos* means 'inflexible' or 'not for turning'. Because we can't always change when the threads of our lives will be cut.

Mr Thomas said that we could remember the name Lachesis because it sounds like Lucky Sister and because her area of expertise is fortune and misfortune, whatever those two might mean. And though Atropos is harder, we could remember the 'tropos' bit from the tropics, the lines on the map marking the most northerly and

southerly points where the sun can be directly overhead and then appear to turn. But Clotho is named for the Greek for spinning and we could remember her from our English word 'cloth'.

And whether our word for cloth does or does not come from the name of a Greek metaphor (unlikely but possible), and whether my first Latin teacher really *was* present at the discovery of documents and linen from the Judaean desert in 1956 (also unlikely but also possible), I learned at least two useful things from that first two hours of my classical education. The best way to teach, and to learn, is through stories with bright images. And thread is as good a metaphor as any for the courses in life that we cannot change as well as the ones that we can.

The fibre spun and measured and cut by the sisters of Fate in Greek mythology is flax, the tall grass, *Linum usitatissimum*,* that is grown to make linen. And for Clotho's distaff to be full of flax means that it's also full of life.

The colour of sand and mountains

Flax grows in most places, but it thrives where river deposits replenish the soil every year: the Rhine, the Scheldt and the Meuse, in Holland and Belgium; the Nile valley, with its annual overflow to feed the flax fields of Egypt; and the Oder, the Neman, the Vistula and the Dvina, enriching the soils of the Baltic lands, which until the mid-nineteenth century traditionally supplied most of the flax spinning wheels of Europe.

As it grows, flax is the colour of sand on a cloudy day, and it has pale-blue flowers, like distant mountains. It is so long and thin that it seems to almost have the nature of thread already. But, unlike cotton (which is pretty much ready for spinning after you remove a few seeds and card it), silk (which often just needs to be reeled and twisted), or wool, which needs to be cleaned and combed but is also essentially itself, for a flax crop to be ready even for basic spinning, some hard work has to happen.

Flax is never cut: it's always pulled. This means that the full length is preserved, root and all. Then it is gathered into bundles, or 'beets', and dried (in the sun if possible, in barns if not), after which the seeds are removed in a process called rippling. In the past, this was variously

* *Usitatissimum* means 'the most useful'.

done with 'ripples' (like giant combs with long nails stuck into them), mallets, rolling pins, or – in Flanders after 1900 – on an instrument called a 'piano', with up to eight hammers, each striking the flax in succession.

After this it is either laid out on the ground to catch the morning dew or in ponds, tanks or slow-moving rivers, weighted down for several days or weeks. The dew makes the flax silver; the ponds make it pale gold. The ponds are said to make better linen, but they always smell terrible: of something dead and sweet. One Irish farmer in the 1950s said that after he'd climbed into a ditch to remove the slimy flax 'no woman would come near me for two weeks'.

This part is called retting, from a Dutch word with the same root as rotting, which more or less describes what is happening. The flax has to be soft enough to allow the separation of the important middle layer from the harder inner core and the rough outer epidermis. As with barkcloth and jute, it's the layer through which the nutrients pass that's needed for the cloth. It's skilled work: you have to allow the pectins to soften just enough, but not too much. Thicker strands ret more quickly – they contain more wood so the pectin layers are thinner – and therefore must be removed from the water earlier. The roots on the flax stop moisture being drawn into the stem; they act as a kind of plug.

Then it's dried again, beaten (or 'scutched' from the Latin *excutere*, to shake out) and then 'hackled' (or 'heckled') by being pulled through an upside-down parody of a hairbrush called a hackling comb, after a Dutch word for hook, *haak*. From this we get the word 'hecklers' to describe people who interrupt public speakers intending to straighten them out.

The origin of the word is likely to be metaphorical, though there's a competing theory in Dundee, where a great deal of linen was processed, that the term came from the city's many textile workers who were known for being outspoken at public hustings.

Grey, ecru and drab

After all this, the flax is still not white. Its natural colour is sometimes called ecru, from the French *écru* or *escru*, meaning cloth that has never been wet.* Other words are greige, grey or drab. The last is often a

* Tapestry makers in seventeenth-century France were forbidden to use fibres that were 'escruës' – not wetted – because they would later shrink when washed.

word of criticism, meaning dullness of attitude, but it originally came from the French for sheet, *drap*, a reference to the brownish colour of sheets that haven't yet been bleached.*

In any case, flax isn't really grey or drab at all. More than anything, it's the soft colour of fine blond hair, which explains why old-fashioned novels sometimes describe blonde heroines as flaxen-haired, and why old-fashioned children's books sometimes refer to cheeky small boys and girls as 'tow-headed'. I used to think this meant that their hair stuck up like straw. But it meant that it was the dirtier goldish colour of tow, the lower-quality flax, which was generally used for rope or coarse fabric.

Why was Sleeping Beauty's spindle so sharp?

Hair and flax, spinning and gold, spindles and fate. As spinners sat together and told stories, it's not surprising that these elements combined into dark or comic narratives. And one of the stories told to Jacob and Wilhelm Grimm, as they toured Central Europe in the early nineteenth century collecting folk tales, was *The Three Spinners*.

It's about a girl who hates spinning. She finds herself in a nightmare scenario where she has to spin three huge rooms of flax in record time. If she succeeds, she will marry a prince. If she doesn't, then her family is shamed forever.

After sitting for three days in a depressed state, she's visited by three old women. They appear like the Three Fates, holding her future in the balance. One has a broad, flat foot, another has an underlip so huge that it hangs over her chin, and the third has a very fat thumb. They can help. All she has to do is invite them to the wedding and call them her aunts and sit them at her table. The girl agrees 'with all my heart' and when the work is done and the prince is won, she keeps her promise.

The prince is curious about the three old aunties. 'How do you come by such a broad foot?' he asks the first. 'By treadling,' she says. 'How do you come by such a lip?' he asks the second. 'By licking,' she says. 'How do you come by your very fat thumb?' he asks the third.

* 'Beige' wasn't used in either French or English until the nineteenth century. Today it is used without specific reference to fibres, but it originally applied mostly to undyed wool.

'By twisting,' she says. The prince is horrified. 'Neither now nor ever shall my beautiful bride touch a spinning wheel,' he says. And so she never does.

That one is straightforward, but a spinning story that has always perplexed me is *Sleeping Beauty*. As we know it from *Grimm's Fairy Tales* and Walt Disney, the plot revolves around a princess who falls into a deep sleep by pricking her finger on a spindle. But spindles aren't particularly sharp. So what was this story about? A code for sexual abuse? A metaphor for starting menstruation? A sewing activity that had got confused with spinning? Sometimes I would wonder.

Then one day we took a path through our valley that we hadn't often followed, and I noticed a tree with the most beautiful fruits I had ever seen. They looked like tiny fairy-tale pumpkins: hot pink on the outside, with the brightest of orange berries nestling inside like offerings. I took a photo and asked for help on the internet. Within moments I learned that it was *Euonymus europaeus*, also known as the spindle tree. Later I found out that it is native to Britain and, more importantly, native to the northern regions of Europe where many of the stories in the Grimm Brothers' collection originated. It is sometimes called skewerwood, or prickwood, because as well as spindles (which are not sharp) it was used for goads and skewers and knitting needles (which are). Also, every bit of the tree is poisonous. The bark can make people and animals sick, while according to the 2007 *Handbook of Poisonous and Injurious Plants*, those tantalising magic pumpkin fruits can lead to 'fever, hallucinations, somnolence' as well as – and this is the key thing – comas. If a young girl had eaten a berry or perhaps even pricked herself on a splinter of spindle wood while spinning flax then perhaps she might indeed have slept for a very long time. Perhaps they might all have thought that she was dead.

The linen press

I find to my surprise that there is actually linen in the drawers of the linen press. I've never looked in it before. The linen press was where my mother kept the presents so I never opened it while she was alive. But she has just died and now the press has to be moved to make room for a hoist to get my father in and out of bed. It's a huge piece of mahogany more than two metres high and a metre and a half wide. It has ebony lines around the doors to mark the death of

Lord Nelson in 1805. It used to belong to my Scottish grandmother and probably to my Scottish great-grandmother. And now there's no space for it and it has to be sold.

But before that it has to be emptied and so I sit on the floor and open the first drawer.

The things my mother called 'the bed linen' – the sheets and pillowcases and duvet covers that are actually made of cotton – are not in here. They're in an upstairs cupboard.

The things my mother called 'the table linen' – the tablecloths and napkins they used just about every day and that are also actually made of cotton – are not in here either. They're in a drawer near the dining table.

This linen is different. This is the linen that wasn't used. This is the *actual* linen.

I find ridiculous numbers of table napkins. They are folded in plastic bags that are crinkly in ways that plastic bags aren't crinkly any more. They're marked things like '21 Napkins F' or '5 Handtowels JVF' – my grandmother's initials – in black wax crayon. In each I find the relevant number of pieces, with the relevant monograms machine-embroidered onto them.

Marking linen with embroidery is an old custom. There are still pieces in French museums dating back to the fourteenth century, with fleur-de-lys patterns picked out in black or yellow or red showing they belonged to one or other of the royal households. In the beginning, monogrammed linen was for the aristocracy, but later it was for anyone who could afford it, to stop the pieces being lost when they were sent out to be washed.

I unwrap some hand towels with 'H' on them. Henderson. My great-grandparents' name. They might have been bought for their wedding in 1888. One has been darned with white linen thread; it's very neat. I look at it. Darning is the sewing closest to weaving. You start by making a 'warp', sewing as many parallel lines as you'll need. Then you wiggle your needle in and out of them, line after line, doing a miniature form of weaving to create a new patch of cloth, and so filling the space left by the rip or tear.

I decide that the darned one is my favourite. The Japanese have a philosophy of seeing beauty in mending, and of mending things so beautifully that the torn and broken pieces seem more precious than the perfect ones. The practice is called *boro*, which means rags,

because that's what these patched clothes were made from. The running stitch used for mending is called *sashiko* or 'little stabs' because of how the needle dips in and out of the fabric like a calligraphy of repair. It is fast and efficient and sometimes in its speed and nonchalance, it is an act of artistry.

I put any browned pieces in a pile. A while ago I'd have thrown them away or given them to a charity shop (which, from my brief experience helping in a charity warehouse, is almost the same thing when it comes to anything even slightly stained). But once, in a small hotel in Sri Lanka, I'd found a book in a drawer in the bedside table. It was titled *The Teaching of Buddha* and was printed in English and distributed specially for travellers. In it I found a story about what happened when Buddha's disciple Ananda was offered five hundred garments by the queen. And it changed me.

> The King, hearing of it, suspected Ananda of dishonesty, so he went to Ananda and asked what he was going to do with these five hundred garments. Ananda replied: 'Oh, King, many of the brothers are in rags; I am going to distribute the garments among the brothers.' 'What will you do with the old garments?' 'We will make bed-covers out of them.' 'What will you do with the old bed-covers?' 'We will make pillow-cases.' 'What will you do with the old pillow-cases?' 'We will make floor-covers out of them.' 'What will you do with the old floor-covers?' 'We will use them for foot-towels.' 'What will you do with the old foot-towels?' 'We will use them for floor-mops.' 'What will you do with the old mops?' 'Your Highness, we will tear them into pieces, mix them with mud and use the mud to plaster the house walls. Every article entrusted to us must be used with good care in some useful way, because it is not "ours" but is only entrusted to us temporarily.'

So I always put the most worn pieces in a pile, ready for their last moment of glory, when they will be cut up into dish-cleaning cloths, and then, when they're done with that, to be floor-cleaning cloths, and then, when they are done with that, to be rags to clean the windows of our stove. It's a gesture towards the environment but it's also a meditation, an act of joy. I always love seeing them again, those sections of shirts and vests and faded sheets and now ancient

mismatched linen towels, doing their work, being present and useful
and in their own way beautiful, until they are really ready to go.

Linen dries better when it's damp

'It's no good for drying your hands,' my brother will proclaim after I
put one of the linen hand towels onto the bathroom rail. He's right.
It's not like the terry cotton towelling we're used to today – named
from the French *tirer* meaning 'to pull' because the process involves
manipulating half the warp threads into loops to make a bigger
surface area to soak the liquid.

This flat linen isn't like that. It involves a different kind of drying.

'I just read that linen dries things better when it's wet,' I'll say,
dipping the towel into water and wringing it out before trying to dry
my hands.

'Good luck with that,' my brother will say, putting a 'proper'
towel on the rail beside my linen one. 'So I can *actually* dry my hands.'

The whiteness of linen

All the linen was startling in its unflinching whiteness. There wasn't a
coloured piece of fabric in the drawer. The very oldest traces of linen
fibre ever found – from thirty thousand years ago in a cave in Geor-
gia's Caucasus Mountains – included one microscopic piece of spun
flax that had been coloured turquoise, and in the same cave there was
another from twenty-three thousand years ago that had once been
pink. So it's not that it can't be dyed. It's just that it's usually at its best
when it isn't.

Pliny told a story from the fourth century BC about how, when
Alexander the Great sailed up the Indus, in what today is Pakistan,
his commanders competed over who could dye their linen flags the
brightest colours, 'and the people along the banks gazed in astonish-
ment as the breeze filled out the bunting with its shifting hues'.

In Pliny's own time, in the first century, many people were still
trying to dye linen bright colours 'to adapt it to our mad extrava-
gance in clothes,' although in most wealthy Roman houses pure
white linen was by far the most celebrated. The finest then was from
Saetabis (now Xàtiva, near Valencia in Spain), but Retovium (Robbio,
near Turin) came a close second. The Retovium linen was not only

very white, fine, and without any of that soft woolliness* that 'some people like about it and others do not', it also had a curious property that meant if you plucked it with your teeth it made a twanging sound.† Pliny reported that it cost twice as much as any other kind.

At that time, it was the German tribes who were most famous for working flax, which they did underground, where the air was humid and therefore better for fine spinning. But it was the tribes of Britain and Gaul who were best known for their bleaching. They'd sometimes add special herbs into the water, particularly the roots of wild poppies, to make it more effective. Though it was never just the chemicals: it takes hard graft to get that snowy white cloth so snowy white.

My grandmother would have sent out to a commercial laundry. But her forebears would have sent theirs to the bleachfields or 'bleaching greens' around Glasgow. Three hundred years ago the workers there would use sour milk and fern ashes and set all the cloths outside in orderly lines for many days. By the early 1800s, many linen workers used vitriol – sulphuric acid – to make their work easier, with the sulphur imported at some expense from Sicily, a by-product of having a volcano.

Wealthy British families in the eighteenth and nineteenth centuries sometimes sent their linen to the Netherlands where the water was famously soft. When you see paintings of the Dutch bleachfields, the sheets had such a shine and were laid out in such straight lines that they almost resemble fields of solar panels today. In Paris, even more extravagant steps were sometimes taken. The Seine and its tributary, the Bièvre, were infamous for giving linen a yellowish tinge. Until commercial laundries appeared in the 1850s, middle-class Parisians had little choice but to accept the yellow and employ some of the two thousand or so freelance washerwomen packing the riverbanks or crammed onto the eighty or so floating wash houses where they rented space at competitive prices. This wasn't good enough for the wealthiest families. They preferred to send their dirty linen out of the country. England and the Netherlands were the most popular destinations, but some of the finest laundry hitched a ride on trading ships to

* *Lanugo nulla.* In cloth, lanugo is woolliness, fluff, down or nap. In medicine it's used to describe the downy hair on a newborn baby.

† 'Nervositas filo aequalior paene quam araneis tinnitusque cum dente libeat experiri; ideo duplex quam ceteris pretium.'

The sheets had such a shine and were laid in such lines they
looked almost like fields of solar panels today. Bleaching field in
Maastricht in around 1790, with the River Meuse behind.

the French West Indies, to be washed where the dew and the sun and
the quality of the water were apparently exactly right.

You could only afford to send it so far away if you were rich. It
wasn't just the shipping. The laundry would sometimes be gone for
six months or more, so the family would have to own many hundreds
of shirts, shifts, tablecloths, bed sheets and items of underwear to
have enough for so many to be out of action for such long periods
of time.

The *blanchisseuses* of Martinique

In 1887 the Greek-Irish writer Lafcadio Hearn was sent by *Harper's
Magazine* to the French Caribbean island of Martinique. And although
the days of Parisian linen being sent to the West Indies for washing
were mostly over, Hearn became fascinated by the professional *blan-
chisseuses* of Saint-Pierre.

> Always before daybreak they rise to work, while the vapors of
> the mornes fill the air with scent of mouldering vegetation –
> clayey odors, –grassy smells: there is only a faint gray light, and
> the water of the river is very chill. One by one they arrive, bare-
> footed, under their burdens built up tower-shape on their trays;

–silently as ghosts they descend the steps to the river-bed, and begin to unfold and immerse their washing.

After soaping the cloth they whipped it to expel the suds. You could hear the sound a great way off. 'It is not a sharp smacking noise, as the name might seem to imply, but a heavy hollow sound exactly like that of an axe splitting dry timber.' Later the laundry was put on the rocks to whiten in the sunshine and then left out overnight in lye vats guarded by watchmen. The next day it was returned to the Roxelane river for rinsing, bleaching, blueing with the indigo that grew on the island, and finally starching and ironing. And always, menacing above them, was the potential of the tranquil stream to turn without warning into a deadly torrent. So the older, wiser, women would always keep watch on the volcano of Mont Pelée as they worked, and if they saw a blackness at the peak, even if it was completely sunny down below, they would give the alarm. Then the 'miles of bleaching linen' would vanish from the rocks in a few minutes, and everyone would run, knowing that others, in the past, had died if they delayed. 'Most of the blanchisseuses are swimmers, and good ones', Hearn wrote. 'But no swimmer has any chances in a rising of the Roxelane.'

As well as being perilous, the laundry tradition of Saint-Pierre was impossibly old-fashioned, even in the 1880s when Hearn was writing about it. But several efforts at introducing a 'less savage style of washing' had already been tried and abandoned and the one attempt to establish a steam laundry had resulted in failure: the *blanchisseuses* were just too good.

White dresses for babies

In one bag I find a white christening dress. It has lace trim at the sleeves and a thick pink satin ribbon threaded round the hem. It looks like the scaled-down dress of a bridesmaid on circus stilts. It's so long it needs tape to measure it, not a ruler. Seventy-eight centimetres. Later I'll learn that christening dresses were long so that a baby would be more visible in a godparent's arms: it gives him or her more body, a kind of gravitas for the occasion.

I think about one of the photographs in my mother's bedroom and I go and find it. It shows me and my slightly bewildered-looking

parents, just after my christening, outside the kitchen of my child-hood. It's winter. They've both dressed up, my father in a jacket and tie, my mother in a chic blue 1960s suit and a dusky rose hat. She looks fantastic. I do the maths. She was thirty. She could be my daughter. In the picture I'm two or three months old. I look like a surprised, plump cushion, with a face peeking out. I must have this dress on underneath, though you can't see it because everything is wrapped by an antique lace blanket.

I remembered the exhibition of fabrics for christenings, weddings and funerals at the American Museum I'd been to with my mother, which had explained why christening clothes changed after baby car-riages were invented in the nineteenth century. The new vehicles were like picture frames for showing off a family's wealth and so baby clothes became more expensive and showy, and often decorated with lace.

I look at the little dress. Now would be the time to give it to a charity shop. I hover it over the box I've set out for that purpose, but I'm not sure. My mother kept it. It feels almost a betrayal to be too careless about getting rid of things she looked after. Not being too careless takes more energy than I have. I fold the dress and put it in the bag to keep, along with just about everything else.

I find other items trimmed with lace: pillowcases; a handkerchief; items labelled 'tray cloths' that seem too small to actually be useful. The lace is of different kinds and qualities, though little of it is old. I look in hope for my antique christening blanket, but it isn't there. It probably went back to my grandmother as soon as the ceremony was over.

The last time I'd been in this flat with my mother we'd sat up late, talking, making plans. If I did do 'that book about fabrics', then we'd go to the Honiton museum of lace together. Why hadn't I ever been there in all the years of them living just five miles from it, we'd won-dered, and we'd agreed that it was because it would always be there to go to and because we would always be there to go to it.

I will remember that conversation a few months later, when I spend a day at the Fashion Museum in Bath learning to make bobbin lace. Though it will take much longer before I visit the Honiton museum.

A lace workshop

The first needle lace developed from a kind of fabric with decorated holes that was popular in Venice in the fifteenth century. That involved taking a piece of linen, cutting square and rectangular holes in it along the weft and warp, then embroidering along and within the cuts, making shapes out of the absences you had created. It could be delicate and fine, and extremely expensive, but it's as if you had designed a house by making a solid block, then chipping into the mass of it in order to make spaces where people can live. There's a sense of completeness to it, but it also holds a memory that there was once something more.

That's cutwork.

Needle and bobbin lace are the opposite. They are grown from almost nothing: just thread, scaffolding and the imagination.

Needle lace emerged when people realised that rather than taking expensive fabric and cutting it up they could instead secure a length of thread onto a temporary parchment backing and make stitches around it. And as long as they did it carefully, they could create whatever shapes they wanted before removing the parchment. It was a way of breaking away from the geometry of loom weaving by creating a fabric almost from empty space. 'Punto in Aria' the Italians called it. Stitch in the air.

Bobbin lace – or 'bone' or 'pillow' lace – was different. It probably developed from the way decorated braids and trimmings were made for dresses and bed hangings, using several lengths of linen thread plaited into patterns. It is quicker than *punto in aria*, though at its best it can be just as fine.

Brussels lace was bobbin lace; as was the famous lace from Bruges, Mechlin, Ghent and Valenciennes.* And Malta and Madeira. And most of the handmade lace in England, in Bedfordshire, Buckinghamshire and Honiton: each location developing slightly different, identifiable designs, along with the techniques to work them. The

* Belgium and the Southern Netherlands became famous for lace in part because the soil was perfect for growing the finest, strongest flax thread. Valenciennes was annexed by France in 1678, though it is essentially Flemish. In the French Revolution the number of lace workers in that city dropped from four thousand to twenty-five; by 1851 only two were left, both in their eighties.

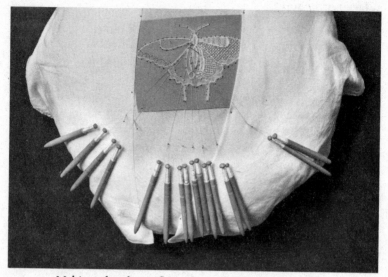

Making a lace butterfly, with wooden bobbins, a pillow,
pins and a piece of cardboard to hold the design.

famous black lace from Chantilly, in northern France, was also bobbin
lace, but usually made from silk rather than linen.

The teacher in the lace workshop, Gwynedd Roberts, will show
us how to fix a piece of card pre-pricked with a pattern of holes ('a
cornflake packet will do')* onto a small, hard pillow, and then set
a first line of pins across the top. Bobbin lace, like house-building,
requires scaffolding, and in the case of lace it's done with pins. They
hold the structure until it's strong enough to hold itself, and then
they are removed. Gwynedd will demonstrate how to hang strands
of thread around each pin and how each end of the thread is wound
around a bobbin, which rattles with coloured glass beads.

'Don't worry about the bobbins,' Gwynedd will say. 'They're the
things you notice first about lacemaking, but they're just the thread-
holders, the weights to aid good tension. The important thing is how
one thread goes over another and how it builds up to make a structure.'
Gwynedd first learned lacemaking after a great-aunt died – leaving a

* A cornflakes packet will only do if you don't intend to make the same pattern
again; if you're going to repeat it, the material should be a little more robust.

box beneath her bed containing a pillow, English bobbins, linen thread and a book in French showing how to make it into lace. 'I was determined to work it out,' she will say. 'And then I became addicted.'

I will learn how a pair of threads is designated the 'runners' or 'workers'. That pair is like the shuttle in a loom, carrying the weft, doing the work. All the others are 'downrights' or 'passives', which act like the warp, forming the lines that have to be crossed over or under by the runner. Gwynedd will show us how to think of each thread as a number, depending on its position right now, and then to cross and twist them over each other, making a stitch.

Imagine two threads, equally wound onto four bobbins, suspended from their middles on two adjacent pins. The threads to the left begin as 'one' and 'two', and those to the right as 'three' and 'four'. Cross 'two' over 'three' then move the new 'two' and the 'four' simultaneously to the left then cross the newest 'two' to the right over the new 'three'. You've made a stitch. The runners are now in position.

Now do the same again with the runner and a new pair of threads hanging over the next adjacent pin to the right. And again. When you reach the end, twist the runner threads, put in a pin to hold them in place and, to give the sides some strength, then work back along the row to the left. Twist and pin again and go back along to the right. Slowly, you'll see that you're making a weave. This is called the clothwork or 'toilé' of the lace. It is the bit that looks like netting.

At the lace workshop I'll be reminded of a childhood friend who had a Rapunzel doll with long hair that you could braid. I didn't much like that doll but it taught me about tension. If she was held in place, you could plait her hair; if she was lolling on the ground she wouldn't resist and you couldn't. Simple lacemaking was like having six Rapunzel dolls fixed in a row, waiting to be braided together.

'One-over-three-then-two-with-four. Then-two-over-three-and-move-over,' I'll recite in my head like a nursery song, over and over, realising that if I didn't say it to myself each time then I'd lose concentration and make a mistake and have to go back and undo it.

Later in the workshop I will learn different rotes relating to different procedures. One will involve twisting some strands together to form spaces and plaiting others to make bars. Another will give twists to the end of each row creating a straight edge or 'footside' that can be used when sewing the lace onto fabric. And through doing this I will understand how these simple movements can expand and grow,

like the DNA of lace, into butterflies and flowers and wonders and words.

There's a kind of music to the notation. 'You have to get used to the rhythm of your hands first,' Gwynedd says. 'And then you can do it without thinking.'

Only then will I realise how astonishing it must have been after 1809 when increasingly complex lacemaking machines were invented: first to copy the basic net, then the other meshes, and finally the patterned areas themselves. At first the simple nets lent themselves to embroidery using needle and hook, so the output of machines was combined with hand embroidery to create a new type of lace – the 'decorated nets'. But this couldn't match the speed of the machines either and over the century that followed, the era of the handmade lace industries gradually ebbed away.

I'll think about how while weaving on a loom is all about ninety-degree angles, with bobbin lace you're not the person on a police search going from one side to another, tracking every inch of the land. You're the spider, starting from a point, going to another, curling your thread around itself to hold another piece in place. You can cross and turn and come back on yourself and wind around and go back in at a different angle. You can make anything you like in this crazy, wonderful kind of plaiting with pins and bobbin weights. You just have to keep your wits about you.

And as well as the clear planning and fine, meticulous work, I'll come to understand how women in the past had to keep their hands clean, and the air clean too. An indoor fire to keep the family warm or get the supper made, a blast of smoke when the wind changes direction – any of this would cause bright white to become dismal grey, and nobody will pay anything for it. 'Remember,' Gwynedd will say, showing us how to fold a cloth over our pieces of lace. 'Any time you leave your work, cover it up … protect it.'

In the class, we'll just make a little bracelet, using eight pairs of bobbins, but I'll see how some pieces of handmade lace are made with three hundred pairs of bobbins or more – though always with just one pair of runners for each patterned area, crossing and tugging and twisting and moving along. I'll also see how – if you knew the right combinations, if you could hear the right music of it – you could make anything with just those five elements: fine thread; pins; a firm pillow; a piece of card; and some little wood or bone bobbins to keep

everything organised. I'll think that if it were not such a small thing, then it would be greatly celebrated, the skill of making lace. You have to plan in advance. You have to know the future; you have to make sure your weighted lines are ready and in the right place for where you will need them to be.

When linen won a battle

All these odds and ends of Scottish linen I'm pulling out of the drawer remind me of a story my father used to tell about the Battle of Bannockburn, in 1314, near Stirling. As he told it, the Scottish forces were massively outnumbered. The king, Robert the Bruce, was at a low point and his soldiers were exhausted. Then something astonishing happened. The servants – the gillies, the men whose job it was to help the army move and eat – rose up, fifteen thousand of them. They picked up every piece of cloth they could find.* And they fixed them all to poles and branches and they ran towards the English army shouting 'Slay! Slay!' And the strange banners and the mismatched sticks made them look huge and dangerous. And as they ran they grabbed weapons from the ground where the dead had fallen, and the English hesitated, thinking reinforcements had arrived. And all that waving of cloth and faltering turned the tide. It's remembered still as a story of the forgotten folk making the difference, and of the strangely winning ways of cloth.

Now I press a piece of linen against my face. I'm so surprised by its temperature that I go and get a piece of cotton to compare. It's August and the cotton is warm. But the linen feels as if cool fingers are brushing my neck and forehead. I understand now by touch why linen was often worn by Europeans in the tropics. It wasn't just light in weight, it was actually cooling.

Through the magnifying glass

When I was growing up I didn't know the difference between linen and cotton. I knew that they were different plants but mostly I didn't

* 'And schetis, that war sumdele brad, / Thai festnyt in steid off baneris, / Apon lang treys and speris: / And said that thai wald se the fycht ; / And help their lordis at thair mycht', from John Barbour, *The Bruce* (*The Brus*) written in around 1375.

think about it. Now I'm sitting here with a load of cloth that seems to symbolise everything in my life that I have no idea what to do with, and I decide that now is the time to think about the linen. And that I'll start by looking at it.

My mother never wore reading glasses even though she needed them. Instead, she bought large magnifying glasses and put one in each room. I find one now, and carry a pile of cloth to the sitting room where my father is dozing. I sit by the window and I look through the lens at one of my grandmother's hand towels. The threads are very straight and very white; it's like examining a finely crafted basket.

The centre is woven in a pattern of regular speckles or 'eyes'. They were made by passing two weft threads over, then under, five warp threads at a time. Later I'll learn that this loose, nubbly weave is called huckaback and that it was to make linen towels more absorbent. The nubbles against your skin were also thought to be good for circulation.

It seems weirder right now to imagine how linen was once a grass than to remember that silk was once a cocoon or cotton a seedbed. It might be that astonishing whiteness. Under the magnifying glass it seems almost to have come from another world, not from a Baltic or Belgian or Scottish or Irish field.

The edges have flowers and ferns woven in a damask technique – named after Damascus in Syria, and probably first brought back to western Europe by crusader soldiers. Close up, it looks like the white-on-white version of hatching on a copper engraving. I remember in my early years as a reporter writing an article about a luxury hotel and being shown how damasked linen is designed for formal dinners, lit by candles. When you look at it straight on, it looks plain. But when, as etiquette suggests, you talk to the person on one side during the first course some parts of the cloth will appear silvery, making elements of the design stand out. At the next course, turning to the other side, other parts of the cloth will appear raised, and the designs will have changed. A damask tablecloth should be ironed on both sides: the underside first, and then the top, to make it shine. Where you don't want lustre you should iron only the back.

I move the hand towel from right to left, then back to the right, absorbed in its little optical miracle. I think about how there was once so much meaning put into linen. What you brought to your marriage, what you used for your table, what sheets you had, what towels; these

things once really mattered to people who had the money, and time, and love of detail for them to matter. In 1966 the singer Janis Joplin fled California to see whether being a 'conventional housewife with a white picket fence' back in Texas would salve the sense of dread in her. Her plans to get married included 'ordering bed linen and planning her trousseau'. And although it didn't work out that way it shows that it wasn't *that* long ago that bridal linen was recognised, even by natural rule breakers, as a signal, not just of status, but of incorporating oneself into the old ways, of being a certain kind of safe.

A trousseau in Tuxedo Park

In 1922 American socialite Emily Post published a book on etiquette. In it she listed the items in the trousseau of a wealthy American bride at the beginning of the Jazz Age. The numbers are mind-boggling: up to two hundred fine linen sheets (with up to four dozen less fine for the servants); up to a hundred and twenty extra-large linen face towels; three to six dozen bath towels; up to fifty-six tablecloths. Up to two dozen napkins *for each tablecloth*. A bride should be modest in how she displays this linen wealth, Post wrote. The enjoyment should be in its use, not its collective effect. 'In cities such as New York, Washington or Boston, it has never been considered very good taste to make a formal display of the trousseau. A bride may show an intimate friend or two a few of her things, but her trousseau is never spread out on exhibition.'

Paper napkins were serious challengers for cloth ones by the time Post was writing. They had been first mentioned in *The New York Times* in 1860, by a journalist visiting Japan, noting the 'paper napkins of filmy texture' among the many strange and marvellous things he saw on this very early press trip to the country. By 1920, half of all restaurants in America were using them.

Not that this meant linen wasn't involved at all. Most paper, then and now, contains flax. Even paper money. A 2017 report in *The New Yorker* recorded that the factory in Dalton, Massachusetts that had been making the paper for US dollar notes since the 1870s 'smells like a clean barn just supplied with fresh hay'. The centre of the building was occupied by a spherical metal drum as big as a house, into which tons of raw flax, cotton and water were poured. Then it was heated and spun as if in 'a giant washing-machine', to break up the fibre.

Knowing this recipe for money gives an extra nuance to the phrase 'losing your shirt', when it refers to someone who's gambled away every dollar they own.

Thread to find your way

I pick up another napkin and see how very separate each of the threads is from the others. The English word 'line' has the same root as linen, and looking at this cloth now it seems as if the material somehow knows its own nature. I remember the most famous ancient story of linen thread, and I find a version on one of my parents' bookshelves.

The hero Theseus is faced with the task of entering into the labyrinth of the monstrous Minotaur. He makes a friend on the enemy side – Ariadne, daughter of King Minos (who ordered the complex underground lair to be built in the first place). After talking to the labyrinth inventor, Daedalus, Ariadne gives Theseus a clew, or ball, of flax. If he attaches one end to the entrance door, and lets it unroll as he walks, then however deep he goes, he can always find his way back. A maze has many paths and the challenge is to pick the right one but a labyrinth has only one path and the challenge is to follow it, to let it guide you into your own mind, to let you find yourself by being lost. By using the thread, Theseus is effectively changing something that is a maze when he goes in, into a labyrinth when he comes out. He's turning a puzzle into a pathway; something disturbing into something that will be calming to the mind. I've remembered the Theseus story often while writing this book. There are so many facts and ideas. But to get out of the labyrinth I have to make them one thread. I have to make chaos into line, or I'll never make it out.

I was familiar with that first part of the story, which ends with Theseus defeating the Minotaur and departing, with Ariadne weeping behind him. But I didn't know another story – which in many ways is a mirror of Theseus and the Minotaur, also involving a problem and a labyrinth and a solution involving linen thread.

In that one it is Daedalus who is the escapee and King Minos the monster in search of him. Everywhere Minos goes, he holds up a spiral shell and promises a reward to whoever can pass a thread right through its coils. When Minos arrives in Sicily, Daedalus emerges to solve the puzzle. He bores a hole into the end of the shell and smears honey around the hole he has made. Then he fastens a gossamer

Third century BC coin from Crete, showing the labyrinth of Knossos.

thread to an ant, which he puts at the entrance. When the insect, looking for the honey, finds its way up the spirals and then out of the hole, it's an easy thing for Daedalus to tie the linen thread to the gossamer and pull it through.

There's another part to the story too, when Theseus later agrees to go with his friend Peirithous into the underworld and they're tricked into sitting on the Chair of Forgetfulness. This time there's no clew and no guide and they stay for a long time, motionless and confused. Peirithous never leaves, but Theseus escapes when another hero, Heracles, turns up and shows him the door back into the human world. I think how for my father there's no linen thread and no Heracles and no door back, and that the only way to escape from the Chair of Forgetfulness is to go the other way.

'What are you looking for?' My father's voice. He's woken up and is perplexed to see me standing still, fixed in the task of examining a table napkin with a magnifying glass. 'Have you lost something?'

'I don't know,' I say. 'I think I might have.'

They think it's pure

'What do you know about these?' I ask my father, showing him one of the monogrammed napkins from the 1920s. His dementia is like a visitor who will stay for ages kicking its heels around his brain but will occasionally go out for five minutes or for a whole hour, leaving him lucid and conversational.

I'm lucky.

He looks at it speculatively. 'It was Mother's,' he says. 'It was very.'

Something is fluttering to escape from the caves of his memory. 'It was very important for it to be white,' he says, after a while.

'Do you and Ma ever use it?' I ask, using the present tense because that's what we're still using.

'I don't know,' he says, and sounds desolated. Then he looks directly at me. 'They think it's pure, but it isn't. Not really.'

'What do you mean?'

But he's looking back at the TV. He could have meant his apple juice. Or the news. But I think he really does mean the linen.

Linen in a way *is* the purest fabric you can find. It's the fabric so many women – including my grandmother and great-grandmother – took to their marriages. It was crisp, white, folded, clean: symbolic of their virginity, though probably not that of their husbands.

It's traditionally used for bandages and wound dressings because it's seen as clean.

In ancient Egypt, it was not only the fabric chosen to wrap the dead, it was also the fabric that priests wore – always linen and never wool, which was thought less clean because it came from animals.

In Christianity, linen is the cloth that wipes the chalice; and the fabric that Christ was shrouded in.

In Islam, linen was traditionally the material of *ihram*, the simple white costume worn by every pilgrim on Hajj. And although today *ihram* is mostly cotton, and even polyester, its simplicity and colour are still a reminder to every pilgrim that, whatever our possessions, we are all the same material. And that one day we will all be wrapped in shrouds.

In Japan, the white ceremonial garments worn by Shinto priests are usually linen. They call them *jōe* or 'pure clothes'. Shintoism believes that every natural object, every rock, every tree and every grass, has its own divine nature. It's logical then that the material making up their sacred robes should be as natural as possible, and that indeed, being plant, flax is said to have a divine nature itself.

In Judaism, linen is the inner material of the tabernacle, the sacred tent that the Israelites carried in the desert as a place to worship. In ancient times the garments worn by Jewish priests were made of linen and were so bright and white they were called 'robes of light'.

The Essenes, a vegetarian Jewish sect in the Qumran desert a few miles south of Jericho, were 'always dressing in white', according to

Josephus, a first-century Jew, who spent years explaining his faith's thought and history to the non-Jewish audience. The Essenes, who were said to have written the Dead Sea Scrolls (first found by a teenager in 1949, with later discoveries in the 1950s, perhaps even with my former Latin teacher present), washed many times a day, and, after every communal breakfast, their linen clothes were laid down 'as holy things'. Linen wasn't just a symbol of purity. It was purity itself.

And when in 1842 the American visionary Amos Bronson Alcott started a transcendentalist commune near Boston (called Fruitlands, which is pretty much what some outsiders thought of it), he modelled it on the Essenes. As well as avoiding meat, fish, dairy, tea, coffee, cocoa, alcohol, wool and haircuts, everyone should wear only white linen. Most of the men wore 'loose trousers, tunic-ed coats and broad-brimmed linen hats', except for one, who said clothes were impediments to spiritual growth and spent the days 'in a state of nature' in his room. Meanwhile, Alcott's four daughters and his long-suffering wife were all seen in baggy linen knickerbockers; and even the children's tutor (who was later asked to leave when discovered eating fish on the quiet) was forced to wear those ugly things. The children never forgot their time at Fruitlands. When Alcott's second daughter Louisa wrote a series of novels many years later, her childhood is remembered in the hard-working mother, the often absent charismatic father, and the sharp longing by the girls in *Little Women* to have some nice clothes.

I write my father's odd phrase about purity in a notebook. The memory of it stays with me through my search into linen. It's the insight of an unreliable narrator, of course. But also of a kind of innocence.

The most famous linen in the world

A few weeks later, I'm in northern Italy. I'd agreed months before to join a press trip to the Turin Opera; with my mother's death I'd forgotten, and now it's too late to cancel. As the plane door opens to let in a warm gust of autumn air it seems strange that all this light has existed while we've been in our darkness. As soon as I'm allowed to switch on my phone I get a text from my brother to say that our father has taken a turn for the worse. I want to stay on the plane and go back. But I have promises to keep. And however terrible the timing of the trip, at least I might be able to do some research into fabric.

After all, I'd just landed in the city that houses the most famous piece of linen in the world.

You can't actually see the Turin Shroud. It's been at the Cathedral of Saint John the Baptist since 1578 but it's rarely on display. There is a museum dedicated to it, however a tiny place, with a sense of calm and plenty of images of this extraordinary piece of linen, 4.42 metres by 1.13, with what some say is an impression of Christ's body preserved on its surface.

Between some burn marks (from when the shroud, folded into eight, caught fire in the sixteenth century) there's a clear, almost photographic negative of a male body – his front, his back, his face, the nape of his neck and the soles of his feet – as well as blood stains that seem to accord with the wounds of a person who'd been crucified. It's not a shroud in the sense of the five-thousand-year-old mummy wrappings in Turin's excellent Museum of Egypt a few streets away, which are bandaged strips, up to a kilometre long, wrapping those bodies like a package, to preserve them against time. This is different. It's more like a flat, rectangular bed sheet that seems to have once been placed under and over a dead or dying man, pressed against his body and face.

A holy shroud relic such as this one was recorded in Athens in 1205, brought by French crusaders who'd probably been present at the sacking of Constantinople the year before. It was in Paris for a while, stored at Sainte-Chapelle in a silver box, and then (if it was the same one) in around 1350 it moved two hundred kilometres south-east, to the small village of Lirey in the Champagne region. There Geoffrey de Charny – a famous knight in his day for his books about chivalry – built a church dedicated to the relic. Thousands of pilgrims arrived. A medieval pilgrim badge from Lirey, found in the mud beneath the Pont au Change bridge in Paris in 1855, has a design on the reverse to celebrate the unusual twill weave pattern of the linen shroud. It's a three-to-one herringbone, and it was made by passing each weft thread under three warp threads and over one, making a broken zigzag pattern. It is perhaps like fish bones but it seemed to me – looking at a close-up photograph – that it looked more like a brown Irish tweed.

By 1453 the cloth was brought to Chambéry, then the capital of the Duchy of Savoy, brought by one of de Charny's descendants fleeing the Hundred Years' War. A century and a bit later the Dukes transferred it to Turin. It's been there ever since, debated by scientists and

theologians and medical experts and others, often dismissed (even on occasion by the Church) as a medieval fake from somewhere in Europe.

Then in 1999 a pollen analysis by Hebrew University in Jerusalem found pollen consistent with species flowering in Jerusalem in spring, the season of Passover when Jesus was crucified. The tests showed ancient pollen grains from the *Zygophyllum dumosum*, a yellow-flowered desert shrub mostly native to the Negev desert, but also found at its most northerly point just outside Jerusalem. The scientists also found traces of the spiny thistle, *Gundelia tournefortii*, the kind of spiky plant that might plausibly have been twined into a crown of thorns. That species is found at its most southerly point in the Hebron valley near Jerusalem and as far north as northern Iran. Where the zones intersected was a very small area, which encompassed the region around Jerusalem. And nowhere else.

The Catholic Church has no official teaching on whether the shroud is authentic. But in 2015 Pope Francis visited, and spent time there praying in silence. He didn't speculate on whether it was genuine, just said that for him it was a reminder of the face 'of every suffering and unjustly persecuted person'. And whether or not it is genuine, the shroud is a real example of how a piece of material can be imbued with significance far beyond its own weaving. But there's another extraordinary fabric mentioned in texts written about that same day: an impossible garment, whose very structure has been puzzled over for centuries.

After Turin, I couldn't get it out of my mind.

The seamless robe

Three of the four gospel writers – Matthew, Mark and John – all recount that, after the crucifixion, Jesus's robe, or *himation*, was divided between the soldiers at the foot of the cross. This echoes a prophecy from the Psalms, a thousand years earlier, predicting that 'they will cast lots for my clothing'.* The other two writers leave it at that, but John mentions another item. It is a *khiton*, or tunic, an

* The Hebrew Bible and the Catholic Bible name this Psalm 22. However, the Septuagint (the Greek translation of the Hebrew texts from the second century BC) combines Psalms 9 and 10, and the relevant Psalm in Protestant versions is number 21.

undergarment which the soldiers decide they won't cut but will leave in one piece, so they cast lots for that one too.

Almost everyone in the Roman world at the time wore a *khiton*. It was standard for both men and women, and it was usually made with two or more panels of either linen or wool sewn together.

But John is very specific about this one.

First, it was unsewn, or *arraphos* (from the same root as *raphis*, meaning needle).

Second, it was whole, *holos*.

And third, it was woven from the top, *anothen*.

To theologians and weaving experts alike this 'seamless garment' has presented a puzzle. It's like an impossible paradox.

How can a tunic be made without sewing, without cutting and having been woven from the top of the loom down to the bottom? You could cut a hole in a cloth and wear it like a poncho, but that was not *holos* and it was not a *khiton*. You could weave a garment from the top of the loom to the bottom, but you'd need to sew the panels together so that's not *arraphos*. You could weave a tubular linen garment using a spiral or tubular loom (like stockings in the eighteenth century), but these would probably need you to weave from the bottom to the top, using loom weights, otherwise keeping the tension would be a nightmare, and even then how would you manage the sleeves? A *khiton* could potentially have been made out of a rectangle, pinned at the shoulders, but that wasn't what most observers thought it was, and it wasn't anything like the two main contenders for the holy robe relic, one at Trier in Germany and the other in Argenteuil in France.* Both of these seem to have sleeves, and indeed both of them are shaped disarmingly like the tau, or T-shaped, cross of St Francis.

In 1680 Johannes Braun, professor of theology at the University of Groningen in the Netherlands, set his mind to puzzling it out. With the help of weavers he imagined how a seamless tunic with sleeves

* In the nineteenth century the Trier cloth was dipped in rubber 'to preserve it', so carbon dating is impossible. When it was put on view in 2012 there was no suggestion by the cathedral that it was original, just that it was sacred because it had been venerated for five hundred years. The relic at Argenteuil (which some argue was the *mantle* or robe of Christ rather than the tunic and therefore came with no stipulations as to the seams), is in several pieces, allegedly cut during the French Revolution 'to keep it safe'. It is made of wool.

could have been made. The loom that he and his advisors created was a wonder of weaving ingenuity. It was also completely bonkers.

To make a seamless robe, Braun-style, involved three distinct stages.

First you laid out the warp in such a way that it would be possible to weave a tubular body. Then, at the top (i.e. at the level of the tunic where the sleeves would go) you extended the wefts another fifty centimetres or so each side, after they had passed the warps. I'm imagining it by putting a narrow notebook portrait-wise on my desk and then putting three pencils across the top, so they make it like a T.

Then you'd remove the garment from the loom, flip it ninety degrees and those extra weft lengths (the three pencils) would transform into the warps, to be woven in their own turn into tubular shapes of sleeves. The weaver would have to stand, rather than sit. She would also have to keep walking in circles, because once she had passed the shuttle from one side to the other she would have to go round the whole loom before she could start the next pick.

It was complicated, and it was hard to keep the cloth at the right tension. But Braun proved that with determination it could be done.

The real question was: why?

Why would a teacher who famously didn't care about material possessions have been wearing such a bizarrely challenging garment? And why would John be the only one who mentioned it? And (probably the most important question) why, at the most desperate moment, when the Messiah has just died and the world has become bleak and dark and full of grief and tears … why should anyone choose this moment to focus in on how some clothes had been manufactured?

I couldn't work it out.

And then I remembered the second time I met my future husband's father. It was a Sunday. As a retired vicar, Derek had just returned from delivering the sermon at his local church. I was sorry to have missed it – he was famous for his sermons. So while the others were preparing lunch, he gave a shortened version, just for me. It was about how Matthew, Mark and Luke – the writers of the first three gospels – were like photographers, trying to represent a kind of reality, each from different angles. John was different. He was more like a painter.

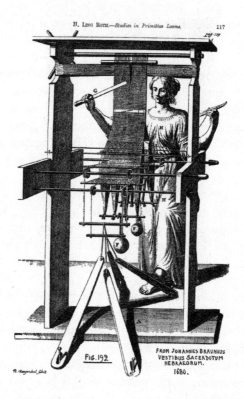

H. LING ROTH.—*Studies in Primitive Looms.* 117

FIG. 192.

FROM JOHANNES BRAUNIUS
VESTIBUS SACERDOTUM
HEBRAEORUM.
1680.

'The sleeves were made by extending the wefts at the top,
and then flipping them to become the warps.'

'Or put it another way,' Derek said. 'You've got three historians,
and you've got T. S. Eliot.'

'The thing you've got to remember about John ...' he continued
(I was rapt. I had never thought much about John before, but I liked
the idea of having something to remember about him), 'is that he was
all about symbols and ideas and poetry and philosophy. Details and
history weren't that important.'

I've never forgotten. Mostly because Derek died of a heart attack
a few months later, and I never saw him again and I'm still sorry. But
partly because that was the first time I ever looked at the Bible as a
literary text.

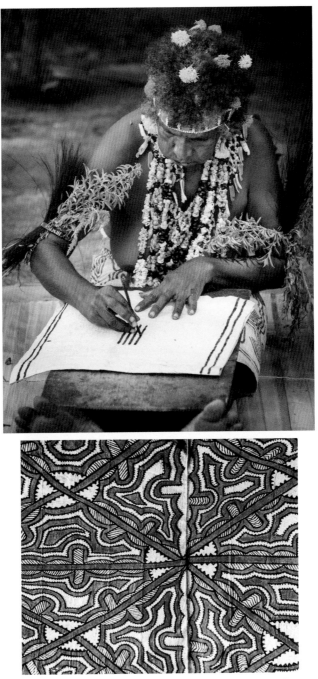

Top: Velma Joyce uses a black palm stick to draw the lines to begin a tapa design. *Bottom:* When the red *dun* paint is freshly applied to Maisin barkcloth, it seems to glow. (Tapa)

Eighteenth century chintz palampore, or bed cover, made on the
Coromandel Coast for the European market. (Cotton)

Vlisco has been making 'Real Dutch Wax' fabric for West Africa since 1846. The company never gives the designs names, although the customers often do. (Cotton)

Cloth woven in the Outer Hebrides is inspired by the land and is the colour of the land. Photo montage by Ian Lawson, adapted from images in his book *Saorsa*, first published as *From the Land Comes the Cloth*. (Tweed)

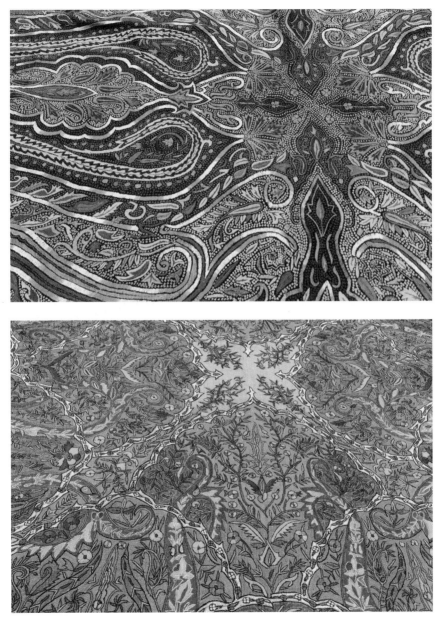

'Some had patterned borders, with the centres left unadorned. Others were fully covered in flowers and designs and those were my favourites, so rich in tiny chain stitch (or buttonhole, stem stitch, satin or herringbone) that you could hardly see the shawl wool at all. *Amlikar* shawls in Taqadus Wani's shop in Leh. (Pashmina)

Putting on an imperial dragon robe was said to switch on the power of the universe. A rare example of an uncut Qing Dynasty robe. Teresa Coleman Fine Arts, Hollywood Road, Hong Kong. (Silk)

Top and bottom right: In 1147 the Norman king of Sicily sent ships to Greece to kidnap Byzantium's most talented weavers. This thirteenth century dragon brocade was woven by their descendants. *Bottom left:* By the Renaissance, Italy was the European centre for luxury silk – like this late fifteenth century velvet in the Metropolitan Museum collection. (Silk)

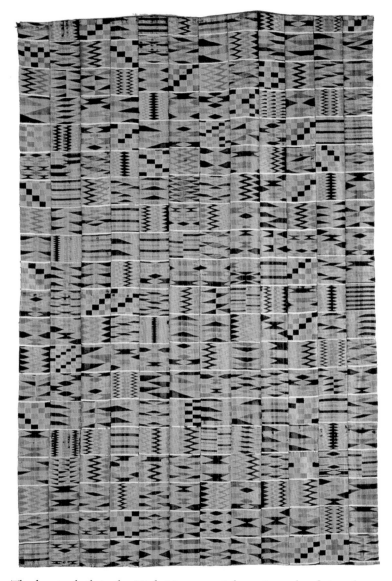

The kente cloth in the High Museum, Atlanta is made of six colours.
The five you can see. And the one that you can hardly see, but
which stripes through the warp and tantalises the eye. (Patchwork)

Now, remembering what I had learned that day about John being different from the other three, steeped in philosophy and quotations and metaphors and definitely not a details man, I was able to start looking at the puzzle of the seamless garment in another way.

What if it wasn't about the sewing, or the cutting, or anything to do with how an ancient tunic might have fitted on an ancient loom? What if something else was happening? And what if – given where it falls in the story – this was something important?

My husband speaks and writes about theology for a living. We have a library on the subject. Martin was away but I went downstairs and pulled out all the relevant books I could find and laid them on the kitchen table. There was a Septuagint, the Greek translation of the Hebrew Bible, compiled a couple of hundred years before John, and which he would have read. There was a modern New Testament in the original Greek, with the English equivalent beside each word, as well as a fuller English text. And there was also a great, torn, cloth-bound *Critical Lexicon and Concordance to the English and Greek New Testament* from 1892, which tells where each Greek word appears in other texts, from Homer to Aristotle to Sophocles to Galen to elsewhere in the Bible.

And I discovered something curious.

Anothen (the word suggesting that the tunic was woven from the top) comes up often and it means 'from on high', as opposed to 'from the earth'. It's used to mean a divine message. It's also used later for the Christian idea of being 'born again'. Reading it as 'from the top of the loom' might be too literal.

Arraphos (the word meaning unsewn or 'without a needle') doesn't come up in any Greek text earlier than John's Gospel. He might have made it up. It certainly wasn't a common or literary word. Which might mean he wanted to achieve a very particular effect.

There was something else. When John and Matthew and Mark talk about what happens to the robe, the *himation*, they use the same phrase as in the Greek translation of Psalm 22 to say 'they drew lots', *ebalon klyron*. But when John goes on to talk about casting lots also, for the seamless garment, he uses another word.

Lachumen.

It's the same root word as the name of the middle sister of the three Fates: Lachesis, the one who measures the thread of our lives. And perhaps what John wanted to do here was to give us a metaphor that would blow our minds. The impossible garment that the

soldiers cast their luck on is unsewn. There is no needle. And there is no thread. So there is no thread to cut, and the Fates and the old ways have no hold.

It means that this strange little story could be John trying to show us the cosmos. In a handful of impossibly constructed cloth.

A few months later I find myself wondering what the original Hebrew version of Psalm 22 says (the song that talks about how the garments were divided, the song that Matthew, Mark and John all refer to). I find it online (to be read from right to left).

יְחַלְּקוּ בְגָדַי לָהֶם;וְעַל-לְבוּשִׁי ,יַפִּילוּ גוֹרָל

Google Translate first rather improbably suggests that this means 'Will be disguised as a detective'. I realise I have accidentally removed a space. I put the phrase in again, more carefully. This time it returns with 'They'll be wearing clothes And weary, doomed'. Closer. Poetic even. But still weird.

I find a website that will identify each word one by one. 'They will distribute … my garments … among them.' That makes sense. Then: 'On top of … the garments … will bring down …' An intriguing echo of John's word *anothen*. But the final word גוֹרָל doesn't turn up anything at all. The results box remains blank. I wait for a while, hoping it's my slow internet. Nothing.

Then I put just that word into Google Translate. And wham! One word.

'Fate'.

It's a word that is used to explain sharing out – in 2 Kings it's used to describe how parts of the Middle East were divided by lot between the twelve tribes. But I will learn later, from a Jewish scholar and rabbi in Jerusalem, it also turns out that if you were a schoolchild in Israel today and had a magical Latin teacher who decided to start your classical education by teaching you about the Fates in Greek then this is the word that he or she might use.

גוֹרָל. Goral. Fate.

Not really pure

My father's almost last comment haunted me over the months that followed. 'They thought it was pure, but it wasn't. Not really.' And one answer to how linen might *not* be quite pure can be found in its own making. It involves retting in stinking ponds and then bleaching,

sometimes with sulphuric acid. Also, for several decades in the nine-
teenth century flax mills (as well as mills producing most other
textiles) employed thousands of very small children to tend their
machines. And it treated them appallingly.

Michael Sadler

A maximum ten-hour working day for children. A maximum fifty-
eight-hour week. No night shifts. And no children younger than nine
to work at all. That's what Michael Sadler dreamed of.

Sadler had started as a linen draper (or 'wholesaler') in Leeds
in 1800, when he was twenty, joining his older brother in the busi-
ness. Importing fine linen from Ireland, he had been disturbed by
stories he'd been told about the conditions in flax mills over there.
He began to realise that he was more passionate about the poor than
about improving his own finances and soon left the business side to
his brother, turning to politics to make the changes he believed were
needed in the world.

Ireland had made linen for a long time. Flax grows well in its
climate and soil. In medieval times Irish flax was used to make the
tunics of noblemen – they called them *leines* and many were dyed
bright yellow using the rare and expensive stigmas of the saffron
crocus. By the end of the sixteenth century, the production of linen
in Ireland had dipped, but it had a resurgence when Huguenot refu-
gees arrived from France a hundred years later. The most famous of
these was Louis Crommelin who set up a linen workshop in Lisburn
in today's Northern Ireland in 1699. Nothing could compete with the
finest linen from Belgium and northern France and the Netherlands
– the old Huguenot lands – but by the end of the seventeenth century
various kinds of fine Continental linen and lace were banned in both
England and Ireland, with the rest of it heavily taxed. So Irish cloth
had become the next best option, and many millions of yards of it
crossed the Irish Sea by ship each year.*

For a while linen was the mainstay of Ireland's economy. But
it wasn't enough to solve the intractable problems of hunger and
poverty throughout the country. The Irish didn't even have a Poor

* In 1710, 1.5 million yards of Irish linen were exported to England. By 1770 that
figure was 19.7 million, more than was imported from Europe.

Law to protect them: conditions for the flax workers and linen makers and the millions of unemployed broke Sadler's heart. In 1829 he stood for Parliament and won. First he focused on a Poor Law in Ireland.* Then, having seen for himself the appalling conditions in the flax mills in his own country, he turned his attention to the child textile workers of Britain.

There had been earlier laws to protect mill children. Three had been brought in by the cotton millionaire Sir Robert Peel, in 1802, 1815 and 1819. But the last, the toughest, had only applied to cotton.

Industrialisation had come late to linen – that old hand-spinner habit of licking the flax to keep it moist was hard for machines to replicate. But by the end of the 1820s it too was being manufactured in a brutal industrial system that depended on cheap child labour. Children from the age of five were working for up to fifteen hours a day. If they didn't concentrate then, like metal Minotaurs, the machines would catch them and tear off their limbs. In one Manchester Sunday school, out of a hundred and six children, forty-seven had suffered accidents in the mills. In one textile factory 'the mangled limbs of a boy were sent home to his mother, unprepared for the appalling spectacle'.

In 1832 Sadler told Parliament that when a doctor examined the textile workers in one area of the north of England he found that all of them had lungs that were 'considerably diseased'. Also, young girls were regularly put to work on night shifts unprotected from the men who were there to watch the engines.

Towards the end of his speech Sadler took out a thong. He struck it against the table, 'the smack of which ... resounded through the House'. It was with such implements that women and girls and children in the mills were regularly beaten, he said. 'Beaten in your free market of labour, as you term it, like slaves.'

The speech led to a parliamentary inquiry and forty-three meetings in which eighty-nine witnesses were summoned. The testimonies they gave were, as Scottish economist John Ramsay McCulloch wrote in a private letter, 'most disgraceful to the nation'.

Elizabeth Bentley, called in; and Examined
What age are you?

* A resolution by Sadler in 1831 to establish a Poor Law in Ireland lost by twelve votes; it finally passed in 1838.

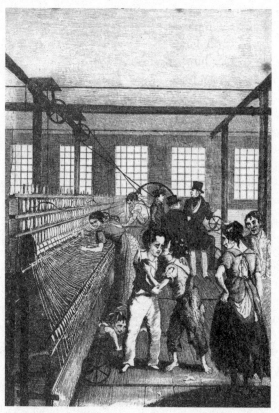

Young scavengers and piecers at work, in an illustration by Auguste Hervieu for Fanny Trollope's *Michael Armstrong: Factory Boy*, 1840.

–Twenty-three.

Where do you live?
– At Leeds.

What time did you begin to work at a factory?
–When I was six years old.

At whose factory did you work?
– Mr. Busk's.

What kind of mill is it?
– Flax-mill.

What was your business in that mill?
– I was a little doffer.*

What were your hours of labour in that mill?
– From 5 in the morning till 9 at night, when they were
thronged. [i.e. very busy]

*For how long a time together have you worked that excessive length
of time?*
– For about half a year.

What were your usual hours when you were not so thronged?
– From 6 in the morning till 7 at night.

What time was allowed for your meals?
– Forty minutes at noon.

Had you any time to get your breakfast or drinking?
– No, we got it as we could.

*And when your work was bad, you had hardly any time to eat it at
all?*
– No; we were obliged to leave it or take it home, and when we
did not take it, the overlooker took it, and gave it to his pigs.

Do you consider doffing a laborious employment?
– Yes.

Explain what it is you had to do?
– When the frames are full, they have to stop the frames, and
take the flyers off, and take the full bobbins off, and carry them
to the roller; and then put empty ones on, and set the frame
going again.

* Doffers replaced full spindles or bobbins with empty ones. 'Doff' from 'do off',
also used for tipping a hat.

Does that keep you constantly on your feet?
– Yes, there are so many frames, and they run so quick.

Your labour is very excessive?
– Yes; you have not time for anything.

Suppose you flagged a little, or were too late, what would they do?
– Strap us.

Are they in the habit of strapping those who are last in doffing?
– Yes.

Constantly?
– Yes.

Girls as well as boys?
– Yes.

Have you ever been strapped?
– Yes.

Severely?
– Yes.

Could you eat your food well in that factory?
– No, indeed I had not much to eat, and the little I had I could not eat it, my appetite was so poor, and being covered with dust; and it was no use to take it home, I could not eat it, and the overlooker took it, and gave it to the pigs.

You are speaking of the breakfast?
– Yes.

How far had you to go for dinner?
– We could not go home to dinner.

Where did you dine?
– In the mill.

Did you live far from the mill?
– Yes, two miles.

Had you a clock?
– No, we had not.

*Supposing you had not been in time enough in the morning at these
mills, what would have been the consequence?*
– We should have been quartered.

What do you mean by that?
– If we were a quarter of an hour too late, they would take off
half an hour; we only got a penny an hour, and they would
take a halfpenny more.

The fine was much more considerable than the loss of time?
– Yes.

Sadler lost his seat in Parliament to a wealthy flax magnate just
before the report was published. When Anthony Ashley-Cooper,
later the Earl of Shaftesbury, was first asked to take Sadler's place, he
hadn't been keen: other causes appealed to him more. But he even-
tually agreed to take up the plight of the textile workers, and later
he visited a mill in Lancashire and was shocked at what he called
the 'crooked alphabet' of children damaged by making cloth for the
nation's prosperity.

The Factory Act passed into law in 1833. It stated that nobody
aged eight or under should work at all, and that all between nine and
twelve years old could work no more than eight hours a day, with at
least two hours schooling provided on top of that. However, after
their thirteenth birthday children could be made to work for up to
twelve hours (with breaks not included). It was far from the ten-hour
day Sadler had wanted but at least for the first time the government
would employ factory inspectors; and for the first time it had powers
to punish any owners found to be ignoring the law.

Six years later, in 1839, Sadler's bill inspired Prussia to introduce a
ten-hour day – the first law in mainland Europe protecting working
children. And when Lord Ashley later found that despite the 1833
Factory Act children *as young as four* were still being employed in

British textile mills, he was able to draw on Prussia's recent lawmaking, and push at last for the British Ten Hours Bill of 1847.*

Postscript: lace museum

I have avoided Honiton's Allhallows Museum of Lace for a long time. It had been the last place my mother and I had planned to go to together; I just couldn't bear going there without her. Then one day, two years after she died, I am driving to my parents' flat to clear it, ready to be sold. And I realise that today I can pull it off. There's something lighter inside me. I park the car, and go in. There are three rooms, and today, with the sun streaming in, they're full of light.

Have I ever really looked at fine lace before? I've seen it of course, in museums and in portraits, including those famous ones of Queen Elizabeth I wearing up to twelve metres of linen lace pleated into huge stiff ruffs† that would have been impossible to maintain had she not employed an official 'Starcher to the Queen'. But have I really looked at it?

Perhaps it is the August sunlight that somehow makes the delicate birds and dragonflies and butterflies laced into these handmade meshes seem as if they're about to set off flying. Or perhaps it is that in these past two years I have sat in the strange silence of grief long enough to learn to love more subtle things. Whatever it is, today everything seems to be alive.

My attention is caught by a banner against a blue background. The white ferns tumbling around the base of a wittily curved white pot, and the white lilies and the white half-opened roses ... oh heck, everything's white and that's the point. It's white on white on air on space on light. This is art in single colours. Its date surprises me: I'd imagined it hundreds of years old, not from the late nineteenth century, when most of the handmade lace industry had disappeared,

* The Netherlands didn't get a Children's Law until 1874; Belgium had to wait until 1889. And the very first law protecting children in mills in America was only passed in 1893, pushed by a woman, Florence Kelly, in Illinois. The first US federal law protecting factory children wasn't passed until 1938.
† In sixteenth-century England these huge ruffs were called 'the French fashion' but when an Englishman first turned up in Paris wearing one the French had no idea what it was and dubbed it *le monstre anglais*.

chased out by machines. But in 1871 the banner was entered by a local woman, Ann Ward, into a competition run by the Bath and West of England Agricultural Society. She didn't win. Not because it wasn't the best in show but because it was so good the judges couldn't believe it hadn't been made in Belgium or the Netherlands. She offered to make another, with the judges as witnesses. Later they gave her the prize but she refused to accept it.

There's a red dress from the 1930s with a cinched waist and a scalloped bust and white lace flowers and leaves running diagonally across it. It's a good example of how Honiton lace was built up using separate bobbin lace motifs, which were later connected to other pieces by another lacemaker, to make a whole piece of extremely fine cloth. This dress belonged to Wallis Simpson, for whom Edward VIII abdicated the throne in 1936. 'I'm not a beautiful woman', she once said. 'I'm nothing to look at, so the only thing I can do is dress better than anyone else.'

There's a nineteenth-century sales catalogue for the separate motifs – a clover for threepence, a lily of the valley for ten, a raised bird a shilling and threepence. And my favourite (for its name as much as for its almost rude, fern-like exuberance): a polypody, a shilling.

I pull open the wooden drawers – just a few centimetres deep, designed especially for large sections of lace – to look at the oldest piece in the museum, dating from 1620, a few decades after Queen Elizabeth I had made lace so fashionable in England.

East Devon had been quick to specialise. It was traditionally a wool area so the women were used to working with fabric, and the region also included an expanse of fields, near Axminster, where conditions were suitable for sowing the finest flax. This was done by putting seeds very close together (as farmers in Flanders had done for years), up to three thousand two hundred per metre, so that the crowded grasses were forced to grow very thin and very weak, and had to be supported by frames stretched over the field.

There's another piece, from 1640, the year King Charles I paid thirty-five pounds for a single shirt collar – about four thousand pounds in today's money, or the equivalent then of six dairy cows. Handmade lace was always crazily expensive. A few years before that Charles I collar was made, a courtier in France had boasted that he had 'thirty-two acres' of his country's best vineyards around his neck. Throughout the seventeenth century the makers of East Devon

Honiton lacemakers made separate motifs of insects and
plants, which they sold for a few pennies each.

responded to the market demand, and by 1669, the Grand Duke of
Tuscany, Cosmo III, visiting east Devon, commented that 'there is
not a cottage in all the county nor that of Somerset where lace is not
made in great quantities'.

The earliest laces in the case are simple: they remind me of paper
cut-outs stuck on to coarse meshes. I find myself more attracted by a
flounce from 1874, more than five metres long and thirty-nine centi-
metres wide, intended to decorate one of the huge crinoline skirts so
popular at the time. It was made by Emma Radford, who was born
in Sidmouth in 1837. Six generations of women in her family were
known to have made Honiton lace; she won prizes for her work.

I put on my reading glasses; I get close. Nobody minds. And the
lace catches me in its net. A garden wasp lands on a leaf. A spider
moves towards a fly caught in its elaborate web. A bird eyes up a cat-
erpillar; it's done with verve and energy, and it feels like I could fall
into its story.

What were Emma Radford and the other lacemakers thinking or
saying or listening to as they made those stitches? Were they sitting
outside one of the pretty thatched cottages shown in the illustrations?
Or were they somewhere less picturesque, darker, colder? Were there
children crying, or playing, or helping? Were they worried about the
rent, or a husband's drinking, or a daughter's pregnancy, or their own?
Those real things would have had to have been there in at least some
of the lace I was seeing. But also there would have been the less verbal

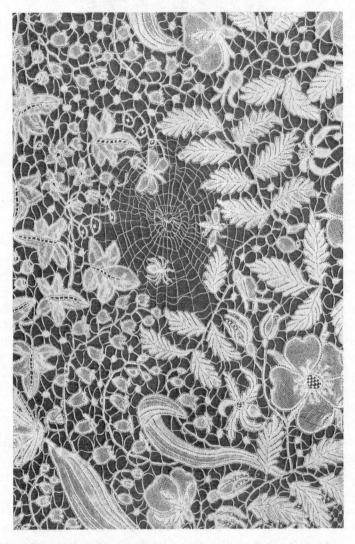

A detail from Emma Radford's lovely lace flounce, from 1874.

thoughts: a curve, a turn, the shape of a branch, the lines against a leaf. And how the plain ground and the elaborate motifs all loop into each other, so everything connects.

As I move towards the exit, my attention is drawn to one of the last cabinets. It has dark lace, designed for the bereaved: black for full mourning, grey or mauve for half.

Making black lace was hard. It destroyed your eyesight; there was no contrast. It was dyed using iron salts, which are corrosive. Sometimes curators open boxes that haven't been examined for years and they find fibres of what once was black lace, like mouse droppings in the corners. I look at a handmade black lace veil for a little longer than I need to, almost politely, as if wanting to give some kind of acknowledgement to the eyesight sacrificed in its making. It is lovely, though; delicate against a midnight-blue silk dress. My attention is caught by an information panel behind it. It's a chart of the recommended Victorian time periods for mourning and remembrance.

A widow for her husband, two years, six months and a day.

A widower for his wife, three months.

In the past, I'd have been outraged. How typical to make women stay in mourning for so much longer than their husbands. But in the past I had thought of mourning periods as restrictions, stopping people – women for the most part – from fully living their lives.

However, I've come to understand that under some circumstances a mourning period is liberating. You don't have to act in normal ways while your heart is grieving. You can wear black and later grey or mauve and people will understand that you are in a liminal place, and can't be fully counted on. There's freedom in mourning time too.

I look further down the list. And then I see it. Wife for her parents:* deep mourning eighteen months, mourning three months, half mourning three.

I add it up. Twenty-four months. Two years. Two years! It's the exact amount of time, to the very day, since I sat with my mother in a hospital room and she'd been breathing heavily, then more lightly, then not at all. Presence and absence. Like lace.

It was strange. I hadn't known how to mark the anniversary today.

* A child would be expected to mourn for a year for a parent, with the first six months of that deep mourning; an adult woman who is married would be expected to mourn for twice that time.

I hadn't known that if I had lived a century and a half ago then today would be my last day of formal mourning. But I have been led to one of the places that my mother and I had planned to go to together, and I've explored the tendrils and the time and the creativity and the absolute potential joy of this stuff that's made of the finest linen thread you can find.

I have lost myself in such things.

It feels almost as if my mother is here.

Post postscript: the linen chest

My parents' Regency linen press sold for just one hundred and fifty pounds. There's not much call for over-sized pieces of antique furniture with funeral lines round their doors. The linen it contained I mostly still have – in the same big canvas bag I first placed it in, now under the eaves of our house. Some of the table napkins I've patterned with fabric paints in coloured dots or with designs of moon and sun inspired by John Piper's stained-glass window in St Peter's in Firle in Sussex, which my mother loved. The linen hand towels remain unused. They've never really worked.

One day soon I'll pull the bag out from under the eaves, and sort it properly and give some of it away and find uses for the rest and in that way cut some of the threads of obligation to some half-imagined past in which inheriting it has tangled me.

It can be so hard to get rid of stuff.

9

SILK

In which the author hears an ancient loom, like wind in dry branches; meets a wild silk moth that isn't killed for its thread; learns the difference between the Greek Fates and the Viking Norns; and appreciates the tender significance of shrouding those you love in the unfurled cocoons of a fat, earth-bound, furry, white Chinese moth.

'They can't fly,' says the manager of the Brochier Soieries silk shop in the old quarter of Lyon. 'Their bodies are too fat. Or their wings are too big. Or something. Anyway, they'd never get off the ground.'

I've never seen a silk moth before. And now here are two, on a table outside this shop. I'd expected something more ethereal, like lace or ghosts. I'd certainly never pictured the small, bat-winged cousins of an angora rabbit.

When I was a child, I learned that if it flies by day it's a butterfly and if it flies by night it's a moth. But what if it doesn't fly at all? The manager, Eliza Ploia, smiles.

'There are some other differences between a butterfly and a moth,' she says, and I search on my phone for a list. Moths have ears and butterflies can't hear. Butterflies are usually coloured, and moths are usually plainer. Butterflies eat and drink and moths don't even have mouths. When moths are resting they usually keep their wings open; butterflies usually have them closed.

And finally, and this is of course critical for silk, moth caterpillars generally spin cocoons, and butterfly caterpillars generally don't.

I look at the moths on the table. They're balancing on wooden rods sticking up from what looks like a cribbage board. One has its wings spread and the other has them upright. So much for that distinction. But their wings are adorable. That's not a technical term, but they are huge and fluffy, like white rabbit ears or toy donkey ears, and

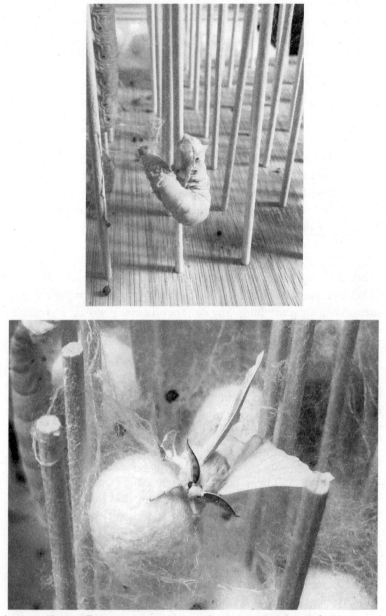

Above: Silkworm preparing to make a cocoon and transform itself into a different creature. *Below:* A silk moth just born: like a mix between an angora rabbit and an ethereal angel.

their antennae are like oversized eyelashes fringed with dark threads. Their forelegs are strong and furry: teddy bear legs. Their eyes are black buttons, and their plump bodies are covered with soft hair. It's as if a puppy has somehow got muddled in the evolutionary mix with a fat white hummingbird.

I hadn't expected to love the silk moth so much.

Below is a broken cocoon from which one of them has emerged. It's the size of a robin's egg and yellow as a lemon. All around is a delicate mesh of fibre catching the sunlight.

'Can I touch?' I ask, pointing to the mesh.

It feels soft. When I close my eyes I'm not even sure my fingers are making contact with anything. I think of how the fineness of a silk filament was once the mark against which all textiles were measured. In France the measurement was named a *denier*, after the smallest possible coin, one twelfth of a sou. Seven-denier tights, the sheerest you can buy today, are about the thickness of seven strands of silk.*

The two moths have recently mated, Eliza says. They'll stay together for a few days then the male will die first, the female not long after.

Later, she lets me sit in a room at the back of the shop where there are hundreds of caterpillars, divided in trays by age. The little ones are a week old. When they hatch from eggs the size of sesame seeds, they look like brown ants. Now they're the size and shape of white mulberries, which is hardly a coincidence as just about the only food they can consume without getting sick is the leaves of the white mulberry tree, *Morus alba*. The leaves, which were picked three days ago, are already curling. They smell vaguely of green tea; some people drink them as an infusion to reduce diabetes and heart disease.

'The worms shed their skin four times and then they are ready,' Eliza said.

On the last table, there's another of the boards with rods sticking up. The biggest worms, or 'fifth instars' are climbing them, reaching out like dancers, weaving their fate. With the light behind them, I can see through their bodies – becoming translucent is one of the signs that they are preparing to build a cocoon.

I see a long dark alimentary canal, a heart beating.

* The metric equivalent is the tex, short for 'textile', the weight in grams of a kilometre of any yarn: 'ten-denier' stockings are approximately 1.1 tex.

There are some half-finished cocoons with silkworms working inside them. I watch one. It's moving its head in the shape of an infinity sign. It turns and breathes and weaves as if it's waving. Sometimes in the very small there is the sense of everything.

In making its cocoon, the silkworm starts with the outer reaches, sketching out the general shape with generous sweeps, like the rough rectangle you mark out before starting a drawing in order to establish the top and the bottom. Then, as the cocoon gets close to be being finished, the worm needs less movement to get to the inside edges. So it weaves tighter and tighter in smaller and smaller movements until in the end it hardly needs to move at all to keep painting its continuous pattern on the wall of its own cave. The secretions come out of two glands in its head, each containing a liquid protein called fibroin and a liquid gum called sericin, which react with each other to make a single, solid thread.

A line of cocoons has been laid out on the table. The larvae inside are dead. When I pick one up, it rattles as if there's a dried bean inside. The casing is very light. It takes five or six thousand to make a kilogram of thread. In the sixteenth century they used to call silk cocoons 'bottoms'. It was a word then for the fundamental character of something: its essential self, its core. Which is how it came to mean, in more concrete ways, a base around which an emerging thread is wound.

This one is about the size of a quail's egg, though it's more elongated, like a peanut in its shell. It smells of oxtail soup.

In a row, they look like a colour chart for 1950s kitchen equipment. Cream white. Citron yellow. Yolk orange. Dusky pink. Chestnut brown. The colours are from natural pigments in the sericin, the gum that surrounds the cocoon to resist the rain and which tastes bitter in order to deter predators. The difference comes from how the individual worms process carotenoids and other substances in the leaves: it's genetic, like how some people have blue eyes and others have brown. And anyway, when the cocoons are later softened in hot water to dissolve the gum, most of the thread turns out white. Though that's a different process to how the silkworms were killed, by being boiled in their cocoons.

I knew about the boiling before I came to this shop.

I knew that the silk of the *Bombyx mori* silkworm is more valuable if the cocoon hasn't been broken.

I knew that in old China the cocoons would be placed in a basin of hot water and stirred with bamboo sticks until the end of the thread could be located and the whole kilometre or so – together with the silk of four or five other cocoons needed to make something strong enough to be a usable thread – could be reeled out with a precise amount of tension using a simple turning wheel.

And I knew that trillions of pupae died in the cocoon every year to make silk, and that this had happened every year for thousands of years.

I knew all that but now I catch myself feeling sad, wanting to protect these blind creatures from their fate.

There is ambient French electro music in the background. I ask Eliza if she would mind turning it off for a while. She doesn't mind. She has shut the shop for lunchtime but has left me in the room, scribbling and listening. It's like being in a forest on a windless day. To start with, you think it's silent but then, when you sit quietly and let your own blood become still, you hear life. The caterpillars are eating, searching, climbing over each other, growing. I think of dappled dachshund puppies, newborn, hairless, pale, moving over each other in mute slow motion. As well as the chomping, there are rustles and then an occasional gentle husky crack – like a Tic Tac box being opened surreptitiously in a cinema – when a worm finds a new piece of leaf.

The Roman poet Ovid retold a Babylonian origin story of silk in his book *Metamorphoses*. It starts beneath a mulberry tree with two lovers, separated by a wall. The girl, Thisbe, appears first, but runs away, leaving her veil on the ground. Her lover Pyramus sees it, and thinking that she has been killed, he kills himself, turning the white fruit of the mulberry red. Then when she finds his body she kills herself, dying by his side. This ancient tale of the veiled moths who live such short lives, and spend as much of them as they can in pairs,* was of course the story that Shakespeare adapted for his play-within-a-play in *A Midsummer Night's Dream*. I realise, standing here in

* The Babylonian story could refer to ordinary cocoons or to 'dupion' where two silkworms are so close together when they start spinning that the thread becomes tangled between the two cocoons. When the resulting silk is woven into cloth it is full of slubs or little irregularities, giving an iridescent effect. It's often deliberately done. Varanasi in India is famous for dupion, particularly for wedding saris.

this room, that his decision to retell the story was never just a comic interlude. It was also a continuation of the theme of the whole play – which, like silk, is all about metamorphosis. *A Midsummer Night's Dream* is in part the story of a weaver, who wakes to find that he has been transformed into a donkey – with ears, I now see, that were like the comic, furry wings of a silk moth. His name was Bottom, which would have been a fine Elizabethan joke, not just about asses, but also about silk.

And as I watch these creatures working so hard to make their sepulchres, I think about how Shakespeare used that old silk story again. In *Romeo and Juliet*. That story of brief lives stopped short just as they reached maturity and ending (as Juliet foresees) 'in the bottom of a tomb'. Another pun about cocoons, I realise.

A phone rings in the next room and the sounds of the world flood back. There are people talking and cars hooting in the Rue du Boeuf outside and it's as if I too have been in a dream.

Behind the trays I notice the silt-coloured saucepan where most of these animals will die. I move it away. I know they can't see it, but it doesn't seem kind.

The oldest ones in the final tray have run out of food. I take a handful of leaves from a pile in the corner and put them in the tray. The silkworms glide towards them, pushing into and over each other as they compete for the leaves. I see how they have crescents and stars and what look like eyes on the backs of their thoraxes and abdomens. And their noses, moving and exploring, look like the heads of seahorses.

The Chinese thought the worms' faces looked like horses

The Chinese also saw them as horses' heads. The most popular ancient origin story of silk in China begins with a girl who lives in the mountains, far away from anywhere. Her father receives a summons to fight for the king and leaves. After a year the girl begins to wonder where he is, and after another year, she starts to worry. One day she's tending to the horse and whispering her fears about her father, when the horse begins to speak. And because this story happens in the magical time, the daughter is not as surprised as we might be under the same circumstances.

'I'll go and find your father,' the horse says.

'Could you?' asks the girl.

'I could. And I ask just one thing in return.'

'What's that?'

'I'd want to marry you.'

The girl looks the horse up and down. And she sees that it is strong and rather nice-looking, and she knows that it has always been a good horse to their family. So she agrees.

The horse gallops over mountains and plains, to far-flung rivers and probably to far-flung constellations (this is a very ancient legend after all) and eventually it finds the father and brings him home. At first, the father is grateful. But then he learns what his daughter has promised, and he's furious. He kills the horse, chops off its head, skins it and then leaves the hide to dry. In one version, the girl runs away in distress. In a darker version, she's complicit, and kicks the hide to punish the horse for its lustful thoughts. Either way, she runs away, followed by the decapitated head of the horse, which, when it catches her, covers her head while the horse's skin wraps itself around her body. The father looks for her everywhere. And just as he is about to give up, he finds her on a mulberry tree. She has become a silkworm with a horse's head, and she's weaving herself the cocoon from which she will emerge as a goddess.

The Horse-headed Mother, or the Silkworm Woman, Can Nü, is still worshipped today in some parts of China. On her festival day, silk farmers in rural areas still buy paper cut-outs of her, placing them in their workshops to ask her – please – to give them an excellent harvest.

The oldest pieces of silk

The clay jar is about thirty centimetres high, with a neck as wide as a dinner plate and a pleasing, plumped-out shape tapering to a slim base, like a spinning top. In the past, it had been broken into fragments the size of a child's hands, but now the pieces have been mended with conserving cement of a paler colour, so you can see the joins. The pot is dark grey and has a gritty texture. It is the first object I see in China's National Silk Museum in Hangzhou. I stand in front of it for a long time.

One day or night, more than five thousand years ago, a mother, perhaps – or perhaps a father or a priest or even a stranger – bent or

kneeled or stood in front of this pot and placed the body of an infant inside it. It was a tiny child, older than a newborn, younger than a toddler. She or he was wrapped tightly in two kinds of silk: one a tabby and the other a pink gauze.*

The tabby is the earliest woven silk ever found, probably made with a backstrap loom. And the gauze is among the earliest coloured woven textiles of any kind. Experts at the Shanghai Textile Research Institute think it was dyed using iron ore.

The jar was buried in a tomb at Qingtai village in Henan in the centre of China. It was found in 1984 by a team from the Zhengzhou Institute of Cultural Relics and Archaeology who were excavating three other tombs in the area when they came across this one.

The pot was in pieces but it was clear that it had been the last resting place of a Neolithic child whose community did not know much about metal but did know how to reel silk. They also knew how to weave it into cloth. And they knew how to wrap it to keep a dead child warm.

Silk is good in graves

The two silks from the Neolithic burial aren't on display at the National Silk Museum. They're too fragile and need to be kept in the dark. But nearby there are several silks from Qianshanyang (near Huzhou beside the lower Yangtze river), which are four thousand four hundred years old. The cache was found in a tomb in 1958 and it included fragments of blackened silk tabby as well as silk ribbons and silk thread, all found in a flattened bamboo basket, like somebody's needlework case, ready for the next world.

* Gauze is a light, open fabric, named after the Palestinian city of Gaza. Sometimes it's just a loose tabby – cotton gauze, used for wound dressings, is made like this. But silk filaments are smoother and tend to move around if they're not fixed. The Qingtai silk gauze was made using a 'doup', or shadow, warp, running beside each stationary warp. The doup is shifted from one side of the stationary warp to the other, causing the fabric to contain twists and expanses, like lace netting. *Doup* is an Old Norse word akin to 'butt' (as in 'the butt of a candle', 'the butt of a joke', 'the butt of a buttock') and is still used in parts of Scotland (as in 'the doup' of an egg). The technique is also called a 'leno' weave, from the same root as linen. That cloth is not as soft, because the interlocks have given it structure, but it is more translucent: enigmatic in its own way.

Silk is good in graves. It lasts longer than most other natural fabrics. I remember reading an account from Philadelphia in 1824, of how the coffin of the daughter of the former governor, William Denny, was dug up to enable the installation of iron pipes in a road beside the burial ground. Her body, which had been interred some thirty years earlier, disintegrated as soon as it met the air but the 'silk riband' on her dress was almost untouched. It was so well-preserved that the gravedigger's daughter kept it and wore it afterwards.

The truth is, worms and insects don't much like silk. Moth larvae rarely make holes in it when they find it in wardrobes. They don't like to eat their own.

I dressed my mother in cotton. But

I chose my mother's favourite blue cotton skirt and blouse for her to wear in her coffin. They were her clothes for summer holidays. In the strange logic of the magical thinking I was experiencing after her death, I wanted to conjure up the sense – for her or for me, I wasn't sure – of going to a wonderful, exciting new place, albeit the one for which no passport or credit card is required.

But if by then I had already stood beside that broken-mended pot in the Silk Museum and had contemplated the death of that Neolithic child ... if I'd known the ancient Chinese symbolism of silk as a metaphor for being reborn as something different ... if I had known all this, I think I might have dressed my mother in silk.

And if it *was* to symbolise her emergence as her own soul's version of a small, plump, furry, white angel, then my mother at least would have found that funny.

My father had a silk handkerchief in his jacket and I don't feel the same about his funeral clothes. For him, the handkerchief would have been quite enough symbolism.

'What on earth would you have put me in?' I can hear him asking, amused. 'My best pyjamas?'

When silk started to unravel

Despite the ancientness of the tradition, the secrets of Chinese silks were protected from outsiders for thousands of years, probably until around the third or fourth century when they reached Persian

farmers, in today's Iran. Even then, the knowledge of sericulture and the physical presence of mulberry and the *Bombyx mori* silkworms was kept within those limited communities, and it took several more centuries until they spread more widely. In the British Museum, there's a piece of wood depicting a princess with a basketful of cocoons. She is Princess Punyesvara, and stories have been told about her for more than a thousand years. One still being told in the 1970s in Dunhuang (on the Silk Road, as you head out of China) relates how, in the middle of the seventh century, the King of Khotan – a Buddhist kingdom based around an oasis town in today's Western China – was so worried about how his country's resources were being spent on silk that he lay awake at nights.

'Don't worry,' said his minister. 'It's not hard to make silk. You just need three things. Mulberry trees, silkworms, and people who know how to cultivate them.' The advice didn't strike the king as helpful. The Chinese emperor had issued an edict forbidding anyone to export mulberry trees or silkworms or silk experts. 'But what if you married a Chinese princess?' the minister suggested. The king agreed. The minister went to the Han emperor's court to make the arrangements, and when he had the chance to talk with the chosen princess in private, he explained the situation. At first she didn't want to disobey her father, the emperor. And anyway, how could she get silkworms through the Yumenguan pass when the guards were searching absolutely everyone?

When they reached the pass that marked the border of China, everyone was searched. When they were done, the princess was allowed to continue, but all the members of her entourage, except her personal maids, were told to go back. The minister was convinced he had failed. But when they were a long way from the pass, the princess removed her headdress and picked tiny silkworm eggs out of her hair. And the mulberry? She opened her medicine cabinet, and there were dozens of seeds.

'Some of them are mulberry,' she said. 'It's so hard to tell the difference.'

'Ah,' said the minister. 'But we don't have the silk experts.'

'We actually do.' The princess called her maids over. 'It's the women not the men who look after silkworms,' she said. And that, according to one of many legends, is how the skill of mulberry silk

cultivation passed out of China and to the regions of Central Asia and Persia – where craftspeople began to excel in the making of luxury brocades – and then moved further and further west.

It's not that there wasn't other silk elsewhere. There are dozens of species of wild moths all around the warmer climates of the world whose cocoons can be unwound to make into yarn. The most celebrated in ancient Greece was *Coa vestis* – 'Kos cloth' – named after the island where there were wild silk moths living on turpentine trees. The philosopher Aristotle in the fourth century BC said that kind of silk had been invented on Kos many centuries before and that there was a class of women on the island who would unreel the cocoons and then weave a fabric 'with the threads thus unwound'. But it came from a different kind of moth – and the silk was not as fine as that from the Chinese *Bombyx mori*.

The West African equivalent was the *Anaphe* moth, which lives on the tamarind tree. Unlike most other silk moths, its caterpillars are communal, and a colony of several hundred will spin themselves into one large cocoon. The cocoon is beige, although inside – where each individual pupa is enclosed in its own pocket – the silk is white. It's woven into a cloth called *aso oke*, and worn only during ceremonies, and especially funerals. *Anaphe* were never domesticated, although in northern Nigeria people would encourage them by growing tamarind. When a hunter found a cocoon, he'd take it to market, and if it still contained any pupae he'd get more for it, because after the silk had been removed, the insects could be roasted and eaten. The cocoon nests would generally be used as purses, or, later, as bags for storing gunpowder while hunting. In Madagascar there's another wild silkworm, *Borocera madagascariensis*, which is made into a cloth called *lamba landy*. It is expensive but it is also dangerous, as its threads are full of tiny hairs that can penetrate the skin and cause infections. It means that you have to trust the maker. It also means that it can take up to a month to make a single metre of cloth. In the past it was for the royal family, and even today it's only worn on special occasions, or occasionally to wrap the dead, when families can afford such an expensive shroud. People used to say that the cocoons of the *Borocera* moth have 'no limbs but many feet', because they were so precious they were worth trading over long distances.

A land named Silk

Although the secrets of growing silk remained guarded, mulberry silk from China has been travelling west for at least three thousand years. Threads from a silk bonnet or ribbon have been found wound into the hair of a woman who died in Thebes in Egypt around 1000 BC. We know it was most likely from China because the Chinese had a particular way of degumming the fibres by boiling them in soapy water to make them softer and better able to absorb dyes. The Ancient Greeks called China 'Seres' which is like calling it 'Silkland' using the old Chinese word for silk, *si*.*

Around the fifth century BC, there was a burst of international trade in silk leaving China. It went north to Siberia where it has been found in graves in the Pazyryk Valley of the Altai Mountains. It also travelled west towards Europe along Persia's 'Royal Road'.

The journey was always dangerous, and by the beginning of the Han Dynasty in the second century BC it had become life-threatening.

The main trouble was the nomads, whom the Chinese called the Xiongnu. A confederation of tribes had formed in the area that corresponds roughly to modern-day Mongolia, Inner Mongolia, Xinjiang, Gansu, and the Lake Baikal region of southern Siberia.

In battle, there'd be up to three hundred thousand of them – strong, fast archers on strong, fast horses. The Chinese farmers and the Chinese army's chariots didn't have a chance. Even the Great Wall, built after around 500 BC, couldn't stop them for long, although its construction could be a reason for the surge in silk exports around that time, because it made it safer for trade caravans to travel.

In the interests of forging an alliance, in 138 BC the emperor Wu sent an emissary to Fergana in today's Uzbekistan. Despite being captured by the Xiongnu, Zhang Qian finally reached his destination and returned to the Chinese emperor with knowledge not only about the nomads but also about lands as far away as Syria. In Fergana itself he was most amazed to see how many Chinese trade goods there already were in every town. He'd thought he was going to exotic places far from anything he knew; instead he found many things that

* *Si* later came to mean any thread. The character has been found on oracle bones from before the Shang Dynasty, i.e. pre 1600 BC. Several colour words carry variations of the silk radical (糸) – 绿色 (lü-sè, green), 红色 (hóng-sè, red), 紫色 (zǐ-sè, purple) – indicating the importance of silk dyeing in ancient China.

were familiar, including fabric woven in Chengdu, thousands of kilometres away.

With Zhang's hard-won information, the emperor was able to establish four military outpost towns (all in today's Gansu Province) as well as a network of post offices and manned watchtowers to protect the trade routes from bandits and war gangs.

He also increased tribute to the Xiongnu, who loved Chinese silk.

In part they craved it because growing mulberries and cultivating silkworms requires settled land and peaceful lifestyles, so they couldn't produce it even if they knew how.

And in part they needed it because, as well as being luxurious and lovely, it was extremely useful worn in battle, under your armour. It could stop some arrows penetrating, and if they did get through without killing you, it made them easier to pull out.

This was the era when silk really started to move. One of its destinations was imperial Rome, already a place of emperors and excess, where both men and women were only too happy to buy as much silk as could be transported to them across the passes of Central Asia. Around 70 AD, Pliny the Elder complained in his *Natural History* that the fashion for silk clothing among Roman nobles was causing a constant drain on bullion.

Travelling the other way were also many goods. Silver of course, as Pliny bewailed, but also amber from the Baltic. And coral. Even today, in Tibet, Ladakh and Mongolia there is a tradition of prizing coral and passing it down from mother to daughter as wealth. In Ladakh, older women sometimes still wear *perak* headdresses covered with turquoise, coral and silver, which were until recently the most valuable items a woman could own. The best corals came from the Mediterranean near Naples and it's likely that the fashion first arrived in Roman times with the trade goods passing east in exchange for the silk.

As more goods travelled in both directions, ideas, stories and words also found new roads.* Religions too. Buddhism travelled

* The phrase 'Silk Road' wouldn't be coined until 1877 when Baron Ferdinand von Richthofen, the Professor of Geology at the University of Bonn (and future uncle of the 'Red Baron' flying ace), searched for an image to support his opinion that rail connections would transform trade links between China and Europe, enabling coal and other resources to be carried cheaply across continents.
He argued that the best routes would be along the old trading pathways: the Seienstraße, or Silk Streets.

from India to China. And in the sixth and seventh centuries, Christianity would also come that way, brought by Persian monks. The first church in China was built in around 640 in Chang'an, now Xi'an – where the great Northern Silk Road began.

Imitations go both ways

From the top of the watchtowers built by Emperor Wu, the guards would have seen many caravans winding along the tracks below them. Many traders carried *jin*, a rich brocade invented around the eighth century BC. *Jin* thread is made by winding gold around a core of silk, and the patterns made from it were so elaborate that when the cloth first appeared in the markets of Baghdad and beyond nobody could work out how it was done.

Here's the issue. As I learned in the cotton chapter, a woven cloth can be warp-faced or weft-faced or a balance of the two. In the former, the warp threads are so close together that you can't see the wefts except at the selvedges. A weft-faced cloth is the opposite, and you can usually tell if a handwoven cloth is weft-faced because motifs can be repeated more easily across the width of the fabric (because they're all created at the same time) and not so easily along the warp (where the timing might be separated by days or even months, and where the tension or even the dye-batch might by then be slightly different).

The Han weavers specialised in warp-faced *jin* brocade. But when the Persians (of today's Iran) and the Sogdians (of today's Uzbekistan and Tajikistan) tried to copy it, they made their version weft-faced because it was the only way they knew.

The exercise involved reinventing their own carpet looms, or *zilu,* using a system of multiple suspended heddles connecting the ordinary warp threads with the extra patterning threads. It was a triumph of technical adaptation and it meant that they also applied some of the Chinese *jin* effects to their own traditional fabric and carpet designs, achieving another kind of transformation. And so the two systems coexisted.

Then, hundreds of years later in the early seventh century, an emperor of China in the Sui Dynasty received a stunning Persian brocade as a gift.

'How do they do it?' he asked his palace weavers. He told them to

copy it and that is how, according to legend, the making of weft-faced brocade first came to China. As a knock-off copy of a knock-off copy, made valuable because it was favoured by an emperor.

In those days, silk was almost always precious, its presence an indication that it was dressing important people. And often the further away from China you found it, the more precious it must have been.

The Vikings liked silk tribute too

In the boat, they found the bodies of two women. One was in her seventies; she had cancer. The other was in her fifties: a daughter's age. She had broken her collarbone a few weeks before she died, and it isn't clear what killed her. Both women were buried together. With honours, and with the greatest cache of Viking silk ever found in Scandinavia.

In 1903, Norwegian archaeologists investigating a ninth-century mound on the Lille Oseberg farm near Oslo, discovered an enormous burial ship. Long, thin ships had been designed for warfare in Viking times, and wide, flat ships had been built for merchants. This one was neither. It was somewhere in the middle: wide, long and highly ornamented, with carved reliefs of dragons along the prow where it touched the water. After excavating they concluded that it had probably been the pleasure barge of a queen.

The Vikings in northern Europe believed that the afterlife was full of snow, and they sent their high-ranking dead off to the next world equipped with sledges and warm clothes and winter blankets. And if they ran out of clothes, then their spirits would only have to rummage in their luggage to find spindles and looms, yarn winders and combs and several balls of yarn so that they could make themselves new ones. But the presence of silk was something different.

In the Viking Ship Museum in Oslo today, you can see what remains of the fabrics from the Oseberg burial. The museum is shaped like a cross. The Oseberg ship takes up the length of it: two other burial ships take the side arms and at the top are all the grave goods. The textiles room is tucked in beside the right arm. It's small and dark, and it's quiet for minutes at a time until, with the rushed swoop of a group, it becomes full of energy. I watch visitors straining to see the figures and designs in the faded chestnut-brown brocades in the half-light, then giving up and returning outside where there are

bigger things to see. But these small things have their own curious stories; they are worth attention.

The two women had been fully dressed in fine clothes, then tucked up in beds and covered with blankets, just as if they had fallen asleep. One of the blankets is mohair, made from the soft belly hair of angora goats – named after the city of Ankara in Turkey, which was famous for them. Now the blanket looks like a map of an archipelago with the insect holes playing the part of the sea; a texture of mostly absences. Many of the bits of woollen cloth are caked solidly together, looking like an old book that's fallen into the water, but the top layer still shows the horses and the ruffled ends of warriors carrying spears. One particularly clear fragment shows an archer on a galloping horse, leaning backwards ready to shoot.

But the real treasures are the silks. They reveal not just that the Vikings had silk in the ninth century, but that they had many kinds of silk and some of them came from very far away. There are several pieces of samite – weft-faced silk brocades named from the Greek word *hexamiton* meaning 'six threads' because they achieve a satin effect by letting the wefts float over at least six warp threads at a time. The Oseberg samites were cut up into strips, probably when the original cloth had become old, and were then sewn onto newer woollen cloth as decorative bands. Most of the silks came from Persia and Central Asia, although one piece is thought to have come from China. Its threads had not been spun but twisted, which is something the Chinese – who generally had access to better-quality silk – traditionally always did, unless the silk came as floss from a broken cocoon.

There are more delicate fragments, embroidered with vines and leaves like illuminated manuscripts. These probably came from England or Scotland as booty when Norse raiders attacked the monasteries of Lindisfarne and Jarrow in Northumbria and Iona in western Scotland at the end of the eighth century. They were mostly after gold and silver and didn't appear to care what treasures it had been crafted into; they'd usually just melt it down. But they also liked the silk.

Cloth had a spiritual relevance to the Vikings. In the Old Norse religion, what happens in our lives is measured by three sisters. Their names are Urd, Vedandi and Skuld, which are sometimes translated as What Has Been, What Is Right Now and What Will Be. They are the Norns and they sit beneath the Yggdrasil, the great ash tree at the centre of the universe, and they spin.

The Norns seem to represent three ways in which destiny plays out in a human life, and in that context their names could be translated as 'What-has-been-predicted-so-clearly-it-is-as-if-it-has-already-happened', 'What-is-unfolding-right-now' and 'what-should-happen-depending-on-your-choices'. Fate. Becoming. Should. And the three kinds of destiny also seem to be embodied in the three stages of the thread as it comes into contact with the spindle. There is the unformed thread that is destined to be spun, the thread that is spinning, and the thread that is spun and destined for its next stage.

The Viking Norns are like the Greek Fates, in that there are three of them and they are described as spinners and midwives who turn up at our birth and have a role in our death. But the Norns came later, and they used their relationship with fabric in a different way. Their threads don't measure the length of your life so much as make up the cloth that will become its quality. They predict what material goods you will own but they also know how great a person you will be. They don't weave your destiny according to their own whims but more blindly, following deeper laws.

The Oseberg burial chamber was closed in the 830s. So each of the textile fragments in that dark room was made before that, quite possibly a long time before. Silk was so valuable that you would inherit it, sell it on, patch it into other clothes or bury it with your best people. You wouldn't just throw it away.

There were two main Viking silk routes to Scandinavia. The silk that came via England and Scotland would have travelled from Byzantium and Central Asia to Italy then over the Alps through France and across the Channel. Other pieces would have travelled up via the Baltic, either along the Dnieper river from Constantinople or along the Volga from the Caspian Sea. By the ninth century, Viking populations were living most of the way along both rivers. They were named the Rus, after the region of Roslagen in Sweden, and this is the origin of the country names Russia and Belarus today.

In 921, the Baghdad diplomat and Muslim missionary, Ibn Fadlan, travelled north along the Volga. He kept notes and tried to learn as much about Viking culture as he could. One day he heard there would be a funeral for a chief, and he went to watch. He noticed the significance of silks.

First, they put the man's body in the grave 'and roofed it over for ten days until they were finished with the cutting and sewing of his

clothes'. The dead man's wealth was gathered, and divided into three. One part was for his family and another was to buy all the alcohol that would be consumed at the wake. The last was to pay for garments to be made for his funeral. On that day a slave girl would also be killed. The girl had apparently volunteered for this, although she couldn't change her mind and she had spent the previous days living in luxury as a kind of terrible, material compensation for what was to happen. On the funeral day a boat was dragged up onto wooden scaffolding and various people walked back and forth uttering words that Ibn Fadlan didn't understand.

> They then came with a bed, put it on the boat and covered it with quilted mattresses and cushions both made of Byzantine brocade. Then an old woman came, whom they call the angel of death. She spread the furnishings on the bed. She took charge of sewing it and putting it in good shape. She is the one who kills the slave girls. I saw her as a young, old witch, massive and sombre.*

Some or all of the silk at that funeral would have come as tribute. In 907, according to the *Russian Primary Chronicle*, combined forces of Rus and Slav warriors besieged Constantinople. They destroyed outlying palaces, burned churches, beheaded some prisoners and tortured others. When the Greeks sued for peace, the Rus proposed their terms. Obviously, they would require a good deal of tribute, some of which was in silk.

In addition, any Rus merchant should be allowed to stay in the city for six months (with baths prepared whenever he wanted), and if his slaves escaped while he was there, he should be given reparation in the form of two pieces of silk for each. And brocade sails should be woven and sewn for the Rus ships, and silk ones for the Slavs.

When the conquerors were finally ready to leave, they unfurled the new sails, and the wind tore them.

* When a Rus king died a twenty-roomed mansion was built. Each room contained a grave, and in each grave was the body of a decapitated man, so that it wouldn't be known in which room the king was buried. 'His grave is called paradise ... and all of the rooms are covered with brocade woven with gold thread', Ibn Fadlan reported.

'We'll keep our canvas ones,' the Slavs said. 'Silk sails aren't made for Slavs.'

Writing on silk

By this point, the Chinese secret of sericulture had already been out for a while. Silk from the *Bombyx mori* had been cultivated and woven around Byzantium – today's Greece and western Turkey – as well as further south in Beirut and Tyre for many years. And even though the Prophet Muhammad (who died in 632) had thought silk a womanish thing, and Islamic law still prohibits men from wearing pure silk, Muslim history from the eighth century is full of stories of caliphs who loved it.

In the eighth century, the Umayyad caliphate controlled a vast area of eleven million square kilometres, making it one of the most powerful empires in history. Its territory stretched from Portugal to northern India, taking in much of north Africa, the Middle East, Persia, Afghanistan and the Arabian Peninsula on the way. Between 715 and 717, the caliph was Sulaiman, a large, unhealthy man in his early forties famous for his love of brocaded silk or *washi*. He wore it while riding and preaching and at most other occasions in between. No servants, not even the cook, were permitted to enter his presence without being dressed in *washi*.

At around that time there emerged a tradition of what became known as *tiraz*. The word meant 'embroidery' in Persian but in the wider world it came to have the specific meaning of cloth (sometimes pure silk, sometimes a silk and linen mix) on which Arabic inscriptions had been woven or embroidered in specialised workshops. Sometimes the words would praise Allah, sometimes they would praise the caliph. *Tiraz* were originally given to a caliph's favourites, and the messages were personal. Later, the texts just wished generally pleasant greetings or included wise quotations in bright colours. Until the tradition faded around the fourteenth century, *tiraz* came to be a little like logos or brand names today – useful propaganda for whichever caliph had their name inscribed on it. A man given a *tiraz* was expected to wear it at all public occasions: it was as if, in our own time, all the most famous male celebrities, soldiers, businessmen and politicians were seen at big events with astonishingly expensive clothes and banners, with the president's name emblazoned in large letters all over them.

Silk to Sicily

'The oranges of the island are like blazing fire among the emerald boughs', wrote the Arab poet Abd ar-Rahman about his homeland of Sicily. And the soil that produced such amazing fruit, fed by the ash of Mount Etna, was also excellent – it turned out – for mulberry trees.

Muslim forces had taken Sicily in 827, bringing with them silkworms and *tiraz*. By the end of the eleventh century, an army of Vikings (by now calling themselves Normans) conquered the island for themselves.

At first, the invaders just kept the Muslim weavers and existing silk workers in place. A red-and-gold silk mantle commissioned by King Roger II of Sicily in 1133, and now held in the Vienna Imperial Treasury, shows two camels being slaughtered by two lions. It symbolises his father's conquest over the caliphate a generation earlier, although in every other way it is in traditional *tiraz* style, with an Arabic inscription to say that it was made in Palermo in the year 528, by the Hegira calendar.

But this was the time of the Crusades and soon Roger II wanted to surround himself with silk that was more Christian in style. In 1147, his military ships sailed towards Greece and when they returned – triumphant after capturing the islands of Corfu and Malta – they had some of Byzantium's most talented weavers in their holds, snatched on demand from Thebes, Athens and Corinth. King Roger built a 'stately edifice' for them in his palace in Palermo, and started a homegrown silk industry in Italy that continues today.

By the early fourteenth century, the Italian silk industry had mostly moved north. Piedmont, near Turin, was one of the great places for cultivating silkworms; Venice was known for weaving cloth of gold; Lucca in Tuscany was famous for all other kinds of luxury silks; and Bologna was scooping up the contracts for sendal, a less expensive kind of silk. Meanwhile, Genoa specialised in black silk velvet. It was so valuable that the weavers had to make special selvedges to show it off because that was how buyers tested the quality of the weave. Velvet is made with two kinds of warp threads: a foundation warp which holds the cloth in shape and a velvet warp, which is much longer and loops back on itself with the pass of every shuttle. Once the cloth is woven, the velvet warp is cut (now by machine, but once by a skilled velvet cutter) so that the loops become a soft pile. Black and white velvet were fashionable then,

but the processes of dyeing black and bleaching white sometimes damaged the silk.

By the early fifteenth century, Italian silk had become a lucrative export trade – both as finished cloth and as good strong warp thread – and other countries watched with interest to see how the silk trade was proceeding. This is what they saw.

Venice had the best imported silk, the brightest imported dyes, and a kind of velvet (the so-called *alto-basso*, high-low) that was designed with varying thicknesses of pile that made it shimmer in exhilarating ways. It also had a general reputation for being at the vanguard of fashion.

Genoa imitated Venice.

Everyone imitated Genoa.

Then, in 1453, the Ottoman empire captured Constantinople. Major sections of the trade routes linking China and Europe were now blocked off.

While the Portuguese and Spanish concentrated on developing ships and sails strong enough to travel long distances to reach India and China by sea, Italy put up its prices for silk.

And the French and English were among those who were not happy at all.

How Lyon became a silk town

Medieval and Renaissance court fashion in Europe *demanded* silk. Virtually all medieval courtly dress from the early twelfth century onwards was inspired by what crusaders had seen on their travels and by what they had brought back. And many of the loose, brilliantly coloured clothes being worn by rich people in the Middle East in the twelfth and thirteen centuries were made of silk.

After the First Crusade in around 1100, Queen Matilda, wife of Henry I of England, led a fashion for women plaiting their hair and wrapping it in silk casings. Some of these silk-wrapped plaits were so long that they (or the secret hair extensions hidden within them) reached right down to the floor, flicking as they passed, attracting the eyes of onlookers.

New too were surcotes: coats and long jackets worn over other clothes. These were copied from loose Middle Eastern clothing and were originally worn by European soldiers over their armour to

protect the chain mail from rusting. It was also a way of looking bulkier and more powerful as you charged into battle with red crosses on white fabric flowing behind. When surcotes arrived in Europe, women adopted them too. The many variations included the cyclas, a sheer silk robe with a side slit, worn over your dress. It was often fashionably cut a few centimetres too short, so as you walked you could lift it and provide a tantalising glimpse of the finer fabric below.

By the early sixteenth century, the post-crusader fashion for wrapping and revealing had morphed into richly brocaded sleeves and tunics that were slashed to show the quality of the fabric below them. Like deliberately torn designer jeans in the late twentieth century and today, they gave an air of being both nonchalant and sexy, and both men and women enjoyed the effect.

In 1514, Lucas Cranach painted Renaissance Europe's first full-length portraits. They showed Henry the Pious, Duke of Saxony, and his wife Catherine of Mecklenburg wearing slashed sleeves. Henry has so much gold lining showing through the profusion of holes in his tunic, coat and breeches that the subtlety is entirely lost.

A generation later, in 1538, Holbein the Younger would paint a famous portrait of King Henry VIII wearing a tunic with diamond-shaped cuts across his chest, with flecks of white silk pushing through each of them, as if they were handkerchiefs trying to escape.

Across the Channel, Francis I of France – three years younger than Henry VIII and one of his great rivals – wanted to be a thoroughly modern fashionable man in a thoroughly modern fashionable country. However, all those imported ruffs and slashed sleeves and gold brocades were bankrupting the Treasury. France was also at war with Italy, which was still Europe's main source of silk.

He needed a plan. Lyon was his second capital. It lies on the confluence of two rivers, the Rhône and the Saône, giving excellent connections. It was close enough to Piedmont in Italy to get there overland in just over a week, whenever war allowed it, and, as a city with royal permission to hold four fairs a year, it was already a centre of the textile trade. There were many weavers living there and the city seemed to present an opportunity for setting up a viable French silk industry.

Also, the climate was not unlike that of Piedmont, which made the king think that perhaps, once they'd figured out how to do it, they might be able to grow mulberries and let silkworms thrive. Francis's

A box of silk cocoons, with an airhole to stop them from getting stale.

distant cousin and predecessor, Louis XI, had tried to do something similar in 1466, by giving privileged status to Lyon weavers, but had failed. Francis was going to do it differently – through tax concessions.

In the early 1530s, two Piedmont master weavers agreed to move to Lyon and weave fabrics of 'gold, silver and silk' in exchange for the promise that they wouldn't have to pay ordinary taxes. In 1536, Francis signed a letter patent confirming this and soon Lyon became France's centre of luxury silk, attracting weavers from Genoa and Avignon as well as from Piedmont. Later, the region became the heart of French sericulture as well.

The English tried to get involved. They didn't actually have any of the things they needed to start their own silk business. They didn't have the eggs. They didn't have the mulberries. They didn't have the skilful people. But they did have the desire to get in on the act. At the time, English merchants would buy counterfeit silks in northern Europe, put the equivalent of 'Made in Venice' labels on them, and sell them around the Mediterranean at a mark-up, to people who either didn't know better or liked to feel they had had a bargain.

In the early seventeenth century, the Scottish-English king, James VI and I, wanted to start a domestic silk industry, so he had a four-acre mulberry garden planted in what are today the grounds of Buckingham Palace. The gardeners were called the King's Mulberry Men. In 1607 it was announced that owners of large estates were expected to buy and plant ten thousand mulberry trees each; more modest

householders understood that it was their patriotic duty to plant at least one. Charlton House, one of the few surviving Jacobean mansions in London, has a mulberry in its garden that is supposedly from one of those first plantings. But the king was wrongly advised. Most of the trees sent from France were black mulberries, not white. They bear nice berries. But silkworms don't like the leaves.

A few of the right mulberry trees did make it to England in the first part of that century, however, and in 1655, a printer near the Black Spread Eagle public house near St Paul's Cathedral published a tract about cultivating silk from them. It was titled *The reformed Virginian silk-worm*, being intended to encourage the industry in America. It became a bestseller on both sides of the Atlantic, with its claims to include a 'rare and new discovery of a speedy way and easie means' for raising silkworms, particularly in the colony of Virginia. It stated that the method had been discovered by 'a young Lady in England, she having made full proof thereof in May, anno 1652'.

The anonymous scientist turned out to be Virginia Ferrar, born in 1627, twenty-four years earlier. Ferrar grew up with her parents and younger sister as well as her aunt, uncle and ten younger cousins in a small religious community in the countryside outside Cambridge. It was called Little Gidding, and the twentieth-century American poet T. S. Eliot would later make it famous by writing one of his *Four Quartets* based on a visit there. Ferrar had been named after the newly established colony in America of which her father had once been deputy governor, and as the English Civil War raged throughout the country from 1642 onwards, she raised silkworms in the community's quiet garden and kept assiduous notes.

She learned that worms enjoyed lettuce, but that they didn't convert it into good silk; and that the best time to sow white mulberry seeds in windy Cambridgeshire is April, in 'ground that is well dunged, and placed so that the heat of the Sun may cherish it, and the nipping blasts of either the North wind or the East may not annoy it'. And the best way to care for the silkworms, she found, was to 'lay them in a piece of Say [a woollen fabric] and carry them around with you close to your body, in a little safe box, and at night lay them in your bed or between warm pillows'.

She (or possibly her father) made notes and drawings in the family atlas. The writing is in the margins; the drawings (including one of a pupa wrapped in its cocoon like a corpse) are in spaces between

sections of printed text, all of which suggests that they needed to be secretive. Much of the research was done when England was at the height of its brief Commonwealth: King Charles I (the son of James I) who had visited Little Gidding several times, had been executed a year after his last visit; Christmas and theatre were banned; and luxuries were frowned on. Silk was not forbidden – the wealthier Puritans sometimes wore it in modest colours beneath their dark clothes. But it wasn't much favoured either.

So why did she risk it? The answer probably comes from her faith, as well as her sense of having a connection with America through her name and her father. Ferrar had always been keen that the silk industry should be taken up in the state she was named after, which was thought to have a similar climate to China's. She believed that tobacco (then as now one of the top export crops in Virginia) was bad, just 'smoak and vapour', while silk is a 'reall-royall-solid-rich-staple Commodity'.

She wanted, by working with the thread that comes from transformation, to help change the industry of a new colony, and enable people to make something to embody the beauty of the world rather than something to encourage addiction, or, as she described it in her book, 'the pernicious blinding smoak of Tobacco, that thus hath dimmed and obscured your better intellectuals'.

When you had no choice but weave

While the English king was ordering that every householder grow mulberry, half a world away in Assam in eastern India another ruler was also making very clear laws about silk. In an edict of 1603, King Swargadeo Pratam Singh made it compulsory for every household to spin and weave silk. Every able-bodied woman in the kingdom had to spin a certain amount of silk every day before sunset, and if she did not, she would be punished. It sounds like the terrible premise of a fairy story or a dystopian novel, but Pratam Singh's law was real.

It was harsh and cruel and greedy, but it meant that every girl at that time learned to spin and to weave, and even today, houses in Assam are more likely than elsewhere in India to contain a loom. It also enabled a remarkable village to be created on the bank of the Brahmaputra River in the western reaches of Assam.

Sualkuchi still exists as a weaving village – 'the Manchester of the

East', the tourist brochures call it, though it's a very pre-industrial and rather small version of the English textiles city.

And it's still famous. Less for what it creates with *Bombyx mori* silk – although that is woven there – than for a different kind of silk. It comes from a wild moth, *Antheraea assamensis*, which originated in the deep forests of the sub-mountainous areas of Assam and Nagaland. Even today in some parts of eastern India its cocoons are more prized than any others. They call it muga.

An empty shuttle

When I arrive at Guwahati, Assam's biggest city, I take a taxi from the airport into town.

'Sorry,' says the driver as he pulls into a massive traffic jam on the overpass. 'We will be here a very long time.'

Taking up the left lane for miles – as the regular traffic inches by – are hundreds of carnival floats. Each blares loud music, each has a variation on the theme of men in red bandanas dancing and drumming before a statue made of glitter and shimmer. The women in some of the cars are in white saris with bright scarlet borders. It's the Korial sari, my driver explains, named from *kora* in Hindi, meaning 'blank' (as in 'blank page'), denoting the undyed, pure nature of the centre of the cloth. It's for married women, and it's especially worn at Durga Puja.

You never know exactly when the nine-day Durga festival – celebrated throughout India but with particular enthusiasm in the east – is going to start, because it depends on the moon. But this evening, there's been a sliver of silver in the sky so the floats have taken to the road.

'Assam will be closed for four days,' the driver says. Which is a shame because I only have three. I'd made my decision to go to Assam at short notice and without access to the internet. I'm cross at myself for not planning better. Then I sit back and breathe out. Sometimes when a loom is still you can concentrate better on how the cloth is created. Perhaps in my visit to Assam during holiday time, I'll find a different kind of insight into the story of this special silk.

That night the music goes on until dawn.

The next day the village of Sualkuchi, thirty-five kilometres from Guwahati, is an empty shuttle. On a normal weekday, the place

Minu Kalita weaves muga silk for a wedding sari.

would be full of weavers, the looms would be like an orchestra, playing a symphony of sticks and wires. But today there's just the sound of cows and the murmur of people preparing food and children playing.

And then I hear a solo song. It's coming from upstairs and on another street. I follow the sound, wood against thread against wood, fast, uneven, like a boat tacking hard into the wind. I go through an open door and cross a courtyard and climb some stairs. I follow the sound into a room with six horizontal wooden handlooms in two lines of three. Only one is occupied. A woman in a white sari and a pastel pink blouse is intent on her work. After a while she senses me there. She turns and smiles, beckoning me to sit on the smooth wooden-plank seat of the loom behind hers. Her name is Minu Kalita. She's forty, she speaks little English, and she's been doing this work for seventeen years. She indicates that I should touch the thread.

'Muga,' she says. It's curious, almost oily, and very strong. Initially the colour seems ordinary. You might describe it as Dark Beige,

Tawny Mouse, Garden String, Wet Hay; bland names, brownish ones. Muga can't be dyed, it needs to be its own colour, so this is what it always looks like. I feel disappointed.

Since there is not much else to do in Sualkuchi I stay, watching this brown thread being meshed into cloth to be worn at a wedding. Minu forgets me and gets into the rhythm of her work – right hand flicking a yellow string to make the shuttle fly, left hand battening the new line into the body of it, pausing as she adjusts the weft to make a subtle pattern, right hand flicking again. I feel happy here, watching this calm woman work in the space between the made and the unmade. I reflect how the part of a woven cloth that's the most important is the part we can only see during the weaving process while the cloth is raw and open. Usually when you contemplate a piece of fabric it appears to consist of basically two dimensions. Width and length, not much depth. But if you look with imagination as well as eyes, you can see that connecting the back and the front is a tight fencing of crossing places where the essence of a cloth is found.

I imagine how, if I were very small, I could be lost inside its complexity.

After a while my eyes adjust, and the colour of the muga becomes interesting, even lovely. It becomes dappled and honey and it starts to shine.

Later I find a shop where different samples have been folded into rectangles, and stacked on shelves behind the counter like a library of books. A curator at the British Museum had once bought silk from them, says the manager. 'We are very famous.'

He pulls out what he tells me is 'tassar' silk, from the cocoons of another kind of wild moth. It's paler beige than muga and more like hay. He shows me a picture of the moth, which is extremely beautiful. As big as a hand – a thirteen-centimetre wingspan – it's mostly the rich golden colour of mangoes, but with four polo-mint circles that look almost as if they've been embroidered, and a ribbon three-quarters of the way down the wings in the complementing colours of raspberries and cream. They are collected by tribal families in the forests, he says. Unlike the *Bombyx mori* these moths can actually fly, so after they emerge they're tied to trees to make sure that they don't escape while laying their eggs. He puts the tassar away and pulls out two more pieces.

'Here is eri,' he says, indicating a soft white cloth that's almost

fuzzy. It is named after the Assamese word *era* meaning castor, which, as well as the vile oil I remember being made to drink by the tea-spoon as a child, produces the leaves on which the eri silkworms most happily feed.

'And here is pure muga,' the manager says, pulling out another beige piece.

'Do the woven cloths smell of anything?' I ask. He shrugs.

'I don't know.' He passes them over. The eri and tassar don't seem to, but the muga is strong. Woody. Mushrooms. I try again. Childhood and darkness. Opening an old book that's been waiting for a long time to be read. Nice smells, but ones that seem to come from the past.

A family comes in. Three teenaged daughters in leggings and Western tops; their mother in a red-and-white Korial sari. They're looking for a wedding sari for the eldest, who's nineteen. A good mulberry would be at least fifteen thousand rupees. The muga is any-thing above twenty-seven thousand. It's the equivalent of at least two months' salary for a schoolteacher.

'Of course we want muga,' the mother says. Her daughter rolls her eyes.

You can be strong together

'"Why have you got tassar silk? It should be muga ..." So many young women get married and then disappoint their husband's family because they didn't bring the more expensive muga silk to the household ... It's a real problem,' says Anurita Pathak Hazarika. She's director of the North East Network in Guwahati, a women's organisation operating in Assam, neighbouring Nagaland and elsewhere in the region.

She and her colleague, Dr Monisha Behal, are working over the holiday, though most of the staff are not. I'm lucky. Today, unusually, they each have a little time to talk.

Behal set up the organisation in the 1990s to empower women. And she found that one of the best ways to do this is through cloth: spinning the cloth, and weaving the cloth,* and tending the silkworms

* Traditional Assamese women's gear is called Mekhela Sador. Unlike a sari, which is one piece of cloth, this has two: the *mekhela*, a cylindrical cloth draped around the waist like a long skirt, and the *sador*, which is a rectangular piece, wrapped around the upper part of the body.

with the leaves from mulberry or castor plants raised in their own backyards. The whole making process is about more than money, she says; it's about earning the right to live on your own terms.

One village woman arrived home late after a training course run by a local woman's organisation. 'She brought back silkworms and they were like her babies; she loved them,' Behal says. 'Her husband was angry and told her to give him dinner, but she took a couple of minutes to tend to the silkworms first, whereupon the husband threw the trays of worms and stamped on them, destroying the small creatures.'

'The woman was hysterical and screamed in disbelief. The husband hit her, while hurling abuse about her work.'

Normally there would be no recourse. Men have the power. 'The women we work with in certain parts of Assam can be targeted as witches. They can be sexually abused, they can be murdered, they can be cast out.' But in this case the other women in the cooperative remembered what they had learned in the training about how strong you can be together.

'They went to see the husband. "We've come to talk to you," they said. "First, you raised your hand against one of us. And secondly, you destroyed the worms and they were not your property. They were the property of our organisation and you must pay us for them".'

The man was taken aback. He paid, and he stopped hitting his wife, at least for a while.

'This was empowering for all of us,' Behal says. Her organisation has done studies on violence-related issues against women throughout India: it comes in several forms – social, economic and emotional.

'Seventy-two per cent of women face violence in Guwahati; this was one time it stopped.'

Like a magical being crossing the road

I was sad not to see wild silk moths during my visit to Assam. Even had I been allowed to visit – traditionally women and strangers are banned from seeing the rearing process – the wild silk farms were closed for the festival. But one day two years later, near Hangzhou in China, I was visiting a series of grottoes where Buddha figures were carved into the walls. It's called Feilai Feng, 'The Peak that Flew Here', because it's so different from the rest of the local geology that

it's said – like Buddhism itself – to have been picked up from India and carried to China.

As we walked from one cave to the next, a strange creature crossed the footpath in front of us. We stopped and gasped and so did several Chinese families. Children looked up from their phones and exclaimed in wonder. We followed it, all of us: we almost couldn't help it. It looked like a butterfly but was the size and heft of a paperback. It was stately as it flew, almost lazily, flapping its wings from the spine. When it settled on a branch, it seemed to weigh it down. It was huge, with kohl eyes on its red-brown wings and it seemed like a magical being. We all watched it, feeling we were seeing something special. I didn't think I'd find a connection to this book; I was just caught up in the mesmerising strangeness of it. But something was familiar.

That evening I looked back at the photos I'd taken at the National Silk Museum two days before. And there it was. The magical being was the eri moth, *Samia ricini*, which can be found right across the warmer latitudes of Asia, eating the leaves of the castor tree. In India its silk is sometimes called *ahimsa* silk – from the Sanskrit for 'against harm' – because the moth isn't killed for its thread but is allowed to break free from the cocoon, leaving a floss that can be spun into the white yarn that I'd seen in the shop in Assam. It's seen as the cloth of poorer people because it doesn't shine. But it is very, very soft.

Silk squares, magic, and the secret of clothes

'Empires arise from chaos and empires collapse back into chaos', begins the great fourteenth-century Chinese novel *Romance of the Three Kingdoms*. But something stays, and the thing that stays is change. In 1644 – while women in Assam were still forced by law to weave silk, and around the time when Virginia Ferrar began her experiments with silkworms – China's Ming Dynasty crumbled. The new rulers were nomads from Manchuria who named themselves the Qing or 'Pure'. Chinese history is packed with nomadic conquerors whose children had assimilated within a couple of generations, so the new rulers took immediate steps to keep their own culture intact in this new country. One of the first things to be regulated was court dress.

The Ming had worn long flowing robes, which were fine if you didn't move much but no good if you might have to jump onto a horse

without notice. Now the Qing required the adoption of court dress – trousers, boots and side-fastening *chaofu* riding jackets – to remind everyone (including their own children and grandchildren) of the dynasty's nomadic origins, while also showing their authority over the Chinese by forcing them to wear their conquerors' style of clothing.

In addition, whenever court wardrobes were redesigned the silk industry boomed, bringing new taxes, so there was a financial justification too.

The Qing had a different relationship with silk from their predecessors. As the descendants of nomads who had grown rich on silk tribute from China, they prized it, wanted it, paraded it. It was symbolic of wealth and of pride. They wore it in new ways, and they used its patterns on porcelain, and they put porcelain patterns upon it.

Emperors came to have exclusive rights to wear yellow silk. Minor princes wore pure blue – the Qing official colour – and blue-black indicated a civil servant.

The Qing inherited the Ming system of civil service examinations, which meant that any man from any background could wear that precious blue-black silk if he had a good enough memory and enough time to memorise. They also inherited the Ming system of marking your rank with a mandarin square, a badge of embroidered silk on your chest and back: a bird if you were a civil servant and an animal if you were in the army. Qiu Xun, an official during the Ming period, had a theory about the division: birds could fly to heaven while animals were destined to stay on the ground. It proved – to him at least – that mandarins were superior to army officers. Needless to say, Qiu was a civil servant.

Meanwhile, for semi-official occasions Manchu men and women wore 'auspicious' or 'dragon' robes, that they called *jifu* or *long pao*.

It seems impossible for a piece of clothing to be a diagram of the visible universe. Yet this is what the *long pao* were.

When I first arrived in Hong Kong in 1991, I often went to Hollywood Road, the street of antiques. I was fascinated by the dusty shops full of treasures: broken carvings of fourth-century Buddhas, with the folds of their robes inspired by ancient Greek statues; tiny silk 'lotus' shoes for women whose feet had been broken and bound when they were children; caps decorated with tigers worn by infants to protect them from harm. One afternoon I pushed open the door of a shop I hadn't visited before. On the wall was a *long pao* robe in

Wearing these robes was believed to bestow power, like a physical
force. This one was woven in the nineteenth century.

yellow silk. 'It's just come in from China. I'll show you,' said a man
emerging from a noisy mah-jong game at the back of the shop. 'I'll
tell you the pictures and I'll tell you the secret.'

At the base were multicoloured *lishui** – or 'mountain-like
waves' – representing the universal ocean. Emerging from it were
four mountains looking like skyscrapers or phallic symbols or the
strongholds of Sauron in Tolkien's *Lord of the Rings*. They were evenly
spaced around the base and represented the four cardinal points.
Above them, and making up the bulk of the robe, was the firma-
ment, patterned with dragons, and this was the area that represented
the Mandate of Heaven – something that every dynasty in China was
wise to pay attention to.

An ordinary high official would have eight dragons, each with
four claws; an emperor or empress would have eight five-clawed
dragons on display and a ninth hidden inside. 'This one's an emperor

* *Lishui* can be translated as 'standing (or upright) water'. On robes it's shown as
billowing, froth-capped waves crashing against tall, phallic rocks, representing the
wide, water strength of yin, the female power, in constant traction with the narrow,
rock strength of yang, the male. The motif was ever popular on bridal clothes.

one,' the shopkeeper told me, showing me the last dragon behind the front flap of the robe.

'Is that the secret?' I asked.

'No,' he said. 'The secret is better than that.'

This was a power robe, he said. Not just because it symbolised power but because it was believed to actually bestow power, like a physical force. 'It's like electricity. You have to switch it on.'

The way you did that was to wear it. When someone puts on the *long pao,* his or her body becomes the missing axis at the centre. It links earth with heaven – closing the circuit between the material world and the world beyond.

'And it's even better than that,' he said, explaining that by putting the robe on and facing north you were making sure that the mountain at the base of the robe would click into its assigned cardinal direction. By doing that, the emperor would effectively be switching on the power of the universe.

There were twelve auspicious signs on a Qing emperor's silk robes. Dots of grain gave sustenance. Waterweed, purity. A pheasant, lightness. Mountains gave stability. A moon (with a hare inside it), immortality. A double archery bow gave justice. Fire gave light and heat, dragons adaptability, and the sun (with a three-legged crow) the source of life. Three stars provided illumination, and an axe the ability to tell the difference between right and wrong. And bronze sacrificial cups engraved with tigers symbolised courage.

You can look for them on any imperial dragon robe and they'll probably be there. And when you find them, you could see them as a checklist of helpful attributes and have the fun of hunting for them in the brocade. But you could also use them, as shamans used to use them, in spiritual practice, repeating the list in your head as a series of mantras, to guide you in how to live your life both wisely and magically.

And this is why I have never forgotten that unexpected guided tour of that old robe on Hollywood Road one afternoon thirty years ago. Because at the Qing Imperial Court, as in many places and times (though not our own), clothing was not just about fashion or display or prestige or practicality or even rank. It was, sometimes, about achieving an actual connection, through material, to a world beyond the material.

On that day I learned this for the first time.

Money made from silk

The robe I saw would have been woven at one of the three Imperial Weaving Factories – Jiangning (today's Nanjing), Hangzhou or Suzhou – all now within a couple of hours by fast train from Shanghai. Two hundred years ago the weaving factories were cities in their own rights, employing hundreds of thousands of people. The Jiangning Imperial Textile Workshop (although much diminished) is still standing, now a museum.

Imperial silk has been woven on that site since at least 1280 when Emperor Kublai Khan set up a silk bureau there. Silk was particularly important to Kublai, whose Yuan Dynasty had descended from nomadic tribal coalitions. The world's first bank note was issued during his reign. It was made of paper but was backed by deposits of silk. It was called the *sichao*. The 'silk note'.

His Jiangning workshop specialised in an extraordinarily complex weave called *yunjin*, or 'cloud-pattern brocade', because the shapes it depicted were as various as clouds in the sky. If you have to weave cloth into something resembling a tapestry without taking the years required by a Kashmiri shawl, you are going to need complex and varied sets of sheds – the spaces in the warp through which the various colours of the weft will pass. And at every shot, or pass of the weft, you will need the sheds to shift in complicated ways. The most obvious way to do it is to divide the labour. Assign one person to weave and beat the weft into place, and another to sit high up in the body of the loom and use cords to raise batches of warp threads as the pattern demands. When the technology for this arrived in Europe from China in the Middle Ages, it was called a 'drawboy' or 'dobby', because the person on the top was usually a boy – someone who was light enough to climb up to the top seat, alert enough to pay attention when he was up there, and junior enough to take orders.

Two-person dobby looms are rare now, and it's even rarer to see them in action. But when I visit the Jiangning Imperial Silk Manufacturing Museum, there is one – and it's in use. I can hear it before I see it. It sounds like the branches of trees whipping as a storm picks up.

The weaver at the base of the loom is in charge. In front of her are the silk warp threads, which are red and strong and will be hidden in the final weft-faced cloth. Also in front of her are about twenty bobbins charged with differently coloured threads. A complicated shed of red warp ends is raised and held in place by a thick wooden batten.

With fast, deft movements, she chooses one bobbin after another and pushes it through one or more warp threads at a time; they click like mah-jong pieces before she battens the new shot into place. It's so fast that I can scarcely see what she's doing. Meanwhile her feet are operating a dozen or more bamboo pedals. She can't see the front of the cloth as she weaves, she just has to look at the tumble of multi-coloured satin on the back and trust that it's right.

At the top, like a lookout in the crow's nest of a ship, a second woman is perched on a plank some three metres above the ground. She's deep in the rigging with her feet resting on a thick piece of scaffolding bamboo, surrounded by scraps of white cloth like torn sails, and what seems to be a grand confusion of cords. They look like a huge muddle, though I know that they are in fact meticulously organised, and that keeping them in order is the work this weaver has been trained to do. Every few minutes she makes some adjustments and pulls a combination of them towards her. The process is called *pang hua*, pulling the flowers. It's a physical job; she has to be strong. Beside her is a jar from which she sips green tea whenever the coloured bobbins are being flicked into place by her colleague, giving her a few seconds of rest.

The cords are linked, via heddle frames, to thin bamboo sticks at the base of the loom. The bamboos sound like ceramic beads in a wooden shaker, or the shimmer of Chinese fortune sticks when you haven't yet made the decision to start coaxing one out of its pot. It's a deliberate sound, constant but yet not quite focused, as if allowing a space for new things to happen, for the emergence of a new cloth, as yet unwoven. There are weights beneath the warp, to make sure that the heddles fall back down when they are released. Most are wrapped in newspaper and tied up with string. One is a heavy padlock, shiny as if it's new. The two women talk constantly, lightly, giving and taking instructions on the combinations of sticks and threads. Underneath, and upside down, a rainbow of *lishui* waves is slowly appearing, to make something resembling the base of a *long pao* dragon robe.

In Qing Dynasty China, this kind of fabric was only for the super-rich. However, the super-rich liked it very much, and it confirmed their status. Also, there was plenty of skilled labour, and the workers needed to be employed: finding a mechanical alternative for the dobby was not very pressing, perhaps not even desirable. But as the eighteenth century dawned and Europe industrialised, just about

At the top, like a lookout in a crow's nest, a second weaver is perched.

every inventor in Europe was trying to work out how to replace the weaver at the top. If you could do that it would surely cut the cost of brocade-making in half. And speed up the process at the same time.

Mechanical ducks

In 1727, a visitor taking dinner at the friary of the Order of the Minims in Lyon was amazed to be served at table not by monks or servants but by machines. The inventor was an eighteen-year-old novice, Jacques de Vaucanson, who had made the automatons for the amusement of his fellows. The visitor was a senior friar; he later ordered the robot waiters destroyed. The order of the Minims (or 'Minimi') had been named for the minimal simplicity of the godliness they aspired to, and he believed that there was something neither quite simple nor quite godly about machines that could wait upon them, and also do the washing-up.

The boy who loved machines was undeterred, although he gave up his vocation as a monk soon after. His later inventions included a model flautist that could play twelve tunes on a real flute and a mechanical duck that ate, drank, paddled and even appeared to poo. At Versailles, Louis XV loved the duck, and in 1741 he gave Vaucanson

the job of Inspector of Silk Manufacture in Lyon, with the goal of casting his eye over the machinery and seeing what could be done to speed things up and make fine French silks cheaper. There had been advances in Italy and England in mechanising the 'throwing' of silk, the process of twisting and doubling the single silk fibres to make a usable warp thread.*

Fashions in textiles too had changed dramatically in the previous half century; and all in all the looms were not keeping up.

When the silk makers became refugees

In 1685, Louis XIV had revoked a law that had previously protected the Protestant population of France. Almost overnight many of the country's textile makers – calico printers, silk weavers, lacemakers, worsted weavers and their families – were fleeing for their lives. Many of these weavers found new homes in the Protestant-friendly areas of the Netherlands, England and Prussia, which generally saw their arrival as a good thing and instituted special funds and bounties to allow them to quickly establish their textile workshops in their new homelands. They became known as Huguenots. Some say the name derives from the Dutch/Flemish term *Huis Genooten*, 'house fellows', describing how they would gather at each other's homes to study the Bible in secret. Another theory claims that it's from the German *Eidgenossen* meaning confederate, or 'oath participant'. Yet another has it that they took the name from a ghost, known as King Hugon, who was said to haunt the French city of Tours late at night (which is when the Calvinists held their assemblies). But whatever the origin of their name, wherever they went in Europe, the Huguenot communities transformed the way textiles were made, and imagined.

In London, many French Protestant silk weavers settled in Spitalfields, just outside the City walls. Property was cheap; it had been a centre for the clothing trade since the Middle Ages; and there were

* In 1717, an Englishman, John Lombe, allegedly bribed the workers at an Italian silk-throwing mill to let him see the machinery. When discovered, he fled, along with two Italians who helped him set up a mill in Derby. It had 468 windows and was 500 feet long, and was by all accounts a wretched place for the workers. Although Lombe couldn't match the quality of Italian silk, he successfully undercut the price. Within a few years he was dead, supposedly poisoned by a female assassin, sent over from Italy.

Huguenot churches already, built by Protestants fleeing earlier persecutions in the 1570s. It was ideal.

Some of the houses built by the new arrivals are still standing, with their unmistakeable high lattice-like windows, designed to allow as much light as possible to fall on the looms beside them. The weavers' main hobbies were keeping songbirds and holding competitions on who could cultivate the best auriculas, little round Alpine flowers like colourful candies. This was a time when the word 'florist' denoted a hobbyist flower grower, and the weavers were champions at it. The silk weavers met in pubs with names like the Three Jolly Weavers, the Crown and Shuttle, the Weavers' Arms and The Mulberry Tree,* examining, with serious expressions, tiny, frilled flowers, competing to make the cultivars more and more 'perfect'.† It drove the newly styled botanists mad. They considered themselves scientists, classifying plants according to how nature made them. The florists, in contrast – holding a (fairly arbitrary) sense of what makes a perfect flower – constantly tried to improve on nature. The difference between the two is a microcosm of the divergent strains of thought expressed in Europe as the new century dawned. It was also reflected in what was happening to the design of fabrics.

The baroque weavers of the seventeenth century had planned their designs around ideals of nature. That usually meant two or three colours, simple repeats, and idealised shapes of flowers and leaves: the woven equivalent of a flower competition. By the eighteenth century, however, fabric fashion had begun to reflect the new interest in scientific investigation. It became about trying to reflect nature as it *really* is; no longer trying to reduce it to any kind of essence, but presenting its infinite variations by looking at it carefully, from the outside.

In part, the ability to translate this change of philosophy into fabric design was due to a painter, and son of a painter, who had arrived in Lyon in around 1710. After apparently being the first textile

* Of these, only the Crown and Shuttle in Shoreditch High Street is still standing.
† Thanks to the silk weavers' passion for flower cultivation, a key element of flower structure was for a long time described by naturalists in silk terms. Where stigmas were higher than petals the flowers were 'pin-eyed'. If shorter (which was thought more beautiful) they were 'thrum-eyed', after the word for the unwoven ends of the warp threads when a cloth is removed from the loom. Later, when Charles Darwin was using the distinction between pin and thrum to observe how flowers cross-fertilised, he misheard, and initially referred to it as 'thumb-eyed'.

designer to put a shadow on one side of an image to make it appear more real, Jean Revel had then set to the task of making the coloured threads seem to blend with each other, like paints on a canvas. His initial problem (and this is forever the theme of silk) was in controlling the place of metamorphosis. In traditional weaving, when you change one weft colour for another there is a point where the colour changes abruptly. It might have been blue at the previous warp thread, but now it's green. Or red or black. Or a different shade of blue. No gradation. But if you're going to try to make a textile appear like a painting, Revel realised, you need to be able to shade.

One solution involved making small horizontal cuts in the weft, which became known as *points rentrés*, or tucked-in stitches. It meant that at the point of intersection, one colour could half become the next and the effect was subtle and realistic, like hatching in drawing or engraving, or the blending of oil paints. Revel had spent his boyhood near the Gobelins Royal Tapestry Factory near Paris, and it's not surprising that he adopted some of the same effects. Sydney's Powerhouse Museum has a brocade in a quince pattern attributed to Revel's workshop. Up close you can see the subtle shading between one rose pink and the next slightly paler shade, almost embroidered into each other, so slight is the join. From a distance the picture seems excessive, too lush, as if something about the essential nature of the fabric has been lost in the detail. But at the time this so-called rococo style was in high fashion, and Revel soon became known and celebrated as the 'Raphael of Fabric' for the realism he brought to textiles.

However, his designs had made fabric making really slow again. It meant, once more, that the looms had to change.

How the weavers began to speed up

When Jacques Vaucanson arrived in Lyon in 1741 to take up his new post as Inspector of Silk Manufacture he would have had all this history in mind. The Chinese dobby loom had evolved since arriving in France a hundred and forty years earlier, and now allowed the assistant to stand beside the loom controlling the sheds rather than looking down at the master weaver's head. And other inventors had already added further refinements.

One of the issues of fabric design has always been about the repeat of patterns. It takes a great deal of time to do it by hand,

and if you lose concentration there'll be mistakes, which are time-consuming and difficult for a weaver to correct. But what if the loom can remember on its own?

The first person to successfully put his mind to this had been Basile Bouchon in around 1725. Bouchon was a weaver and the son of an organ maker – not big church organs but the kind of portable easy-to-play barrel organs that buskers had been playing on the streets of northern Europe since at least the fifteenth century. The organ-grinder turns a cylinder studded with pins of different lengths. Each pin opens one of a series of pipes for a certain length of time, allowing a note to play. What struck Bouchon was how he had seen writers of a piece of music draft the placing of the pins onto a piece of paper before it was transferred onto metal. He had the idea of adding a mechanism to his loom that rotated a roll of hand-perforated paper around a cylinder. Instead of opening pipes, this loom paper would meet a series of rods, each connected to a different warp thread, and held within a wooden 'selecting' box.

Each time you make a shed for the shuttle to pass through, each warp thread either rises up (to be the top of the tunnel) or it doesn't (to stay as the base).

With Bouchon's invention, each rod pushed onto the paper would either meet a hole (in which case it would pass through and nothing would happen) or it would meet paper, in which case a mechanism would move the warp thread to make the shed. No. Yes. Zero. One. The binary system of the loom had been set onto paper.

Paper tore too easily, however, and soon Bouchon's colleague Jean-Baptiste Falcon had replaced it with a chain of cardboard punch cards. When Falcon later invented a 'reading machine' to perforate the cards, it meant that the same design could be sold to several workshops – so one type of brocade could be launched right across the city, and the Lyon ateliers could respond to changes in demand more swiftly.

But an assistant was still required. And that's where Vaucanson's experience with automata would come in.

The marvel of the macro

A year after I started at Reuters as a management trainee, I was given the assignment of going into a stock control department to see why it was so slow. It was like being a spy. I didn't like it much, but I agreed.

When I arrived, the office was full of bored clerks inputting data into spreadsheets, each of which required a thousand or more keystrokes. I was given a desk and set to work.

'Isn't there a macro for this?' I asked at the end of the second day. The computers were primitive – green letters, black screens – but there had to be a way of programming the keystrokes to be done automatically.

'No,' I was told. But when I phoned the software company in the US they sent a user manual by courier and I learned how to create a macro. I could press a few keys and the computer would build a spreadsheet while I went for a walk or read a newspaper (or, as I realised the implications, worried about the future of my new colleagues). But it still wasn't completely right. Someone still had to be there every half hour or so to pick up the new data and press the keys again. What was needed was a macro to set off the macro. And that, in a way, was what was needed for the drawloom in Europe in the mid-eighteenth century.

Like the stock control department in Reuters in 1989 it was, regrettably, going to involve losing jobs; although, as things became more efficient, it would also generate new ones.

Within three years of his arrival in Lyon, Vaucanson had overhauled Bouchon's binary machine, which included putting a drum at the top of the loom, instead of the cards, and also working out how to rotate it using water power. The mechanism was complicated. But it didn't need a second weaver. Vaucanson had invented the macro to change the macro.

As soon as they realised how many jobs would be lost, the silk workers in Lyon rioted and the government moved quickly. Workers were banned from gathering in groups of five or more; some were arrested. One rioter who specialised in crocheting was condemned to stand in the centre of town wearing only a shirt and a sign around his neck saying 'seditious crochet worker'.

Vaucanson had stones thrown at him and by November 1745 he had responded by building a loom worked by a donkey. He wanted to prove that 'a horse, an ox or a donkey can make better cloth than the very best silk-workers'.*

In the end, the silk workers won, at least for their generation and that of their children. Vaucanson left for Paris and his loom never went into production. When he died in 1782, he left all his prototypes

* 'un cheval, un boeuf ou un âne font des étoffes bien plus belles et bien plus parfaits que les meilleurs metiers.'

to the Crown. After the Revolution of 1789, they came into the posses-
sion of the Republic, which meant that after years of being forgotten
in storage they would end up on display at the Conservatory of Arts
and Trades in Paris.

Every civil servant must wear silk

After 1789, the national economy tumbled by 40 per cent, and the
demand for fine silk sank close to nil. Before the Revolution it had
taken some twelve thousand Lyon weavers to dress the people, cur-
tains and sofas of Europe. Afterwards, most of those twelve thousand
were out of work, and many of them were starving. In 1802, Premier
Consul Napoleon Bonaparte visited the city with his wife Joséphine.
They toured some of the silk workshops and saw the hardships of
the people, and Napoleon later made an order for thirty kilometres
of fabric. He believed that the new empire should dazzle and amaze,
electrify and overwhelm. And he also knew that hungry workers
could cause a great deal of trouble.

'I am afraid of these insurrections based on lack of bread,' he
would say to his first Minister of the Interior, the chemist Jean-
Antoine Chaptal. 'I would be less afraid of a battle of 200,000 men.'

Napoleon issued an order that every person working for the
French government should wear clean and fine clothes. They should
dress in new silk from France only, and they needed to change their
clothes often. He himself adopted for a while a scarlet taffeta* coat
embroidered with gold thread, which was widely known as *l'habit
rouge*, the red garment. Monsieur Levacher, Joséphine's silk mercer,
had shown Napoleon the coat and urged him to revive the prosperity
of Lyon by making it fashionable again to wear shiny clothes, after
the austerity of the first decade of the Republic. 'I will not deny',
Napoleon remarked privately, 'that I have some repugnance to equip
myself in this fantastic costume ...' But equip himself he did, and for
this and for all the money he sent in its direction, he won the love of
the city.

Napoleon encouraged those women who could afford it to follow
his example and to understand that feeling preposterous wasn't a

* Taffeta is an expensive, glossy, tabby silk. The word comes from medieval Latin
taffata and originally from the Persian *tāftan*, meaning shine.

good enough reason not to buy French silk. 'I do not like to see you in those English muslins, which are sold at the price of their weight in gold,' he told them. 'Wear leno [gauze], cambric, and silk, and then my manufactures will flourish.'

Those were times when France was at war with just about every other country in Europe, and when there were rewards for those who could devise machines that would allow France to compete with industries emerging overseas. They were just the right kind of times for an impoverished former maker of straw hats to see an old invention on display at the Conservatory of Arts and Trades and be inspired to make something that would change the future of patterned textiles.

A dusty machine in a corner

Joseph-Marie Charles was the son of a Lyon weaver. His mother, a pattern reader* in the workshop, had died eight days after his tenth birthday. He had continued to help his father, pulling the threads as the drawboy, inheriting the business when he was twenty, in 1772, after his father died. Unusually for the time, he had learned to read and do accounting from his sister's husband, who was a bookseller. However, he had later made some bad decisions and had fallen into debt, eventually losing the workshop. He was forced to take various odd jobs, including joining his wife as a day worker in a straw-hat factory.

But post-Revolutionary France was a new world, where ordinary people with good ideas could sometimes rise to great heights, and after a while he picked himself up, looked at his own strengths, and started again. In 1801, he entered a new kind of treadle loom into the Exposition in Paris. It attracted a bronze medal, though it didn't bring him the financial reward that he dreamed of – the weavers smashed it.

He had started working on another idea, this time for a loom to weave fishing nets (if France's new regime didn't appear to need silk then it certainly needed fish) when one day he saw Vaucanson's old loom mechanism in a corner of the Conservatory of Arts and Trades.

* For complicated brocade designs it was helpful to have someone reading out instructions about what threads should be picked up and which dropped, and which colour wefts should be inserted on each pick, not unlike the *ustad* with the *talim* in the making of Kashmir shawls.

It didn't have any instructions, and nobody had been able to work it out. But it gave him an idea. If he could combine Vaucanson's automated punch cards with some further improvements that Falcon had gone on to make in the 1740s ... Well, in that case it might just work. And it did.

With one foot movement from the weaver, the loom could now read the pattern card, open the pattern shed, revolve the cylinder to put the next card in position, close the pattern shed, then align the card in preparation for the next shoot of the shuttle. Easy. Or at least easier.*

It is perhaps right that the man remembered for an invention he had largely appropriated from other people should be remembered by a name also largely appropriated from someone else. Charles's father Jean came from a large family with many branches, and his became known, using the suffix '-ard', as Jack's branch. Or Jacquard.

Later, after improvements by other inventors in the 1810s, the Jacquard loom attachment would change the making of complex fabrics forever. And it would make its named inventor rich.

Even before the Revolution, France had introduced a system of rewarding intellectual property that contributed to the common good. Artisans were expected to share their inventions rather than keep them to themselves. However, to make sure that invention was rewarded, the government ran a bounty fund that paid in relation to the usefulness of the invention. In 1806, Napoleon arranged for Jacquard to receive a lifelong pension of three thousand francs a year and also a royalty of fifty francs per machine sold for the next five years. By 1811, there were eleven thousand Jacquard loom attachments in France, which (if everyone paid) would have produced more than half a million francs in royalties.

And although today the punch cards have largely been replaced by computers, the binary interrogation of each warp end has remained more or less unchanged. And the connection with computers is more intimate than that: in the one-or-zero choice made for each bit of software, computers are simply the latest inheritors of the binary workings of the Jacquard loom, adapted from Bouchon's inspiration.

* Even with the new invention, pattern looms were slow. In 1960, the textiles at the Palace of Versailles were restored, with all the fabrics made in Lyon using handlooms with Jacquard attachments. It took twenty-three years, and every weaver assigned to the project managed less than two centimetres per day.

You could also argue that this simple kind of inquiry (yes-or-no? up-or-down? one-or-zero?) – asked over and over again to create something greater than the sum of its parts – has been with us for a very long time. Ever since someone invented the first loom.

The other Silk Road

Despite being at the forefront of technological advances, the French silk industry still relied on Italy. The strong, twisted warp yarns from Piedmont were the best in the world, and French weavers needed them. They were called 'organzines', after the oasis city of Urgench on the border of Turkmenistan and Uzbekistan, formerly one of the most important sites on the Silk Road.

In the eighteenth century, organzine could travel to Lyon from Piedmont by ship, but that was expensive. It involved going south overland to Nice or Genoa, by ship to the mouth of the Rhône, then up to Lyon with plenty of loading and unloading and people to pay at each point. The simplest and fastest way was across the mountains, over the Mont Cenis pass, through the narrow Saint-Jean-de-Maurienne valley and then past Chambéry to Lyon. Today this is skiing country – Saint-Jean-de-Maurienne lies between the resorts of Le Corbier and Valmorel – but in those days there was only one legal cash business for the locals: the transportation of silk.

There was always the threat of bandits, though with France's army on one side and Savoy's on the other, most cargoes got through safely. The main problem was logistics. At times, the route contracted into tracks so steep that the silk had to be removed from the mules, repacked into smaller bundles and carried for several miles by porters. This created bottlenecks and it also meant that the silk was vulnerable. It could be crushed, or switched for something cheaper. The weather, too, was a worry. Silk retains moisture, so too much rain during the repacking could (until the 1841 invention of an adequate desiccating machine)* play havoc in a system that sold this valuable commodity by weight.

* In 1841 Léon Talabot, designer of the heating and ventilation system for Lyon's Grand Theatre, was commissioned to solve the problem of inconsistent humidity in silk batches. Within three months he had produced the first Étuve Talabot (Talabot Stove), and then spent the next ten years improving it. Early models were waist-high cylinders, decorated with paintings representing Lyon, the

The logistics were managed by freight-forwarding companies, of which Bonafous, Bourg et Cie was the most prominent. They had originally been Huguenots, but like many Protestants who had stayed in France after 1689, the Bonafous family had converted to Catholicism and found alternative, less prominent sources of income, in their case making cheap wadding in a remote Alpine valley. They were fortunate to have chosen the valley through which the French-Italian 'silk road' passed and by 1760, they were doing well in the silk-shipping business. Later they added a postal system, and later still, at the end of the eighteenth century under Franklin Bonafous, they'd begun the spectacularly expensive initiative of transforming the old trails into roads that would be open to transport silk and other goods and passengers through most of the year. Between 1803 and 1810 Napoleon set three thousand men to the task of building a crossing on Mont Cenis, including building great bridges and cuttings, and for the winter season a rapid eight-kilometre descent, traversable in seven minutes on a sledge capable of supporting a carriage.

It was one of the great early road transport revolutions of Europe.

When Franklin died in 1812, his eldest son, nineteen-year-old Matthieu, went to Piedmont. He was more interested in science than business, however, and as soon as the family realised this, his half-brothers were despatched to take charge of the shipping and Matthieu was allowed to have the ideas. One was to set up an agricultural research station in the valley of Saint-Jean-de-Maurienne to find new crops that could provide livelihoods for the many porters, guides, mule-men and their families who had lost their income thanks to his father's new road. Another was to raise pashmina goats and Merino sheep to boost the French wool industry. But Matthieu's main interest was improvements in silk. He funded a translation of a Japanese book on sericulture, which had been smuggled out of the Dutch trading port of Deshima. He also became a leading expert on the mulberry.

cultivation of silkworms in China, or similar motifs. Silk samples were put into a wire basket, the lid was closed and a stream of warm air blown in. This desiccated the silk to indicate the absolute weight. But because fully dried silk is fragile, and not so nice to touch, 11 per cent of humidity (the maximum decreed by French Royal Order) was added back in. This meant that silk batches could be bought by weight, with confidence.

In 1821 the Swiss naturalist Guerrard Samuel Perrottet sent him a new kind of mulberry tree from the Philippines. He called it *Morus fil-ipinii*, though Bonafous preferred *Morus cuculatta* to reflect the hood shape of its leaves.* In the end it would be remembered as *Morus multicaulis*, 'caulis' as in cauliflower, because as well as its 'monstrous size' it had an unusually large number of stalks and therefore an unu-sually large number of leaves.

If you're in the silkworm business your relationship with the mul-berry tree depends on a few simple questions. Do the silkworms like it? Does it grow easily in your climate? How many leaves can you get from each tree to feed your worms?

Multicaulis looked promising on all three fronts. But Bonafous and his colleagues were cautious. It needed more testing to see how good it would be for silkworms.

The first *multicaulis* from France landed in America in 1826. Within thirteen years fortunes would be won and lost. But mostly lost. It would be a national disaster. This is what happened.

How to start a financial bubble

America had never been successful with sericulture, despite efforts by Virginia Ferrar and others. The arrival of the first *multicaulis* saplings in 1826 had therefore attracted little attention.

By 1835 it was hard to find anybody very interested in them. Then a nurseryman on Long Island, finding himself with stock he couldn't shift, had an idea. In a devious plan, which he later described in some detail to a reporter (on condition of anonymity), he took a boat to Rhode Island, about a hundred miles away to the east and north, and at the first nursery he came to in Newport he asked, in a deliberate tone of excitement, whether they had any *multicaulis*.

'A few,' was the reply.

His strategy was then to offer fifty cents apiece – more than twice the market price – and, as he suspected, in every case the offer was rejected. Surely, the logic was, if this incomer was willing to pay such a high price, it must be because he knew something.

The man from Long Island visited every nursery in Newport, Providence, Worcester, Boston, Springfield and Northampton over

* From Latin *cucullus* from which we get 'cowl' meaning a monk's hood.

the next few days, each time adopting that same voice and each time getting that same answer.

'I came back without any trees,' he said. 'But you could not have bought *multicaulis* trees, in any of the towns I had visited, for a dollar apiece, although a week before they would have been fully satisfied to have obtained twenty-five cents.'

Over the next four years the price of the silk trees soared. Men and women alike 'seemed to be affected with a strange frenzy'. By spring 1839 Dr Daniel Stebbins – the first person in America to import silkworm eggs directly from China – was seen rejoicing over a dozen *multicaulis* cuttings. He'd bought them for twenty-five dollars apiece. He was convinced they were worth sixty.

The trouble was that however many leaves and branches it might have, a mulberry tree can only be converted into so much raw silk. Above a certain price the only way to profit from a tree is from selling it on. Pushing up the pressure was a financial crisis – the so-called 'Panic of 1837'. It had been sparked initially by cheap credit causing people to buy more and more land to grow more and more cotton, which eventually led to too much cotton. Cotton and land prices fell, ramped up by other ruinous speculations in timber and China tea. Like gamblers emerging bleary-eyed from casinos at dawn, investors were desperate to get their money back and many plunged headlong into *multicaulis*.

Even the original nurseryman was caught up in the excitement, although of everyone, he was the one who knew best that the price had only risen through an act of dissimulation. In early 1839 he sent an agent to France with eighty thousand dollars to buy 'a million or more' *multicaulis*. By the time the ship returned at year end the bubble had burst. He tried to offer his saplings to farmers at a dollar a hundred 'for pea brush'. But no one was interested. He couldn't give them away.

Another band of speculators, seeing the crash on the east coast, chartered an ancient vessel that looked as if it would sink at the first wave, filled it with *multicaulis*, insured it at a high price, and sent the cargo by way of New Orleans to Indiana, along the Mississippi. To their disappointment the ramshackle vessel reached New Orleans. And by the time the trees reached Indiana nobody would even accept them as gifts.

The losses throughout the country were so devastating that although by the end of the nineteenth century the silk industry would

be important in the United States, employing a million people, the country would never be a big player in sericulture. And this wariness would be important for what happened next.

A scattering of pepper

In 1849, a few silk farmers in southern France noticed black dots on some of their worms. They looked like they had been dusted with pepper, so the disease they were suffering from quickly became known as pébrine, after the Provençal *pebrino*, meaning pepper. Worms who had it ate little and grew slowly, and if they survived long enough to make a cocoon the silk was sickly, brittle, unreliable. Initially, the farmers sourced the eggs from elsewhere – Italy first, then Greece and Turkey, then Syria and the Caucasus, but each time, after a few seasons, the batches became infected.

The pébrine changed everything. There's a saying that when a butterfly flaps its wings the world changes, but when a furry moth first laid her flawed eggs in France, the world shifted its course in ways that were at first subtle and then not subtle at all. The black spots would bring great changes in the world's technology, its shipping, its balance of trade and its medicine. They would lead to the discovery of vaccines against infectious diseases, to new kinds of fabric, and to the rapid militarisation and growth of Japan. They would alter the course of the Second World War. They would lead to many saved lives and to many deaths.

Louis Pasteur finds a solution

When he was young, the would-be scientist Louis Pasteur had written to the great chemist Professor Jean-Baptiste-André Dumas, asking if he could become his teaching assistant.* That appointment had started his career. Now Dumas – who had been born at Alès in the south of France, and who could see the suffering the pepper disease was causing to farmers in that region – called in the favour. He wanted his former student to address pébrine. Pasteur, busy with his research into fermentation at the École Normale in Paris, had his qualms.

* Dumas used to attract crowds of seven hundred or more students to his lectures at the Sorbonne: Pasteur once said he could 'set fire to the soul'.

'Consider,' he protested. 'I have never handled a silkworm.'

'So much the better,' answered Dumas. 'If you don't know anything about the subject then you'll only have ideas that come from your own observations.'

Pasteur's own observations were complicated by what he soon realised was a second silk disease, which he named *flacherie* because it made the worms weak and flaccid. Once he'd separated the two, he realised that pébrine could be detected under the microscope as oval corpuscles in the blood of the female moth. He also realised that silkworms could either inherit the sickness from their mother or be infected by other worms. Pasteur devised a method to stop both kinds of transmission. It relied on keeping the females separate from each other, so if one was sick then only its eggs (and no others) had to be destroyed. It took two more years before he could persuade farmers to adopt it.

Here is the Pasteur system, in six basic steps.

1. Determine the sex of the chrysalis by weighing the cocoon. The females are heavier.
2. Place a male and a female together under a cone on a leaf so they can mate.
3. Several hours after the mating separate the moths and keep the female under the cone until she lays her eggs.
4. If left alone, she might live a few more days, but instead she is killed by crushing. Grind her body in a mortar, adding salt and water.
5. Examine under a microscope.
6. If the mixture contains oval corpuscles, eliminate the entire clutch. And find a source of healthy eggs, even if you have to look far and wide.

It had to be done like this. The pébrine was too devastating. But I find it hard, reading the rules of this method, to forget that the loyalty of silk moths to their mates inspired the stories of Pyramus and Thisbe, Romeo and Juliet. And I find it hard not to be sad that all they have – still, today – is those few hours together under a cone, before they are forcibly separated and killed.

During those two years in the south of France, Pasteur had plenty of time to reflect about the nature of infectious diseases: how you

could inherit them as well as be infected by them, and also how specific bacteria led to specific diseases, a theory known as 'specific aetiology'; obvious now, but radical at the time. Later, the Pasteur Institute in Paris became a centre for life-saving research into septicaemia, anthrax, rabies and other deadly infections, and the vaccines and theories of disease developed there were partly inspired by his meditations, research and realisations among the silkworms.

Silk for armaments

The French silk makers didn't just hang around waiting for a solution to pébrine. They went looking for alternative silk supplies. By 1860, Italian farmers were seeing pepper spots on their own worms, so they were no longer a reliable source. The trade with China and Europe had been thrown into chaos by the second Opium War, culminating in the burning of the Summer Palace outside Beijing by French and British troops in 1860. Germany and England had tried sericulture several times and had failed. America, after its *multicaulis* bubble, was having none of it. But after hundreds of years of being closed to Europeans (except for one Dutch port), Japan was beginning to open its markets. And Japan had clean, uninfected silk.

The French had some of the best military technology in the world. They had the latest guns and torpedoes and warships and weapons, as well as a reputation for discipline and modern strategy. And Japan wanted all of it. In 1864 France sent a silk expert from Lyon to Japan to look at the raw silk, along with many military specialists to advise on defence. By the time the fourteen-year-old Meiji emperor came to the throne four years later, the soldiers for his new army were in dark-blue French-style uniforms; the first modern Japanese warships were being built in sparkling shipyards whose construction had been directed by French experts; and the first young Japanese men were learning foreign languages in new foreign language institutes. And the French had their silk.

To the rising internationally aware middle class in Japan, however, it was clear that unless they were very careful, they were going to lose all the advantages of having virtually a world monopoly, simply by not knowing how the rest of the world operated its business.

Japanese silk man in New York

In 1876, twenty-year-old Rioichiro Arai arrived in New York. He came from a wealthy landowning family in the mountains of Kozuke, a hundred kilometres north of Tokyo. The region was then the heart of Japanese sericulture: almost every peasant family was involved in raising silkworms. It was hard work for the women. To get two kilograms of silk in a year, they had to spend the spring and summer constantly feeding about seven thousand worms with some two hundred kilograms of mulberry leaves, which they were also responsible for picking. 'No one who has heard the sound will ever forget the low, all-night roar created by the munching of thousands of voracious silkworms in a Japanese mountain farmhouse', wrote Arai's granddaughter Haru Matsukata Reischauer, from whose family memoir I've taken this account.

While Arai had been busy learning English after the Meiji Restoration (which happened when he was fourteen years old), his older brother Chotaro Hoshino had been apprenticed in the silk trade. Silk had been reeled by hand for centuries, but that was about to change. By spring 1875, Chotaro had built his own Western-style mill, using a no-interest government subsidy of three thousand yen. He installed some machines for reeling the silk from the cocoons (rather than doing it by hand), and other machines for throwing it – combining filament strands and twisting them together, ready for the loom.

Working with the local farmers and making their raw silk into yarn was all fairly straightforward. The hard thing, he was about to discover, was selling it at a profit.

First, he tried consigning the threads to a *ninushi*, the local merchant who dealt directly with foreign traders in Yokohama, Tokyo's closest port. He was horrified to realise that he'd sold at a loss. He transported the next year's shipment the hundred or so kilometres to Yokohama himself, avoiding the *ninushi*'s high commission, but once he'd paid the tax and the shipping to London he made almost nothing. Most foreigners wouldn't deal with him or other producers directly; they preferred to use Chinese middlemen, along the lines of the old comprador system that had worked in Macau, Hong Kong and China for years.*

* Comprador: from the Portuguese for 'buyer', used in Macau from the sixteenth century.

It was impossible at first to find out what silk prices were overseas and so know what price they could demand. It was only when one silk merchant found a copy of *The Times* that they realised how high the price of silk was in London and understood that the only way to succeed in this new, international world was to go to the end buyers themselves.

Now, in March 1876, Chotaro's brother Arai was one of six young Japanese men walking up the gangplank of the SS *Oceanic* heading from Yokohama to San Francisco. He carried a carpetbag of samples as well as a purse full of Mexican silver dollars – the international currency of East Asia – and three spare Western-style suits, a new thing for Arai who until then had only worn kimono. His two hundred and seventy yen had paid for a hammock in a berth with no windows, where he had to sprinkle red pepper at least once a day to get rid of the stench.

In New York he learned that Japanese silk had a bad reputation. The few bales that had arrived via Europe over the previous few years had been poor quality, with bits of metal stuffed into them to increase the weight. Nevertheless, after a few weeks he secured his first order, from a silk merchant on Mercer Street called Richardson: just four bales, weighing a hundred pounds each, at $650 a bale, with delivery by September and 10 per cent off for early payment.

It would be the first time Japanese merchants had exported silk directly to North America, and the first time any Japanese silk had arrived in North America via the Pacific, and not via Europe. It was a coup.

Shortly after he and the buyer shook hands, the price of silk shot up. After another outbreak of pébrine, Italy and France had ordered an emergency ten thousand bales from Japan, with the price almost doubling overnight. In a series of letters – each taking several weeks to arrive as the trans-Pacific cable was still two years away – Chotaro begged his brother to raise his price: it was going to take everything the family owned to fulfil the deal. Arai refused; he'd made an agreement.

And he was right: although the brothers lost two thousand dollars on that first transaction, it paid off. From then on, they, and Japanese silk, were trusted.* And by 1929, from the original four bales in 1876, more than five hundred and thirty thousand bales of silk would be

* Arai would be the first Asian elected to the board of the Silk Association of America and his company would handle nearly a third of all silk exports.

imported from Japan – many arriving on special 'silk trains' speeding across Canada or the United States in under eighty hours coast to coast to beat down the extremely high transport insurance rates.

In 1880, however, four years after that first order, and on his first visit home, Arai had his first understanding of how quickly things were changing in his native land. Dressed in the latest New York fashions – complete with gold chain and fob watch – he was astonished to realise that nobody looked at him at all. All his male friends were also wearing Western clothes, and in fact it was Arai who was the one to keep remarking at how things had changed. No samurai swords on the streets, the shops full of Western goods. And how expensive everything was.

That year was also the first time the sound of a power loom could be heard in Nishijin, the traditional silk-weaving district in Kyoto. Also the patterns were changing. Jacquard attachments had arrived seven years earlier, brought back by two Japanese weavers who had made the journey to Lyon to learn how to use them, and by 1880 many more weavers were using them than ever before.

It was raw silk that helped Japan control its runaway inflation in 1881, and it was raw silk that helped it build up a trade surplus of twenty-eight million yen four years later. It was raw silk that paid for all the rapid military upgrades, which meant that when Japan went to war with the stuttering Qing Dynasty in China over influence in Korea in 1894, Japan won; and when, in 1904, Japan and Russia went to war over Manchuria and Korea, Japan won again.

Silk kept delivering. Even during a depression in America in 1907, the demand for Japanese silk scarcely faltered. People turned away from the expensive Italian silks, but they still wanted the cheaper Japanese ones.

It was in large part due to the sudden increase in wealth caused by the silk trade that Japan had the financial wherewithal and links to the West that enabled it to rapidly industrialise and militarise. This contributed to the Japanese expansionist movement extending beyond Korea into China and then throughout South East Asia and the Pacific. It helped Japan become the military powerhouse it was in the 1930s when it invaded China, and later in the 1940s when it invaded much of South and East Asia. If it hadn't been for the massive amount of capital and technical knowledge that had flowed into the country because of Europe's silk famine, industrialisation would

have been slower to arrive. And the pattern of the world would have shifted in different ways.

When the first woman flew

On 7 October 1908 Edith Berg became the first woman to ride in an aeroplane. There's a photo of her next to Wilbur Wright. They're surrounded by what look like balsa-wood struts. Berg's hat is fixed to her head with a scarf and her long skirt is tied around her calves with string to stop it ballooning. She looks calm and slightly amused.

After the flight – which lasted two minutes and took them to the dizzy height of ten metres – another photograph was taken. This one showed her walking away from the plane, her skirt still tightly gathered around her legs. One person who saw the picture was Parisian fashion designer Paul Poiret. He loved the look. The next season the 'hobble skirt' was born. Two years later, Poiret introduced 'harem pants', based on his interpretation of what Turkish women wore ('minus the veil' as *The New York Times* correspondent in Paris noted). The trouble for the silk industry was that neither hobble skirts nor harem pants required an item of clothing that until then had been a staple of Western women's wardrobes. The petticoat.

In 1912, *The New York Times* was reporting that American silk was in crisis. A quarter of a million workers unemployed, a great industry brought low. And all the fault of the women of America. If they could only realise how selfish they were. If they could just start wearing petticoats again, the industry would be saved. France was the same, the reporter wrote. 'In the north of France, an actual famine is reported, due to nothing but the dearth of employment caused by the small production of dress and petticoat fabrics.' An effort was being made – 'not by fashion authorities, not by moralists, but by economists and business men – to put an end to the fad of skimpy clothes and give back their work to hundreds of thousands of persons thereby'.

In retrospect, nobody in America in 1912 needed to worry much about the silk industry, not quite yet. Two years later, the First World War would start. The Wright Brothers' inventions would morph into fighting aircraft, their wings held together with skins made of silk. Silk parachutes would be invented for pilots to jump out of such aircraft.

When Edith Berg hobbled her skirt to take her place beside Wilbur Wright on a plane on 7 October 1908, she hastened the end of petticoats.

Ships needed flags. Processions needed banners. Sailors needed silk neckcloths.

Germany nearly ran out of silk in that war. It nearly ran out of all textiles. By 1916, German civilians were wearing clothes woven from paper – you could wash them just two or three times before they decomposed. By 1917, even paper was too precious. Every textile was needed for the front.

Petticoats wouldn't come back, but, once the war was over, from New York to Chicago to Paris to Shanghai to Saigon, there'd be demand for a new kind of silk dress. Wherever in the world they emerged, these new post-First World War dresses tended to be short and sheer and sexy, and inspired by Hollywood and sometimes by nationalism and, sometimes, by women's recently won right to vote.

In Europe and America, it would be called the 'flapper dress'.

In China, the Qing dynasty had collapsed in 1911, and young women in the new Republic of China had begun to wear a radical variation of the old Manchu riding jacket. It was a blend of freedom and flappers and the fashions of Paris and Hollywood. It had the cinched

waist and tight fit of clothes coming out of Europe and America, but it kept that traditional crossed front of Qing court jackets and their side fastenings with knot buttons made of silk. In Shanghai it was called the *qipao*; in Hong Kong the *cheongsam*. In the French colony of Vietnam it was the *áo dài*, an elegant long white dress worn over loose pants, redesigned in 1921 for a Paris fashion show and refashioned in 1934 by the Hanoi artist Nguyen Cat Tuong. As Vietnam edged towards independence after the Asia-Pacific War, this new-old eastern-western fashion soon became part of Vietnamese identity.

Like so many items of middle-class Asian clothing in the twentieth century, it was descended from colonialism but a symbol of freedom.

How to tell if it's silk

I came back from primary school one day and announced that I had to get a piece of silk and look at it and work out how it was made.

My mother went to get one of my father's old handkerchiefs, the kind that's less about blowing your nose and more about making an effort. I have something like it in front of me now. It's frayed in one corner and when I hold it up I can almost see through it. Since my father died I've used it as an actual handkerchief. It seems to always smell faintly of soap – being animal, silk picks up scents almost as well as a cat's fur does – and whenever I find it, balled up in a pocket or a handbag, it feels like touching the past.

For homework that evening, we had to smell it, touch it, pull it, scrunch it, and examine it through a magnifying glass, and if we could find a piece of silk that didn't matter then we had to (and I'm pretty sure schools today would not recommend this) set fire to it.

The next day in science class we did more tests to tell the difference between several fabrics. When one was held with tongs over a flame it smelled like a barbecue, and left fine, dark ash. Another felt similar but reacted differently, burning slowly and melting into grey beads.

The first was silk; it's the protein that makes it smell like charred meat. The second was the fabric that at one point was predicted to take over from silk but didn't. Not quite. It was invented less than a century ago, out of oil and heat and pressure. But before that it existed in the imagination.

Our end is our beginning

Silk comes from something that through most of its life is driven by the desire to consume as much as it possibly can. And then at a certain point it stops needing much of anything. Just air and time and a nice, warmish temperature and a stick or a twig to rest on. Now, having been dependent almost entirely on external things, it finds itself dependent only on itself. It begins to weave its future with small deliberate actions that, deep inside, it has always known how to make. And then after days of darkness and stillness and turning in on itself, it is ready to be reborn as a different kind of being altogether. Other natural fabrics – linen, jute, hemp, cotton, barkcloth, horsehair, wool – come from a crop, a growth event, a haircut. But silk? Silk is a miracle.

10

IMAGINED FABRICS

In which the author finds a beauty in hydrocarbons.

For a long time this chapter existed as a series of folders labelled 'Nylon', then later 'Artificial' then 'Human-made'. And whatever the name, it felt like something heavy at the end of a book that otherwise felt full of lightness. Of course I had to include the nylons and the rayons and things beginning with poly- or ending with -tex. I knew that. But these fibres weren't formed on a creature or grown in a field or cultivated with digging sticks in a Pacific garden. Pliny didn't write about them, and I wasn't sure I wanted to either. I didn't think I even liked them.

But then I examined the labels on my clothes. Most of the sportswear, all of the rainwear, my favourite 'silk' trousers – all were made of fibres that were unknown before the end of the nineteenth century or the middle of the twentieth. Swimsuits. Cycle shorts. Bras. Even a few shirts I'd have sworn were cotton. Anything with elastic. Or stretchiness. Or zips. They all contained human-made fibres, and if they had one thing in common it was that they all seemed to be clothes that enabled me to *do* something.

What if I tried reimagining that part of my wardrobe as a place of magic? As a repository for materials that opened doors into new worlds? Could I learn to love these fabrics then?

I switched off the light, closed my eyes and felt my way along my wardrobe rail. I listened to the sounds my hands made as they touched different clothes, and later opened my eyes to check what the fabric was. A lowish hum was cotton; a dry-sand scrape the combed worsted wool of a jacket. I stopped at a little *zzz*, hardly a sound at all. More like the echo of a mosquito. It was my oldest item of clothing, a shirt I've owned for nearly thirty years, since my days in Hong Kong as a young journalist. A friend of my boyfriend was visiting

from Australia. 'I love your shirt,' I said. And when he left, he gave it to me. It's silky; it never needs ironing; it can be washed in a sink and dried overnight; and the subtle brightness of its cascading crimson roses, purple poppies and soft green leaves has never faded. A few years back the collar started to fray but I had sent the shirt to a tailor and it then looked almost new again; the hatched machine darning on the new underside of the turned collar is a thing of beauty.

But was it rayon? Or nylon? Or polyester? I wasn't sure that I knew the difference, though I knew that rayon was made from natural plant fibres and is therefore technically 'regenerated' or 'semi-synthetic' and that the other two were made from oil using entirely chemical processes and are therefore technically 'synthetic'.

I sliced a sliver from an inside hem, and when I picked it up with tweezers and held it to a flame, it flared yellow and smelled for an instant like a smoky Buddhist temple full of butter lamps, then it roared and there was black smoke. When it stopped it had turned to a hard ashy nugget. My 'burn test' guide told me that if it had shrunk away from the flame and left a black bead, and if the smell had been chemical, it would have been polyester. And if it had shrunk away from the flame and left a grey bead like gunshot it would have been nylon. But my silky shirt material behaved like cotton and smelled like chemicals, which suggests that it is a polyester-rayon or -cotton mix.

The exercises with the wardrobe and the candle flame helped me realise that the key to this chapter was looking at things from a different direction. And remembering that these relatively new, often problematic and sometimes difficult to love fabrics can also, at their best, be beautiful.

A different way of seeing

When I was twenty-four, I was sent to Sweden as a marketing executive for Reuters. The local airline was offering a promotion of cheap standby tickets and one weekend I took a train to the airport and waited to see where the next flight was heading. It was Kiruna, in the Arctic Circle, and when I arrived, I booked to spend the night camping in the forest with a Sami guide.

As he cooked fish on an open fire, he talked about Sami beliefs. 'We believe there's a heaven and an earth and there's an under,'

he said. 'But the different thing about the Sami is that under isn't hell, it's actually upside down.' So people living in the under walk on the earth too, he explained, but their feet touch its surface from below. I watched the fire sparks flick onto the muddy ground and imagined people very like us sitting upside down, just an idea away from where we were sitting now.

'It might seem funny,' he continued, 'but I've always thought it was code for how to think. If you have a problem, try imagining you're one of the people walking underneath. How would you solve it then? And if you look at how we're hurting the earth, then try imagining the underneath. How would you protect it then?'

I told my mother about that image. A few months later, when I was trying to decide whether to leave Reuters, with nothing but a vague dream of being a newspaper journalist, my mother sent a postcard. She'd drawn a stick figure standing on the ground and another figure standing under, like a reflection in a puddle. Think about it upside down, she meant, and then make your decision.

The metaphor holds again and again with the story of invented cloth. For a long time, there's a way of doing something. Then someone has a wild and impractical thought, a moment of standing on the other side, and approaching things in a different way – and everything can change. And what may seem to us now to be the most uninspired of fabrics – with names made in offices, and reputations for hurting the natural world – can turn out also to be forged from dreams. And to carry us beyond the surface of the earth itself, if only we think to look.

On first looking into Hooke's *Micrographia*

Robert Hooke was the first Curator of Experiments at the Royal Society in London in 1662, and he was the first person anywhere to depict in detail what can be seen through a microscope. Microscopes had been around since the 1590s but few people could afford them and

even fewer could explain to others what they saw. But Hooke had a superpower. Not only was he a brilliant scientist, he could also really draw. At thirteen he'd apprenticed with one of the great portrait artists, Peter Lely. But then he had the chance to go back to school, and later, during the Civil War, had studied at Oxford alongside some of the country's greatest scientists and thinkers. He'd been the assistant to the natural philosopher Robert Boyle; he was friends with the great astronomer (and, later, the even greater architect) Christopher Wren; and he'd had lively and bitter arguments with Isaac Newton. He was well connected and well placed for helping others see nature with a new perspective.

The microscopes he first got hold of had not been good enough. But by placing a glass globe filled with brine between the lens and the lamp he invented a way of gathering enough light to see the natural world from so close that it must sometimes have felt he was inside it.

In 1665, when he was twenty-nine, he published the drawings he had made over the previous three years, together with his observations about what he'd observed as he drew them. He titled his book *Micrographia*. The playwright Thomas Shadwell parodied him, referencing 'a Sot, that has spent £2000 in Microscopes, to find out the nature of Eels in Vinegar'. But most people, including the king, were astonished by the wonders that can be found in the familiar if we look at it closely enough. Samuel Pepys stayed up until two in the morning reading the copy he had rushed to buy as soon as it was on sale. He called it 'the most ingenious book that ever I read'.

Micrographia is best remembered for its giant, almost tender, portrait of a flea. And for being the first publication to use the word 'cell' to describe the building blocks of organisms. And for including the world's first detailed drawing of a clothes moth, *Tinea argentea*, which through Hooke's eyes isn't a hated household pest but a lovely ghost – a delicate 'white long wing'd Moth', with floaty, feathered wings. Its inclusion was a tacit reference to how a clothes moth had recently made its first appearance in the Order of Burial, to be used at every funeral, and its presence (in the 1662 *Book of Common Prayer*, which is still used) was a reminder of how earthly beauty cannot last, but is instead consumed by time, 'like as it were a moth fretting a garment'.

The book begins more simply though, with three inanimate objects: the point of a pin, the edge of a razor – and a piece of silk. Hooke was fascinated by how, close up, the apparently smooth

Above: The silk ribbon reminded Hooke of doormats,
or the straw seats of simple chairs.
Below: The 'white long wing'd' clothes moth, looking like a lovely ghost.

threads of the silk were uneven and textured, and looked more like 'Door-matts' or the straw seats of simple chairs. A piece of white silk was like a bundle of clear, transparent cylinders, while red silk seemed to reflect light, as if it was seen through rubies.

He was the first person to observe any textile in such detail.

Looking so closely for all those hours, Hooke had ample opportunity to let his mind wander. And one of the consequences was to imagine that humans could copy silkworms, and make their own kind of silk.

'I have often thought,' he wrote in that book,

> that probably there might be a way found out, to make an artificial glutinous composition, much resembling, if not full as good, nay better, then that Excrement, or whatever other substance it be out of which the Silk-worm wire-draws his clew ... This hint therefore, may, I hope, give some Ingenious inquisitive Person an occasion of making some trials ... and I suppose he will have no occasion to be displeas'd.

He was right. There would be plenty of profit in it. And plenty of ingenious inquisitive people. But there would also be several occasions to be displeas'd.

Because, it turns out, the process can be appalling. To make thread like the silkworm makes thread, you have to reduce the underlying muscle of organic fibres into a kind of digestive slurry, before reconstituting them into something that can be woven. And sometimes that involves using poison.

Before scientists could embark on even the first stage of this, however, it was necessary for a cotton apron to explode.

The mystery of the disappearing apron

It was 1846 and the German chemist Christian Schönbein was in the family kitchen in Basel in Switzerland distilling nitric acid from sulphuric acid as part of an experiment. The mixture spilled, and to mop it up, Schönbein grabbed for the closest thing, which happened to be a cotton apron. After wiping up the spill he hung the fabric over the stove to dry and moved on to something else.

Then something amazing happened.

The apron vanished in a flash of light. There wasn't even a visible sprinkling of ash to show where it had once been. Schönbein was mystified. And as he tried to work out what had happened to the cloth, he began to realise that he might have solved a question that had been perplexing industrial scientists for some time. They had been trying to dissolve plant fibres – by then called 'cellulose' following Hooke's naming of 'cells' some two centuries before – to make a substance that would dry into a hard, transparent film, rather like egg-white. Although no one thought about its potential for making thread, they could already see a multitude of possibilities, including coating plates for the new science of photography.

The first problem was breaking down the cellulose. They'd been trying nitric acid, which almost worked, but the solution was too wet to become a film.*

Then came Schönbein's apron.

If you drop sulphuric acid onto a piece of paper, it appears to burn it. It leaves a charred edge just as if you had held a match to it. But it isn't burning. Sulphuric acid is hygroscopic, which means that it absorbs moisture. When it comes into contact with paper (which, like all organic things, is made up of hydrogen, oxygen and carbon), it absorbs the H_2O – the water – leaving just a trace of carbon, C, as a black residue.

So during that explosion in the Basel kitchen the accidental addition of sulphuric acid (with the cotton apron playing the role of the cellulose) removed the water from the equation. It made a compound that was both very wonderful and very dangerous. Its chemical name is nitrocellulose, though most people called it guncotton.

You know guncotton, even if you don't think you do. It's the flash paper in a conjuror's trick. It's the main film-forming agent in nail polish. It's the main film-forming agent in film itself. It's the reason that old movie archives sometimes spontaneously catch fire. And – although people wouldn't find this out straight away – it's also the main ingredient for the artificial silk that Robert Hooke had imagined.

* The equation for the first part of the process is $C_{12}H_{20}O_{10} + 6HNO_3 = C_{12}H_{14}O_4(O.NO_2)_6 + 6H_2O$: i.e. plant material plus nitric acid equals nitrocellulose plus too much water. Adding sulphuric acid then removes the $6H_2O$.

Setting Prince Albert alight

Within months, Schönbein was in England showing his discovery to Prince Albert at Osborne House on the Isle of Wight. He first offered to demonstrate it on the palm of a British military officer who was present, but the man declined. Albert, however, was game to try 'and off went the cotton without smoke, stain, or burning of the skin. Thus encouraged, the Colonel took his turn; but ... it gave him such a singeing that he leaped up with a cry of pain.'

The first buyers were military. Up until that point gunpowder had given out so much black smoke that after a few minutes it was hard for an army to see exactly where it was firing. But nitrocellulose was virtually smokeless. It would give whichever side had it a huge advantage, at least until both sides had it.

Schönbein sold the British rights to a factory near Faversham in Kent that made gunpowder for the armed forces, but in July 1847 two of the buildings blew up, killing twenty-one people. France, Russia and other countries soon had their own fatal nitrocellulose explosions, and it would take another forty years before anyone worked out how to stabilise it for gunpowder.

The substance wasn't all bad. If you dissolved it in ether and alcohol and made a substance called collodion – after the Greek for glue – you could make 'liquid bandages' for surgical procedures. You could also make coatings for photographic plates, a big improvement on the egg white used until then. And over the next few decades it became apparent that if someone could just work out a way to reshape it, safely, this plastic also had potential to be formed into a kind of thread. Just as Hooke had predicted.

Imagine

In 1855, Georges Audemars in Switzerland patented a yarn-making process that involved adding nitric acid to cellulose from the inner bark of mulberry trees, then dipping needles into the gloop and pulling it out into threads.

But it still wasn't fine enough; it wasn't quite there.

Then came the shortages. The worldwide crisis in silk after the silkworm diseases of the 1850s. The worldwide crisis in cotton, due, in part, to the American Civil War in the 1860s. A Europe-wide shortage of flax, caused initially by the Crimean War and then by the

emancipation of serfs in Russia that followed, and also by all those shortages of silk and cotton and flax that were causing the demand for every other textile fibre, including wool and hemp, to soar as well.

The Renaissance after the fifteenth century – with its expansion of trade and exploration, followed by the arrival of new knowledge and ideas – had in part been generated by the desire of European nobles to obtain luxury goods from the rest of the world.

Now, in the nineteenth century, it was the turn of the European and American middle classes. As the century progressed, they had seen the treasures being brought in through international trade and colonialism, and the opening of Japan. They had also, ever since the first department stores had opened in London and Manchester in 1796 (and especially since three huge stores made of windows and glass and brightness and space had opened in Paris from the 1850s), been able to see and buy these objects in radically different environments. Also, after 1856, people all around the world had seen the arrival of coal-tar dyes which could render fabrics and carpets in just about any colour imaginable. And now, in the recently installed domestic gas lamps (soon to be superseded by electricity), they even had a new kind of lighting by which to see their clothes and possessions in the evenings. They expected to be able to buy affordable fine cloth, and they expected it in the designs and colours they craved.

If nature couldn't provide, perhaps artifice could.

How much textile fibre does it take to make a light bulb?

In 1878, chemist, physicist and inventor Joseph Swan switched on a light bulb in the home in Gateshead, County Durham, that he shared with his wife Hannah. Theirs was the first house in history to be lit by a light bulb.

Electric arc lamps – which worked by sending an electric current in an arc between two carbon rods – had been lighting urban streets for a couple of years by then but they were large and extremely bright. Homes and smaller buildings needed something on a different scale.

Swan made his first carbon filaments out of paper, but he soon had the idea of squirting nitrocellulose through a bath of alcohol to make a reconstituted carbon thread. It was thinner than the thread made from paper, and it worked much better. Although the new thread was intended for light bulbs, Hannah Swan conducted her

own experiments, and in 1883 crocheted it to make the scalloped lace edges of a silk handkerchief. It was the first textile made of Hooke's imagined fibre ever to be displayed in public and it made its first outing in 1885, at the International Inventions Exhibition in London, attended by nearly four million people. Today it's in the collection of the Science Museum in South Kensington, a few hundred metres away from where it was first displayed.

Hannah Swan proved that the fibre worked as a thread. But it was far from being beautiful, nor was it delicate, and although Joseph Swan did take out a patent for it as a fabric fibre, in the end he was more interested in the electricity.

It was a Frenchman, Louis-Marie-Hilaire Bernigaud, Count of Chardonnet, who found the next piece of the puzzle. And it's appropriate, given Hooke's prediction, that the further development of artificial silk should require insights gained from examining silkworms through a microscope.

Chardonnet had studied science under Louis Pasteur in the 1860s and had seen how his mentor had addressed the pébrine scare by looking closely at eggs and silkworms. And one day, Chardonnet had this thought: the silkworm extrudes its glue through spinnerets, so what might happen if he were to make spinnerets out of glass? If he forced collodion – made from guncotton, ether and alcohol – through very small holes and straight into a bath of sulphuric acid, the acid (being hygroscopic) would surely dry it out as threads.

In France, Chardonnet's spinnerets were dubbed *verres à soie*, 'silk glasses'. It was a play on *vers à soie*, the word for silkworms.

They looked like shower heads, with hundreds of tiny holes through which the solution was extruded into an acid bath. The glass ones were fragile, and soon they were replaced with spinnerets made from a platinum-gold alloy because that was the only material that could withstand the corrosion.

Chardonnet displayed his invention at the Exposition Universelle in Paris in 1889 – the event for which the Eiffel Tower was constructed. Two years later, he set up a plant in his home town of Besançon in eastern France, in a spectacular setting beside the River Doubs, close to a paper mill, which would supply the cellulose. It would produce fabric until the First World War when production would switch to guncotton.

Chardonnet called his invention *soie artificielle*, 'artificial silk',

or 'art silk' although it was also called 'Chardonnet silk' and many people loved it for its shimmeriness. Some of his workers, though, took to calling it 'mother-in-law' silk on account, in its early days, of how flammable the fabric was, and how you might therefore choose to give it to someone you didn't like.

As it turned out, a job at Chardonnet's factory was also something you might choose to give to someone you didn't like. All that acid. All those hours breathing in toxic fumes. By 1908 the place was known locally as 'the penal colony' because conditions were so terrible. The eight hundred women and four hundred men who were employed there in 1908 could be recognised all too easily in town: they were the thin ones, with startling, pallid faces. City councillor, Léon Brédillot, reported visiting Besançon's hospital that year, and seeing factory workers' babies, with their pale, blue skin. Many would die within hours of being born.

There were two ways of seeing this invention: it was revolutionary and beautiful.

And it was toxic to its core.

Then there were all the deaths

The same year in which Chardonnet was setting up his plant in France, three English chemists, working out of a laboratory near the tube station at Kew Gardens, had arrived at another recipe. Clayton Beadle, Edward Bevan and Charles Cross steeped wood pulp in caustic soda before shredding it and adding carbon disulphide – which up until then had mostly been used as a solvent in the rubber industry. This made an orange syrup that could then be forced through a spinneret, straight into an acid bath. They called the threads 'viscose', after the viscous gloopiness of the substance they were formed from.

Whether used for film or thread, the viscose process was dangerous for workers. It was even worse than the toxic fumes used in Chardonnet's artificial silk, and the reason for that was mainly the carbon disulphide.

Today, about three-quarters of the world's carbon disulphide is used in textiles. The rest is used for fumigating storage warehouses, getting rid of nematodes – those little worms with sharp, root-eating teeth that do so much damage to cotton crops – or as an insecticide.

It is, in short, a serious poison. It's one of the reasons that we have to wash any fruit or vegetables we buy; and it's one of the reasons why the history of this beautiful silky fabric is not clean.

American historian Paul Blanc describes the process of forcing syrup through tiny spinning nozzles in a sulphuric acid bath as 'sprinklers irrigating a Hadean garden' and describes how carbon disulphide 'led to acute insanity in those it poisoned'. This was recognised as early as the 1850s, so there was no excuse for it to be used so casually. Now there are other chemicals that can be used – the lyocell/Tencel process is one of the best, using a different solvent, which is much cleaner – and responsible manufacturers use a closed loop process that limits workers' exposure to the chemicals and makes sure that those chemicals are used again and again. But it's not perfect. Some manufacturers don't do it; there are still accidents.*

Mr Cellophane

If you push Beadle, Bevan and Cross's gloopy orange syrup through very small round holes – maybe forty microns wide, about half the width of a human hair – you get fine yarn for silky cloth. If you push it through holes two centimetres (or twenty thousand microns) in diameter, you get thick cords that are strong enough to be used for car and truck tyres, much tougher than the cotton cord used in the early days. And if you push it through long slits, like the openings of micro letterboxes, you get very thin transparent waterproof sheets.

That's what Swiss chemist Jacques Brandenberger did after he saw spilled red wine pooling onto a tablecloth in a restaurant one evening in 1900, and imagined what might have happened if the fabric had repelled the wine rather than absorbing it. He tried spraying liquid viscose onto cloth, but the resulting fabric was too stiff for tablecloths. However, when he realised that the coating he had invented would peel off, he had another idea, and, twelve years later,

* The carbon disulphide is just in the process; it's gone by the time the cloth leaves the factory. However, other nasties, also common to other fabrics, remain: dyes that can cause reactions on sensitive skin; and urea-formaldehyde (chemically related to urine), which is added to many clothes at the finishing stage to stop mildew forming on long sea journeys and to make clothes appear brighter in the stores than they ever will be again.

he patented a thin, supple film that you could look right through. He called it cellophane.

Cellophane would later be cut into shiny threads as an industrial weaving material, and used as rain capes and gas protection for soldiers in the Second World War. It would also, with glue pasted on one side, become a household staple as Sellotape in the UK, and Scotch tape in America.* In the beginning, though, it was usually just used for wrapping sweets.

After the First World War, viscose became the wonder of art deco fashion. In the UK it was exclusively made by a firm that – before it bought the rights from Beadle, Bevan and Cross in 1891 – had been a struggling silk-making company with a line of black mourning crape,† which at the end of the century was not as fashionable as it once had been. It was called Courtaulds, after the Huguenot silk maker who had started it years before, and in 1910 it expanded to the US as the American Viscose Corporation where it was later bought up by Monsanto. It was one of the most successful European companies ever. The Courtauld Institute of Art in London was built on the success of artificial silk.

Seven habits of highly successful German industrialists

At the dawn of the twentieth century, German manufacturers were making the best artificial fabrics – and clothing dyes – in the world. They were also making the best profits.

In 1903, Scottish MP Richard Haldane tried to uncover their secret. And he realised that German industry had approached the issue of new products in an entirely different way from the British. He gave the example of cellulose, the raw material of viscose.

'We have not yet succeeded in making it so white as they do, and for many of the uses to which cellulose is now put whiteness is an essential quality', he told an audience in London.

* The name 'Scotch tape' came after its US inventor was teased for being mean with the glue on his early prototypes. It was felt that the joke might not carry to Scotland, so another name was invented for the UK.
† Crepe, or crêpe, is derived from the old French word crespe, or curled, referring to its crinkled surface. Since the early sixteenth century the crimped gauze used for mourning garments and clerical dress has been spelled 'crape', to distinguish it from more festive uses of this fabric.

How did the German manufacturers set about doing this?'

The answer, he said, is that a few years before, twelve companies had joined forces and put down a total of one hundred thousand pounds (equivalent to some twelve million pounds today), along with the commitment to provide a further twelve thousand pounds every year. They used it to found an institution in one of the suburbs of Berlin, 'which we have nothing like in this country'. A distinguished professor of chemistry was headhunted from the University of Berlin, given a large salary as director, and the licence to hire the best technically trained assistants that the university and the technical schools of Berlin could produce. People who (although Haldane didn't use those words) were able to see differently, have new perspectives on chemical questions, and act creatively on what they observed.

> Whenever they had a problem, whenever they found that the British manufacturer was making his celluloid a little whiter, they said to their experts, 'Will you show us how to make ours whiter still?' The investigators were set to work, and we were beaten nearly out of the field ... How would retaliatory duties or Protective duties help us here? We have been beaten, not by tariffs, but by our inferior knowledge of our own business.

A speaker today might have summed up the German success as being about collaboration above competition; looking at a problem from both microscopic and telescopic angles; interdisciplinary R & D; strategic thinking; and being as creative about advertising as about manufacturing.

These would be the skills and strategies of the twentieth century – as much as, or more so than, actual invention. And if they didn't quite yet have the buzzwords for them, German businesses had identified them before the century began.

The old stuff is out

Standing in the German trenches during the First World War, an architect had a moment of blinding understanding. He realised that – in his words – 'the old stuff is out', and that therefore nothing would be the same again.

He was Walter Gropius, and after the war he dedicated his energy

to setting up an entirely new place of learning. The idea was to bring together students from all the crafts of home- and building-making, to plan the houses of the future together. There were architects of course, but there were also cabinetmakers and interior designers and colour theorists. And there were weavers.

He located his school in the cultural city of Weimar in central Germany, and he called it the Bauhaus – the House of Building. It took that German instinct for making connections between creativity and industry that Haldane had noticed in 1903, and combined it with something new. Something that was born of nihilism and despair but also of clarity and lightness and the sense of being on the edge of a new future, of championing the skill of seeing things differently.

One student was Annelise Fleischmann. She had hoped to take classes in painting, or stained glass, and she confessed later that she had thought weaving was 'sissy'. But when she arrived there wasn't space on the stained-glass course so she signed up for weaving. To her surprise, she found the department exciting – mostly because nobody, neither students nor teachers, had any formal training in industrial textiles. They had no baggage; everything could be fresh. 'It is no easy task to throw useless conventions overboard', she wrote later, adding that teachers who had trained at art academies told her they had felt a 'sterility' there and had come to believe that only by working directly with the materials would they be able to relate to the problems and the new kinds of thinking of their own time.

In her first year, the students were encouraged to come to their classes in an 'unprejudiced' way. They were to be playful, their only purpose to make and explore. But twelve months later, Gropius made a fundamental change to what the Bauhaus was about. Germany was in financial meltdown. At Christmas 1922, the Deutschmark had been at thirty-five thousand to the British pound. In January 1923 it was six times that. By February, million-mark notes were coming off the presses. Nothing was stable, nothing was the same. Gropius adopted the slogan 'Art into Industry' and announced that in place of its initial stated aim of 'unifying art through craft', the Bauhaus would now only be about designing for mass production.

When that limitation was imposed, something profound happened: the students and faculty began to think in different ways. Far from stifling creativity, the restriction seemed to boost it. It was as if when they could do anything, the students produced less. But when

they were forced to focus within rigid parameters, the possibilities were endless. Fleischmann realised that the challenge of answering someone else's need for something was a stimulant to the imaginative mind, not just hers but her fellow students', too.

Here are some of the materials they experimented with:

- steel thread (actually cotton yarn, treated with paraffin and wax), used to design the canvas for the tubular steel furniture that would be a hallmark of the Bauhaus style;
- diaphanous drapes for the huge square windows of the huge square homes the architects were designing;
- plenty of things from viscose;
- and cellophane, cut and twisted into threads, like thin rice noodles, ready to be woven into a cloth that shone.

In 1929 and now married, Anni Albers as Annelise was now known, was commissioned to make a wall covering for the auditorium at the Federal Trade Union School in Bernau. It had to be light-reflective, soundproof, absolutely modern and absolutely useful.

Albers wove the front by alternating cotton with cellophane to make it gleam. She made the back with chenille, a fat thread like a furry caterpillar,* to hold the sound deep inside. She didn't use bold colours or complicated patterns as they would distract from its function.

A reconstruction of the fabric was shown at the Anni Albers retrospective at the Tate Modern in 2018. It was as big as an industrial door, thick and heavy and grey-blue like steel. At first I found it dull, like a heavy emergency blanket, or something to protect the floor of a factory. I wanted to move on to the many examples of Albers's work that I knew would come later in the show; pieces where the bright colours and patterns *would* distract from their function. Or, more accurately, where they were *part* of their function.

But I always play a game at exhibitions. I scan each room from the doorway. I ask myself which piece I'd like to take home, which one I'd like to know more about, and which one I like least. And I make

* Chenille was originally made by cutting woven woollen cloth into strips and frizzing them with hot rollers to make a thick, fuzzy yarn. Its name comes from the French for caterpillar.

sure that when I enter I give all three equal attention. That way, I get to examine my own preferences and prejudices; I learn something I might not have learned otherwise; and sometimes it means I get to reflect and meditate on the nature of beauty.

So I stood in front of this one, trying to understand how such a talented maker had made such a solid, industrial, ugly-looking thing. After a short while, I began to forgive it. After a longer while, I entirely changed my mind about it. It was soothing. It could absorb troubles into its depths. It felt like a warm, steel- and earth-coloured act of the imagination. I'll bet it was soundproof, too.

In 1930 Albers won her Bauhaus diploma on the strength of it.

That year the twenty-four-year-old American architect Philip Johnson saw the Albers fabric in the Federal Trade School in Germany, and he didn't forget it. In 1933, by then at the Museum of Modern Art, Johnson was asked to be advisor for a new kind of school in rural North Carolina. Black Mountain College would bestow no qualifications. Instead it would be a place to have time to consider ideas. A place for explorations, for thinking upside-down.

It was to be a pacifist, modernist, American answer to that same urge to find a new way of living that Gropius had experienced just over a decade earlier. And most of all it was to be a place for things to be invented and made and improved that were different from things that had been invented and made and improved before. When Johnson considered possible teachers for Black Mountain College, he remembered that dark, imaginative industrial fabric he had seen in Germany and he invited Albers to join the staff. She was from a Jewish family, and the Nazi movement was rising. The cellophane textile was her passport to America. It probably saved her life.

Further into the imagined

Viscose and cellulose and many of the other 'regenerated' fabrics had largely emerged from the European reimaginings of natural processes. But by the time Albers made her Atlantic crossing, something had been invented in America that would take the creation of fabrics far beyond nature, and much further into the imagined.

In the nineteenth and twentieth centuries, scientists were starting to realise the potential of oil, which comes, of course, from below the planet's surface in a quite literal underworld. Oil is made from

the bodies of organisms that lived millions of years ago; it has all the elements of life stored in it; they are matured and condensed, but they are still there, and the shapes of their molecules are different from anything that has recently been alive. As in any kind of organic structure there are four main elements: carbon, hydrogen, nitrogen and oxygen. But as scientists started to look at them, it became clear that they could be combined and recombined in all sorts of ways. It was like a great library and, although made up of just a few letters, within them they hold some of the greatest secrets of life.

A gunpowder family in America

When you look at the history of artificial fibres, the name DuPont keeps coming up. If a new textile material wasn't made by them, it was probably made by somebody who once worked for them, or by the child of somebody who once worked for them.

So who are they?

Éleuthère Irénée du Pont de Nemours was the son of a watch-maker turned political economist in eighteenth-century France. When he was fourteen he wrote a paper on the manufacture of gun-powder, and two years later, in 1787, he started studying advanced explosives under the tutelage of the celebrated chemist Antoine Lavoisier. Six years later the French Revolution was in full swing, Lavoisier had been guillotined, and Paris was no place for anyone possessing a quadruple-barrelled surname.

The family survived prison and arrests, and on 1 January 1800 du Pont, some of his relatives, and his library of four thousand books landed in America. He was twenty-nine. By 1802 he'd opened his first gunpowder factory on the Brandywine Creek in Delaware, building his home close to the works, as he believed that it was the responsibil-ity of a boss to share the risk of explosions with the workers. America had nothing like it: up until then powder was usually made in people's homes and was of variable quality and often very dangerous. Over the next century he and his children and his children's children built a business empire. But as is the way with empires, the du Pont descend-ants grew increasingly conservative and – as the company fragmented among various relatives – increasingly mired in petty disputes.

In 1884, there was an explosion and one of those killed was the founder's grandson, Lammot du Pont. His eldest son, fourteen-year-old

Pierre Samuel, became de facto head of his family overnight. Lammot had been a man of fixed ideas (he had often remarked, for example, that no man could amount to anything if he 'smoked cigarettes, wore eye-glasses or played on the piano'), and Pierre was determined to do things differently.

He enrolled at the Massachusetts Institute of Technology (MIT) in Boston – itself a novel establishment in which sciences and applied industry were combined, and where women were welcomed as well as men – and graduated with new ideas about how to move the family business into the next century. He was ready, metaphorically, to walk upside-down.

Two of his cousins shared his way of thinking, and in 1902 – realising that their older relatives were on the verge of selling out to competitors – they raised capital, bought out their uncles and aunts, and formed one large company out of almost a hundred small ones.

One of the first, and perhaps most important, things they did was to set up an Experimental Station employing top graduates from MIT and other schools, and inviting them to experiment with new ways of looking. The station deliberately did not impose pressure to make anything immediately profitable and concentrated instead on giving its scientists time just to think. In a way, the table tennis and beanbags and dartboards and meditation breaks of today's Silicon Valley tech companies, as well as the whole ethos of what it means to have 'creative space', came out of what began that year in Delaware.

A newcomer arrives in town

In 1927, Wallace Carothers arrived at the Experimental Station. He was thirty-one, a chemistry lecturer from Harvard known for his moody, eccentric brilliance and for the cyanide pill he always carried.

He was also something of a magician at the job of the academic scientist, which one of his biographers described as:

> the task ... of holding in one hand 'stuff': a shiny crystalline gallstone, or silky white needles obtained from coffee extracts ... naming them and then representing them with a precise, unique, written structure, drafted in the chemist's unequivocal alphabetic notation. This is the first step of pure science – describing reality in abstract form.

Carothers had initially declined DuPont's offer of a job, but was ultimately persuaded, not so much by the extra money as by the promise of freedom. And in the beginning he was happy, cycling to the station every day through green woodlands. 'Nobody asks any questions as to how I am spending my time or what my plans are. Apparently it is all up to me', he wrote.

The research area of the moment was polymers. At the turn of the century, chemists had been convinced that these big molecular clumps found in substances extracted from petroleum were made up of many small molecules held together by something, nobody knew quite what. By the 1920s, it was accepted that they were actually just extremely enormous molecules. Still, no one really understood most of their properties. In 1929, Carothers sketched out his ideas about them in what would become several articles in the 1932 edition of the *Journal of the American Chemical Society*.

He spent most of his time at DuPont in the library. He would hold a pencil between his index and his middle finger, as his father had once taught him to do, which helped him to go into a different creative dimension. And then he would allow his mind to envisage – imagine in a literal sense – molecules joining up together in longer and longer chains. And in that half-liminal state, he would explore – by picturing the possibilities – what kind of chemical reactions might allow them to do it.

None of his colleagues had ever seen a thinking process like it.

He had a suspicion that these enormous polymers could be rendered still more enormous, and since the Experimental Station was all about experimenting, he set his mind to discovering, for pure interest, how big he could make them. He decided to start with simple molecules called esters.*

With an assistant, Julian Hill, he conducted various experiments, but they couldn't make anything with a molecular weight of more than six thousand, which was much as scientists elsewhere had found.

Then, on 17 April 1930, one of Carothers' other assistants, Arnold Collins, discovered a strange substance in a test tube he had left forgotten on a bench the week before. They had been trying to

* Esters are formed when an acid meets an alcohol. The word is a contraction of the German words Essig, vinegar, and Äther, ether: Essigäther ... Ester.

synthesise rubber by removing impurities from the oil-based compound divinylacetylene, to see whether, when it was cleaned up, it would be usefully rubbery. When Collins looked at the contents of the test tube, however, he found that it had formed something unexpected. Today we know it as neoprene, and it's made into wetsuits.

While the team celebrated, Carothers started thinking about that test tube in the context of his ongoing attempt to make the biggest polymer in the world. He started to wonder whether the problem came from too much water in the mix, and with Hill he adapted a lab instrument called a molecular still to try and remove it.

On 28 April 1930, just eleven days after Collins's discovery of neoprene, Hill returned to one of his and Carothers' experiments with the adapted still, and he too discovered something extraordinary: a 'festoon of fibres', entirely new kinds of polymers. They were also huge. With a molecular weight of twelve thousand, they were twice as heavy as anything that had ever been seen before. And when Hill dipped a glass rod into them, a string of fibre followed.

It wasn't yet what we would today recognise as nylon – it was too soft, and wouldn't hold its shape in water – but what Hill ran down the corridor with that day would make it possible to make nylon. And five years later, after a short break and a nervous breakdown, Carothers was able to announce that he had identified how to make an entirely new kind of spinnable fibre.

This one wasn't regenerated, like viscose. It was made of something that nobody had ever made thread from before: petroleum. It was the first synthetic yarn. He called it Fibre 6.6. It's named for the number of carbon molecules in its structure, but there's a thriller title in there somewhere.

Perhaps it was a part of his brilliance, or perhaps it was apart from his brilliance, but throughout his life Carothers was burdened by the pressures of sadness. When he was in a good humour, colleagues said that there was nobody funnier. But 'when he was low, he was low, lower than a snake's belly'.

As a nineteen-year-old his favourite poem had been Algernon Charles Swinburne's 'The Garden of Proserpine'. He quoted one verse so often that his friends remembered it too:

I am weary of days and hours,
Blown buds of barren flowers,

> Desires and dreams and powers
>> And everything but sleep.

In April 1937, that weariness overwhelmed him. Just after his forty-first birthday, Wallace Carothers checked into a hotel in Philadelphia and killed himself. Beside his body, police found crystalline grains of potassium cyanide and a squeezed lemon. A scientist to the last, he knew that the acid would make the poison act more quickly.

In September 1938 DuPont unveiled a new 'lustrous and silky' fabric, as yet unnamed.

Two months later *The New York Times* published a story to say that DuPont had pledged to make it clear from the beginning that this new fibre was nothing to do with silk. It reported that the market had already expressed alarm that if Fibre 6.6 was as durable as rumour said it was, then the market for women's silk stockings might crash.

'Hosiery men scoffed at this fear, however, asserting that it would be several years before [this new fabric] can be widely sold in place of silk.' Hosiery men were wrong.

A run on nylons

In April 1939 DuPont launched the new fibre at the World Fair in New York. It was, the company proclaimed, 'created wholly from Coal-Air-Water'. Six months later the first four thousand pairs of 'nylon' stockings were put on sale, but only to residents of Wilmington, Delaware. The idea was to enable researchers to visit customers personally, and check what they thought. What actually happened was that hundreds of women from around the country booked into hotel rooms in Wilmington, or even rented apartments, or faked local addresses, so they would qualify to buy these new stockings.

Nylon stockings officially went on sale around the country on 15 May 1940, and even though they were twice the price of silk, the first four million pairs sold in two days. The problem, DuPont discovered, wasn't finding buyers, it was allocating what they produced so that the product didn't cause fights.

And then America declared war, and the government asked for the stockings to be given back.

A 'Hose Drive' was launched in November 1942 to collect used

A woman gives her used stockings to Uncle Sam.
She is now wearing socks.

silk and nylon stockings.* 'If of silk it will be used for powder bag,†
but if of nylon there's a secret', announced *The New York Times*, under
the headline 'Old Stocking Good for Socking Hitler'.

By February 1943, seventeen million pairs of used nylons had been

* They specified 'used' stockings rather than new because this was in essence a
recycling drive: the stockings were just as useful to the recyclers after being worn,
which meant that women got to wear their hosiery rather than feeling that it was
unpatriotic to do so.
† Powder bags contain the charges needed to fire large-calibre guns, and they're
placed within the firing mechanism. They have to be made of silk because silk
burns up completely, while other fibres – wool or cotton or viscose – could leave
a smouldering residue inside the gun, which might cause the next charge to
explode early.

collected, out of an estimated sixty-four million bought the previous year. The 'secret' need for them (it was revealed many years later) was to be melted and recycled into parachutes. For every two hundred and twenty-two pairs handed in, one airman would have his chance of a safe drop.

It wouldn't work today though – nylon stockings and tights now contain a certain percentage of another synthetic fibre, spandex (also known as Lycra, or elastane), which gives them elasticity, but which can't be separated easily from the nylon to allow them to be recycled into parachutes or anything similar.

More uses of nylon were found during the war, when there was scarcely any silk available. Mosquito netting, tents, even shoestrings. And flak vests, boot uppers, mechanic gloves, brush bristles. Nylon tyre cords on aircraft meant that they could carry bigger bombs; nylon backpacks could be carried further than canvas ones; and nylon ropes were so strong that they could tow gliders, moor ships, tether balloons and fasten anchors. It was even used in the special high-grade paper used to print US dollars.

Later, in the Vietnam War, nylon was a powerful tool *against* the Americans. Vietcong soldiers would carry hammocks made from parachute nylon, folded into a small packet about twenty centimetres by ten. With this, as well as a thin blanket and a square of waterproof cloth to hang above them like a canopy, the communist fighters could go anywhere, in any weather, and move around more quickly and silently than American troops with their huge packs and equipment.

Eighty years on, Carothers' and Hill's invention is still important. Of the one hundred and eleven billion kilograms of fabrics produced in 2019 more than five billion, just over 5 per cent, were nylon, while 6 per cent were rayon and similar. However, both these figures are dwarfed by a completely different kind of human-made textile, which makes up about 52 per cent of the fabric produced in the world today.

It is a fabric that was invented by chance, after a library journal fell open on a certain page.

Epiphany in the library

The Manchester Central Library opened in 1934. It is a round building based on the Pantheon in Rome, with a large circular reading room at its centre. It was built as part of a deliberately expensive

job-creation programme in the Depression. Manchester had been the City of Cotton for more than a century, but now global demand was down: people in India were refusing to buy its cloth, and competitors for cotton manufacture were emerging everywhere.

The library, nicknamed 'the Ref', became a popular place to meet in town. Being a public library, its opening meant that in the snip of a ribbon there was a whole new world of information, open to anyone who entered. I researched part of my first book in the Manchester Central Library. There is something about the roundness of the reading room that takes the sounds away. It's as if the architecture is pushing all the distractions up into the dome so that it's just you and the books and the ideas, and the silence that comes when you let what is inside you take over.

One day in 1935, a thirty-four-year-old chemist pulled up a chair at one of the tables in the Ref and opened a volume of the *Journal of the American Chemical Society*.

John Whinfield had studied at Cambridge and had then taken his first job in London with Cross & Bevan, the company set up by two of the three inventors of viscose. Cross had died in 1921, the year before Whinfield arrived, but Bevan was still around, one of the few fabled experimental chemists of the fabric world.

Now Whinfield worked for the Calico Printers' Association in Manchester, which had been formed at the turn of the century as a merger of about sixty small companies, with the idea that they'd all do better if they shared their research and development and their marketing resources, even if those weren't the words they used. Back in 1900, the members of the Calico Printers' Association were between them producing 80 per cent of Britain's printed textiles (which in those days was a substantial proportion of the world's printed textiles). Now, with the recession, they were struggling.

Until then, Whinfield's work had concentrated on the surfaces of fabrics – improving or reducing their lustre, or increasing their resistance to creases.

Now, as he flicked through the *Journal*, looking for an article on starch, his attention fell on one of the papers written by Wallace Carothers in 1929.* It spelled out the similarities in structure

* In his book *Studies in Innovation*, James Allen speculates that it was papers XII or XV in vol. 54 of the *Journal of the American Chemical Society* (6 April 1932, 1557–99) that Whinfield read that day.

between silk, cellulose and the big polymers you could get from petroleum.

Whinfield was mesmerised. He read everything he could find (which was mostly Carothers' other papers in the same journal) and later that year travelled to London to attend a lecture given by Carothers at the Faraday Society (now the Royal Society of Chemistry). It was the only occasion on which those two men – who would within a few years be responsible for the two most important human-invented fabrics in the world today – were ever in the same room.

Whinfield started experimenting with polymers. But the laboratory didn't have the specialist equipment that he needed – an X-ray machine, a molecular still – and he moved on to other projects. Then in early 1941, with the war on and new equipment available, he started thinking about polymers again. He knew that in one of his experiments Carothers had made polyesters from phthalic acid and that they didn't form crystals and they didn't make fibres. But what if they tried a slightly different acid? Terephthalic acid had been isolated from turpentine, a tree resin, a century earlier in France, and more recently it had been synthesised from oil. So far it had proved interesting but ultimately useless. But perhaps, if it was put in an oil bath, with ethylene glycol at a temperature of, say, two hundred degrees Celsius, it might be what they were looking for.

His young Scottish assistant, James Dickson, carried out the experiment.

'Anyway, he presently came running to me to say that the whole mass had suddenly set solid at this temperature', Whinfield remembered. 'This was to me, quite an unexpected piece of good fortune, but I was equally delighted to notice that the solid mass was opaque.' Cautiously, they raised the temperature until the substance melted again at around two hundred and sixty degrees. 'After some hours we ended up with a very discoloured polymer which, however, showed a feeble though quite definite tendency to draw' – by which he meant that it could be stretched into something like threads.

Nobody said anything: the substance was weak, and it was wartime so research resources were scarce unless directly applicable to military strength. They also didn't want to inadvertently give an advantage to Nazi Germany, whose scientists might well discover how to make the substance workable before they did. The discovery was marked Top Secret.

Soon after the war ended, Whinfield and Dickson applied for a patent and it was granted in 1946. Three years on, after royalties had been agreed with the Calico Printers' Association, the polymer, now improved and no longer discoloured, was launched by Imperial Chemical Industries Ltd – ICI – under the name Terylene. It was the first polyester fabric.

It was named after the terephthalic acid that was so important in the recipe, but there was also the echo of an older cloth – terry, used for towelling – that gave this entirely new substance an association, through a trustworthy-sounding name, with something that already existed.

ICI had a patent-sharing arrangement with DuPont and in 1953 Dacron went into mass production in the US. Same thing, different name. That was also the year that the word 'drip-dry' was first recorded.

Polyester was hailed as a 'miracle fabric'. It didn't crumple, didn't need ironing, resisted staining, and held inside it an unusual brightness after being dyed. It does have two problems. It has a tendency to hold static electricity. And it has a tendency to smell.

I remember a chemistry teacher at school saying that her first job was in a laboratory that tested deodorants. The chemists had to evaluate the different levels and types of odour generated by various fabrics and see how they were affected by each deodorant. The smell couldn't be measured by a machine. 'Just the scientists, sniffing underarms,' she told us, cheerfully. And if it was polyester, they'd dread it, because they knew it would be the worst.

We now know that this is because the substance has a tendency to encourage bacteria. Modern-day efforts to combat the issue tend to concentrate on anti-bacterial solutions, or on mixing polyester with cotton, wool or something else (as in my own favourite shirt), in an attempt to get the best of both worlds.

Clothes for walking upside-down

The first time I saw Neil Armstrong's Apollo 11 spacesuit at the Smithsonian Air and Space Museum in Washington DC I was disappointed. It seemed so ordinary, with its canvas-like fabric and uneven stitches around the pockets. Something in me had wanted these clothes that had been *in* space to be somehow *of* space. I thought back to that

'Those suits were mini spacecraft,' Neil Armstrong once said. 'If those suits failed, that was it.' Moon landing, 20 July, 1969.

night in July 1969 when I watched those two white-and-grey figures float like magical beings across the screen, and, as the black-and-white TV flickered, it's perhaps not surprising that my four-year-old mind equated them with angels. So when I saw the spacesuit again at the age of twenty, maybe it's no wonder that I expected something more ethereal. Like a seamless robe, perhaps. Not actually sewn.

I went back many years later and this time those stitches were what I liked most. I'd since learned that the spacesuit had been made by a small team of women borrowed from the production line of the International Latex Corporation of Delaware, better known as Playtex.

It might seem a startling juxtaposition – a maker of bras making suits for astronauts – but in the 1950s and 1960s it wasn't such a huge leap from underwear to space-wear. Bra and girdle companies had emerged in the 1950s from companies commissioned to make anti-gravity abdominal belts for air-force pilots, first in the Second World War and later in the Korean War, to stop them fainting as their blood

pressure changed erratically during high-tension aerial combat. It had required only slightly upside-down thinking after the war to adapt their factory production lines to making other sculpted and structured clothing. So for Playtex to make spacesuits was less of a step into the unknown and more like a returning, in a way, to origin.

NASA's clothing engineers had initially imagined people wearing something more armour-like in space, more like what space explorers in comic strips were wearing. But real-life astronauts found hard plastics uncomfortable. So with the team from Playtex, they came up with a softer, flexible but sustaining suit, which would allow astronauts to move more freely. The mood was in fact fairly similar to those sales pitches that the advertising creatives on Madison Avenue were coming up with in the 1950s to promote a new kind of women's underwear ('You can be Free! Lithe! And Glamorous … with Heavenly Comfort').

The women on the spacesuit production line weren't told what they were being asked to do until they were actually doing it. In 2019 several of them, then in their eighties, were interviewed by CBS News to explain the task. They had to sew a total of twenty-one layers of neoprene, nylon, spandex, stainless steel, glass-fibre, Teflon and Mylar (a kind of plastic) – all gossamer thin – on an old-fashioned Singer sewing machine, which was the only kind of sewing machine that could do the task. They did it extremely slowly.

'Our sewing shop didn't go brze-brze-brze-brze like commercial sewing shops,' project manager Homer Riehm said. 'It went kerloop, kerloop, because we were interested in accuracy.'

The work was stressful. All those fabrics had to be sewn to a precise tolerance of one sixty-fourth of an inch, about 0.4 millimetres – tolerance being the maximum room for error in a garment's measurements. For clothing, this is usually around one eighth of an inch, so this was four times more demanding. Anna Lee Minner said she often went home and cried, 'because I knew I couldn't do it … Because I was scared'. They knew that if they made a mistake, a man could die. They knew that theirs were some of the hands responsible for helping those strange white angels from the space programme come safely home.

'Those suits were mini spacecraft,' Armstrong once said. 'You were one pin-prick away from death. If those suits failed, that was it.'

Fabric for the moon itself

It was nylon, in the end, of all the possible fabrics in the world, that was left behind on the moon. According to fabric historian Anne Platoff, the nylon flags planted by the astronauts for the TV cameras were never intended to last, or even to be left behind. Very little thought had gone into it at all. They had just been ordered off the shelf, from a government supply catalogue.

Nobody has stood on the moon since December 1972, so we have no idea what has happened to those flags. Platoff supposes that the combination of intense sun and the impact from micro-meteors has darkened and tattered them; others speculate that they've been bleached by the extreme ultraviolet rays.

Symbolically – given that the things can't be removed right now – the second seems the best scenario: flags without a nation; flags that can no longer easily be seen. The moon is, after all, for all of us. Or perhaps it's just for itself.

Improving tyres, inventing something else

Back on earth, new fabrics were needed to solve new problems. In 1964, DuPont predicted a world gasoline shortage. If fuel costs soared then people and companies would care more about how many miles per gallon or kilometres per litre they got, and one way to improve that was to have tyres and vehicles and aircraft that were lighter and stronger, requiring less energy to propel them along.

An Experimental Station team set to work. Their aim was to make tough and light fibres to take the place of tough but heavy steel wires in tyres. They had been asked not to work with sulphuric acid because it was too costly. (Not because the acid itself was too expensive but because, by the 1960s, the equipment needed to keep sulphuric acid safe and responsibly disposed of all added to production costs.)

One of the senior chemists in the team was Stephanie Kwolek, who had been at DuPont since 1949. It was the golden age of polymer chemistry, mostly because there wasn't any pressure, and 'even if there was pressure, it generally didn't get down to our level'.

In 1959, she and her boss Paul Morgan had published a paper on 'The Nylon Rope Trick', something that is still used by teachers to demonstrate not only how nylon is made, but also how chemistry itself is about manipulating the structural magic of transformation.

From the viewing benches in a school lab, the Rope Trick looks like the teacher is pouring one clear liquid (xyclohexane) over another clear liquid (diaminohexane and water), and then a pool of silvery film forms at the place where they meet. When the film is picked up with tweezers and pulled gently upwards, a thread follows, like a never-ending length of bright translucent string.

I saw it at school. Chemistry up until then had seemed a subject devoid of enchantment, which was surprising, for a subject born from alchemy. Yet there was something about *this* experiment – the smoothness of the way in which a something emerged from an almost nothing; the apparent confidence of this material in its own transformation – that made me feel lifted myself. As if I and this strange molecule were the same thing, as if I were part of how this impossibly ancient remnant of life was changing into something else. Then it switched, and I was back sitting on a tall stool at a tall table stained with ink and etched with the compass scratches of those who had sat there before me.

The Kwolek and Morgan Nylon Rope Trick probably turned many young scientists into material engineers. It probably helped others see for the first time a poetry in science.

But now, at the end of 1964, things were not going so smoothly.

Kwolek was trying, as she had tried on so many other days since the summer, to get long chains of dissolved polyamides from a polymer called 1,4-B to spin into a super-strong fibre. And she was finding, as she had found every other time, that the two-hundred-degree Celsius heat needed to make the polymers dissolve made the fibres weak. If the temperature was any lower, they didn't dissolve at all.

Then she noticed an odd solution from just one of the many experiments. It wasn't like the others, which were viscous and transparent. This one was watery and cloudy, 'and you thought, "Well, this is one of the no-no's as far as spinning is concerned".'

She filtered the solution and it was still cloudy, then she put some on a spatula and it flowed easily, but in a different way from water, 'which usually drips after a while'. It was too interesting to ignore.

She told the man in charge of the spinning equipment that she wanted it to be spun. He refused. 'He looked at that thing and he said "It's too thin. It's cloudy. It's going to plug up the holes."'

So she went back to her own lab and spun it herself, through a

hypodermic syringe. And what she made that day was a substance that, when she heated it, was unusually tough.

She went back to the laboratory assistant.

I tormented him for a while, and he finally conceded and said he would spin it. I think he probably thought, 'Well, I'll give it a try and if it fails, then that's the end of that.' We spun that 1,4-B solution and the fibre was very strong. It spun beautifully. Then I submitted the fibre to the physical test lab, because every fibre we make is tested for strength.

Tests were done by clamping a fibre at both ends, then stretching it until it snapped. But this new fibre was so strong that instead of breaking, it just popped out of the clamps. It was only when the lab technicians devised new kinds of clamps that Kwolek discovered that it was five times stronger than steel.

Its chemical name was polyparaphenylene terephthalamide. DuPont launched it in 1971 as Kevlar. It did not, as some have speculated, stand for Kwolek's Experimental Viscous Liquid Aramide. 'Like many of our other brands,' a DuPont spokesperson told me, it was just 'a random generated made-up word for trademark ownership.'

Kevlar would resist flames and would protect structures against bombs; it would replace hemp to make the strongest strings for archery. As a bulletproof vest it would save so many lives that there is now a Kevlar Survivors Club for police officers in the US.

It would rarely be used in tyres, though. It was just too good.

A thousand per cent stretch

One synthetic fabric discovery had nothing to do with imagining. It had nothing to do with how things that are visualised can sometimes be made to become real. It was more unexpected than that.

One night in October 1969, thirty-two-year-old Bob Gore was alone in the laboratory of the family firm in Newark in Delaware. It had been set up by his parents Bill and Vieve Gore back in 1958 after his father had left the Experimental Station to develop a new product he had had an idea for. That one was based on a tough, slippery DuPont-developed plastic – called polytetrafluoroethylene or PTFE or Teflon – which was about to come out of patent.

'And it stretched a thousand per cent.' Bob Gore recreating the discovery of Gore-Tex for the Chemical Heritage Foundation, now the Science History Institute in Philadelphia.

Only three months earlier, all of Gore's colleagues had gathered around their TVs to watch their own PTFE cable coverings – fire-proof, cold-proof, heat-proof and the rest – landing on the moon. They had also invented similar cable coverings that were being used for most of the new computers being produced by IBM (which in the early days had so many cables hanging out the back that it was hard to get the housing to fit it all).

Now Bob was determined to improve on the product. He had an

instinct that he needed to start by stretching out Teflon rods to make them thinner and more flexible. He slowly pulled them out by hand but every time he did, however careful and gentle he was, the rod would snap. It was keeping him late in the lab night after night, trying to puzzle out what to do.

Other human-made fabrics were invented when scientists and companies started thinking in different ways. But for Gore it was only when he stopped thinking that something amazing happened.

'I was frustrated because everything I seemed to do worked worse than what we were already doing,' he told an interviewer from the Science History Institute. 'I ... said to myself if you won't pull slowly I'm going to give you a jerk – and it stretched a thousand per cent. I was stunned.'

When he went back the next morning, he called in the chief engineer and then 'pretty soon everyone in the plant was doing the experiment. And when I showed my Dad this experiment he immediately could envisage all the wonderful things that could be made out of this material.'

When you see him on video re-enacting that night, the material looks like chewing gum. They called it Gore-Tex – it was his father's idea – and he used to joke that ever afterwards he was just known as Bob Goretex. Today it is used in biotech, surgery, cars, computers, guitar strings and space, as well as conserving illuminated manuscripts and making outdoor clothing that has a decent chance of keeping you dry.

It has also been controversial.

In 2005, DuPont was fined more than sixteen million dollars for covering up the fact that one of the main ingredients of Teflon (which itself is one of the main ingredients of Gore-Tex) was seriously hazardous for workers and the environment. It has since changed the formula. Also, in common with just about every other kind of waterproofing fabric (as well as microwave popcorn bags, carpets, pizza packaging, some kinds of dental floss, and other products designed to repel water or oil), making Gore-Tex clothing historically involves using particular kinds of fluorochemicals, or PFCs, which can be seriously damaging to the environment. In 2016 the product was the most namechecked in a damning Greenpeace investigation into PFCs in outdoor gear, arguing that some of these chemicals have been proved to cause harm to reproduction, promote the growth of tumours and affect the hormone system, and are found everywhere in the world,

including in secluded mountain lakes, and in the livers of polar bears in the Arctic. The following year, the company started working with Greenpeace to reduce its use of those PFCs; it plans to have stopped using them entirely by 2023.

Gore-Tex made the family rich. By 2018 Bob Gore was listed by *Forbes* as the richest man in Delaware. Which, in a state packed with du Ponts, is not bad going.

Gore had a recommendation for anyone who thinks that they've invented something good.

'Jump in and see if you can swim. You can study something and not foresee all the problems but the moment you jump in your energy goes way up as you try and concentrate on not sinking.'

What's in a name

Gore-Tex and Kevlar weren't the only science fiction supervillain-moons-of-Jupiter names applied to new fabrics. Naming had always been a problem in the industry.

Beadle, Bevan and Cross had struggled back in 1891 when they called their invention 'viscose', which is almost as awful a name as it is a process, coming from the same place as the Latin for birdlime, the substance smeared on twigs to catch songbirds. It would be like real silk being named 'gummy' or 'wormspit', as if buyers actually want to know what a substance is in its early, unpretty, stages. For a while manufacturers tried to call it 'glos', as voted for by the US public, though that name didn't even make the Oxford English Dictionary. Artificial silk, which did, was probably the best name, particularly in its abbreviated form 'art silk', which seemed to elevate it from something merely industrial to something from the imagination, but the sellers felt that it suggested the material was a poor imitation of something else, not something amazing in its own right. In the beginning, the names were differentiated by process – art silk from the French technique, viscose from the English – but in 1924, a naming committee met in the US to decide on a generic word for the fabric, regardless of how it was made. Twenty people. All men.

What might I have called it, this shiny, supersoft cloth made from puddles of jelly? Shimmersilk? Dazzle? Fabulose? Or maybe swansilk, after Hannah Swan, who was the first person to make a fabric from it.

The committee decided to call it rayon.

'We started with no idea', said Samuel Salvage of the American Viscose Corporation later, 'but we felt that a two-syllable word would be preferable, and a member of the committee suggested that as the product had a brilliant luster, one syllable should denote brilliancy, and also suggested that that syllable be *ray*, and we finally concluded to tack *on* to it, and thus the word rayon was born.' Meanwhile, the Germans called it Glanzstoff, from an old word meaning splendour. We get our word gloss from Glanz. And glamour. And gleam. And we also get the verb 'to glance', as in to catch a flash of light.

Ten years later, DuPont's naming committee had the same conundrum when Carothers' invention was still just Fibre 6.6. A few votes went to delawear, and we also narrowly escaped having norun, rayamide, silkox or dusilk, before they landed on another nonsense word, nylon. Company chemist William Hale Charch wanted it to be duparooh to stand for DuPont Pulls a Rabbit out of a Hat, and I'm sorry that more people didn't agree. I'd like a world filled with duparooh backpacks and ten-denier duparoohs; though by now they'd probably just be 'doops'.

Here are some of the other synthetic textile words: vinyon, Saran, metallic, Lurex, Nomex, Gore-Tex, modacrylic, olefin, acrylic, Tyvek, aramid, PBI, Sulfar ... names tossed like coins from conference rooms. Today most of us can identify only a few; most of the others could just as well be baddies in a comic strip. But there are patterns. Some are acronyms in disguise as words, some are words in disguise as acronyms. At least one has the name of its inventor, at least one is an anagram, and most of the others have a combination of two words in various languages to make something that someone in a marketing department once thought people would want to buy.

It was chemists, mostly, who were creating or approving these names so no wonder the process was mostly either to mix up letters and shake or to combine different elements and see what happened.

It's worth spending time on names though. They can add glamour, or a false familiarity. Or the subtle tint of green-washing.

Bamboo or not bamboo

In Hong Kong's hills on a sunny day, you can sometimes hear bamboo growing. A creak, then a squeak and then a rustle as the joints settle down. Some days it can grow fifty centimetres; no wonder it makes a

noise. It's not fussy; even if you're not a deliberately organic farmer there's not much need for fertilisers or pesticides. It's a big, strong, ethical, grass: you can eat its shoots; you can use it as construction scaffolding; it absorbs plenty of carbon dioxide. Which is why, when I first heard of bamboo fabric, I liked the sound of it.

And when I got to touch it, I found that it feels nice, like clouds or gentleness.

I imagined that somewhere in Asia, farmers were cutting bamboo from great fields, and that they were then treating it like jute or flax: retting it, scutching it, heckling it, but always keeping the 'it' to it, allowing the material to retain its essential character.

Some bamboo fabric – a very little bit and nothing that feels very soft – is indeed made that way. That kind is also called 'bamboo linen'.

But most is no more bamboo than cotton viscose is cotton, or silk is mulberry leaf. It has moved on; it is something else now and the transformation has involved acids and gloop and spinnerets and the need to dispose of toxic hazardous waste. In short, almost all bamboo fibre is not only *like* rayon; it *is* rayon, just (as with so much of the story of imagined fabrics) by another name. It was launched in the early 2000s after research by universities in Beijing to identify how one of China's great natural renewable resources could have a new life as something to wear.

If you've bought some bamboo viscose and intended to buy regenerated fibres anyway, it's fine (except that in the US at least, according to the Federal Trade Commission, 'it can't be called "bamboo"'). Of all the raw materials used for cellulose, bamboo is better for the environment than most. There are improvements every year in the management of waste and chemicals across the whole rayon industry. And, like other types of rayon, bamboo fabrics do biodegrade.

However, if you thought you were buying something with the scent of the bamboo forest about it, something more natural than rayon, something with the original antibacterial properties of bamboo, then it isn't fine.

If you have some then keep it: it's safe to wear and it exists now so use it and use it and use it. And perhaps when the time comes to replace it there'll exist a reliable system of assessing whether companies have used responsible processes – processes good for workers and good for the earth – to make this useful grass into thread to be woven into cloth.

Stand upside-down again

When Carothers and Kwolek and Whinfield and Gore and all the others had their flash-paper moments and invented their incredible fabrics, most could never have imagined the landfill, the waste and the pollution or indeed the dangers involved in making things that last for centuries and do not slide back into the clay.

Today we don't have to imagine. We can see it.

A terrible parody of a kite

I was walking in the hills above Dharamshala in northern India, where many of the houses and roadways in the mostly Buddhist villages are wreathed with *khadags*. These are the usually white Buddhist ceremonial scarves given as greetings to visitors, or hung in the wind as blessings. In the past, *khadags* were usually silk, although cheaper ones were cotton gauze. Today they are almost all nylon or polyester. So while a few decades ago they would last a year or two and then decay, now scarves clutter almost every mountainside.

I turned a corner and saw a sparrow caught in a dirty white *khadag* that someone had hung from a small tree. The yarn had unravelled from the fringe and had become tangled around the bird's leg. Each time the bird tried to get away, the nylon tightened. It made a terrible parody of a kite. I climbed the tree and by the time I caught the bird a crowd had collected.

I cut the main bit of thread with my penknife and passed the sparrow down. We had to hold its fluttering body in a towel while we tackled the knotting on its legs. We didn't manage to remove it all. The sparrow flew away, and, ever since, if I'm given a nylon *khadag* I dispose of it, wrapped in something else, so it will take no prisoners before it arrives to stay in landfill, not decomposing for hundreds or thousands of years.

Reconstituted and synthetic fabrics have given us so much. They've saved lives during surgeries or in dressings or as bulletproof vests or airbags or parachutes, and they continue to save lives. They've given us cheap and functional and wonderful and seemingly endless clothes, and they've enabled us to dye them all the colours of an oil slick. They've given us car seats and stockings and elastic and sacking and running clothes and waterproofs and so much else of what we think we want and need.

But although rayon fabrics are made of wood pulp and decay like cotton, many of the other human-made fabrics are from petroleum and don't decay for a very long time. And some of them (and especially polyester fleeces) leave tiny plastic beads in the sea for fish to eat and then – when the beads start coalescing, as their chemical nature compels them to do – to choke on. And when we eat those fish and consume that water, the same thing might in the end happen to us.

The clothes moth will not fret them, and although they are useful, and often they make us safer, and dryer, and more protected, making them and disposing of them is hurting the earth. And its animals. And its people.

We need to find a way of doing both things much better.

Weaving with nylon

At my niece Charlotte's wedding, I'm sitting next to a woman who's spent more than fifty years working in Yorkshire textile factories. Her name is Rose Ellison.

'What kind of fabrics were you weaving?' I ask.

'I started with cotton,' she says. 'Then I moved on to nylon.'

What was the difference?

Rose pauses, considering.

'Cotton really *feels* like fibre; it reaches out and extends,' she says, moving her fingers to suggest something you could push against. 'But when you weave with nylon there's nothing to make it catch. It's too smooth, too quick.' She pauses again. The speeches are about to start. As the room settles into silence, she leans towards me and whispers.

'Weaving with nylon is like weaving with nothing.'

11

PATCHWORK

In which the author learns to make a nine-patch.

'Hey! This book isn't a patchwork like you promised,' shouts a child from the crowd. 'It's just a string of words, one after the other.'

The nine-patch

I learned how to make a real patchwork while I was researching this patchwork of a book. I learned how to make it at Gee's Bend, Alabama, a place named after a nineteenth-century slave owner and a loop in the Alabama river so deep that it's like three sides of a square. The settlement was bizarrely renamed Boykin in the 1940s, after a white congressman, now remembered for his adultery, alleged bribery, and his opposition to the Civil Rights Act. But most people today still call it Gee's Bend, and it's famous for its astonishing quilts.

I turn up at Gee's Bend, hoping to learn how to make them, though my emails and real letters don't seem to have arrived, and I haven't got through on a phone.

I know I'm heading in the right direction because I see big wooden banner boards at intervals along the road, printed with images of some of the patchworks that made this place famous. They're all around: it feels like a pilgrim trail. I'm not sure where I'm going, but the person I ask jumps in her car to lead the way and I follow to a weatherboard community hall with 'Gee's Bend Quilters' on a sign by the door. There's a small shop to one side and a main room with two quilting frames and several sewing machines and piles of fabric everywhere, on tables and spilling out of dustbin bags on the floor. Two women are there working side by side. One is the manager of the Gee's Bend Quilting Collective, Mary Ann Pettway. She says she doesn't give lessons but we can talk, so we sit down. I tell her how

Above: Mary Ann Pettway at her quilting frame.
Below: The Gee's Bend community hall.

this book started with a plan to make a patchwork to get over my father's death, but then my mother died first and I still don't know how to make one.

'I'll teach you the nine-patch,' Mary Ann says, suddenly. 'My mama taught it to me when I was six or seven, and I'll teach it to you … I never do this usually,' she says. 'But I'm sorry about your mother and not knowing.'

The way she learned is by watching so that's how she will teach me. She starts by cutting nine squares, five of one colour, four of another – 'don't worry if they're even' – then sews them by machine into three lines of three, irons them (only on the back so that the front doesn't get shiny) then joins them into nine.

I sew the first three sets of three squares together. I haven't used a sewing machine for a while. Before I iron, I open out the fabric and, without thinking, press the seams open. Mary Ann stops me.

'Never open out the seams. It makes them weak,' she says, folding them back. This does mean that, as the patterns get bigger, I'll have to make sure a seam folded in one direction doesn't find itself needing to fold in another direction later – which sounds implausible but is something I'll find myself doing over and over. 'It's just practice,' Mary Ann will say. 'You can always undo.' I become good at undoing. There's no pattern or template to cut around; everything's done by eye; the playful thing is to make it a bit accurate but not too much, and then to subvert it just enough.

Once I've done a few nine-patch squares, she shows me how to sew a panel on the top and another on the bottom in one of the two colours. For this she uses a grid, to get the corners right-angled. 'Within a block doesn't matter, but if you want to make it easy for yourself, then make sure the edges fit.'

There's a TV at the end of the room. When visitors are expected, which is often, it plays an hour-long documentary on a loop. The audio track of the story it tells, over and over, becomes the backdrop to my days at Gee's Bend.

Gee's Bend

In the Great Depression, Gee's Bend was one of the poorest places in America. As the cotton price collapsed – from forty cents a pound in 1920 to just five cents a pound eleven years later – many people

living as tenants on the land where their grandparents had been slaves were forced to borrow money to buy cotton seeds, fertiliser and basic equipment. Then in 1932 a merchant over the river in Camden died. Most Gee's Bend families owed him money. His widow sent in the bailiffs and they took everything that could be moved: every piece of equipment, every chicken, every pig, every bucket, every cart, every peanut, every sweet potato being stored for winter. And when they swept out of town with their trucks full of other people's stuff, they left the farmsteads empty, just trash on the ground and hunger setting in. That winter, families survived by fishing and gathering berries and picking up Red Cross parcels sent to the Alabama ferry landing. If the landlord hadn't allowed everyone to stay rent-free they might have starved to death.

Most houses in those days were made from rough planks, with the wind whipping through the gaps in the floor. The women made quilts with every fabric they could find: old work clothes, the tails of shirts, the parts of dresses that had been protected from wear by the aprons worn over them. They stuffed them with raw cotton that they'd whipped into softness, and they sewed them fast so that each bed could have several quilts.

At the end of the 1930s, Gee's Bend qualified for a radical federal assistance programme. The government bought land and gave low-interest loans to families to buy parcels, with each lot including some woodland for timber, some pasture for animals and an area to grow cotton and corn. This meant that during the civil rights protests a quarter of a century later, nobody could be thrown off the land for insisting on their right to vote, unlike in other parts of the South. It also meant that families would stay, and there would be a continuity that other African American communities, with most people tenanting the land, would never have.

The Freedom Quilting Bee was set up in 1966 by the Reverend Francis X. Walter, who'd come to support those black families in Wilcox County who didn't own their own land and were being evicted for joining in the march from Selma to Montgomery demanding equal treatment. When he arrived, he saw quilts hanging out to dry and was curious about who was making them, and whether they could be part of the revival plan for the area.

The first plan was to buy them, and auction them in New York, returning the proceeds to the community. But the quilts were

unusually good quality, and soon there was a twenty-thousand-dollar contract from Bloomingdale's in New York. Other contracts followed, and by 1969 a sewing centre was set up on the County Road, near Rehoboth to the north. It wasn't easy. Department stores wanted standard patterns, along the lines of the traditional white quilting designs brought to America in the early years by Dutch and British immigrants. And they wanted them to be perfect, sending back anything they felt was not. Some at Gee's Bend did this well. Others were frustrated. One quilter, Annie Mae Young, didn't get on with it – 'too many little blocks' – and although she saw her sister making regular money from it, she never joined.

In 1972, the Bee was commissioned by the mail-order company Sears to make corduroy sham pillows – cushion covers with frills around their edges. Corduroy is characterised by its ribs, or wales (we use a variation of that word in 'weals', the marks on skin after being whipped). They mean that the fabric can be easily cut along the warp – often with a satisfying *szzrrrip* – or slightly less easily along the weft. But when you cut it on the diagonal, it frays. It's also tough to sew. So when the Sears corduroy off-cuts in their brilliant colours found their way into people's homes to be incorporated into their own quilts, it guided them towards using big blocks and strips, and contributed to the particular shapes and forms that are the wonder of Gee's Bend.

In 1992, a photographer arrived. Roland Freeman had worked for *Time* magazine and the Magnum photo agency. Then in his fifties, he was documenting African American quilts from all around the South for a book that would be the first large-scale survey of the subject by an African American. In Gee's Bend, he interviewed Annie Mae Young and took a picture of her and her little great-granddaughter Shaquetta, standing outside her house with two quilts thrown over a woodpile behind them. Six years later, a white collector of African American art, William Arnett, was arrested by that photograph.

The main quilt had a wide frame of worn blue denim strips, and the centre was two big squares next to each other. One had yellow and red stripes; the other brown and red stripes, almost as if it were the first one in shadow. The result was vibrant and unexpected, and reminded Arnett of abstract impressionist art. Arnett obtained an introduction to Young and drove to Gee's Bend. He asked what other

Gee's Bend quilts: American treasures.

quilters there were in the area, and eventually made contact with more than a hundred and fifty, documenting seven hundred quilts dating from the 1920s to the 1990s. Soon, there were exhibitions being held in several major US museums; in 2006, the US Post Office produced a series of ten stamps with images of the quilts; the discovery of Gee's Bend patchworks was hailed as one of the greatest finds of 'undocumented' art in America.

Mary Ann told me how she spent most of her working life making uniforms at a sewing factory near Selma. Between a mortgage to pay and looking after her children, she didn't have time for quilts. But she had a friend whose grandmother, Arlonzia Pettway (no relation to Mary Ann), was a star quilter. She used to talk about the trips they all went on, the museum openings, the workshops they gave, and one day Mary Ann joked that she was tired of hearing about these good times: she wanted to start having a good time too.

'So get quilting,' Arlonzia said.

And she watched for a bit what Arlonzia did, and recalled her childhood sewing with her mother, and then she got quilting.

Barnett Newman, Josef Albers, the rest

Towards the end of the documentary, which has been playing all the while, there's footage from one of the museum shows. 'There's two reasons why this show is so important,' we hear a curator saying.

> One is the art: it's the quilts; seeing the compositions; the bold patterns; the asymmetry. These quilts are fantastic works of art ... They had no influences ... a lot of people made connections with these works and works of modern contemporary art. [But the quilt makers] didn't know Barnett Newman's work, they didn't know Josef Albers' work. These designs came out of their heads.

Later I ask Mary Ann if she's ever looked up Barnett Newman and Josef Albers – given that she hears those names just about every hour, hundreds of times a year – as examples of what she and her neighbours at Gee's Bend had never seen. She grins.

'Nope.'

She looks at what I've done and nods. Tomorrow she'll show me courthouse steps, and prison bars.

Courthouse steps and prison bars

I walk to see the river, where the ferry had been suspended in 1965 to stop people voting and was only resumed in 2006. When I come back, there are visitors; one asks me what I'm doing at the collective, and I tell her about learning to make a nine-patch.

'You'd better take care you do it real neat, now you're learning from an expert,' she says.

Mary Ann and I catch each other's eye and smile. Because I'm not looking for neat; I'm looking to find how not-neat is done, by someone who's a master at it.

Mary Ann shows me courthouse steps. You start with a blue square sewn between two white half squares, then you turn it by ninety degrees to add a blue band at each end, then turn another ninety degrees and add another two bands in white and repeat and repeat. Simple as they are, as they grow, the steps of the blocks tease your eyes, flipping from one shape to another like that old drawing that could be a duck and could be a hare, a moment which, in some cultures, is said to be the place where magic appears.

My sampler (*top left*: courthouse steps; *bottom left*: nine patch; *right*: prison bars with triangle) and a patchwork by Mary Ann.

We're doing prison bars – alternating strips of two colours – when Mary Ann tells me how she was imprisoned when she was a child. It was the 1970s, she was fourteen and there were still businesses down in Camden where African Americans couldn't get jobs even when there were vacancies. So they protested, and as they walked and sang and prayed they were tear-gassed, and arrested.

'I never expected that tear gas,' she says.

She went to the jailhouse downtown but one of her sisters was older and she went to the prison camp with the adults.

'We was some of the younger ones,' she tells me. 'But we wanted to show: you never can jail us all.'

Her older brother, Henry, had been on the bridge out of Selma on Bloody Sunday, she says.

That was the day in March 1965 when six hundred civil rights demonstrators marching peacefully towards the State Capital of Montgomery were attacked on the Edmund Pettus Bridge. They were met by state troopers and the Ku Klux Klan, with tear gas, billy clubs and whips. Photographs of one of the organisers, Amelia

Boynton, lying unconscious on the ground after being beaten were sent around the world. They – and the march to Montgomery, which was resumed a few weeks later – were among the pivotal moments in the Voting Rights Act later that year.

More than fifty years on, that bridge is still named after Edmund Pettus, a Ku Klux Klan leader, I say.

'Uh huh,' Mary Ann says. There's silence for a while as she sews and I lay out pieces of fabric. And I think about the road I had driven up, from Montgomery to Selma, and all the fears and fury marchers must have had, and she no doubt thinks about her brother Henry, and injustices, and being in a jail cell that day.

'If we as Black people were to feel angry, there would be a lot of trouble,' she says, after a while.

My blue and white prison bars are not long enough to fit onto the other blocks, so I add one more – but this time it's not a pure rectangle but a rectangle with a triangle inset, to break up the regularity. Mary Ann shows me. 'You don't want that triangle too long and you don't want it too short, you want it just right.' Then she looks at the composition and goes into a humming half dream as she considers how to join it together: she punctuates one of the dark-blue linking strips with a parallelogram of white. It's as if to keep the whole in balance, you have to put the individual elements out of balance. Like life, I think.

The tabletop

'Honey, here's one I love!' A woman comes out of the salesroom carrying a square piece about seventy centimetres long. Mary Ann calls it a 'tabletop' but size-wise it's more like the cover for a fairly large tray. It has courthouse steps like a Mayan temple, in gold and white and maroon.

'Hmm,' her husband says, noncommittally.

I feel for her. It's like trying on clothes or looking at art you're not sure of in front of people you don't know. You want to be thought to have taste but you also know you're just guessing at the rules. She brings it to the table and looks at it. Then turns it.

'Maybe it's this way round. No. This way. No ...' She flips it and looks at the label on the back guaranteeing it was made in Gee's Bend, then turns it another ninety degrees. 'I think it's this way.'

'Don't matter which way you have it,' laughs Mary Ann.

'I think the artist wanted it *this* way,' the woman says, a little defensively, back where she had started.

'It's yours, then it's yours, you can hang it any which way,' Mary Ann says.

We all look at the little patchwork.

'Oh,' says the woman in a deflated voice. 'It's symmetrical.'

'Nothing wrong with that,' says her husband.

'NO,' she mouths at him desperately. 'It's symmetrical …!!'

Museum-quality Gee's Bend quilts are not symmetrical; she knows that for sure. She goes back into the other room and ends up with three beautiful little quilts. 'A thousand dollars, nearly,' she says ruefully, showing me. They are all definitely not symmetrical.

The spirit of the cloth

Another couple comes in. The woman looks at the patchwork Mary Ann has just made as a demonstration for my lesson. It has a nine-patch and courtyard steps and striped prison bars all in exuberant strips of black, red and white. And I know what she's going to say, because I agree. I want it too.

'Is this one for sale?' she asks. Mary Ann says she doesn't know when she'll have time to make it up into a quilt, but the woman is still keen to buy. She agrees to wait for as long as it takes, and they settle on a price. 'Now it needs a name,' Mary Ann says. She says some of the things that go into a name are the name of the design and the history of how it was made. Or sometimes just what comes into the maker's mind.

So today, probably in New England, there's a little quilt made of blocks and strips and triangles in red and white and black and it's called 'Victoria's Nine-Patch'.

Later, as I unpick yet another seam, I think about that. The buyer from New England knew it; I knew it; that little cloth had so much life in it, we could almost hear it shouting. In her autobiography, Barbara Hulanicki, the founder of the 1960s fashion company Biba, wrote about that quality of some pieces of cloth. A sample made by hand in the workshop might have a sense of personality to it that the pieces that came in from a factory wouldn't, Hulanicki said. She would pat and talk to rails of dresses 'to put some life in them … Even a driver

Quilt designs are printed up as billboards throughout Gee's Bend.
This shows the 'Housetop' twelve-block 'half-log Cabin' sewn from
cotton, wool and corduroy by Lillie Mae Pettway (1927–90) circa 1965.

can make a difference when he loads up a van. If he treats the clothes
with respect they seem to come to life.' A few of the manufacturers
had a magic to the clothes they produced and their deliveries would
always sell out first. 'Even if the garment was a good design, some-
thing that didn't sell took on a sad look. A winner seemed to have a
halo round it.'

Back in the UK, I'll find the book – Roland Freeman's *A Commun-
ion of the Spirits* – whose photograph of Annie Mae Young kicked
off the new life of Gee's Bend quilts. In 1940, when he was three,
Freeman learned about his late great-grandmother's 'healing quilt', a
bold red and black patchwork used when people were ill. That had a

particular quality to it too. He kept asking questions about that piece of cloth. When he was nine, his grandmother – the daughter of that special great-grandmother – told him more. She told him about 'the old ones', the spirits of the ancestors. She said that while the healing quilt had been made by her own mother some of the pieces had been worn by her mother's mother, who was born and died a slave. When there was a birth in the family, even in the 1940s, Freeman wrote, the baby would be put on it to connect them with the old ones and gain that ancestral protection. Some babies were happy, others screamed, and from that the older women predicted what kind of life might be ahead. What did *I* do? he asked. 'You cried when we took you off it,' she said, 'Maybe that's why you're always asking questions.'

And the quilting

'Are you ready to try some quilting?' Mary Ann asks. It's my last day.

'I am,' I say. She asks me first to sew four white lengths around one of my practice patchworks ('I looked at all the old pieces in the museum and they've almost all got white frames,' she says, in explanation) and then put a temporary edge around that of a few extra centimetres, in bright pink chintz. That pink outside frame will be cut away later but meanwhile it makes the edges of the quilt easier to work. She cuts polyester batting to the same size, and beneath it a matching piece of thick white cotton. Everything is fixed in place with a plastic frame she'd bought for her grandson to practise on. 'It's like a quilt sandwich,' she says. 'This is the top slice, this is the bottom slice, and right here in the middle is the filling.'

And now we are actually going to sew with our hands, not with a machine.

Mary Ann doesn't use a needle threader. 'Tried once; tangled up'. Her method is to hold the needle still and push the thread towards it; not the other way, which is how I think I've always done it. 'You don't have to look,' she says. 'You just have to trust. It'll find its way.' I try and, after a few goes, I see that she's right.

There's another trick. She winds the thread round the needle six or seven times. Then, holding the twists tight and imagining they're the body of a piece of cloth that she's sewing into, she pulls the needle through, guiding the twists right along the thread, and a knot forms at the end. Cut the tail off, and it's ready.

The first thing is to push the needle into the back of the quilt and out of the front, then tug until the knot goes right through the first layer and is hidden inside the body of it – 'listen out, you can hear it pop' – and now we're ready to quilt. I grow to like that pop. It's satisfying. It sounds like a joint clicking into action. Now that I know what to listen for while Mary Ann is quilting, I hear it quite often. I imagine that tiny sound in communities right across the world for hundreds of years. Pop, and the work begins.

When I was little and my brother had just been born, I was taken by a family friend to stay with her parents in a mining town in South Wales (presumably to give my mother a break). We travelled by steam train, one of the last, and at night, before her mother sang me to sleep, we counted how my bed had five quilts, and I learned the peculiar heaviness of that old way of sleeping.

Those quilts in Wales were not patchwork but wholecloth: two pieces of cloth sandwiching a filling of carded wool, with the skill being the fine running stitches holding all the elements in place. They are often white-on-white or cream-on-cream, and the appreciating of them is a subtle thing, like you have to concentrate, or wait, until the half-hidden patterns of leaves and flowers and curls reveal themselves. In the nineteenth century, most farmsteads in Wales had their own quilting frame, kept out of the way for most of the year. Then an itinerant quilter would arrive with her stories and her threads, and, using materials bought by the farmer's wife, she would make quilts for the family, and particularly for the dowry chests of any of the unmarried daughters. Some would work by candlelight, with glass globes for magnifying, like the one Robert Hooke invented for his microscopy in the 1660s. They would use templates to plan out the designs and then draw guidelines in blue laundry pencil, which would vanish in the washing. Some of the quilters were famous. Mary Jones, who died in 1900, could use both hands at the same time, making her twice as fast as anyone else.

In the late 1920s, mining communities in South Wales and County Durham in Northumberland were suffering disastrous downturns in their economic fortunes. Newspapers put out appeals: Aberdare in the Rhondda Valley, whose population had swelled in the previous years due to the need for coal to power steam trains, was particularly stricken. A few years earlier, two recent Oxford graduates, Mavis Doriel Hay (a future crime writer) and her friend Helen Fitzrandolph,

had made a survey of rural industries after the war. Now Hay (who had married Helen's brother, so was now called Mrs Fitzrandolph) went back to some of the communities they had visited. In one village she saw a quilt – rough work, harsh-coloured sateen – hanging on a washing line and she wondered if the local women could turn their skills to producing something finer. She raised eight hundred pounds through the Rural Industries Board, and spent it on arranging classes (with teachers appointed from among the best quilters in the community) as well as on supplying the fabrics, scissors, thread and frames. In autumn 1928 her friend Muriel Rose held an exhibition in The Little Gallery near Sloane Street in London.* It attracted enough orders to keep the quilters busy for months. In Wales they focused on six communities – Aberdare, Blaina, Merthyr Tydfil, Abertridwr, Splott in Cardiff and Porth in the Rhondda. Unemployed men became skilled at cutting templates out of plywood or tin, while their wives, sisters and mothers traced around them, to plan out their designs. They would also help by threading needles, and doing the washing up, 'because when your hands are softened by being much in water they more easily become sore from needle pricks'.

In one house in County Durham (where the cloths were called 'twilts') Mrs Fitzrandolph was examining a partly worked quilt in its frame, and seeing how it reached from one wall of the kitchen to the other, when there was a sound at the door. 'Can we come in?' asked a male voice. The woman hastily swathed her delicate pale silk quilt in an old sheet 'before calling in her husband and son, who, black from the pit, crawled carefully under the frame and went on into the scullery for their baths'.

Through the 1930s, as the Depression hit the whole country, the revolving doors of the great hotels – Claridges, the Dorchester, the Ritz – kept turning, and many of the guests slept under immaculate white quilts from the mining valleys.

* Muriel Rose opened The Little Gallery in Ellis Street in 1928, using four hundred pounds left by her brother, who had died in the First World War. The shop would showcase some of the best British textile makers of the 1930s, including Phyllis Barron, Dorothy Larcher and Enid Marx. Clients included Queen Elizabeth (mother of Queen Elizabeth II), and Walter Gropius at the Bauhaus.

A sense of community that comes from sewing

In Gee's Bend, the quilting lines are less important than the patches. But when you flip your attention away from the bright squares and blocks and focus on the stitches holding them in place, there are curves and broken patterns like the skeletal structures of a leaf, and they have a beauty too, if you stop to look. Unlike in Welsh quilts there are no templates or guidelines. This is all by eye. I do it wrong and sew my first lines very close together. I have a choice: I can set myself up for a very long piece of work ahead, or I can just accept (as I do) that it's a practice piece, and then do the rest with wider spacing.

There are no machine sounds except a radio in the background. Mary Ann's tuned in to a gospel station. Often they start a quilting session with a gospel hymn and a prayer, she says. There are two other quilters from Gee's Bend this morning, one sewing, one sitting drinking coffee. Sometimes we chat – about politics or our mothers or about funny things that happened when they went to a quilting show. But usually we lapse into silence.

This is what my mother and I hoped to find when we planned to make the worst patchwork in the world. Calmness. Laughter. A sense of community. Strength. I learned from my mother that when something bad happens, I should think of how I might raise a glass to it in the future. It doesn't mean the thing was good, just that if I can find something good in the end, then we haven't lost. Life hasn't lost.

If my mother hadn't died, I wouldn't be here, learning to quilt from someone who's at peace with what has happened in her life, and who has opened her skill and her home and her kindness to me. And I look up to the right, as I do when I want to find my mother, and I smile, and I mouth: 'Thank you'.

Rhapsody in cloth

As I finish the piece – with its nine-patch about mothers, and its court-house steps about fighting for fairness, and its irregularities about the happenstances of life – I think of an ancient story retold in Ovid's *Metamorphoses*, about a woman who was silenced, so could only communicate with cloth.

The king of Thrace has rescued Athens from its enemies and in return is given the young Princess Procne in marriage. Thrace is a long way away, in the far north of Greece, and Procne misses

Philomela then wove her terrible story
into cloth. Wood-engraving, 1896,
Edward Burne-Jones.

home. Most of all she misses her younger sister, Philomela. Five autumns on, and recently a mother, she asks her husband if her sister can visit. Not only can she visit, he says, I'll collect her myself. When he sees young Philomela – modest, virginal, all of that – he grows mad with desire. At the moment when Philomela is begging her father to let her accompany the king to Thrace, the king is imagining what he will do to her. When they arrive, instead of going to the palace, he takes her to a terrible house in the forest, and he rapes her. When she regains consciousness, she speaks to him in an awful voice. Kill me, she says, or I will tell everyone what you have done and my words will wake the echoes in the woods and move the compassion of the rocks. He doesn't kill her but he ties her up and cuts out her tongue. Then, having raped her again, he leaves her there, with a maidservant. Twelve months pass.

'But even in despair and utmost grief, there is an ingenuity which gives inventive genius to protect from harm,' writes Ovid. And although Philomela cannot speak, there is a loom in the cottage. She weaves what has happened to her into a tapestry, with purple and white threads. And when it is done, she begs the maid to take it in secret to her sister. Procne understands the message and takes her revenge on her husband by killing their son, and serving the child's flesh to him to eat, 'and her tongue can find no words for her despair'.

This is a story full of the inability to speak. But the one thing that does speak is the fabric. Philomela's is a story of rape and later one of terrible revenge, but it's also the story of how women through history have had a language, a way of communicating, through their fingers, through their work, through their shuttles and through their cloth.

The loom and the lyre of ancient Greece were similar to look at, both being upright instruments with cords held taut between two bars. And although one was usually operated by women, the other by men, they were often used as metaphors for each other. In one poem, the poet Sappho in the sixth century BC referred to Eros, god of love, as 'storyweaver' (mythoplokos, μυθοπλοκος), and she seems in another fragment to describe working a loom as she might also have described playing a harp: 'χορδαισι ... κρεκην', 'xordaisi ... krekín', 'to strike upon the strings'.*

Also, the Greek word for 'to sew' is *rhaptein*. We get the word 'rhapsody' from it. It means something that is sung and something that is patched; both of those things.

Royal cloth

I drive back to Atlanta, and the next morning, before my flight, I go to the High Museum. There's only one quilt on show: there are more in the collection but, as with all textiles, they can't be out in the light for too long. It was made by Irene Williams at Rehoboth in 2004: blocks and stripes, in black and teal and royal blue, with surprising flashes of yellow and red squares. She started making quilts when she married, in 1937, at seventeen, into what other people said was the poorest family in the area. She quilted, surrounded by children but mostly apart from other women, in a house that, even in 2002, was without electricity. And she made the kinds of pieces that were later said to be

* When the tenth-century poet Cynewulf ended his long poem *Elene* (St Helen) with the observation that: 'Thus I ... wordcraft wove and wonders gathered (wordcraeftum wæf/ond wundrum læs)' he was juxtaposing two skills that were usually seen as quite different: epic storytelling and weaving. Yet however simple they might appear, Old English poems have complex interlacings, like lines of tapestry. A poem that was like good cloth had to be very skilful indeed. In modern English, text and textile (and tissue, too) have the same word origin, in the Latin *texere*, to weave.

'outrageous'– quilts that 'can sometimes look as though they come from ... another planet'.

'I just put stuff together,' Williams said then. 'I didn't do the best I could, because in them years I didn't have nothing but what little we got to make quilts and things out of.'

I'm heading towards the exit when there, occupying a wall on its own, is a piece of cloth nearly a metre wide, a metre and a half high. It's part of a kente ceremonial cloth from Ghana, made some time between 1900 and 1925, and it makes me stop. I've seen kente before, but nothing like this.

It consists of twelve narrow strips, woven on a backstrap loom and then later sewn together. Every strip is made up of twenty squares, each separated by a few lines of white, and where they've been joined to each other, along their lengths, are big crimson stitches. It looks like a patchwork of squares, although in fact it's a patchwork of long woven rectangles. Each square is different. There's a chequerboard. Zigzags. Stripes. A design with shapes like centipedes. A design with a shape like KER-POW!!! A design with shapes I have no name for.

At first, I see five colours in the weave – the white linking bands plus black, yellow, green and blue – as well as the bold, red stitching holding them together. But as I stand there, I realise that the cloth has a kind of secret. It's weft-faced, so the warp is hidden, but when I concentrate, or more accurately when I stop concentrating, I realise that the warps are made of thick red bands interchanged with thinner bands in the other colours. The red makes the cloth seem almost alive, with blood-coloured stripes running through hidden textile veins. It tantalises the eye.

When it was part of a robe worn by an Asante king, it must have seemed like magic.

The cloth was made by men: it was thought to be too powerful for women to weave. It was so complicated that it needed at least three heddles, maybe six; but as well as that it was said to be sacred.

The kente is different from the quilts of Gee's Bend, but it is like them too. It could be the brilliance of the unevenness, or the way in which the patterns seem witty and nonchalant. Or it could be in the rip of improvisation and the composition of strips and blocks and the skeleton threads hardly visible.

I find a huge book about Gee's Bend in the High Museum book-shop and I read it on the plane. I realise then that the quilts made at Gee's Bend have links with West Africa that are so close they have actually touched.

The book includes an interview with Arlonzia Pettway (who got Mary Ann into quilting), in which she talks about how her great-grandmother Dinah arrived in America as a slave when she was thirteen. She might have come on the *Clotilda*, the last illegal slaving ship known to have made it through the barricade, in which case she would have embarked from Dahomey – about four hundred kilome-tres from the Asante kingdom – in 1859.

In 1930, when Arlonzia heard those stories, Dinah was maybe eighty-five, and she would sit at table telling stories to the children whom she would beckon to gather around.

Arlonzia was six or seven then, and that was the time when she started helping her mother, Dinah's granddaughter, prepare to make her quilts. Arlonzia had to stack all the pieces in colour-matched piles so that her mother could reach easily for what she needed. 'She would start about nine in the morning making the quilt, and by four in the evening she was through piecing it. She would not start quilting until she had made about ten tops.' And meanwhile the little girls would be busy threading the needles and watching the older women show how it was done. And whether the influences were from her great-grandmother or her mother or her friends or just stuff she had seen around her, the quilts she made were often in strips, linked by white bands between the blocks, and an exuberant irregularity. Not unlike that kente cloth in the museum.

Most kente designs have a name. 'There's fire in the Oyoko nation' is one. 'What is novel is what we have not seen and heard before' is another. Sometimes it's simpler: 'Sweetheart', 'Snail-shell', 'Bellows'.

The kente in the High Museum is *oyokoman adweneasa*.

Oyokoman is the name of the Oyoko clan, from which the royal family of the Asante are descended.

And *adweneasa*?

That one's a direct message from the weaver.

It means: 'I have used up all my creativity'.

THE TACKING STITCH

*In which the author shows some of the
stitches that hold this book together.*

When you want to attach two pieces of fabric together you start by applying a tacking stitch, or pins, to hold them in place. Later you remove them; they're not meant to be seen. But for a while they provide the foundations for whatever item you are making, before it's able to stand on its own.

Normally I wouldn't have made the tacking stitches so visible. But in the spirit of this book, which has seemed to insist from the beginning on laying bare some of its own workings, here is my rough raw stitch, my foundation; here are my pins.

It's the story of the death of my mother. It is what happened after I flew back from Ladakh in India early on the morning of 16 August 2015, knowing that by the time I touched down, my mother (my happy, busy, popular, meditating, bossy, forgetful, funny, loving, five-foot-nothing, eighty-one-looks-ten-years-younger, beautiful mother) would surely be dead.

But she wasn't.

'Hello Ma.'

'Hello lovely.'

She peers down from her hospital bed, which is raised up. I'm on a plastic, stackable, blue chair. A small one.

'You're rather far down,' she says. With a strange, posh voice that I'm not used to. It isn't hers, it's part of the flotsam and jetsam the bleed in her brain has brought with its tide.

'I *am* far down,' I agree. 'I'll find something else.'

There's a swivelling office chair on the opposite side of the Intensive Care Unit beside a computer terminal. Nobody's using it. I take it, feeling slightly selfish.

My parents in 2000, standing together at the Sendang
Gile waterfall, Lombok, Indonesia.

'I've got a good seat now,' I say.

'Yes. There are flowers coming from it,' she says. 'James says there are flowers from the seat which we should take advantage of.'

'There aren't any flowers.'

'Oh. Aren't there?'

I feel I might have spoiled an illusion. I also feel like I'm in *Winnie the Pooh*. I don't say I don't know who 'James' is.

My mother doesn't look like my mother. She looks like other people that I don't know. But she still has beautiful hands. One of the nurses says with a kind smile that I should take her rings, so they would be safe. My mother's wedding ring. My great-grandmother's sapphire. I slip them on the fourth fingers of each hand. 'I'll give them back, Ma,' I say. I don't think 'this is the passing on of the baton, now, just now', but of course it is.

My brother has stepped away for a walk. He's hardly slept, and two nights ago, alone, he had to make the decision to authorise the removal of our mother's life support system. He had talked to my husband to check that I would have agreed. And then he had sat there, holding her hand, thinking about how she had talked about this decision so many times that it had become almost a family joke.

'Nick,' she would say. 'If I ever get brain damage, you will turn off the machines, won't you?' He would, he would always say. 'And if I ever get dementia or something you will take me to Switzerland, won't you?'

'Switzerland' had been shorthand for the assisted dying that is in some circumstances legal in that country, and carried out by the Dignitas centre in a village outside Zurich.

'OK, if that's what you really want,' he had said.

'And you won't tell Toria, will you?' At which my brother had laughed. 'You mean I should tell my sister that we're off for a boat ride on Lake Zurich, and then when I get back and she says "Did it go well?" and I say "Sort of", and then she says "Where's Ma?" and I'd have to say "Oh, sorry, she didn't make it" … She'd murder me!'

When my brother told me about that conversation I roared with laughter, and then I drove down to talk to my parents, and particularly to my mother. I said that even though I am a magistrate, and believe in law and in justice, sometimes the two are in conflict. And sometimes if you disobey the law you just have to take the consequences, and if that is what she would want more than anything then I would

be prepared, as my brother would be prepared, to go to prison for her. And we had teased her about the Swiss lakes after that, but we had listened to her too. Because for a life-loving person she had been remarkably clear about her right to choose death. How strange it was that it would have come down to this choice for us.

When Nick had agreed that they should withdraw the breathing tubes he had held her hand and waited for her to die. And instead she had breathed. And now she is talking. And eating a little and drinking water.

We sit on either side of the bed, holding her hands. She seems to have drifted off. I look towards the monitor with its graphs and numbers.

'I was squinting at that all yesterday,' Nick says in a quiet voice so as not to disturb her. My mother's eyes slam open.

'Nick. You shouldn't squint,' she says, and then she closes her eyes again. Her hearing has always been acute. Nick and I catch each other's eye and grin. She's back! This could be wonderful news.

There's the chance of an operation to put a coil in her brain to stop this happening again, the consultant says. They just need to make sure that she's fit, and that an operation would help.

A family friend comes to visit.

'Jeannie, you gave us a scare.'

'I gave myself a scare,' my mother says.

The aneurysm had always been a possibility in my mother's brain, although none of us had known. It's a little hidden fuse, a blister in the wall of an artery that – like 1 per cent of all the people you will meet – she was born with. What probably set it off now was high blood pressure. She was prescribed pills; she didn't take them. She always believed she could treat things with healthy food and meditation. I considered, for a moment, being angry about that. But anyway, a doctor friend pointed out, maybe all the yoga and meditation and salad meant that she didn't have the haemorrhage years ago when we were children and not even slightly ready for her death. You can never know.

The aneurysm has me constantly doing calculations in my head. Adjusting the numbers: 30 per cent die straight away; another 30 per cent die within two weeks; 20 per cent live, but with severe brain damage; 19 per cent live, but with some brain damage. About 1 per cent make a full recovery. So that means, two days in, she now has a

1.5 per cent chance of making a full recovery. Things are looking up. Though there's a massive chance of brain damage. She wouldn't like that.

On the second day she's more confused.

'Who are you?' she asks.

'I'm your daughter,' I say.

'You're not my daughter,' she says. 'My daughter is much younger than you.' She's eating, the nurses say. I say she doesn't eat meat and they say they'll write it down. The consultant says he doesn't think she would be strong enough yet for an operation.

'It's down to you now, Ma,' I tell her.

The third day she is on a new ward, and she is asleep.

'Sorry,' the nurse says with a kind smile. There is a plate on a tray beside her. They have been trying to feed her. It's some kind of puréed brown meat.

'Sorry, Ma,' I whisper. 'That must have been disgusting.' I curse myself for not writing VEGETARIAN on her hands. I will be haunted – I am still haunted – by the thought that it was the shock of having meat pushed into her mouth that changed her course. I move the tray away and try to give her water to wash out the taste, but she can't be woken. I can't bear that the beef might be the last thing she ate.

I'd thought the 'sorry' was about the meat. But it was about the news we will now have to hear.

Our mother had been doing so well earlier, the consultant says, but not today. They definitely wouldn't be able to do the operation. Actually they didn't think they would be able to do very much. They've decided to move her to her own side room. Visiting hours don't count any more, he says. We can stay for as long as we want.

There was another thing our mother wanted, we say. She had read articles about the Liverpool Care Pathway, which was originally about allowing people to die without having their life prolonged or undergoing invasive treatments. Put simply, it involved removing all apparatus including intravenous nutrients and fluids. It was relatively quick, but dehydration can be hard. My mother had said she wouldn't mind the life support apparatus going, and that she had never minded not having food – she'd been slimming all her life so it would be a bonus to lose weight, she used to joke – but she couldn't bear to have no water.

I don't mention the weight bit, but I say the rest. The doctor says

he will arrange the fluids. He shakes our hands in a formal way. I think this is as if to say, respectfully and sympathetically, 'Goodbye. And good luck'. As if he doesn't expect to see us again. As if this was the last night.

Miracles. There are three words in the Bible that are translated as 'miracle'. One is *semeion* or sign. One is *teras* or great wonder (the Romans translated it as *monstrum*, something that is shown, something that can also be monstrous). And the one I like best is *dynamis*, which in Greek means a power that resides in you because of your nature.

The nurses at the ICU had called my mother a miracle when she had survived the first twenty-four hours. And as we sit beside her now, I catch myself wondering what kind of miracle that was. A sign – probably not, although I wouldn't mind if it was. A wonder for certain, because I got back in time to be with her. But what I want more than anything is for it to be a power that resides within my mother. Because we, and Western medicine, can do nothing for her now but hold her hand and wait. Having the room to ourselves probably means we don't have much time.

The visitors' toilet is two corridors away. I don't want to use the one on the ward designated for patients, it doesn't seem considerate, and anyway I like to walk. Each time I go, I pass a sign to the morgue. I make myself look at it. It's like a reminder of the future. But it is also not the now. She could still open her eyes and say 'Toria!'

We stay together in the room that night, sitting on chairs, and in the morning our bodies are stiff and painful. Our mother is still alive. We agree we'll do twenty-four hours each. One of us probably won't be there when she dies, but it means we'll be able to look after our father and catch enough rest to survive the next thing.

I take the first shift. I massage my mother's feet. She has such beautiful feet. I massage her hands too, but there are cannulas in them, feeding her with those fluids she'd asked for. One of them had leaked in the night. Her hands are swollen and quite bruised now. I stroke the bruises.

The consultant comes in. He is, I think, impressed that we are still here. That *she* is still here.

'It happens, sometimes,' he says. I think he says: 'a few people do survive' or perhaps he says: 'a very few'. Even a moment later I can't remember which one. I have to write down everything anyone says now. Though I do know he also says: 'let's see'.

I do the calculations. She has been alive four days. There could be an almost 2 per cent chance of a full recovery. I ignore, in my mind-mathematics, the fact that we are now giving my mother no nutrients, just water, and that she is already on the wrong side of the accounting column.

I walk through the corridors when the nurses are turning my mother, which they do every three hours. There are just a few of us, the people who wander at night, not patients, not staff, just the relatives of the ones who are waiting to die. In a strange way I like the feeling. It feels as if I have a realm, a place I belong. It is as if I am a ghost.

I've almost been here before. On Boxing Day 2004 my parents were in Sri Lanka when the tsunami came. For three days I didn't know they had survived. They told me later that they had been in a small boat, heading out to an island. 'We looked back and the beach had disappeared,' my mother said. 'The deckchairs were in the palm trees ... And Patrick and I were both thinking we were lucky, we'd had our lives, but the others ... it wasn't fair.' And then my mother had started to sing, a chant she'd learned in yoga. And I'd never lost the picture of this woman, my mother, believing she was about to die, singing into the waves. In the superstitious reaches of my heart, I'd always imagined it had somehow saved their lives. I try to remember it and I hum it, even though I can only remember the first three words.

'Sorry Ma, hope it's not torture.'

There's a chapel two floors up, and on the ground floor there's a café that is open all the time. I like it best at two in the morning. Or five, when the electric doors open to allow people in for their shifts and I can smell the cold early-morning summer air coming in with them. Sometimes I go to the garden and close my eyes and sit very still. Once I see two goldfinches on the bench, red and gold and fast like hope, and I feel happy as well as sad.

When I was eleven, my mother arranged for me to learn to meditate. I'd actually liked it. And even though at thirteen I'd announced I wasn't going to do it any more I took it up again in my twenties, and I still find it helpful. My mother went further and further into it. When I was at university, she signed up for a residential 'advanced course', which, she informed me, was going to include levitation.

'Levitation!' I said. It was ridiculous; she was being conned. I

probably said those things. But she phoned me while she was there, and she was so happy.

'It's not really flying, just a sort of bouncing that you do from a cross-legged position,' she said. 'You have to sit on a mattress so you don't hurt yourself.' She was the first in her class to bounce and she did it so well that she fell onto the floor.

The students weren't allowed to go outside the grounds. But my mother went on an early-morning exploration anyway. She bumped into someone from the course and they walked together along a country lane.

'I won't tell on you if you won't tell on me,' she said.

'Well, I won't tell on you,' he replied. 'But I'm one of the teachers.'

'What's the trick?' I asked her later. I was doubtful, but I had seen the bruises. She hadn't answered then, but long afterwards – after my father's stroke – she told me.

The group had started by meditating on words and phrases including 'Friendliness', 'Compassion', 'Happiness', and her favourite, 'Strength of an Elephant'. And then after you've gone through that list you have to concentrate on the long phrase 'the relationship between body and air ... light as cotton fibre' and you have to say it again and again. 'The relationship between body and air ... light as cotton fibre' and then all of a sudden, she said, you're up in the air.

'Is that it?' I asked. Sceptical. It didn't seem much of a magic spell.

'That's it ... But Toria, if you do it, do make sure you have a mattress.'

I have a mattress now; the nursing auxiliary staff have brought it to put beside my mother's bed. I lie on it, thinking this is too precious a time to spend in sleep. My mother's breathing is loud, like snoring. She would hate that I'd written 'loud, like snoring'. But she would probably like that she has a whole chapter almost to herself, so there are balances.

I sit on the chair next to her, and then at three in the morning I climb onto her bed and curl up beside her. For the first two hours we hold hands and then I sleep. At dawn a pigeon lands outside the slightly open window and tries to get through the small gap. It is persistent.

'No, pigeon,' I think. 'You can't collect her just yet. She isn't ready.'

One day the duty doctor comes. I step outside.

'I'm sorry,' he says, coming out to the visitors' room where I'm waiting. 'I don't think she's conscious.'

'How do you know?'

'She couldn't squeeze my hand.'

After he's gone, I try, and she can't squeeze mine either. I have an idea. 'Ma. If you can hear me, stick out your tongue.' And she opens her mouth and sticks out her tongue. 'You're brilliant,' I say.

I ask the doctor if he could come by when he's finished the round. 'I know my mother's dying,' I say. 'I know this isn't going to change anything for her, but I'd like to show you something.' I ask her to stick out her tongue and she does, and he gives a laugh, and an impressed look, and shakes his head, as if to say: 'you learn something every day' and then he says 'Good'.

On the ninth day Nick and I are both there at the same time. Our lives are full of silence right now, as well as that hard, loud breathing. My brother glances in my direction, and then looks perplexed. He stands up and goes to the wall behind me. There is a door in it. Neither of us have noticed it before. Behind it is a bathroom. There has been one all along, but we've never once looked up to find it.

On the tenth day she is still alive. Another kind of miracle, the nurses say. 'It's unusual; she's really strong.'

I feel proud, like she's passed a kind of test. We have agreed to move my mother to the hospital in Exeter if they have a space; it might even happen today. When the nurses are turning her, I go to the chapel. I'm there on my own. I get down onto my knees and I beg. Then I stand at the lectern and open the Bible at random. Psalm 91. I read it aloud and I take a photograph of it, so that I can read it to my mother later:

He will defend you under his wings, and you shall be safe under his feathers ... No disaster can overtake you, no calamity shall come upon your home. For he has charged his angels to guard you wherever you go. They will carry you in their arms in case you trip over a stone.

Later I will learn that this is the section in the Bible most often used as a spell of protection. It won't surprise me. I have sat beside the curtain that links one world and the next for ten days now. I might not have seen behind it, but I have heard rustlings.

'I'm not like this,' I think. Reading the Bible. Opening it and looking for messages. Begging on my knees for my mother's life.

I believe there's more than this world; I believe I've sometimes seen it. But I have no idea what it might be. I'm also a journalist. I like facts.

However, a kind of unhinged hingedness has come on me in the past days. It feels as if the ropes that tie me to this world are still there, but they have somehow become luminous. And four years later, writing this, I can still sense those ropes, and it still sometimes seems that they are glowing.

When I return to the ward the room is empty.

'She's gone,' says the nurse.

There are new white sheets on the bed. The spare mattress is propped on its side. My little world, my everywhere. My mother. For a moment I cannot speak.

'You've moved her body already?' I ask. I think of Rip Van Winkle. Surely I cannot have been gone for so long.

'She's gone to Exeter,' the nurse clarifies.

I laugh and hug her. This is a gift. A tiny, tiny gift, but it is mine. My mother is not dead.

In the car I talk hands-free to the doctor in Exeter, who is just in the process of checking my mother in from the ambulance. I explain how she had wanted fluids though she didn't care about nutrients. The doctor has a kind voice. She says that sometimes fluids at the end can be complicated. 'Of course,' I say, negotiating the holiday traffic and caravans. 'Of course.'

My mother is in a large room on her own. Pastel colours. Windows. A bed in the middle of the room, not at the edges. I sit beside her and I remind her of something she once said, which changed my life.

My mother did not grow up with a mother and father to look after her. There was an aunt in a wheelchair who was nice, and later there was another aunt not in a wheelchair who wasn't so nice, and there was a house with daisies on the lawn and evacuee children coming to stay from London, and a silent Order monastery at the bottom of the garden with monks she didn't know she shouldn't talk to until one of them broke his vow to explain. There was a half-sister married to a rubber planter who was a prisoner-of-war on the Burma railroad and returned home a broken man, and that's about all I know. There were no photographs.

But once, when I was a teenager and sad about something, she told me that when she was sixteen, she looked into the mirror and

said to herself: 'This is a face that nobody in the world loves. And I am not going to let *that* be my story.'

I tell her that this has helped me. It's helped me deal with the tougher things that have happened in my life, and it's helped me to try to find something good in them. And to make sure that the bad things are not going to be my story.

And anyway, I tell her, now she's loved by many people.

'You've really turned that one around,' I say, wetting her lips with a sponge.

I read aloud the cards and letters and texts and emails that have been coming in over the past ten days, and as I come to the end I realise that she's still making that gasping sound but it's lighter. I find the nurse. She confirms this would be a good time to call my brother.

'Nick's coming. Just wait a little while,' I say.

I'm not praying for miracles any more. But if I can pray for just one thing now, it's that my brother is there too when she dies. It's not such a big thing.

I think my mother hears. Her breathing becomes steadier. She's waiting. After half an hour my brother arrives.

'She's still alive,' I say.

And it's hard to know when she slips away. It doesn't seem to be a moment, more like a process. Her arms feel warm for a long time, her cheeks, her forehead. For a while I can't tell if she has a pulse, it's as if death is not quite absolute. We sit for a while. Then in time we go and find the nurse, who confirms she has died. 'There's no need to leave for a bit,' she says.

She makes us mugs of sweetened tea.

Nick leaves at some point to be at home with our father. I stay. If she's still around, I want my mother not to feel alone. I want her to know, at the very end, that her face is loved.

Later I will cry and cry in great hollow howls. Later I will understand what it is to keen, to feel a crazed, dark sound emerging from the deep, hard, rock fields inside my body. Later my husband will come into the bathroom to find me spread out, fully dressed, face down across the tiles, unable to hold up my own body. Later I will catch myself standing for many minutes at a time, not moving, looking at a piece of floor, or a small square of earth, or the whorls of wood on a table. Later I will learn that grief is so physical it makes you walk differently. Later I will begin to grieve, and it will

last for many years. But I still have a few hours before that has to begin.

I curl onto her bed for the last time and sleep. She's small, but even in death she seems strong. I wake up a while later. I want to stay longer. But I know it's time. I kiss my mother's forehead. I walk to the door. I turn and look back. Pale light is coming in through the window. It falls on her face. She is not grey. She is beautiful. There is no difference between body and air.

Light as lint.

Light as cotton fibre.

A NOTE ABOUT THE COVER

The image on the cover is a detail from *Penelope and the Suitors* painted in 1912 by the Pre-Raphaelite artist John William Waterhouse (1849–1917). Waterhouse was known right through his career for his fine depiction of fabrics in his paintings.

"Part of this was inspired by his (older) hero Lawrence Alma-Tadema's similar reverence," confirmed his biographer, Peter Trippi. "But I also believe Waterhouse was especially attuned to textiles because his father's family fortune was derived from wool/rug manufacturing around Leeds. And because Waterhouse was sur-rounded by artistic women (his mother, half-sister and wife) who surely worked in textiles as much as other media."

The story of Penelope, her loom, and her suitors, is featured in Homer's *Odyssey*, which is thought to have been written around 700 BC, though it might well come from an oral tradition from before that time.

The *Odyssey* is, of course, in large part the story of the long journey back from Troy by Odysseus, King of Ithaca. But it is framed, towards the beginning, middle and end, by three accounts of how Penelope—Odysseus' wife, and Queen

of Ithaca—deflected the attention of numerous suitors who wanted to marry her and claim her house and lands.

"A daemon* breathed the thought in my head to weave a garment, fine of thread and very wide, after setting up a great web in my halls,' Penelope explained later in her own account of the matter. The cloth† was to be the shroud of her father-in-law, Laertes, who was at that time still very much alive, and the suitors were to be told that she would marry again, but only when the work was done.

By day Penelope wove her cloth (on what, historically, is much more likely to have been an upright loom). But by night—with that part of the story conjured, in Waterhouse's painting, by the cage-like lantern—she unpicked all that she had done. It was like a kind of magic; a way to use the act of weaving to unpick time. The English word "analyse" comes from the word used here for unravelling the cloth.

For three years Penelope made the suitors wait, until one of her maids let slip the truth. She was then saved from what seemed like inevitable remarriage by another trick, where she said she would choose (out of the 108 candidates) the one who could string her husband's great bow at first attempt. She knew that no man could do so but Odysseus.

A loom and a bow: taut threads in suspension

The shroud would have been made of flax thread, and bowstrings too were made of flax-thread. The Greek word for bow, *toxon*, τόξον links—as weaving itself does more obviously—to begetting, birthing and even to "simple" fabric itself, probably because a shuttle for plain weave or twill shoots across a loom in a similar way to an arrow shooting across a landscape. So perhaps with Penelope at the loom, and Odysseus at the bow we're witnessing two sides of a similar process. Weaving and war, female arts and male arts, both said to be overseen by the goddess Athena.

The painting was commissioned by the Aberdeen Art Gallery in Scotland, at a time when voices in Britain were getting louder in their demand for women's suffrage. Galleries were actively looking to buy work depicting strong women of antiquity, with Penelope particularly popular, in part because she was beautiful, in part because she epitomised a woman of strength, but also put her loyalty to her husband at the fore.

* Daemon [δαίμων] has been translated as divinity, spirit, fate, guardian angel, and genius. It might be understood as our inner guide, the essence at the heart of creativity, in art and craft and art and skill.

† Waterhouse was criticised when the painting first went on show for having depicted Penelope's picked and unpicked cloth as multicoloured. If it had been a shroud, critics said, it would surely have been plain white or undyed. But then again, if it had been plain white or undyed, why would anybody have believed it could have taken so long?

The women's suffrage movement in Britain was itself greatly affected by the socialist Arts and Crafts movement of which the later Pre-Raphaelite brotherhood and sisterhood were part. So many areas of influence were closed to women— politics, universities, many elements of trade, the fine arts—that the so-called domestic arts of weaving, tapestry and embroidery, boosted by people like John Ruskin and William Morris, became critical in canvasing support for the suffragettes. As women worked on their own great webs, responding to the new market demand for something handmade, they talked together. They attended lectures, and discussed the writings of Karl Marx and Friedrich Engels—works that had, as we saw in the Cotton chapter, been inspired by the working conditions among the poor in and around British textile mills. And they decided to empower themselves.

Two other women, hidden

Not visible on the cover, but present in the painting itself are two other women. They are Penelope's maids. One sits at her mistress's feet, and one looks at her from across the loom. We know that one of them will betray her, and will be one of the twelve servants killed for alleged treachery by Penelope's son, Telemachus.

But also, by choosing to depict three women, one beside the spun thread, one beside the loom and one cutting the thread, it is clear that Waterhouse is summoning for us an image of the Three Fates, albeit in the form of young women. And a suggestion that Penelope's cutting of the thread with her teeth marks the death of something that's held its place too long—the cage of women's half-life in society— and the destiny for something different.

It is almost accidental, but it feels significant, that on the cover of a book, with the subtitle *The Hidden History of the Material World*, mythical representations of life, death and fate should be concealed beneath a swathe of material.

The work of the thread

The red cloth is a stock image, and my first thought is that the filament that doodles across it suggests thread turned loose upon itself. Not only from a loom unravelled, but also like the ball of linen flax carried by Theseus in the Minotaur's labyrinth, a way for us to find our route home.

But as I keep glancing at the image of the cover on my computer screen, sent by email from my American publishers three months before the US edition is published, I have come to see something else there too.

In its exuberance and its hue, that line feels like a symbol of our urgent need to care for nature more—which is the green thread that underpins all the stories of this book.

A NOTE FOR THE FUTURE

In 2009 the corporate giant Walmart and small, sustainable Californian outdoor clothing company Patagonia held an extraordinary meeting. They wanted to discuss how clothing companies could be more environmentally accountable. One serious problem was that each buyer they dealt with seemed to have different questions about ethical sourcing, while each supplier seemed to have different ways of answering. So even when intentions were good, paperwork was horrendous.

What was needed, they agreed, was a standard questionnaire. That way they could assess the energy that was used, the water, how much air pollution was caused, what chemicals were used (and how they were managed afterwards) and how workers were treated. They called in other companies – including The Gap, Nike, Marks & Spencer, H&M, W. L. Gore, big names – and the index was launched in 2012. They called it the 'Higg', after the quest by physicists to find the Higgs Bosun particle, because, they said, their intention for their fabrics and clothes was to 'search for the particles of sustainability'.

The Higg was relaunched in 2020, with a new section in the questionnaire on how each item of clothing is used and what happens to it after it stops being useful, at the end of its life.

It is still for internal use only, but the intention is that in the future the Higg information will be publicly available, at point of sale, that buyers might be able to see if the fabric is too high on the Higg (or too low, depending on how the calibration is made).

Imagine: a world where we buy our fabric and clothes, as we increasingly buy our food, knowing where they have come from. Knowing who has made them and where. And knowing how much they have cost the earth.

ACKNOWLEDGEMENTS

Part way through writing this book I went to lunch with friends. I was recounting how *Fabric* had started out being just about fabrics but that it had turned and changed, almost by its own will, into a book about fabrics and grief. 'Oh!' said someone further down the table. 'I do love grief!' We looked at her in astonishment, until we realised that she'd misheard, and had thought I'd said Greece.

But this book did turn and change, and it did so almost by its own will, and it did take a long time, so I'd like to thank my commissioning editor Rebecca Gray and her colleagues at Profile Books, especially Penny Daniel, Cecily Gayford and Calah Singleton, first for having the idea to ask me to write it and later the forbearance to wait for it to arrive. Also my agent Simon Trewin for helping at the critical contract moments and writing me encouraging postcards when I needed them most. And Susanne Hillen, for a brilliant and careful copy-edit, both delicate and precise. And most of all my editor Shan Vahidy, for cutting and tailoring the first, long manuscript so sensitively. And for writing comments in the margins that made me laugh aloud.

Many, many other people have helped. They include: Tim Aldred of Carloway Mill in Lewis; Mark Atkin and Bruce Mitchell who gave advice about PNG; Andrew Baker in Brisbane for sending catalogues; Roya and Brian Boustridge; Paul and Nicky Bray for deciding to keep pedigree Ryelands, and putting them in a field on my walk just when I needed them to be there; Clare Brown, machine interpretation supervisor at the National Trust's cotton mill museum at Quarry Bank in Manchester for checking the weaving and spinning bits; Malcolm Butler for the beer on the train, and the anecdote about jute; Mariel Carr and Annabel Pinkney from the Science History Institute in Philadelphia for their help with the stills from Bob Gore's oral history video; Pamela Christie at PNG Trekking Adventures who introduced me to Florence Bunari; Dekila Chungyalpa, who reminded me about the *khadags*; Rosie Collins for those wonderful maps; Teresa Coleman of Teresa Coleman Fine Art in Hong Kong, who let me use her pictures of the *long pao* dragon robe; Mike Even, my 'friend in New England', for telling me about the snow; my brother, Nick Finlay, for trusting me to do this right; Serena Frasconá at Maya Traditions Foundation for checking my account of backstrap weaving; Jan Hasselberg who told me more about tattoos in Papua New Guinea; Clarice Hui for giving access to the Hong Kong Polytechnic University library; Jen Jones, owner of

Ada Jones's patchwork quilt, which started me on this journey, and her colleague Hazel Newman who helped with the details; Ketkan Kumphuang in the library at the Queen Sirikit Museum of Textiles in Bangkok, who let me keep reading until the last moment despite a secret and unscheduled visit to the compound by a member of the royal family; Ian Lawson; Frances Lennard; Margaret Lewis, curator at the Allhallows Museum in Honiton, Devon; Edna Longley; Michael Longley, who not only gave permission for me to use his poem 'The Design' as the epigraph to this book, but recited it to me on a coach, driving between World War I battle-fields in northern France; Maria de Los Angeles Gimenez in St Gallen; Fachruddin Mangunjaya for the Bahasa origins of the word 'gingham'; Katia Marsh for being my companion and photographer in Papua New Guinea and elsewhere; Andy Mills for spending a whole day talking tapa; Mark Miodownik; Nell Nelson for being 'my Scottish friend'; Mel Ruth Oakley, curator at Verdant Works, for checking the jute section; Anna Ploszajski for reading through the science; Helen Peden (and colleagues including Maddie Smith and Alexa McNaught-Reynolds) at the British Library for enabling my close examination of Alexander Shaw's barkcloth book when it was out for conservation; Kari-Ann Pedersen at the Norwegian Museum of Cultural History; Ian Potts for the shirt; Gwynedd Roberts for checking the lace section; Isabel Robertson in Melbourne for encouraging me, a complete stran-ger, to keep going with my PNG plans; Professor Neil Robertson; Erin Rodgers at Kew; Rabbi Daniel Sperber and Phyllis Magnus, for checking the Hebrew; Hilary Stevens for giving me a demonstration of hand-spinning in her garden, with the alpacas peering over the fence; David Suddens (and Zara, Ruud, Marjo, Jana and Cor) for arranging such a splendid day at Vlisco; Marci Tate Davis at the High Museum; Dr Barry Teperman and his colleagues from No Roads Expeditions for giving me antibiotics when I needed them; Taqadus Wani; David Weir for hunting out obscure references at Paisley Library; Mary Ann Wise of Multicolores in Gua-temala; John Wooding of H. Huntsman & Sons in Savile Row; Helen Wyld at the National Museums of Scotland for help about Janet Gothskirk's tunic. And every-one working at *Selvedge* magazine. Every issue is a delight.

The first time I walked into a dedicated textiles library I looked around and thought 'what on earth have I committed myself to?' There were SO many books on the subject already. Those daunting stacks were at the Textile Museum at George Washington University in Washington DC. Since then I've consulted fabric books in the V&A; the Queen Sirikit Museum of Textiles in Bangkok; the Paisley Library and National Library of Scotland; the archives at Vlisco in Helmond; the Massachusetts Historical Society; the St Gallen Textilmuseum; the Bibliothèque municipal de Lyon; Bath Central Library; Hong Kong Polytechnic University; the design library at Bath Spa University; and of course the British Library, which has the whole world inside it.

After each of my previous books a few people have asked how I could have landed such a huge expense account to travel to so many places. The answer is that I didn't: I paid for it myself from a dwindling advance. However, I was fortunate

that some journeys for other assignments were quite easily extended into fabric research trips. For this book I'm especially grateful to: Kevin Kwong at the *South China Morning Post*; all at the Hong Kong Arts Festival; Mary Louise Totton at Western Michigan University Kalamazoo; Allerd Stikker and friends and family for a timely visit to China; James Kidner at Improbable Worlds; Lourdes Gaza, and COMEX in Mexico; Sonam Wangchuk Shakspo (and the government of India) for getting me to Ladakh; and, always, my colleagues at the Alliance of Religions and Conservation.

Thanks too to friends who've offered advice, support, clues, contacts, hospitality and inspiration during these five years of research and writing. They include: Tanya Atapattu; Marcus Brouggy; Alice Cairns; Sue Copeland; Shirley Edwards; Hadiza El-Rufai; Chris Elisara; Donald and Catriona Farquharson; Annie Farrelly-Smith; Genevieve Fox; Emma Geen; Hilary Goddard; Angela Graham-Leigh; Nick and Machtold Hills-Buma; Susan Jordan; Olav Kjørven and Teresa Sola; Charlotte and Ashleigh Lambert-Martin; Chris and Chrissie Mallet; Jo Mathys; Richard McClure; Gretel McEwen; Sophie McGovern; Lizzie and Mike Miller; Bel Mooney and Robin Allison-Smith; Ab Mould; Nigel Palmer; Simon and Baba Reid-Kay; Mike Shackleton; Jane Shemilt; Gunbir Singh; Ravneet Pal Singh; Nicola Stevenette; Jean-Pierre Sweerts; Mimi Thebo; Peter Trippi; Vanessa Vaughan; Margaret Williams. And also to John Boyne, whose single tweet about how to put symbols onto letters in Microsoft Word (by pressing the key down just a little longer and picking a number) has transformed my ability to take notes. I thank him in my head each time.

I'm grateful to every member of the Maisin tribe in Uiaku who made our stay there so special, particularly Scott and Scholar Bunari; our guides Jesset Sagi and Jane Gangai and their families; Annie Sevaru, who led the guesthouse committee and her husband Arthur, the young chief, who not only facilitated so much, but also climbed the coconut tree in front of our house because he was worried a branch might fall on us; Jane and Bartholomew Oira; Velma and Adi and Sarah and Victoria (my nomi, or namesake); the many elders who spent time with us, especially Adelbert Gangai, John Wesley Vaso, Gideon Ifoki and Aaron Kasai, and the team of young men who, before we arrived, built us a bathroom, and each night, clan by clan, stood guard to make sure we weren't attacked by wild pigs. Also the women of the Mothers' Union who spent a morning with us, talking about life, God, and how they got their face tattoos. And, of course, Florence Bunari, of Buna Treks and Tours, who arranged the whole adventure. If any reader would like to visit the Maisin through Florence's company Buna Trekkers (so providing money to support the tribe's medical and educational needs) then bring as much medicine and children's books as your luggage will hold, and I envy you already.

The greatest thanks to my husband, Martin Palmer. While I was, like Penelope, weaving and unweaving the same material without apparent end, he reminded me to have faith, and believe that if I just kept turning up at this desk I would (as always, at the last possible moment) eventually find the clew.

NOTES

General

For English definitions I consulted *The New Shorter Oxford English Dictionary*, Lesley Brown, ed., 1993.

Calculations of equivalent value today are, unless indicated, from the Bank of England inflation calculator.

'The Design', Michael Longley, from Longley, *Collected Poems*, 269. By permission of the author.

Introduction

p. 2, 'Hatched, Matched, Despatched – and Patched': American Museum, Bath, 2015.

p. 2, 'two burial skirts' and 'a quilted patchwork made in Llanybydder': from the Jen Jones collection, Lampeter, Wales.

p. 4, footnote: 'Balderich ... brightest colours': Ariès, *The Hour of Our Death*, 164.

Chapter 1: Barkcloth

p. 7, 'Pacific Barkcloth Exhibition. Room 91': 'Shifting Patterns: Pacific Barkcloth' at the British Museum, 5 February to 6 December 2015.

p. 11, 'It was the summer of 1757 ... extreme aversion ... outside playing sport': Brougham, *Men of Letters and Science*, 200ff.

p. 12, 'Rules to be observed': Cook et al., *The Three Voyages*, 84ff.

p. 12, 'My peice of Cloth ...': Banks, *Endeavour Journal*, 14 April 1769, 219.

p. 13, 'The superiour people ... as it is in Europe', 'a cloth as thick ... delicious to the feel': Banks, *Endeavour Journal*, 201.

p. 13, 'Despite its slightly oily, corrugated texture': Shaw, *A catalogue of the different specimens of cloth*, 5.

p. 13, footnote: 'breadfruit tree barkcloth was used for ... baby carriers': Scott Bunari, interview May 2018.

p. 14, 'and I may venture to say a brighter and more delicate colour': Banks, *Endeavour Journal*, 220.

p. 14, 'on which it shews with its greatest beauty': Banks, *Endeavour Journal*, 222.

p. 14, 'a profusion of Good Cloth': Beaglehole, ed., *The Endeavour Journal of Joseph Banks*, 96ff.

p. 15, 'under the awning were numberless rags': Banks, *Endeavour Journal*, 162.

p. 15, 'so extraordinary ... tolerable Idea of it': Banks, *Endeavour Journal*, 378.

p. 17, 'Sister, listen ... not river': Tomlin, *Awakening*, 133.

p. 17, 'the worst volcanic catastrophe for half a century ... avoid stepping on them': Johnson, *Fire Mountains*, 149ff.

p. 19, 'They became busier, and more packed with symbols ... desert painting movement': Thomas, *Made in Oceania*, 22.

p. 19, 'One tells the origin myth of barkcloth designs': retold from Modjeska, 'Fabric of wisdom', 26.

p. 19, 'Her name was Suja': retold from Ömie Artists, *Hijominoe Modejade*, 8–9.

p. 20, 'Marshall Sahlins retells the ancient story': Sahlins, *Islands*, 85ff.

p. 23, 'Not possessed of masi ... gods!': Williams and Calvert, *Fiji*, 94.

p. 23, 'the path down which the god descends': Sahlins, *Islands*, 85.

p. 23, 'horrified when in 2013 the national airline': Fiji Women's Rights Movement Press Release, 1 February 2013, 'No to the trademark of kesakesa designs'.

p. 23, 'but then I learned that sunglasses are taboo in Lau': Kevin Rushby, 'Fiji does it', *The Guardian*, 9 September 2011.

p. 24, 'I learned that the people of Erromango': this section from Carillo-Huffman et al., 'Indigenous knowledge', 176–98, and conversations with Kirk Huffman, 2017–2018.

p. 27, 'The auction at Privy-Garden Whitehall': Skinner & Co., *A catalogue of the Portland Museum*, 58–59.

p. 27, 'took a particular liking to an old blunt iron': Shaw, *A catalogue of the different specimens of cloth*, 8.

p. 28, 'reading how the eccentric eighteenth-century owner': Haynes, 'A "Natural" Exhibitioner: Sir Ashton Lever', 10.

p. 31, 'the king was wearing a splendid yellow barkcloth': Speke, *Journal of the Discovery of the Source of the Nile*, 161.

Chapter 2: Tapa

p. 48, 'I had read that there were other rules ... could not say its name while you were using it': Hermkens, *Painting the Past*, 15.

p.56, 'grottoes... springs': Malinowski, Magic, Science and Religion, 112

p. 59, 'In the early 1990s, the Maisin elders debated': Barker, *Ancestral Lines*, 167ff.

Chapter 3: Cotton

p. 68, 'On 13 August 3114 BC the maize god': Schele, 'Foreword' in *The Maya Textile Tradition*, 9–10.

p. 68, 'It is really too much of a good thing': Huxley, *Beyond the Mexique Bay*, 139.

p. 72, 'or the beautiful goods': O'Bryan, *The Diné*, 37.

p. 78, 'Neith ... said to reweave the world': Wallis Budge, *From Fetish to God*, 59.

p. 79, 'archaeologists found ... cotton seeds and cotton fibres': Shady Solís et al., 'Dating Caral', 723–26.

p. 79, footnote: 'the earliest known *khipu*': Jude Walker, 'Pre-Incas kept detailed records too', Reuters, 20 July 2005, http://www.abc.net.au/science/news/ancient/AncientRepublish_1418372.htm

p. 79, 'Flutes were discovered ... hundreds of kilometres': Masterson, *The History of Peru*, 24–25.

p. 81, 'the thread is cotton, which is said to be the purest': Rodricks, *Moda Goa*, 70.

p. 81, 'a scrap of fibre found curled inside a copper bead': Moulherat et al., 'First evidence of cotton', 2002.

p. 81, 'people in the Middle East and Africa domesticating their own': Viot, 'Domestication and varietal diversification of Old World cultivated cottons', 1ff.

p. 82, 'Once a year the northern hemisphere of the planet': Rosser and Imray, *The Seaman's Guide*, 59ff.

p. 83, 'even the parrots spoke many different languages': Totton, *Wearing Wealth*, 6.

p. 83, 'a thousand Gujarati merchants ... traded it for spices': Pires, *The Suma Oriental*, 45.

p. 83, 'Whoever is Lord of Malacca': Pires, *The Suma Oriental*, lxxv.

p. 85, 'young girls ...natural oil': *Great Exhibition of the Works of Industry of all Nations 1851*, Part IV, 934.

p. 85, 'Pliny mentions a "wool" that is found in "forests" ... charms in public' ('lanicio silvarum nobiles ... tam multiplici opere, tam longinquo orbe petitur ut in publico matrona traluceat'): Pliny, *Natural History* Book VI, 20.

p. 85, 'for a bride to dress in the weave of the wind' ('Aequum est induere nuptam ventum textilem/palam prostare nudam in nebula linea?'): Petronius, *Satyricon*, section 55 (my translation). This poem by the first-century BC poet Publilius Syrus has been lost, but was referenced a century later in Petronius's scurrilous satire.

p. 85, 'Expanded smoke': *Purananuru* v. 397, 1: 19, quoted in Rasanayagam, *Ancient Jaffna*, 134.

p. 85, 'vapour of milk': *Perumpán* I: 469, quoted in Rasanayagam, *Ancient Jaffna*, 134.

p. 85, 'a hundred yards ... pure water': Rodricks, *Moda Goa*, 79.

p. 86, 'five times': Roe, ed. Foster, *The Embassy of Sir Thomas Roe II*, 390.

p. 86, 'For presents, I have none, or so meane ... too poore of valew': Roe, ed. Foster, *The Embassy of Sir Thomas Roe I*, xvii.

p. 86, 'the light that day was very bad': Roe, ed. Foster, *The Embassy of Sir Thomas Roe I*, 214.

p. 86, 'The emperor took everything ...toyes ... Coat to weare': Roe, ed. Foster, *The Embassy of Sir Thomas Roe II*, 380–90.

p. 87, 'Portuguese pedlars arriving with their "calicús"': Lemire, *Cotton*, 159.

p. 87, 'which were also called *pintados*': Brédif, *Toiles de Jouy*, 14.

p. 88, 'known as the "Great Caravan"': Brédif, *Toiles de Jouy*, 12.

p. 88, 'The Fabric of India' exhibition, 3 October 2015 to 10 January 2016, Victoria & Albert Museum, London.

p. 90, 'Many Armenians arrived': Kouymjian, *Armenian Altar Hangings*, 62–73.

p. 91, 'versions made with Indian chintz became popular too … Japan …': Jackson and Behrens, 'Wrap session', 24–27.

p. 91, 'With a nose soiled with tobacco dust': Gately, *Tobacco*, 117–21.

p. 92, 'shifts and shirts … Northern parts of the world' (letter to William Gifford, governor at Fort St George from Jos. Child, London, 9 October 1682). Dodwell, ed., *Despatches*, 15.

p. 92, 'A million pieces landed in England in 1684 alone': Horwell, 'Brocade Parade'.

p. 93, 'Those locked facilities … Rue Très Cloîtres': Kwass, *Contraband*, 65–69, 109.

p. 94, 'Multitude of Weavers … tore, cut and pull'd off her Gown and Petticoat … naked in the Fields': Old Bailey Proceedings Online, July 1720, trial of Peter Cornelius (reference: t17200712-28).

p. 95, ' "Callico Bitch" is what she was called in the streets': Old Bailey Proceedings Online, July 1719, trial of John Larmony and Mary Mattoon (reference: t17190708-57).

p. 95, 'locked up in Warehouses … Person having or selling any of them': Anderson, *Origin of Commerce*, 228.

p. 98, '[He is] annoyingly hard to control' ('Cet artiste bien connu par son industrie a l'inconvenience d'être difficile à gouverner'): Harris, *Industrial Espionage*, 79ff.

p. 100, footnote: 'In the Channel Islands the wheel … flax, or cotton': Leadbeater, *Spinning*, 5.

p. 101, 'He expressed his surprize': Rees, *The Cyclopaedia* ('Cotton'), 126ff.

p. 102, 'of how to form squares from oblongs without adding or diminishing': Fitton, *The Arkwrights*, 6–7.

p. 103, 'whole Town believes they are gone there but every body thinks they will not like it': Fitton, *The Arkwrights*, 6–7.

p. 103, 'These cotton mills …most luminously beautiful … impudent mechanic': Byng, *Rides*, 187–88, 18 June 1790.

p. 105, 'the habit of thinking … then tucked up my petticoats about my waist': French and Cole, *The Life and Times of Samuel Crompton*, 33ff.

p. 108, 'It struck me … three movements which were to follow each other in succession': Strickland and Strickland, *Edmund Cartwright*, 23–55.

p. 110, 'in 1784 eight bags were apparently seized … at the Liverpool docks': Bates, *The Story of the Cotton Gin*, 5.

p. 110, footnote, 'he happened upon a cotton tree he didn't recognise': Kingsbury, *Hybrid*, 123.

p. 111, 'Chief of all the Magicians' (letter dated 1 May 1793): Lakwete, *Inventing the Cotton Gin*, 54–55 (and section).

p. 111, 'Is this the machine advertised … Manufactory?' 'From Thomas Jefferson to Eli Whitney, 16 November 1793', Founders Online, National Archives, https://founders.archives.gov/documents/Jefferson/01-27-02-0359. (Original source: *The Papers of Thomas Jefferson*, vol. 27, 1 September–31 December 1793, John Catanzariti. ed. Princeton: Princeton University Press, 1997, 392–93.)

p. 112, footnote: 'The gin he claimed … patent was not issued': 'To Alexander Hamilton to Thomas Marshall, 25 November 1793', Founders Online, National Archives, https://founders.archives.gov/documents/Hamilton/01-15-02-0333. (Original source: *The Papers of Alexander Hamilton*, vol. 15, June 1793–January 1794, Harold C. Syrett, ed. New York: Columbia University Press, 1969, 408–409.)

p. 112, 'very near 300lb … the assistance of children'; quoted in the Philadelphia *National Gazette*, 29 December 1792. Cited *Founders Online*, National Archives, https://founders.archives.gov/documents/Hamilton/01-15-02-0333.

p. 113, 'The hands are required to be in the cotton field … standing idle in the field': Northrup, *Twelve Years A Slave*, 167–80.

p. 115, 'In the winter … forming tiny little snowflakes': Ronald Bacon, oral history, Boott Cotton Mills Museum, 1984.

p. 116, 'powered by two horses in the basement': Rosenberg, *Francis Cabot Lowell*, 203.

p. 116, 'Their first visit was during a light snowfall': Rosenberg, *Francis Cabot Lowell*, 298.

p. 120, 'Arkwright said that Lanark would probably "become the Manchester of Scotland"': Fitton, *The Arkwrights*, 73.

p. 121, 'our first question every morning was: "Any news of Dr Livingstone?" Rose, *The Intellectual Life of the British Working Classes*, 336.

p. 122, 'the perpetual smoke of the city … air of mystery to the whole place': Thomas, *The Cathedral Church of Manchester*, 1901.

p. 123, 'hundreds of African soldiers from today's Ghana': van Kessel, 'West African soldiers', 41–60.

p. 124, '"We have destroyed the manufactures of India", testified Mr Larpent': Dutt, *The Economic History of India*, 108ff.

p. 127, 'all lying in attics as useless lumber': Rajmohan Gandhi, *Gandhi*, 212.

p. 127, 'Kasturba Gandhi was initially so reluctant about the *khadi* idea': Kalarthi, *Ba and Bapu*, 63–65.

p. 127, 'White was a colour worn primarily by men and by widows … widowhood was a terrifying state': Tarlo, *Clothing Matters*, 111.

p. 127, 'I thought of Gandhiji as a brigand': Das, *My Story*, 12.

p. 128, 'My dear … you have no idea what poverty is': 'When Gandhi met

Darwen's mill workers', BBC, 23 September 2011, https://www.bbc.co.uk/news/uk-england-lancashire-15020097.

p. 128, 'C. C. Lee had a problem': Becker, *C.C. Lee*, 15ff.

p. 133, 'every bale of raw cotton grown in 2020 end to end': in February 2021 USDA projected 2020 world production of cotton at 114.1 million bales. Each bale is 1.4 m long (and *c*.480 lbs/220 kg) so end to end would measure 160,000 km. The equator is *c*.40,075 km long; the moon is 384,400 km from the earth. https://www.cotton.org/econ/cropinfo/

p. 133, 'Every night, a train rattles three hundred kilometres … 2010 study … three-quarters of the pesticides': Praveem Donthi, 'Cancer Express', *Hindustan Times*, 17 January 2010, https://www.hindustantimes.com/india/cancer-express/story-Goi4G2mnoQnLDRryokiV6L.html

p. 134, 'After using them for a while, the land can't do without them': Gigesh and De Tavernier. 'Farmer-suicide in India', 2017.

p. 134, 'a new kind of pink bollworm … didn't care what the cotton was called': Naik et al., 'Cotton pink bollworm', 2020.

p. 134, 'drop it in a bucket of poison … swimming': Joe Bavier, 'How Monsanto's GM cotton sowed trouble in Africa', Reuters, 8 December 2017.

p. 134, 'didn't fully stop the pesticides': Sean Gallagher, 'The Silent Fields', December 2013; https://gallagher-photo.com/environmental-stories/pesticide-poisoning-punjab-india/

p. 135, 'by drinking pesticide, after the failure of the so-called "Bollgard" crops': Stone, 'Biotechnology and suicide in India'.

Chapter 4: Wool

p. 139, 'a wonderful colour guide to the seventy-four breeds of sheep': *British Sheep & Wool*.

p. 140, 'When the Romans occupied Britain … most went straight to Rome': *British Sheep & Wool*, 4.

p. 140, 'But it was the Cistercian monasteries … the year's entire wool clip': Walling, *Counting Sheep*, 28.

p. 141, 'Grasper was on the run': Genesis 28–31.

p. 144, 'Of the other three white ones, two would have one coloured chromosome': Pearson, 'Jacob's Sheep', 51–58.

p. 144, 'One trick of telling the two varieties apart': Feliks, 'Relation between heredity and environment', 10.

p. 147, 'every springtime on 15 March': Carter, *Wool Correspondence*, 136.

p. 147, 'The main droving roads, the cañadas': Guerra, 'Transhumance', 177ff.

p. 148, 'itinerant judges whose job it was …': Klein, 'Mesta', 108.

p. 149, 'some would escape and travel the roads anyway': The Society for the Diffusion of Useful Knowledge, *Planting*, 153.

p. 150, 'Basque archaeologists in 2016 announced': Polo-Diaz et al., 'San Cristóbal rock-shelter', 202ff.

p. 150, 'the palest fleece and the softest wool' ('Lanae albae, Velleribus primis Apulia'): Martial, xiv, Ep. 155, quoted in Yates *Textrinum*, 97.

p. 152, 'Making a Royal Manufactory deliberately to hurt English, Dutch and Flemish trade ...sweet thing': Ripperda, *Memoirs*, 24.

p. 153, 'He brought in sheep from Roussillon, Flanders ... and the breeding began': Carter, *His Majesty's Spanish Flock*, 50.

p. 154, 'Young people in France just weren't that interested': Daubenton, *Advice*, liii.

p. 154, 'Q: Can ewes with kemp?': Daubenton, *Advice*, 72.

p. 154, 'Alstroemer might have argued ... common for workers to run away': Swedburg, 'Mercantilist-Utopian', 70.

p. 155, 'Throughout the 1760s and 1770s, little flocks were shipped to Saxony': Carter, *His Majesty's Spanish Flock*, 36ff.

p. 156, 'When we know the price and value of our wool abroad ... Hellstedt spent ... assume the character of an English American': Carter, *His Majesty's Spanish Flock*, 24ff.

p. 158, 'Winchester's Westgate Museum has a unique set of original weights': Wilde, 'Weights and Measures': 237ff.

p. 159, 'best connected and least scrupulous crooks on the face of his planet': Davies, 'The Poet's Tale', review.

p. 160, 'In 1966 ... wool from fourteen wool-producing Commonwealth countries': Hansard, 26 January 1966, vol. 272 cols 75–76 https://api.parliament.uk/historic-hansard/lords/1966/jan/26/the-woolsack.

p. 160, 'When my father occupied the Woolsack, our wise Victorian ancestors': Hansard, 16 January 1986, vol. 469, cols 1161–62, https://api.parliament.uk/historic-hansard/lords/1986/jan/16/the-woolsack

p. 161, 'In 1583 his favourite uncle, Henry Shakespeare, was fined for not doing so': Pogue, *Shakespeare's Family*, 25–28.

p. 161, 'Those were the bad old days of the Romney Marsh gang': Ashworth, *Customs and Excise*, 166–68.

p. 161, 'In the 1660s, an estimated twenty thousand woolpacks ... Calais illegally': Sussex Archaeological Society, *Antiquities of the County*, 72–74.

p. 163, '"Monsieur Ram" and "Madam Ewe" arrived at the end of the summer': Carter, *His Majesty's Spanish Flock*, 54–57.

p. 164, 'from the Negretti *cavaña*, one of the best, second only (in Banks's estimation) to the Perales': Carter *His Majesty's Spanish Flock*, 113.

p. 165, 'To add insult to injury ... deteriorated even further': Walling, *Counting Sheep*, 181–82.

p. 165, 'Nothing will give me greater pleasure than to receive the Spanish sheep': R. J. Gordon to Hendrik Fagel, 10 April 1778 (ref: 10.29.2515, nos. 11 and 12); https://www.robertjacobgordon.nl/letters/letter-to-hendrik-fagel-10th-april-1778

p. 165, 'The twenty-five-year-old soldier had already been in Cape Town for over a year': Linder, *The Swiss at the Cape*, 150–53.

p. 166, 'such celestial sounds burst upon our ears': Hickey, *Memoirs*, 108ff.

p. 166, 'the wool from a lamb's lamb': R. J. Gordon to Hendrik Fagel, 10 March 1780 (ref: 10.29.2543, no. 2); https://www.robertjacobgordon.nl/letters/letter-to-hendrik-fagel-10th-march-1780

p. 166, 'The duels had started before they had even left the harbour': Salmon, 'Captain John Macarthur', 16.

p. 167, 'with unrestricted access to convict labour': Conway, 'Macarthur, Elizabeth', *Australian Dictionary of Biography*.

p. 168, 'he committed suicide in his garden, surrounded by the plants': Rookmaaker, *Zoological Exploration*, 61–65.

p. 168, 'There are no resources which art, cunning, impudence and a pair of basilisk eyes can afford': Steven, 'John Macarthur', *Australian Dictionary of Biography*.

p. 169, 'When English settler Samuel Butler arrived', 'I obtained the loan of a horse': Butler, *A First Year*, 33ff.

p. 170, 'But he had begun to question his faith': S. B. to Charles Darwin, 1 October 1865, Butler, *Canterbury Pieces*, 149ff

p. 172, 'were kept in a situation "I had rather forget than describe"': Arthur Young letter, 19 October 1787. Carter, *His Majesty's Spanish Flock*, 52.

p. 172, 'An undercover film … Fremantle to the Middle East': Wahlquist, 'Shocking live export', 8 April 2018.

p. 172, 'They need to favour lambs with smoother skins, so they're less susceptible to flies': RSPCA Australia; https://kb.rspca.org.au/what-is-mulesing-and-what-are-the-alternatives_113.html

p. 172, 'A study at the University of Cambridge in 2017', Knolle et al., 'Sheep recognize familiar and unfamiliar faces'.

Chapter 5: Tweed

p. 177, 'I'd read how Charlemagne – my backside is frozen': Einhard and Notker, *Two Lives of Charlemagne*, 133.

p. 178, 'that you get them made just like the ones we used to get in the old times' ('ut tales jubeatis fieri, quales antiquis temporibus ad nos venire solebant'); 'I catch cold because my backside is frozen' ('ad necessaria naturae secedens tibiarum congelatione deficio'): Owen-Crocker et al., *Encyclopedia of Medieval Dress*, 179.

p. 182, 'Our Harris Tweed suits cannot be beaten': Hunter, *The Islanders and the Orb*, 12–13.

p. 182, 'fell down in a fit': *Daily Mail*, 11 August 1906, in Hunter, *The Islanders and the Orb*, 12.

p. 184, 'One company in the early 1960s … a shed full of looms on the quay at

Tarbert' (the company was A & J Macnaughton of Pitlochry): Hunter, *The Islanders and the Orb*, 98.

p. 187, 'My father asked MacLeod … but permission was not given': British Parliamentary Papers, 1884, 1200.

p. 189, 'ultimately to a smart suit … India or the New World': Hunter, *The Islanders and the Orb*, 44.

p. 190, 'said to be the oldest visible fragments of Europe': Thompson, *Harris Tweed*, 14.

p. 195: 'telling *The Herald* that the tweed "is an integral part of the Western Isles"': Leask, 'English Harris Tweed tycoon', 3 September 2019.

p. 196, 'The two had met during a British trade mission to Havana in 1998': Wilson, 'My toast to a legend', 27 November 2016.

p. 196, 'drinking the last two bottles of 1956 Bordeaux': Barber, 'Vitol's Ian Taylor on oil deals', *Financial Times*, 3 August 2018.

p. 199, 'Last night Lady Rasey shewed him the operation of wawking cloth': Johnson and Boswell, *Tour to the Hebrides*, 238 (Saturday, 11 September 1773).

p. 199 'A BBC documentary… strangers': New Generation Thinkers BBC Radio 3, Sunday 13 November 2016; bbc.co.uk/programmes/b082k9db. Produced by Clare Walker.

p. 199, footnote: 'They told him the chorus was generally unmeaning': Johnson and Boswell, *Tour to the Hebrides*, 282 (Wednesday, 22 September 1773).

p. 200, 'its famous "Home Counties" smell',: Finlay MacDonald, *Crowdie*, 198.

p. 200, 'pee-tubs of Harris, time was trickling out': Magnusson, *Life of Pee*, 1ff.

p. 201, 'I give a sunwise turn dependent on the Spirit,' Thompson, *Harris Tweed*, 46–47.

Chapter 6 Pashmina

p. 204, 'a tutor employed to teach the children': Chandra, 'Kashmir shawls', 7–8.

p. 204, 'One legend claims that the eighth Sultan …': von Hügel, *Kashmir*, 9.

p. 207, 'cost up to twenty thousand dollars': Maron, 'A rare antelope', 26 April 2019.

p. 211, 'And pressing mee to take a Gould shalh': Roe, ed. Foster, *The Embassy of Sir Thomas Roe I*, 223.

p. 211, 'For men, the fashions were more sober': Cunnington, *Costume*, 39ff.

p. 212, 'Many Roman statues … *palla* … wearer's shape and bearing': Harlow, '*Pallu, pallu, chador*', 15ff.

p. 212, 'A 1778 English fashion plate': http://findit.library.yale.edu/catalog/digcoll:291684

p. 212, 'I have received the shawls'; 'wore them only because the dress was strange': Memes, *Memoirs*, xxxiii.

p. 213, 'She had dresses made of them … cushions for her dog': de Rémusat, *Memoirs of the Empress Josephine, Volume II*, 43.

p. 213, 'Once, in 1800 … catching neither of them': de Bourrienne, *Memoirs*, 1839, 48.

p. 213, 'from the beauty of its quality, must have cost a hundred guineas': Jesse, *The Life of George Brummell*, 77–78.

p. 215, 'not to "touch even a blade of grass"': Handa, *Buddhist Western Himalaya*,184.

p. 216, 'acknowledges the supremacy … three pairs of Cashmere shawls': Lévi-Strauss, *Cashmere*, 17ff.

p. 218, 'the nomads … warp and weft to describe the fabric of their society.' Ahmed, 'Making cloth', 150–51.

p. 221, footnote: 'people arriving on private jets': Maron, 'A rare antelope', 26 April 2019.

p. 229, 'are very apt to be worm-eaten, unless frequently unfolded and aired': Bernier, *Travels*, 267 and 402–03.

p. 229, 'placed around the flower beds … drive away the bugs': Donkin, *Dragon's Brain Perfume*, 62 and 73.

p. 229, footnote: 'In 2019 there was a moth crisis at Newhailes House': Horton, 'Moth problem', 4 February 2019.

p. 230, 'peony red, verdigris and cinnamon … saffron ground': Irwin, *The Kashmir Shawl*, 50 and plate 4.

p. 231, 'This year, in the little palace garden … more than one hundred of them': Jahangir, *Memoirs*, 145.

p. 233, 'William Moorcroft …': Moorcroft et al., *Travels*, 175ff, and Moorcroft MSS G28, 27 June 1823 (quoted in Rizvi, *Pashmina*, endnote 55).

p. 238, 'A specific blue-green English woollen broadcloth was boiled': Rizvi, *Pashmina*, 53.

p. 238, 'In 1872 Hungarian-born linguist Gottlieb Wilhelm Leitner': Leitner, *Account of Shawl-weaving*, 1–4.

p. 238, 'each ornament should be softly and not harshly defined': Jones, *The Grammar of Ornament*, 161.

p. 239, 'The Exhibition of 1851 as a Lesson in Taste': Choudhury, 'It was an imitashon to be sure', 194–95.

p. 242, 'such extraordinary swearing': *The New York Times*, 'They all knew the shawl', 30 May 1886, 14; https://timesmachine.nytimes.com/timesmachine/1879/01/01/issue.html

p. 242, 'Thomas Vigne in 1840 called their "ineffable softness"': Lévi-Strauss, *Cashmere*, 24.

Chapter 7: Sackcloth

p. 245, 'They went in single file': conversation with former HMP Shepton Mallet guards, Graeme and Laura Miller, August 2018.

p. 246, 'When the occupants … and stop the wooden supports of the walls from being set ablaze': Smith, *Dictionary of Greek and Roman Antiquities*, 282.

p. 246, 'The King of Samaria': 2 Kings, 6:30.

p. 247, footnote: 'The Turkish name for them is *kil keçi*': Yalçin, *Sheep and Goats*, 5.2.2.

p. 247, '*Cilicii* … to humble the soul': St Basil, *The Rule*, 219.

p. 247, footnote: 'Si licet ... humilitate animae': St Basil, *The Rule*, 219.

p. 247, 'St Rose of Lima ... hung them in the sun to dry': Mills and Taylor, *Colonial Spanish America*, 197–202.

p. 249, 'two shirts of hair made of great knots': de Voragine, Ellis, ed., *Golden Legend*, 192ff.

p. 249, 'The 1346 inventory of relics held in Saint-Omer Church': Biggs et al., *Reputation*, 117.

p. 249, 'In *Tartuffe* ... ('ma haire')': Molière, *Tartuffe*, act 3, scene 2.

p. 251, 'We have no English name for this': Lalvani, *The Making of India*, 334.

p. 252, 'Villagers traditionally twisted', 'affords a magnificent sight ... newly-fallen snow': 'Jute', *The New York Times*, 13 May 1877.

p. 254, 'Since my return to Bengal ... *Corchorus olitorius* and *capsularis* ... a substitute for flax?' 20 August 1794, William Roxburgh, Calcutta, to James Edward Smith, London; http://linnean-online.org/62321/

p. 254, 'Dundee linen merchant William Anderson ... fond of her wheel': Warden, *The Linen Trade*, 67.

p. 256, 'Now a still photograph from the Crimean War': The end of Balaclava Harbor', Felice Beato and James Robertson (Robertson & Beato partnership), 1855.

p. 259, 'Tough, gummy stuff': Wallace, *The Romance of Jute*, 13.

p. 259, 'Capper applied ... for a patent for the "bleaching of jute and other vegetable fibres"': Capper and Watson, Patent 87, 1853.

p. 260, 'My first reaction was to quickly rush ... never to enter again': Fraser, *A Home by the Hooghly*, 114.

p. 262, 'on bicycles and gramophones and German-made battery torches': Ray, *Bengali Chemist*, 405.

p. 267, 'The strikers ...or to replace filled spools on the spindles ... 30 mills here, instead of three': *The New York Times*, 30 March 1886, 'Local Labor Troubles; Three Hundred of the Employes of the Chelsea Jute Mills on Strike'.

p. 268, 'While a good article of jute should attain a growth': Legislature of the State of California 1891, 29–34.

p. 269, 'In all 600 men ... risked their lives': *The San Francisco Call*, vol. 107, 3 April 1910.

p. 269, 'In 1911, a former guard at San Quentin': *Santa Cruz Evening News*, 18 December 1911. https://www.cdcr.ca.gov/insidecdcr/2018/08/09/cdcr-time-capsule-dec-18-1911-former-officer-describes-life-in-prison-for-new-inmate/

p. 270, 'It was... shortly after my entrance to prison': London, *The Jacket*, 55–57.

p. 271, 'Tennichi Koichi ... Six million sacks': Shigeru, 'Japanization in Indonesia', 270–96.

p. 272, 'Today we discovered isotactic polypropylene ... like a mystery magazine': *The New York Times*, 'Sketches of 5 Nobel Laureates', 6 November 1963.

p. 272, 'This quality is called chirality': Levi, *Black Hole*, 146–49.

Chapter 8: Linen

p. 278, 'Flax is never cut ... a "piano" ... kind of plug': Heinrich, *The Magic of Linen*, 15ff.

p. 279, 'no woman would come near me for two weeks': Jack Larkin, flax grower, quoted in Heinrich, *The Magic of Linen*, 22.

p. 279, 'Its natural colour is sometimes called ecru ... cloth that has never been wet': Furetière, *Dictionnaire universel*, 375.

p. 281, 'fever, hallucinations, somnolence': Nelson et al., *Handbook of Poisonous and Injurious Plants*, 16.

p. 283, 'The King, hearing of it ... entrusted to us temporarily': Bukkyo Dendo Kyokai, *The Teaching of Buddha*, 221–22.

p. 284, 'The very oldest traces of linen fibre ever found': Kvavadze et al., '30,000 years old wild flax fibers'.

p. 285, 'if you plucked it with your teeth it made a twanging sound': Pliny, *Natural History*, 19.2.1.

p. 285, 'They'd sometimes add special herbs': Warden, *The Linen Trade*, 717.

p. 285, 'infamous for giving linen a yellowish tinge': Roche, *The Culture of Clothing*, 389.

p. 285, 'The Seine and its tributary ... rented space at competitive prices': Bonneville, *Fine Linen*, 55–56.

p. 286, 'Always before daybreak ... style of washing': Hearn, *Two Years in the French West Indies*, 241–53.

p. 293, 'They picked up every piece of cloth': quoted in White, *Battle of Bannockburn*, 1871, 6–7.

p. 295, 'In 1966 the singer Janis Joplin ... "planning her trousseau"': Barber, 'Burnt out at 27', 21 December 2019.

p. 295, 'Emily Post published a book', '"trousseau is never spread out on exhibition"': Post, *Etiquette*, 327.

p. 295, 'paper napkins of filmy texture': 'Frigate Niagara, Yedo, Japan, Visit of the Ambassadors', *The New York Times*, 12 February 1861.

p. 295, 'smells like a clean barn just supplied with fresh hay': Adam Davidson, 'How the dollar stays dominant', *The New Yorker*, 4 September 2017.

p. 296, 'The hero Theseus is faced with the task ...Heracles turns up': Graves, *The Greek Myths*, 314–15 and 335–36.

p. 296, 'In that one it is Daedalus ... pull it through': Graves, *The Greek Myths*, 336–37.

p. 296, 'But a labyrinth has only one path ...find yourself by being lost': Ruskin, *Fors Clavigera*, 468–69 and Hillis Miller, *Ariadne's Thread*, 1–6.

p. 298, 'always dressing in white': Beall, *Josephus*, 46.

p. 299, 'loose trousers, tunic-ed coats and broad-brimmed linen hats': Sears, *Bronson Alcott's Fruitlands*, 68ff.

p. 300, 'It's been at the Cathedral of Saint John the Baptist since 1578 ... And nowhere else': information from Museo della Sindone, Turin.

p. 301, 'a pollen analysis by Hebrew University': William K. Stevens, 'Tests trace Turin Shroud to Jerusalem before A.D. 700', *The New York Times*, 3 August 1999.

p. 301, 'Pope Francis ... face "of every suffering and unjustly persecuted person"': Ann Schneible, 'Shroud of Turin reminds us of all human suffering, Pope Francis says', Catholic News Agency, Turin, 21 June 2015; https://www.catholicnewsagency.com/news/shroud-of-turin-reminds-us-of-all-human-suffering-pope-francis-says-29925

p. 301, 'Three of the four gospel writers ... was divided between the soldiers at the foot of the cross': Matthew 27:35; Mark 15:24; John 19:23–24.

p. 302, 'Johannes Braun ... puzzling it out': Roth, *Studies in Primitive Looms*, 122.

p. 306, 'if you were a schoolchild in Israel ... Goral. Fate': personal communication, Rabbi Daniel Sperber, January 2021.

p. 308, 'the machines would catch them and tear off their limbs' Seeley, *Sadler*, 369.

p. 308, 'the smack of which ... resounded through the House': Seeley, *Sadler*, 355ff.

p. 308, 'most disgraceful to the nation': Sorenson, 'Laissez faire', 255.

p. 308, 'Elizabeth Bentley, called in; and Examined': British Parliamentary Papers, Report from the Select Committee on Bill to Regulate Labour of Children in Mills and Factories, 1832.

p. 315, 'there is not a cottage in all the county ... made in great quantities': Yallop, *Honiton Lace Industry*, 35.

Chapter 9: Silk

p. 324, 'ending (as Juliet foresees) 'in the bottom of a tomb': Shakespeare, *Romeo & Juliet*, act 3, scene 5.

p. 325, 'In one version, the girl runs away in distress. In a darker version, she's complicit': the first version is from the Silk Museum, Hangzhou; the second version is from the fourth century, *A Record of Researches into Spirits*, retold by Anne Birrell *Chinese Mythology*, 199–200.

p. 325. 'The clay jar is about thirty centimetres high ... ready for the next world': National Silk Museum, Hangzhou, China.

p. 327, 'so well-preserved that the gravedigger's daughter kept it': Watson, *Annals*, 424–25.

p. 328, 'One still being told in the 1970s in Dunhuang ... further and further west': retold from Chen, ed., *Tales from Dunhuang*, 91–95.

p. 329, 'and then weave a fabric "with the threads thus unwound"': Aristotle, *History of Animals*, Book IX.

p. 329, 'The West African equivalent ... over long distances': Picton and Mack, *African Textiles*, 28–29.

p. 329, 'People used to say ... "no limbs but many feet"': van Huis, 'Lepidopera'.

p. 330, 'wound into the hair of a woman who died in Thebes': Lubec et al., 'Use of silk', 25.

p. 330, 'most amazed to see how many Chinese trade goods there already were in every town': Hansen, *The Silk Road*, 14.

p. 331, 'Pliny the Elder complained ... constant drain on bullion': Barber, *Prehistoric Textiles*, 16.

p. 331, 'The first church in China was built in around 640 in Chang-an': Palmer, *The Jesus Sutras*, 39, 227.

p. 331, footnote: 'The phrase "Silk Road" wouldn't be coined ... Silk Streets': Grimmer-Solem, *Learning Empire*, 115.

p. 332, 'An emperor of China in the Sui Dynasty ... favoured by an emperor': National Silk Museum, Hangzhou, China.

p. 333, 'In the boat they found the bodies ... throw it away': from the Viking Ship Museum, and see also Vedeler, *Silk for the Vikings*, 20ff.

p. 335, 'Their names are Urd ... following deeper laws': Buzina, *Dostoevsky*, 119.

p. 335, 'In 921, the Baghdad diplomat', 'young, old witch, massive and sombre': Ibn Fadlan, 'The Risalah of Ibn Fadlan', 40ff.

p. 336, 'In 907, according to the *Russian Primary* Chronicle', '"Silk sails aren't made for Slavs"': Cross and Sherbowitz-Wetzor, *Russian Primary Chronicle*, 64–65.

p. 337, 'In the eighth century, the Umayyad caliphate ... No servants ... without being dressed in *washi*': Folsach and Bernsted, *Woven Treasures*, 7.

p. 338, 'The oranges of the island are like blazing fire': British Museum, 'Sicily: Culture and Conquest' exhibition label, March 2016.

p. 338, 'King Roger built a "stately edifice"': Gibbon, *Decline and Fall*, volume 10, 15.

p. 339, 'And many of the loose, brilliantly coloured clothes ... were made of silk': Brooke, *English Costume of the Early Middle Ages*, 38.

p. 339, 'New too were surcotes ... finer fabric below': Johnston, *All Things Medieval*, 162–63.

p. 340, 'Lucas Cranach ... first full-length portraits': Bikker, *High Society*, 20 and 74.

p. 341, 'In the early 1530s, two Piedmont master weavers agreed to move to Lyon': Information in this and Jacquard section from the Musée des Tissus et des Arts décoratifs, Lyon; and Maison des Canuts, Lyon.

p. 342, 'a rare and new discovery'; 'a young Lady in England'; 'ground that is well dunged ... warm pillows': Ferrar and Hartlib, *The reformed Virginian silk-worm*, title page and 1–3.

p. 342, 'She (or possibly her father) made notes and drawings in the family atlas': John Carter Brown Library, Brown University.

p. 343, 'smoak and vapour ... reall-royall-solid-rich-staple Commodity': Ferrar and Hartlib, *The reformed Virginian silk-worm*, 10.

p. 343, 'the pernicious blinding smoak of Tobacco, that thus hath dimmed and obscured your better intellectuals': Ferrar and Hartlib, *The reformed Virginian silk-worm*, 20.

p. 343, 'Every able-bodied woman ... a certain amount of silk ... would be punished': Mazumdar, *Textile Tradition of Assam*, 24

p. 349, 'It's seen as the cloth of poorer people': Zethner et al. *South Asian Ways of Silk*, 36–37.

p. 350, 'to remind everyone (including their own children …) … nomadic origins': Vollmer, *Clothed to Rule*, 49.

p. 350, 'a mandarin square, a badge of embroidered silk': Garrett, *Mandarin Squares*, 35ff.

p. 350, 'birds could fly to heaven while animals were destined to stay on the ground': information in this section from China National Silk Museum, Hangzhou; and from Jiangning Imperial Textile Workshop Museum, Nanjing.

p. 350, 'a piece of clothing to be a diagram of the visible universe': conversation with Hollywood Road antique dealer; also found in Vollmer, *Clothed to Rule*, 33–34.

p. 354, 'The process is called *pang hua*, pulling the flowers': Broudy, *The Book of Looms*, 127.

p. 355, 'In 1727, a visitor taking dinner at the friary of the order of the Minims in Lyon was amazed': Wood, *Edison's Eve*, 19ff.

p. 356, '*Huis Genooten* … confederate, or 'oath participant'… King Hugon': Gray, *Origin of the word Huguenot*, 352, 349, 355.

p. 356, footnote: 'In 1717, an Englishman, John Lombe': William Hutton, *The History of Derby*, 1791, 191–209, in D. B. Horn and Mary Ransome, *English Historical Documents*, 458–61.

p. 357, footnote: 'Later, when Charles Darwin … "thumb-eyed"'Gilmartin, 'Observations of heterostyly in *Primula*', 42.

p. 359, 'Bouchon was a weaver … Jean-Baptiste Falcon had replaced it with a chain of cardboard punch cards': Péres, 'Inventing in a world of guilds', 241ff.

p. 360, 'a horse, an ox or a donkey can make better cloth than the very best silk workers': Académie des sciences, *Mémoires*, 93.

p. 360, 'seditious crochet worker': Wood, *Edison's Eve*, 77.

p. 361, 'I am afraid of these insurrections … 200,000 men': Draper, *The Arts under Napoleon*, 4.

p. 361, 'I will not deny … some repugnance to equip myself … manufactures will flourish': Abrantès, *Memoirs of Napoleon*, 46.

p. 362, 'Joseph-Marie Charles was the son … someone invented the first loom': information in this section from (inter alia) the Musée des Tissus et des Arts décoratifs (Lyon); Maison des Canuts (Lyon); Essinger, *Jacquard's Web*, 22ff; and the Silk Museum and Paradise Mill, Macclesfield, Cheshire.

p. 363, footnote: 'In 1960, the textiles at the Palace of Versailles': Maison des Canuts, Lyon.

p. 365, 'Bonafous, Bourg et Cie was the most prominent': Zanier, 'Overcoming the barrier of the Alps', 1–14.

p. 366, 'In 1821 the Swiss naturalist Perrottet': Bonafous, *Traité*, 525ff.

p. 366, 'Then a nurseryman on Long Island ... accept them as gifts': Brockett, *The Silk Industry*, 39–40.

p. 369, 'Consider ... I have never handled a silkworm': Davidson *Big Fleas*, 6–24; and Vallery-Radot, *Louis Pasteur*, 134ff.

p. 369, ' Pasteur's own observations were complicated ... female moth': Hukuhara, 'The etiology of flacherie', 15ff.

p. 369, 'Here is the Pasteur system, in six basic steps': information from Maison des Canuts, Lyon.

p. 370, 'Japan was beginning to open its markets': Ma, 'Why Japan', 374ff.

p. 371, 'No one who has heard the sound': Reischauer, *Samurai and Silk*, 193ff.

p. 373, 'but they still wanted the cheaper Japanese ones': Reischauer, *Samurai and Silk*, 253–54.

p. 374, 'In 1912, *The New York Times* ... petticoats ... thousands of persons thereby': *The New York Times*, 'Women's narrow skirts play hob with textile industry', 28 January 1912.

p. 374, 'On 7 October Edith Berg': *The New York Times*, 8 October 1908, 'Woman flies with Wright. Mrs Hart O Berg first of her sex to ride in an aeroplane.'

p. 374, 'minus the veil': *The New York Times*, 'Skirts are Doomed', 25 December 1910.

p. 374, 'their wings held together with skins of silk ... neckcloths': from Silk Association of America report, 12 December 1917, quoted in Reischauer, *Samurai and Silk*, 254–55.

p. 375, 'Germany nearly ran out of silk ... By 1917, even paper was too precious': Deutsches Historisches Museum (German Historical Museum), Berlin, museum label.

Chapter 10: Imagined Fabrics

p. 380, 'Robert Hooke was the first': Jardine, *Ingenious Pursuits*, 42ff.

p. 381, 'a Sot, that has spent £2000 in Microscopes, to find out the nature of Eels in Vinegar': Drake, *Restless Genius*, 130.

p. 381, 'the most ingenious book that ever I read': Pepys, *Diary*, 21 January 1665.

p. 381, 'white long wing'd Moth': Hooke, *Micrographia*, 195–96.

p. 383, 'I have often thought ... no occasion to be displeas'd': Hooke, *Micrographia*, 7.

p. 385, 'and off went the cotton ... such a singeing that he leaped up with a cry of pain': *The Spectator*, 'Miscellaneous', 3 October 1846, 9.

p. 385, 'Schönbein sold the British rights ... in July 1847 two of the buildings blew up': *The Spectator*, 'The Provinces', 17 July 1847, 6.

p. 386, 'In 1878, chemist, physicist and inventor Joseph Swan ... in the collection of the Science Museum': Science Museum, object number: 1927-214.

p. 388, 'City councillor Léon Brédillot ... pale, blue skin': Mensch, *La Rhodiacéta de Besançon*, 13–15.

p. 389, 'American historian Paul Blanc ... still accidents': Blanc, *Fake Silk*, consulted for this section; quote from viii–x.

p. 389, 'That's what Swiss chemist Jacques Brandenberger did': Jewkes et al., *The Sources of Invention*, 238.

p. 390, 'In 1903, Scottish MP Richard Haldane ... not yet succeeded in making it so white as they do ... inferior knowledge of our own business': *The Spectator*, 'Protection or Education,' 5 December 1903, 24.

p. 391, 'The old stuff is out': MacCarthy, *Walter Gropius*, 102.

p. 392, 'One student was Annelise Fleischman ... won her Bauhaus diploma on the strength of it': 'Anni Albers', exhibition at Tate Modern, 11 October 2018 to 27 January 2019.

p. 393, 'Fleischmann realised that the challenge': Albers, *On Weaving*, 3–5.

p. 394, 'Federal Trade School in Germany ... saved her life': Siebenbrodt and Schöbe, *Bauhaus*, 139ff.

p. 395, 'Éleuthère Irénée du Pont ... just to think: DuPont Chandler Jr and Salsbury, *Pierre S. du Pont*, 12ff.

p. 396, 'the task ... of holding in one's hand ... killed himself': Hermes, *Enough for One Lifetime*, 26ff.

p. 399, 'In September 1938 DuPont unveiled ... print US dollars': Ndiaye, *Nylon and Bombs*; Witzel, *Fifty Key Figures*, 80–83; E. I. du Pont de Nemours: *Nylon: The First 25 Years;* and Moncrieff, *Man-Made Fibres*, 330ff.

p. 399, 'Hosiery men scoffed at this fear ... in place of silk': *The New York Times*, 'Nylon will avoid errors of rayon', 3 November, 1938.

p. 400, 'Old Stocking Good for Socking Hitler': *The New York Times*, 10 November 1942.

p. 401, 'Vietcong soldiers would carry hammocks ... American troops with their huge packs and equipment': *The New York Times*, 13 September 1964.

p. 402, 'Now, as he flicked through the *Journal* ... first polyester fabric': Allen, *Studies in Innovation*, 69–81.

p. 404, 'drip-dry was first recorded': Merriam-Webster, https://www.merriam-webster.com/dictionary/drip-dry

p. 406, 'The women on the spacesuit production line': interviewed by CBS News; 14 July 2019, https://www.cbsnews.com/news/apollo-11-the-seamstresses-who-helped-put-a-man-on-the-moon/

p. 407, 'the nylon flags planted by the astronauts ... extreme ultraviolet rays': Platoff, 'Where no flag has gone before'.

p. 407, 'One of the senior chemists in the team was Stephanie Kwolek', 'even if there was pressure, it generally didn't get down to our level ... five times stronger than steel': Kwolek interview by Bernadette Bensaude-Vincent, 1998.

p. 407, 'The Nylon Rope Trick': Ted Lister, *Classic Chemistry Demonstrations*, Royal Society of Chemistry, 1996, 159–61.

p. 409, 'One night in October 1969 ... puzzle out what to do': *Bloomberg*

Businessweek, 9 May 2019. 'The company behind Gore-Tex is coming for your eyeballs', Drake Bennett, https://www.bloomberg.com/features/2019-gore-artificial-cornea/

p. 411, 'I ... said to myself if you won't pull slowly I'm going to give you a jerk – and it stretched a thousand per cent': Gore, interview, Science History Institute; https://www.sciencehistory.org/historical-profile/robert-w-gore

p. 411, 'In 2005, DuPont was fined ...environment': Michael Janofsky, 'DuPont to pay $16.5 million for unreported risks', *The New York Times*, 15 December 2005.

p. 411, 'damning Greenpeace investigation into PFCs ... polar bears in the Arctic': Greenpeace, *Leaving Traces*, 1–44.

p. 412, 'Jump in and see if you can swim ... not sinking': Gore, interview, Science History Institute.

p. 412, 'For a while manufacturers tried to call it "glos"... the word rayon was born': Stimpson, *Information Roundup*, 82–84.

p. 413, 'DuPont's naming committee ... Pulls a Rabbit out of a Hat': Hermes, *Enough for One Lifetime*, 295.

p. 414, 'But most is no more bamboo than cotton viscose is cotton ... woven into cloth': Sindyan Bhanoo, 'F.T.C. Comes down on bamboo fiber claims', *The New York Times*, 22 October 2009. https://green.blogs.nytimes.com/2009/10/22/ftc-comes-down-on-bamboo-fiber-claims/?searchResultPosition=5

p. 414, 'except that in the US at least, according to the Federal Trade Commission ... "bamboo"': https://www.ftc.gov/system/files/documents/plain-language/alt172-how-avoid-bamboozling-your-customers.pdf

Chapter 11: Patchwork

p. 421, 'In 1992, a photographer arrived': Freeman, *A Communion*, 333–38.

p. 426, 'to put some life in them ... Even a driver can make a difference ... A winner seemed to have a halo round it': Hulanicki, *From A to Biba*, 102–103.

p. 428, 'the old ones ... Maybe that's why you're always asking questions': Freeman, *A Communion*, 8.

p. 429, 'They are often white-on-white or cream-on-cream ... Mary Jones, who died in 1900, could use both hands at the same time, making her twice as fast as anyone else': Jones, *Welsh Quilts*, 13ff.

p. 430, *'because when your hands are softened ... needle pricks'*: Fitzrandolph, *Traditional Quilting*, 32.

p. 430, 'before calling in her husband and son ... went on into the scullery for their baths': Fitzrandolph, *Traditional Quilting*, 73.

p. 431, 'The king of Thrace has rescued Athens from its enemies': Ovid, *Metamorphoses* Book VI.

p. 433, 'The loom and the lyre ... the strings': Snyder, 'The web of song', 193–96.

p. 433, footnote: 'When the tenth century poet Cynewulf ... very skilful indeed': Cynewulf, *Elene*, 1236–37 and Leyerle, 'Interlace Structure of *Beowulf*', 1ff.

p. 434, 'outrageous … another planet', 'I just put stuff together': Arnett and Arnett, eds, *The Quilts of Gee's Bend*, 43–44 and 126.

p. 435, 'how her great-grandmother Dinah arrived in America as a slave when she was thirteen': Arnett and Arnett, *The Quilts of Gee's Bend*, 92ff.

p. 435, '*Oyokoman* … royal family of the Asante are descended': Ross, 'Asante cloth names and motifs', 107 and 112.

A Note about the Cover

p. 448, "fine depiction of fabrics … other media," Peter Trippi, (personal communication,) February 16, 2020.

p. 448, "framed … by three accounts", Homer, *Odyssey*, 2.85-120 (told by the bitter suitor Antinous), 19.137-158 (told by Penelope) and 24.126-7 and 24.145-149 told by another suitor, Amphimedon.

p. 449, "A daemon breathed the thought…fine of thread and very wide," Homer, *Odyssey*, 19: 138-140

p. 449, "The English word 'analyse' … unravelling the cloth", Ioanna Papadopoulou, 'Penelope's great web: the violent interruption'. *Classical Inquiries*, 10 March, 2016. https://classical-inquiries.chs.harvard.edu /penelopes-great-web-the-violent-interruption/#_ftn3 The word comes in the *Odyssey* at 19.149–150. The form ἀλλύεσκον is the poetic imperfect iterative of ἀναλύω.

p. 449, "The Greek word for bow, toxon … begetting, birthing,"

p. 449, "according to some… fabric itself," Strong, James. *Strong's Exhaustive Concordance of the Bible*. Abingdon Press, 1890 p1677

p. 450, "the women's suffrage movement … popular". Trippi, *J.W.Waterhouse* p. 213

p. 450, "the so-called domestic arts of weaving … suffragettes … attended lectures… Friedrich Engels", Lack, Jessica, 'The Role of Artists in Promoting the Cause of Women's Suffrage', *Frieze*, 2 September, 2018. https://www .frieze.com/article/role-artists-promoting-cause-womens-suffrage

A Note for the Future

p. 451, 'The corporate giant Walmart … Higg': Gunther, 'Behind the scenes at the Sustainable Apparel Coalition'.

p. 451, 'The Higg was relaunched in 2020': Adegeest, 'The Sustainable Apparel Coalition updates Higg Index'.

MUSEUMS

While researching *Fabric* I visited dozens of wonderful museums with textiles in their collections, whose permanent displays and temporary exhibitions both inspired and informed this book in more ways than I can say. They are each worth visiting and supporting.

In the UK they included: All Hallows Museum, Honiton; American Museum, Bath; Ashmolean Museum, Oxford; Bradford Industrial Museum; Bristol Museum & Art Gallery; British Museum, London; Brunei Gallery, London; Dales Countryside Museum, Hawes; Fashion & Textile Museum, Bermondsey, London; Fashion Museum, Bath; Fitzwilliam Museum, Cambridge; Hunterian, Glasgow; Macclesfield Silk Museum and Paradise Mill; Museum of London; National Gallery, London; National Museum of Scotland, Edinburgh; National Portrait Gallery, London; New Lanark Visitor Centre, Lanarkshire; Paisley Museum, Renfrewshire; Quarry Bank Mill, Styall; Quilters' Guild Museum, York; Royal Academy, London; Royal Albert Memorial Museum, Exeter; Ruskin Museum, Coniston; Salts Mill, Saltaire; Sir Richard Arkwright's Masson Mills Working Textile Museum, Derbyshire; Tate Modern, London; Verdant Works, Dundee; Victoria & Albert Museum, London; Welsh Quilt Centre, Lampeter; Whitworth Art Gallery, Manchester.

Elsewhere they included: Beaux-Arts Museum of Arras, Arras; Boott Cotton Mills Museum, Lowell, US; Cojolya Museum, Santiago Atitlán, Guatemala; Deutsches Historisches Museum, Berlin, Germany; Shift Field Museum, Chicago; High Museum, Atlanta, US; J. Paul Getty Museum, Los Angeles, US; Hong Kong Museum of History, Hong Kong; Jiangning Imperial Silk Manufacturing Museum, Nanjing, China; Kunsthaus Zurich Switzerland; LACMA, Los Angeles, US; Maison des Canuts, Lyon, France; MAK, Vienna, Austria; Manufacture des Gobelins, Paris, France; MOA Museum of Art, Atami, Japan; Musée des Arts Décoratifs, Paris, France; Musée des Confluences, Lyon, France; Musée des Tissus et des Arts décoratifs, Lyon, France; Museo della Sindone (Holy Shroud Museum), Turin, Italy; Museo Egizio, Turin, Italy; Museum of Fine Arts, Boston, US; National Museum of Ireland – Decorative Arts and History, Dublin; National Silk Museum, Hangzhou, China; Queen Sirikit Museum of Textiles, Bangkok, Thailand; Rijksmuseum, Amsterdam, Netherlands; St Gallen Textilmuseum, Switzerland; Art Institute of Chicago, US; Field Museum, Chicago, US; The Textile Museum, George Washington University, Washington DC, US; Vikingskipshuset på Bygdøy (Viking Ship Museum), Oslo, Norway.

PICTURE CREDITS

Colour plate section

p. 1 (Top) Portrait of Velma Joyce; (Bottom) sample of local barkcloth. Photo: Katia Marsh

p. 2 Eighteenth century palampore. Photo: Heritage Images/Getty

p. 3 Four designs from VLISCO. Photos courtesy of VLISCO

p. 4 Photo montage of tweed and the land by Ian Lawson. Adapted from his book *Saorsa*. Reproduced with kind permission of Ian Lawson

p. 5 Two Kashmir *Amlikar* shawls. Author photos

p. 6 An uncut imperial dragon robe and inset. Courtesy Teresa Coleman Fine Arts Ltd, Hong Kong, with kind permission

p. 7 (Top) Thirteenth century brocade. (Right) dragon brocade; (Left) fifteenth century, pink Italian silk. Photos: Metropolitan Museum, New York

p. 8 The kente cloth held in the High Museum, Atlanta. Reproduced with the kind permission of the High Museum.

While every effort has been made to contact copyright-holders of illustrations, the author and publishers would be grateful for information about any illustrations where they have been unable to trace them, and would be glad to make amendments in further editions.

SELECTED BIBLIOGRAPHY

Abdel-Salam, M. E. and Mohamed A. M. El-Sayed Negm, *The Egyptian Cotton: Current Constraints and Future Opportunities*. Alexandria: Textile Industries Holding Co. Modern Press, 2009.

Abrantès, Laure Junot Duchesse d', *Memoirs of Napoleon, His Court and Family Volume 2*. London: R. Bentley, 1836.

Académie des sciences (France), *Mémoires*. Paris: Chez G. Martin, Jean-Baptiste Coignard, H.-L. Guerin, 1830.

Adegeest, Don-Alvin, 'The Sustainable Apparel Coalition updates Higg Index to better measure sustainability', Fashion United UK, 7 August 2020, https://fashionunited.uk/news/fashion/the-sustainable-apparel-coalition-updates-higg-index-to-better-measure-sustainability/2020080750245

Ahmed, Monisha, 'Making cloth – gender and place in Rupshu, Eastern Ladakh', *India International Centre Quarterly* 27/28, 2001, 149–59, http://www.jstor.org/stable/23005707

Albers, Anni, *On Weaving*. Princeton: Princeton University Press, 2017.

Allen, James Albert, *Studies in Innovation in the Steel and Chemical Industries*. Manchester: Manchester University Press, 1967.

Almalech, Mony, 'The eight kinds of linen in the Old Testament', *Lexia* 7, January 2013, 325–64.

Anderson, Adam, *An Historical and Chronological Deduction of the Origin of Commerce, from the Earliest Accounts; Containing an History of the Great Commercial Interests of the British Empire, Volume 2*. London: A. Millar et al., 1764, 228.

Ariès, Philippe, *The Hour of Our Death: The Classic History of Western Attitudes Towards Death Over the Last One Thousand Years*, trans. Helen Weaver. New York: Alfred A. Knopf, 1981.

Arnett, William and Paul Arnett, eds, *The Quilts of Gee's Bend*. Atlanta: Tinwood, 2002.

Ashworth, William J., *Customs and Excise: Trade, Production, and Consumption in England, 1640–1845*. Oxford: OUP, 2003.

Banks, Joseph, *The Endeavour Journal, Volume 1, 25 August 1768 – 14 August 1769*. Mitchell Library, State Library of New South Wales. http://acms.sl.nsw.gov.au/_transcript/2015/D04977/a1193.html.

Banks, Joseph, *The Endeavour Journal of Joseph Banks 1768–1771*, John Cawte Beaglehole, ed. Sydney: Trustees of the Public Library of New South Wales, 1962.

Barber, Elizabeth Wayland, *Prehistoric Textiles: The Development of Cloth in the Neolithic and Bronze Ages*. Princeton: Princeton University Press, 1993.

Barber, Lionel, 'Vitol's Ian Taylor on oil deals with dictators and drinks with Fidel', *Financial Times*, 3 August 2018, https://www.ft.com/content/2dc35efc-89ea-11e8-bf9e-8771d5404543

Barber, Lynn, 'Burnt out at 27: the tragedy of Janis Joplin', *The Spectator*, 21 December 2019; a review of *Janis: Her Life and Music* by Holly George-Warren; https://tinyurl.com/yx4hfne4

Barker, John, *Ancestral Lines: The Maisin of Papua New Guinea and the Fate of the Rainforest*. Toronto: University of Toronto, 2016.

Barine, Arvède, *The Great French Writers: Bernardin de St. Pierre*, trans. James Edward Gordon. Chicago: A. C. McClurg & Co., 1893.

Barlow, Frank, *Thomas Becket*. Berkeley: University of California Press, 1990.

St Basil, Bishop of Caeserea, *The Rule of St Basil in Latin and English: A Revised Critical Edition*, trans. Anna Silvas. Collegeville: Liturgical Press, 2013.

Bates, Edward Craig *The Story of the Cotton Gin*. Westborough, MA: The Westborough Historical Society, 1899.

Bavier, Joe, 'How Monsanto's GM cotton sowed trouble in Africa', Reuters, 8 December 2017. https://www.reuters.com/investigates/special-report/monsanto-burkina-cotton/

Beall, Todd S., *Josephus' Description of the Essenes Illustrated by the Dead Sea Scrolls*. Cambridge: CUP, 2004.

Becker, Jasper, *C. C. Lee: The Textile Man*. Hong Kong: Textile Alliance, 2011.

Bernier, François, *Travels in the Mogul Empire AD 1656–1668*, trans. Archibald Constantine, revised by Vincent Smith. Oxford: Humphrey Milford, 1916.

Biggs, Douglas L., Sharon D. Michalove, Albert Compton Reeves, eds, *Reputation and Representation in Fifteenth-Century Europe*. Leiden & Boston, MA: Brill, 2004.

Bikker, Jonathan, *High Society: Life-Size, Standing and at Full-Length*. Amsterdam: Rijksmuseum, 2018.

Birrell, Anne, *Chinese Mythology: An Introduction*. Baltimore, MD, and London: The Johns Hopkins University Press, 1993.

Blanc, Paul David, *Fake Silk: The Lethal History of Viscose Rayon*. New Haven, CT: Yale University Press, 2016.

Bonafous, Matthieu, *Traité de l'éducation des vers à soie*. Paris: L. Bouchard-Huzard, 1840.

Bonneville, Françoise de, *The Book of Fine Linen*, trans. Deke Dusinberre. Paris: Flammarion, 1994.

Bourrienne, Louis Antoine Fauvelet de, *Memoirs of Napoleon Bonaparte: From the French of M. Fauvelet de Bourrienne*. London: P. F. Collier, 1901.

Bradford, Gamaliel, *The History and Analysis of the Supposed Automaton Chess Player of M. de Kempelen: Now Exhibiting in this Country by Mr. Maelzel*. London: Hilliard, Gray, 1826.

Braudel, Fernand, *Civilization and Capitalism 15th–18th Century Volume I: The Structures of Everyday Life*, trans. Sian Reynolds. London: William Collins, 1985.

Brédif, Josette, *Toiles de Jouy: Classic Printed Textiles from France 1760–1843*, trans. Nina Bogin. London: Thames and Hudson, 1989.

British Parliamentary Papers, *Evidence (Volume II) taken by the Royal Commissioners of Inquiry on the Condition of the Crofters and Cottars in the Highlands of Scotland*, 'Volume XXXIV Session 5 February – 14 August 1884, Highland Crofters continued'. Shannon: Irish University Press, 1884.

British Parliamentary Papers, Report from the Select Committee on Bill to Regulate Labour of Children in Mills and Factories, 8 August 1832. London: 1832.

British Wool Marketing Board, *British Sheep & Wool*, 2010.

Brockett, Linus Pierpont, *The Silk History in America, A History: Prepared for the Centennial Exposition*. New York: Silk Association of America, 1876.

Brooke, Iris, *English Costume of the Early Middle Ages: The Tenth to the Thirteenth Centuries*. London: A. & C. Black, 1936.

Broudy, Eric, *The Book of Looms: A History of the Handloom from Ancient Times to the Present*. Hanover, NH: University Press of New England, 1979.

Brougham, Henry Lord, *Lives of Men of Letters and Science who Flourished in the Time of George III, Second Series*. Philadelphia: Carey & Hart, 1846.

Bukkyo Dendo Kyokai, *The Teaching of Buddha, Wheel of Dharma*. Tokyo: Bukkyo Dendo Kyokai, 1966.

Bullinger, Rev. Ethelbert, *A Critical Lexicon and Concordance to the English and Greek New Testament*, London: Longmans, Green & Co., 1892.

Butler, Samuel, *A First Year in the Canterbury Settlement*. London: A. C. Fifield, 1914.

Butler, Samuel, *Samuel Butler's Canterbury Pieces*. London: A. C. Fifield, 1914.

Buzina, Tatyana, *Dostoevsky and Social and Metaphysical Freedom*. Lewiston, NY: Edwin Mellen Press, 2003.

Byng, John, Viscount Torrington, *Rides Round Britain*, Donald Adamson, ed. London: The Folio Society, 1996.

Capper, John and Thomas John Watson, Capper & Watson's Improvements in Preparing and Bleaching Jute &c, Patent Application AD 1853, no. 87.

Capper, John, *The Three Presidencies of India*. London: Ingram, Cooke, and Co., 1853.

Carillo-Huffman, Yvonne, Chief Jerry Taki Uminduru and Kirk Huffman, 'Indigenous knowledge, engagement and the role of museums in cultural reactivation', in Peter Messenholler and Oliver Lueb, eds, *Made in Oceania: Tapa – Art and Social Landscapes*, 176–98. Köln: Rautenstrauch-Joest-Museum; Mainz am Rhein: Nünnerich-Asmus, 2013.

Carter, Harold C., *His Majesty's Spanish Flock: Sir Joseph Banks and the Merinos of George III of England*. Sydney: Angus & Robertson, 1964.

Carter, Harold C., ed., *The Sheep and Wool Correspondence of Sir Joseph Banks*. London: British Museum, 1979.

Chandra, Moti, 'Kashmir shawls', in *Bulletin of the Prince of Wales Museum of Western India No.3 (1952–1953)*. Bombay: Prince of Wales Museum, 1954, 1–24.

Chen Yu, ed., *Tales from Dunhuang*, trans. Li Guishan, Artem Lozynsky. Beijing: New World Press, 1989.

Choudhury, Suchitra, 'It was an imitashon to be sure': the imitation Indian shawl in design reform and imaginative fiction', in *Textile History* 46(2), November 2015, 189–212.

Chrisman Campbell, Kimberley, 'Paisley before the shawl', in *Textile History* 33(2), November 2002, 162–77.

Constantine, Emperor, Constantine Porphyrogenitus De Administrando Imperio, Gy. Moravcsik, ed., trans. R. J. H. Jenkins, new revised edition. Washington, DC: Dumbarton Oaks Center for Byzantine Studies, 1967.

Conway, Jill, 'Macarthur, Elizabeth (1766–1850)', *Australian Dictionary of Biography*, National Centre of Biography, Australian National University, https://adb. anu.edu.au/biography/macarthur-elizabeth-2387/text3147.

Cook, James, Joseph Banks and Dr Hawkesworth, *The Three Voyages of Captain Cook Round the World. Vol. I. Being the First of the First Voyage*. London: Longman, Hurst, Rees, Orme and Brown, 1821.

Cross, Samuel Hazzard and Olgerd P. Sherbowitz-Wetzor, eds, *The Russian Primary Chronicle*, Laurentian Text. Cambridge, MA: Mediaeval Academy of America, 1953.

Cunnington, Phillis, *Costume*. London: A & C Black Ltd, 1966.

Cynewulf, *Elene*, trans. Lucius Hudson Holt. New York: Henry Holt, 1904.

Darwin, Charles, *On the Origin of Species*, Facsimile of the First Edition. London: John Murray, 1859.

Das, Kamala, *My Story*. New Delhi: Sterling Publishers, 1976.

Daubenton, *Advice to Shepherds and the Owners of Flocks*, trans. a Gentleman of Boston. Boston, MA: Joshua Belcher, 1811.

Davidson, Elizabeth, *Big Fleas Have Little Fleas: How Discoveries of Invertebrate Diseases are Advancing Modern Science*. Tucson, AZ: University of Arizona Press, 2006

Davies, Steve, 'The Poet's Tale', a review of *Chaucer and the Year that Made the Canterbury Tales*, by Paul Strohm, *The Independent*, 15 January 2015.

De Voragine, Jacobus, Archbishop of Genoa, *The Golden Legend Or Lives Of The Saints Volume Two*, trans. and ed. F. S. Ellis. London and New York: Temple Classics, 1900.

Debré, Patrice, *Louis Pasteur*. Baltimore, MD: Johns Hopkins University Press, 2000.

Dodwell H., ed., *Despatches from England, 1681–1686*. Madras: Superintendent Government Press, 1914.

Donkin, R. A. *Dragon's Brain Perfume: An Historical Geography of Camphor*. London: Brill, 1999.

Drake, Ellen Tan, *Restless Genius: Robert Hooke and his Earthly Thoughts*. Oxford: OUP, 1996.

Draper, James David, *The Arts under Napoleon*. New York, Met Publications, 1978.

DuPont Chandler Jr, Alfred, and Stephen Salsbury, *Pierre S. Du Pont and the Making of the Modern Corporation*. Washington DC: Beard Books, 2000.

Dutt, Romesh, *The Economic History of India In the Victorian Age, Vol. II*. London: Kegan, Paul, Trench, Trubner, 1904.

E. I. du Pont de Nemours: *Nylon: The First 25 Years*. Wilmington, DE: E. I. du Pont de Nemours & Co., 1963.

Earnshaw, Pat, *The Identification of Lace*. Princes Risborough: Shire, 1994.

Eekelen, Willem Frederik van, *Indian Foreign Policy and the Border Dispute with China*. Leiden: Martinus Nijhoff, 1964.

Einhard and Notker the Stammerer, *Two Lives of Charlemagne*, trans. Lewis Thorpe. Harmondsworth: Penguin Books, 1969.

Essinger, James, *Jacquard's Web: How a Hand-loom Led to the Birth of the Information Age*. Oxford: OUP, 2007.

Feliks, Yehuda, 'Relation between heredity and environment', in *Nature & Man in the Bible: Chapters in Biblical Ecology*, London: Soncino, 1981, 6–13.

Ferrar, Virginia (published anonymously, under the name of Samuel Hartlib), *The reformed Virginian silk-worm, or, a rare and new discovery of a speedy way, and easie means, found out by a young lady in England, she having made full proof thereof in May, anno 1652*. London: Samuel Hartlib, 1655.

Fitton, R. S., *The Arkwrights: Spinners of Fortune*. Manchester: Manchester University Press, 1989.

Fitzrandolph, Mavis, *Traditional Quilting: Its Story and its Practice*. London: B. T. Batsford Ltd, 1954.

Folsach, Kjeld von and Anne-Marie Keblow Bernsted, *Woven Treasures: Textiles from the World of Islam*, trans. Martha Gaber Abrahamsen. Copenhagen: The David Collection, 1993.

Forbes Royle, J., *The Fibrous Plants of India, Fitted for Cordage, Clothing, and Paper. With an Account of the Cultivation and Preparation of Flax, Hemp, and their Substitutes*. London: Smith Elder & Co., 1855.

Francis, Richard, *Fruitlands: The Alcott Family and Their Search for Utopia*. New Haven, CT: Yale University Press, 2010.

Fraser, Eugenie, *A Home by the Hooghly: A Jute wallah's Wife*. Edinburgh: Mainstream Publishing, 1989.

Freeman, Roland L., *A Communion of the Spirits: African American Quilters, Preservers, and their Stories*. Nashville, TN: Rutledge Hill Press, 1996.

French, Gilbert James and Robert Cole, *The Life and Times of Samuel Crompton: Inventor of the Spinning Machine*. Manchester: Thomas Dinham & Co. 1860.

Furetière Antoine, *Dictionnaire universel: contenant generalement tous les mots françois, tant vieux que modernes & les termes des sciences et des arts*. Rotterdam: Reinier Leers, 1708.

Gandhi, Rajmohan, *Gandhi: The Man, his People and the Empire*. Berkeley, CA: University of California Press, 2008.

Garrett, Valery M., *Mandarin Squares*. Hong Kong: OUP, 1990.

Gately, Iain, *Tobacco: A Cultural History of How an Exotic Plant Seduced Civilization*. London: Simon & Schuster, 2001.

Gibbon, Edward, *The History of the Decline and Fall of the Roman Empire (A new edition)*, volume 10. London: Strahan, Cadell, Davies, 1797.

Gilmartin, P. M., 'On the origins of observations of heterostyly in *Primula*', *New Phytologist* 208(1), 10 August 2015, 39–51; https://doi.org/10.1111/nph.13558

Gordon, Beverley, *Textiles: The Whole Story*. London: Thames & Hudson, 2011.

Gore, Robert, Science History Institute interview, 'Scientists You Must Know: Robert Gore'. Chemical Heritage Foundation 2015, https://vimeo.com/103516807

Grant, James Augustus, *A Walk Across Africa: Or, Domestic Scenes from My Nile Journal*. London: Blackwood, 1864.

Graves, Robert, *The Greek Myths*. London: Folio Society, 1996.

Great Exhibition Catalogue, *Great Exhibition of the Works of Industry of All Nations, Official Descriptive and Illustrated Catalogue Part IV*. London: Spicer Brothers, 1851.

Greenpeace, *Leaving Traces: The Hidden Hazardous Chemicals in Outdoor Gear*. Hamburg: Greenpeace Germany, 2016.

Grimm, Jacob and Wilhelm, *Household Tales: The Harvard Classics*, Charles W. Eliot, ed. New York: P. F. Collier & Son, 1909–1914.

Grimmer-Solem, Erik, *Learning Empire: Globalization and the German Quest for World Status 1875–1919*. Cambridge: CUP, 2019.

Guerber, H. A., *Myths of the Norsemen: From the Eddas and Sagas*. London: George G. Harrap, 1914.

Guerra, Victor, 'Transhumance in the Cordillera Cantabrica', in Robin Walker, *Walking in the Cordillera Cantabrica: A Mountaineering Guide*. Milnthorpe, Cumbria: Cicerone, 2010, 177–81.

Gunther, Marc: 'Behind the scenes at the Sustainable Apparel Coalition', Guardian Sustainable Business US, 26 July 2012. https://apparelcoalition.org/behind-the-scenes-at-the-sustainable-apparel-coalition/

Handa, O. C., *Buddhist Western Himalaya: A Politico-Religious History*. New Delhi: Indus Publishing 2001.

Hansen, Valerie, *The Silk Road: A New History*. Oxford, OUP, 2015.

Hareven, Tamara K., *The Silk Weavers of Kyoto: Family and Work in a Changing*

Traditional Industry. Berkeley and Los Angeles, CA: University of California Press, 2002.

Harlow, Mary, '*Palla, pallu, chador*: draped clothing in ancient and modern cultures', in Marie-Louise Nosch, Zhao Feng and Lotika Varadarajan, eds, *Global Textile Encounters*. Oxford and Philadelphia: Oxbow Books, 2014, 15–24.

Harris, John R., *Industrial Espionage and Technology Transfer: Britain and France in the Eighteenth Century*. London: Routledge, 1998.

Hawkesworth, John, John Samuel Wallis, John Byron, Philip Carteret, James Cook, Joseph Banks. *An Account of the Voyages Undertaken by the Order of His Present Majesty for Making Discoveries in the Southern Hemisphere Volumes 1 and 3*. London: Strahan and Cadell, 1773.

Haynes, Clare, 'A 'Natural' Exhibitioner: Sir Ashton Lever and his Holosphusikon', *British Journal for Eighteenth-Century Studies* 24, 2001, 1–14.

Hearn, Lafcadio, *Two Years in the French West Indies*. New York: Harper & Brothers, 1890.

Heinrich, Linda, *The Magic of Linen: Flax Seed to Woven Cloth*. Victoria, BC: Orca Books, 1992.

Hermkens, Anna-Karina, *Engendering Objects: Dynamics of Barkcloth and Gender among the Maisin of Papua New Guinea*. Leiden: Sidestone Press, 2013.

Hermkens, Anna-Karina, *Painting the Past And The Future: Barkcloth of the Maisin People in Papua New Guinea*. Leiden: National Museum of Ethnology, 2005.

Hermes, Matthew E., *Enough for one Lifetime: Wallace Carothers, Inventor of Nylon*, Washington DC: American Chemical Society and the Chemical Heritage Foundation, 1996.

Hickey, William, *Memoirs of William Hickey, Volume II (1775–1782)*. Alfred Spencer, ed. London: Hurst & Blackett, 1782.

Hillis Miller, J., *Ariadne's Thread: Story Lines*. New Haven: Yale University Press, 1995.

Hobbs, Sandy, Jim McKechnie, Michael Lavalette, *Child Labor: A World History Companion*. Santa Barbara, CA: ABC-Clio, 1999.

Honig, Emily, *Sisters and Strangers: Women in the Shanghai Cotton Mills 1919–1949*. Stanford, CA: Stanford University Press, 1986.

Hooke, Robert, *Micrographia, or, Some Physiological Descriptions of Minute Bodies Made by Magnifying Glasses*. London: Royal Society, 1665.

Horn, D. B. and Mary Ransome, eds, *English Historical Documents, Volume X, 1714–1783*. New York: Oxford University Press, 1969.

Horton, Helena, 'National Trust for Scotland to freeze entire contents of 17th-century home to solve moth problem', *The Daily Telegraph*, 4 February 2019. https://www.telegraph.co.uk/news/2019/02/04/scottish-national-trust-undertake-largest-ever-moth-extermination/

Horwell, Veronica, 'Brocade parade', a review of *The Cambridge History of Western Textiles*, David Jenkins, ed., *The Guardian*, 24 April 2004.

von Hügel, Charles, *Kashmir Under Maharaja Ranjit Singh: its Artistic Products,*

Taxation System, Imports & Exports, and Trade, trans. D. C. Sharma. New Delhi: Atlantic, 1984.

Huis, Arnold van, 'Cultural significance of Lepidoptera in sub-Saharan Africa', *Journal of Ethnobiology and Ethnomedicine* 15(26), 2019.

Hukuhara, Toshihiko, 'The etiology of flacherie, one of the great scourges of sericulture', *Journal of Insect Biotechnology and Sericology* 83(2), 2014, 25–31.

Hulanicki, Barbara, *From A to Biba*. London: Hutchinson, 1983.

Hunter, Janet, *The Islanders and the Orb: The History of the Harris Tweed Industry 1835–1995*. Stornoway: Acair, 2001.

Huxley, Aldous, *Beyond the Mexique Bay*. London: Chatto & Windus, 1934.

Ibn Fadlan, 'The Risalah of Ibn Fadlan: An annotated translation with introduction', trans. James E. McKeithen (PhD dissertation), Department of Near Eastern Languages and Literatures, Indiana University, 1979. https://studylib.net/doc/7357503/the-travel-account--indiana-university

Irwin, John, *The Kashmir Shawl*. London: Her Majesty's Stationery Office, 1973.

Jack, Alfred, *Pop Goes the Weasel*. London: Penguin, 2008.

Jackson, Anna and Edward Behrens, 'Wrap session', *V&A Magazine*, Winter 2019, 24–27.

Jahangir, Nur-ud-din, *Memoirs of Jahangir (The Tuzuk-i-Jahangir)*, volume II, trans. Alexander Rogers, Henry Beveridge, ed. Delhi: Low Price Publications, 2001.

Jardine, Lisa, *Ingenious Pursuits: Building the Scientific Revolution*. London: Abacus, 1999.

Jenkins, David, ed., *The Cambridge History of Western Textiles*. Cambridge: CUP, 2003.

Jesse, William, *The life of George Brummell Commonly Called Beau Brummell, Volume 2*. London: Saunders & Otley, 1844.

Jewkes, John, David Sawers and Richard Stillerman, *The Sources of Invention*. London: Palgrave Macmillan, 1969.

Johnson, R. Wally, *Fire Mountains of the Islands: A History of Volcanic Eruptions and Disaster Management in Papua New Guinea and the Solomon Islands*. Canberra: ANU Press, 2013. http://press-files.anu.edu.au/downloads/press/p223471/pdf/cho82.pdf

Johnson, Samuel and James Boswell, *A Journey to the Western Islands of Scotland / The Journal of a Tour to the Hebrides*. London: The Folio Society, 1990.

Johnston, Ruth A., *All Things Medieval: An Encyclopedia of the Medieval World, Volume 1*. Santa Barbara, CA: Greenwood, 2011.

Jones, Ann Rosalind and Peter Stallybrass, *Renaissance Clothing and the Materials of Memory*. Cambridge: CUP, 2000.

Jones, Jen, *Welsh Quilts*. Carmarthen: Towy, 1997.

Jones, Owen, *The Grammar of Ornament*. London: Day & Son, 1856.

Kalarthi, Mululbhai, *Ba and Bapu*, trans. Gurdial Mallik. Ahmedabad: Navajivan Publishing House, 1962.

Kessel, Ineke van, 'West African soldiers in the Dutch East Indies', *Transactions of the Historical Society of Ghana*, New Series, no. 9, 2005, 41–60.

Kimbrel, Andrew, ed., *Fatal Harvest: The Tragedy of Industrial Agriculture*. Sausalito: Island Press, 2002.

Kingsbury, Noel, *Hybrid: The History and Science of Plant Breeding*. Chicago: University of Chicago Press, 2009.

Klein, Julius 'The alcalde entregador of the Mesta', *Bulletin Hispanique* 17(2), 1915, 85–154.

Knolle, F. et al., 'Sheep recognize familiar and unfamiliar human faces from two-dimensional images', *Royal Society Open Science*, 8 November 2017; DOI: 10.1098/rsos.171228

Kolanjikombil, Mathews, *Encyclopaedic Dictionary of Textile Terms*. New Delhi: Woodhead Publishing, 2017.

Kouymjian, Dickran, 'Armenian altar hangings: New Julfa to Jerusalem', *Hali* 186, Winter 2015, 62–73.

Kvavadze, Eliso, Ofer Bar-Yosef, Anna Belfer-Cohen, Elisabetta Boaretto, Nino Jakeli, Zinovi Matskevich and Tengiz Meshveliani, '30,000 years old wild flax fibers – testimony for fabricating prehistoric linen', *Science* 325(5946), 11 September 2009, 1359. http://nrs.harvard.edu/urn-3:HUL.InstRepos:4270521

Kwass, Michael, *Contraband: Louis Mandrin and the Making of a Global Underground*. Boston, MA: Harvard University Press, 2014.

Kwolek, Stephanie, interview by Bernadette Bensaude-Vincent, Wilmington, DE, 21 March 1998 (Philadelphia: Chemical Heritage Foundation, Oral History Transcript #0168). https://oh.sciencehistory.org/sites/default/files/kwolek_sl_0168_full.pdf

Lakwete, Angela, *Inventing the Cotton Gin: Machine and Myth in Antebellum America*. Baltimore, MD, and London: Johns Hopkins University Press, 2003.

Lalvani, Kartar, *The Making of India: The Untold Story of British Enterprise*. London: Bloomsbury, 2016.

Lasteyrie, Charles, *An Account of the Introduction of Merino Sheep Into the Different States of Europe, and at the Cape of Good Hope*, trans. Benjamin Thompson. London: John Harding, 1810.

Lawson, Ian, *Saorsa: The Outer Hebrides, Scotland*, Lake District: Ian Lawson Books, 2019.

Leadbeater, Eliza, *Spinning and Spinning Wheels*. Oxford: Shire Publications, 1979.

Leask, David, 'English Harris Tweed tycoon gifts Stornoway mill to its local manager', *The Herald*, 3 September 2019. https://www.heraldscotland.com/business_hq/17875894.english-harris-tweed-tycoon-gifts-stornoway-mill-local-manager/

Legislature of the State of California, Appendix to the Journals of the Senate and Assembly of the 29th Session, Volume VIII. Sacramento, CA: State Office, 1891.

Leitner, Gottlieb Wilhelm, *Account of Shawl-weaving and of the Signs for the*

Numbers and Colours Used in the Manufacture of Shawls as Well as by an Analysis of a Shawl-pattern, and by Four Pages of Shawl-writing. India: Punjab Government Civil Secretariat Press, 1882.

Lemire, Beverly, *Cotton: Textiles that Changed the World*. Oxford and New York: Berg, 2011.

Levi, Primo, *The Black Hole of Auschwitz*, Marco Belpoliti, ed., trans. Sharon Wood. Cambridge: Polity Press, 2005.

Lévi-Strauss, Monique, *Cashmere: A French Passion 1800–1880*. London: Thames & Hudson, 2013.

Leyerle, John, 'The Interlace Structure of *Beowulf*', *University of Toronto Quarterly* 37(1), 1967: 1–17, muse.jhu.edu/article/571732

Li, D., et al., 'The oldest bark cloth beater in southern China (Dingmo, Bubing basin, Guangxi)', *Quaternary International* 354, 15 December 2014. http://dx.doi.org/10.1016/j.quaint.2014.06.062

Linder, Adolphe, *The Swiss at the Cape of Good Hope, 1652–1791*. Basel: Basler Afrika Bibliographien, 1997.

Lister, Ted, *Classic Chemistry Demonstrations: One Hundred Tried and Tested Experiments*, Catherine O'Driscoll and Neville Reed, eds. London: Education Division, Royal Society of Chemistry, 1995.

Liu, Xinru, *Silk and Religion: An Exploration of Material Life and the Thought of People AD 600–1200*. Delhi: OUP India, 1998.

London, Jack, *The Jacket*. London: Mills & Boon, 1915.

Longley, Michael, *Collected Poems*. London: Jonathan Cape, 2007.

Lubec, G., J. Holaubek, C. Feldl, B. Lubec & E. Strouhal, 'Use of silk in ancient Egypt', *Nature* 362, 1993, 25.

Ma, Debin, 'Why Japan, not China, was the first to develop in East Asia: lessons from sericulture, 1850–1937', *Economic Development and Cultural Change* 52(2), February 2004, 369–94 DOI: 10.1086/380947

MacCarthy, Fiona, *Walter Gropius: Visonary Founder of the Bauhaus*. London: Faber & Faber, 2020.

Macdonald, Donald, *Lewis, A History of the Island*. Edinburgh: G Wright, 1978.

MacDonald, Finlay J., *Crowdie and Cream and Other Stories: Memoirs of a Hebridean Childhood*. London, 1982.

Magnusson, Sally, *Life of Pee: The Story of How Urine Got Everywhere*. London: Aurum Press, 2011.

Maiwada Salihu and Elisha Renne, 'The Kaduna textile industry and the decline of textile manufacturing in Northern Nigeria, 1955–2010', *Textile History* 44(92), November 2013.

Malinowski, Bronislaw, *Magic, Science and Religion and Other Essays*. London: Souvenir Press, 1974.

Mariner, William, *An Account of the Natives of the Tonga Islands, in the South Pacific Ocean, Volume 1*. London: Constable and Company, 1827.

Maron, Dina Fine, 'A rare antelope is being killed to make £15,500 scarves',

National Geographic, 26 April 2019. https://www.nationalgeographic.co.uk/
environment/2019/04/rare-antelope-being-killed-make-ps15500-scarves

Masterson, Daniel, *The History of Peru*. Westport, CT, and London: Greenwood Press, 2009.

Mazumdar, Labanya, *Textile Tradition of Assam: An Empirical Study*. Guwahati: Bhabani Books, 2013.

Mee, Arthur, ed., *Somerset: County of Romantic Splendour*. London: Hodder & Stoughton, 1940.

Memes, John S., *Memoirs of Napoleon Bonaparte, from the French of M. Fauvelet de Bourrienne, Volume I*. Edinburgh: Constable and Co., 1831.

Mendelson, Cheryl, *Laundry: The Home Comforts Book of Caring for Clothes and Linens*. New York: Scribner, 1999.

Mensch, Nicolas, *La Rhodiacéta de Besançon: Paroles ouvrières*. Paris: L'Harmattan, 2018.

Meserve, H. C., *Lowell – An Industrial Dream Come True*. Boston, MA: The National Association of Cotton Manufacturers, 1923.

Mills, Kenneth and William B. Taylor, eds, *Colonial Spanish America: A Documentary History*. Wilmington, DE: Scholarly Resources, 1998.

Modjeska, Drusilla, 'Fabric of wisdom: the context of Ömie nioge', in Sana Balai and Judith Ryan, *Wisdom of the Mountain: Art of the Ömie*. Melbourne: National Gallery of Victoria, 2009, 21–30.

de Monchaux, Nicholas, *Spacesuit: Fashioning Apollo*. Cambridge MA: MIT Press, 2011.

Moncrieff, R. W., *Man-Made Fibres*. New York: Halstead Press, 1975.

Moorcroft, William, George Trebeck and Horace Hayman Wilson, *Travels in the Himalayan Provinces of Hindustan and the Panjab; in Ladakh and Kashmir; in Peshawar, Kabul, Kunduz, and Bokhara from 1819 to 1825, Volume 2*. London: John Murray, 1841.

Moulherat, Christophe, Margareta Tengberg, Jérôme-F. Haquet, Benoît Mille, 'First evidence of cotton at Neolithic Mehrgarh, Pakistan: analysis of mineralized fibres from a copper bead', *Journal of Archaeological Science* 29, 2002, 1393–1401 https://www.harappa.com/sites/default/files/pdf/First_Evidence_of_Cotton_at_Mehrgarh.pdf

Muir, Kenneth, 'Pyramus and Thisbe: a study in Shakespeare's method', in *Shakespeare Quarterly* 5(2), Spring, 1954, 141–53.

Murray, Anna and Grace Winteringham, *Patternity: A New Way of Seeing*. London: Hachette, 2015.

Myers, Kathleen Ann, *Neither Saints nor Sinners: Writing the Lives of Women in Spanish America*. Oxford: OUP, 2003.

Nagy, Zs., A. Németh, S. Mihályfi, 'The short history of Hungarian sheep breeding and Hungarian merino breed', http://journal.ke.hu/aak/index.php/aak/article/viewFile/566/566

Naik, V. B., P. P. Pusadkar, S. T. Waghmare et al., 'Evidence for population

expansion of Cotton pink bollworm *Pectinophora gossypiella* (Saunders) (Lepidoptera: Gelechiidae) in India', *Scientific Reports* 10, 4740, 16 March 2020; https://doi.org/10.1038/s41598-020-61389-1

Namgail, Tsewang, Vash Veer Bhatnagar, Charudutt Mishra, Sumanta Bagchi, 'Pastoral nomads of the Indian Changthang: production system, land use and socioeconomic changes', in *Human Ecology* 35, 2007, 497–504.

Ndiaye, Pap A., *Nylon and Bombs: DuPont and the March of Modern America*, trans. Elborg Foster. Baltimore, MD: The Johns Hopkins University Press, 2007.

Nelson, Lewis S., Richard D. Shirh, Michael J. Ballick, *Handbook of Poisonous and Injurious Plants*. New York: Springer, 2007.

Northrup, Solomon, *Twelve Years A Slave: Narrative of Solomon Northup, a Citizen of New-York, Kidnapped in Washington City in 1841, and Rescued in 1853 from a Cotton Plantation near the Red River in Louisiana.* London: Sampson Low, Son & Co., 1853.

Norwich, John Julius, *The Normans in the South*. London: Solitaire, 1967.

O'Bryan, Aileen, *The Dîné: Origin Myths of the Navajo Indians*. Washington DC: US Government Printing Office, 1956.

Olmsted, Denison, *Memoir of Eli Whitney, Esq*. New Haven, CT: Durrie & Peck, 1846.

Ömie Artists, *Hijominoe Modejade (Guided by Ancestors)*, Brennan King, ed. Brisbane: Andrew Baker, 2015.

Owen-Crocker, Gale, Elizabeth Coatsworth and Maria Hayward, eds, *Encyclopaedia of Medieval Dress and Textiles of The British Isles, c. 450–1450*. Leiden: Brill, 2011.

Palliser, Mrs, *A History of Lace*. London: Sampson Low, 1902.

Palmer, Martin, *The Jesus Sutras: Rediscovering the Lost Scrolls of Taoist Christianity*. New York: Ballantine, 2001.

Parker, Rozsika, *The Subversive Stitch*. London: The Women's Press, 1984.

Parry, Caleb Hillier, *An Essay on the Nature, Produce, Origin, & Extension of the Merino Breed of Sheep*. London: W. Bulmer & Company, 1807.

Pearson, John D. 'A Mendelian interpretation of Jacob's sheep', *Science & Christian Belief* 13.1, April 2001, 51–58.

Peck, Amelia, ed., *Interwoven Globe: The Worldwide Textile Trade 1500–1800*. London: Thames & Hudson, 2013.

Peck, Harry Thurston, ed., *Harpers Dictionary of Classical Antiquities*. London: Osgood & Co. 1897.

Péres, Liliane, 'Inventing in a world of guilds: silk fabrics in eighteenth-century Lyon', in S. R. Epstein and Maarten Prak, eds, *Guilds, Innovation and the European Economy 1400–1800*, Cambridge: CUP 2008, 232–63.

Petronius, *Satyricon*, trans. Michael Heseltine. London: William Heinemann, 1913.

Picton, John and John Mack, *African Textiles*. London: British Museum Press, 1989.

Pires, Tomé, *The Suma Oriental of Tomé Pires: An Account of the East, from the*

Red Sea to Japan, Written in Malacca and India in 1512–1515, trans. Armando
Cortesão. London: Hakluyt Society, 1944.

Platoff, Anne M., 'Where no flag has gone before: political and technical aspects
of placing a flag on the moon', NASA Contractor Report, 1 August 1993.
https://escholarship.org/uc/item/93t5x9dq

Pliny, *The Natural History*, trans. John Bostock and H. T. Riley. London: Henry G.
Bohn, 1860.

Poczai, Péter, Neil Bell, Jaakko Hyvönen, 'Imre Festetics and the Sheep Breeders'
Society of Moravia: Mendel's forgotten "Research Network"', *PLOS Biology*
12(1), January 2014.

Pogue, Kate Emory, *Shakespeare's Family*. Westport, CT: Praeger, 2008.

Poiret, Paul, *King of Fashion: The Autobiography of Paul Poiret*. London: V&A
Publishing, 2009.

Polo-Díaz, A., M. Alonso Eguíluz, M. Ruiz, S. Pérez, J. Mújika, R. M. Albert, J.
Fernández Eraso, 'Management of residues and natural resources at San
Cristóbal rock-shelter: contribution to the characterisation of chalcolithic
agropastoral groups in the Iberian Peninsula', *Quaternary International* 414,
September 2016, 202–25.

Ponting, K. G., *A History of the West of England Cloth Industry*. London:
MacDonald, 1979.

Post, Emily, *Etiquette in Society, In Business, In Politics and at Home*. New York: Funk
& Wagnalls, 1922.

Prichard, Sue, ed., *Quilts 1700–2010: Hidden Histories, Untold Stories*. London, V&A
Publishing, 2010.

Purananda, Jane, ed., *The Secrets of Southeast Asian Textiles: Myth, Status and the
Supernatural*, the James H. W. Thompson Foundation Symposium Papers.
Bangkok: River Books, 2007.

Rasanayagam, Mudaliyar C., *Ancient Jaffna: Being a Research into the History of
Jaffna*. New Delhi, Chennai: Asian Educational Services, 2003.

Ray, Prafulla Chandra, *Life and Experiences of a Bengali Chemist*. Calcutta:
Chuckervertty, Chatterjee & Co., 1932.

Rees, Abraham, *The Cyclopaedia, Volume 10*. London: Longman, Hurst, Rees,
Orme & Brown, 1820.

Reischauer, Haru Matsukata, *Samurai and Silk: A Japanese and American Heritage*.
Harvard: Belknap Press, 1986.

Rémusat, Madame de, Lady-in-Waiting to the Empress, *Memoirs of the Empress
Josephine, Volume II*. New York: P. F. Collier & Son, 1879.

Richards, Eric, *The Highland Clearances*. Edinburgh: Birlinn, 2000.

Riello, Giorgio and Prasannan Parthasarathi, *The Spinning World: A Global History
of Cotton Textiles 1200–1850*. Oxford: OUP, 2009.

Ripperda, Johan Willem, *Memoirs of the Duke de Ripperda*. London: John Stagg,
1790.

Rizvi, Janet, *Pashmina: The Kashmir Shawl and Beyond*. Mumbai: Marg Publishing, 2009.

Roche, Daniel, *The Culture of Clothing: Dress and Fashion in the Ancien Regime*, trans, Jean Birrell. Cambridge: CUP, 1977.

Rodricks, Wendell, *Moda Goa: History and Style*. Noida U.P.: HarperCollins, 2012.

Roe, Thomas Sir, *The Embassy of Sir Thomas Roe to the court of the Great Mogul, 1615–1619, as Narrated in his Journal and Correspondence Volumes I and II*, Sir William Foster, ed. London: Hakluyt Society, 1899.

Roe Smith, Merritt, 'Eli Whitney and the American system of manufacturing', in *Technology in America: A History of Individuals and Ideas*, Carroll W. Pursell, ed. Cambridge, MA: MIT Press, 1981, 45–61.

Rookmaaker, L. C., *The Zoological Exploration of Southern Africa 1650–1790*. Rotterdam: A.A. Balkema, 1989.

Rose, Jonathan, *The Intellectual Life of the British Working Classes*. New Haven, CT: Yale University Press, 2001.

Rosenberg, Chaim M., *The Life and Times of Francis Cabot Lowell, 1775–1817*. Lanham, MD: Lexington Books, 2011.

Ross, Doran H., 'Asante cloth names and motifs', in *Wrapped in Pride: Ghanaian Kente and African American Identity*, 107–26. Los Angeles, CA: UCLA Fowler Museum of Cultural History, 1998.

Rosser, William Henry and J. F. Imray, *The Seaman's Guide to the Navigation of the Indian Ocean and China Sea: Including a Description of the Wind, Storms, Tides, Currents, &c., Sailing Directions*. London: J. F. Imray, 1867.

Roth, Henry Ling, *Studies in Primitive Looms*. Halifax: F. King & Sons, 1918.

Ruskin, John, *Fors Clavigera: Letters to the Workmen and Labourers of Great Britain, Volume I*. London: George Allen, 1902.

Sahlins, Marshall, *Islands of History*. Chicago: University of Chicago Press, 1985.

St Clair, Kassia, *The Golden Thread: How Fabric changed History*. London: John Murray, 2018.

Saint-Pierre, Jacques-Henri Bernardin de, *Paul et Virginie*. Paris: L'Imprimerie de Monsieur, 1789.

Salmon, Mary, 'Some Australian pioneers: Captain John Macarthur no. 4', *The Sunday Times* (Sydney), 12 December 1909, 16.

Sato, Shigeru, 'Japanization in Indonesia re-examined: the problem of self-sufficiency in clothing', in *Imperial Japan and National Identities in Asia, 1895–1945*, Li Narangoa and Robert Cribb, eds. London: Routledge, 2003, 270–96.

Schele, Linda, 'Foreword', in *The Maya Textile Tradition*, Jeffrey J. Foxx, Linda Asturias de Barrios, Margot Blum Schevill et al., eds. New York: Harry N. Abrams, 1997.

Schoeser, Mary, *Silk*. New Haven, CT: Yale University Press, 2007.

Sears, Clara Endicott, *Bronson Alcott's Fruitlands*. Boston, MA: Houghton Mifflin, 1915.

Seeley, Robert Benton, *Memoirs of the Life and Writings of Michael Thomas Sadler.* London: R. B. Seeley and W. Burnside, 1842.

Shady Solis, Ruth, Jonathan Haas, Winifred Creamer, 'Dating Caral, a preceramic site in the Supe Valley on the central coast of Peru,' *Science* 292(5517), May 2001, 723–26.

Shaw, Alexander, ed., *A Catalogue of the Different Specimens of Cloth Collected in the Three Voyages of Captain Cook to the Southern Hemisphere.* London: Alexander Shaw, 1787.

Siebenbrodt, Michael, Lutz Schöbe, *Bauhaus: 1919–1933, Weimar-Dessau-Berlin.* New York: Parkstone Press, 2009.

Skinner & Co., *A catalogue of the Portland Museum: lately the property of the Duchess Dowager of Portland, deceased: Which will be sold by auction by Mr. Skinner and Co. On Monday the 24th of April, 1786, and the thirty-seven following days, at Twelve o'clock, Sundays and the 5th of June, (the Day his Majesty's Birth-Day is kept) excepted*, 1786.

Smith, William, *A Dictionary of Greek and Roman Antiquities.* London: John Murray, 1875.

Snodgrass, Mary Ellen, *World Clothing and Fashion: An Encyclopedia of History, Culture, and Social Influence.* London: Routledge, 2015.

Snyder, Jane McIntosh, 'The web of song: weaving imagery in Homer and the Lyric Poets', in *The Classical Journal* 76(3), February–March 1981, 193–96.

Sorenson, Lloyd R. 'Laissez faire and the Factory Acts', in *The Journal of Economic History* 12(3), Summer, 1952, 247–62.

Speke, John Hanning, *Journal of the Discovery of the Source of the Nile*, 2nd edition. Edinburgh: W. Blackwood & Sons, 1864.

Steven, Margaret, 'Macarthur, John (1767–1834)', *Australian Dictionary of Biography*, National Centre of Biography, Australian National University, http://adb. anu.edu.au/biography/macarthur-john-2390/text3153.

Stewart, G. 'Endgame for jute: Dundee and Calcutta in the twentieth century', in J. Tomlinson and C. A. Whatley, eds, *Jute No More: Transforming Dundee.* Dundee: Dundee University Press, 2011.

Stimpson, George, *Information Roundup.* New York and London: Harper and Brothers, 1948.

Stone, Glenn Davis, 'Commentary: biotechnology and suicide in India', *Anthropology News* 43(5), May 2002, 5. https://doi.org/10.1111/an.2002.43.5.5.2

Strickland, Mary and Jane Margaret Strickland, *A Memoir of the Life, Writings, and Mechanical Inventions of Edmund Cartwright.* London: Saunders and Otley, 1843.

Sussex Archaeological Society, *Sussex Archaeological Collections Relating to the History and Antiquities of the County*, Sussex Archaeological Society, 1858.

Sutton, Ann, *The Structure of Weaving.* London: B. T. Batsford, 1982.

Swedburg, Richard, 'Mercantilist-utopian projects in eighteenth-century Sweden',

in *The Economy of Hope*, ,Hirokazu Miyazaki and Richard Swedburg, eds. Philadelphia: University of Pennsylvania Press, 2017.

Tarlo, Emma, *Clothing Matters: Dress and Identity in India*. London: Hurst & Co., 1996.

The Society for the Diffusion of Useful Knowledge, *Useful and Ornamental Planting*, London: Baldwin & Cradock, 1832.

Thomas, Gigesh, and Johan De Tavernier, 'Farmer-suicide in India: debating the role of biotechnology', *Life Sciences, Society and Policy* 13(1), 2017, 8. https:// www.ncbi.nlm.nih.gov/pmc/articles/PMC5427059/

Thomas, Nicholas, 'Introduction', in *Made in Oceania: Tapa – Art and Social Landscapes*, Peter Messenholler and Oliver Lueb, eds. Köln: Rautenstrauch-Joest-Museum; Mainz am Rhein: Nünnerich-Asmus, 2013, 14–23.

Thomas, Rev., *The Cathedral Church of Manchester*. London: George Bell, 1901.

Thompson, Francis: *Harris Tweed: The Story of a Hebridean Industry*. Newton Abbot, Devon: David & Charles (Publishers) Ltd, 1969.

Thomson, Thomas, *Western Himalaya and Tibet: A Narrative of a Journey Through the Mountains of Northern India, During the Years 1847–8*. London: Reeve and Co., 1852.

Tomlin, James William Sackett, *Awakening: A History of the New Guinea Mission*. London: New Guinea Mission, 1951.

Tortora, Phyllis G., and Robert S. Merkel, *Fairchild's Dictionary of Textiles 7th Edition*. New York: Fairchild Publications, 1996.

Totton, Mary-Louise, *Wearing Wealth and Styling Identity: Tapis from Lampung, South Sumatra, Indonesia*. Hanover, NH: Hood Museum of Art, 2009.

Trippi, Peter, *J W Waterhouse*. London: Phaidon, 2005.

Vainker, Shelagh, *Chinese Silk: A Cultural History*. London: British Museum, 2004.

Vallery-Radot, René, *Louis Pasteur, His Life and Labours, by his Son-in-Law*, trans Lady Claud Hamilton. New York: D. Appleton & Co., 1886.

Vedeler, Marianne, *Silk for the Vikings*. Oxford: Oxbow Books, 2014.

Veys, Fanny Wonu, *Unwrapping Tongan Barkcloth: Encounters, Creativity and Female Agency*. London: Bloomsbury, 2017.

Viot, Christopher, 'Domestication and varietal diversification of Old World cultivated cottons (*Gossypium* sp.) in the Antiquity', *Revue d'ethnoécologie: Cotton in the Old World* 15, 2019. http://journals.openedition.org/ ethnoecologie/4404

Vollmer, John E., 'Clothed to rule the universe: Ming and Qing Dynasty textiles at the Art Institute of Chicago', Chicago: Art Institute of Chicago, 2000.

Wahlquist, Calla, 'Shocking live export conditions not uncommon, animal rights groups say', *The Guardian*, 8 April 2018, https://www.theguardian.com/world/2018/apr/08/ shocking-live-export-conditions-not-uncommon-say-animal-rights-groups

Wallace, D. R., *The Romance Of Jute: A Short History Of The Calcutta Jute Mill Industry, 1855–1927*. London: W. Thacker & Co., 1928.

Walling, Philip, *Counting Sheep; A Celebration of the Pastoral Heritage of Britain*. London: Profile Books, 2014.

Wallis Budge, E. A., *From Fetish to God in Ancient Egypt*. London: Routledge, 2005.

Warden, Alex Johnston, *The Linen Trade, Ancient and Modern*. London: Longman, Roberts & Green, 1867.

Watson, John F. *Annals of Philadelphia and Pennsylvania in the Olden Time, Volume 2*. Philadelphia, 1857, 424–25.

Watt, James C. Y., Anne E. Wardwell, Morris Rossabi, *When Silk was Gold: Central Asian and Chinese Textiles*. New York: Metropolitan Museum of Art, 1997.

White, Robert, *A History of the Battle of Bannockburn*. Edinburgh: Edmonston and Douglas, 1871.

Wignall Simpson, B. S., *A Mountain Chapelry in Cumbria*. Ulpha, Cumbria: Ulpha Chapel Pamphlet, 1934.

Wilde, Edith E., 'Weights and Measures of the City of Winchester', reprinted from the Hampshire Field Club and Archaeological Society's Papers and Proceedings, 1931, 237–48. http://www.hantsfieldclub.org.uk/publications/hampshirestudies/digital/1920s/vol10/Wilde.pdf

Williams, Thomas and James Calvert, *Fiji and the Fijians Vol. I*. New York: D. Appleton & Co., 1858.

Wilson, Brian, 'My toast to a legend – but not in Old Havana', *The Sunday Times*, 27 November 2016, https://www.thetimes.co.uk/article/my-toast-to-a-legend-but-not-in-old-havana-dn7rglg62

Wilson Witzel, Morgan, *Fifty Key Figures in Management*. London: Routledge, 2003.

Wood, Gaby, *Edison's Eve: A Magical History of the Quest for Mechanical Life*. New York: Anchor Books, 2002.

Wood, Roger and Vítězslav Orel, 'Scientific breeding in Central Europe during the early nineteenth century: background to Mendel's later work', *Journal of the History of Biology* 38, 2005, 239–72.

Xue Yan, ed., *Living in Silk; 5000 Years of Chinese Silk Textiles*. Hangzhou and Prague: China National Silk Museum and Prague National Museum, 2006.

Yalçin, B. C., *Sheep and Goats in Turkey*. Rome: Food and Agriculture Organisation, 1986, http://www.fao.org/3/ah224e/AH224E05.htm

Yallop, H. J., *The History of the Honiton Lace Industry*. Exeter: University of Exeter, 1992.

Yates, James, *Textrinum Antiquorum: An Account of the Art of Weaving Among the Ancients. Part I. On the Raw Material Used for Weaving*. London: Taylor and Walton, 1843.

Ye, Lang, Zhengang Fei, Tianyou Wang, eds, *China: Five Thousand Years of History and Civilization*. Kowloon: City University of Hong Kong, 2007.

Zanier, Claudio: 'Overcoming the barrier of the Alps: silk and intellectual legacy of Mathieu Bonafous between Lyon and Turin', *Cromohs* 17, 2017, 1–14.

Zethner, Ole, Rie Koustrup, Dilip Barooah et al., *South Asian Ways of Silk*. Guwahati: Bookbell, 2015.

INDEX